W9-BCN-859

European Paintings
of the 16th, 17th, and 18th Centuries

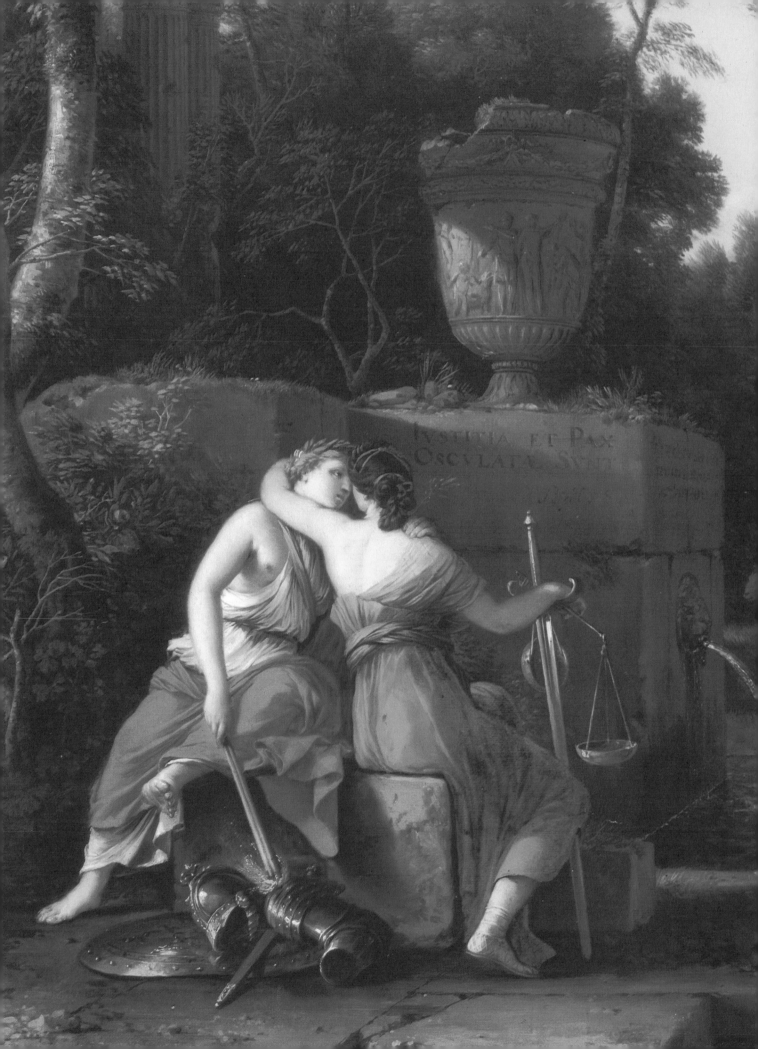

European Paintings of the 16th, 17th, and 18th Centuries

THE CLEVELAND MUSEUM OF ART
CATALOGUE OF PAINTINGS

PART THREE

WITHDRAWN
FROM THE
CARL B. YLVISAKER LIBRARY
Concordia College, Moorhead, MN

Published by The Cleveland Museum of Art : 1982

Trustees of
The Cleveland Museum of Art

George P. Bickford
James H. Dempsey, Jr.
George M. Humphrey II
James D. Ireland
Mrs. Edward A. Kilroy, Jr.
Ruben F. Mettler
Severance A. Millikin
Mrs. R. Henry Norweb, *honorary*
George Oliva, Jr.
A. Dean Perry
Mrs. Alfred M. Rankin
Daniel Jeremy Silver
Mrs. Frances P. Taft
Paul J. Vignos, Jr.
Alton W. Whitehouse, Jr.
John S. Wilbur, *honorary*
Lewis C. Williams
Norman W. Zaworski

The Cleveland Museum of Art
Catalogue Series

Catalogue of Paintings

Part One *European Paintings before 1500*
 (published 1974)
Part Two *Illuminated Manuscripts*
Part Three *European Paintings of the 16th, 17th,*
 and 18th Centuries (published 1982)
Part Four *European Paintings of the 19th Century*
Part Five *American Paintings to 1900*
Part Six *Modern Paintings*

Catalogue of Textiles

Part One *Early Christian and Islamic Tapestries*
 and Off-Loom Techniques
Part Two *Early Christian, Islamic, and European*
 Drawloom Silks

Catalogue of Oriental Art

Eight Dynasties of Chinese Painting: The Collections
 of the Nelson Gallery–Atkins Museum, Kansas City,
 and the Cleveland Museum of Art (published 1980)
Indian Miniatures
Japanese Prints

Catalogue of Ancient Art

Egypt

Frontispiece: Detail of *The Kiss of Peace and Justice*
by Laurent de La Hyre. Catalogue number 33.

Copyright 1982 by The Cleveland Museum of Art
11150 East Boulevard, Cleveland, Ohio 44106

Printed in the United States of America
Typesetting by The Stinehour Press, Lunenburg, Vermont 05906
Printing by The Meriden Gravure Company, Meriden, Connecticut 06450

Distributed by Indiana University Press, Bloomington, Indiana 47401

Library of Congress Cataloging in Publication Data
Cleveland Museum of Art
 The Cleveland Museum of Art Catalogue of Paintings.
 Includes index.
 Contents: — pt. 3. European paintings
of the 16th, 17th, and 18th centuries.
 1. Painting—Ohio—Cleveland—Catalogs.
2. Cleveland Museum of Art—Catalogs.
I. Lurie, Ann Tzeutschler.
N552.A574 759.94'074'017132 81-3961
ISBN 0-910386-66-8 AACR2

iv

Contents

Preface and Acknowledgements

Having fulfilled my promise of tardiness in the preface to *European Paintings Before 1500*, Catalogue of Paintings: Part One (published 1974), we are now able to present another catalogue devoted to the Cleveland Museum's collection of European paintings. This one, like its predecessor, was generously supported by a grant from the Ford Foundation.

In the foreword to the first catalogue Henry S. Francis, former Curator of Paintings and of Prints and Drawings who retired in 1967, paid tribute to the enlightened leadership and generosity of the individuals who founded this Museum and who were joined by many other generous benefactors over the years. Their gifts, bequests, and endowments enabled the steady growth of the Museum's collection of paintings, while maintaining the same high standards of quality set by the founders in 1916. Some of the paintings singled out for mention by Mr. Francis in the first catalogue actually appear in this one. In addition, in the span of the last ten or so years alone some sixty outstanding paintings have entered the collection; among them are such fine works as Ruisdael's *Landscape with a Dead Tree*, Oudry's *Hare and Leg of Lamb*, Gainsborough's *George Pitt, First Lord Rivers*, Liss's *Amor*, Bronzino's *Portrait of a Young Lady*, Caravaggio's *Crucifixion of St. Andrew*, Liotard's *Portrait of François Tronchin*, Boucher's *Fountain of Venus*, and Chardin's *Still Life with Herring*. All paintings from the given period in the permanent collection are included in this volume—even those relegated to storage for reasons of condition, attribution, or quality.

Like its predecessor, the present catalogue is the cumulative effort of many years, based on the work begun by Henry S. Francis and continued by his associates and the present staff of the Department of Paintings. Joining in this effort temporarily was the late Wolfgang Stechow, Professor Emeritus of Art History, Oberlin College, who studied and catalogued a large part of the collection of Dutch and Flemish paintings.

Of the nearly-250 paintings included in this catalogue, ninety-eight are being published for the first time since their acquisition by this Museum; and others that had been published previously have been reexamined in the light of the most recent research and literature. Since a period of three centuries and a great variety of styles and national schools are covered, the authors have relied on the cooperation of numerous scholars who patiently answered many inquiries and who generously lent their time and special knowledge to us. Their opinions are included with those of the authors.

Thus, rather than always making definite statements about the paintings and their attributions, we hope to offer a catalytic impetus for further research. We express our deep gratitude to those scholars whose names appear in these discussions, as well as to others whose names do not appear but who nevertheless provided invaluable help.

We are particularly grateful to the Frick Art Reference Library and the Metropolitan Museum of Art Library in New York, the British Museum Library and the Courtauld Institute of Art in London, the Bibliothèque Nationale in Paris, the Rijksbureau voor Kunsthistorische Documentatie in The Hague, the Cleveland Public Library and the Freiberger Library of Case Western Reserve University in Cleveland for their splendid cooperation.

Finally, our thanks go to all of the authors, especially Nancy Coe Wixom, who wrote the majority of the catalogue entries, and to those staff members of our own Museum who worked with the authors on various aspects of their research or aided in the production of this catalogue: Ann Tzeutschler Lurie, Curator of Paintings, who was the principal researcher and coordinator; Henry H. Hawley, Chief Curator of Later Western Art, who was most helpful in reviewing the penultimate draft; the Conservation Department, headed by Ross Merrill; Louise S. Richards, Curator of Prints and Drawings; Jack Perry Brown, Librarian; Georgina Gy. Toth, Associate Librarian for Reference; Hannelore I. Osborne, Assistant, Department of Paintings; Linda L. Jackson, Secretary, Department of Paintings; David Ditner, Cleveland Museum of Art Fellow; Nicholas C. Hlobeczy, Photographer; and Jane Farver, Photograph Librarian. Merald E. Wrolstad, Chief Editor of Publications, was responsible for the design of the catalogue; and Sally W. Goodfellow, Associate Editor, coordinated the editing and production. Norma J. Roberts copy-edited the catalogue and compiled the index.

We are now up to the year 1800 in the Catalogue of Paintings series, but have temporarily bypassed the considerable number of manuscripts and manuscript illuminations that will be the subject of a separate catalogue (Part Two in the series). Also planned are catalogues of European nineteenth- and early twentieth-century paintings, American paintings through the nineteenth century, and modern paintings. The 1980 publication of *Eight Dynasties of Chinese Painting: The Collections of the Nelson Gallery–Atkins Museum, Kansas City, and The Cleveland Museum of Art*, intended primarily as an exhibition catalogue, will serve as our catalogue of the permanent collection of Chinese paint-

ings for some years to come. Except for the last-mentioned one, delay is still a reality in the production of such catalogues—so prudence dictates that no specifics be suggested. The Museum staff will continue the struggle, and the necessary volumes will be forthcoming. Thanks are well deserved for what has been accomplished and for the patience of all concerned.

Sherman E. Lee, *Director*

The following donors and funds have enabled the collection of paintings that are catalogued herein.

DONORS

Commodore Louis D. Beaumont
Mrs. Benjamin P. Bole
Mrs. Ella Brummer
Mr. and Mrs. Noah L. Butkin
Dr. and Mrs. N. Lester Farnacy
The Friends of The Cleveland Museum of Art
Mr. and Mrs. Edward B. Greene
Mrs. Salmon P. (Carrie Moss) Halle
Leonard C. Hanna, Jr.
Mrs. L. E. (Delia E.) Holden
Mrs. Albert S. (Jane Taft) Ingalls
Harry D. Kendrick
Henry W. Kent
Charles G. King, Jr.
Ralph T. King
Mrs. Ralph T. (Fanny Tewksbury) King
Woods King
Dr. and Mrs. Sherman E. Lee
William Gwinn Mather
Mrs. Myron E. Merry
Mrs. Otto Miller
Mr. and Mrs. Severance A. Millikin
James Parmelee
Amadore Porcella
Mrs. Francis F. (Elisabeth Severance) Prentiss
John D. Rockefeller, Jr.
Mrs. Grace Rainey Rogers
Mrs. Charles E. Roseman
Rosenberg & Stiebel, Inc.
Arthur Sachs
Mr. and Mrs. Preston H. Saunders
Mrs. Gilbert P. (Frances King) Schafer
John L. Severance
Mrs. Henry A. Stephens
Mrs. Harry F. Stratton
Dr. and Mrs. Paul Vignos, Jr.
Mr. and Mrs. J. H. Wade
Felix Wildenstein
Mr. and Mrs. Samuel D. Wise

FUNDS

Louis Dudley Beaumont Foundation
Hanna Fund
Leonard C. Hanna Jr. Bequest
Delia E. Holden Fund and L. E. Holden Fund
The John Huntington Art and Polytechnic Trust
Hinman B. Hurlbut Fund
Andrew R. and Martha Holden Jennings Fund
Mr. and Mrs. William H. Marlatt Fund
John L. Severance Fund
J. H. Wade Fund

Explanations

This is Part Three in the series, The Cleveland Museum of Art: Catalogue of Paintings. Part One, *European Paintings Before 1500*, was published in 1974. Part Two, *Illuminated Manuscripts*, will be published at a later date.

Catalogue entries have been prepared by several authors, whose initials appear at the end of their texts. The authors are:

Jean Kubota Cassill	JKC
Elizabeth de Fernandez-Gimenez	EFG
Ann Tzeutschler Lurie	ATL
Wolfgang Stechow (1896–1974)	WS
William S. Talbot	WST
Nancy Coe Wixom	NCW

Catalogue Format

Works are arranged in sections, first according to the artist's national origin or area of principal activity or predominant influence in style, then according to the artist's name, in alphabetical order. Where there is more than one painting by the same artist, the works follow in order of their acquisition by this Museum. Paintings by unidentified artists which are close to works of a known artist follow that artist's works, with the designations Attributed to, Follower of, Circle of, or School of, depending on their proximity to autograph paintings. All other works of a given national origin by anonymous artists are grouped at the end of each section in chronological order, to the best of our present knowledge.

To the left of the title of each painting is its catalogue number; to the right of the title is the accession number assigned by the Cleveland Museum.

For all paintings the medium is understood to be oil unless otherwise noted. Height precedes width in all measurements. If the dimensions of the painted surface differ from the dimensions of the panel, both sets of dimensions are given.

Former collections are listed chronologically, to the best of our knowledge. In some cases the life dates of the collector are noted parenthetically to indicate a general chronology of ownership. Specific dates of ownership are given when known, without parentheses, but these do not necessarily signify the entire duration of ownership. Names in brackets are dealers. Sales are noted parenthetically. The last line in the Collections section is the Museum credit line, with the year of acquisition of the work.

The discussion of each painting begins with a condition report based on the previous history of restoration and summary examinations. X radiographs were taken of those paintings with specific problems. In general, iconography has been discussed only where it is of special significance or where it is not readily apparent.

The final section of each entry, comprising Exhibitions and Literature, includes all temporary exhibitions where the painting is known to have appeared and the scholarly publications in which the work is mentioned. Exhibitions or publications of The Cleveland Museum of Art are identified by the initial letters CMA. The CMA Year in Review is an annual exhibition of works acquired by the Museum during the preceding year; its catalogue is always the CMA *Bulletin* for the month in which the exhibition is held.

Full citations of abbreviated exhibitions or publications are given on pages xv and xvi.

Footnotes have not been used. Instead, references are given in parentheses within the body of the text in full bibliographical form at first mention; *op. cit.* and *ibid.* are used for succeeding mentions in the same entry. Full references are always given in the biographical sketch of the artist even though the reference may appear again elsewhere in the catalogue entry. Abbreviated citations are given:

1. If the reference appears in the Exhibitions or Literature section at the end of the entry;
2. If the reference is one that occurs frequently enough throughout the catalogue to be included in the Abbreviations on pages xv and xvi.

Letters from scholars are on file in the Museum archives unless otherwise noted.

Portrait Miniatures

The Museum has an important collection of over 100 miniatures by European painters of the sixteenth to the nineteenth centuries—too large to include in this catalogue. Eighty-five of these came as a gift from the Edward B. Greene Collection and were published by the Museum in 1951 (see *Portrait Miniatures: The Edward B. Greene Collection*). Of these, one, the *Portrait of Sir Thomas More (1477/8–1525)* by a follower of Hans Holbein the Younger, has been included here (Painting 70). Of the remaining twenty-six from other sources, the most important is the portrait of *Sir Anthony Mildmay* by Nicholas Hilliard (Painting 79).

Photograph Credits

Bundesdenkmalamt, Vienna: 1*a*, 1*b*
John D. Schiff, New York: 5*b*
Edgar Barbaix, Ghent: 8*c*
Intermuseum Laboratory, Oberlin, Ohio: 10
A. Dingjan, The Hague: 10*c*, 97*a*
Caisse Nationale des Monuments Historiques et des Sites,
 Service Photographique, Paris: 27*a*
J. E. Bulloz, Paris: 39*a*
MAS, Barcelona: 47*a*, 47*b*, 216*a*, 216*b*, 216*d*, 217*b*
P. Dumont & J. Babinot, Reims: 48*a*
Service de Documentation Photographique de la Réunion
 des Musées Nationaux, Paris: 57*a*, 201*a*
Taylor & Dull, Inc., New York: 57*b*
Jörg P. Anders, Berlin: 57*c*, 126*a*
R. B. Fleming & Co., Ltd., London: 73*a*
A. C. Cooper, Ltd., London: 81*a*, 125*a*
Sindhöringer, Vienna: 131*a*
Blinkhorns Photography, Banbury: 131*b*
Alinari, Florence: 133*a*, 153*a*, 191*a*
Alinari—Art Reference Bureau, Ancram, New York: 177*a*
Foto Soprintendenza ai Beni Artistici e Storici, Naples:
 134*a*
Mario Perotti, Milan: 134*b*
Giovetti, Mantua: 137*a*
Martin Linsey, Scottsdale, Arizona: 141*a*
Gabinetto Fotografico Nazionale, Rome: 142*d*, 193*a*
Eric Pollitzer, Hempstead, New York: 154*a*
Fornari & Ziveri, Parma: 163*a*
Archivio Fotografico della Soprintendenza alle Galleria,
 Modena: 175*a*
Vasari Foto, Rome: 176*a*, 176*b*
Deutsche Fotothek, Dresden: 178*a*
Bruckmann, Munich: 183*a*
Foto A. Villani & Figli, Bologna: 185*a*
O. E. Nelson, New York: 216*c*
M. Moreno, Seville: 218*a*
Herbert P. Vose, Wellesley Hills, Massachusetts: 224*a*

Abbreviations

EXHIBITIONS

Boston (1883). American Exhibition of Foreign Products, Arts, and Manufactures: Art Department, "Jarves Collection," pp. 20–22. (A checklist of the collection exhibited by James Jackson Jarves at the Boston exposition; the collection was viewed and subsequently purchased, *in toto*, by Mr. and Mrs. L. E. Holden of Cleveland.)

Cleveland (1894). Cleveland Art Loan Exhibition. Held in the Hickox Building. Catalogue.

New York (1912). Loan Exhibition of the Holden Collection. Held at the Metropolitan Museum of Art. Catalogue: *Bulletin of the Metropolitan Museum of Art*, VII, no. 10 (October 1912), 174–83; author, Bryson Burroughs.

Cleveland (1913). Cleveland Art Loan Exhibition. Held in the Kinney & Levan Building. Catalogue.

CMA (1916). The Inaugural Exhibition of The Cleveland Museum of Art. Catalogue.

CMA (1934). Art of the Seventeenth and Eighteenth Centuries. Held at The Cleveland Museum of Art. No catalogue.

CMA (1936). The Twentieth Anniversary Exhibition of The Cleveland Museum of Art. Catalogue.

CMA (1942). Exhibition of the John L. Severance Collection. Held at The Cleveland Museum of Art. Catalogue.

CMA (1956). The Venetian Tradition. Held at The Cleveland Museum of Art. Catalogue; author, Henry S. Francis.

CMA (1958). In Memoriam Leonard C. Hanna, Jr. Held at The Cleveland Museum of Art. Catalogue.

CMA (1963). Style, Truth, and the Portrait. Held at The Cleveland Museum of Art. Catalogue; author, Rémy G. Saisselin.

CMA (1966). Golden Anniversary Acquisitions, The Cleveland Museum of Art. Catalogue: *Bulletin of The Cleveland Museum of Art*, LIII (September 1966).

CMA (1973). Dutch Art and Life in the Seventeenth Century. Held at The Cleveland Museum of Art. No catalogue.

LITERATURE

Alsop (1966) Alsop, Joseph. "Treasures of The Cleveland Museum of Art," *Art in America*, LIV, no. 3 (May–June, 1966), 21–44.

Berenson (1932) Berenson, Bernard. *Italian Pictures of the Renaissance, a List of the Principal Artists and Their Works with an Index of Places*. Oxford, 1932.

Berenson (1957) Berenson, Bernard. *Italian Pictures of the Renaissance, a List of the Principal Artists and Their Works with an Index of Places: Venetian School*, 2 vols. London, 1957.

Berenson (1968) Berenson, Bernard. *Italian Pictures of the Renaissance, a List of the Principal Artists and Their Works with an Index of Places: Central Italian and North Italian Schools*, 3 vols. London, 1968.

M. L. Berenson (1907) Berenson, Mary Logan. "Dipinti italiani in Cleveland, S.U.A." *Rassegna d'arte*, VII (January 1907), 1–5.

CMA *Bulletin* (1914–) *The Bulletin of The Cleveland Museum of Art*.

CMA *Handbook* (1978) *Handbook of The Cleveland Museum of Art*. Cleveland, 1958; rev. eds. 1966, 1969, 1978.

Coe (1955) Coe, Nancy. "Cleveland Private Collections," Volume II: "Catalogue of European Paintings and Drawings in Cleveland Private Collections," M.A. thesis, Department of Fine Arts, Oberlin College, 1955.

Dizionario (1972–76) *Dizionario Enciclopedico Bolaffi dei pittori e degli incisori italiani, dall' XI al XX secolo*, 11 vols. Turin, 1972–76.

Donzelli & Pilo (1967) Donzelli, Carlo, and Pilo, Giuseppe Mario. *I pittori del seicento veneto*. Florence, 1967.

Francis (1942) Francis, Henry S. "Bequest of John L. Severance, 1936," *The Bulletin of The Cleveland Museum of Art*, XXIX (November 1942), 132–36.

Fredericksen & Zeri (1972) Fredericksen, Burton B., and Zeri, Federico. *Census of Pre-Nineteenth-Century Italian Paintings in North American Public Collections*. Cambridge, Mass., 1972.

Gaya Nuño (1958) Gaya Nuño, Juan Antonio. *La Pintura española fuera de España*. Madrid, 1958.

Graves (1913–15) Graves, Algernon. *A Century of Loan Exhibitions, 1813–1912*, 5 vols. London, 1913–15.

Hofstede de Groot (1907–27) Hofstede de Groot, Cornelis. *A Catalogue Raisonné of the Works of the Most Eminent Dutch Painters of the Seventeenth Century Based on the Work of John Smith*, 8 vols. Trans. Edward G. Hawke. London, 1907–27.

Jaffé (1963) Jaffé, Michael. "Cleveland Museum of Art: The Figurative Arts of the West ca. 1400–1800," *Apollo*, LXXVIII (December 1963), 457–67.

Jarves (1884) Jarves, James Jackson. *Handbook for Visitors to the Hollenden Gallery of Old Masters*. Cleveland, 1884. (A descriptive catalogue prepared by J. J. Jarves after Mr. and Mrs. L. E. Holden had purchased their collection from him in 1883; privately printed.)

van Marle (1923–38) Marle, Raimond van. *The Development of the Italian Schools of Painting*, 19 vols. The Hague, 1923–38.

Milliken (1958) Milliken, William M. *The Cleveland Museum of Art*, Great Museums of the World Series. New York, 1958.

Morassi (1953) Morassi, Antonio. "Una mostra del Settecento Veneziano à Detroit," *Arte Veneta*, VII (1953), 49–62.

Morassi (1955) Morassi, Antonio. *G. B. Tiepolo, his life and work*.... London, 1955.

Morassi (1973) Morassi, Antonio. *Guardi: Antonio e Francesco*, 2 vols. Venice, 1973.

Pigler (1956) Pigler, Andor. *Barockthemen*, 2 vols. Budapest, 1956.

Rossi Bortolatto (1974) Rossi Bortolatto, Luigina. *L'opera completa di Francesco Guardi*, Classici dell'Arte, no. 71. Milan, 1974.

Rubinstein (1917) Rubinstein, Stella. *Catalogue of the Collection of Paintings, Etc., Presented by Mrs. Liberty E. Holden to The Cleveland Museum of Art*. Cleveland, 1917.

Selected Works (1966) *Selected Works: The Cleveland Museum of Art*. Cleveland, 1966.

Smith (1829–37) Smith, John. *A Catalogue Raisonné of the Works of the Most Eminent Dutch, Flemish, and French Painters*, 8 vols. London, 1829–37.

Smith (1842) Smith, John. *Supplement to the Catalogue Raisonné of the Most Eminent Dutch, Flemish, and French Painters*. London, 1842.

Thieme-Becker (1907–50) Thieme, Ulrich, and Becker, Felix. *Allgemeines Lexikon der Bildenden Künstler*, 37 vols. Leipzig, 1907–50.

Underhill (1917) Underhill, Gertrude. "The Holden Collection," *The Bulletin of The Cleveland Museum of Art*, IV (February 1917), 19–21.

A. Venturi (1901–39) Venturi, Adolfo. *Storia dell'arte italiana*, 11 vols. Milan, 1901–39.

L. Venturi (1931) Venturi, Lionello. *Pitture italiane in America*. Milan, 1931.

L. Venturi (1933) Venturi, Lionello. *Italian Paintings in America*, 3 vols. New York and Milan, 1933.

Waagen (1854) Waagen, Gustav Friedrich. *Treasures of Art in Great Britain*, 3 vols. London, 1854.

THE CATALOGUE

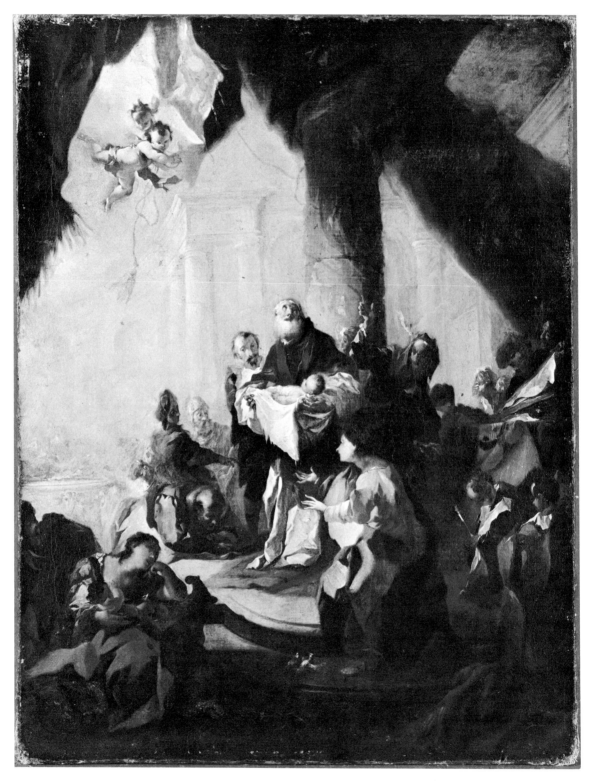

Figure 1.

Austria

FRANZ ANTON MAULBERTSCH
1724–1796

This Austrian painter of the late baroque was born in Lang-
enargen on Lake Constance in 1724. He first studied with
his father, Anton, who was also a painter. In 1739 he be-
came a pupil of the fresco painters Franz Joseph Spiegler
(1691–1757) and Peter van Roy (born 1683/4). He then
went to the Academy in Vienna, where he studied with
Jacob van Schuppen (1670–1751) and Joseph Ignaz Mil-
dorfer (1719–1775). His training at the Academy was in-
terrupted during the War of the Austrian Succession (1740–
48), but he enrolled again after the war when the Academy
reopened; he won the annual students' competition for an
allegory painting in 1750. About this time he began to
receive commissions from all over the Hapsburg domin-
ions. In 1745 he married Barbara Maria Anna Schmid from
lower Austria. Whether or not Maulbertsch ever visited
Italy is not documented, but Paul Troger (1698–1762),
who traveled extensively in Italy, had a great influence on
his style in the 1740s, and Maulbertsch's works indicate he
was impressed by Venetian eighteenth-century painters,
particularly Piazzetta and Pittoni. He was also influenced
by the paintings of Rembrandt. By 1759 he was a full mem-
ber of the Academy in Vienna. About 1770 he was appointed
court painter. He had many pupils and was very active and
influential. His frescoes and altar paintings for churches,
monasteries, and castles are found mostly around Vienna
and in Hungary and Bohemia, where Maulbertsch enjoyed
a reputation similar to that of Tiepolo. He became a mem-
ber of the Berlin Academy in 1788. He died in Vienna in
1796.

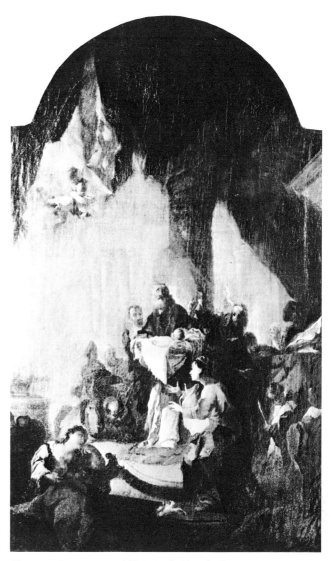

Figure 1a. *Presentation of Christ in the Temple*. On canvas, 84 x 51 cm.
Maulbertsch. St. Ulrich's Church, Vienna. Owned by the Benedikti-
nerabtei zu unserer Lieben Frau bei den Schotten (Schottenstift), Vienna.

1 *The Presentation of Christ* 63.326
 in the Temple

Canvas, 69.5 x 52.3 cm.

Collections: Count Gyula Andrássy, Budapest; Countess F. K.,
London (granddaughter of Count Gyula Andrássy); Franz Szabó,
London; Judith Szabó, London.

Mr. and Mrs. William H. Marlatt Fund, 1963.

Surface dirt and grime were removed from the painting in
the Cleveland Museum laboratory in 1978, at which time a
weak and embrittled lining canvas was removed and the
painting was relined. The paint has been somewhat abraded,
especially in the thinly painted red tones at the top right.

There are scattered retouches, particularly in the lower
quarter of the painting and along all the edges.

The painting was labeled as a Tiepolo or his school when
it was received as a gift by Countess F. K. in London from
her grandfather in Budapest. Later Klára Garas (1963)
identified the Cleveland painting as a first design for Maul-
bertsch's final version (Figure 1a), which is in the choir of
St. Ulrich's Church in Vienna. Garas also stated that the
sketch which Maulbertsch probably submitted to the pa-
tron is the painting now in the Schottenstift in Vienna (Fig-
ure 1b). Both of the Vienna paintings were formerly attrib-
uted to Johann Bergl.

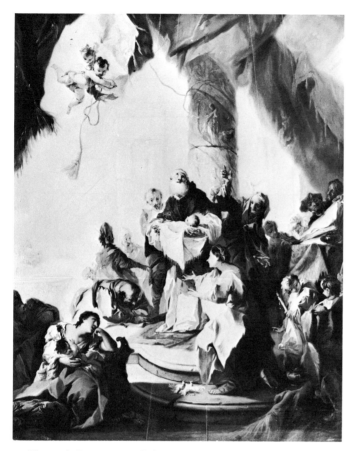

Figure 1b. *Presentation of Christ in the Temple.* On panel, 68 x 52 cm. Maulbertsch. Gallery of the Benediktinerabtei zu unserer Lieben Frau bei den Schotten (Schottenstift), Vienna.

A larger version of the subject by Maulbertsch (canvas, 97 x 67.5 cm) is in the collection of Georg Schäfer, Obbach, near Schweinfurt, Germany. This is generally considered a weaker repetition after the Cleveland painting (Garas, 1963, p. 30).

A variant of the subject, entirely different in composition and detail, probably by Johann Bergl, is in a private collection in Vienna (canvas, 91 x 65 cm; Otto Benesch, "Maulbertsch, zu den Quellen seines malerischen Stiles," *Städel Jahrbuch*, III–IV, 1924, pl. XXIV, opp. p. 116). Garas (1960, p. 238) does not accept this as the work of Maulbertsch.

Charles de Tolnay (1961) dated the Cleveland painting ca. 1750–1755, basing his conclusion partly on an attribution expertise written by Otto Benesch, Vienna (dated November 10, 1958). Garas (1963 and 1974) dated it ca. 1748 to 1750, as does Kent Sobotik (Exh: 1972), who justifies the early dating because of a discernible influence of Piazzetta through Paul Troger, which was particularly evident in Maulbertsch's works of the 1740s.

The Cleveland painting is closely related in style to the *Circumcision of Christ* in a private collection in Budapest (Garas, 1963, p. 30) and *Let All the Little Children Come*

to Me in the Bayerisches Nationalmuseum, Munich (inv. no. 9013).

Maulbertsch may have based his composition on a monumental altarpiece by another Venetian. Giambattista Pittoni, for example, painted a version of the same subject a generation earlier (now in the Museo Correr in Venice) which resembles the Museum sketch in certain aspects—the circular dais, the position of Simeon, the asymmetrical architectural backdrop, and the clouds and angels (Tolnay, 1961, p. 400, illus.). Maulbertsch intensified the spatial drama in his own composition by developing a restless, spiral, upward movement. In this early painting the artist's very personal blend of colors—warm brown and silvery blues, pinkish reds, and brilliant yellow—so different from that of contemporary Italian painters, is already well developed.

Maulbertsch followed closely the biblical story of the presentation in the temple (Luke 2:22–39). Mary and Joseph—represented by the artist in a humble posture, vaguely reminiscent of Rembrandt's figures—have come to the temple to present their Child to the Lord. They have brought with them, according to the custom of the law, the two sacrificial doves seen on the center axis in the lower foreground. Simeon is pictured as a pious old man, glancing toward Heaven in recognition of the Child he holds. The head of the Child is in the exact center of the painting. The prophetess Anna (described in Luke 2:36–38) is to the right of Simeon, gesturing toward the Child; above her is the Dove of the Holy Spirit. A few figures are gathered around the central scene, and an altar appears in the left background. A mother with her child occupies the lower left of the composition. The curtain is pulled aside at the upper left to reveal the angels, and a bold shadow funnels off to the right from the heavy column behind the central scene.

Quite similar in iconography but much more advanced in style is a sketch by Maulbertsch dating from about 1756 (Garas, 1974, p. 253) for a fresco in a half-dome now in the Österreichische Galerie in Vienna (inv. no. 2062). Maulbertsch sustained an interest in this subject throughout his life. In correspondence with Bishop Szily, dated February 26 and March 7, 1794, he describes a *Presentation in the Temple* for the Szombathely cathedral dome, which sounds exactly like the Cleveland sketch (Janos Kápossy, *A Szombathelyi Székesegyház és Mennvezetképei*, Budapest, 1922, p. 107; and Garas, 1960, p. 277, from documents CXLV and CXLVII in the Bischöfliches Archiv, Aedif. 40, Szombathely). The *modello* he then painted, however, differs greatly in style and is an expansion of his original ideas of about forty-five years earlier (now in the Stiftsgalerie in Klosterneuberg; Garas, 1960, p. 230, no. 385, pl. CCXXXIX, fig. 314). N C W

EXHIBITIONS: CMA, December 1963: Year in Review, cat. no. 91, illus.; Sarasota, Florida, John and Mable Ringling Museum of Art, 1972:

Central Europe 1600–1800, cat. no. 82, illus. (catalogue by Kent Sobotik); University of Chicago, The David and Alfred Smart Gallery, 1978: German and Austrian Painting of the Eighteenth Century, cat. no. 16.

LITERATURE: Klára Garas, *Franz Anton Maulbertsch* (Budapest, 1960), cat. no. 13, p. 198; Charles de Tolnay, "Ein unbekanntes Frühwerk des Franz Anton Maulbertsch," *Festschrift H. P. Hahnloser*, eds. Ellen J. Beer, Paul Hofer, and Luc Mojon (Basel and Stuttgart, 1961), pp. 397–404, illus. pp. 399 and 401; Garas, "Nachträge und Ergänzungen zum Werk Franz Anton Maulbertschs," *Pantheon*, XXI, pt. 1 (1963), 30, 33, fig. 2; Henry S. Francis, "Franz Anton Maulbertsch: *The Presentation of Christ in the Temple*," CMA *Bulletin*, LI (1964), 15–18, illus. opp. p. 15, details pp. 16, 17; Garas, "Franz Anton Maulbertsch Neue Funde," *Mitteilungen der Österreichischen Galerie* (Vienna), XV (1971), 17; Garas, *Franz Anton Maulbertsch: Leben und Werk* (Salzburg, 1974), pp. 10, 239; CMA *Handbook* (1978), illus. p. 166.

ANONYMOUS MASTER

Eighteenth century, formerly attributed to Mildorfer

2 *The Return from the Flight* 74.2
 to Egypt

Canvas, 118.2 x 84.2 cm.
Collections: Dr. Kurt Rossacher, Salzburg.
Mr. and Mrs. William H. Marlatt Fund, 1974.

The painting has been glue lined and is applied to a plain, open-weave, brown linen. There are numerous surface disturbances in the bottom half of the canvas and in the top right quarter, apparently resulting from tears in the original canvas and from ground and paint losses, all of which have been filled and retouched. The paint is considerably abraded and there are numerous scattered flake losses.

Scenes of the Holy Family returning from Egypt can be distinguished from those of the flight into Egypt by the difference in the represented age of the Christ Child. The story of the return, based on Matthew 2:19–21, became popular among artists in the thirteenth century largely because of the dissemination of such writings as the *Legenda Aurea* of Jacopo Voragine and the *Meditationes Vitae Christi* of the Pseudo Bonaventura. During the Counter Reformation this subject gained increasing popularity.

The Cleveland painting closely corresponds to seventeenth-century precursors, Italian as well as others. One example from Italy is Giovanni Baglione's painting in the Convent of the Holy Apostles in Rome (recently rediscovered by Herwarth Röttgen). Another was certainly the lost version by Giovanni Lanfranco, mentioned by Bellori, dating from ca. 1616 to 1617 (Erich Schleier, "Panico, Gentileschi, and Lanfranco at San Salvatore in Farnese," *Art Bulletin*, LII, 1970, 173–74). Rubens painted two versions (Wadsworth Atheneum and collection of the Earl of Leicester, Holkham Hall) that date from ca. 1618 to 1620, both of which include a palm tree, as does the Cleveland painting. The Christ Child in the Cleveland painting, with his

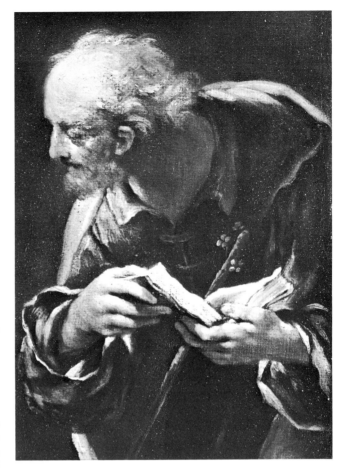

Figure 2a. *Mary and Joseph Adoring the Child* (detail). On canvas. Giuseppe Maria Crespi, Italian, 1665–1747. The Van Ackeren Gallery, Rockhurst College, Kansas City, Missouri.

curly hair, long pink robe, and blue sash, was clearly inspired by Murillo, who created this type of representation in his painting called *The Holy Family* (Nationalmuseum, Stockholm).

The painting was attributed to Josef Ignaz Mildorfer (1719–1775) by its former owner, Kurt Rossacher, who made a study of Mildorfer and owns several of his important works (Rossacher, "Der Tiroler Barockmaler Josef Ignaz Mildorfer in neuer Sicht," *Zeitschrift Alte und Moderne Kunst*, CXXIII, 1972, 16–23). Rossacher confirmed his opinion in a letter dated April 4, 1978, saying that the painting was done in the artist's little-known, very early, sketchy style. There are certain stylistic similarities between the figures in our painting and those by Mildorfer. Compare, for example, the young virgin in the *Immaculata and the Apostles Peter and Paul before Their Martyrdom* (Österreichisches Barockmuseum, Vienna) with the Christ Child in our painting, or compare our Joseph with his counterpart in one of Mildorfer's two small devotional panels of 1741 (Rossacher, *op. cit.*, fig. 120).

On the other hand, the Cleveland painting bears little

5

Figure 2.

resemblance to Mildorfer's battle paintings, such as the *Battle of Schärding* (collection of Dr. Kurt Rossacher), with its feverish surface excitement, the maze of narrow-ribboned highlights, and its rapid changes from pastel to deep shadow colors. For this reason all the scholars of south European baroque who were consulted—Gert Amman on behalf of Erich Egg, Hans Aurenhammer, Bruno Bushart, Jiři Kotalík, Edward Maser, J. Neumann, and Eduard Safařik—found the attribution to Mildorfer untenable. Names like Peter Brandl, Franz Xaver Karl Palko, Franz Sebald Unterberger, and Joseph Haller have been suggested, only to be dismissed again.

The attribution problem is characteristic of many Austrian, and specifically Tirolean, paintings dating from the early to mid-eighteenth century, when the borders of Tirol reached as far south as Trentino, the native region of the Guardi family. The political union of these Austrian and Italian regions fostered a lively artistic exchange and a fusion of styles. Artists studied and worked in both Venice and Vienna, the two major art centers of the area. Mildorfer's teacher, for example—Paul Troger (1698–1762), an Austrian—studied and worked with Venetian masters such as Giovanni Battista Piazzetta; Troger also collaborated for nearly three years, beginning in 1724, with Giuseppe Maria Crespi in Bologna.

Most scholars agree that the Cleveland painting reveals strong influences from northern Italy; masters such as Piazzetta, Sebastiano Ricci, the Guardis, and Giuseppe Crespi come to mind. The Joseph in our painting, for example, seems particularly close to the one in Crespi's *Mary and Joseph Adoring the Child* (Figure 2a). The Mary of our painting, shrouded in a dark shawl, also evokes echoes from the north of Italy, through Troger, whose St. Anne in *Tobias and St. Anne* (Österreichisches Barockmuseum, Vienna) she resembles.

The two versions of the subject closest to the Cleveland painting are both Venetian: Gasparo Diziani's lost painting from the Chiesa Arcipretale in Longarone (in which the Christ Child looks up to Joseph, as he does in the Museum painting), variously dated between 1727 and 1750 (Anna Paola Zugni-Tauro, *Gasparo Diziani*, Venice, 1971, p. 105 [under lost works], pl. 159); and Giovanni Guardi's version (collection of Alessandro Brass, Venice; Antonio Morassi, *Guardi*, II, Venice, 1973, cat. no. 31, fig. 40). As Morassi pointed out, Guardi's *Return from the Flight to Egypt* is stylistically related to his Tobias series on the organ shutters of the church of Arcangelo Raffaelo in Venice, dating from ca. 1750 to 1753, in which Tobias as a boy is shown walking between his parents, wearing a pink robe with a blue sash, as does Guardi's Christ Child and the Child in the Cleveland painting. ATL

EXHIBITIONS: CMA, March 1975: Year in Review, cat. no. 49, illus.

LITERATURE: CMA *Handbook* (1978), illus. p. 166.

Flanders

HERRI MET DE BLES
Ca. 1510 – ca. 1572

Little is known about the life of Herri met de Bles (meaning "with the lock"). He was born sometime around 1510 in Bouvignes, Belgium (or in Dinant; see Robert A. Koch, *Joachim Patinir*, Princeton, 1968, p. 6). It has been suggested that he was the "Herri de Patenir" who was recorded in the Antwerp artists' guild in 1535. It has also been suggested that Bles was a descendant of Joachim Patinir (died ca. 1524); Joachim apparently had no sons, but it is possible that Bles was his nephew. No records other than the uncertain listing in the Antwerp artists' guild confirm Bles's presence in Antwerp. In Italy his paintings were familiarly attributed to "Il Civetta," the owl, for he often included an owl in his pictures. An ecclesiastical history published in 1621 by an Italian writer, Marcantonio Guarini, noted that "Il Civetta, most celebrated painter," was buried in Ferrara (*Compendio historico dell'origine, accrescimento e prerogative delle chiese e luoghi pii della città e diocesi di Ferrara . . .*, 1621, p. 225). On the basis of this remark, it has been supposed that Bles's life ended in Italy, although his presence there was not otherwise recorded. Because an engraved portrait of Bles appeared in a book by Domenicus Lampsonius that was published in Antwerp in 1572, it has been assumed that he was still living at that date.

3 *Landscape with St. John the Baptist* 67.20
 Preaching

Panel (oak), 29.8 x 42 cm.

Collections: Private collection, Cumberland, England; [Herbert Bier, London].

Andrew R. and Martha Holden Jennings Fund, 1967.

When the painting was inspected under ultraviolet light, some strengthening was found in the figures clustered around St. John and in the trees among the buildings. There were minor losses along the upper edge of the panel and pinpoint retouchings in the sky. Otherwise, the paint surface is in good condition.

There is an owl on the rock in the foreground, but this in itself is not a secure basis for an attribution to Bles, for he did not always include it in his pictures, and other artists of the period occasionally used the same motif (see Painting 4). However, there are strong similarities between the landscape in the Cleveland painting and the landscapes in two

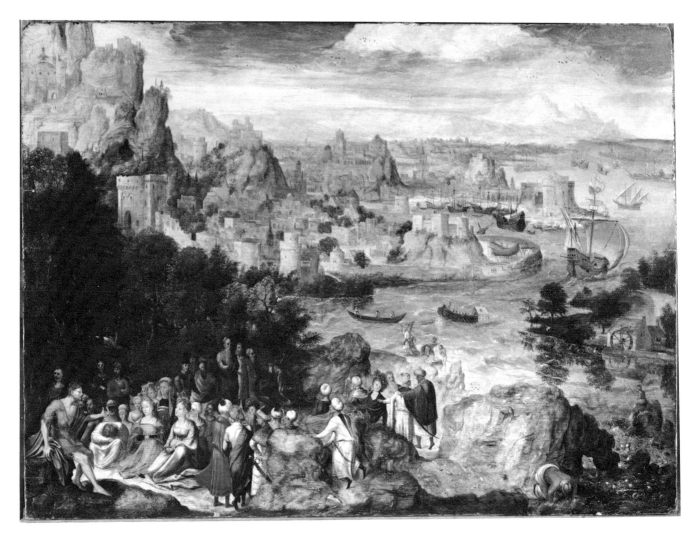

Figure 3.

paintings which have been generally accepted as Bles's work: *Landscape with a Sleeping Peddler Robbed by Monkeys* (Dresden, Staatliche Kunstsammlungen; identified from van Mander's description of a painting he saw in the home of Martin Papenbroeck in Amsterdam) and *Holy Family* (Basel, Kunstmuseum; assigned on the basis of an entry in the Amerbach inventory of 1586).

It has been assumed that, like Patinir, who collaborated with Quentin Massys and Joos van Cleve, Bles rarely painted his own figures. The figural style in a number of works by Bles is consistent with that of the Cleveland painting. Compare it, for example, with *Landscape with Christ Going to Emmaus* in Vienna, Kunsthistorisches Museum; *Landscape with Christ Going to Emmaus* in Antwerp, Mayer van den Bergh Museum; and *The Road to Calvary* at Princeton University's Art Museum. Whether or not the figures were executed by Bles cannot be determined, but clearly some of the figures in the Cleveland painting were borrowed from

other artists (Friedländer, 1975, p. 26). John the Baptist, for example, and the sleeping man at his feet were adapted from a woodcut of ca. 1530 by Jan Swart van Groningen (Figure 3*a*). A very similar grouping of figures (reversed) is in two other versions of the same subject attributed to Bles: one in Paris, Heim-Geirac collection (Heinrich Gerhard Franz, *Niederländische Landschaftsmalerei*, II, Graz, 1969, fig. 89), and another in Brussels, Musées Royaux des Beaux-Arts de Belgique (Friedländer, 1975, fig. 61).

Other related versions of John the Baptist preaching are as follows: in Vienna, Kunsthistorisches Museum (Friedländer, 1975, pl. 31); in Dresden, Staatliche Kunstsammlungen (uncertain attribution); in Amsterdam, Collection Garschagen and the collection of Sir Francis Dashwood (both illustrated in *Mostra Il Paesaggio del Cinquecento e scorcio del Seicento; Maestri Fiamminghi ed Olandesi*, exh. cat., Turin, 1976, cat. no. 4); in Barcelona, Museo de Bellas Artes de Cataluña; and in the City of York Art Gallery (a

8

fragment from a larger panel, with only the foreground figures).

The Cleveland panel is similar in treatment to the Vienna *St. John Preaching* and is probably close in date. Franz (*op. cit.*, p. 91) dates the Vienna painting 1535 to 1540, which would place it among Bles's early works. Bles's stylistic progression was from landscapes with figures prominently set in the foreground toward more spatially integrated landscapes with fewer and much smaller figures in the foreground, such as in the Berlin *Mountain Landscape with a Valley*. JKC

EXHIBITIONS: CMA, December 1967: Year in Review, cat. no. 50, illus. p. 309; CMA (1973).

LITERATURE: Walter S. Gibson, "Herri met de Bles: *Landscape with St. John the Baptist Preaching*," CMA *Bulletin*, LV (1968), 78–87, figs. 1, 3–6; Wolfgang Stechow, *Pieter Bruegel the Elder* (London, 1970), p. 114, fig. 73; Max J. Friedländer, *Early Netherlandish Painting*, Vol. XIII: *Antonis Mor and His Contemporaries*, trans. Heinz Norden (Brussels, 1975), n. 110, p. 120; CMA *Handbook* (1978), illus. p. 121.

Figure 3a. *St. John the Baptist Preaching*. Woodcut, 28.6 x 34.9 cm. Jan Swart van Groningen, Dutch, born ca. 1490–1500, died ca. 1553–58. Reproduced by courtesy of the Trustees of The British Museum, London.

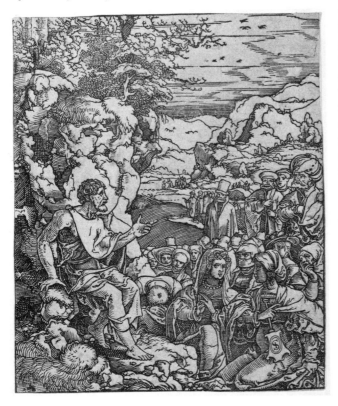

GILLIS VAN CONINXLOO III
1544–1606/07

Gillis van Coninxloo III was born in Antwerp into a family that for generations had been known for its painters. According to Carel van Mander (*Dutch and Flemish Painters*, trans. from the *Schilderboeck* by Constant van de Wall, New York, 1936, p. 306), Coninxloo was a pupil of Pieter Coecke van Aelst the Younger (born ca. 1527, died before 1559), although this seems unlikely because Coninxloo was only fifteen years old when van Aelst died. Van Mander also mentions that Coninxloo was the pupil of Lenaert Kroes and Gilles Moestaert. After completing his training, Coninxloo traveled to France. He returned to Antwerp in 1570 and in that same year became a member of the Guild of St. Luke. After the recapture of Antwerp in 1585 by Alexander Farnese, the Duke of Parma, many Protestants —Coninxloo, among them—fled to Frankenthal, south of Frankfurt, where a place of exile had been established (in 1562) for Flemish emigrants by the Elector Frederick III of the Palatine. While in Frankenthal Coninxloo was influenced by South German masters, particularly Altdorfer. He was undoubtedly also impressed by the hilly and wooded landscape of his host country, for gradually he transformed his panoramic *Weltbild* views with unreal, craggy mountains into convincing landscapes receding into the distance on one side and with increasingly prominent woods on the other. Before his departure for Rome in 1600 the young Adam Elsheimer from Frankfurt had absorbed some of these influences through his admiration for Coninxloo's wooded landscapes. Coninxloo settled in Amsterdam after leaving Frankenthal in 1595, and there he wielded a strong influence on Dutch landscape painters such as Roelant Savery and David Vinckeboons. Van Mander (*op. cit.*, p. 308) claimed that after Coninxloo arrived in Amsterdam, there was a considerable change in the way artists represented trees. Thus, it can be said that Coninxloo's landscapes were direct forerunners of the wooded landscapes of artists of the seventeenth century in Holland. Coninxloo died in Amsterdam in late 1606 or early 1607; he was buried on January 4, 1607.

4 *Landscape with Venus and Adonis* 62.293

Copper panel with mahogany mounting, 37.8 x 53.6 cm. Signed with monogram on tree at left (see Figure 4a).

Collections: (Possibly) Gillis van Coninxloo the Elder (inventory of January 19, 1607); (possibly) Jacques Kina (N. de Roever, "De Coninxloo's," *Oud Holland*, III, 1885, 42); (possibly) Anna de Schot (inventory of April 21, 1663; see J. Denucé, *De Antwerpsche 'Konstkamers' Inventarissen van Kunstverzamelingen te Antwerpen in de 16 en 17 Eeuwen*, II, Amsterdam, 1932, 238); Henry Doetsch, London, 1895; (sale: Christie's, London, June 22–25, 1895, no. 282, illus.); M. Greene, London, 1932; Harry Quilter, London, 1961; [F. Kleinberger, New York].

Mr. and Mrs. William H. Marlatt Fund, 1962.

Figure 4.

The painting was inspected under ultraviolet light in 1962, at which time some retouchings were discovered in the foliage and contour of the hill in the foreground, in the top branches of the trees, on the left side of the painting, and in the figures. The landscape at the right is untouched.

The earliest-known landscape from Coninxloo's Frankenthal period is the *Judgment of Midas*, dated 1588, in Dresden (Gemäldegalerie, cat. no. 857). While in this picture Coninxloo included the panoramic view that was characteristic of earlier works, he has here introduced large foreground forms that enhance the impression of distance and has added groups of large enframing trees. In the Cleveland painting, Coninxloo gave up nearly half of the space to an area of dense woods that encloses his small figure group featuring Venus and Adonis. The hilly landscape with a castle and river suggests Coninxloo's increasing interest in topography (see Gibson, 1968, p. 82) and even suggests a specific region, the Neckar Valley, around Neckarsteinbach, near Heidelberg (letter from Heinz Amberger, dated April 23, 1963). In a later work, the *Wooded Landscape* of

1598 (Vienna, Kunsthistorisches Museum), a forest interior covers the entire canvas.

Lurie (1963) suggested that the Museum landscape was painted sometime between the one in Dresden and the one in Vienna, most likely prior to or shortly after Coninxloo's return to the North. Kurt Zoege von Manteuffel (1912) also places the Cleveland painting in Coninxloo's middle period, along with two in Milan (Bibliotheca Ambrosiana, nos. 5 and 11—now called "in the manner of Bruegel") and the *Latona and the Lycian Farmers* in The Hermitage, Leningrad. Heinrich Gerhard Franz (1969, p. 283) votes for an earlier date, in the 1570s, maintaining that the trees in our painting lack the dramatic strength of Coninxloo's later works; Franz, however, was probably influenced in his dating by a comparison with *Venus and Adonis in a Wooded Landscape in front of the Beersel Castle*, which he thought to be by Coninxloo but actually is by an earlier, inferior, anonymous Netherlandish master (Kunstmuseum, Basel; tempera on canvas, 33 x 44 cm, inv. no. 673).

Unless another *Landscape with Venus and Adonis* bear-

Figure 4a. Detail showing monogram on tree.

ing Coninxloo's monogram (Figure 4a) turns up, our painting is very likely the one mentioned in Coninxloo's own collection as "een stucxken van Coninxloo, principael van Venus ende Adonis." The painting was offered for sale after his death and was purchased by the painter Jacques Kina (alias Jacob Quina), who had accompanied his teacher, David Vinckeboons, to the auction (N. de Roever, "De Coninxloo's," *Oud Holland*, III, 1885, 40). A *Landscape with Venus and Adonis* by Coninxloo was in the inventory of a certain Anna de Schot, wife of the late Niclaes Cheeus of Venus Street, Antwerp, in 1663 (Lurie, 1963, p. 253, n. 8). No other mention of the painting has been found between the possible ownership of Anna de Schot and its appearance in the sale of the collection of Henry Doetsch at Christie's in London in 1895.

Jan Bruegel the Elder painted a *Landscape with Venus and Adonis* (*Gemälde der Ruzicka Stiftung*, exh. cat., Zurich, 1949, pl. VI) which implies knowledge of the Cleveland painting or a similar painting by Coninxloo (Lurie, 1963, n. 13), and it lends support to Yvonne Thiery's observation (1953, p. 69) that several of Bruegel's works from the mid- to late nineties resemble works by Coninxloo.

The figures in both Bruegel's and Coninxloo's *Venus and Adonis* paintings are inspired by Venetian examples; in Coninxloo's case they likely were painted by an Italianate collaborator, or it is also quite possible that an engraving served the artist as a model which he adapted to his own use. Several names have been suggested as Coninxloo's collaborators, among them, Sebastian Frank (Gerard Hoet, *Catalogus of Naamlyst van Schilderyen . . .* , The Hague, 1752, I, 140), van Balen (*ibid.*, p. 516), and Terwesten (*ibid.*, p. 24). Van Mander (*Dutch and Flemish Painters*, New York, 1936, p. 306) maintained that Martin van Cleef painted Coninxloo's staffages, but as van Cleef died in 1581, and the Museum painting is presently presumed to date between 1588 and 1598, van Cleef therefore could not have painted the figures in our landscape. ATL

EXHIBITIONS: CMA, December 1963: Year in Review, cat. no. 86; CMA (1973).

LITERATURE: Eduard Plietzsch, *Die Frankenthaler Maler* (Leipzig, 1910; reprint ed., Soest, 1972), pp. 40, 50, no. 5, pl. III; Kurt Zoege von Manteuffel, in Thieme-Becker, VII (1912), 303; Joseph Alexander Graf Raczinski, *Die Flämische Malerei vor Rubens* (Frankfurt, 1937), p. 32; Arthur Laes, "Gillis van Coninxloo, Rénovateur du Paysage Flamand au XVIe siècle," *Annuaire des Musées Royaux des Beaux-Arts de Belgique*, II, (1939), 111, n. 2; Yvonne Thiery, *Le Paysage Flamand au XVIIe siècle* (Paris and Brussels, 1953), pp. 15, 21, 69, 179; Ann Tzeutschler Lurie, "*A Landscape with Venus and Adonis*," CMA *Bulletin*, L (1963), 252–58, figs. 1, 3, 5, 6, 9; Walter S. Gibson, "Herri met de Bles: *Landscape with St. John the Baptist Preaching*," CMA *Bulletin*, LV (1968), 86, fig. 13; Heinrich Gerhard Franz, *Niederländische Landschaftsmalerei im Zeitalter des Manierismus* (Graz, 1969), pp. 283, 286, fig. 412; CMA *Handbook* (1978), illus. p. 122.

SIR ANTHONY VAN DYCK
1599–1641

Anthony van Dyck was born in Antwerp in 1599. He was a pupil of Hendrik van Balen. By 1615/16 he was working independently. He collaborated closely with Peter Paul Rubens between 1618 and 1620, during which time he also made his first trip to England. He was active in Brussels before and after his stay in Genoa, from 1621 to 1627. In 1632 he went to London, remaining there until his death in 1641. He was extremely popular in England, where he established the formula for aristocratic portraiture that was to endure for the next two hundred years. He was knighted by Charles I in London in 1632. He made a brief trip to Brussels in 1634/35 and another to Paris in 1640/41. Van Dyck was a very versatile and prolific painter who also excelled as a draftsman and engraver. His oeuvre includes many religious and mythological pictures as well as portraits. After Rubens, he was one of the most important Flemish painters of the seventeenth century.

5 *A Genoese Lady with Her Child* 54.392

Canvas, 217.8 x 146 cm.

Collections: Du Pré Alexander, Second Earl of Caledon, purchased through George Augustus Wallis in Florence, March 1829; J. Pierpont Morgan (1837–1913), London and New York, by 1902; [M. Knoedler & Co., New York].

Gift of Hanna Fund, 1954.

The paint film is in good condition. The painting was lined in the past, at which time the original canvas was trimmed off on all sides and 3.5 to 5 centimeters of canvas was added on all sides except the top. The painting was cleaned by William Suhr in 1954.

Unfortunately, the very early history of the painting is unknown. It was purchased in 1829 by the Second Earl of Caledon, a transaction that is documented by two letters to Lady Caledon (now in the Pierpont Morgan Library in New York), written from Florence in 1828 by Mrs. Callcott, who had helped to conclude the negotiations.

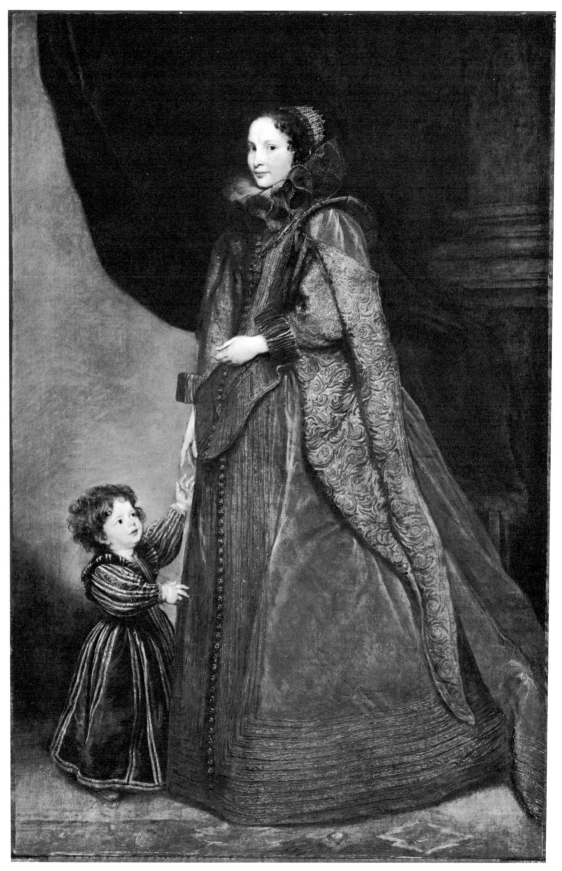

Figure 5.

The Museum portrait is typical of the ones that van Dyck painted of the local aristocracy in Genoa in the first half of the 1620s. These stately portraits combine the strong technical influence of Rubens with echoes of Venetian composition and color and reveal the artist's personal gift for suggesting the high station of his sitters.

The subjects of the Museum's portrait are not known, but since the early nineteenth century the woman has been called the Marchésa Spinola, a daughter or relative of Ambrogio, Marchése Spinola. According to W. R. Valentiner (letter of March 29, 1955), the woman, more likely, is Geronima Doria, daughter of Paolo Doria, procurator of the Republic of Genoa, who married Filippo Spinola, son of Ambrogio, in 1623, and whose child could have been the age of the one in the picture by 1627, the probable date of the painting. A portrait of the Marchésa Geronima Spinola, which bears considerable likeness to ours, is in the museum in Berlin-Dahlem (Figure 5a).

Van Dyck frequently made drawings and oil sketches on paper and canvas as studies for his portraits. An oil sketch of the woman's head is presently owned by Mrs. Elisabeth Drey in New York (Figure 5b; ex collections: Leo Koppel, Berlin; L. Koppel, Toronto; Böhler, Lucerne). If the earlier provenance of this sketch were known, it might be of help in identifying the sitter. N C W

Figure 5a. *Marchésa Geronima Spinola*. On canvas, 221 x 147 cm. Van Dyck. Staatliche Museen Preussischer Kulturbesitz, Gemäldegalerie, Berlin.

Figure 5b. *Study for the Head of the Genoese Lady with Her Child*. On canvas, 48 x 38 cm. Van Dyck. Collection of Mrs. Elizabeth M. Drey, New York.

EXHIBITIONS: London, British Institution, 1832, cat. no. 46, and 1854, cat. no. 62; London, Royal Academy of Arts, 1902: Exhibition of Works by the Old Masters, cat. no. 102; Brussels, Nouveau Palais, 1910: Trésor de l'art belge au XVIIᵉ siècle (catalogue published 1912; see Literature below); New York, Metropolitan Museum of Art, 1913: A Loan Exhibition of Mr. Morgan's Paintings (catalogue: *Bulletin of the Metropolitan Museum of Art*, VIII, January 1913, 6, illus. p. 4); CMA, 1956: The Venetian Tradition, cat. no. 13, pl. XVI; CMA (1963), cat. no. 24, illus.

LITERATURE: *The Library of Fine Arts*, III (1832), 114; Smith (1842), *Supplement*, p. 395, no. 97; Gustav Friedrich Waagen, *Galleries and Cabinets of Art in Great Britain*, IV, A Supplement to *Treasures of Art in Great Britain* (London, 1857), 151; Jules Guiffrey, *Sir Anthony van Dyck —His Life and Work*, trans. William Alison (London, 1896), p. 302, no. 858; F. M. Haberditzl and Gustav Glück, in Thieme-Becker, X (1904), 266; Alfred von Wurzbach, *Niederländisches Künstlerlexikon*, I (Vienna and Leipzig, 1906), 462; T. Humphry Ward and W. Roberts, *Pictures in the Collection of J. Pierpont Morgan at Princes Gates and Dover House*, II (London, 1907), no. 3, illus.; Emil Schaeffer, *Van Dyck: Des Meisters Gemälde*, Klassiker der Kunst (Stuttgart and Leipzig, 1909), p. 188, illus.; L. Dumont-Wilden, "Exposition de l'art belge au XVIIᵉ siècle à Bruxelles," *Les Arts*, IX (October 1910), 26, illus. p. 21; Max Rooses, "De Vlaamsche Kunst in de XVIIᵉ Eeuw tentoongesteld in het Jubelpaleis te Brussel in 1910," *Onze Kunst*, X, no. 19 (1911), 42, 43, illus. opp. p. 42; *Trésor de l'art belge au XVIIᵉ siècle: Mémorial de l'exposition d'art ancien à Bruxelles en 1910*, I (Brussels and Paris, 1912), no. LXIX, p. 154, pl. 60; Guy Pène du Bois, "The Old Masters in the Morgan Collection," *Arts and Decoration*, III (May 1913), 235–36, illus. p. 234; Graves (1914), IV, 1502, 1504, 1523; Gustav Glück, *Van Dyck, Des Meisters Gemälde in 571 abbildungen*, Klassiker der Kunst (Stuttgart and New York, 1931), p. 205; Henry S. Francis, "A Genoese Portrait by Van Dyck," CMA *Bulletin*, XLII (1955), 115–17, illus. pp. 113 and 117 (details); Milliken (1958), p. 41 illus.; Jaffé (1963), p. 465, fig. 7; Jaffé, "Van Dyck's Portraits in the De Young Museum and Elsewhere," *Art Quarterly*, XXVIII (1965), 42, 47, fig. 6; CMA *Handbook* (1978), illus. p. 154.

Figure 6.

14

Circle of SIR ANTHONY van DYCK

6 *Portrait of Charles I (1600–1649)* 16.1039

Canvas, 116.8 x 96.3 cm.

Collections: Duke of Hamilton (sale: Paris, June 17, 1882, no. 6);
[Charles Sedelmeyer, Paris]; [Durand-Ruel, Paris]; H. O. Have-
meyer, New York; [Durand-Ruel, New York]; Mr. and Mrs. Jeptha
H. Wade, Cleveland, 1897.

J. H. Wade Collection, 1916.

This painting was lined and retouched considerably at some
time prior to acquisition. The top and bottom margins have
been slightly cropped, judging by the marks of the original
tacking still present at the very edges of the canvas. Cropping
at both sides of the painting seems to have been quite radi-
cal. The fragment of the curtain at the upper right and the
fact that the king's hand is extended toward someone or
something suggests that this painting was copied from a
version that included the queen. X radiographs (Figure 6a)
taken in 1978, in fact, show the queen's hand under the
repaint at the right side of the canvas, just above the king's
hand.

According to Glück (1931), the Museum portrait is one
of several copies of van Dyck's double portrait of Charles I
and Queen Henrietta Maria (90 x 100 cm), now in the
collection of the Duke of Grafton at Euston Hall. More
recently, Oliver Millar ("Some Painters and Charles I,"
Burlington Magazine, CIV, 1962, 329, fig. 7) suggested that
the autograph double portrait is not the Euston Hall ver-
sion but the version in the Archbishop's Palace, Picture
Gallery, at Kroměříž, Czechoslovakia (Figure 6b). Both
double portraits show the crown nearly in its entirety,
whereas in the Cleveland painting part of the crown was
eliminated when the canvas was cut on the left side. More
of the lower part of the crown and the king's doublet show
in the Kroměříž and Cleveland paintings than in the Euston
Hall painting, which suggests that our painting is more
closely tied to the Kroměříž painting. A comparison of the
Cleveland painting with both double portraits seems to
bear this out, allowing, of course, for the fact that approx-
imately one-third of the Museum canvas has been cut off
along the right side, eliminating the queen, and that about
ten centimeters have been cut from the left.

A reduced copy of the Kroměříž painting is in the Vic-
toria and Albert Museum, London (45.78.5, Townshend
Bequest). This painting has been attributed to Gonzales
Coques by Waagen (*Galleries and Cabinets of Art in Great
Britain*, IV, London, 1857, 179) and by C. M. Kauffmann
(in *Catalogue of Foreign Paintings*, Vol. I: *Before 1800*,
London, 1973, no. 70).

Among other workshop replicas and contemporary cop-
ies of the double portrait are the following: one in the Bru-
kenthal Museum in Sibiu, Rumania (The *Brukenthal Mu-
seum of Fine Arts Gallery*, Sibiu and Bucharest, 1964, pl.
26, attributed to Sir Anthony van Dyck); one in Bucking-

Figure 6a. Panchromatic of X-ray composite.

ham Palace, London (now attributed to Daniel Mytens; see
Millar, *op. cit.*, pp. 326–30); and a full-size copy at Knole,
the great Elizabethan house in Kent.

The Cleveland painting, formerly attributed to van Dyck
himself (CMA *Bulletin*, January 1917, p. 3), seems on fur-
ther study not to warrant that attribution. Stylistically, it is
closer to van Dyck than any of the above-mentioned copies,
and it certainly deserves its present placement in the circle
of that master's close followers.

The van Dyck double portrait was engraved by Robert
van Voerst in 1634. NCW

EXHIBITIONS: Cleveland (1913), cat. no. 172D.

LITERATURE: "The Wade Collection," CMA *Bulletin*, IV (1917), 3, illus.
p. 5; Gustav Glück, *Van Dyck, Des Meisters Gemälde in 571 Abbildungen*,
Klassiker der Kunst (Stuttgart and New York, 1931), p. 559, n. 374; Coe
(1955), II, 255, no. 37.

Figure 6b. *Charles I and Henrietta Maria*. On canvas, 113.5 x 163 cm.
Van Dyck. Archbishop's Palace, Picture Gallery, Kroměříž,
Czechoslovakia.

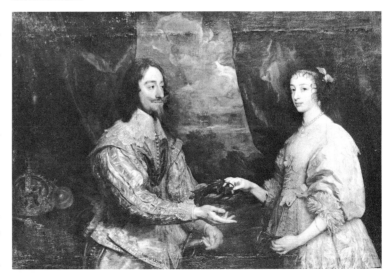

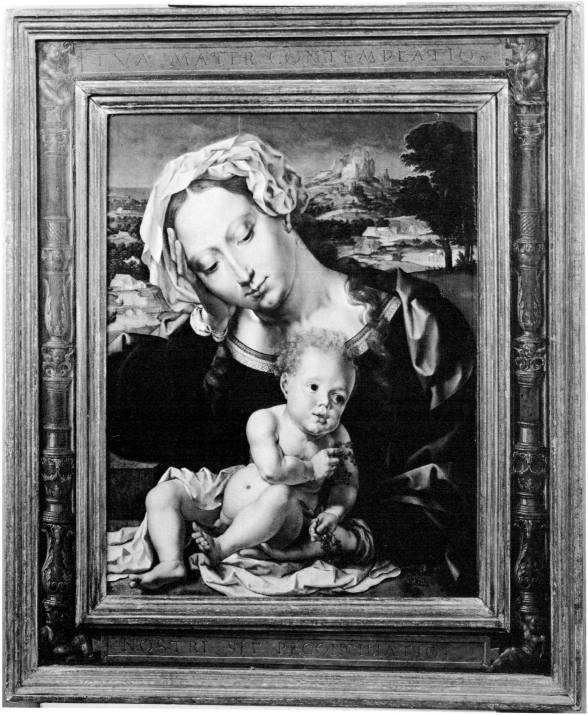

Figure 7.

JAN GOSSART de MABUSE
Ca. 1475 to 1478–1532

Jan Gossart was born in the town of Maubeuge, known colloquially as "Mabuse," from which his surname is derived. He died in 1532, possibly in Antwerp, according to a document found by Pater March in the Archivo del Palau in Barcelona, Spain, in 1949 (J. M. March, "Juanin Gossart, Nota sobre el retrato de Don Juan de Zuniga y Avellaneda," *Boletín de la Sociedad Española de Excursiones*, LIII, 1949, 219–21; see also Gibson, 1974, p. 287, n. 5). The document further revealed that at the time of his death Gossart was in the employ of the Marquésa Mencía de Mendoza, wife of Hendrick III of Nassau.

Under the name Jennyn van Henngouwe (the last name referring to Hennegau, the region in which Maubeuge was located), Gossart was registered as a Free Master of the guild in Antwerp as early as 1503 and until 1507. His travels in Italy in 1508 and 1509 had great impact on his stylistic development. With one of his most loyal patrons, Philip of Burgundy (bastard son of Philip the Good), Gossart visited Rome, Verona, and Florence, studying and copying antique statuary and the art of the Renaissance. He returned to Middleburg in Zeeland in the latter part of 1509 and continued to work for Philip of Burgundy, decorating his nearby Castle Souburg. Here he was in contact with the Venetian painter and printmaker Jacopo de Barbari, who also worked for Philip. Jacopo's influence reinforced Gossart's impressions from Italy. When Philip was appointed Bishop of Utrecht in 1517, Gossart followed him there. He returned to Middleburg after his patron's death in 1524, then to serve Adolph of Burgundy, the Marquis van der Veren. Among his other prominent patrons were Margaret of Austria, governess of the Netherlands; her chancellor, Jean Carondelet; Emperor Charles V; Eleanor of Portugal; and Christian II of Denmark, whose children Gossart painted in 1526.

7 *Madonna and Child in a Landscape* 72.47

Panel (oak), 48.9 x 38.4 cm. Signed and dated: 1531 JOANES MALBOD PIGEBAT [the D is mostly covered by the right knee of the Infant]. In original frame, probably decorated by Gossart de Mabuse.

Collections: Private collection, Madrid; [Wildenstein & Co., New York, 1929]; Cranbrook Academy of Art, Bloomfield Hills, Michigan, 1944, on loan to The Detroit Institute of Arts since 1950; (sale: Parke-Bernet, New York, May 18, 1972, no. 73).

John L. Severance Fund, 1972.

The panel is cradled and the back has been planed to a thickness of six millimeters. Its original thickness is not known. A walnut (?) strip about six millimeters wide has been added to all sides to increase the outside dimensions of the panel. The panel is in good condition except for a 22.5-centimeter-long separation of the vertical join at 23 centimeters from the bottom and 13.5 centimeters from the left

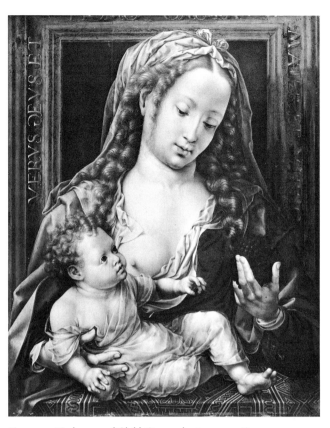

Figure 7a. *Madonna and Child*. On panel, 46 x 37 cm. Gossart. Staatliche Museen Preussischer Kulturbesitz, Gemäldegalerie, Berlin.

margin, running through the left eye, the nose tip, and corner of the mouth of the Madonna. Losses along this separation had been filled and retouched prior to acquisition. There are scattered small-to-moderately-large areas of abrasions and retouching. In some areas, colors are somewhat affected by incomplete cleaning of dirty varnishes. Although the inner and outer moldings of the frame, which is made of oak, are modern, the broad, flat support for the painted design is contemporary with the panel painting.

The panel, dated 1531, was painted one year before Gossart's death. The armrest in the lower left corner bears the date and the words *Joan[n]es Malbod[ius] pi[n]gebat* ("painted by Jan of Mabuse"), the Latin form of his name, which he used regularly after 1516.

Gibson (1974) convincingly argued that the complex contrapposto movement of the Infant toward the right, his glance in that same direction, and the bunch of red currants in his right hand, offered, as it seems, to an unseen observer, all strongly suggest that the Cleveland painting may have had a companion panel depicting a donor. The artist had earlier painted a diptych of similar description, called *Carondelet and the Madonna and Child* (Paris, Louvre), dated 1517.

Although the half-length composition of the Madonna and Child is traditional in Flemish painting, the figures in

Gossart's painting show the direct influence of an example by Albrecht Dürer, the *Madonna and Child*, in Vienna (Kunsthistorisches Museum), painted in 1512. Another influence from Dürer is seen in the Infant's head, which recalls Dürer's *Drawing of a Child* in the Louvre (Gibson, 1974, pp. 291–92). As Gibson observed, the pose of the Madonna was directly influenced by yet another of Dürer's paintings, his *St. Jerome in Meditation* (dated 1521, the year Dürer visited the Netherlands), in which St. Jerome, like Gossart's Madonna, rests an arm on a block.

Stylistically, our panel is closely related to Gossart's *Madonna and Child* in Berlin-Dahlem (Figure 7a). In both there is an animated play of folds and a strong plasticity of forms and facial types.

The Cleveland panel stands out among comparable Madonnas by Gossart because its setting includes a distant landscape. To Dietrich Schubert (1976) the stylized rendering of trees suggests collaboration with the anonymous Master of the Half-Length Figures, a well-known landscapist close to Patinir.

The red currants held by the Infant in the Cleveland panel may be a symbol of the Eucharist, foreshadowing Christ's death and resurrection. The Madonna, in Friedländer's opinion, expresses a premonition of her Son's suffering. Gibson finds her gaze and pose expressive rather of deep thought or contemplation. Both interpretations are supported by the Latin inscription in the upper and lower parts of the frame: TVA MATER CONTEMPLATIO and NOSTRI SIT RECONCILIATIO ("Mother, may your contemplation be our reconciliation"). According to Charles Scillia (Gibson, 1974, p. 292, n. 38), this rather enigmatic plea to the Virgin is that the incarnation and passion of her Son become the means of our reconciliation with God.

The Madonna in the Cleveland panel is clearly dependent on van Eyckian forerunners. Her contemplative calm is mitigated by the effect of the robust, wriggling Child; by the intensely animated surface, illuminated by a strong light entering from two sources; and by a strong sense of weight which Gossart learned both in Italy and by studying the graphic works of Dürer and the art of Jacopo de Barbari. The subtle tension and mood of foreboding are unprecedented in Gossart's Madonnas, but befit the late date of the panel.

The frame was very likely decorated by Gossart himself. It has an elaborate Renaissance "candelabra" ornament supported by *putti* who also hold the tablets with the inscriptions. The ornamentation is similar to that in two panels by Gossart, *St. John* and *St. Peter*, in the Toledo (Ohio) Museum of Art, dating from 1521, and to that in the *Madonna and Child* in the Calouste Gulbenkian Foundation Museum in Lisbon (which Max J. Friedländer, in *Jan Gossart and Bernard van Orley*, 1972, p. 95, cat. no. 37, believes to have been executed by an assistant).

There are three coarse, nearly identical copies after the figure group, but without the landscape background, the inscription, and the red currants (Gibson, 1974, p. 296, n. 6). One of these is in a private Welsh collection. ATL

EXHIBITIONS: Los Angeles Museum, 1933: A Collection of European Paintings from the Early Renaissance to the Modernists, cat. no. 9, illus.; Toledo (Ohio) Museum of Art, 1935: French and Flemish Primitives, cat. no. 16, illus.; New York, M. Knoedler and Co., 1942: Flemish Primitives, illus. opp. p. 84; CMA, March 1973: Year in Review, cat. no. 118, color illus.; CMA (1973).

LITERATURE: Max J. Friedländer, *Die Altniederländische Malerei*, Vol. VIII: *Jan Gossart, Bernart van Orley* (Berlin, 1924), pp. 40, 56, 156, no. 32, pl. XXX (trans., Heinz Norden, *Early Netherlandish Painting*, Vol. VIII: *Jan Gossart and Bernart van Orley*, Leyden, 1972, pp. 28, 36, 94, no. 32, pl. 31, fig. 32); *Art Digest*, VIII (December 15, 1933), cover illus.; E. P. Richardson, "A Cistercian Abbot by Mabuse," *Bulletin of The Detroit Institute of Arts*, XXIV (1945), 62, illus. p. 61 (abbreviated in *Art Quarterly*, VIII, 1945, 76 and 79); Sadja Jacob Herzog, "Jan Gossart, Called Mabuse (ca. 1478–1532): A Study of His Chronology with a Catalogue of His Works" (Ph.D. dissertation, Bryn Mawr College, 1968; Ann Arbor, Michigan: University Microfilms, 1975), II, 315–17, and III, pl. 65; Walter S. Gibson, "Jan Gossart de Mabuse: *Madonna and Child in a Landscape*," CMA *Bulletin*, LXI (1974), 286–99, figs. 1, 8, 14, 15; Dietrich Schubert, "Die Landschaft mit Jagdgesellschaft aus der ehemaligen Sammlung Wesendonk," *Jahrbuch des Kunsthistorischen Institutes der Universität Graz; Festschrift Heinrich Gerhard Franz* (Graz, 1976), pp. 72 no. 13, 76 n. 12, pl. XLVII; CMA *Handbook* (1978), illus. p. 122.

JACOB JORDAENS
1593–1678

Jordaens was the pupil of his father-in-law, Adam van Noort. In 1615 he became a member of the St. Luke's guild in Antwerp. He worked as a painter, tapestry designer, and engraver—first as one of Rubens's chief assistants and later, after Rubens's death in 1640, as head of his own large workshop. He remained in Antwerp all his life, except for one visit to Amsterdam in 1661, when he participated in the decoration of the new town hall. Earlier, in 1652, he completed the decorations for the Huis ten Bosch in The Hague. Although he almost never left home, he received commissions from most major European countries. He combined Rubens's dynamic figure compositions and affinity for Venetian color with his own love for depicting common people in everyday life. He created a highly personal style which built on sixteenth-century Flemish genre and lifted it to a new and grander scale. Together with van Dyck and Rubens, Jordaens was a part of the great triad of Flemish seventeenth-century artists.

8 The Betrayal of Christ 70.32

Canvas, 225.5 x 246.3 cm.

Collections: (Possibly) Count Otto Thott, Gaunø Castle, Denmark (died 1785); Holger Reedtz, grandson of Otto Thott's mother's brother (died 1797), who took the name Reedtz-Thott in honor of his benefactor, Count Otto Thott, who had no male heirs; Baron Otto Reedtz-Thott (died 1862), son of Holger Reedtz-Thott; Baron Kjeld Thor Tage Otto Reedtz-Thott (died 1923), son of Baron Otto Reedtz-Thott; Baron Otto Reedtz-Thott (died 1927), son of Kjeld Thor Tage Otto Reedtz-Thott; Baron Axel Reedtz-Thott, Gaunø Castle, Denmark (sale: Sotheby's, London, July 10, 1968, no. 78); [Agnew & Sons, London]; [Pinakos, Inc., New York].

Purchase, Leonard C. Hanna Jr. Bequest, 1970.

The painting was superficially cleaned by Zoltan von Boer, Keeper of the Gaunø Castle Collection, before it was sold in London in 1968. Before it came to this Museum, Mario Modestini of New York removed numerous layers of darkened and solidified varnishes. Because of the large size of the painting, Modestini used two pieces of canvas to line the original canvas, which consists of three lateral parts joined by seams. A few losses at the edges of the canvas were retouched.

Joachim von Sandrart (*Academie der Bau-, Bild- und Mahlerey-Künste von 1675*, ed. A. R. Peltzer, Munich, 1925, p. 215) described a *Betrayal of Christ* by Jordaens that closely resembles the one in this Museum. Other versions by Jordaens are mentioned in seventeenth- and eighteenth-century sources: one in a 1691 inventory of the collection of Jürgen Ovens (Hans Hampke, "Der Nachlass des Malers Jürgen Ovens," *Kunstchronik*, N.F. VIII, no. 30, 1896/97, 469, no. 60), who also owned a copy after a

Betrayal by Jordaens (*ibid.*, p. 470, n. 18); another was listed in a sale in 1703 in Amsterdam (Gerard Hoet, *Catalogus of Naamlyst van Schilderyen...*, The Hague, 1752, I, 69); and a third appeared in a sale in Brussels in 1779 (Max Rooses, *Jacob Jordaens, His Life and Work*, London and New York, 1908, p. 26). Only in the last reference were measurements given: 142.2 x 114.3 centimeters—considerably smaller than the Cleveland *Betrayal*.

Arnold Houbraken (*De Groote Schouburgh der Nederlantsche Konstschilders en Schilderessen*, I, reprint ed., Maastricht, 1943, 122) mentions twelve scenes of the Passion which Jordaens supposedly painted for the King of Sweden. Since scenes of the Passion traditionally included the Betrayal of Christ (John 18:3 and 10), one was most likely among these twelve. None, however, has been identified.

The Cleveland painting was first mentioned and firmly attributed to Jordaens in an inventory of the paintings at Gaunø Castle in 1876 (Lange, 1876), where it was listed as no. 42 (not no. 52, the number on the canvas in the lower right corner). Madsen (1914) suggested that the *Betrayal* at Gaunø may be the copy that Ovens owned. Held (1939) saw it in poor light and, therefore, refrained from making an attribution. Gerson (1960) thought it was one of Jordaens's later works, modeled after Rubens and van Dyck.

Jaffé, in his exhibition catalogue (1968), listed and reproduced the *Betrayal* among comparative works by Jordaens, referring to it in his entry (no. 28) on the oil sketch of the same subject now in the Royal Museum of Fine Arts, Copenhagen (Figure 8a). He suggested a date for the sketch

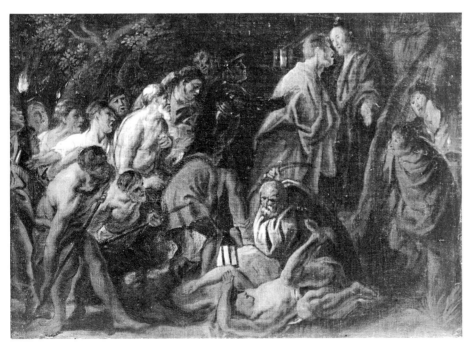

Figure 8a. *The Betrayal of Christ.* On canvas, 46.4 x 66.2 cm. Jordaens. The Royal Museum of Fine Arts, Copenhagen.

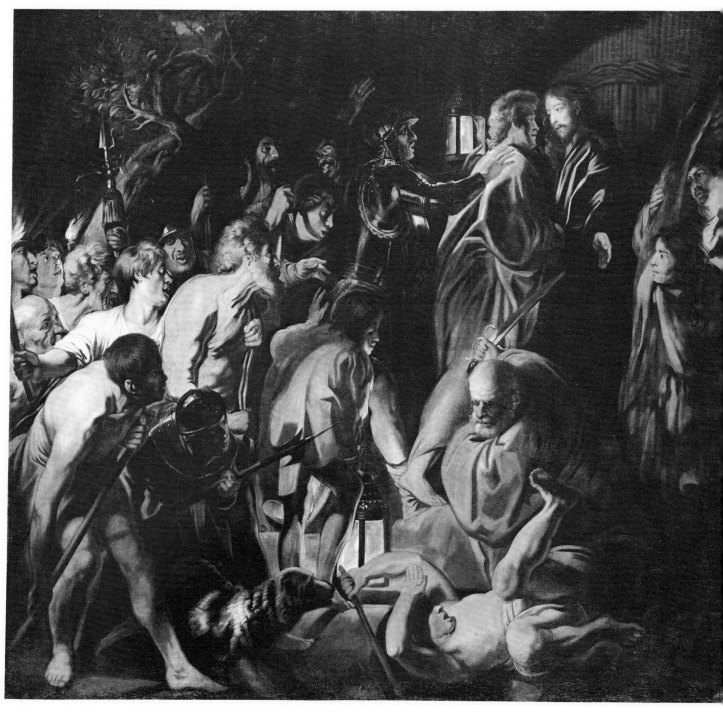

Figure 8.

in the twenties because of its closeness in style to the *Alexander the Great* tapestries (which, according to Jaffé, were woven after Jordaens's designs between 1622 and 1627), and also because of its relationship to van Dyck's *Betrayal of Christ* (Madrid, Prado) of ca. 1619 (which, in turn, was inspired by a lost composition by Titian). Rooses (*op. cit.*) saw the Copenhagen painting as the first sketch for the lost *Betrayal* mentioned by Sandrart (*op. cit.*). In color and composition the sketch is unquestionably related to the Cleveland *Betrayal*. Suggested dates for the sketch differ widely, ranging from the 1620s to 1654 (Lurie, 1972, no. 27).

There are three other preparatory studies for a *Betrayal* by Jordaens: one closely copying van Dyck's Prado *Betrayal* (Jaffé, 1968, no. 144), which some scholars doubt is actually by Jordaens; a wash drawing (Figure 8*b*) that anticipates the Cleveland composition; and a sketchy study of a *Betrayal* on the verso of *Christ and the Adulteress* in Ghent (Figure 8*c*).

In style and psychological content the Cleveland *Betrayal* is related to Jordaens's works of the late 1650s, such as the *Expulsion of the Money Changers from the Temple* of ca. 1657 (The Hague). It is also related to a yet-later painting that represents another event in the betrayal drama (from John 18:6), *The Soldiers Come to Bind Christ Are Struck Down* (or *The Tumbling of the Catchpoles*), in the collection of Heinz Kisters. The Cleveland *Betrayal* shares with these works certain mannerisms, a sense of crowding—at times overcrowding—of figures in turbulent action; in all, the figure of Christ is dominant. Perhaps the choice of subject and the serious tone of the picture reflects Jordaens's growing involvement in the Calvinist faith which began in the 1650s. ATL

EXHIBITIONS: CMA, February 1971: Year in Review, cat. no. 42, illus. p. 22.

LITERATURE: Julius Lange, *Baroniet Gaunø's Malerisamling* (Naestved, 1876), pp. 43–44, no. 42; Karl Madsen, *Fortegnelse over to Hundrede af Baroniet Gaunøs Malerier af aeldre Malere samt over dets Portraetsamling* (Copenhagen, 1914), no. 77, pp. 24–25; Madsen, "Malerisamlingen Paa Gaunø," *Kunstmuseets Aarsskrift*, IV (1917), 42; Julius S. Held, "Malerier og Tegninger Af Jacob Jordaens i Kunstmuseet," *Kunstmuseets Aarsskrift*, XXVI (1939), 15, n. 16; H. Gerson and E. H. Ter Kuile, *Art and Architecture in Belgium 1600–1800* (London, 1960), pp. 132–33; Michael Jaffé, *Jacob Jordaens* (exh. cat., Ottawa, 1968), p. 21, fig. XII and pp. 47, 86–87; Jaffé, "Reflections on the Jordaens Exhibition," *The National Gallery of Canada Bulletin*, no. 13 (1969), p. 24; Ann Tzeutschler Lurie, "Jacob Jordaens' *Betrayal of Christ*," *CMA Bulletin*, LIX (1972), 67–77, figs. 1–3, pp. 65, 84 (color); R.-A. d'Hulst, *Jordaens Drawings*, I, Monographs of the National Centrum voor de Plastische Kunsten van de XVIde en XVIIde Eeuw, Vol. V (Brussels, 1974), 165; CMA *Handbook* (1978), illus. p. 155.

Figure 8*b*. *The Betrayal of Christ*. Pen, brown ink, and brown wash over black chalk on paper, 38.1 x 28.6 cm. Jordaens. Collection of Mrs. Sidney E. Rolfe, New York.

Figure 8*c*. *The Betrayal of Christ* (verso of *Christ and the Adulteress*). Red chalk on paper, 27.7 x 22.2 cm. Jordaens. Musée des Beaux-Arts, Ghent, Belgium.

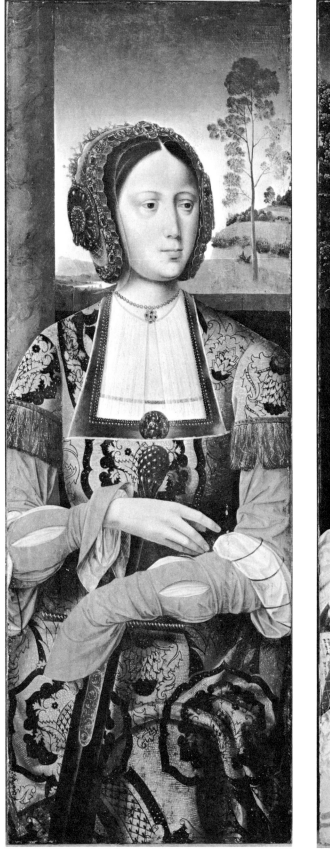

Figure 9A.

Figure 9B.

MASTER OF THE HOLY BLOOD

Bruges, active ca. 1520

The Master of the Holy Blood was so called by G. Hulin de
Loo (*Exposition de tableaux flamands des XIVᵉ, XVᵉ et XVIᵉ
siècles*, Bruges, 1902, p. 33, no. 126) for his triptych the
Lamentation of Christ in the chapel of the Brotherhood of
the Holy Blood (Saint-Sang) in Bruges—the only work by
this master that has remained in its original site. M. J. Fried-
länder (1931, pp. 96–100, 152–55) attributed about thirty
paintings to this unknown painter, including the triptych of
the *Glorification of the Virgin* in the Church of St. James in
Bruges, the triptych of the *Annunciation* in the Museo del
Prado (cat. no. 2494), the triptych of *The Descent from the
Cross* in the Metropolitan Museum of Art (no. 17.187A–
C; see also Harry B. Wehle and Margaretta Salinger, *A
Catalogue of Early Flemish, Dutch, and German Paintings*,
New York, 1947, p. 81), and the panels now in Cleveland.
This artist, although not particularly innovative, was facile
and competent. He helped supply the demand for devo-
tional pictures in northern Europe in the years around
1520. Because he was much indebted to the work of Quen-
tin Massys for his style and his compositions, there has been
speculation that he may have come from Antwerp and per-
haps even from Massys's workshop there.

9A	*St. Catherine*	42.633
9B	*St. Barbara*	42.634

Tempera on panel, 86 x 29 cm (each).

Collections: Claude A. C. Ponsonby (sale: Christie's, London,
March 28, 1908); J. H. Dunn; [Bacri, Paris]; John L. Severance,
Cleveland.

John L. Severance Collection, 1936.

These two paintings were transferred from their original
panels by William Suhr in 1942. A vertical split in the *St.
Catherine* panel, to the right of center, resulted in a few
minor losses and necessitated some repairs. Otherwise,
both panels are in satisfactory condition.

These two panels, painted about 1520, were probably
the wings of a triptych, the central portion of which has
been lost. In the earliest-known publication on the panels—
in the catalogue for the exhibition in 1907—they were
assigned to the Flemish painter Herri met de Bles. Claude
Philips, in his review of the exhibition in *The Daily Tele-
graph* of January 5, 1907, suggested the more general attri-
bution of School of Herri met de Bles. Max J. Friedländer
(1931) was the first to associate these two panels with the
Master of the Holy Blood. Other scholars have since agreed.

St. Barbara (right panel), with the ostrich plume, book,
and ring, and St. Catherine (left panel), who traditionally
accompanies her, are represented by this master on the
wings of other triptychs, such as the *Holy Family* in the
Kunsthalle, Hamburg (Figure 9a). The slender, elongated

Figure 9a. *Triptych with the Holy Family*. On panel; center panel
105 x 75 cm; wings 105 x 31 cm each. Master of the Holy Blood.
Kunsthalle, Hamburg, West Germany.

fingers; the exaggerated facial shadows, particularly in the
St. Catherine; and the rich surface textures are all typical of
the style of the Master of the Holy Blood.

The *St. Catherine* is very close stylistically to the sibyl at
the extreme left in the triptych *Glorification of the Virgin*,
in St. James's Church, Bruges (Figure 9b). N C W

Figure 9b. *Triptych of the Glorification of the Virgin* (detail).
Center panel 94.5 x 116 cm. Master of the Holy Blood.
St. James's Church, Bruges, Belgium.

EXHIBITIONS: London, Royal Academy, Burlington House, Winter Exhibition, 1907: Works by the Old Masters, and Deceased Masters of the British School Including a Collection of Watercolors and Chalk Drawings, cat. nos. 12 and 15; CMA (1936), cat. nos. 202 and 203; CMA (1942), cat. nos. 9 and 10, pl. III; Bruges, Groeningemuseum, 1969: Primitifs Flamands Anonymes, Maîtres aux noms d'emprunt des Pays-Bas meridionaux du XVe et du début du XVIe siècle, cat. no. 36, pp. 84–85, 229–30, illus. p. 84 (catalogue entry by M. Baes-Dondeyne).

LITERATURE: Max J. Friedländer, *Die Altniederländische Malerei*, Vol. IX: *Joos van Cleve, Jan Provost, Joachim Patenier* (Berlin, 1931), p. 153, no. 196 (trans. Heinz Norden, *Early Netherlandish Painting*, IXb [Leyden and Brussels, 1973], 118 and fig. 196); Francis (1942), p. 132; Coe (1955), II, 233, nos. 9 and 10.

SIR PETER PAUL RUBENS

1577–1640

Peter Paul Rubens was born in Siegen, Westphalia, in 1577. He studied in Antwerp with Adam van Noort from about 1592 to 1596 and with Otto van Veen from about 1596 to 1598. In 1600 he traveled to Italy. In Mantua he was appointed court painter to Vincenzo Gonzaga I, who sent him to Rome in 1601 and to Spain in 1603. From 1605 until 1608 Rubens spent considerable time in Rome with his erudite brother, Philip, who was librarian to Cardinal Ascanio Colonna. In 1608, because of the fatal illness of his mother, he returned to Antwerp, where, in 1609, he was appointed court painter to the Archduke Albert and the Infanta Isabella. Also in 1609 he married Isabella Brant, who bore him three children; Isabella died at a young age, perhaps of the plague, in 1626. In 1622 he was invited to Paris to undertake a series of paintings illustrating the life of Marie de Medici which were destined for the new Palais du Luxembourg. He returned to Paris again in 1623 and 1625. From 1623 until the death of the Infanta Isabella in 1633, he was engaged in various diplomatic missions on behalf of the regent for the Netherlands. In 1624 he was ennobled by Philip IV of Spain. In 1630 he was knighted by Charles I of England in recognition of his efforts in the cause of peace between England and Spain, in pursuit of which he traveled to Madrid in 1628 and to London in 1629–30. In 1630 he married Helena Fourment, the sixteen-year-old daughter of his deceased wife's sister. He was occupied the next few years in Antwerp on the ceiling paintings destined for the Banqueting-Hall at Whitehall in London, which were installed in 1635. In that same year he acquired the Château of Steen, the country house at Elewyt, between Malines and Vilvorde, which is represented in some of the landscapes he painted in this last period of his life. He died in Antwerp in 1640.

10 *Portrait of Isabella Brant* 47.207

Panel, 57.1 x 47.9 cm (overall). Painted surface: 55.8 x 46.6 cm.

Collections: Lord Glanusk (sale: Sotheby's, London, April 29, 1914, no. 88); Hugh Blaker, Old Isleworth, Middlesex; Marcus Kappel, Berlin (sale: Paul Cassirer, Berlin, November 25, 1930, no. 16, pl. XVI); private collection, New York; [Rosenberg & Stiebel, New York].

Mr. and Mrs. William H. Marlatt Fund, 1947.

The painting was most recently restored around 1946 by William Suhr (see Figure 10*a*, showing the painting during treatment in a stripped-down state). Suhr transferred the painting from its original oak support to a masonite panel and added strips on all four sides during the process, increasing the overall dimensions (see above). An X radiograph (Figure 10*b*) taken in the Cleveland Museum laboratory indicated that the original panel consisted of three vertical members of equal height and varying widths, mounted side by side, and that a fourth member, differing in density from the upper three, was added to the bottom of the main panel at right angles to the vertical members. Such construction, while unusual, seems to have been characteristic of Rubens (Kelch, 1978, p. 17, and G. Martin, *National Gallery Catalogues: The Flemish School, Circa 1600–Circa 1900*, London, 1970, App. 1, nos. 66, 157, 852). There are flake losses along the bottom edges of the three vertical members that comprise the upper portion of the panel, and running upwards from this point are two splits extending through the right breast of the figure (one of these continues to the upper edge of the panel). It is probable that the present lower cross-member was not always a part of this painting. The density of the ground and the brushwork in the lower member are inconsistent with the upper areas of the portrait. In marked contrast, there is perfect consistency in the ground and brushwork across all three of the vertical members. A definitive statement awaits further laboratory tests, but present evidence strongly indicates that the lower horizontal section of the painting is not contemporary with the rest of the portrait. Because the proportions of the painting would be unthinkable if the work were to have been a finished, displayed piece composed only of the three vertical members, it is tempting to theorize that the painting was originally executed in its present format and that it subsequently suffered damage which necessitated replacing and/or restoring the lower member. The main body of the painting is in exceptionally good condition, apart from minor flake losses and the splits mentioned above.

This portrait was discovered in 1914 at the sale of the collection of Lord Glanusk by Hugh Blaker (Urquhart, 1963). It was first published in that same year by Bode, who bought it for the Kappel collection. Puyvelde (1937, 1940) at first said that it was coarse and vulgar, undoubtedly because of its dirty condition; in a later publication (1952) he retracted his remarks.

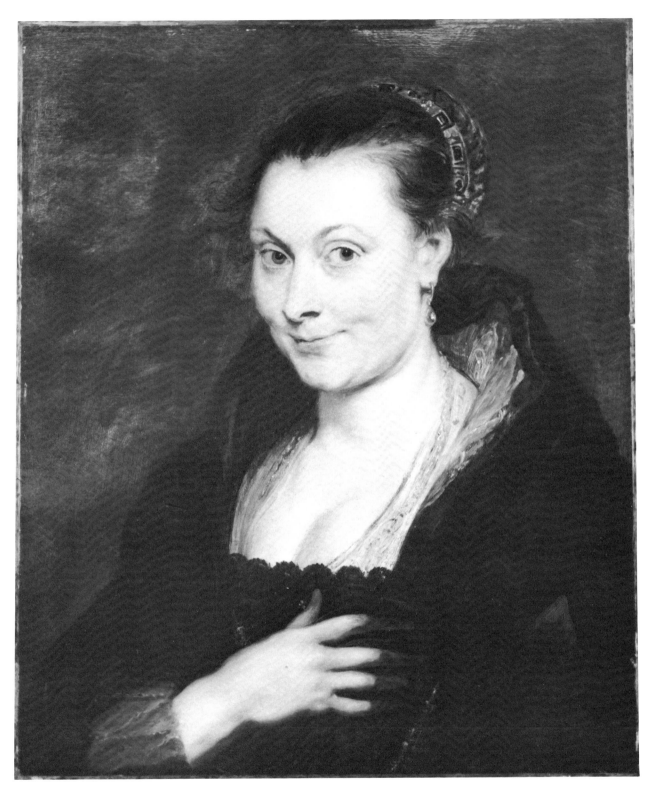

Figure 10.

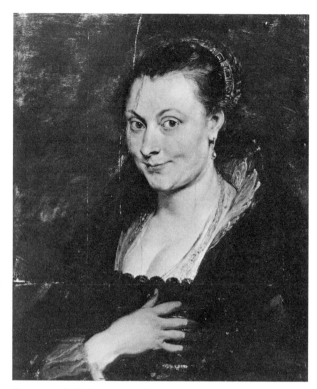

Figure 10a. Painting in stripped state.

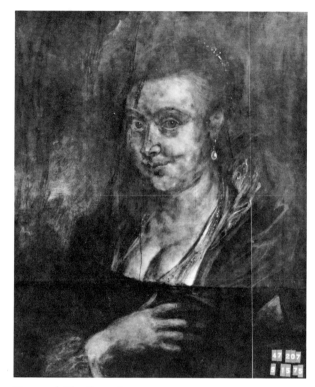

Figure 10b. X radiograph.

Isabella Brant, the subject of the portrait, married Rubens in 1609 when she was eighteen years old. Her father was Jan Brant, the city registrar of Antwerp, and her mother was Clara de Moy, the eldest sister of the wife of Rubens's brother Philip. Isabella and Rubens had three children, Clara Serena (b. 1609), Albert (b. 1614), and Nicholas (b. 1618). The daughter died in 1623, and three years later, at the age of thirty-five, Isabella herself died very suddenly. Rubens's tragic loss was expressed very poignantly in his letter (dated July 15, 1626) to the French philosopher Pierre Dupuy (Charles Ruelens and Max Rooses, *Correspondance de Rubens et documents epistolaires concernant sa vie et ses oeuvres*, Antwerp, 1885, III, 444).

The spirited facility of execution and the sympathetic depiction of personality in this portrait mark it as one of Rubens's best, probably painted for his own enjoyment. Isabella's expression speaks of a very vital and intimate relationship between the two. Some scholars (Glück, 1920; Puyvelde, 1940, 1952; Cabanne, 1967), however, have seen in this portrait a superficial radiance, with overtones of Isabella's impending illness.

The earliest portrait of Isabella is the famous double portrait (now in Munich) painted shortly after her marriage to Rubens, when she was a young girl of eighteen.

A portrait closely related to ours is in Berlin, Staatliche Museen, painted ca. 1620. Puyvelde (1940) and others have suggested that the subject may not be Isabella, but one of her sisters. Jan Kelch (1978) argued unconvincingly that this is a posthumous portrait of Isabella, started before her death and finished afterwards by Rubens. Kelch said it was closely related to the Cleveland portrait as it was originally designed.

A portrait of a more serious Isabella (Figure 10c), painted about 1620, is in The Hague, Mauritshuis (see also Max Rooses, *L'Oeuvre de P. P. Reubens*, Antwerp, 1890, IV, no. 897; and Karl Voll, *Die Meisterwerke der Königlichen Gemäldegalerie im Haag*, Munich, 1903, illus. p. 76). There are two replicas of this portrait of Isabella shown with her hands clasped at her waist: one in London, Wallace Collection (panel, 102 x 73 cm; Rooses, *op. cit.*, no. 898); and the other in Paris, collection of S. A. R. Prince Mohammed Aly Ibraham, formerly in the collection of Jules Porges, Paris. A similar version was in the collection of Edmond Huybrechts, Antwerp, in 1902 (panel, 94 x 68 cm; recorded by Rooses in *Bulletin-Rubens*, v, Antwerp, 1897, p. 89, where he says it is authentic but largely overpainted).

A large formal portrait of Isabella (Figure 10d) seated before the elaborate gateway to Rubens's garden is in Washington, National Gallery of Art (ex collection: Catherine II, for The Hermitage, Leningrad). A replica of the bust of Isabella after the Washington portrait is in Dijon (J. Magnin, *La Peinture au Musée de Dijon*, Besançon, 1929, no. 71, illus. p. 38). Although the National Gallery portrait has been attributed to Rubens, a number of scholars have given it to van Dyck, dating it prior to his Italian journey in 1621. The formal quality of the painting has suggested to

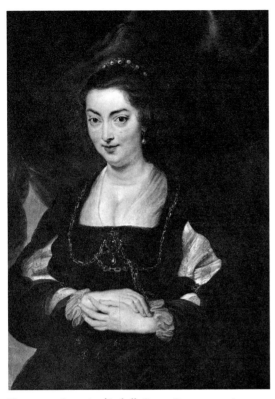

Figure 10c. *Portrait of Isabella Brant*. On canvas, 96 x 73 cm. Rubens. Mauritshuis, The Hague.

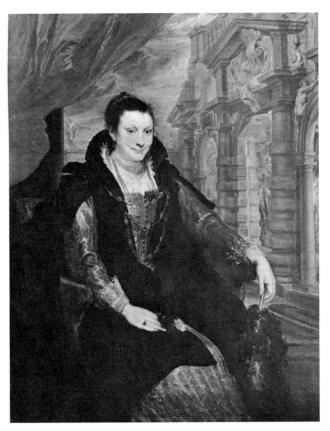

Figure 10d. *Isabella Brant*. On canvas, 153 x 120 cm. Rubens. National Gallery of Art, Washington, Andrew Mellon Collection.

Figure 10e. *Isabella Brant*. Chalk, pen, and ink on light brown paper, 38.1 x 29.2 cm. Rubens. Reproduced by courtesy of the Trustees of The British Museum, London.

Figure 10f. *Isabella Brant*. Ink and wash on paper, 11.4 x 9.2 cm. Flemish, after Rubens. Worcester (Massachusetts) Art Museum, Bequest of Susan Chapman Dexter, 1917.78.

some it was executed posthumously, based on sketches of Isabella made around 1620. The Museum portrait was painted at about this same time or shortly after, ca. 1622, and perhaps just before the death of their daughter.

There is a very beautiful drawing of Isabella by Rubens in which she looks almost straight at the spectator (Figure 10e). The drawing is generally considered to be a study for the Washington portrait; Held (1959, I, no. 103, pl. 115), however, suggested it is a study for the Cleveland portrait. It is certainly very close to the Museum portrait in spirit and probable date.

Another drawing (Figure 10f), possibly of the eighteenth century, after a lost Rubens painting of about 1622, is in the Worcester (Massachusetts) Art Museum. It shows Isabella looking slightly to the right; she wears the same jewelled headband, collar, and bodice as in the Washington and Cleveland portraits, and the same double strand of pearls as in the Washington portrait. The lost oil sketch from which it was copied might have been the study for the Washington portrait, since that is the only portrait in this group in which Isabella faces to the spectator's right.

The last important portrait of Isabella by Rubens was painted shortly before her death (Florence, Uffizi, panel, 86 x 62 cm, ex collections: Pitti Palace, ca. 1624 to 1700, and Villa del Poggio, 1773; Adolf Rosenberg, *P. P. Rubens: Des Meisters Gemälde*, Klassiker der Kunst, Stuttgart, 1921, illus. p. 282). In this picture she looks almost straight at the spectator. Her expression is more modest and sober, and she is shown with some of the same attributes of costume and jewelry that appear in other portraits, but this time she holds a prayer book in her hand.

Other portraits of Isabella are in the following collections: the Museum in Nantes, France; the Duke of Norfolk, London; and Margret Köser, Hamburg (canvas, 64 x 54 cm, without the hands, formerly August Neuerburg collection; see Glück, 1933, p. 385, where Burchard is quoted as saying he feels the Neuerburg portrait is entirely by the hand of Rubens). Puyvelde (1937, p. 7, n. 1) pointed out another replica, formerly in the Uffizi and later on the Paris art market in the late 1930s, which he says is by the hand of the master (except for the flesh tones).

In addition to the portraits, there are other compositions in which Isabella appears. Rubens used her as a model many times. She is, for example, seen as the nymph at the extreme right in this Museum's *Diana and Her Nymphs Departing for the Chase* (Painting 11). An interesting portrait of Isabella is also included in the painting *Christ Blessing the Children* (Ottawa, National Gallery of Canada, given to van Dyck; Garas, 1955, fig. L), which must have been executed about 1618 because her three children are included in the composition and the youngest one appears to be about a year old. Her face appears thinner than in the other portraits. NCW

EXHIBITIONS: Art Gallery of Toronto, 1950: Fifty Paintings by Old Masters, cat. no. 40; CMA (1963), cat. no. 21, illus.; Antwerp, Royal Museum of Fine Arts, 1977: P. P. Rubens: Paintings, Oil Sketches, Drawings, cat. no. 58, illus.

LITERATURE: Wilhelm von Bode, "Ein Neuaufgefundenes Bildnis von Rubens' erster Gattin Isabella Brant," *Jahrbuch der Königlich Preussischen Kunstsammlungen*, XXV (1914), 222, illus. opp. p. 222; Bode, *Die Meister der holländischen und flämischen Malerschulen* (Leipzig, 1917), p. 352, illus. p. 346 (edition of 1921, p. 328, illus. p. 322; edition of 1951, ed. Eduard Plietzsch, p. 425, illus. p. 417); Gustav Glück, "Rubens' Liebesgarten," *Jahrbuch der kunsthistorischen Sammlungen*, XXXV (1920), 61; *Verzeichnis der National Wertvollen Kunstwerke* (Berlin, 1927), no. 158; Paul Wescher, "Nachrichten: Berlin," *Pantheon*, VI (1930), 574; Glück, *Rubens, van Dyck und ihr Kreis* (Vienna, 1933), pp. 95, 385; Leo van Puyvelde, "Les portraits des Femmes de Rubens," *Revue de l'Art*, LXXI (1937), 7, n. 1; Puyvelde, "Van Dyck's Portrait of Isabella Brant," *Art in America*, XXVIII (1940), 7, n. 8; W. R. Valentiner, "Rubens Paintings in America," *Art Quarterly*, IX (1946), no. 67, p. 160; Jan-Albert Goris and Julius S. Held, *Rubens in America* (New York, 1947), p. 26, no. 1, pl. XI; Henry S. Francis, "*Portrait of Isabella Brant* by Peter Paul Rubens," CMA *Bulletin*, XXXIV (1947), 247–49, illus. p. 245; Erick Larsen, *Peter Paul Rubens* (Antwerp, 1952), pp. 216–17, no. 51; Puyvelde, *Rubens* (Paris and Brussels, 1952), pp. 158–59; Klára Garas, "Ein unbekanntes Porträt der Familie Rubens auf einem Gemälde Van Dycks," *Acta Historiae Artium*, II (1955), 190–91, n. 6; Wolfgang Schöne, *Peter Paul Rubens: Die Geissblattlaube* (Stuttgart, 1956), pp. 18, 20, pl. 5; Milliken (1958), illus. p. 40; Held, *Rubens: Selected Drawings*, I (London, 1959), 137; Jaffé (1963), p. 458; Sherman E. Lee, "Style, Truth, and the Portrait," *Art in America*, LI (1963), color illus. p. 29; Murray Urquhart, "The Blaker Diary: Some Extracts with a Memoir by Murray Urquhart," *Apollo*, LXXVIII, N.S. (1963), 295, fig. 1; *Selected Works* (1966), no. 161; Pierre Cabanne, *Rubens* (London, 1967), p. 187; Frans Baudouin, *Pietro Paulo Rubens*, trans. Elsie Callander (New York, 1977), pp. 202, 204, 376 n. 44, pl. 52 (color); Didier Bodart, *Rubens e la pittura fiamminga del Seicento nelle collezioni pubbliche fiorentine* (exh. cat., Florence, 1977), p. 204, under no. 85; *Rubensjaar 1977*, ed. Frans Baudouin (Antwerp, 1977), color illus. p. 100; CMA *Handbook* (1978), illus. p. 154; Jan Kelch, *Peter Paul Rubens, Kritischer Katalog der Gemälde im Besitz der Gemäldegalerie Berlin* (Berlin-Dahlem, 1978), pp. 16–18, fig. 9.

SIR PETER PAUL RUBENS

11 *Diana and Her Nymphs Departing for the Chase* 59.190

Canvas, 215.9 x 178.7 cm.

Collections: Family of Valckenier, Amsterdam; Elisabeth Hooft, widow of Wouter Valckenier (sale: Amsterdam, August 31, 1796, no. 32); Mr. Bryan, Pall Mall, London (sale: Coxe, Burrel & Foster, London, May 17, 1798, no. 42); Sir Simon H. Clarke, Bart., Oakhill, Hertfordshire (sale: Christie's, London, May 14–15, 1802, no. 71); Mr. Bryan, London (?); Mr. Birch, London (?) (sale: Greenwood & Co., London, February 19, 1803, not catalogued in sale, known from MS notation in catalogue); Sir Simon H. Clarke, Bart., Oakhill, Hertfordshire (estate sale: Christie's, London, May 8–9, 1840, no. 52); Mr. Nieuwenhuys; Thomas Baring, Lord Ashburton, 1854; Thomas George Baring, First Earl of Northbrook; Germaine, Baroness de Rothschild (widow of Edouard de Rothschild), Chantilly, France; [Rosenberg and Stiebel, New York].

Purchase, Leonard C. Hanna Jr. Bequest, 1959.

Figure 11.

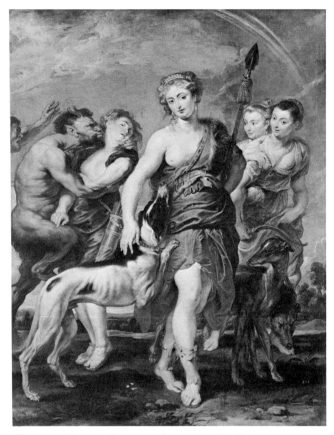

Figure 11a. *Diana and Her Nymphs Departing for the Hunt.* On canvas, 284 x 180.3 cm. Rubens. The J. Paul Getty Museum, Malibu, California.

Figure 11b. *Diana and Her Nymphs Departing for the Hunt.* On canvas, 252 x 200 cm. Studio of Rubens. Staatliche Kunstsammlungen, Kassel, West Germany.

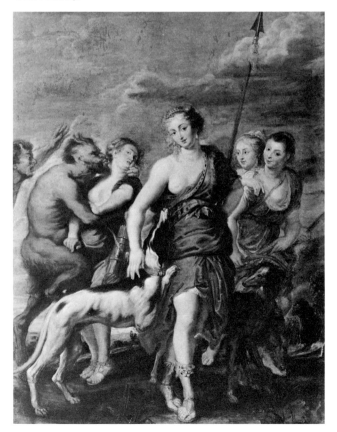

This lined canvas was cleaned in 1959 by William Suhr, who removed discolored varnish from a paint surface that was generally in a good state of preservation. There are slight overall abrasions in the sky. There are some paint losses along the right edge of the canvas extending into the breast, arm, and shoulder of the nymph at the far right, who also has a vertical tear through her forehead, damages in her right eye and nose, and a tear through her right hand. Diana has a small scratch in her neck. The nymph in the arms of the satyr has two tears in her hair, the lower part of her blue garment is abraded, and there is a vertical scratch extending from her legs to the left hind leg of the dog. There are abrasions along the left edge of the canvas, and the face of the satyr at the extreme left is partly lost. The canvas has been cut down along both vertical edges, so that the satyr rushing in from the left is now barely noticed, and Diana is nearer the center of the picture than was intended. The loss has disturbed the original balance of the composition and weakened its dramatic tension; compare, for example, with the engraving of 1810 by James Ward (Rooses, 1890, pl. 187), after the Cleveland painting, in which more of the satyr's face is shown.

The Cleveland painting has gained some notoriety because of its relationship to another large version of the subject (Figure 11a) which was discovered after years of oblivion and published in 1962 when it was purchased by J. Paul Getty for the J. Paul Getty Museum (ex collections: Marqués de Léganès, Madrid, 1655; said to have been in the collection of the Eighth Duke of Altamira; said to have been in the collection of the Duke of Salamanca; Roblot family, Paris, 1870–1951; [Jean Neger, Paris]; see Fredericksen, 1972, no. 83, pp. 66–68). The Getty painting was aggressively defended at the expense of the Cleveland painting by Jean Neger (1960). Julius Held (in Getty, 1965) also felt that the Getty version was by the master's hand "in all essential details," whereas the Cleveland painting, he said, was more pedantic in execution. The controversy has cast undeserved doubt on the authenticity of the Cleveland painting. There are subtle differences in quality and emphasis and many obvious differences in details. Diana and the nymph behind the dog both wear leggings or sandals in the Getty version, whereas they are barefooted in the Cleveland version. The tops of the quiver and the lance are more decorative in the Cleveland version than in the Getty painting. The two birds in the upper sky of the Cleveland painting (which have been given to Snyders by Waagen, 1854, and others) are not in the Getty version. Perhaps most important is the difference in treatment of the distant landscape. In the Getty painting there is a low horizon line, before which the figures appear like a sculptural frieze. The landscape in the Cleveland painting is more illusionistic; in the small area on either side of the wrist of the nymph on the far right, the landscape has been placed somewhat arbitrarily in relation to the lower horizon line on the left—a feature which is most certainly Rubens's own invention.

A cruder version of the subject in Kassel (Figure 11*b*), with Diana and the nymph in sandals, follows the Getty painting closely, although the landscape in the foreground differs in detail. The Kassel painting is generally considered to be a studio replica; however, some scholars, such as Rooses (1890, p. 72), Wurzbach (1910), and Glück (1933), do not agree. Ludwig Burchard (letter of November 19, 1958) and others have suggested that the Kassel painting was probably abandoned unfinished by Rubens and completed at a later date, perhaps in the 1630s, by assistants in the studio.

A small studio sketch on panel (Figure 11*c*), having the details of the Getty version, is in the collection of Secondo Pozzi in Novara, Italy. In an expertise provided for the owner, dated May 14, 1962, Yvonne Thiéry states that this is a preliminary sketch for the Getty version and that it dates from about 1610 to 1613.

A later miniature copy, somewhat modified but based on the Getty version, is in the collection of Lady Exeter, Burghley House, Stamford. Executed in the style of Hendrik van Balen (1575–1632) and designed as an inset for a cabinet, it attests to the continued popularity of Rubens's design.

A small version of the Cleveland *Diana* was brought to our attention in 1963 by its owner, Ludwig Meyer of Munich (letter of October 22, 1963). This unpublished sketch (Figure 11*d*) was thought by the owner to be a studio copy of about 1620. It follows the Cleveland painting in virtually every detail.

The Munich sketch is also closely related to an 1810 engraving by James Ward which was taken directly from the Cleveland painting. As Ludwig Burchard pointed out (letter of November 19, 1958), Max Rooses (1890) made his unenthusiastic evaluation of the Cleveland painting based on his study of this engraving; he probably never saw the painting itself on his visits to English collections.

Another version, designated "after Rubens," is mentioned in the estate inventory taken after the death of Henri-Jules, Duke of Bourbon, in 1709. The Château of Chantilly is the location of this version given in *Documents du Minutier Central concernant l'histoire de l'art* (ed. M. Rambaud, Paris, 1964, I, 529).

The Cleveland painting had been virtually neglected in the literature after the turn of the century, until its acquisition by this Museum in 1959. Burchard (letter of November 19, 1958) accepted it as the work of Rubens except for the hounds, which he felt were executed by Frans Snyders after Rubens's designs. Burchard dated it not later than 1615, partly because of the silvery bluish tones that are typical of Rubens's work between 1612 and 1615. Michael Jaffé, in a letter of January 14, 1962, said that the Cleveland painting is a "splendid masterpiece," entirely by Rubens's hand, executed about 1615; the Getty painting, he said, is by assistants, retouched by the master before it left the studio. Recently, Wolfgang Adler (1980) said that the

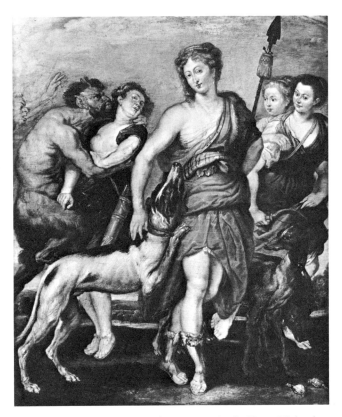

Figure 11*c*. *Diana and Her Nymphs Departing for the Hunt.* Oil sketch. Studio of Rubens. Collection Secondo Pozzi, Novara, Italy.

Figure 11*d*. *Diana and Her Nymphs Departing for the Hunt.* On panel, 53 x 65 cm. Copy after Rubens. Present whereabouts unknown.

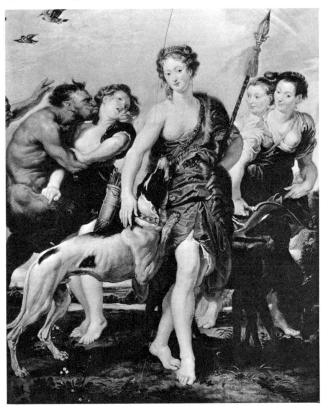

nymphs, the satyr, and the dogs are by Rubens, but the landscape details are by Jan Wildens.

The Cleveland painting is associated with many others dating from 1612 to 1618, all of which reflect Rubens's fascination with the subject of Diana and the hunt. It is also related in date and style to the *Rape of the Daughters of Leucippus* in Munich (Alte Pinakothek), dated ca. 1615 to 1617, in which Rubens used the same model who appears in the Cleveland painting as the nymph in the arms of the satyr (in both paintings her figure is brilliantly foreshortened). The model for the nymph at the far right was Isabella, the artist's wife, the subject of the Museum's *Portrait of Isabella Brant* (see Painting 10). NCW

EXHIBITIONS: London, British Institution, 1821, cat. no. 61; London, British Institution, June 1839, cat. no. 141; Manchester, 1857: The Art Treasures of Great Britain, cat. no. 549 (no. 563 in provisional catalogue).

LITERATURE: W. Buchanan, *Memoirs of Painting with a Chronological History of the Importation of Pictures by the Great Masters into England since the French Revolution*, I (London, 1824), 284; Smith (1830), II, 210, no. 752; André van Hasselt, *Histoire de P.-P. Rubens suivie du catalogue géneral et raisonné de ses tableaux, esquisses, dessins et vignettes* (Brussels, 1840), no. 698; Waagen (1854), II, 182; W. Bürger (Thoré), *Trésors d'art exposés à Manchester en 1857 et provenant des collections royales, des collections publiques et des collections particulières de la Grande-Bretagne* (Paris, 1857), pp. 183, 185; Waagen, *A Walk through the Art-Treasures Exhibition at Manchester* (London, 1857), p. 22; Max Rooses, *L'Oeuvre de Rubens*, III (Antwerp, 1890), 73, no. 587, pl. 187; W. Roberts, *Memorials of Christie's, A Record of Art Sales from 1766–1896*, I (London, 1897), 65; Eduard Fuchs, *Illustrierte Sittengeschichte vom Mittelalter bis zur Gegenwart*, I (Munich, 1909), illus. after p. 168; Alfred von Wurzbach, *Niederländisches Künstler-Lexikon*, II (1910), 496; Hippolyte Mireur, *Dictionnaire des ventes d'art faites en France et à l'étranger pendant les XVIIIme & XIXme siècles*, VI (Paris, 1912), 352; Graves (1914), III, 1160, 1162, 1165; Gustav Glück, *Rubens, Van Dyck, und ihr Kreis* (Vienna, 1933), p. 192; Erik Larsen, "Rubens' First Version of Diana's Return from the Hunt," *Apollo*, LX (1954), 159, n. 9; *Katalog der Staatlichen Gemäldegalerie zu Kassel* (Kassel, 1958), p. 135, no. 93; *Life Magazine*, September 28, 1959, color illus. p. 63; Henry S. Francis, "Peter Paul Rubens, *Diana and Her Nymphs Departing for the Chase*," CMA *Bulletin*, LXVII (1960), 19–27, illus. pp. 20–22, color illus. p. 17; Jean Neger, *I Accuse: Professor Ludwig Burchard's Deliberate Mistake* (privately printed pamphlet, Paris, 1960); *Life Magazine*, January 12, 1962, p. 54, and February 9, 1962, p. 95 ff.; Jaffé (1963), 457; J. Paul Getty, *The Joys of Collecting* (New York, 1965), p. 108; Leo van Puyvelde, *Le Siècle de Rubens* (exh. cat., Brussels, 1965), pp. 193–94; Alsop (May–June 1966), p. 23, illus. p. 25; Horst Gerson, "Das Jahrhundert von Rubens," *Kunstchronik*, XIX (1966), 61, fig. 1b; *Selected Works* (1966), no. 162; Pierre Cabanne, *Rubens* (London, 1967), p. 118; Gregory Martin, *National Gallery Catalogues: The Flemish School, Circa 1600–Circa 1900* (cat., London, 1970), p. 112; Burton B. Fredericksen, *Catalogue of the Paintings in the J. Paul Getty Museum* (Malibu, California, 1972), pp. 67–68; Wolfgang Adler, *Jan Wildens: Der Landschaftsmitarbeiter des Rubens* (Fridingen, 1980), pp. 101 no. G 34, 163 fig. 51.

Workshop of SIR PETER PAUL RUBENS

12 *The Church Triumphant* 16.1037
 through the Holy Eucharist

Panel (oak), 72 x 145.5 cm.

Collections: Madrazzo, Madrid; M. Thiers, President of the French Republic, Paris; Duchesse de Bauffremont, Paris; E. Warneck, Paris; [Durand-Ruel, Paris]; Mr. and Mrs. Jeptha H. Wade, Cleveland, 1891.

J. H. Wade Collection, 1916.

This panel had been cradled and the picture was restored in the past. In 1939 William Suhr removed the dark and yellowed varnish and a few areas of repaint, revealing a transparent quality of lightness and sketchiness that one would expect in a Rubens *modello*. The paint film was in splendid condition except for a few chipped areas in the sky and at the edges of the upper third of the panel where there were darkened retouches and blisters.

This panel and many other paintings of the subject are related to the series of tapestries called *The Triumph of the Holy Sacrament*, designed by Rubens and commissioned by the Archduchess Isabella Clara Eugenia, Governess of the Netherlands. Isabella had spent eight months before her marriage in the Convent of the Descalzas Reales in Madrid, and after the death of her husband Albert in 1622, she resumed the dress of the Poor Clares. In 1625 she decided to give her favorite order, and the convent in which she had a special interest, a royal gift of a series of tapestries woven at Brussels by Jan Raes after designs by Rubens. Work was begun on this series in 1625 and the tapestries were completed in July 1628. They were sent to the convent in Madrid, where they are now on permanent exhibition.

The subjects designed by Rubens for this series numbered at least thirteen (Elias Tormo, "La Apoteosis Eucaristica de Rubens," *Archivo Español de Arte*, XV, 1942, 119). The Cleveland workshop sketch is of a subject from this series, *The Church Triumphant through the Holy Eucharist* (sometimes called *Triumph of the Holy Sacrament over Ignorance and Blindness*). In it, Ecclesia, the allegorical figure representing the Church, bears the monstrance with the Eucharist and is seated on a triumphal chariot. In the right foreground, chained to the chariot wheel, are two male figures—one (with ass's ears) representing Ignorance, and the other, Blindness—being led by the Spirit of Light. Hatred, Discord, and Fury (sometimes described as Envy) are being crushed under the wheels of the chariot. An angel is holding the papal tiara over the head of Ecclesia, while another angel is riding the white horse and carrying the pontifical keys. Among other allegorical figures are the four female figures which may represent Fortitude, Justice, Prudence, and Temperance (Scribner, 1976, p. 140). The first, who leads the procession and carries a labarum, disappears behind the twisted column at the extreme left.

This tapestry series was very popular; there were at least

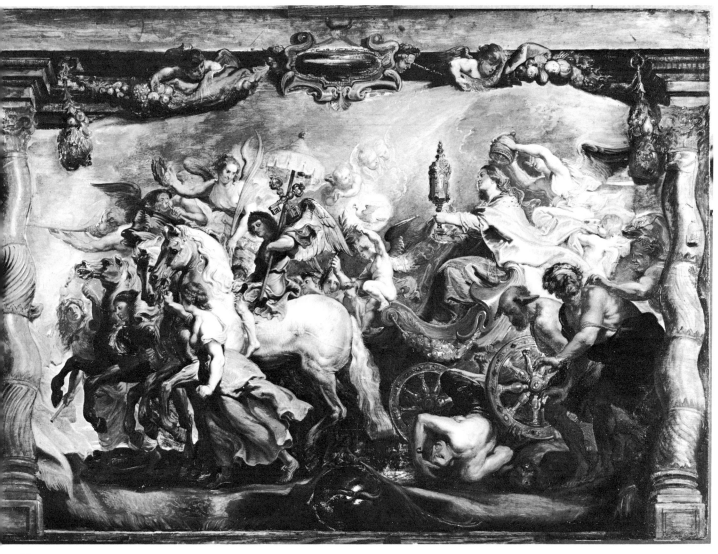

Figure 12.

seven sets after Rubens's designs woven in Brussels in the seventeenth century (Elbern, 1955, pp. 84–86; and Madeleine Jarry, "'New Testament' Tapestries in St. John's Cathedral, Malta: 'Triumphs' after Rubens," *Burlington Magazine*, CII, 1960, 150, fig. 11).

The problem of determining the relationship of the various painted versions and replicas surrounding this ambitious project is complicated by their great number. Scholars in general (except for Puyvelde, 1947, and Burchard and Elbern, 1954–55) think that the ten small grisaille oil sketches on panel were Rubens's first ideas, the *bozzetti*, for the tapestry cycle; between these and the finished tapestry there were other steps in which the original ideas were developed and in some cases changed considerably (de Poorter, 1978, I, 83–94). Of the ten grisaille sketches, seven, including the *Triumph of the Eucharist over Ignorance and Blindness* (Figure 12a), are in the Fitzwilliam Museum,

Cambridge, England (H. Gerson and J. W. Goodison, *Catalogue of Paintings*, I, Cambridge, 1960, pp. 103, 106); two are in the Musée Bonnat, Bayonne (nos. 950, 951); and one other is in The Art Institute of Chicago. These sketches are in the same sense as the tapestries, that is, not in reverse.

After the grisaille *bozzetti*, apparently, came the *modelli*, which were used by Rubens's studio in the preparation of the large cartoons on canvas for the use of the tapestry weavers. Unlike the *bozzetti*, the *modelli* and the cartoons were in reverse of the tapestry image. The *modello* for the subject represented in the Cleveland painting is generally considered to be the *Triumph of the Eucharist over Ignorance and Blindness* (Figure 12b) now in the Prado, Madrid (no. 1698; panel, 87 x 180 cm; original dimensions, 63 x 106 cm). The Prado has eight paintings on panel of subjects in this series.

Six of the original, full-size cartoons, in oil on canvas,

Figure 12*a*. *Triumph of the Eucharist over Ignorance and Blindness.* On panel, 16.2 x 24.4 cm. Rubens. Fitzwilliam Museum, Cambridge, England.

Figure 12*b*. *Triumph of the Eucharist over Ignorance and Blindness.* On panel, 87 x 106 cm. Rubens. Museo del Prado, Madrid.

executed by Rubens's studio after his *modelli*, for the Descalzas Reales tapestries, still survive. Four are now in the John and Mable Ringling Museum of Art, Sarasota (nos. 211–14), and the other two are in the Louvre, Paris (nos. 2076 and 2083). The rest of the original, large cartoons were burned in 1731 in the fire at the king's palace in Brussels. A copy on canvas (250 x 351 cm) of a lost cartoon in this series, of the same subject as our painting, perhaps by Theodore van Thulden (1606–1669), hangs in the church of St. Pierre (also known as Notre-Dame) in Ghent.

Of the many versions and copies of this subject, the Cleveland painting comes closest in quality to the Prado *modello* and like it, is in reverse of the tapestry design. The painted architectural framework at the top and bottom of the Cleveland panel has been reduced, and there is more area for the sky, but otherwise—in the relationship of the figures to each other, in the horizontal treatment of the space, and in the way that the lateral figures disappear behind the twisting columns—the two paintings are very similar.

Various artists in Rubens's workshop have been named as author of the Cleveland painting. Burroughs (1938) suggested Erasmus Quellinus (1607–1678). Others have suggested Cornelis Schut (1597–1655) and Daniel Seghers (1590–1661). Valentiner (1914), Suida (1949), and Puyvelde (1947) have all called our painting a studio replica. There are some less meaningful passages of paint that suggest it is a studio version, but there are also areas of brilliant brushwork and sparkling highlights (more apparent after the cleaning in 1942) that suggest it may have been retouched by Rubens himself.

There are many more known versions of the subject executed after the Prado *modello*. A copy by David Teniers the Younger, painted in 1673, known to have been in the museum in Pontevedra, Spain, attests to its popularity. To the long list of copies that have been catalogued by Nora de Poorter (1978, I, 327–30), at least three others—whose present whereabouts are unknown—should be added (unless they eventually can be identified with versions in de Poorter's catalogue). These are: 1) copy in the collection of W. P. Wsefolojsky, Riabowo, near Leningrad (Baron N. Wrangell, "La vie de châteaux russes," *Starye Gody*, July–September 1910, pp. 24, 73, n. 40, illus.); 2) L. Cardon sale, Brussels, June 27–30, 1921 (panel, 33 x 57 cm); 3) sale, Galerie Giroux, Brussels, November 13, 1928 (no. 191, panel, 116 x 167 cm).

Numerous engravings have also been made after the subjects in the tapestry series. One, of the same subject as the Cleveland painting, probably after the Prado *modello*, was made by Schelte a Bolswert (Stedelijk Prentenkabinet, Antwerp). NCW

EXHIBITIONS: Cleveland Art Loan Exposition, 1913, cat. no. 153D; CMA (1936), cat. no. 239; Columbus (Ohio) Gallery of Art, 1940: Paintings by Rubens, cat. no. 7; New York World's Fair, 1940: Masterpieces of Art, cat. no. 70, pl. 70; Akron (Ohio) Art Institute, 1950: Inaugural Exhibition for New Building; Buffalo (New York), Albright Art Gallery, 1954: Painter's Painters, cat. no. 7, pl. 7; CMA (1956); Northampton (Massachusetts), Smith College, 1963: Art II Survey Course.

LITERATURE: W. R. Valentiner, *The Art of the Low Countries* (Garden City, New York, 1914), p. 236, no. 25; "The Wade Collection," CMA *Bulletin*, IV (1917), 4, illus. p. 6; Gertrude Underhill, "Some Recent Acquisitions of The Cleveland Museum of Art," *Art & Archeology*, VI (1917), 42, fig. 1; "In Memoriam Jeptha Homer Wade," CMA *Bulletin*, XIII (1926), 64, illus. p. 77; Alan Burroughs, *Art Criticism from a Laboratory* (Boston, 1938), p. 134; Valentiner, "Rubens' Paintings in America," *Art Quarterly*, IX (1946), 164, no. 25; Jan-Albert Goris and Julius S. Held, *Rubens in America* (New York, 1947), no. A76, p. 53; Leo van Puyvelde, *The Sketches of Rubens* (London, 1947), p. 83 (incorrectly states that the painting is on canvas); William E. Suida, *A Catalogue of Paintings in the John and Mable Ringling Museum of Art* (Sarasota, Florida, 1949), p. 187; Victor H. Elbern, *Peter Paul Rubens: Triumph der Eucharistie, Wandteppiche aus dem Kölner Dom* (exh. cat., Cologne, 1954), p. 37; Coe (1955), II, 254, no. 32; Elbern, "Die Rubensteppiche des Kölner Domes; Ihre Geschichte und ihre Stellung im Zyklus 'Triumph der Eucharistie,'" *Kölner Domblatt*, II, no. 10 (1955), 85; Matías Díaz Pedrón, *Museo del Prado: Catálogo de Pinturas*, Vol. I: *Escuela Flamenca Siglo XVII* (Madrid, 1975), p. 293; Charles Scribner, "*The Triumph of the Eucharist Tapestries Designed by Peter Paul Rubens*" (Ph.D. dissertation, Princeton University, 1977; Ann Arbor, Michigan: University Microfilms, 1976), p. 145; *Corpus Rubenianum Ludwig Burchard*, Pt. 2, *The Eucharist Series*, Nora de Poorter (Brussels, 1978), I, 327, and II, 471; Julius S. Held, *The Oil Sketches of Peter Paul Rubens: A Critical Catalogue* (Princeton, 1980), I, 156 (under cat. no. 106); Mark M. Johnson, *Idea to Image* (exh. cat., Cleveland, 1980), pp. 76–78, fig. 96.

JAN SIBERECHTS

1627–1700

Jan Siberechts was born and baptized in Antwerp in 1627. His father was a sculptor. By 1648 or 1649 he was a member of the Antwerp guild. He was active in Antwerp until 1672, when the Duke of Buckingham saw his work and brought him to England. In England Siberechts did watercolor landscapes and topographical paintings of estates of the nobility, and he continued, for a time, to paint his more usual subjects—peasants and animals fording a stream. The parallel and preceding developments in Dutch and Flemish painting did not go completely unobserved by him, but his emphatic detail and solidity of form, along with an ever-present luminosity, somehow place him outside his time and make him a harbinger of the naturalism of the nineteenth century. He died in London in 1700.

13 *Pastoral Scene* 69.18

Canvas, 99.7 x 122.5 cm. Signed at lower left: J. Sibrechts. A. anvers.

Collections: Private collection; [Frederick Mont, New York].

Mr. and Mrs. William H. Marlatt Fund, 1969.

The painting was examined under ultraviolet light in 1974, and was found to be in good condition. There were some scattered spots of retouching in the open sky between the trees, one irregular patch in the right foreground (below the sheep, second from the edge), and a few very small spots across the foreground. All the darker areas were intact, including the lower left corner with the signature.

An old, gnarled, willow tree stump with new shoots silhouetted against the sky—which appears at the right in this painting—is a motif Siberechts repeated in other paintings. In a picture tentatively dated 1665 (National Gallery, London; Gregory Martin, *The Flemish School, Circa 1600–Circa 1900*, cat., London, 1970, p. 237, cat. no. 2130), the stump is fairly simple and upright, with branches shooting upward. The form is more twisted and complex in a work of 1670 (Berlin, Staatliche Museen; T. H. Fokker, *Jan Siberechts*, Brussels and Paris, 1931, pl. 17), and by 1672 it had become a massive shape that dominates the picture (Budapest, Museum of Fine Arts; Fokker, *op. cit.*, pl. 21). On the other hand, there was little change in Siberechts's approach to figures and animals; he used the same models and poses over a span of time. Even after he moved to England he painted Flemish peasant women carrying water jugs, but against rolling English hills. Stylistic development and variations seem more apparent in his landscape backgrounds. As in the case of the tree stumps, these changes occur within a fairly limited range of compositions which he utilized throughout his career.

On the basis of comparison with dated works such as *L'Arc-en-ciel (The Rainbow)*, of 1669, and *Le Vieux Saule mutilé (The Blasted Willow)*, of 1670 (Fokker, *op. cit.*, pls. 16 and 17), the Cleveland painting would seem to date around the same time. JKC

EXHIBITIONS: CMA, January 1970: Year in Review, cat. no. 151; CMA (1973).

LITERATURE: CMA *Handbook* (1978), illus. p. 155.

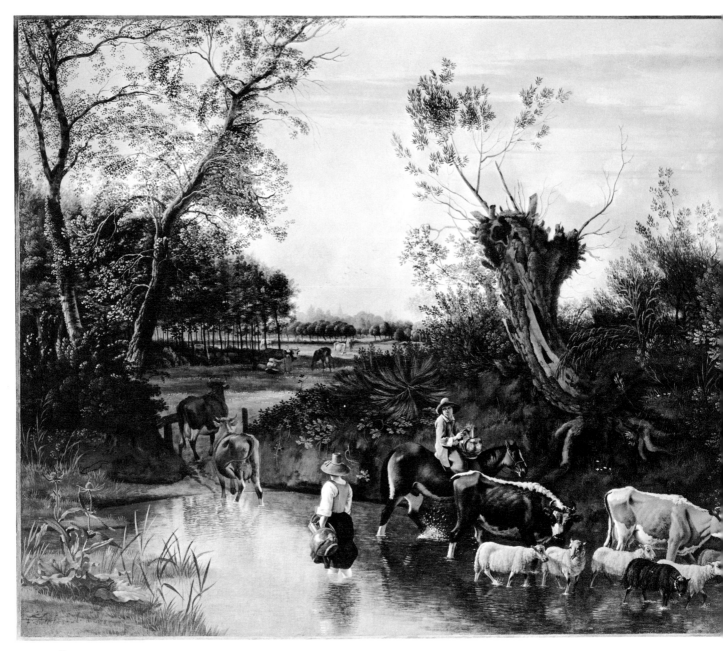

Figure 13.

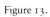

Circle of BARTHOLOMAEUS SPRANGER

Spranger was born in 1546 in Antwerp. His early training was in Antwerp, but after that he traveled continuously. He was in Paris in 1565. He then went to Italy, where he was influenced by Parmigianino, Correggio, and Taddeo Zuccaro. He was named painter to Pope Pius V in Rome. In 1575 he was called to the court of Maximillian II in Vienna, and in 1581 to the court of Rudolf II in Prague. He was a printmaker as well as a painter. His work was popularized by the prints of Jan Müller, Saedeler, and Goltzius, among others.

14 *Allegorical Figures of Summer and* 16.805
 Autumn or *Ceres and Bacchus*

> Canvas, 164 x 99.5 cm.
> Collections: James Jackson Jarves; Mrs. Liberty E. Holden, Cleveland, 1884.
> Holden Collection, 1916.

Figure 14a.

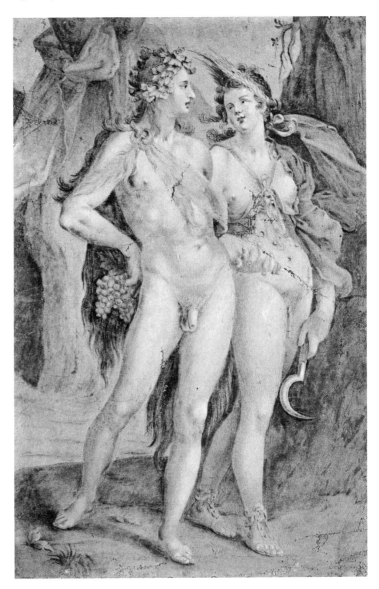

The painting was examined by the Intermuseum Laboratory in Oberlin, Ohio, in 1973. There are extensive small losses throughout the painting and abrasions on the woman's face. From top to bottom along the left side there is a layer of overpaint that extends at least sixteen centimeters into the image. The visual effect of the painting is distorted by the uneven surface of the ground and paint surface; the crackle pattern; cupping and cleavage; abrasion; and the dark, discolored varnish.

Jarves (1884) attributed this painting to Pellegrino Tibaldi, and M. L. Berenson (1907) attributed it to Paolo Farinati. Niederstein (1937) called it a copy after a painting by Spranger that is now in Vienna, *Ceres and Bacchus Abandoning Venus* (canvas, 161.5 x 100 cm; ex collection: Rudolf II, inv. no. 2435; signed and dated 1590; see *Verzeichnis der Gemälde*, Vienna, Kunsthistorisches Museum, 1973, p. 166). Konrad Oberhuber did not include the Museum painting in his doctoral dissertation on Spranger's works (*Die stilistische Entwicklung im Werk von Bartholomaeus Spranger*, Vienna, 1958), but in letters (to Ann T. Lurie, July 2, 1973, and to Wolfgang Stechow, June 23, 1965) he gave his opinion that the painting is a copy after the engraving by Jan Harmensz. Müller (Adam Bartsch, *Le Peintre Graveur*, III, Vienna, 1803, 288, no. 74) which is after the Spranger painting in Vienna. (Another painting, 200 x 100 cm, after the Müller engraving, is in the collection of Göran Folkesson, Huskvarna, Sweden.)

Spranger painted a number of pictures depicting Bacchus and Ceres about 1590. According to Oberhuber, Spranger and others used the composition again after 1600. There is a drawing by Spranger in the collection of de Boer in Amsterdam. Another drawing, close in detail to the composition of the Museum painting (British Museum; Popham, 1932, no. 5), was formerly attributed to Goltzius and is a

Figure 14.

copy of the upper half of Müller's engraving. A pen and ink sketch (43.1 x 33.4 cm) recently appeared in an auction at the Palais Galliera, Paris (June 3, 1975, no. 13; formerly collection of Ph. Pfister, secretary to King Ludwig II of Bavaria). There was another pen and wash drawing (43.2 x 32.4 cm) at the Herbert E. Feist Gallery in New York (*Master Drawings through Five Centuries*, 1976, no. 6, illus. on cover). Another drawing after the Müller engraving is in the National Gallery, Prague (inv. no. K 8875; pen drawing with brown tone, 44.2 x 36.1 cm; inscription: Bart. Spranger Antonius/Coll^on/Greill 1750), probably executed about 1750, according to Jiří Kotalík of the Prague National Gallery (letter of August 19, 1976), who also stated that the Cleveland painting is a later copy of the Vienna painting.

Though there are echoes of Spranger in the Cleveland painting, his Italian Mannerist elegance is missing. The forms are more Northern and robust. Unfortunately, the condition of the painting precludes a more definite statement on the attribution or dating of the work at this time.

There is a copy of this painting (Figure 14*a*) in the Museum collection (48.172, canvas, 45 x 30 cm; collections: S. B. Grimson, New York; Mrs. Benjamin P. Bole, Cleveland, 1928; Gift of Mrs. Benjamin P. Bole, 1948). From a conservator's point of view, this painting is unique. A red ground covers the canvas, and over this is a thin application of oil paint which has been flocked with cotton fibers to achieve an overall effect of softened textures. The flocking technique was developed during the third quarter of the fifteenth century in south Germany, where it was used in prints to emulate a velvet texture. A similar technique used in the seventeenth century for wallpapers developed into an industrial process in the late nineteenth and early twentieth century. In this painting, details such as eyes and eyebrows and accents throughout were added in oil on top of the flocking. All the edges have been trimmed. The original design is carried around the sides of the stretcher at the top and at the left and right edges. The bottom edge is cut flush with the stretcher and tacked through from the front to the stretcher. The painting was represented as a pastel when it was sold to Mrs. Bole, and it had been attributed to Bartholomaeus Spranger by Harold Parsons, Henry Kent, and Sir Robert Witt, according to the dealer, S. B. Grimson (letter of February 24, 1928). Its technique and style indicate that it possibly could have been executed as late as the late nineteenth or early twentieth century. N C W

EXHIBITIONS: Boston (1883), cat. no. 421; New York (1912), cat. no. 27, p. 183; CMA (1936), cat. no. 106.

LITERATURE: Jarves (1884), no. 18, p. 11; Mary Logan Berenson, "Dipinti italiani in Cleveland," *Rassegna d'arte*, VII, no. 1 (1907), 5; Rubinstein (1917), no. 49; A. E. Popham, *Catalogue of Drawings by Dutch and Flemish Artists in the British Museum*, V (London, 1932), 180; Albrecht Niederstein, in Thieme-Becker, XXXI (Leipzig, 1937), 404; René Brimo, *L'Evolution du goût aux Etats-Unis d'après l'histoire des Collections: Art et goût* (Paris, 1938), p. 67.

DAVID TENIERS THE YOUNGER
1610–1690

Teniers was born in 1610 in Antwerp. He was the son of the painter David Teniers I and the father of another painter, David Teniers III. David II, or David the Younger, became a master in Antwerp in 1632–33; he worked there until 1651, when he moved to Brussels. He was court painter to Archduke Leopold Wilhelm, Regent of the Netherlands and a notable collector. Teniers became keeper of the archduke's paintings. Later, he was court painter to the succeeding regent, Don Juan of Austria. Teniers was the main founder of the Antwerp Academy, which opened in 1665. Though he painted many kinds of pictures, he is best remembered for his genre scenes of peasant life. In his own time he was a leading favorite among collectors, including Philip IV of Spain, and was held in high esteem by critics and connoisseurs. He was widely imitated (see, for example, Stechow, 1968, p. 28, fig. 1). In his later years he was apparently overcome by his own popularity, and he required assistants to help him meet the enormous demand. At the same time, his own work became routine and repetitious. All of this causes confusion concerning the attribution of paintings to Teniers. After his death in Brussels in 1690, his pictures continued to be in great demand, and his reputation lasted well into the nineteenth century.

Figure 15.

15 *Peasants Smoking and Drinking:* 16.1046
Interior of a Public House

Panel (oak), 37.1 x 26.3 cm. Signed at lower left:
D. TENIERS FEC.

Collections: Louis de Bourbon-Condé, Comte de Clermont, Paris; [purchased by J. B. P. Lebrun, Paris, in 1796 for Richard Codman]; John Codman (1755–1803), Boston; Charles R. Codman (1784–1852); Richard Codman; Mr. and Mrs. J. H. Wade, Cleveland, purchased in 1893 from Boussod-Valadon.

J. H. Wade Collection, 1916.

The panel was examined and cleaned in 1938 by William Suhr, who removed a thick, yellowed layer of varnish that was obscuring the color. There was darkened repaint on the coat of the center figure and along the left side of the picture. Some flaking had occurred along the right and left edges. Suhr did some slight retouching in the background, in the head and face of the center figure, and in the hair of the man on the right.

This painting, executed ca. 1640, reflects the influence of Adriaen Brouwer, who was active in Antwerp at the same time as Teniers (Gerard Knuttel, *Adriaen Brouwer*, The Hague, 1962, fig. 75). The careful composition and lightly touched surface are characteristics of Tenier's work during his best period.

A copy of this picture, now in the Museum of the Historical Society of Western Pennsylvania, Pittsburgh (Stechow, 1968, pp. 32–33, fig. 5), was made by David G. Blythe (1815–1865) when the original was still in the possession of Charles Codman in Boston. Blythe, a native of East Liverpool, Ohio, was in the U. S. Navy and stationed in Boston Harbor between December 9, 1838, and January 7, 1839, during which time he would have been able to work directly from the Codman's Teniers painting.

The painting was engraved (in reverse) by Louis-Simon Lempereur and titled *Délices des Flamands*. With a companion piece, *Amusements Flamands*, it was part of a series dedicated to the Comte de Clermont. A painting attributed to Thomas van Apshoven (Antwerp, 1622–1665), copied from the engraving, is reproduced in *Flandern und Holland im 17. Jahrhundert* (exh. cat., Vienna, 1973, p. 15). JKC

EXHIBITIONS: Cleveland (1913), cat. no. 163D; CMA (1936), cat. no. 243; Bloomington, Illinois, 1939: Central Illinois Art Exposition, cat. no. 12; CMA (1973).

LITERATURE: Smith (1831), III, no. 567; "The Wade Collection," CMA *Bulletin*, IV (1917), 4; Cora Codman Wolcott, "A History of the Codman Collection of Pictures" (Brookline, Massachusetts, Twin Pines Farm, 1935), pp. 3, 21, 40, 103, 108; Dorothy Miller, *The Life and Work of David G. Blythe* (Pittsburgh, 1950), p. 65; Coe (1955), II, 255, no. 34; Wolfgang Stechow, "Teniers in the Cleveland Museum," CMA *Bulletin*, LV (1968), 28–34, fig. 3; CMA *Handbook* (1978), illus. p. 155.

16 *Game of Backgammon* 43.377

Transferred from panel to canvas, 59.1 x 80.6 cm. Signed at lower left: D. TENIERS.

Collections: Philippe, Duke of Orléans, Regent of France; brought to London by Thomas Moore Slade, 1792 (exhibited for sale in the Royal Academy, London, April 1793); George Hibbert, London; T. Penrice, Great Yarmouth, 1824; John Penrice (sale: Christie's, London, July 6, 1844, bought by Farrer); private collection (sale: Christie's, London, July 17, 1925, no. 119); S. A. Hecht, London; Mr. and Mrs. Samuel D. Wise, Cleveland.

Gift of Mr. and Mrs. Samuel D. Wise, 1943.

The present support is a moderately fine linen fabric. A horizontal line of retouching which runs from side to side near the top edge may indicate a split in the original panel. The lined painting is approximately two centimeters larger than the original design size. When William Suhr cleaned the painting after it was given to the Museum, he found numerous small, scattered, repaired flake losses; general abrasion; and extensive strengthening, and he noted that the area in the lower right corner was better preserved. A handwritten label on the back of the picture explains its present condition: "This picture by David Teniers has been transferred from panel to canvas and as [*sic*] been lined by me. Fred Leedham November 1845." Almost every part of the picture, including the signature, was altered in the process of transfer.

The painting has a distinguished history, originally having been in the collection of Philippe, Duke of Orléans. The picture may well have been one of Teniers's finer works, but losses are too extensive for it to warrant that status now. The figures especially have been changed by the retouching; there is a stiff and dry quality in the painting of most of the facial features and clothing. The light-handed touch which distinguishes Teniers's style is lacking in almost the whole painting except for the dog in the lower right corner and the objects around him. JKC

EXHIBITIONS: CMA (1956); Denver Art Museum, 1961: Images of History, no cat. no.

LITERATURE: Dubois de Saint-Gelais, *Description des tableaux du Palais Royal* (1727), p. 114 (as *Des Joueurs*); *La Galerie du Duc d'Orléans au Palais Royal*, II (Paris, 1808), 267 (as *Des Joueurs*, engraved in reverse by [L. E. F.] Garreau); W. Buchanan, *Memoirs of Painting with a Chronological History of the Importation of Pictures by the Great Masters into England since the French Revolution*, I (London, 1824), 188 (called *The Game of Tric-Trac*); Smith (1831), III, no. 373; Waagen (1854), II, 503; Casimir Stryienski, *La Galerie du Régent, Philippe, Duc d'Orléans* (Paris, 1913), p. 191, no. 515; Louise H. Burchfield, "A Painting by David Teniers the Younger," CMA *Bulletin*, XXXI (1944), 5–7, illus. p. 2; Wolfgang Stechow, "Teniers in the Cleveland Museum," CMA *Bulletin*, LIV (1968), 28–34, fig. 2.

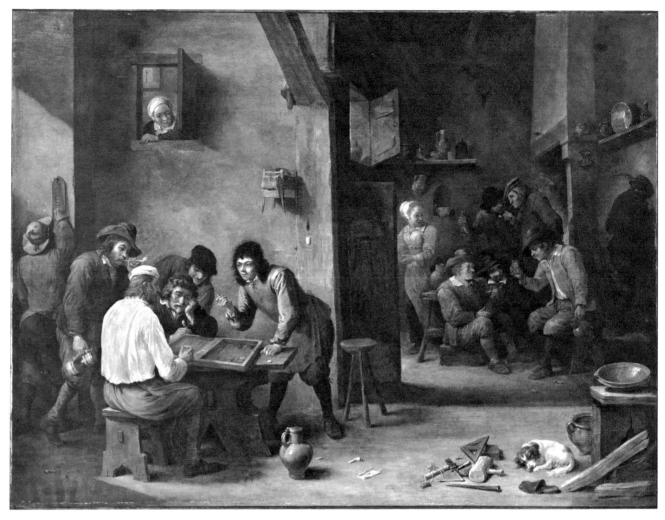

Figure 16.

17 *A Flemish Fête* 77.122

Canvas, 37.7 x 71.3 cm. Signed on bench at lower right center: D. TENIERS FEC. (See Figure 17*a*.)

Collections: M. Marin (sale: March 22, 1790, no. 16); M. Catelan, to 1816; M. le Chevalier Erard, Paris (sale: 21, rue de Cléry, Paris, August 7–14, 1832, no. 150); Count Horace François Bastien Sebastiani (1772–1851), Marshal of France (sale: rue du Faubourg Saint Honoré, November 24–28, 1851, no. 157); Thomas Jefferson Bryan, until 1867; gift of Thomas Jefferson Bryan to New York Historical Society (sale: Parke-Bernet Galleries, New York, December 2, 1971, no. 89); Mr. and Mrs. Noah L. Butkin, Cleveland.

Gift of Mr. and Mrs. Noah L. Butkin, 1977.

The original support of the fine, plain-weave fabric was recently lined. The lining canvas of plain bleached linen is backed by a piece of heavy, plain, double-thread linen. The painting is in good condition except for small flake losses and abrasion. There is considerable retouching in the sky and foreground but very little in the figures.

In the manuscript of her forthcoming monograph on Teniers II, Margret Klinge identifies the Cleveland painting as no. 313 in Smith's *Catalogue Raisonné* (1831, III, 344) and no. 90 in his *Supplement* (1842, p. 435). Smith's de-scription matches our painting in all details (note, however, that he consistently cited directions opposite those of the spectator's viewpoint). According to Smith, the painting first became known in 1759, when it was engraved by Jean Daullé (Figure 17*b*; see also Delignières, 1873, p. 88, no. 119). The engraving was announced in the *Mercure de France* in March 1759, but the location of the painting itself at that time was not known. The painting appeared in sales in 1790 and, presumably, 1816 (see Collections above), and it was in the collection of the Chevalier Erard until his death in August 1831. Erard's collection was sold a year later. (Note that there are two catalogues for sales of the Erard collection, one dated 1831, the other, 1832. Lugt lists two sales in 1832 [Lugt, no. 12962 and no. 13071]. A number of notations in various copies of the Erard cata-logues make it clear that, in the end, there was actually only one sale, August 7–14, 1832.)

The Cleveland picture is a charming example of the Flem-ish fêtes in celebration of weddings, kermises, or other vil-lage holidays which Teniers painted in great numbers in the late 1640s and early 1650s. Though the setting is never exactly the same, the paintings all feature frolicking peas-ants against the background of one, two, or more cottages or a Flemish ale house called the *guinguette*. The painting belongs to a group of some eighteen compositions listed by

Figure 17.

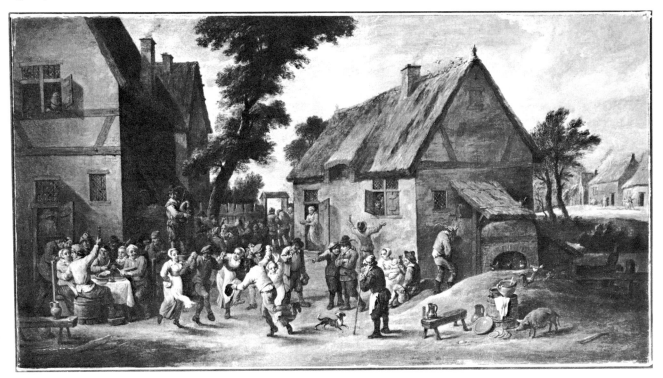

Figure 17a. Detail showing signature on bench.

Smith (1831, nos. 6, 94, 156, 178, 199, 289, 313, 445, 457, 462, 488, 495, 498, 584, 628, 648, 659), all of which include a bagpiper standing on an overturned tub.

The player on the tub is closely related to a figure in a drawing by Teniers (formerly in the Dresden Kupferstichkabinett, now lost; Adolf Rosenberg, *Teniers der Jüngere*, Bielefeld and Leipzig, 1895, p. 17, fig. 14), which likely served the artist as a model for this type of musician. F. P. Dreher (letter of May 20, 1978) pointed out a number of other stock figures, such as the running dog (cf. the *Village Wedding* of 1650, The Hermitage) and the old man leaning on a staff (cf. *Village Dance*, Metropolitan Museum of Art), which frequently appeared in versions of the theme executed by Teniers in the years around 1650. At close range the figures in the painting betray Teniers's admiration for Adriaen Brouwer (1605–1638). Also evident is Teniers's skill and humor in portraying such a lively gathering of peasants and his fondness for still-life paraphernalia such as the sparkling earthenware and the bench on which he has signed his name.

Klinge disagrees with Dreher's and this author's dating of ca. 1650, suggesting a later date, around 1665 to 1670, when Brouwer's influence had faded.

A close variant on copper appeared in a sale in Dordrecht in 1917 (Veilingmeesters A. Mak., October 23, 24, 25, no. 121, called *Boeren-feest . . .*, 52 x 70 cm; illustrated in the sales catalogue preserved at the Rijksbureau voor Kunsthistorische Documentatie, The Hague). ATL

EXHIBITIONS: CMA, January 1978: Year in Review, cat. no. 44.

LITERATURE: Smith (1831), III, 344, no. 313; Smith (1842), *Supplement*, p. 435, no. 90; Emile Delignières, *Catalogue raisonné de l'oeuvre gravé de Jean Daullé . . .* (Paris, 1873), p. 88, no. 119; *Catalogue of the Gallery of the New York Historical Society* (New York, 1915), no. 174; Margret Klinge (forthcoming).

Figure 17b. *Les Plaisirs Flamands.* Engraving. Jean Daullé, French, 1703–1763. Bibliothèque Nationale, Paris.

Imitator of DAVID TENIERS II
Late seventeenth or early eighteenth century

18 *Old Man and Woman* 18.865

Panel, 13.8 x 12 cm. Initialed in top right corner with David Teniers's monogram.

Collections: Miner K. Kellogg, Paris; Mrs. Liberty E. Holden, Cleveland.

Holden Collection, 1918.

There are two wax seals on the back of the panel. One is a small round seal impressed in red wax, with letters and figures in Arabic script, the meaning of which is too conjectural for positive identification. The other seal consists of an illegible emblem and the handwritten inscription *D. Teniers Jr*. The paint was applied on paper which may have been primed but was not grounded. This was mounted to a panel of diffuse, porous, hard wood, which is now slightly worm-tunneled. There are small losses in the paper. Two small holes at about 6.5 centimeters from the bottom and 7.8 centimeters from the left edge, and a small break nearby, indicate that perhaps the painting was pasted to the panel after it was completed. There are minor scattered paint losses, particularly in a small area at the top left, which have been retouched. Strengthening has occurred in both eyes of the woman, in the man's left eye, and in the corners of the man's mouth.

Although the panel is signed with David Teniers's monogram, it is merely an imitation of a work representing the sense of taste, from the master's series on the five senses (once in the Demidoff de San Donato and Secrétan Collections; Stechow, 1968, p. 28, n. 4). As Stechow pointed out, the panel is better than many other copies of this sort, particularly with regard to color, but "its design is crude and the closeness of its plump figures to the spectator is a vulgar feature alien to Teniers." ATL

EXHIBITIONS: None.

LITERATURE: Wolfgang Stechow, "Teniers in the Cleveland Museum," CMA *Bulletin*, LV (1968), 28–29, 34 n. 3, fig. 1.

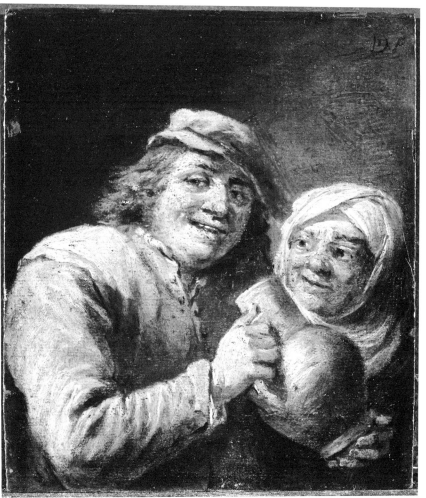

Figure 18.

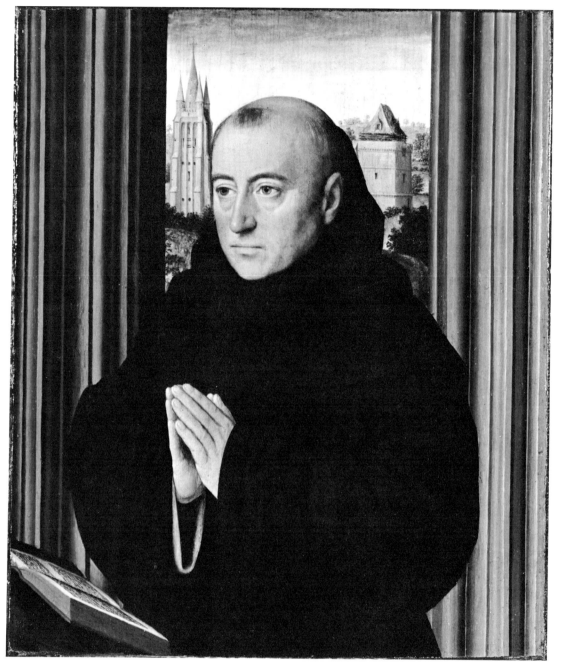

Figure 19.

ANONYMOUS MASTER
Bruges, early sixteenth century

19 *A Monk at Prayer* 42.632

> Panel (oak), 37.5 x 32 cm. Painted surface: 36 x 30.4 cm.
> Collections: Rodolphe Kann, Paris, 1907; John L. Severance, Cleveland.
> John L. Severance Collection, 1936.

Figure 19a. *Portrait of a Monk*. On panel, 34 x 26 cm. Gerard David, Flemish, ca. 1460–1523. The National Gallery, London.

In 1954 a few small, shallow blisters were laid down by Joseph Alvarez; otherwise the paint surface was well preserved. The panel is cradled.

The painting is patterned closely after the *Portrait of a Monk* by Gerard David in London, National Gallery (Figure 19a). The only important differences are in the head and habit of the sitter, the width of the framework on the right, and the addition of a prayer book in the lower left corner of the Cleveland painting. The last two features make it appear very doubtful that our panel was part of a diptych, as the London picture most probably was. The towers in the background are usually identified as Notre Dame's (on the left) and St. Sauveur's (on the right) in Bruges—those in the Cleveland panel having a more convincing resemblance than those in the London panel.

Another work by David, a drawing in the British Museum (Popham, 1932), though of a different person, is somewhat related to both panels, but in spite of these connections with David's work, the Cleveland picture, with its ruddy flesh tones and somewhat schematic features (the frame and the contour of the right hand), shows little real resemblance to David's style.

The painting is probably the work of a Bruges artist of the first quarter of the sixteenth century. A connection with Adriaen Isenbrandt, suggested by von Bodenhausen (1905), is not convincing. WS

EXHIBITIONS: CMA (1936), no. 208; CMA (1942), cat. no. 12.

LITERATURE: Eberhard von Bodenhausen, *Gerard David und seine Schule* (Munich, 1905), p. 229, no. 123a (recto: 124); *Catalogue of the Rodolphe Kann Collection*, II (Paris, 1907), p. XXI, no. 111, illus. opp. p. 16; A. E. Popham, *Catalogue of Drawings by Dutch and Flemish Artists Preserved in the Department of Prints and Drawings in the British Museum*, V (London, 1932), 15; Francis (1942), 132; Martin Davies, *Early Netherlandish School* (cat., London, 1945), p. 26 (second ed., 1955, p. 30); Davies, *Les primitifs flamands, Corpus de la peinture des anciens Pays-Bas Méridionaux au quinzième siècle*, I (Antwerp, 1953), 79; Coe (1955), II, 234, no. 12.

Figure 20.

ANONYMOUS MASTER
Bruges, ca. 1525

France

20 *Madonna and Child under a Canopy* 46.282

> Panel (oak), 64.8 x 40 cm.
> Collections: Ralph King, Cleveland.
> In memory of Ralph King. Gift of Mrs. Ralph King; Ralph T.,
> Woods, Charles G. King; and Frances King Schafer, 1946.

The painting is almost perfectly preserved. The cradled panel was cleaned in 1959 by Joseph Alvarez, who found the paint film to be firm and in excellent condition. Two small areas in the sky, just above the horizon, to the right of the column on the right, were retouched.

At the bottom center of the painting is a coat of arms that consists of a white cross on gules, four pairs of crossed keys in the quarters, and some unidentified animals on the arms of the cross. The coat of arms, as yet unidentified, probably belongs to an ecclesiastical institution. (The arms of the Abbey of Jumièges consist of a similar cross between four *single* keys.) To the left of the coat of arms is the letter A, and to the right, the letter B; these could refer to a donor rather than to the artist.

The canopy, particularly its upper part, is based directly on the one in Jan Gossart's *Malvagna Triptych* in Palermo, Museo (Max J. Friedländer, *Die Altniederländische Malerei*, VIII, 1930, pl. III; see also Adriaen Isenbrandt's copy of the triptych, *ibid.*, XI, 1933, pl. LVIII). The small pyxis-like elements in front of the bases are also seen in the structures painted by Barend van Orley (*ibid.*, VIII, 1930, pl. LXXXIII). Other similar forms occur in the works of Isenbrandt, whose landscape style, too, is related to our painting.

Altogether, the style of the panel is more closely connected with Bruges than with Antwerp. The motif of the Madonna under an open canopy suggests a revival of the art of the Bruges master, Petrus Christus (Charles Cuttler, orally, 1965), whose female types are also related to the Madonna in the Cleveland painting; compare, for example, Christus's *Madonna with St. Barbara and a Carthusian Monk* (*Die Gemäldegalerie: Die deutschen und altniederländischen Meister*, cat., Berlin, 1929, 523B, p. 176).

When the painting entered the Museum collection, it was attributed to Cornelis van Coninxloo—an attribution that remained unchanged until closer investigation made it unacceptable. WS

EXHIBITIONS: CMA (1973).

LITERATURE: Henry S. Francis, "Gift in Memory of Ralph King: Paintings," CMA *Bulletin*, XXXIV (1947), 24; Coe (1955), II, 110, no. 10; CMA *Handbook* (1978), illus. p. 121.

JACQUES-ANDRE-JOSEPH-CAMELOT AVED
1702–1766

Aved was born in the Flemish city of Douai. He spent his early youth in Amsterdam, where he studied drawing, first with François Boitard (ca. 1670–ca. 1715) and later with Bernard Picart (1673–1733). In 1721 he went to Paris and worked with the portrait painter Alexis-Simon Belle (1674–1734). In Paris he came to know Carle van Loo (the favorite painter of Louis XV), François Boucher, and Chardin; with Chardin he shared a long and close friendship. Aved became a member of the Academy in 1734. Ten years later, in 1744, he became a counsellor of the Academy and that same year was named Peintre du Roi (he did not receive his pension for the latter appointment until 1764). He showed regularly at the Salon between 1737 and 1759. The influence of his early training in Amsterdam and his exposure to the conservative tradition of Dutch painting is evident throughout his oeuvre. His competence and technical facility, his concern with the psychological aspect of his sitters, as well as his distinctive style, set him apart from the taste popular at court. His clientele were principally bourgeoisie. He died in Paris in 1766, a greatly respected painter.

21 *Portrait of M. Jean-Gabriel* 64.89
 de La Porte du Theil

> Canvas, 124.5 x 92.4 cm.
> Collections: Edouard Kann, Paris, in 1922; Delaney, Paris (sale:
> Paris, Hôtel Drouot, December 10, 1956, under "J," illus.);
> [Wildenstein & Co., New York, in 1963].
> John L. Severance Fund, 1964.

This painting was restored before it entered the Museum collection, but records of the restoration are not known. When examined in the Museum laboratory in April 1977 the painting was found to be in satisfactory condition. There are areas of extensive restoration on the left side of the painting: in the wall-covering above the gilt-metal desk set, extending from there to the top of the painting; in the tablecloth to the left of the sitter's knee; and in the edge of the documents on the table. There are also restorations along the right edge of the painting. Residues of the old, darkened varnish can be seen in the recesses of the paint.

According to Georges Wildenstein, this painting was admired and respected long before either its author or its subject were known. As a result of Wildenstein's research,

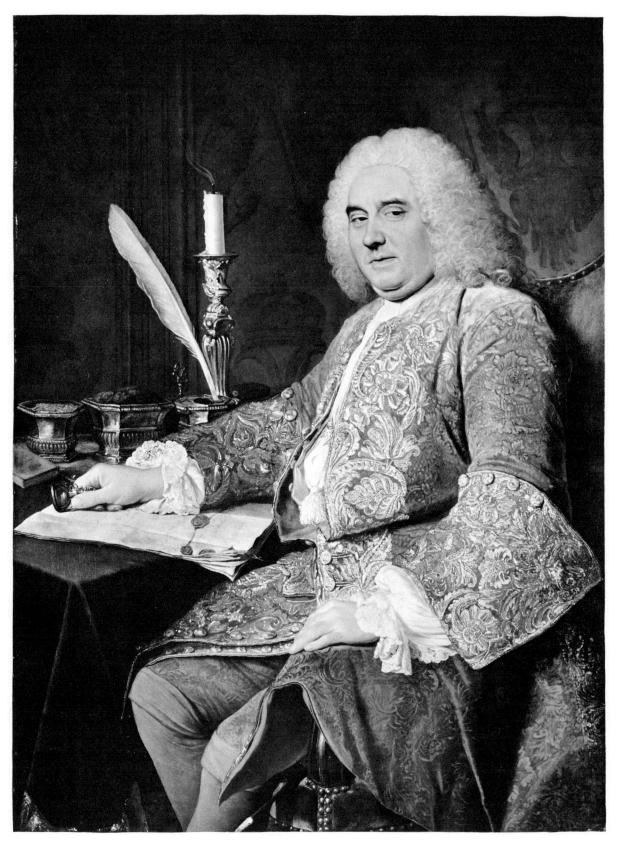

Figure 21.

published in 1922 (see Literature), the painting was identi-
fied as no. 85 in the Salon of 1740.

A brilliant portrait in its own right, the painting also
documents an important moment in French history, when
the shrewd and capable du Theil signed the treaty of Vienna
that ended the War of the Polish Succession in 1738. Smoke
is still rising from the candle that heated the wax for the seal
du Theil is holding in his hand. At the instigation of Car-
dinal Fleury, confidant of Louis XV, du Theil, then secre-
tary of foreign affairs, had strategically arranged the pact,
ostensibly for Stanislas, the deposed king of Poland, but
principally for France, which thereby acquired the duchy of
Lorraine. Du Theil is represented here with the pink cord
and star of the order of St. Lazare upon his breast. On the
wall are escutcheons bearing the insignia of the Imperial
House of Austria.

Although du Theil was not of aristocratic birth or title,
his contributions as a statesman were considerable. In addi-
tion to the role he played on the occasion documented by
the painting, he served in many other positions of state as
well; he was, for example, minister plenipotentiary and
ambassador extraordinaire at the conference of Breda in
1747.

The portrait dates between 1738, when the treaty of
Vienna was signed, and 1740, when the picture was first
exhibited. N C W

EXHIBITIONS: Paris, Salon, 1740, cat. no. 85; CMA (1963), cat. no. 48,
illus.; Toledo (Ohio) Museum of Art, Art Institute of Chicago, and Na-
tional Gallery of Canada (Ottawa), 1975/76: The Age of Louis XV,
French Painting, 1710–1774, cat. no. 2, pp. 13, 19, and pl. 58 (catalogue
by Pierre Rosenberg); Berlin, Nationalgalerie, Staatliche Museen Preussi-
scher Kulturbesitz, 1980: Jubiläumsausstellung der Preussischen Museen
Berlin 1830–1980; Bilder vom Menschen in der Kunst des Abendlandes,
cat. no. 43, illus.

LITERATURE: Jules Guiffrey, Collection des livrets des anciennes exposi-
tions depuis 1673 jusqu'en 1800 (second ed., Paris, 1869–71), VII, 24;
Georges Wildenstein, Le Peintre Aved, sa vie et son oeuvre (Paris, 1922), I,
51, 53–55, 66, 72, 118, 121, and II, no. 47, illus. opp. p. 66; Pierre Claude,
"Un grand réaliste Jacques Aved," La Renaissance de l'Art, V (1922), 376;
François Boucher, review of Wildenstein's Le Peintre Aved, sa vie et son
oeuvre, in Gazette des Beaux-Arts, VI (1922), 255–56, pl. opp. p. 254; N.
N. Vodo, "An Unpublished Portrait of the Playwright Crébillon by Aved,"
Travaux du Musée Pouchkine des Beaux-Arts (Moscow, 1960), p. 256,
illus. p. 254; Henry S. Francis, "Two Portraits by Aved and Gros," CMA
Bulletin, LI (1964), 196–204, illus. p. 197; William S. Talbot, "Largil-
lierre, Comte de Richebourg le Toureil," CMA Bulletin, LVIII (1971), 3,
fig. 3; CMA Handbook (1978), illus. p. 177.

FRANÇOIS BOUCHER
1703–1770

Boucher was born in Paris in 1703. He studied first with his
father, an obscure painter, and then for a short time in 1720
with François Lemoine (1688–1737). Because his speed
and dexterity as a draftsman suited him well for book illus-
tration, he was led to enter the studio of the engraver Lau-
rent Cars. Boucher played a major role in engraving the
works of Watteau for publication by Jean de Jullienne. He
won the Prix de Rome of the Academy in 1723, although he
was not in Italy before 1727, when he went there with Carle
van Loo. Upon his return to France in 1731 he was received
into the Academy as a painter of history and in 1734 be-
came a full member. From 1734 to 1736 he illustrated an
edition of Molière's plays. He also designed tapestries for
the Beauvais factory. His first royal commission, for the
ceiling of the chambre de la reine at Versailles, came in
1735. Thereafter he was involved in many important deco-
rations and remodelings at Versailles, Fontainebleau, Marly,
and Choisy, as well as for the Hôtel de Soubise. He received
portrait commissions from the court and was the favored
artist of Mme de Pompadour, who commissioned his pic-
tures for her Château de Bellevue. In 1752 he obtained
coveted quarters in the Louvre. In 1756, under the patron-
age of Mme de Pompadour and Louis XV, he became direc-
tor of the Gobelins tapestry works. In 1765 he became
Premier Peintre du Roi. The most successful French painter
of his century, he was overwhelmed with commissions. His
enormous output has not yet been thoroughly catalogued
but includes plans for public festivals; stage designs for the
opera; cartoons for tapestries, drawings, and paintings—
landscape, pastoral, genre, religious, and mythological—as
well as book illustrations.

22A	*Music and Dance*	48.181
22B	*Cupids in Conspiracy*	48.182

Canvas, 68.6 x 122.8 cm (22A) and 68.8 x 123.2 cm (22B). The
latter is signed on base of fountain at left: f Boucher.

Collections: J. Carpenter Garnier, Rookesbury Park, Fareham,
England (sale: Christie's, London, July 13, 1895, as a pair, called
Cupids Sporting near Fountains, to A. Werthemeyer for £1071);
Baron Gustav Neufeld von Schoeller (?), Vienna; [Duveen Broth-
ers, New York]; Commodore and Mrs. Louis Dudley Beaumont,
Cap d'Antibes, France.

Gift of Louis Dudley Beaumont Foundation, 1948.

Both paintings are in good condition. *Music and Dance* was
lined in 1963. An auction stencil on the stretcher of *Cupids
in Conspiracy* refers to the 1895 sale at Christie's.

The Baron Neufeld von Schoeller provenance, provided
by Duveen Brothers, is not verified. Gustav Neufeld received
the name and arms of von Schoeller from his uncle in 1911,
presumably before Duveen Brothers acquired the picture.

These two pictures of cupids and children playing before

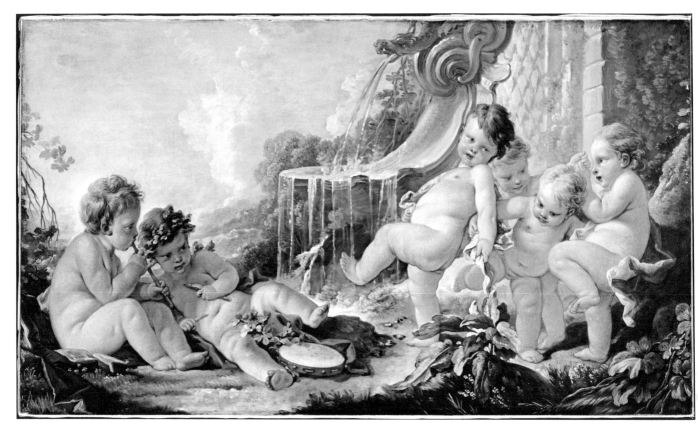

Figure 22A.

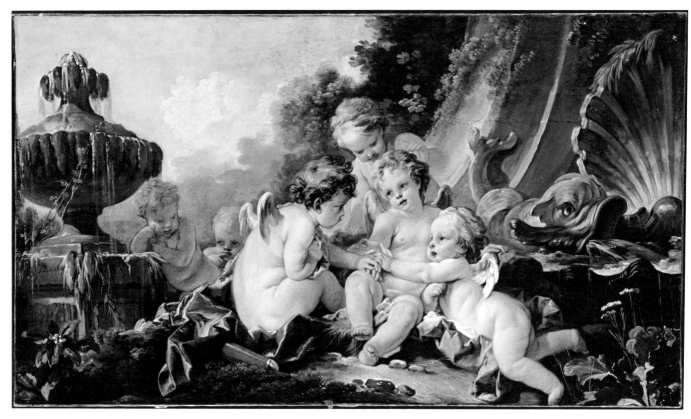

Figure 22B.

Figure 22a. *Design for a Fountain* (from *Livre de Fontaines*, no. 3). Etching after a drawing by Boucher. Gabriel Huquier, French, 1695–1772. Gift of Erich Lederer. CMA 53.673.

strongly sculptural, animated infants in a setting of garden ornament does not appear in Boucher's works after the decade of the 1740s. W S T

EXHIBITIONS: Detroit Institute of Arts, 1926: French Paintings of the Eighteenth Century, cat. no. 3, as a pair of decorative panels called *Infants at Play*; Hartford, Wadsworth Atheneum, 1929: French Art of the Eighteenth Century, cat. no. 1, as *Cupidons*; London, 25 Park Lane, 1933: Three French Reigns, Louis XIV, XV, XVI, cat. nos. 1 and 117, as two overdoors.

LITERATURE: Henry S. Francis, "A Gift of the Louis Dudley Beaumont Foundation," CMA *Bulletin*, XXV (1948), 223–24, *Cupids in Conspiracy* illus. p. 228; CMA *Handbook* (1978), *Cupids in Conspiracy* illus. p. 177; Alexandre Ananoff, "The New Boucher Catalogue," *Burlington Magazine*, CXXI (July 1979), 444 ("Letters" section); Ananoff, *Boucher*, Classici dell'Arte (Milan, 1980), p. 100, nos. 194 and 195.

FRANÇOIS BOUCHER

23 *Fountain of Venus* 79.55

Canvas, 232.5 x 214.8 cm. Signed and dated at lower right corner: f Boucher/1756.

Collections: Baron Edmond de Rothschild, Paris, and descendants; [P. & D. Colnaghi, London].

The Thomas L. Fawick Memorial Collection, 1979.

The painting is in very good condition. There are scattered areas of minor restoration at the extreme upper left, along a narrow horizontal line below center, and along all edges. X radiographs of the edges reveal some cusping in the original ground at the right but none at the left, which suggests that the painted surface may have been slightly reduced at the right and, to a greater extent, at the left. When the canvas left France in 1976 it had a rounded top and an arch at bottom center; eighteen centimeters of the rounded top were clearly a later addition, as were thirteen centimeters at the lower right and left (see Figure 23a). The painting had also been lined. In London, Robert Shepherd removed the rounded top and the areas at the lower right and left, filled the extreme top corners and the shallow arch remaining at the bottom, and relined and cleaned the picture.

Whether the original canvas was quadrilateral or the more complex shape is not known. If the latter, it must have been reduced at some time to a quadrilateral and then changed back again—perhaps to fit it into some rococo decoration, such as in the house of Edmond de Rothschild on the Faubourg Saint-Honoré, Paris (André Blum, "Le Baron de Rothschild Amateur d'Art [1845–1934]," *Institut de France Académie des Beaux-Arts Bulletin*, no. 20, July–December 1934, 78). The illusion of water flowing over the curb of the base of the fountain, seemingly into the spectator's space, suggested to Henry Hawley of this Museum that the painting may have hung over a fountain in a garden room, creating the impression of joining waters.

imposing fountain sculptures were most certainly overdoor compositions painted for an unidentified decorative project undertaken by Boucher at the height of his career. Free from weighty allegorical or religious meaning, the two pictures are full of happy life. Boucher's infants, delighting in a childish romp to music, and his cupids, conspiring in some mischievous plot, are skillfully woven into decorative compositions without losing their robust presence.

A date close to 1740 is suggested for these two paintings because of their similarities to other works by Boucher dating from that time. The cherubs and bold fountain sculpture are similar to those in the *Livre de Fontaines* of 1736, engraved by Huquier after Boucher's designs (see Figure 22a), and in the sequel of the same title, engraved by Aveline in 1738. A similar figure style is seen in Boucher's *La Terre* and *L'Air* of 1741 (Alexandre Ananoff, *François Boucher*, Lausanne and Paris, 1976, I, cat. nos. 182 and 183); and similar monumental elements are seen in the background of other paintings, such as *Le Printemps* of 1744 (*ibid.*, cat. no. 275). Ananoff, in a letter of June 16, 1977, dated the paintings 1740. The combination of

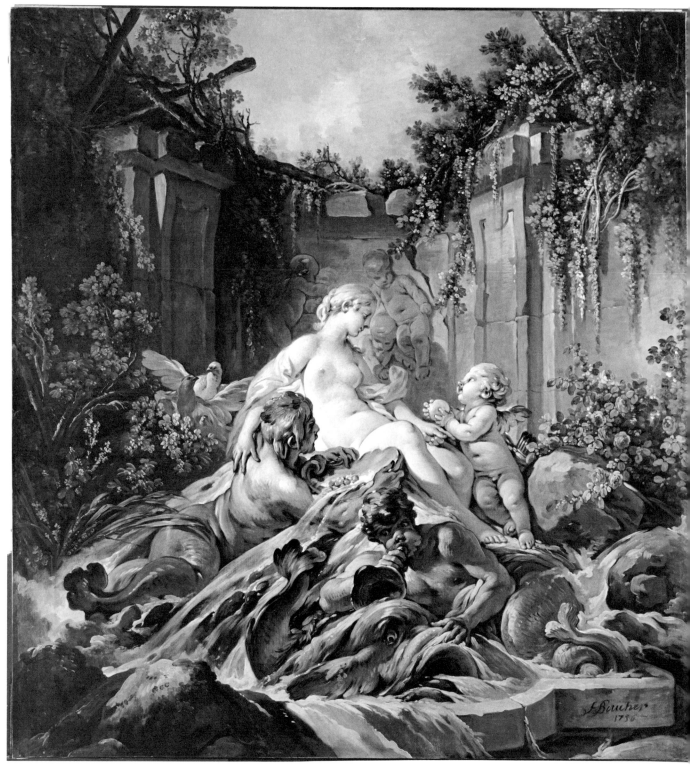

Figure 23.

▥	Removed in 1976
▥	Added in 1976
– – –	Shape 1976
———	Present Shape

Figure 23*a*. Reconstruction drawing showing changes in shape and dimensions.

214. 8 cm

20 cm

265. 7 cm

13. 2 cm

Fountains were particularly appealing to the decorative taste of the eighteenth century. Sculptors and architects, as well as artists in other media, produced numerous designs. Boucher's *Recueil de Fontaines* was published in two volumes called *Livres de Fontaines* (Paris, 1736 and 1738), the first volume etched by Gabriel Huquier, the second by Pierre Aveline. The *Fountain with a Naiad, Two Tritons, and an Amor* (Figure 23*b*) from the first volume most closely suggests the idea of the Cleveland *Fountain*, painted some twenty years later.

Boucher often depicted fountains in his paintings (see Paintings 22A and 22B); but they were, for the most part, only accessories functioning as backdrops, until the Cleveland painting, when the fountain itself became the subject. Even though the background of walls, flowers, and shrubs, as well as the curving stone relief with playful *putti*, still link the painting with Boucher's pastoral landscapes, their main function here is to create a niche for the fountain itself and to project it into the foreground.

The Cleveland *Fountain* features Venus sitting at the apex of a pyramid of rocks, plants, and cascading water. Amor, at Venus's knee, offers her an apple, while a triton, resting under Venus's arm, looks on. Another triton and large fish in the foreground complete the pyramid. Boucher has chosen subdued colors for his grisaille-like images, using the lightest tones—imitative of white marble—for Venus and Amor and darker tones for all the other elements. By such choices he enhanced the interplay of nature and art and subtly transformed a mere portrait of a fountain into a pictorial allegory. The image of Venus in the moment of her triumph over Juno and Minerva is inspired by Euripides' *Judgment of Paris*; however, Boucher substituted Amor for Paris in the presentation of the apple. A Brussels tapestry model which is closest to the composition of the Cleveland *Fountain of Venus* is the one at Gobelins, dating probably from the 1750s (Alexandre Ananoff, *François Boucher*, Lausanne and Paris, 1976, II, cat. no. 485/2). Especially similar are the poses of Venus and Amor, the spouting fish, and the tritons in a watery setting.

The composition of Boucher's type of Venus *à la pomme* was anticipated in his painting *Venus Leaving Her Chariot to Enter Her Bath*, painted for the Hôtel de Soubise ca.

Figure 23*b*. *Design for a Fountain* (from *Livre de Fontaines*, no. 4). Etching after a drawing by Boucher. Huquier, Gift of Erich Lederer. CMA 53.674.

55

Figure 23c. *Head of a Woman*. Red, black, and white chalk on buff paper, 22.2 x 17.1 cm. Boucher. Collection of Mrs. George Coumantaros, New York. Reprinted from *François Boucher*, exh. cat. (New York, 1957), pl. VII.

Figure 23d. *Love's Offering to Fidelity*. Engraving after a painting by J. B. Huet. Louis Marin Bonnet, French, 1736–1793. Reprinted from C. Gabillot, *Les Hüet* (Paris, 1892), p. 151.

1737, and is known through the engraving by Jean Baptiste de Lorraine (Pierette Jean-Richard, *Musée du Louvre, Cabinet des Dessins, Collection Edmond de Rothschild, Inventaire général des gravures: Ecole française*, Paris, 1978, no. 1403). Boucher repeated the composition, slightly varied, in two later versions, one in 1762 (Edmond de Rothschild collection) and the other in 1766 (Ananoff, *op. cit.*, II, cat. no. 636, fig. 1670). In an oval composition of the *Judgment of Paris* of 1744 (lost, surviving in a copy by Jacques Charlier; *ibid.*, I, cat. no. 270/3, fig. 804) and in the intimately related, larger, horizontal painting in blue monochrome of the same subject, painted in ca. 1759 (private collection, Paris), Boucher explains Amor's role as intermediary between Paris and Venus. In these works, Paris hands the apple to Amor for presentation to Venus; in the pendant to the oval of 1744 (also lost; *ibid.*, cat. no. 269), Amor then hands the apple to Venus.

Closest in date to the Cleveland painting is a reclining Venus *à la pomme* (The Wallace Collection, London) painted by Boucher in 1754, the same year he was commissioned by the Marquise de Pompadour to paint four large mythologies devoted to the loves of Venus (all in The Wallace Collection). One of these is yet another version of the *Judgment*, which included not only Paris but also Venus's two dismayed competitors, Juno and Minerva. Another among these four paintings, the *Imprisoned Amor*—with its pyramid of young nymphs by the side of a fountain—most directly anticipates the Cleveland composition, although fountain and figures had not yet become integrated.

Innumerable analogies exist between the Venus and Amor group in the Cleveland painting and those in other Boucher paintings of related subjects. The artist alternatively pictured a seated, reclining, or standing Venus with Amor on her right side one time, on her left, another. It followed that Boucher depended on drawings which could serve him, if slightly altered, as models for numerous figures. Thus, the drawing of *Amor* (Cailleux collection, Paris; Ananoff, *L'Oeuvre Dessiné de François Boucher*, Paris, 1966, cat. no. 815, fig. 131) which is a direct study for the Amor in *Toilet de Venus* of 1743 (private collection, New York) also may have proven useful for the Cleveland Amor. Boucher's nymphs and deities, often easily interchanged, likewise reveal their dependence on common drawings and models. One such drawing (Figure 23c)—stylistically close to the study for the woman in Boucher's *Drawing Lesson* (private collection, New York) of 1751—suggests itself for a particularly close comparison to our Venus, even though the hairstyle is somewhat different.

The same close analogies exist among Boucher's various marginal figures—tritons, naiads, and fish. The conch-blowing triton in Cleveland's *Fountain of Venus*, for example, is anticipated in Boucher's fountain design of 1736, *Two Tritons Blowing a Conch* (an etching of this by Huquier is in the Cleveland Museum, acc. no. 52.518), and in

the *Triton* drawing of 1743 (Ananoff, *op. cit.*, I, cat. no. 243/9, fig. 739). Similarly, the triton with a shell in the Cleveland painting is closely related to one in a drawing in The Art Institute of Chicago.

Surprisingly, our painting has never been published, nor is anything known about its history prior to Baron Edmond de Rothschild's ownership. The painting is dated 1756, at the height of Boucher's career, when he was richly patronized by King Louis XV and his mistress, the Marquise de Pompadour, and when he was inspector of the Gobelins tapestry manufactory, having been appointed after Oudry's death in 1755. Our inquiry into the painting's history must, therefore, include a search for tapestries, even though not all of Boucher's tapestry designs were executed. Some of his tapestry models do share close analogies with our painting: for example, the strongly pyramidal composition and curving masonry with water running over are seen again in the tapestry model *Neptune and Amymone* of ca. 1764 (Ananoff, *op. cit.*, II, cat. no. 483/7); and the pose of the Cleveland Venus is very close to that of her counterpart in *Vulcan Presenting the Arms for Aeneas to Venus* (Paris, Louvre), a tapestry design that was painted by Boucher one year after he painted the *Fountain of Venus*.

The triumphant Venus and the equally magnificent *Portrait of the Marquise de Pompadour* (Bayerische Hypotheken und Wechselbank in der Alten Pinakothek, Munich), both painted in the same year—1756, seem most appropriate mementos of an important event in the life of the marquise—her official nomination as Dame de la Reine (Emile Campardon, *Madame de Pompadour et la Cour de Louis XV au Milieu du Dix-Huitieme Siècle*, Paris, 1867, p. 294). No documents have yet been found, however, that can trace the Cleveland *Fountain* to any of the royal residences for which Boucher is known to have received commissions or to substantiate the tempting hypothesis that it was painted for the Marquise de Pompadour in that year of her triumph.

Visual proof that Boucher's *Fountain of Venus*—or a painting with a comparable Venus *à la pomme*—existed in eighteenth-century France is suggested by the color engraving by Louis Marin Bonnet after *Love's Offer to Fidelity* (Figure 23d) by Jean-Baptiste Huet (1745–1811). Huet, one of Boucher's young collaborators, was notorious for his habit of copying Boucher. Although his frieze-like composition is entirely different from Boucher's, his Venus and Amor to the far left strike a familiar note. Instead of a triton, however, Huet painted a dog to symbolize fidelity, a reminder of Cellini's famous *Nymph* at Fontainebleau, with which both artists were familiar. ATL and WST

EXHIBITIONS: CMA, March 1980: Year in Review, cat. no. 22 and color cover.

LITERATURE: None.

PHILIPPE DE CHAMPAIGNE
1602–1674

Philippe de Champaigne was born in Brussels in 1602. At the age of nineteen he went to Paris, where he worked under various French masters. After a visit to his native country in 1628, Champaigne married a French woman, the daughter of the painter Duchesne, for whom he had worked. Several commissions from Marie de' Medici launched Champaigne on a very successful and lucrative career. He was also in the service of King Louis XIII of France and he found favor with the foremost patron of the arts of his era, Cardinal Richelieu, whose portrait he painted on several occasions. His career extended into the reign of Louis XIV, for whom he painted his last important work, the decoration of the Château de Vincennes, where the king resided after his marriage. Champaigne eventually became director of the Royal Academy in Paris. He died in Paris in 1674.

Philippe de Champaigne excelled in portrait painting and was also a competent painter of landscapes. He received countless commissions for religious paintings for churches. A grave yet sensuous and earnest reality characterizes his work.

24 *Charles II, King of England* 59.38

Canvas, 125.7 x 99 cm. Dated 1653.
Collections: Jules Féral (sale: Paris, Hôtel Drouot, May 30, 1903, as portrait of James II by Lely); [E. Gimpel and Wildenstein, New York]; Stanley Mortimer, New York (sale: Parke-Bernet, December 2, 1944, no. 85, illus. p. 57); [Duveen Brothers, Inc., New York].
The Elisabeth Severance Prentiss Fund, 1959.

This remarkable portrait was cleaned in 1958, when it was in the possession of Duveen Brothers. At that time an extremely dirty, dark-brown varnish was removed, revealing the previously unnoticed date, 1653, on the bottom of the column. The cleaning also revealed more clearly the pentimenti in the drawing of the sitter's right hand. There is a tear in the canvas to the left of the right hand, and there are some small damages in the right eye, the sash, and the background, and some slight abrasions on the nose and chin, but otherwise the painting is in excellent condition. The frame is contemporary with the painting.

This portrait of Charles II (1630–1685) was painted when Charles was in exile at Saint-Germain, near Paris, where he had fled in 1651, and where he lived more or less as a refugee and the head of an exiled court. In 1654 he took refuge at Cologne, later withdrawing to Holland, where he received news of Cromwell's death. He was recalled to England permanently in 1660.

The château at Saint-Germain was also the refuge of Charles's mother, Henrietta Maria. Later it was the French home in exile of another English king, James II, who died

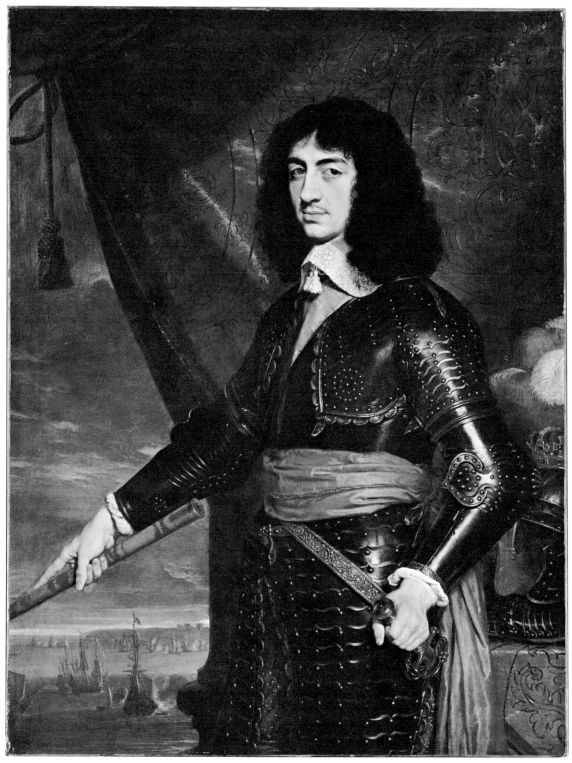

Figure 24.

there in 1701. Charles had apparently left the painting in Saint-Germain, for it eventually came into the possession of Jules Féral, who also had a château at Saint-Germain. When the Féral collection was sold in 1903, the portrait was identified as *James II*, by Peter Lely. It was not until 1944, at the time of the Stanley Mortimer sale, that Charles Sterling correctly identified the subject as Charles II and the artist as Philippe de Champaigne.

The Stuart king is represented in dress armor, with a rose-red sash, a lace-edged white collar with tassel tie, and a blue ribbon of the Order of the Garter. He is holding a baton in his right hand and clasping the hilt of his sword with his left. His plumed helmet is resting on a table at the right. The view of Dover's cliffs and the waiting fleet symbolize the king's hope that he will ultimately return to England.

Maurice Brockwell (letter of July 18, 1950) described a replica of the Cleveland portrait in the collection of the tenth Duke of Grafton (a descendant of Henry Fitzroy, first Duke of Grafton, the son of Charles II and Barbara Villier [Countess of Castlemaine and Duchess of Cleveland]). Brockwell had seen the painting *in situ*, over the mantel in the dining room of Euston Hall (shown in Exhibition of Royal Portraits, Royal Academy, London, 1953, see *Illustrated London News*, March 14, 1953, illus. p. 391; and Ian Dunlop, "The 'Frenchness' of Euston Hall, Suffolk," *Connoisseur*, CLXIII, 1966, illus. p. 147). This replica is generally considered to be a Flemish copy; it is inferior in quality to the Cleveland painting, and there are a few minor differences in detail.

Ronald Cohen, in his forthcoming publication on the Le Nain Brothers, compares the Cleveland portrait with various works which he ascribes to Mathieu Le Nain, "Peintre du Roi" and "Valet de Chambre" at the court of Louis XIV in 1652–53, i.e., at the time our portrait was painted.

<div style="text-align: right">N C W</div>

EXHIBITIONS: Pittsburgh, Carnegie Institute, 1951: French Painting 1100–1900, cat. no. 68, illus.; Paris, Orangerie des Tuilleries, 1952: Philippe de Champaigne, cat. no. 28 (incorrectly gives Duke of Grafton as ex collection); Ghent, Museum of Fine Arts, 1952: Philippe de Champaigne, cat. no. 28, illus. p. 16; New York, Duveen Brothers, 1952: French Art in Painting and Sculpture of the Eighteenth Century, cat. no. 7; CMA, December 1959: Year in Review, p. 230; Raleigh, North Carolina Museum of Art, 1963: Carolina Charter Tercentenary Exhibition, cat. no. 64, pl. 64, color illus. on cover; CMA (1963), cat. no. 6, color illus.; Musée de Bordeaux, 1966: La Peinture Française dans les Collections Américaines, cat. no. 5, illus.; Ottawa, The National Gallery of Canada, 1967: A Pageant of Canada: The European Contribution to the Iconography of Canadian History, cat. no. 36, pl. XV (color).

LITERATURE: Alfred M. Frankfurter, "International Portraits of Baroque Royalty," *Art News*, XLV (March 1946), 35, 64, illus. p. 35; Margaret R. Toynbee, "Adriaen Hanneman and the English Court in Exile," *Burlington Magazine*, XCII (1950), 75; Anthony Blunt, "Philippe de Champaigne at the Orangerie, Paris," *Burlington Magazine*, XCIV (1952), 175; Camille Bournequel, "Journal à plusieurs voix," *Esprit: Revue Internationale* (April 1952), p. 681; André Mabille de Poncheville, *Philippe de Champaigne* (Paris, 1953), p. 66, pl. XI; Nancy Coe Wixom, "*Charles II, King of England*," CMA *Bulletin*, XLVI (1959), 163–64, illus. p. 162; Charles Mauricheau Beaupré, "Philippe de Champaigne à l'Orangerie des Tuilleries," *Arts Plastiques*, no. 4 (Brussels, 1962), 265, fig. 151; Rémy G. Saisselin, "The Portrait in History: Some Connections between Art and Literature," *Apollo*, LXXVIII (1963), color illus. p. 283; Sherman E. Lee, "The Forest and the Trees in Chinese Painting," *National Palace Museum Quarterly*, I, no. 2 (1966), 4, pl. X; *Selected Works* (1966), no. 158, illus.; Gordon C. Aymar, *The Art of Portrait Painting; Portraits through the Centuries as Seen through the Eyes of a Practicing Portrait Painter* (Philadelphia and London, 1967), pp. 249–50, pl. 122; Ann Tzeutschler Lurie, "Portrait of Cardinal Dubois," CMA *Bulletin*, LIX (1967), 236, fig. 12; Bernard Dorival, *Philippe de Champaigne 1602–1674: La Vie, l'Oeuvre et le Catalogue raisonné de l'oeuvre*, II (Paris, 1976), 89, no. 157, pl. 157; CMA *Handbook* (1978), illus. p. 171.

JEAN SIMEON CHARDIN
1699–1779

Chardin was the son of a cabinetmaker; he was born in Paris in 1699. He studied under the academician Pierre-Jacques Cazes (1676–1754) from 1718 to 1720 and under Noël-Nicolas Coypel (see Painting 27) from 1720 to 1728. As Coypel's assistant, Chardin became a painter of accessory objects. Although inspired by Dutch and Flemish still lifes, he soon developed his own style. He achieved recognition in 1728 at the Place Dauphine with the exhibition of his *Rayfish* (Paris, Louvre). Largely on the merits of this painting he was accepted as a still-life painter in the Royal Academy, which he later served as treasurer. By 1735 Chardin was painting genre pictures, such as *The Return from Market*, of 1739 (Louvre). Charles Nicolas Cochin (1688–1754) and other engravers reproduced many of his paintings, thus providing Chardin with a significant source of income and many lesser artists with ready models. Chardin's patrons included members of the aristocracy as well as fellow artists. In 1757 he was granted lodgings in the Louvre under a royal warrant. Chardin returned to still-life painting in the 1750s, but after 1770 he painted portraits in pastel almost exclusively. These portraits were not highly regarded until the late nineteenth century, despite such examples as his *Self-Portrait with Eyeshade* of 1775 (Louvre), which reveals the vivid and forceful handling of colors characteristic of his last years.

Contemporary critics praised him as "the French Rembrandt" for his naturalism and tonality, but Chardin's style has since been more clearly recognized as distinct and original. He marks the beginning of a new development in French painting—away from the opulent display of many early eighteenth-century still lifes, and toward simplified form and composition. Some artists who continued this trend were Henri-Horace Roland de la Porte (1725–1793), Jean-Etienne Liotard (see Paintings 226, 227), and Anne Vallayer-Coster (see Painting 61).

25　*Still Life with Herrings*　74.1

Canvas, 41 x 33.6 cm. Signed at lower right on the edge of stone shelf: chardin.

Collections: Benoist (sale: Paris, Hôtel Drouot, March 30, 1857, no. 12); Monsieur R. (sale: Paris, Hôtel Drouot, April 28, 1860, no. 12); Henri Viollet, Tours, 1873; M. Mame, Tours (sale: Galerie Georges Petit, Paris, April 26–29, 1904, no. 7, illus. opp. p. 22); Alexis Vollon (son of Antoine Vollon), Paris, 1904 to 1909; David David-Weill, Paris, 1925 to 1947; [Rosenberg and Stiebel, New York, in 1952]; Sidney J. Lamon, New York, 1952 to 1973 (sale: Christie's, London, June 29, 1973, no. 21, illus.); [Frederick Mont, New York].

Purchase, Leonard C. Hanna Jr. Bequest, 1974.

The painting had been lined at some unknown time before William Suhr cleaned it in 1952. A narrow area of loss extends upwards from the top of the pepper box diagonally through the dark side of the kettle; there is a small area of loss at the lower right, below the stone ledge; and there are flake losses at the base of the jug handle. Abrasion, though general, is most noticeable in the blue design on the jug.

This is one of Chardin's "kitchen still lifes" which he painted in the 1720s and 1730s. The painting shows the ingredients of a fast-day meal of herring, squash, and turnip. Three cherries in the left foreground introduce a note of color and a precarious balance unusual in Chardin's

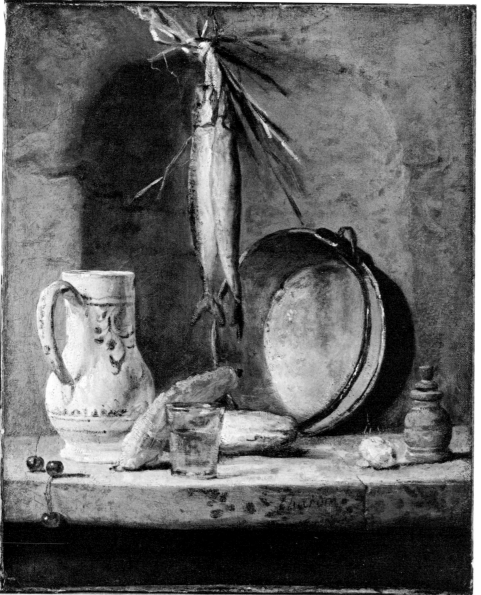

Figure 25.

60

early still lifes. The cherries are repeated in the blue decoration of the faience water jug, which is unique to this particular composition in Chardin's work. The shape of the jug is echoed by the pepper caster, giving the picture a more balanced arrangement and cohesiveness than was common in the artist's still lifes of the early 1730s, such as *Menu de maigre* and *Menu de gras*, companion pictures dated 1731 (Louvre). While these pictures lack the simplicity and unity of the Cleveland painting, they share some close parallels with it—particularly in the similar placement of the kettle and herring in *Menu de maigre*.

Wildenstein (1969) dated the Cleveland painting ca. 1758, but in dimensions and subject it corresponds more closely to the kitchen still lifes of the 1730s. Its simplicity and monumentality suggest a date among later works in this group, and its unusual blond tonality seems related to *La Fillette au volant* and *La Tabagie*, both recently dated to 1737 by Pierre Rosenberg (1979, nos. 72 and 74).

Fruits et ustensiles de cuisine was listed as a pendant to the Museum picture in the Benoist sale of 1857 (lot 13), but it cannot be identified now.

The Cleveland painting was once in the David-Weill collection, Paris; a variant that is almost identical in dimensions and composition still remains in that collection (Rosenberg, 1979, no. 49). Each picture has passages slightly harder in execution than corresponding passages in the other, making it difficult to conclude from a stylistic comparison which was painted first. An X radiograph made in 1979 of the Cleveland painting, however, reveals that the jug and nearby vegetable were originally on the right and the kettle was on the left (Figure 25*a*)—a strong indication that the Museum painting was the first of the two versions. W S T

EXHIBITIONS: Tours, Musée des Beaux-Arts, 1873: Exposition retrospective, cat. no. 501; Paris, Galerie Georges Petit, 1907: Exposition Chardin et Fragonard, cat. no. 68; New York, Arnold Seligmann—Helft Galleries, 1947: French Still Life from Chardin to Cézanne, cat. no. 9; CMA, March 1975: Year in Review, cat. no. 46, illus.; Grand Palais (Paris), CMA, and Museum of Fine Arts (Boston), 1979: Chardin, cat. no. 48, illus. (catalogue by Pierre Rosenberg).

LITERATURE: "Chronique, Documents, Faits Divers," *Revue Universelle des Arts*, VI (1857), 181; Armand Dayot and Léandre Vaillat, *L'Oeuvre de J.-B.-S. Chardin et de J.-H. Fragonard* (Paris, 1907), see Introduction, and nn. on p. iv, no. 19, illus.; Jean Guiffrey, "Exposition Chardin-Fragonard," *Revue de l'Art Ancien et Moderne*, XXII, (1907), 102; Maurice Tourneux, "L'Exposition Chardin-Fragonard," *Gazette des Beaux-Arts*, XXXVIII (1907), 98; Henri Frantz, "The Chardin-Fragonard Exhibition in Paris," *The Studio*, XLII (1908), illus. p. 29; Otto Grautoff, "Jean-Baptiste Siméon Chardin," *Kunst und Künstler*, VI (1908), 498; Guiffrey, *Jean-Baptiste Siméon Chardin Catalogue Complet de l'oeuvre du maître* (Paris, 1908), p. 90, no. 220; Herbert E. A. Furst, *Chardin* (London, 1911), p. 132, pl. XXXII (mistakenly catalogued as National Gallery of Scotland, Edinburgh); Gabriel Henriot, "La Collection David-Weill," *L'Amour de l'Art*, VI (1925), 2, pl. 111; Henriot, *Collection David-Weill*, I (Paris, 1926), 35–36, illus. frontispiece and p. 37; Georges Wildenstein, *Chardin* (Paris, 1933), no. 896, fig. 125, and no. 898 (mistakenly catalogued as National Gallery of Scotland, Edinburgh); Wildenstein, *Chardin* (Manesse, 1963), no. 272, fig. 127, and no. 56, fig. 27 (mistakenly catalogued as National Gallery of Scotland, Edinburgh); Wildenstein, *Chardin* (Greenwich, Connecticut, 1969), no. 272, fig. 127, and no. 56, fig. 27; *Country Life*, August 16, 1973, p. 434, illus.; Carol C. Clark, "Jean-Baptiste Siméon Chardin, *Still Life with Herring*," CMA *Bulletin*, LXI (1974), 309–14, color illus. p. 285, figs. 3 and 4; CMA *Handbook* (1978), illus. p. 178; Mark M. Johnson, *Chardin 1699–1799, Notes on the Exhibition* (Cleveland, 1979), p. 16, figs. 10 and 11.

Figure 25*a*. X radiograph showing pentimenti.

Attributed to CORNEILLE DE LYON
Died 1574

Information about the life and works of Corneille de Lyon is confusing and incomplete. His works were virtually ignored until the end of the nineteenth century. A native of The Hague, he established himself in Lyons, where he is first recorded in 1540. There is no record of his family or of what brought him to Lyons from Holland. He was court painter for Henry II, both in 1541 when Henry was dauphin and after he became king in 1551. Later he worked for Charles IX. He was naturalized by Henry II in 1547. The Venetian ambassador Giovanni Capelli visited Corneille's studio in 1551 and reportedly saw there a display of the artist's small portraits of great men of history. With the rise of religious persecution, Corneille gave up Protestantism and in 1569 became a Catholic, as did his wife and daughter. He died in 1574.

The attribution of certain paintings to Corneille is based on the opinion of Robert de Gaignières (died 1715), a buyer of portraits in Lyons in the seventeenth century. There are five extant paintings which Gaignières certified as works of Corneille de Lyon; these, however, are not accepted as autograph works by Louis Dimier, author of *Histoire de la peinture de portrait en France au XVIᵉ siècle* (3 vols., 1924–26), who further confused the attribution problem by giving other, closely related, portraits to artists such as "le peintre de Rieux-Chateauneuf," "le peintre de Brissac," and "l'anonyme de M. Benson." Unfortunately, the portraits now assigned to Corneille are uneven in quality, and some exist in several copies. A great deal more study is required before a reliable oeuvre can be established.

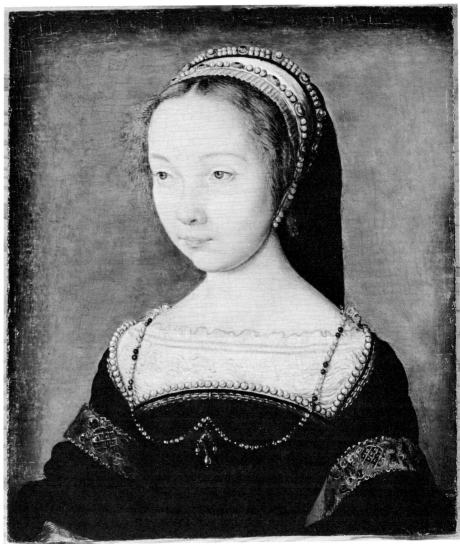

Figure 26.

26 Portrait of a Princess (?) 42.48

Panel (oak), 16.5 x 14.8 cm.

Collections: Lancaster, Lisbon.

Gift of Grace Rainey Rogers in memory of her father, William J. Rainey, 1942.

Note: This painting was stolen from the Museum galleries on February 21, 1974.

The panel, cleaned by Joseph Alvarez in 1970, has a fine craquelure and is in generally good condition. There is some abrasion of the thin glazes (which are characteristic of works by Corneille) and some minor retouching in the background, as well as evidence that the panel was cut across the bottom. The sixteenth-century-style frame is modern.

Felix Wildenstein (letter of January 28, 1942) informed the Museum that the painting was formerly in the collection of Lancaster, Lisbon, and at one time had been attributed to François Clouet (ca. 1515–1572). Corneille's works are easily distinguished from Clouet's, however, by their fine, translucent delicacy, and this quality being present in the Cleveland painting suggests Corneille's authorship.

The sitter may have been a member of the Valois family. This representation bears a strong resemblance in type and style to Corneille's drawings of the daughters of Henry II: Elizabeth of France (one drawing in The Hermitage, Leningrad, and one in the Musée Condé) and Marguerite of Valois (E. Moreau-Nélaton, *Les Clouet et leur émules*, II, Paris, 1924, figs. 208, 219, 265). Our portrait is also stylistically related to the portrait of Marguerite de Bourbon, Duchess of Never (Musée de Versailles), which has been attributed to Corneille. NCW

EXHIBITIONS: None.

LITERATURE: Henry S. Francis, "Paintings in the Rogers Gift," CMA *Bulletin*, XXIX (1942), 66–67; CMA *Handbook* (1969), illus. p. 102.

NOEL-NICOLAS COYPEL

1690–1734

Noël-Nicolas Coypel was born in Paris in 1690. He studied first with his father, Noël Coypel (1628–1707), a rector of the Academy and later its director. Antoine Coypel (1661–1722) was Noël-Nicolas's half-brother, and Charles Antoine Coypel (1694–1752) was his nephew. Noël-Nicolas was admitted to the Academy in 1716 with a *Transfiguration* and became a full member in 1720 with *Neptune Carrying Off Amymone* (Musée des Beaux-Arts, Valenciennes). He became a professor in 1733. His *Roman Charity* appeared in an exhibition of younger painters held in 1724. He competed to great popular acclaim in the 1727 concours for history painting with a *Rape of Europa* (Philadelphia, private collection), but the official prize went to

François Lemoine and Jean François de Troy. A private patron, seeing the injustice of the award, purchased the picture by Noël-Nicolas for the same amount officially promised for the winning painting. Among his works are numerous mythological subjects; an altarpiece and cupola decorations for St. Sauveur, Paris (destroyed 1776); and pictures for churches in Paris, Versailles, and Chantilly. His clear drawing, sharp lighting, and less complicated color give substantial force to his compositions. He died relatively young and in greatly reduced circumstances. Though the least successful of the Coypels, he is now generally regarded as the best painter of the family.

27 St. James the Great 29.96
and the Magician

Canvas, 102.2 x 80.6 cm. Signed and dated at lower left: N. Coypel/1726.

Collections: Elliott Gregory, New York; Felix Wildenstein.

Gift of Felix Wildenstein, 1929.

The painting was lined at some unknown time before it entered this Museum. It was cleaned here in 1961. There are a few scattered, minor retouchings in the lower right.

St. James the Great was the apostle who established Christianity in Spain. According to the *Golden Legend*, after he returned to Judea from Spain he converted Philetus, the disciple of a magician who had been sent to convict the apostle of false doctrine. In a rage, the magician Hermogenes paralyzed Philetus, but James released him from the paralysis. Hermogenes then sent demons to seize the apostle, but an angel bound the demons with fiery chains, which James loosed only on condition that they seize the magician instead. As a demonstration of Christian magnanimity, James then released Hermogenes and gave him his pilgrim staff with its attached gourd of water as a protection against the angry demons. The magician brought his books of magic to the apostle to be destroyed and threw himself at James's feet begging forgiveness. These two spectacular conversions so angered the high priest that he convinced Herod Agrippa to condemn James to death. He was being led to martyrdom by Josias, a scribe who had been a prominent persecutor, when a man with palsy cried out to be cured. James cured the man in the name of Christ, whereupon Josias fell at the apostle's feet begging forgiveness and asking to be baptized.

The Museum painting seems a conflation of three miracles: the conversion of the magician Hermogenes, whose books lie at the apostle's feet; the cure of the palsied man, who rises from his pallet; and the conversion of the scribe Josias. In the Museum picture the kneeling figure represents both Hermogenes and Josias. The prominence of this figure may have been inspired by the kneeling pilgrim in the foreground of Poussin's *Virgin Appearing to St. James* of 1629–30 (Paris, Louvre).

Figure 27.

Noël-Nicolas may also have been inspired by his father's *St. James Led to Execution* (painted in 1661 for Notre Dame), in which a kneeling Josias wrings his hands in remorse before St. James. A reduced version (Figure 27a) of this picture was exhibited in the Salon of 1699 and has been displayed since 1811 in the Church of St. Merri, Paris. The elder Coypel's painting, with its impressive classical architecture and heroic figure style, is more restrained and measured than the flamboyantly dramatic, psychologically charged painting by Noël-Nicolas.

The face of the cloaked figure at the extreme right is a self-portrait of the artist; it closely resembles the 1730 terra-cotta portrait of Noël-Nicolas by Jean Baptiste Lemoyne (Louvre, no. 1400).

Because of a misread signature initial, the Museum's painting had formerly been attributed to Charles Antoine Coypel. The present attribution, suggested by Pierre Rosenberg (letter of July 6, 1971, and publication of 1975), is borne out by stylistic considerations and a closer examination of the signature.

Unfortunately, nothing is known of the early history of this painting, which in clarity and power of composition ranks as one of the artist's more important works.

WST

EXHIBITIONS: CMA (1936), cat. no. 57; Montreal Museum of Fine Arts, Le Musée de la Province de Québec, National Gallery of Canada (Ottawa), and Art Gallery of Toronto, 1961/62: Héritage de France, French Painting 1610–1760, cat. no. 20, illus. p. 90; Denver Art Museum, 1966: Great Stories in Art.

LITERATURE: Pierre Rosenberg, *The Age of Louis XV, French Painting 1710–1774* (exh. cat., Toledo, 1975), p. 31.

FRANÇOIS HUBERT DROUAIS

1727–1775

For three generations during the eighteenth century the Drouais family produced painters of some renown: Hubert (1699–1767), his son François Hubert (1727–1775), and François's son, Jean-Germain (1763–1788). François Hubert received careful training from his father and was then sent to study with Carle van Loo, Charles Joseph Natoire, and François Boucher. He was admitted provisionally to the Academy in 1755 and exhibited at the Salon every year after that. Through his father, who painted many prominent actresses, he gained an entrée into the theatrical world and painted many of its celebrities. His work attracted immediate attention. He became court painter in 1756, during the late years of the reign of Louis XV. A rival of Nattier, he was patronized by Mme du Barry and Mme de Pompadour, despite the consistent criticism of Diderot. His portraits of children were his greatest contribution to French eighteenth-century painting. His style gradually became superficial and mannered, perhaps due to his spectacular success.

Figure 27a. *St. James Led to Execution.* On canvas, 116 x 97 cm. Coypel. Church of St. Merri, Paris.

Figure 28.

Canvas, 101 x 80 cm. Signed at upper left: Drouais fecit 1759.

Collections: M. de Callieux, Lyons, descendant of the sitter; [Wildenstein & Co., New York]; John L. Severance, Cleveland, purchased from CMA exhibition, 1928.

John L. Severance Collection, 1942.

This painting was cleaned by William Suhr in 1942 and again in 1962 by Joseph Alvarez at the Museum. It is in good condition, with only minor retouching in the lower right, in the background, and in the face. There is a 2.5-centimeter vertical tear in the canvas, near the vertical painted molding on the right. The painted molding has been repaired and retouched.

This painting is typical of the facile draftsmanship of Drouais and exemplifies his sensitive and meticulous rendering of velvets, satin, and embroidery. Little is known of the sitter, the Marquise d'Aiguirandes, who was the daughter of Mlle Leduc de Jourvoie and Louis de Bourbon-Condé, a prince of royal blood and the Comte de Clermont. According to a letter from Wildenstein & Co., New York (dated July 7, 1942), the sitter's husband was a cavalry captain in the regiment of the Comte de Clermont and also the comte's master of the hunt.　　　　NCW

EXHIBITIONS: CMA, 1928: Representative Art through the Ages; London, Royal Academy, Burlington House, 1932: Exhibition of French Art from 1200–1900, cat. no. 249; CMA (1936), cat. no. 58, illus.; CMA (1942), cat. no. 4; Winnipeg (Manitoba) Art Gallery, 1956: Portraits, Mirror of Man, cat. no. 24, illus.; CMA (1963), cat. no. 51, illus.

LITERATURE: Georges Wildenstein, "Paintings from America in the French Exhibition," *Fine Arts*, XIX (January 1932), 26, illus. p. 23; Wildenstein, "Le XVIIIᵉ siècle," *Gazette des Beaux-Arts*, VII (1932), 65, fig. 12; *Commemorative Catalogue of the Exhibition of French Art, 1200–1900* (London, 1932), no. 160, p. 44; Hans Tietze, *Meisterwerke europäischer Malerei in Amerika* (Vienna, 1935), p. 259, illus. (caption incorrect); William M. Milliken, "World Art at Cleveland," *American Magazine of Art*, XXIX (1936), illus. p. 435; Francis (1942), p. 135, illus. p. 130; Helen Comstock, "The John L. Severance Collection at Cleveland," *Connoisseur*, CXI (1943), 61, illus. p. 63; M. Wagner de Kertesz, *Historia Universal de las Joyas* (Bueños Aires, 1947), illus. p. 513; Edmond L. and Jules A. de Goncourt, *French XVIII-Century Painters: Watteau, Boucher, Chardin, La Tour, Greuze, Fragonard* (reprint ed., New York, 1948), p. v; Coe (1955), II, 231, no. 4; François Boucher, review of Gunnar W. Lundberg's *Alexander Roslin: Liv och verk (Sa vie et son oeuvre)*, in *Gazette des Beaux-Arts*, LVI (1960), 243, fig. 2; Francis Spar, "La lettre d'information de Francis Spar: Les nouveaux goûts," *Connaissance des Arts*, no. 140 (October 1963), 49, illus.; Boucher, *Histoire du costume en occident de l'antiquité à nos jours* (Paris, 1965), p. 297, fig. 716; CMA *Handbook* (1978), illus. p. 179.

Gaspard Dughet (sometimes called Gaspard Poussin), one of the leading landscape painters in Italy in the seventeenth century, was a contemporary of Nicolas Poussin, Claude Lorrain, and Salvator Rosa. His contribution to landscape painting was to anticipate the "*style champêtre*" of such eighteenth-century painters as Boucher, Pillement, and Claude Joseph Vernet, and of the romantic and naturalistic landscapists of the nineteenth century. Major sources concerning his life and work are: Filippo Baldinucci, *Notizie dei professori del disegno . . .*, VI (Florence, 1728), 54 ff.; Lione Pascoli, *Vite de' pittori, scultori, ed architetti perugini . . .*, I (Rome, 1730), 57–63; and, more recently, Denys Sutton, "Gaspard Dughet: Some Aspects of His Art," *Gazette des Beaux-Arts*, LX (1962), 269–312.

Gaspard was born in Rome in 1615, the son of an Italian mother and a French father, a cook. He grew up among Northern painters in the artists' quarter, near the Piazza di Spagna. In 1630 his sister, Anne-Marie Dughet, married Nicolas Poussin. Gaspard worked in Poussin's studio between 1631 and 1635, after which he set himself up in four studios: one at Frascati, one at Tivoli, and two in Rome. He was never able to match Poussin's profound intellectual interpretation of the past, but neither was he dominated by the greater master. There was probably a mutual exchange of influences and ideas. Unlike Poussin, Gaspard made oil sketches from nature. He exploited the romantic and mysterious aspects of nature and the effects of wind and storms. A prolific decorative painter, whose works varied in quality, he also made prints and painted cabinet pictures and frescoes in palaces and churches (some datable). He lived comfortably and never married. He died in Rome in 1675.

29 *Landscape with Hunting Figures* 70.30

Oval canvas, 127 x 175.2 cm.

Collections: The Honorable George Ellis Vestey (1884–1960), Warter Priory, Yorkshire (private auction, March 1969, as Gerard von Edema); [Hazlitt Gallery, Ltd., London].

John L. Severance Fund, 1970.

The painting was restored in 1969 while still on the London art market. There was some damage to the paint film where the original oval had once been adapted to a square stretcher and frame, and some loss in the lower left part of the canvas, but otherwise the painting is in very good condition.

The early history of the painting is not known. Its presence in England is perhaps explained by Gaspard's popularity there. Nearly two thirds of his easel paintings were in English private collections. According to the dealer from whom the painting was purchased, it had probably hung in Warter Priory since Victorian times (letter from Hazlitt Gallery, dated October 17, 1969).

The lack of signed and dated paintings by this artist

Figure 29.

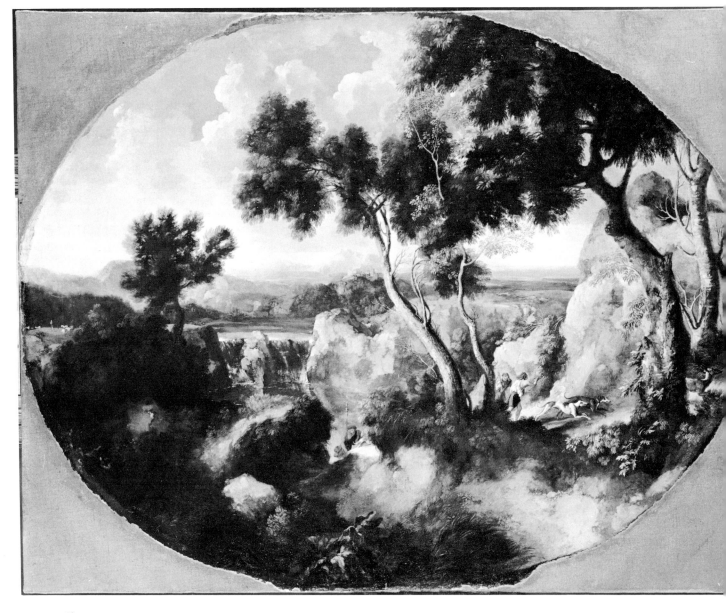

makes it difficult to establish a reliable chronology of his work. Recently, however, scholars have made some progress in exploring the development of his style (Denys Sutton, "Gaspard Dughet: Some Aspects of His Art," *Gazette des Beaux-Arts*, LX, 1962, 277, fig. 6; Salerno, 1975; and Boisclair, 1976). Stylistically, the Cleveland painting is close to the *Landscape with Sportsmen* in the collection of Sir Orme Sargent, Bath (Sutton, *op. cit.*, p. 277, fig. 6). Both paintings indicate an influence from the North; both are views from an elevated point; and both are similar in the treatment of trees, flat areas of rock and earth, reflecting water, and figures and animals. An etching (Figure 29a) in the collection of Professor E. K. Waterhouse, Oxford (*ibid.*, p. 299, fig. 26), is related in subject and style to these two landscapes. The etching shows that, when he wished, Gaspard could competently execute figures, a task he often left to collaborators such as Jan Miel or Pieter van Laer.

Boisclair (1976) assigned the Cleveland painting to Dughet's early period, dating it ca. 1634–35. The silver birch at the extreme right in the painting would support such an early dating, for it appears almost like a signature in a group of this master's early works, which had once been attributed to the so-called Silver Birch Master.　　N C W

EXHIBITIONS: CMA, February 1971: Year in Review, cat. no. 38, illus.

LITERATURE: Luigi Salerno, "La cronologia di Gaspard Dughet," *Etudes d'art français offertes à Charles Sterling* (Paris, 1975), p. 229, fig. 146; Marie-Nicole Boisclair, "Gaspard Dughet: Une chronologie révisée," *Revue de l'Art*, no. 34 (1976), 30, fig. 2; CMA *Handbook* (1978), illus. p. 172; William S. Talbot, "Some French Landscapes: 1779–1842," CMA *Bulletin*, LXV (1978), 79, fig. 6.

Figure 29a. *Landscape*. Etching. Dughet. Collection of Professor E. K. Waterhouse, Oxford, England. Reprinted from *Gazette des Beaux-Arts*, LX (1962), 229.

JEAN-HONORE FRAGONARD
1732–1806

Fragonard was born into a merchant family of Italian origin in Grasse, Provence, in 1732; he died in Paris in 1806. At about the age of six he moved with his family to Paris. He spent six months in the studio of Chardin in 1747/48 and then studied with Boucher. He won the Grand Prix de Rome in 1752 and was admitted to the Ecole Royale des Elèves Protégés, directed by Carle van Loo, where he studied for three years. At the end of 1755 Fragonard left for Rome to study at the French Academy, then under the direction of Natoire. With his friends Hubert Robert and the amateur draftsman-engraver the Abbé de St. Non he traveled to Naples, Bologna, Venice, and other cities. Fragonard was particularly influenced by the decorative painters of the baroque style, such as Pietro da Cortona in Rome and Tiepolo in Venice. He was also influenced by seventeenth-century Northern painters such as Rubens, van Dyck, Jordaens, Frans Hals, and Rembrandt (whom he copied). He returned to Paris in 1761 and was elected an *agréé* of the Academy in 1764. Although never received into the Academy, he was very much in demand among a less official clientele and occasionally exhibited at the Salon with great success. In 1769 he married Marie-Anne Gérard from Grasse, who became a painter of miniatures. Between 1771 and 1773 he executed a series called *The Progress of Love* (now in The Frick Collection, New York), commissioned but later refused by Mme du Barry. From 1773 to 1774 he was again in Italy. After his return, his sister-in-law Marguerite Gérard joined his household and in 1775 became his pupil. Fragonard's passion for her inspired a group of pre-romantic paintings, such as *The Souvenir*, *The Fountain of Love*, *The Stolen Kiss* (all in The Wallace Collection, London) and *The Convocation of Love* (John M. Schiff collection, New York, in 1960). At about the same time, Fragonard began to paint scenes representing domestic virtue; he also painted a group of rustic and domestic idylls inspired by Jean Jacques Rousseau, as well as some brilliant portraits and landscapes. An admirable draftsman, he preferred the technique of applying bister washes over pen and crayon. He illustrated *Don Quixote*, La Fontaine's *Fables*, and Ariosto's *Orlando Furioso*. In 1793 the painter Jacques-Louis David appointed him a member of the Museum Commission, a group responsible for establishing the national collections and the Musée du Louvre; he resigned this post in 1799. His output declined markedly in the last twenty-five years of his life, but overall he was a very prolific artist. Because he seldom signed his works or had them engraved, there has been some art-historical debate about the attribution of some of his paintings and the chronology of his work.

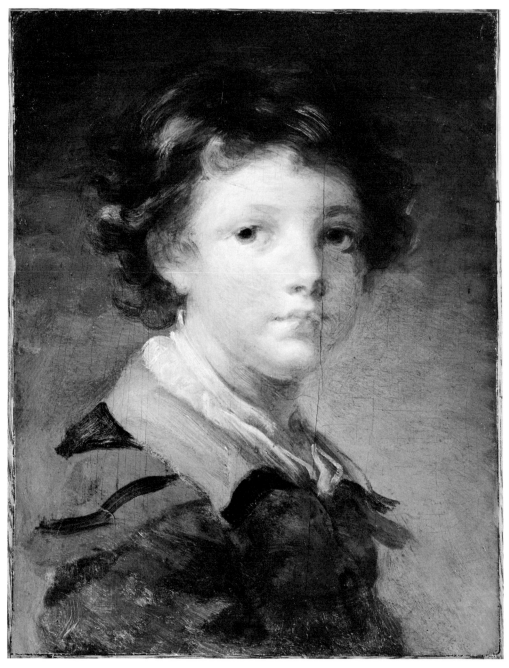

Figure 30.

30 *Young Boy Dressed in a Red-Lined Cloak (Portrait of Alexandre-Evariste Fragonard ?)* 42.49

Panel (hard wood), 21.2 x 17.2 cm overall. Painted surface: 20.8 x 16 cm.

Collections: Hippolyte Walferdin (1795–1880), (sale: Paris, Hôtel Drouot, April 12–14, 1880, no. 4); Comte Cahen d'Anvers, 1889; Nicolas Ambatielos; [Wildenstein & Co., New York]; Grace Rainey Rogers.

Gift of Grace Rainey Rogers in memory of her father, William J. Rainey, 1942.

The painting was cleaned by Joseph Alvarez in 1969 in the Museum laboratory. Strips tacked to all edges of the .3-centimeter-thick, hard-wood panel increase the overall size to 21.2 x 17.2 centimeters. The panel is cradled. A sixteen-centimeter-long vertical crack runs through the left half of the boy's face. The white ground, which has been evenly applied on the panel, is visible in the boy's sketchily described coat. The thinly applied oil paint lacks brushmarks. The overall monochrome of the painting is relieved by touches of brilliant red—probably vermilion—accenting the mouth, nostrils, and hairline of the sitter and by the red in the lining of his coat, from which the picture takes its name. The painting is in good condition. There are only a few abrasions, and these were inpainted during the most recent cleaning.

In the years after 1780, when his production had declined, Fragonard painted some of his most delightful portraits and genre scenes of family life, some of which include his own children (his older daughter Rosalie was born in 1769 and died in 1788; his son Alexandre-Evariste was born in 1780). It has been suggested by Wildenstein (1960, p. 316) that the Museum sketch is probably a portrait of the artist's son, who later worked in David's studio and became a mediocre painter and sculptor. Fragonard painted several portraits of a young boy, each describing the same general physiognomic type, with high, broad cheek bones; full, puckered lips; and curly hair. An oval panel formerly in the collection of the Princesse Gagarine (Wildenstein, 1960, no. 517) is closely related to the Museum portrait and is also assumed to be a portrait of that artist's son. Wildenstein presumed that a portrait of a younger child (private collection; see Wildenstein, 1960, no. 516) also represents Alexandre-Evariste. Another portrait (New York, private collection; see Wildenstein, 1960, no. 513) bears a close resemblance to the others mentioned but cannot be positively identified. The very beautiful portrait of *A Boy Dressed as a Pierrot* (Wildenstein, 1960, no. 520) is closely related to the Museum portrait but is less sketchy. Although this latter portrait is a pendant to the *Girl with a Pearl Necklace* (Wildenstein, 1960, no. 521), presumably a portrait of Fragonard's daughter Rosalie, Wildenstein thinks the subject has been wrongly identified as Fragonard's son.

If the child in the Museum portrait is indeed Fragonard's son, the Museum sketch would date ca. 1785 to 1789, when Alexandre-Evariste was between the ages of five and nine. N C W

EXHIBITIONS: Paris, 1860: Tableaux et dessins de l'école française, principalement du xviiie siècle, tirés de collections d'amateurs et exposés au profit de la caisse de secours des artistes, peintres, sculpteurs, architectes et dessinateurs, cat. no. 146 (catalogue by Philippe Burty); CMA (1963), cat. no. 60, illus.

LITERATURE: W. Bürger (Thoré), "Exposition de tableaux de l'école française ancienne tirés de collections d'amateurs," *Gazette des Beaux-Arts*, VII (1860), 348; Roger Portalis, "La Collection Walferdin et ses Fragonards," *Gazette des Beaux-Arts*, XXI, series 2 (1880), 321; Portalis, *Honoré Fragonard, sa vie et son oeuvre* (Paris, 1889), p. 281; Pierre de Nolhac, *J.-H. Fragonard, 1732–1806* (Paris, 1906), II, 114; Henry S. Francis, "Paintings in the Rogers Gift," CMA *Bulletin*, XXIX (1942), 66–67, illus. p. 47; Edmond L. and Jules A. De Goncourt, *French XVIII-Century Painters: Watteau, Boucher, Chardin, La Tour, Greuze, Fragonard* (reprint ed., New York, 1948), p. v; Georges Wildenstein, *The Paintings of Fragonard* (London, 1960), no. 515, p. 316; CMA *Handbook* (1978), illus. p. 186.

CLAUDE GELLEE (called Lorrain)
1600–1682

Claude was born in the little village of Chamagne (Vosges) in the French part of Lorraine in 1600. He moved to Rome, possibly as early as 1613. His principal master was Agostino Tassi, for whom he worked first as a servant; later as an assistant; and finally, it is said, as the manager of the household. The important biographies of the artist are by Joachim von Sandrart (*Academie der Bau-, Bild- und Mahlerey-künste*, Nuremberg, 1675) and Filippo Baldinucci (*Notizie dei professori del disegno . . .*, 5 vols., Florence, 1843–47). Tassi's legal records from the year 1619 yield additional biographical information on Claude. In 1625 he returned to Nancy (capital of Lorraine); in 1626 or 1627 he settled in Rome, where he remained (with the exception of only one recorded absence—in 1660) until his death in 1682. In 1633 he joined the Accademia di S. Luca and later held several offices. According to Sandrart, Claude's friends in the 1630s were Sandrart himself, Pieter van Laer, Herman van Swanevelt, François Duquesnoy, and Nicolas Poussin. Claude remained on good terms with Poussin until the latter's death in 1665. He was also acquainted with the collector Antonio Ruffo of Messina, in whose correspondence during the years 1660–71 Claude's name is mentioned several times. Claude, who started in the Northern tradition of Brill and Elsheimer, was to become one of the seventeenth century's greatest painters of atmospheric and poetic landscapes. To protect himself against forgeries and imitators, he began the great record of his compositions known as *Liber Veritatis*, in which he documented each painting by a drawing and inscribed on the back of each the name of the collector or place for which the corresponding painting was intended. The part recording Claude's early works is incomplete, but the *Liber Veritatis* is a complete chronological inventory of the 195 paintings Claude executed after 1640.

31 *Italian Landscape* 46.73

Canvas, 101.5 x 137 cm. Inscribed to the right of lower center: CLAUDIO. I. V. 163[?].

Collections: Earls of Effingham, England (last owner, H. A. Gordon, fourth Earl of Effingham); private collection, England; [Thomas Agnew, London]; [Arnold Seligmann, Rey & Co., New York].

Mr. and Mrs. William H. Marlatt Fund, 1946.

The painting was examined in the Museum laboratory in the fall of 1978. X radiographs of all four corners of the painting show that all the tacking margins have been removed and the dimensions have been increased by about 1.5 centimeters along all edges. Abrasion with overpaint is found in all areas of the painting, especially in the sky and foreground. Previous cleanings have severely reduced the usual crisp ridges of brushstroke and have diminished the impasto. Minor residues of old, darkened varnish are seen in the recesses of the brushstrokes, and yellowed varnish and overpaint obscure the original appearance of the painting.

Marcel Röthlisberger (1968) stated that after a recent cleaning the full date of this landscape could be discerned, but even now the last digit of the date is unclear.

The letters I.V. next to the signature stand for *in urbe*, or "in the city [of Rome]."

The painting had not been published before it was acquired by this Museum. At the time of purchase, an expertise (dated November 6, 1946) was written by Walter Friedländer, who identified the subject as Tivoli, in the Sabine Mountains. For years the painting was known by this description.

Marcel Röthlisberger (1961, I, no. 243, and II, fig. 24) catalogued the painting under "most notable imitations," dating it from the early 1630s. Röthlisberger qualified his remarks by adding that the Cleveland painting "could reasonably be admitted as genuine" if one compared it with Claude's *Cephalus and Procris* (destroyed; formerly in Berlin, Staatliche Museen). Both paintings lack framing elements and are of an unusually large size for Claude. Röthlisberger (1968) later accepted the attribution to Claude, basing his opinion on some newly discovered information on the artist in the legal records of Agostino Tassi and the discovery of several other signed paintings from Claude's early years. These paintings form a consistent group that includes the Cleveland painting. Also included are Claude's first dated picture—of 1629—now in Philadelphia (Röthlisberger, 1961, II, fig. 344); a coastal view with sunset, signed and dated 1630 (present whereabouts unknown; Röthlisberger, 1968, fig. 3); a river scene (Washington, National Gallery), signed and dated 16[3]2 (Röthlisberger, 1961, II, fig. 345); and the pastoral landscape in the collection of Lord Leicester (*ibid.*, fig. 340). Röthlisberger also cautiously associated a group of unsigned canvases to this

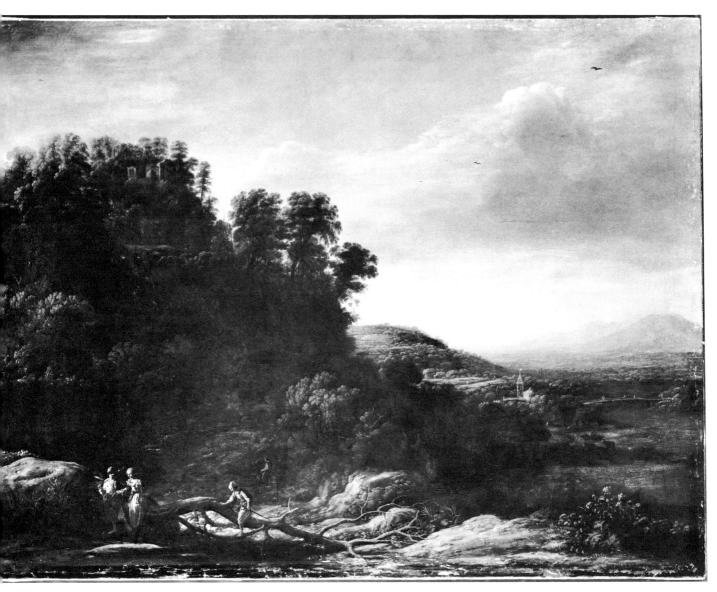

Figure 31.

early period when Claude was still very much influenced by the Northern painters Brill and Elsheimer, through his master Agostino Tassi. Röthlisberger published the painting again in 1975, dating it ca. 1630 to 1635. Again he compared it with the destroyed *Cephalus and Procris*, noting in particular the open composition and Flemish tradition of both paintings.

N C W

EXHIBITIONS: New York, Wildenstein & Co., 1946: A Loan Exhibition of French Painting of the Time of Louis XIII and Louis XIV, cat. no. 10, illus.; Montreal Museum of Fine Arts, 1952: Six Centuries of Landscape, cat. p. 18, illus. p. 17.

LITERATURE: Henry S. Francis, "*Roman Campagna near Tivoli* by Claude Gellée de Lorrain," CMA *Bulletin*, XLIII (1946), 178–80, illus. p. 173; Marcel Röthlisberger, *Claude Lorrain* (New Haven, 1961), I, 14, 512, 517, no. 248, and II, fig. 342; Röthlisberger, "Addition to Claude," *Burlington Magazine*, CX, pt. 1 (1968), 116; Röthlisberger and Doretta Cecchi, *L'Opera completa di Claude Lorrain*, Classici dell'Arte, vol. 83 (Milan, 1975), no. 28, p. 87, illus.; CMA *Handbook* (1978), illus. p. 172; George Szabo, *Seventeenth and Eighteenth-Century French Drawings from the Robert Lehman Collection* (New York, 1980), unpaginated, cat. no. 20.

CLAUDE GELLEE

32 *Landscape with Rest on the Flight 62.151
into Egypt*

Canvas, 208 x 152.5 cm.

Collections: Count Francesco Crescenzi or Giovanni Battista Crescenzi (1577–1660?), Spanish Marquess de la Torre; Sir William Lowther (1727–1753), third and last Baronet of Marske (Holker Hall, Lancashire); Lord George Augustus Cavendish (d. 1794), Holker Hall, Lancashire; William Cavendish (1808–1891), seventh Duke of Devonshire and second Earl of Burlington; Lord Richard Frederick Cavendish (1871–1946) (sale: Christie's, London, December 12, 1930, no. 37, illus.); Richard Edward Osborne Cavendish, Esq., Holker Hall, Lancashire (sale: Christie's, London, April 1, 1960, no. 87, illus.); [Rudolf Heinemann, New York].

Purchase, Leonard C. Hanna Jr. Bequest, 1962.

This painting is in generally good condition. The only major damage to the paint film is in the sky and at the edge of the foliage to the left of the central group of trees. Under ultraviolet illumination, scattered retouching can be seen throughout the sky.

This painting is documented by a drawing in Claude's *Liber Veritatis* (no. 88); on the back of the drawing is the inscription: *quadro faict per illmo Conte Crescence, Claudio Fecit in V.* The only "Conte Crescence," or Count Crescenzi, who was a contemporary of the artist was Francesco, a resident of Rome. It may have been his brother, Giovanni Battista Crescenzi, the Marquess de la Torre, however, who commissioned the painting. Giovanni Battista was an important collector. After 1630 he was superintendent of buildings and grounds for Philip IV, during

which time he probably commissioned the series of canvases that Claude painted around 1639 for Buen Retiro, the pleasure palace of Philip IV. Among these paintings was a *Finding of Moses* (Madrid, Prado, inv. no. 2253), to which our painting is related. Because of Giovanni Battista's familiarity with the Spanish series, he may have influenced the choice of composition for the Cleveland painting, which has been tentatively dated about 1645 (Röthlisberger, 1961, I, 243). Recently published evidence, however, may dictate that the entire sequence of dates associated with these works be re-examined (Enriqueta Harris, "G. B. Crescenzi, Velázquez and the 'Italian' Landscapes for the Buen Retiro," *Burlington Magazine*, CXXII, no. 929, August 1980, 562–64).

Claude re-used the landscape of the *Finding of Moses* in the Cleveland painting five or six years later. Like the paintings in the series of about 1639, the picture in Cleveland is unusually large. With the exception of some variations in details (such as the group of trees at the right center), its landscape is based directly on the *Liber Veritatis* drawing (no. 47) after the painting *The Finding of Moses*. The drawing rather than the painting served as model, perhaps because it was Claude's only record of the composition after the painting left his studio. Because of its close ties to the drawing of about 1639, the Cleveland picture may be dated appropriately in the 1640s.

The subject was a favorite of Claude's. He repeated it in several paintings and drawings with similar figures, usually including one or two angels playing with the Christ Child; note, for example, the *Rest on the Flight into Egypt* in the University Art Gallery, Notre Dame, Indiana (Röthlisberger, 1961, I, no. 38, and II, fig. 97). Other related compositions are the *Landscape with Hagar and the Angel*, of 1646/47, in the National Gallery, London (*ibid.*, I, no. 106, and II, fig. 187); and the *Pastoral Landscape with the Flight into Egypt*, of 1663, in the collection of Sir David Williams, Bart., Dorset (*ibid*, I, no. 158, and II, fig. 260). An octagonal bistre wash drawing on blue paper (24 x 19 cm) in the Robert Lehman Collection of the Metropolitan Museum is taken directly from the Cleveland painting and was probably executed soon after it.

N C W

EXHIBITIONS: Manchester, England, 1857: Art Treasures of Great Britain, cat. no. 654; CMA, October–November 1962: Year in Review, cat. no. 92; Detroit Institute of Arts, 1965: Art in Italy 1600–1700, cat. no. 23, illus. (catalogue by Donald Posner).

LITERATURE: Smith (1831), VIII, 238, no. 88; W. Bürger (Thoré), *Trésors d'Art exposés à Manchester en 1857 et provenant des collections royales, des collections publiques et des collections particulières de la Grande-Bretagne* (Paris, 1857), pp. 333–34; Waagen (1857), IV, 421; Bürger (Thoré), *Trésors d'Art en Angleterre* (Paris, 1865), pp. 333–34; M. Stephens, "The Private Collections of England: No. XXXI, Holker Hall," *Athenaeum*, no. 2601 (September 1, 1877), p. 282; Mrs. Mark Pattison [Lady Emilia Francis Dilke], *Claude Lorrain, sa vie et ses oeuvres* (Paris, 1884), p. 230, no. 5; Graves (1913), I, 177; *Holker Hall Guide*, English Life Publications (London, 1953), pl. 9; Marcel Röthlisberger, "Les

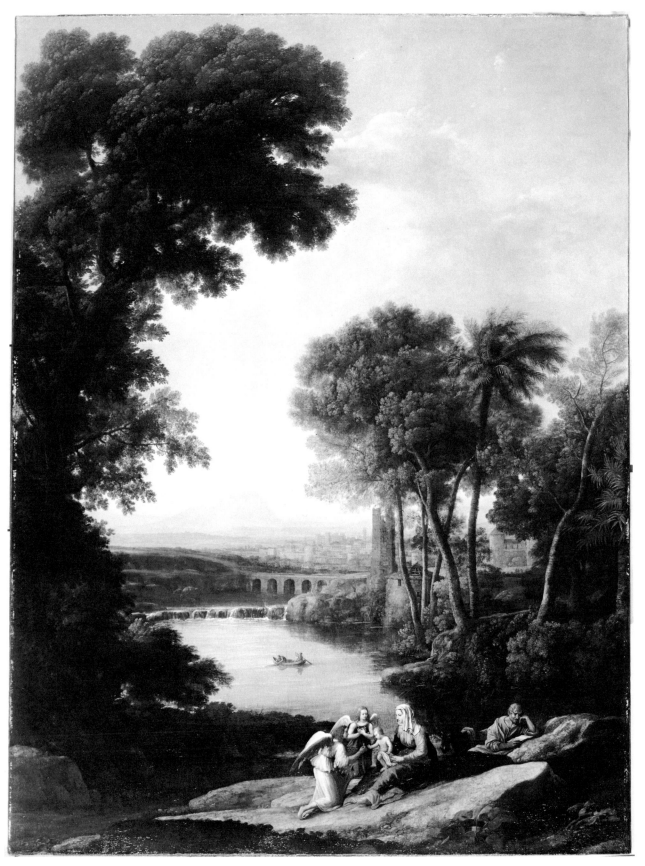

Figure 32.

Fresques de Claude Lorrain," *Paragone*, x, no. 109 (1959), 46, 49, pl. 25; Röthlisberger, *Claude Lorrain* (New Haven, 1961), I, 18–19, 90, 168, 243–44, 308, 374, no. 88, and II, fig. 168; Henry S. Francis, "Claude Gellée, *Landscape with Rest on the Flight into Egypt*," CMA *Bulletin*, XLIX (1962), 230–35, color illus. p. 229; Donald Posner, "The Baroque Revolution in Italy," *Art News*, LXIV, no. 2 (April 1965), illus. p. 32, no. 3; Rémy Saisselin, "Art Is Imitation of Nature," CMA *Bulletin*, LII (1965), 35, illus. p. 34, fig. 1; *Selected Works* (1966), no. 156, illus.; Alsop (1966), p. 23, illus. p. 29; Röthlisberger and Doretta Cecchi, *L'Opera completa di Claude Lorrain*, Classici dell'Arte, vol. 83 (Milan, 1975), no. 151, p. 105, illus.; CMA *Handbook* (1978), illus. p. 172; Michael Kitson, *Claude Lorrain: Liber Veritatis* (London, 1978), p. 109 (under no. 88).

LAURENT DE LA HYRE
1606–1656

After receiving his elementary training from his father, Etienne de La Hyre, and after studying the works of the Fontainebleau Mannerists, Laurent de La Hyre joined the then-leading workshop in Paris, that of Georges Lallemand (died ca. 1640). In 1648 La Hyre became one of the twelve founders of the Royal Academy. He himself never went to Italy, but he profited greatly from the experience of those who did. Claude Lorrain and Poussin's Roman classicism, for example, affected both La Hyre's landscapes and figure style. Vouet and Blanchard, who returned to France ca. 1627 and ca. 1628, respectively, transmitted to him the principles of Caravaggesque naturalism and chiaroscuro. La Hyre assimilated and modified these Italian impressions and integrated them into his own graceful, decorative style, in which landscape played an increasingly important part. While his large mythologies and religious paintings—for example, *Pope Nicolas V at the Opening of the Grave of St. Francis of Assisi* (Paris, Louvre), *The Conversion of St. Paul* (Paris, Notre-Dame Cathedral), and the *Allegory of Peace* (Louvre)—are in a grandiose baroque style, with figures often close to those of Vouet, his landscapes reveal an intimate poetry close in spirit to the Northern landscapists who shared his admiration for Claude Lorrain. La Hyre showed an early predilection for landscape. He had explored the countryside for motifs, which he reproduced in a series of engravings in 1640. His friends Désargues and Abraham Bosse, both ardent students of perspective, seem to have inspired his own exploration into aerial perspective. Thus, more and more, his interest focused on atmospheric landscapes that receded into luminous distances through subtle gradations of tones. At his best, La Hyre created a poetry all his own.

33 The Kiss of Peace and Justice 71.102

Canvas, 54.9 x 76.2 cm. Signed and dated on stone in right foreground: L de la Hyre in[venit] & F[ecit] 1654. Inscribed on stone behind figures: IUSTITIA ET PAX OSCULATAE SUNT.

Collections: Evrard Titon du Tillet, Paris, probably 1762; Randon de Boisset, Receveur Général des Finances, Paris (sale: Paris, February 27 – March 25, 1777, no. 170); Joulin [Joullain?]; Marquis de Sabran; purchased by J. B. P. Lebrun in 1796 for Mr. Codman (see Literature, 1935); (sale: Christie's, London, November 27, 1970, no. 52, illus., and dated 1659); Lady Nathan; [Cyril Humphris, London].

John L. Severance Fund, 1971.

The painting is in excellent condition, with the exception of a few scattered paint losses along the upper edge.

The subject was rarely treated by French painters; it was more frequently represented in Netherlandish and Italian paintings. Among the latter, Giovanni Lanfranco's *Justice and Peace* (Rome, Palazzo Costaguti) may have been known to La Hyre through an engraving, since La Hyre's figures correspond closely to Lanfranco's two intertwined figures. Rosenberg and Thuillier, who were the first to publish the Cleveland painting, postulated (1974, p. 304 and n. 18) that it may have been based on Flemish engravings—perhaps, Ann Tzeutschler Lurie now suggests, two by Goltzius (see F. W. H. Hollstein, *Dutch and Flemish Engravings and Woodcuts*, VIII, Amsterdam, 1953, no. 103: *Justitia. Prudentia*, and no. 104: *Concordia. Pax*)—or on a widely used composition which seems to have originated in Fontainebleau (see, for example, *Two Allegorical Figures*, now in the Neger collection in Paris [*Fontainebleau e la maniera italiana*, exh. cat., Naples, 1952, illus. pl. 46]).

La Hyre himself had earlier painted a large *Allegory of Peace* (Louvre) in celebration of the Peace of Westphalia in 1648. This painting was certainly inspired by Vouet—either by his *Allegory of Victory* in the Louvre, or by a work directly related to Vouet, such as the *Allegory of Peace* (attributed to School of Vouet, in the Musée des Beaux-Arts de Nantes).

The figure of Peace in the Cleveland painting is related to that of Fame in La Hyre's *Fame Proclaiming the Glory and Fidelity of Paris*, dating from 1654 (Paris, private collection; see Rosenberg and Thuillier, 1974, figs. 4 and 5).

The subject of the painting is made explicit by the artist in the antique inscription, "IUSTITIA ET PAX OSCULATAE SUNT." Like numerous other subjects chosen by La Hyre, this, too, may have been inspired by the Bible. In Psalm 85:10 we read: "righteousness [or justice] and peace have kissed each other." The gentle pastoral mood of the painting seems to reflect the meaning of yet another verse in the same Psalm (85:12): "Yea, the Lord shall give that which is good, and our land shall yield her increase." La Hyre often read the Bible; his awareness of approaching death may have increased his piety in the last years of his life when he executed the painting now in Cleveland.

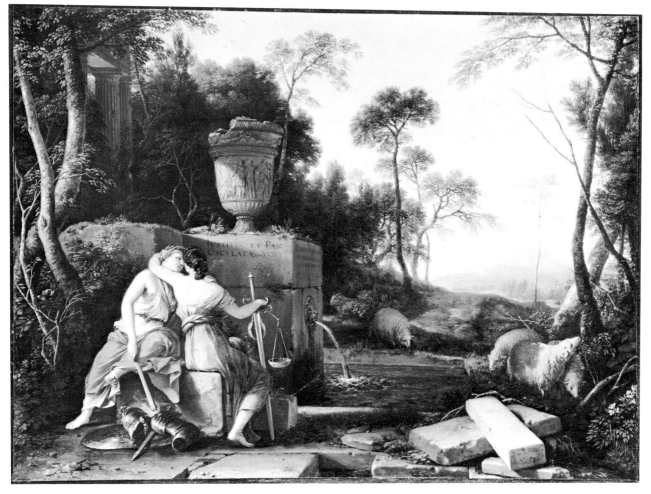

Figure 33.

Rosenberg and Thuillier (1974, p. 305) reflected upon La Hyre's choice of the torch as his symbol of peace rather than the more traditional olive branch he used in *Allegory of the Peace of Westphalia* (Louvre); the torch, they said, raised against war's weapons seemed a more emphatic symbol. Significantly, in 1653, one year before La Hyre painted his allegory of war and peace, the exiled cardinal and statesman Mazarin had returned to Paris more powerful than ever after the cruel battles of the Fronde that tore Paris and, indeed, all France apart. La Hyre's *Kiss of Peace and Justice*, then, was painted during a time of new hope for the return of peace and tranquility.

A drawing (Figure 33a) by Gérard de Lairesse (1641–1711), which faithfully repeats the central portion of our painting, indicates that the painting was well known by the first part of the eighteenth century. (The drawing is documented in a sale in Paris, Villenave, December 1–8, 1842, no. 501, 37 x 43 cm.)

In his *Voyage Pittoresque de Paris* (1757), Dézallier d'Argenville described the painting as "La Justice et la Paix qui s'embrassent, dans un beau paysage, par la Hyre," saying also that it had belonged to the famous Parisian collector and financier Evrard Titon du Tillet. Following that, it was in the collection of Randon de Boisset, who sold it to "Joulin" for £301 (sale: Paris, February 27 – March 25, 1777; catalogue now in the Bibliothèque de L'Insititut d'Art et d'Archéologie, Paris). Joulin could be the well-known dealer Joullain, who may have acquired it for one of his clients rather than for himself (none of the Joullain sales between 1779 and 1781 included it; see Rosenberg and Thuillier, 1974, nn. 12 and 13). A T L

EXHIBITIONS: CMA, January 1972: Year in Review, cat. no. 53.

LITERATURE: A.-J. Dézallier d'Argenville, *Voyage Pittoresque de Paris* (Paris, 1757; reprint ed., Geneva, 1972), p. 291; Louis Courajod, *Livre-Journal de Lazare Duvaux*, I (Paris, 1873; reprint ed., Paris, 1965), cccxxii; H. Mireur, *Dictionnaire des Ventes d'art* (Paris, 1911), p. 517; Cora Codman Wolcott, "A History of the Codman Collection of Pictures" (Brookline, Massachusetts, Twin Pines Farms, 1935), p. 2; John Herbert, ed., *Christie's Review of the Year 1970/71*, illus. p. 45; Pierre Rosenberg and Jacques Thuillier, "Laurent de La Hyre: *The Kiss of Peace and Justice*," CMA *Bulletin*, LXI (1974), 302–8, figs. 1, 3, 9, colorplate on pp. 300–301; CMA *Handbook* (1978), illus. p. 173; Mark M. Johnson, *Idea to Image* (exh. cat., Cleveland, 1980), pp. 12 and 13, fig. 4.

Figure 33a. *The Kiss of Peace and Justice.* Red chalk, 37.6 x 44.1 cm. Gerard de Lairesse, Dutch, 1641–1711. Gift of Cyril Humphris. CMA 72.216.

NICHOLAS LANCRET
1690–1743

Lancret, the son of a coachman, was born in Paris. He studied first with Pierre Dulin (1669–1748), a history painter and a member of the Academy. Lancret himself studied briefly at the Academy, but having failed in a bid to win the Prix de Rome in 1711, he gave up history painting and followed Watteau into the studio of Claude Gillot, a painter of picturesque scenes from contemporary life and the theater. With Watteau's encouragement, Lancret began to create his own compositions. He was received into the Academy in 1718 as a painter of *fêtes galantes*, a genre which had been accepted by the Academy only one year earlier in recognition of the talent of Watteau. Lancret's ability soon attracted the patronage of connoisseurs like Mariette, Julienne, and Crozat, and with the passing of both Watteau (in 1721) and Gillot (in 1722), he became the leading artist in his field. By 1735 he received an honor never attained even by Watteau, a royal commission to decorate the Petits Appartements at Versailles. In addition to *fêtes galantes*, Lancret painted scenes inspired by the theater and the pastimes of genteel society. The grace and vivacity of his figures—engaged in concerts, games, and festive outdoor meals—derive from numerous drawings from life. The immediacy and involvement of these figure studies distinguish them from the remote, pastoral figures in Watteau's poetic reveries. Compared to Watteau and Pater, Lancret's preference for warm, strong color is balanced by the brilliant, glancing accents in draperies and the subtle airiness of foliage. His painting gave lyrical expression to the elegant, leisurely life of his time. His was an ephemeral style that virtually disappeared after his death.

34 *Declaration of Love* 44.86

Canvas, 80.1 x 64.3 cm.

Collections: William Sharp Ogden, Finchley (sale: Christie's, December 6, 1927, no. 50); [Wildenstein & Co., New York]; Elisabeth Severance Prentiss, Cleveland, 1928.

Elisabeth Severance Prentiss, Cleveland, 1944.

The painting was cleaned and relined at the Museum in 1976. An X radiograph (Figure 34a) shows two bust-length portraits beneath the present painting: one of a female oriented in the same direction as the present picture; the other of a male figure upside down, executed in an oval format which is not centered with respect to the present canvas. There is moderate abrasion in the foliage and along a previously overpainted, arching line in the upper right. The arching line seems related to the oval format of the underlying portrait of a male, which may be the earliest composition. A very dark layer, which is visible through the marked abrasion in the drapery of the central female figure, may also be related to the portrait of the male. Despite the underlying

Figure 34a. X radiograph showing underpainting.

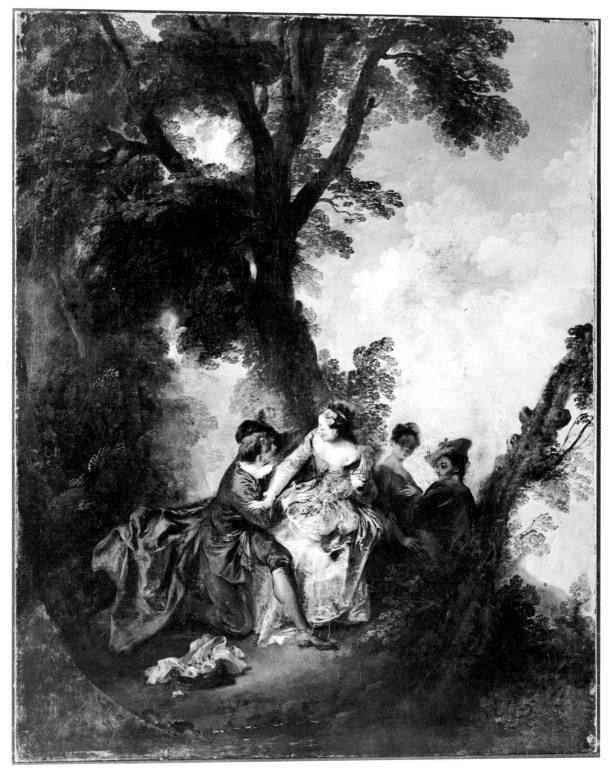

Figure 34.

portraits and the painting's present condition, the stylistic evidence of the uppermost design layer tends to support a Lancret attribution.

This picture, which fits into a relatively large group of *conversations galantes* by Lancret, seems to relate to an early version of the same subject which served as the artist's presentation piece when he was admitted to the Academy in 1718. The earlier work is known through an engraving by Jacques-Philippe Le Bas (1707–1783), whose own admission to the Academy—in 1743, the year of Lancret's death—was by virtue of his engraving after Lancret's painting. Lancret's *Conversation Galante* of 1718 is probably the one now in The Wallace Collection, London (Figure 34*b*); an eighteenth-century commentary, however, cites conflicting measurements for the painting that inspired Le Bas's engraving (*Wallace Collection Catalogues: Pictures and Drawings*, London, 1928, no. 422, p. 150; and Georges Wildenstein, *Lancret*, Paris, 1924, cat. nos. 284 and 285, p. 90). The central pair of figures in the Wallace Collection painting, the *commedia* characters Gilles and Colombine, are similar to the couple in the foreground of the Cleveland picture. The slight variation in vantage point and gesture is a subtle and knowing adaptation to the differences of setting. In the Wallace painting, Colombine rises from her seat with a look of surprise, perhaps in reaction to one of Gilles's pranks. Her response is mild, vaguely theatrical, and attracts the attention of only one character in the tableau. In the *Declaration of Love* the lady reacts more strongly, twisting away from her suitor and rejecting his advances with one upraised hand. Whatever the exchange may have been, it has clearly attracted the attention of their companions, who sit a little way off. The tone of the narrative has moved away from the poetic, Watteau-like quality of the Wallace painting toward the immediacy of an observed incident—one that nevertheless still possesses considerable refinement. This development of the theme, as well as the more strikingly illusionistic light which breaks through the foliage of the trees, suggests that the Cleveland picture followed the Wallace painting. The clearly stage-like setting of both scenes is a common conceit in *galante* subjects, but a more spirited play of light and shadow enlivens the Cleveland picture. The two works seem to be similar in technique: their affinity is particularly noticeable in the highlights of the drapery, where rather dry, delicate brushwork is laid on in lines that are alternately dashing and sinuous.

A chronology is difficult to establish in the oeuvre of Lancret. Because of the relationship between the Cleveland painting and the Wallace *Conversation Galante* of 1718, and because the artist used a second-hand canvas (an indication he was still struggling for the success he was later to enjoy), we may postulate a date early in his career, but later than 1718. WST

EXHIBITIONS: CMA (1934); CMA, 1944: Exhibition of the Elisabeth Severance Prentiss Collection, cat. no. 8, p. 25, color frontispiece; Columbus (Ohio) Gallery of Fine Arts, 1949: Hats in History, cat. no. 6; Montreal Museum of Fine Arts, 1950: The Eighteenth-Century Art of France and England, cat. no. 28, p. 11; University of Michigan Museum of Art (Ann Arbor) and Grand Rapids (Michigan) Art Gallery, 1951/52: Italian, Spanish, and French Paintings of the 17th and 18th Centuries, cat. no. 35, frontispiece; Cedar Rapids, Iowa, 1952: Centennial Exhibition, cat. no. 10, illus.; West Palm Beach, Florida, Society of the Four Arts, 1952/53: Eighteenth-Century Masterpieces, cat. no. 13; Richmond, Virginia, Museum of Fine Arts, 1956: Les Fêtes Galantes (no catalogue); CMA (1956), cat. no. 21, p. 25; Baltimore Museum of Art, 1959: Age of Elegance: The Rococo and Its Effect, cat. no. 18, illus. p. 47.

LITERATURE: "Recent Important Acquisitions of American Collections," *Art Quarterly*, VII, no. 3 (1944), 223–25, illus. p. 222; CMA *Bulletin*, XXXI (1944), 89, color cover; *Art News*, XLIII (October 1, 1944), color cover; Rémy G. Saisselin, "The Rococo as a Dream of Happiness," *Journal of Aesthetics and Art Criticism*, XIX (Winter 1960), illus. p. 150, fig. 2.

Figure 34*b*. *Conversation Galante*. On canvas, 74 x 58 cm. Lancret. Reproduced by permission of the Trustees, The Wallace Collection, London.

35A	*The Gardener*	48.176
	Canvas, 151.1 x 36.8 cm.	
35B	*Horticulture*	48.177
	Canvas, 151.1 x 36.8 cm.	
35C	*The Vintage*	48.178
	Canvas, 149.8 x 82.5 cm.	
35D	*The See-Saw*	48.179
	Canvas, 150.7 x 89.5 cm.	
35E	*The Swing*	48.180
	Canvas, 151.1 x 90.2 cm.	

Collections: Viscount Pierre de Chézelles; [Lord Duveen, London, by 1926]; Commodore and Mrs. Louis Dudley Beaumont, Cap d'Antibes, France, ca. 1935–36.
Gift of the Louis Dudley Beaumont Foundation, 1948.

There is less abrasion in *The Gardener* and *Horticulture* than in the other, larger canvases, which have been extensively abraded and overpainted to varying degrees, especially in the white backgrounds. The decorative designs in the larger canvases have also been reinforced. The skirt of the figure in *Horticulture* has been retouched, but the mauves and golds of the decorative designs, which are somewhat thin, have not been reinforced. There is some overall abrasion in *The Gardener* but very little reinforcement; of all the canvases, it shows the most delicacy of drawing and color. Tack holes around the overpainted edges of *The See-Saw* indicate that it may have been enlarged. *The Vintage* appears to have been cut down slightly, probably when it was lined.

These five paintings—originally part of a larger group—were the sort that decorated the salons of fashionable Parisian residences in the eighteenth century. Such ensembles were designed and executed for installation in a specific room and had to fit particular wall spaces between windows and doors, which accounts for the variation in sizes within the group. The ensemble in Cleveland is traditionally thought to have been installed in the house at 28, Place Royale (now Place des Vosges), Paris. The paintings may have been commissioned by a member of the family of the dukes of Melun, owners of the property from at least 1721

Left to right

Figure 35A.
Figure 35B.
Figure 35C.

Figure 35D.

Figure 35E.

(at the very beginning of Lancret's career) until 1763 (Lucien Lambeau, "La Place Royale, nouvelles contributions à son histoire," *Ville de Paris: Commission du Vieux Paris*, 1915, pp. 58, 62, and 66). The house was purchased in 1763 by Pierre-Nicolas Caulet d'Hauteville; it passed from his family, presumably by marriage, to the family of the viscounts Le Sellier de Chézelles. When the property was

again sold in 1826, the decorative ensemble was apparently removed from the building and stored at the home of the Vicomte de Chézelles, the Château du Boulleaume, Oise.

The group, it seems, dispersed early in this century. Wildenstein (*Lancret*, Paris, 1924, p. 120, nos. 738–41) records a series of four paintings called *The Four Seasons*, in the collection of Baron Edmond de Rothschild, Paris. These

paintings were subsequently in the collection of Mr. and Mrs. Deane Johnson, California (sale: Sotheby Parke Bernet, Inc., New York, December 9, 1972, lot no. 81, illus. pp. 97–100), and are now in a private collection in New York. Wildenstein (*op. cit.*, p. 120, no. 742) also mentioned five or six other paintings from the same decorative ensemble, then in the possession of the Chézelles family, which he described as smaller than the others in the group. Wildenstein was possibly referring to the Cleveland paintings, which at the time of his writing may well have been in the possession of the Chézelles family. Only two of the Cleveland paintings, however, are "smaller"; the others are very similar in size to the *Four Seasons* paintings.

Decorative ensembles became popular in France early in the eighteenth century. Each typically follows a theme such as the times of day or the seasons. The *Four Seasons* series seems to have been the core of the ensemble to which our paintings belong. The five Cleveland paintings are elaborations on the main theme, representing pastoral activities and games which in Lancret's work are commonly associated with the seasons. The bird and animal emblems that crown the decorative designs in the *Four Seasons* paintings and in the larger Cleveland paintings (*The Swing, The See-Saw,* and *The Vintage*) also seem related to the seasonal imagery, but specific meanings cannot be assigned to every element of the design.

Traditionally, the ensemble in Cleveland has been given to Lancret. Other artists also painted decorative ensembles of a similar kind: Claude Gillot, for example, the teacher of both Watteau and Lancret, executed several such series, as did Watteau, who in addition designed others. Only one of Watteau's series—that at the Château de Chantilly—survives intact. Dozens of his designs, however, were engraved and used as models by artists all over northern Europe throughout the eighteenth century. Only one group of arabesques can be definitely documented as Lancret's; these were originally installed in the Hôtel de Boullongne (Figure 35*a*) and are now at the Musée des Arts Décoratifs, Paris. Another group of six paintings, at the Metropolitan Museum of Art, was originally given to Lancret but subsequently attributed to a "follower of Watteau." No documentary evidence is known which clearly links the Cleveland group and *The Four Seasons* to Lancret, but such elements as color, facial types, figural poses, and treatment of foliage seem to support their attribution to him. W S T

Figure 35*a*. Decorative paintings from the Hôtel de Boullongne. On canvas, 300 x 59 cm, 300 x 80 cm, 300 x 57 cm. Lancret. Musée des Arts Décoratifs, Paris.

EXHIBITIONS: Detroit Institute of Arts, 1926: The Fourth Loan Exhibition of Old Masters, French Paintings of the Eighteenth Century, cat. nos. 32–33 (all five paintings); London, 25 Park Lane, 1933: Three French Reigns, Louis XIV, XV, XVI, cat. no. 82, p. 19 (*The See-Saw, The Vintage,* and *The Gardener* only).

LITERATURE: "A French Rococo Collection Goes to Cleveland," *Art News,* XLVII (September 1948), 29; Henry S. Francis, "A Gift of the Louis Dudley Beaumont Foundation," CMA *Bulletin,* XXXV (1948), 222, illus. 226–27; CMA *Handbook* (1978), illus. p. 175 (*The Swing* only).

NICOLAS DE LARGILLIERE
1656–1746

When Largillière was three his family moved their hatmaking business from Paris to Antwerp. In 1668 the young Largillière was apprenticed to Antoon Goubau (1616–1698), a painter of landscapes, genre, and altarpieces. Under Goubau's tutelage Largillière became especially proficient in still life. At the age of sixteen he was received into the Antwerp painter's guild. Largillière then went to London, where he entered the studio of Sir Peter Lely (1618–1680) and soon became a valued assistant. The death of Lely, the dispersal of his studio, and the persecution of Catholics forced him to leave England. In 1682 he settled in Paris. Largillière's reputation was built on his early successes with large history paintings which had been commissioned by the city of Paris—such as *The Delivery of Paris from Drought by Ste. Geneviève,* 1696 (Paris, St. Etienne-du-Mont), and *The Reception of Louis XIV at the Hôtel de Ville,* 1687 (destroyed; sketches are in the Louvre, Paris, and Musée de Picardie, Amiens). Portraiture still remained a specialty, but the secure position of Hyacinthe Rigaud as court portraitist led Largillière to seek commissions from the bourgeoisie and lesser nobility, a clientele to which his history paintings had introduced him. Late in life he was honored by the Academy, which appointed him rector in 1722 and director in 1738. His contemporaries praised him for his versatility (Pierre-Jean Mariette, *Abécédario,* Paris, 1854–56, III, 60–63); later, critics usually singled him out for his portraiture; and most recently, his accomplishments as a painter of history, landscape, and still life have been recognized (Françoise Maison and Pierre Rosenberg, "Largillierre—peintre d'histoire et paysagiste," *Revue du Louvre,* XXIII, 1973, 89–94). He was a prolific painter, having produced an estimated 1500 to 2000 works, the chronology of which still remains partially obscure. At least sixty engravings after Largillière's paintings have been published. Among his many students were Jean-Baptiste Oudry (see Painting 45) and Jacques van Schuppen (1670–1751).

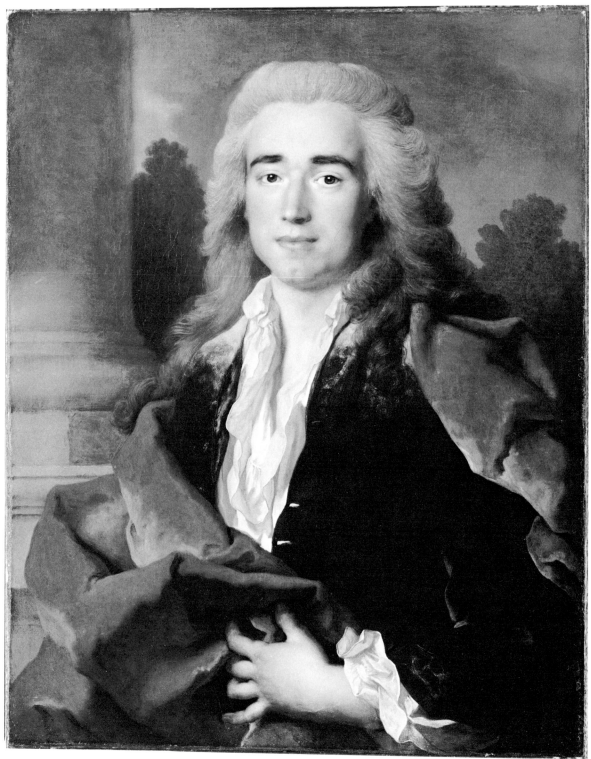

Figure 36.

36 *Portrait of Anne Louis* 70.31
Goislard de Montsabert,
Comte de Richebourg-le-Toureil

Canvas, 80.6 x 63.8 cm. Signed and dated on back of original
canvas: peint par/N de Largillierre/1734.

Collections: Anne Louis Goislard de Montsabert and the Montsa-
bert family, until ca. 1880; Comte André de Ganay; Charles Fair-
fax Murray; [Thomas Agnew & Sons, 1905]; Calouste S. Gulben-
kian, 1907; [Thomas Agnew & Sons, 1907]; Charles Fairfax Mur-
ray (sale: Galerie Georges Petit, Paris, June 15, 1914, to Bousquet);
[Cailleux, Paris, 1959–1966]; Ernest Kanzler, Detroit; [E. V.
Thaw, New York].

Mr. and Mrs. William H. Marlatt Fund, 1970.

The painting is in good condition. Minor losses along all
edges and small, scattered flake losses elsewhere have been
retouched. The support is lined with a wax-type adhesive
which is also in good condition. The signature and date
inscribed on the back of the original canvas are now con-
cealed by the lining. An early photograph of the inscription
(Figure 36a), when compared with the artist's known sig-
natures, indicates the signature is authentic.

The Comte de Richebourg-le-Toureil (1708–1780), a
lesser noble from the Angers area, is identified from an
inscription pasted to the back of the frame. The subject,
a member of a well-established family of lawyers, rose to
the first court of inquiry by 1757 and was advisor of the
Grande Chambre from 1762 to 1771. An enlightened and
curious man, his interests encompassed the arts, literature,
science, and philosophy, as well as law. He was a member
of the academies of Lyons and Angers and of the Bureau of
Agriculture of Angers. His appointment to the Parlement
de Paris in 1732 and his subsequent succession to the title
Lord of Montsabert in 1733 may have prompted the com-
mission for this portrait.

Largillière has focused on the sitter's personality rather
than on symbols of his achievement or status. The alert face
is strongly lighted, and the costume—though rich in color
—does not impose. There is a studied informality in such
details as the hair powder on his dark coat, and the open
shirt front, painted in the most delicate half-tones. The
artist used thin glazes to achieve depth and subtlety in the
shirt and in the flesh tones of the face and the heavy, yet
tensile, hands.

Largillière was a central figure in the development of the
informal portrait—so well exemplified by the Museum
painting—during the first half of the eighteenth century.
While his rival, Rigaud, usually represented his subjects
seated in formal court dress, surrounded by sumptuous
accessories, Largillière usually preferred informal dress, the
simpler and more intimate half-length format, and a mini-
mum of furnishings. The comte is typical of Largillière's
sitters, made lively by the artist's portrayals of engaging,
direct glances and his use of warm, fluidly modeled color.
 WST

Figure 36a. Detail showing inscription on back of canvas.

EXHIBITIONS: London, Thomas Agnew & Sons, 1905: Annual Exhibi-
tion, cat. no. 5; London, Burlington Fine Arts Club, 1913: French Art of
the Eighteenth Century, cat. no. 2; CMA, February 1971: Year in Review,
cat. no. 43, illus. p. 35.

LITERATURE: William S. Talbot, "Largillierre: *Comte de Richebourg-le-
Toureil*," CMA *Bulletin*, LVIII (1971), 2–9, illus. figs. 1, 4, and color
cover; CMA *Handbook* (1978), illus. p. 176.

GEORGES DE LA TOUR
1593–1652

La Tour was born in Vic-sur-Seille, close to the border of
Germany. A remarkable artist, he was virtually ignored
until the twentieth century; consequently, little is known of
his history and development. One of several children of
Jean de La Tour, a baker, he was, presumably, brought up
as a Catholic in a well-established, though undistinguished,
bourgeois family. It has been said that he left Vic in 1616;
Thuillier (*Georges de La Tour*, exh. cat., Paris, 1972, pp.
44, 61) and others have suggested that he went to the Neth-
erlands or Italy, but there is no documentation or early
work from this period to substantiate such claims. He is
first mentioned as a painter in 1617, in his marriage con-
tract with Diane Le Nerf (1591–1652), whose grandfather
had become a noble in 1555, and whose father was trea-
surer to the Duke of Lorraine. La Tour moved to his wife's
town of Lunéville, where he undoubtedly saw prospects of
both professional and personal advancement. He remained
there until his death in 1652. He was patronized by the
Duke of Lorraine in 1623–24. In 1639 he was appointed
Peintre du Roi. He is frequently mentioned in Lunéville
town documents of the 1620s and early 1630s. Between
1636 and 1642, however, such references are erratic, lead-
ing scholars to theorize that during this time he may have
traveled to the Netherlands, Paris, or Italy. Most scholars
believe that he must have seen the work of the Dutch lu-

minist painters or of Caravaggio in Rome, for his style reflects these influences. His son Etienne (1621–1692) worked in his studio and is probably responsible for some of the paintings now attributed to the elder La Tour. Etienne abruptly gave up painting after his father's death to become an inspector of property for the king; he was ennobled by Charles IV of Lorraine in 1670 for his efforts.

37 *The Repentant St. Peter* 51.454

Canvas, 114 x 95 cm. Signed and dated at upper right: Georg⁵ de La Tour Inve et Pinx 1645.

Collections: (Possibly) Alleyn's College of God's Gift, Dulwich, Surrey, until 1857; Reverend William Lucas Chafy, until 1878; family of Reverend Chafy, Bath, Somerset, until May 1951; [Marshall Spink, London]; [M. Knoedler & Co., New York].

Gift of Hanna Fund, 1951.

William Suhr cleaned the painting in 1960, at which time he also removed a later addition across the entire top of the canvas—a repainted fragment of another painting, measuring seven centimeters in height. When discolored varnish and repaint were removed, abrasions and breaks in the canvas along the left, right, and bottom edges, and abrasions in the garment of St. Peter and in the background were revealed. Suhr attenuated these losses and inpainted to minimize the strong crackle pattern, most disturbing in the face and hands.

This painting, along with others, and a cash gift were supposedly presented by Alleyn's College of God's Gift, Dulwich, to Reverend William Lucas Chafy upon his retirement in 1857, according to the present Mr. Chafy, the only surviving member of the Chafy family (letter of May 30, 1951, from C. Marshall Spink, dealer, to Charles R. Henschel of M. Knoedler & Co., New York). The painting is not listed in the Alleyn's College inventories—the Cartwright inventory of ca. 1686 or the Bourgeois manuscript of 1813—nor is there any painting of a like description in these inventories with another attribution (the names of Honthorst and Rembrandt are faintly discernible in red on the back of the old lining). The painting may never have been an official acquisition of the college, or it may have entered the Chafy family collection from another source.

Aside from its visual beauty, the Cleveland painting is of enormous importance in the study of Georges de La Tour's work, for it is one of only two dated paintings by the artist. The other, the *Denial of St. Peter*, in the Musée des Beaux-Arts in Nantes, dated 1650, is badly damaged, and art historians have suggested there was collaboration in its execution. Because both of these paintings are dated in La Tour's late period, they afford little help in the chronological ordering of the artist's previous oeuvre. Except for a brief reference to it by Blunt in 1949, the painting did not appear in the literature until 1950, when Vitale Bloch published his monograph on the artist. The painting has since

been generally accepted as the one sure point of reference on which to base a study of La Tour's oeuvre.

Establishing a chronology of the painter's works is a complicated task because of his tendency to repeat details or stylistic devices, with years elapsing between repetitions. The lantern in the Cleveland painting, for example, is the same as the one in the *St. Sebastian Tended by St. Irene* (one of ten versions after a lost original) in Kansas City, Nelson Gallery-Atkins Museum (Nicolson and Wright, 1974, fig. 100, no. 43D), which is generally dated ca. 1636 to 1638.

Spear (Exh: 1971/72) was the first to point out the significance of the vine leaf in the upper left of the canvas as a symbol of faithfulness (the biblical basis for the symbolism is found in John 15:5–6). Spear also suggested that the subtle, pitiful remorse epitomized in the figure of the weeping Peter reflects a direct influence from Caravaggio. Certainly there is empathy for the human condition which goes above and beyond the stylistic qualities and the use of light and color that La Tour may have derived from Northern paintings by Honthorst and others.

Nicolson and Wright (1972, pp. 44–45) compare St. Peter to the figure of Joseph in the poorly preserved *Adoration of the Shepherds* in the Louvre, noting particularly the similarity in treatment of the beards. They date the Louvre picture "1643(?)."

A copy of a lost *Penitent St. Peter* (107 x 85 cm), closely related to the Cleveland painting and probably from about the same date, has been in a French private collection for the last fifty years (Pariset, 1967, pp. 241–46, who first suggested it was the same subject as the Cleveland picture; Thuillier, 1973, no. 61, illus. p. 235; Nicolson and Wright, 1974, no. 36, p. 179, fig. 100). The clasped hands and the upper part of the figure are based directly on the Cleveland *St. Peter*. Nicolson and Wright suggested that the copy had perhaps been cut down, for the symbols of the saint—the cock and keys—are missing. The same lantern appears on the stone ledge, at the level of the clasped hands. N C W

EXHIBITIONS: CMA (1958), cat. no. 59, illus.; CMA, 1971/72: Caravaggio and His Followers, cat. no. 39, illus. p. 119 (catalogue by Richard E. Spear); Paris, Orangerie des Tuileries, 1972: Georges de La Tour, cat. no. 23, pp. 40, 43, 51, 77, 108, 111–12, 188, 190–93, 261, 263 (catalogue by Pierre Rosenberg and Jacques Thuillier).

LITERATURE: Anthony Blunt, review of S. M. M. Furness's *Georges de La Tour of Lorraine 1593–1652*, in *Burlington Magazine*, XCI (1949), 297; Vitale Bloch, *Georges de La Tour* (Amsterdam, 1950), no. 18, p. 53, pl. 18; François-Georges Pariset, "*Le Saint Pierre Repentant* de Georges de La Tour," *Arts*, no. 304 (1951), 1, 4, illus. p. 1; Charles Sterling, "Observations sur Georges de La Tour à propos d'un livre recent," *La Revue des Arts*, I (1951), 154, pl. 18; Henry S. Francis, "*The Repentant St. Peter* by Georges de La Tour," CMA *Bulletin*, XXXIX (1952), 174–77, illus. p. 170; Blunt, *Art and Architecture in France 1500 to 1700* (Harmondsworth, 1953), p. 178, no. 64 (second ed., 1970, p. 159); Pariset, "Mise au point provisoire sur Georges de La Tour," *Cahiers de Bordeaux, Journées Internationales d'Etudes d'Art* (1955), p. 87; F. Grossmann, "A Painting by Georges de La Tour in the Collection of Archduke Leopold Wilhelm," *Burlington Magazine*, C (1958), 90; Milliken (1958), illus. p.

Figure 37.

38; Pariset, "La Servante à la Puce," *Extrait du Pays Lorrain*, no. 3 (1958), 106, illus. pp. 105–6; Annette-Marie Bouvier, *Georges de La Tour, Peintre du Roy* (Paris, 1963), pp. 92–93; Pariset, "La Tour," *Enciclopedia Universale dell'Arte*, VIII (Venice, 1963), 544; Pariset, "Y à-t-il affinité entre l'art espagnol et Georges de La Tour?" *Velasquez, son temps, son influence, Actes du Colloque tenu à la Casa de Velasquez, December 7–10, 1960* (Paris, 1963), p. 62, pl. XXXVIIIa; Clifford S. Parker and Paul L. Grigaut, *Initiation à la culture française* (second ed., New York, 1963), p. 125, illus.; Jacques Thuillier and Albert Châtelet, *La Peinture française*, Vol. I: *De Fouquet à Poussin* (Geneva, 1963), pp. 184, 186; Pariset, *Encyclopedia of World Art*, IX (New York, London, and Toronto, 1964), 164; Alsop (1966), p. 23, illus. p. 29; Alsop, "Les Chefs-d'Oeuvre de première importance du second Musée des Etats-Unis," *Connaissance des Arts*, no. 172 (1966), 57, 60, color illus. p. 57, no. 4; Anna Otani Cavini, *Georges de La Tour*, I Maestri del colore, no. 140 (Milan, 1966), 4; *Selected Works* (1966), no. 155, illus.; Pariset, "L'Ermite à la lanterne et Georges de La Tour," *Hommage à Hans Haug, Cahiers Alsaciens d'Archéologie d'Art et d'Histoire*, XI (1967), 242–44, illus. p. 244; Ann Tzeutschler Lurie, "Gerard van Honthorst, *Samson and Delilah*," CMA *Bulletin*, LVI (1969), 340, 344 n. 26, fig. 13; Christopher Wright, "A Suggestion for Etienne de La Tour," *Burlington Magazine*, CXI, pt. 1 (1969), 296 (says incorrectly CMA painting is signed "George" de la Tour); Agnes Szigethi, *Georges de La Tour* (Budapest, 1971), fig. 44; Blunt, "Georges de La Tour at the Orangerie," *Burlington Magazine*, CXIV (1972), 520; Evelina Borea, "Considerazioni sulla mostra 'Caravaggio e i suoi seguaci' a Cleveland," *Bollettino d'Arte*, LVII (1972), 159; Cavini, "La Tour a l'Orangerie e il suo primo tempo Caravaggesco," *Paragone*, XXIII, pt. 2, no. 273 (1972), 20, n. 17; Jacques Paul Dauriac, "Zur Wiederentdeckung und Würdigung von Georges de La Tour," *Die Kunst und das Schöne Heim* (1972), p. 727; Julián Gállego, "Crónica de Paris: La Tour, Iluminado," *Goya*, no. 109 (1972), 37; Julius S. Held, "Caravaggio and His Followers," *Art in America*, LX (1972), 43, 45, illus.; Benedict Nicolson and Christopher Wright, "Georges de La Tour et la Grande-Bretagne," *La Revue du Louvre et des Musées de France*, XXII (1972), 135, 141, n. 1; Hidemichi Tanaka, "Observations sur l'Evolution stylistique de Georges de La Tour," *Evolution générale et développements régionaux en histoire de l'Art*, Actes du XXIIe Congrès International d'Histoire de l'Art, Budapest, 1969 (Budapest, 1972), II, 45–47, and III, pl. 271, no. 13; Ulysse Moussalli, *A la Recherche de Georges de La Tour* (Paris, 1972), pp. 66, 72, 75–76; Carlo Volpe, "Annotazioni sulla mostra Caravaggesca di Cleveland," *Paragone*, XXIII, no. 1 (1972), 69; Arnauld Brejon de Lavergnée and Jean-Pierre Cuzin, *I Caravaggeschi Francesi* (Rome, 1973), pp. 39–40; Everett Fahy and Sir Francis Watson, *The Wrightsman Collection* [Metropolitan Museum of Art], Vol. V: *Paintings, Drawings, Sculpture* (New York, 1973), p. 134; Gállego, "Actualidad de Georges de La Tour," *Goya*, no. 112 (1973), 206; Pierre Rosenberg and François Macé de l'Epinay, *Georges de La Tour, vie et oeuvre* (Paris, 1973), p. 158, illus. p. 159; François Solesmes, *Georges de La Tour* (Lausanne, 1973), pp. 111, 121, n. 1, 153, 162, illus. pp. 110 and 162; Thuillier, *Tout l'oeuvre peint de Georges de La Tour*, Classici dell'Arte, vol. 65 (Milan and Paris, 1973), 8, 95, no. 51, illus. p. 94, pls. XL and XLVII; Thuillier, "Georges de La Tour: un an après," *Revue de l'Art*, no. 20 (1973), 95, 99; Nicolson and Wright, *Georges de La Tour* (London, 1974), pp. 13, 15, 43, 49, no. 35, pls. 70 and 71, fig. 96; Henri Tribout de Morembert, "Considérations sur Georges de La Tour," *Gazette des Beaux-Arts*, LXXXIII (April 1974), 227, 230; *The Cleveland Museum of Art*, The Little Art Book, ed. Berthold Fricke (Hannover, 1975), p. 47, color illus. p. 46, fig. 20; Richard E. Spear, review of Nicolson and Wright, *Georges de La Tour*, in *Burlington Magazine*, CXVIII, pt. 1 (1976), 235; Mark Roskill, *What Is Art History?* (New York and London, 1977), p. 134, fig. 96; Wright, *Georges de La Tour* (New York, 1977), pp. 10, 16, pls. 38 and 39 (color); CMA *Handbook* (1978), illus. p. 171; Nicolson, *The International Caravaggesque Movement* (Oxford, 1979), p. 65; Lurie, "*The Weeping Heraclitus* by Hendrick Terbrugghen in The Cleveland Museum of Art," *Burlington Magazine*, CXXI (1979), 284, n. 29.

Attributed to MAURICE QUENTIN DE LA TOUR
1704–1788

This prominent French pastelist of the eighteenth century was born in St. Quentin in 1704. He went to Paris in 1723 and remained there until 1784, with the possible exceptions of a trip to London about 1724 and a trip to Holland in 1766. Little is known of his early work. From 1737 until 1773 he exhibited regularly at the Paris Salons. He became a member of the Royal Academy in 1746. In 1750 he met Mlle Marie Fel, a celebrated singer with the Paris Opera, with whom he had a poignant life-long romance. Among La Tour's sitters were members of the royal family, the nobility, and leading intellectuals such as D'Alembert, Voltaire, and Rousseau. He amassed great wealth as a portraitist, but gave a great deal of money to the poor. In 1778–79 he founded a drawing school in his native St. Quentin. He also established prizes for the Académie des Sciences, Arts et Belles-Lettres in Amiens. Toward the end of his painting career he became increasingly critical of his own work and often reworked his portraits, with a compulsive striving for perfection. He also experimented—with disastrous results—in the preservation of the very perishable medium of pastel, often using his own works. In 1784, in very poor health, he returned to St. Quentin, where he died in 1788.

38 *Portrait of a Man* 46.465

Pastel on gray paper, glued to board, and backed with canvas, 57 x 46 cm.

Collections: (sale: Mensing & Fils, Amsterdam, April 27, 1937, no. 239, illus.); [Arnold Seligmann & Rey, Paris]; Edward B. Greene, Cleveland, purchased from Seligmann in 1937.

Gift of Edward B. Greene, 1946.

This pastel is on blue-gray paper that has been glued to a paper backing and adhered to a thick pulp board. The back is disguised with canvas, which is nailed to an elaborate stretcher. Eventually, the paper will have to be removed from the backing. There is considerable abrasion, and there has been widespread restoration with pastel, which is now deeply rubbed in. A patched hole is evident between the bottom of the sitter's nose and his upper lip. In 1978 the pastel was examined by Anne Clapp at the Henry Francis Dupont Winterthur Museum Paper Conservation Laboratory. She reported (in a letter of June 16, 1978) that the pastel had been reworked considerably and that much of the background pastel is not original, for it extends over the edge tape that was added when the picture was remounted.

Maurice Quentin de La Tour was a prolific artist. His portraits are characterized by a facility of draftsmanship and an interest in the human as well as the physical attributes of the sitter. Although the Museum portrait appears

Figure 38.

Figure 39.

to be a typical example of a portrait by La Tour, its poor condition precludes any firm attribution to that master.

Unfortunately, the early history of the pastel is unknown, and the sitter has not been identified. NCW

EXHIBITIONS: None.

LITERATURE: Henry S. Francis, "Three Eighteenth-Century Pastel Portraits," CMA *Bulletin*, XXIV (1947), 213–15, illus. p. 236.

LE NAIN BROTHERS

There were three Le Nain Brothers, all born in Laon: Antoine (ca. 1588–1648), Louis (ca. 1593–1648), and Mathieu (1607–1677). Mathieu, the youngest, outlived his brothers, both of whom had a deep influence on him. In 1630 the three brothers were living and working together in Paris and were probably collaborating on paintings. Mathieu was more worldly than his brothers; he moved in court circles and participated in the king's civilian guard, in which he became "lieutenant de la compagnie bourgeoise du sieur du Ry" in 1633 (Jacques Thuillier, *Les Frères Le Nain*, exh. cat., Paris, 1978, p. 46). All three brothers became members of the Royal Academy in Paris at its founding in 1648. After the deaths of Antoine and Louis (both in 1648), Mathieu went on to follow the Northern painters of the Haarlem School and came indirectly under the influence of Caravaggio. His paintings have an elegance and a refinement that set them apart from the works of his brothers.

39 *Dance of the Boys and Girls* 57.489

Canvas, 92 x 120.2 cm.

Collections: Count Ottone Ponte di Scarnafigi of Sardinia (died in Paris in 1788); Count Louis de Seyssel, Turin; Salmon P. Halle, purchased from Count de Seyssel in 1916.

Gift of Mrs. Salmon P. Halle in Memory of Salmon Portland Halle, 1957.

The canvas is in generally satisfactory condition. There is moderate-to-marked abrasion throughout, especially in the sky and the thinly painted flesh tones. The painting was cleaned by Joseph Alvarez in 1962. It had been restored and retouched in the past to repair streaks caused, perhaps, by some liquid spilled on the paint surface. Infrared photographs taken in 1962 showed that the profile of the little girl, fifth from the left, had been completely obscured by painted-in hair. This was removed, and the original paint surface was found to be, for the most part, intact. Old, dark glazes from a former restoration were also removed from the clothes of the man in the foreground. Minimal retouching attenuated these minor losses. X radiographs taken in 1978 showed that the dimensions have not been greatly altered; the original tacking margins are missing, however.

A series of seven paintings of the same size was acquired by Count Ottone Ponte de Scarnafigi when he was the Sardinian ambassador to France between 1777 and 1788 (Valabrègue, 1904, p. 116). Later, when the paintings were in the de Seyssel collection in Turin, they were brought to the attention of Champfleury by his colleague Léon Lagrange. Champfleury (1865) briefly mentions the series, but he states incorrectly that there were only six paintings and that they were acquired from the sale of the Prince de Conti's collection. He may have been confused by a version of *The Family Repast* by Mathieu Le Nain which was formerly in the collection of the Prince de Conti and is now in The Toledo (Ohio) Museum of Art (see also the version in the Cleveland Museum, Painting 41). The series dispersed after being in the collection of Count Louis de Seyssel. Three paintings were exhibited at the Galerie Louis Sambon, Paris, in 1923; universally attributed to Mathieu, these are: *The Dancing Lesson* (Figure 39a), in the collection of Maurice Bérard, Paris; *The Trictrac Players*, in the Louvre, Paris; and *Interior Scene (Le Jardinier)* (illus. Fierens, 1933, pl. LXXXVII, as "collection hollandaise"). The other four, including the present painting, were sold to Salmon P. Halle of Cleveland in 1916 and are now in this Museum (see also Paintings 40A, B, and 41).

The *Dance of the Boys and Girls* in the Cleveland Museum is close in style and quality to *The Dancing Lesson* and *The Trictrac Players*, all dating from the period 1647–48. The year 1648 began a period of interruption for Mathieu because of the sudden death of his brothers, which might perhaps account for the unfinished state of our painting. Because the painting is unfinished, the musician(?) in

Figure 39a. *The Dancing Lesson*. On canvas, 95 x 120 cm. Mathieu Le Nain. Collection of Maurice Bérard, Paris.

the foreground has an unusual appearance; he would have been more subtly integrated into the composition had the painting been finished. The standing man at the right and the sky were left in the state of a sketch. The foliage in the upper corner was painted by a later hand.

Jacques Thuillier, on a visit to the Museum in 1971, suggested that the landscape is also unfinished and that perhaps the tree at the left was painted by a later hand. Thuillier (Exh: 1978) then wrote that this is the only painting from the Halle collection that is by the Le Nain Brothers; although it is unfinished, he said, it is of high quality. At the same time, he mentioned a third version of dancing children, also called the *Dance of the Boys and Girls*, whose present whereabouts is unknown (sale: Christie's, London, December 16, 1938, no. 7).

Blunt (1978) and Cuzin (1978) proposed that our painting and some others that have been traditionally given either to Mathieu or, more conservatively, to the three brothers are by an artist they call "Le Maître des Jeux," a Fleming working in Paris. NCW

EXHIBITIONS: CMA (1934); Toledo (Ohio) Museum of Art, 1947: The Brothers Le Nain, cat. no. 13, illus.; Musée de Bordeaux, 1966: La Peinture française dans les collections américaines, cat. no. 9, pl. 11; Paris, Grand Palais, 1978/79: Les Frères Le Nain, cat. no. 53, pp. 216, 254, 266–67, illus. (catalogue by Jacques Thuillier and Michel Laclotte).

LITERATURE: Jules Champfleury, "Documents positifs sur la vie des frères Le Nain," *Gazette des Beaux-Arts*, XIX (1865), 62; Antony Valabrègue, *Les Frères Le Nain* (Paris, 1904), pp. 116, 121, 122; Robert Clermont Witt, *Illustrated Catalogue of the Pictures by the Brothers Le Nain* (London, 1910), p. 33; Paul Jamot, "Sur les frères Le Nain," *Gazette des Beaux-Arts*, V (1922), 305; Jamot, "Sur quelques oeuvres de Louis et de Mathieu Le Nain," *Gazette des Beaux-Arts*, VII (1923), 33–35; Jamot, *Les Le Nain* (Paris, 1929), pp. 95, 122; Paul Fierens, *Les Le Nain*, Art et Artistes Français (Paris, 1933), p. 52, pl. XCIII; George Isarlo, "Les Trois Le Nain et leur suite," *La Renaissance*, XXI (May 1938), 34, 46, no. 101, fig. 44; Thomas Bodkin, "Chêfs-d'oeuvre perdus et retrouvés," *Bulletin de la Société Poussin*, no. 3 (May 1950), 26; Coe (1955), II, 69, no. 2, pl. XVI; CMA *Bulletin*, XLV (1958), 73, illus.; Anthony Blunt, "The Le Nain Exhibition at the Grand Palais, Paris: 'Le Nain Problems,'" *Burlington Magazine*, CXX (1978), 873; CMA *Handbook* (1978), illus. p. 171; Jean-Pierre Cuzin, "A Hypothesis Concerning the Le Nain Brothers," *Burlington Magazine*, CXX (1978), 875; H. Loyrette, "Les Frères Le Nain," *La Revue du Louvre et des Musées de France*, XXVIII (1978), 298, 300; Jacques Thuillier, "Le Nain: Leçons d'une exposition," *La Revue du Louvre et des Musées de France*, XXIX, no. 2 (1979), 163.

Contemporary of LE NAIN BROTHERS
Mid-seventeenth century

| 40A | *Vintage Scene* | 58.175 |
| 40B | *Dance of the Children* | 58.176 |

Canvas, 92 x 121 cm (40A) and 91.8 x 120.3 cm (40B).
Collections: Count Ottone Ponte de Scarnafigi of Sardinia (died in Paris, 1788); Count Louis de Seyssel, Turin; Salmon P. Halle, purchased from Count de Seyssel in 1916.
Gift of Mrs. Salmon P. Halle in Memory of Salmon Portland Halle, 1958.

Both paintings were partially cleaned in 1962 by Joseph Alvarez. Although there are scattered paint losses over both canvases, they are generally in satisfactory condition. There is moderate, temporary disfigurement due to uneven surface texture and the residue of yellowed varnish and surface grime. X radiographs taken of both paintings in 1978 indicate that although the original tacking margins are missing, the dimensions have not been greatly altered.

Valabrègue (1904) accepted these paintings without question as part of the series of seven paintings formerly in the de Seyssel collection (see discussion, Painting 39), all of which, he thought, were by the same hand. Later scholars, however, have not been able to accept the attribution of the entire set to the Le Nain Brothers, dismissing these two paintings—*Vintage Scene* and *Dance of the Children*—in particular as inferior in quality. The two paintings seem to be by the same artist, apparently an independent French artist who, like the Le Nains, was active in the mid-seventeenth century.

Little is known about the contemporaries of the Le Nains other than their names. Although one could make stylistic comparisons to the works of Jean Michelin, Thuillier dismissed that idea on the occasion of his visit to this Museum in 1971. He suggested an attribution to "Le Maître des Béguins," so called after the caps the children wear (Thuillier and Laclotte, Exh: 1978). Later, Thuillier (*ibid.*) suggested that the artist was a Fleming who worked in Paris around 1650 to 1660—one who had profited from his knowledge of the Le Nains' work. This opinion was seconded by Blunt (1978). NCW

EXHIBITIONS: Toledo (Ohio) Museum of Art, 1947: The Brothers Le Nain, cat. nos. 14 and 15, illus.; Paris, Grand Palais, 1978/79: Les Frères Le Nain, cat. nos. 69 and 70, pp. 254, 318–19, 321–22, 324, illus. p. 321 (catalogue by Jacques Thuillier and Michel Laclotte).

Figure 40A.

LITERATURE: Jules Champfleury, "Documents positifs sur la vie des frères Le Nain," *Gazette des Beaux-Arts*, XIX (1865), 62 (*Vintage Scene* only); Antony Valabrègue, *Les Frères Le Nain* (Paris, 1904), pp. 116, 120, 122–25, illus. opp. pp. 16 and 144; Robert Clermont Witt, *Illustrated Catalogue of the Pictures by the Brothers Le Nain* (London, 1910), p. 33; Paul Jamot, "Sur les frères Le Nain," *Gazette des Beaux-Arts*, V (1922), 305; Jamot, "Sur quelques oeuvres de Louis et de Mathieu Le Nain," *Gazette des Beaux-Arts*, VII (1923), 33–35, 39; Jens Thiis, "De tre brodre Le Nain, Notater ag iagttagelser om deres Billeder," *Kunstmuseets Aar-skrift 1921–23* (Copenhagen, 1924), p. 301 (*Vintage Scene* only); Jamot, *Les Le Nain* (Paris, 1929), pp. 95, 122–23; W. R. Valentiner, "A Painting by Mathieu Le Nain," *Bulletin of The Detroit Institute of Arts*, X, no. 4 (January 1929), 49, n. 2 (*Dance of the Children* only); Paul Fierens, *Les Le Nain*, Art et Artistes Français (Paris, 1933), pp. 48–53, p. XCIV; Louis Carré, ed., *Georges de La Tour and the Brothers Le Nain* (exh. cat., New York, 1936), mentioned with no. 20 (*Dance of the Children* only); George Isarlo, "Les Trois Le Nain et leur suite," *La Renaissance*, XXI (May 1938), 34, figs. 45 and 48; Coe (1955), II, 69, nos. 1 and 3; Anthony Blunt, "The Le Nain Exhibition at the Grand Palais, Paris: 'Le Nain Problems,'" *Burlington Magazine*, CXX (1978), 873; Jean-Pierre Cuzin, "A Hypothesis Concerning the Le Nain Brothers," *Burlington Magazine*, CXX (1978), 875; Jacques Thuillier, "Le Nain: Leçons d'une exposition," *La Revue du Louvre et des Musées de France*, XXIX, no. 2 (1979), 161–62.

Figure 40B.

Copy after LE NAIN BROTHERS

41 *The Family Repast* 58.174

Canvas, 92 x 120.5 cm.

Collections: Count Ottone Ponte di Scarnafigi of Sardinia (died in Paris in 1788); Count Louis de Seyssel, Turin; Salmon P. Halle, purchased from Count de Seyssel in 1916.

Gift of Mrs. Salmon P. Halle in Memory of Salmon Portland Halle, 1958.

The painting was cleaned by Joseph Alvarez in 1962. There has been extensive restoration and repainting, particularly in the heads and faces, in the floor, and in the wall at the right. There is some temporary disfigurement due to uneven surface texture, yellowed varnish, and surface grime. Although the original tacking margins are missing, the X radiographs taken in 1978 indicate that the canvas has not been greatly reduced. X radiographs also showed clearly that the heads of the two men had been entirely repainted because of extensive damage and that major restoration work had been done to the hands of the men, although the damage there was less severe.

There are at least six other versions of this subject. Most scholars agree that the original version is the painting in The Toledo (Ohio) Museum of Art (canvas, 82.5 x 109.2 cm; ex collections: Duc de Choiseul, 1772; Prince de Conti, 1777; Sollier, 1781; Prince de Soubise; Sir Audley Neeld; see Jacques Thuillier and Albert Châtelet, *French Painting from Le Nain to Fragonard*, Geneva, 1964, p. 20; see also *The Toledo Museum of Art, European Paintings*, Toledo, Ohio, 1976, p. 95). Thuillier (*op. cit.*) thinks the Toledo picture is a family portrait, dated ca. 1645 to 1648. It has been engraved as follows: first by C. Weisbrod in 1771 for a book on the collection of the Duc de Choiseul; and later, in 1862, by Pisan for Charles Blanc's *History of Painters*. Other engravings were made by Best-Hotelin Reguirs and Cousinet.

Figure 41.

Another version (George Isarlo, 1938, pl. 43), also of high quality, was formerly in the collection of the Poullain family (sold in 1780 to Lord Harberton; then to Paul Rosenberg; present whereabouts unknown). This painting varies from the Toledo picture only in small details, such as the physiognomy of the subjects, said to be the family who commissioned it (described by Lebrun in the catalogue of the sale: Paris[?], March 15, 1780, no. 103, "Le Nain").

Other versions are as follows: 1) formerly in the collection of Captain Pitts (exhibited Paris, Petit Palais, 1934: Le Nain, peintures, dessins, cat. no. 46); 2) formerly in the collection of Dr. Paul Müller, Paris (Robert Clermont Witt, 1910, pl. 29, as replica of the pictures in the collections of Count de Seyssel and Mme Kestner); 3) formerly in the collection of Mme Kestner (Witt, 1910, listed p. 28; Paul Jamot, 1929, p. 96, n. 1; Valabrègue, 1904, p. 117); and 4) presently in the collection of Henri Prarond, Abbéville (Valabrègue, 1904, p. 119; Witt, 1910, p. 29). In the latter version the valet at the left is not included.

The Cleveland replica closely follows the composition of the Toledo and Poullain paintings, but it varies in details: the hair styles, the fowl on the platter on the table, the inferior quality of the faces, and the differences in physiognomies. It was probably commissioned as a family portrait to follow the composition of the Toledo painting. Although accepted as the work of Mathieu Le Nain by earlier scholars such as Valabrègue and Jamot, it is now generally thought to be a copy. NCW

EXHIBITIONS: CMA (1934); Toledo (Ohio) Museum of Art, 1947: The Brothers Le Nain, cat. no. 12, illus.; Paris, Grand Palais, 1978/79: Les Frères Le Nain, cat. no. 68, pp. 254, 258, 300–301, illus. (catalogue by Jacques Thuillier and Michel Laclotte).

LITERATURE: Jules Champfleury, "Documents positifs sur la vie des frères Le Nain," *Gazette des Beaux-Arts*, XIX (1865), 62; Antony Valabrègue, *Les Frères Le Nain* (Paris, 1904), p. 51, n. 1, and pp. 116–19, 120, 125, illus. opp. p. 112; Robert Clermont Witt, *Illustrated Catalogue of the Pictures by the Brothers Le Nain* (London, 1910), p. 33; Paul Jamot, "Sur les frères Le Nain," *Gazette des Beaux-Arts*, V (1922), 305; Jamot, "Sur quelques oeuvres de Louis et de Mathieu Le Nain," *Gazette des Beaux-Arts*, VII (1923), 33–34, 36, 39; Jamot, *Les Le Nain* (Paris, 1929), pp. 95–96; W. R. Valentiner, "A Painting by Mathieu Le Nain," *Bulletin of The Detroit Institute of Arts*, X (1929), p. 49, n. 2; Paul Fierens, *Les Le Nain*, Art et Artistes Français (Paris, 1933), pp. 48–53, pl. LXXXVI (erroneously said to be in Holland, private collection); George Isarlo, "Les Trois Le Nain et leur suite," *La Renaissance*, XXI (May 1938), 26, 48, no. 113; Thomas Bodkin, "Chefs-d'oeuvre perdus et retrouvés," *Bulletin de la Societé Poussin*, no. 3 (May 1950), 26; Coe (1955), II, 69, no. 4; *The Toledo Museum of Art, European Paintings* (Toledo, Ohio, 1976), p. 95; Jean-Pierre Cuzin, "A Hypothesis Concerning the Le Nain Brothers," *Burlington Magazine*, CXX (1978), 875.

NICOLAS-BERNARD LEPICIE
1735–1784

Nicolas-Bernard Lépicié was the son of François-Bernard Lépicié, an engraver to the king and the permanent secretary of the Academy in Paris. Lépicié studied with Carle van Loo. In 1759 he received a second prize at the Academy and in 1764 became an *agréé* at the Academy. He exhibited regularly at the Salons beginning in 1765. In 1770 he became an adjunct professor and in 1777 a full professor. He had originally wanted to become a history painter, but his large and diversified oeuvre includes religious paintings, portraits, and many genre scenes showing the strong influence of minor, seventeenth-century Dutch masters. He died in 1784 at the age of forty-nine.

42 *Young Girl Reading* 64.288
 (La Liseuse or *L'Etude)*

> Canvas, 46.3 x 37.8 cm. Signed and dated at left center, at the edge: Lépicié/1769.
>
> Collections: [Cailleux, Paris, 1960]; Mr. and Mrs. Severance Millikin, Cleveland.
>
> Severance and Greta Millikin Collection, 1964.

Early restoration records for this painting are not available. X radiographs made during a preliminary examination in the Museum laboratory in 1978 confirmed that either extensive changes were made by the artist or the picture was painted on a canvas that had been previously worked. If the latter, the subject of the underlying composition cannot be clearly defined. There are a few scattered losses of ground paint layers, which have been filled and retouched. Abrasion is apparent in several areas, particularly in the sitter's hair and in the background; some of these areas have been retouched, as have been fissures in the chest area. Excess pressure when the painting was lined sometime in the past may account for the flattened and modified paint texture. The paint surface is somewhat disfigured by slightly yellowed varnish and residues of grime. There is no substantial change from the original size.

From 1769 until his death, Lépicié exhibited genre pictures in the Salon, many of them small scenes with a single figure. A young woman reading or studying was one of his favorite subjects. He would often paint two and even three versions of a particular scene (F. Ingersoll-Smouse, "Nicolas-Bernard Lépicié, III: Lépicié peintre de Genre," *Revue de l'Art*, XLVI, 1924, 124). The Museum painting may well have been one in such a series. A smaller version is in the Musée d'Amiens. A version having the same dimensions as our painting was exhibited at the Salon in 1769 (no. 127; see also Philippe Gaston-Dreyfuss, *Catalogue Raisonné de l'Oeuvre peint et dessiné de Nicolas-Bernard Lépicié, 1735–1784*, Paris, 1923, nos. 153 and 162, pp. 70–71).

Figure 42.

It is tempting to try to identify the painting in the Salon of 1769 as either the painting now in the Cleveland Museum or one of similar size called *Une Jeune Fille Lisant*, sold in Paris on January 25, 1779 (no. 64, measuring "17 x 14 pouces"). Unfortunately, there is no documentation to support either claim. With the exception of the enigmatic *Rien* ("nothing") in Denis Diderot's commentary (*Salons*, IV, Oxford, 1967, 101), there is no further mention or description of the painting to be found in any of the Salon commentaries or in the annotations of Gabriel de Saint-Aubin.

The antique lamp used as an inkwell in a pyx in the Museum painting also appears in Lépicié's *Woman Writing* (41 x 33 cm; ex collection: M. Meunié; sale: Charpentier, Paris, December 14, 1935, no. 80, illus.), which is similar in mood and decorative sophistication. N C W

EXHIBITIONS: None.

LITERATURE: None.

JEAN MARC NATTIER
1685–1766

Nattier's portraits were the epitome of the brilliant and elegant court life of Louis XV. For a quarter of a century Nattier was the favorite portraitist of Queen Maria Leszczyńska (daughter of the exiled king of Poland) and her daughters. Nattier's father, Marc Nattier, was a portrait painter and his mother, Marie Courtois, was a skillful miniature painter. He studied first with his parents and then with Jean-Baptiste Jouvenet. In 1703 he enrolled in the Royal Academy. In 1715 he was called to Amsterdam and The Hague to paint portraits for Peter the Great of Russia. When Peter invited him to come to St. Petersburg, Nattier declined and instead returned to Paris. He was received into the French Academy. From 1737 he exhibited regularly in the Paris Salons. He enjoyed the patronage of the Orléans family and the royal court. Following the example of Nicolas de Largillière (see Painting 36), Nattier helped revive the Fontainebleau tradition of the mythological presentation of court ladies. He tended to idealize his female sitters after the convention of the period, portraying them as flawless, healthy, and boneless. By 1754 this formula had run its course, and Nattier ultimately fell into disfavor. He died in Paris in 1766.

43 *Mme de Pompadour as Diana* 42.643

Canvas, 100.4 x 79.5 cm. Signed and dated on tree stump at left: Nattier P. x./1752.

Collections: Comte de Pimodan, Paris; Mme Dainhaut; [Wildenstein & Co., New York]; John L. Severance, Cleveland.

John L. Severance Collection, 1942.

The painting was cleaned by William Suhr in 1942. In 1962 the yellowed varnish was removed by Joseph Alvarez. The paint film is in generally good condition, although slightly abraded in the shadow parts. There is some damage in the cuff of the sitter's left sleeve, in the head of the leopard skin, and in the lower right corner; there are some minor losses in the head of the sitter.

When this painting was purchased by John L. Severance it was thought to be a portrait of Mme Henriette de France, one of the daughters of Louis XV and Queen Maria Leszczyńska. However, E. P. Richardson (1943), basing his opinion on Pierre de Nolhac's research, agreed with Nolhac and identified the sitter as Mme de Pompadour because of her very close resemblance to two portraits of Mme de Pompadour in France: one, dated 1748, in the museum of Saint-Omer; and the other (Richardson, 1943, fig. 6), a replica by Nattier, in Versailles. The Marquise de Pompadour—unquestionably the prime political influence in France for twenty years, but perhaps more successful as a patron of the arts—is represented with the attributes of Diana, the bow and quiver with arrows. (For a discussion of Mme de Pompadour as Diana, see *Livre-Journal de Lazare Duvaux, Marchand-bijoutier du roy, 1748–1758*, I, Paris, 1965, p. CXCI.)

Court ladies in the role of Diana undoubtedly were favorite subjects of Nattier. In another painting, a *Portrait of a Lady as Diana*, dated 1756 (now in the Metropolitan Museum of Art; see *A Catalogue of French Paintings XV-XVIII Centuries*, 1955, p. 122, illus.), he used the same landscape setting and tree stump, with the same bow, quiver and arrows, and leopard skin, adjusting the composition slightly to accommodate a different sitter. N C W

EXHIBITIONS: CMA (1934); CMA (1936), cat. no. 62, pl. IV; CMA, (1942), cat. no. 11, pl. VIII; New York, Wildenstein & Co., 1951: Jubilee Loan Exhibition 1901–51, Masterpieces from Museums and Private Collections, cat. no. 18; CMA (1963), cat. no. 54; London, Royal Academy of Arts, 1968: France in the Eighteenth Century, cat. no. 498.

LITERATURE: *Art Digest*, x (July 1936), illus. p. 7; Francis (1942), p. 135, illus. 131; Helen Comstock, "The John L. Severance Collection at Cleveland," *Connoisseur*, CXI (1943), 61; Edgar Preston Richardson, "*Madame Henriette de France*, by Nattier," *Art Quarterly*, VI (1943), 250–51, fig. 5, p. 255; *French XVIIIth-Century Paintings* (New York, 1948), p. v; Francis, "Two Portraits by Aved and Gros," CMA *Bulletin*, LI (1964), 198, fig. 2; Gordon C. Aymar, *The Art of Portrait Painting* (Philadelphia, 1967), p. 290, pl. 142; CMA *Handbook* (1978), illus. p. 179.

Figure 43.

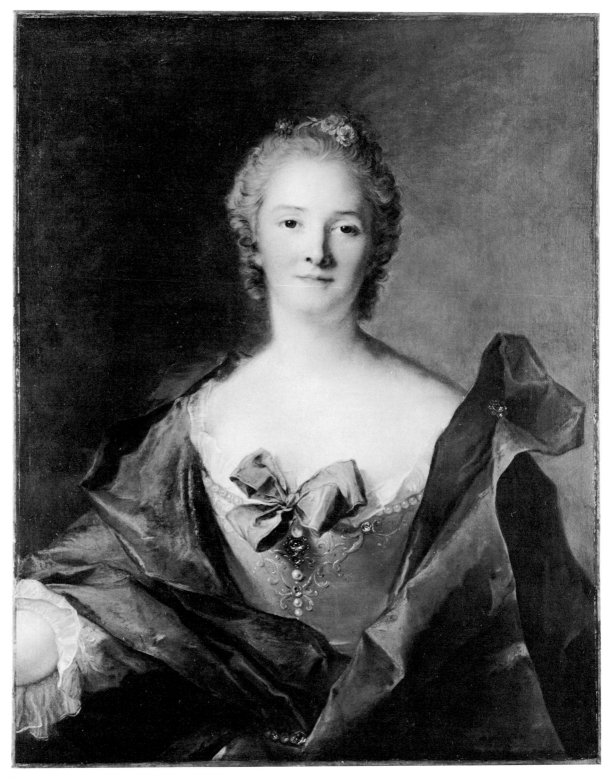

Figure 44.

JEAN MARC NATTIER

44 *Mlle de Savigny (?)* 48.183

Canvas, 81.9 x 64.9 cm.

Collections: (Possibly) Maurice de Talleyrand-Perigord, Duc de Dino, Paris; (possibly) Frederick H. Allen, Pelham Manor, New York; [Duveen Brothers, New York]; Commodore and Mrs. Louis Dudley Beaumont, Cap d'Antibes, France.

Gift of the Louis Dudley Beaumont Foundation, 1948.

The restoration history of this painting is not known. Originally, it may have been a larger portrait.

The provenance of the painting and the identity of the sitter were provided by Duveen Brothers for the Beaumonts when they purchased the painting before World War II. There is no documentation for any of the provenances prior to the Beaumonts' ownership or for the identity of the sitter.

Pierre de Nolhac, in his *J.-M. Nattier, peintre de la cour de Louis XV* (Paris, 1905, p. 150; second ed. rev., Paris, 1925, p. 267), listed a *Portrait of Mademoiselle Savigny (?)* of 1748 in the collection of Mme Livingstone Sampson, saying that it had been engraved after Nattier in *Cent chefs-d'oeuvres des collections parisiennes* published in Paris in 1888. In its edition on exhibitions for that year, the *Gazette des Beaux-Arts* (XXXVII, 1888, p. 513) offered the following information: "Cent chefs-d'oeuvres des collections parisiennes; par Albert Wolff. Cent tableaux des maîtres anciens et modernes gravés à l'eau-forte par MM. Boulard, Bracquemond. . . . In 4° colombier, III–126 p., Paris, imprimeries Motteroz; G. Petit et Baschet, éditeurs." There is, however, no record that such an exhibition actually took place. A catalogue by Albert Wolff, having the same title as the presumed exhibition, was published in 1883 (not in 1888), but it does not contain a portrait of Mlle de Savigny or any other portrait by Nattier.

In the second edition (revised) of his Nattier catalogue, Nolhac (*op. cit.*, p. 267) again listed the portrait of Mlle de Savigny, still with a question mark and still as dating from 1748 and belonging to Mme Livingstone Sampson. In the same edition (on p. 192) Nolhac suggested that a portrait of 1748—supposedly of Demoiselle Coraline, an actress of the Comédie Italienne—exhibited but not listed in the catalogue of the Salon of that year could in fact have been that of Mlle de Savigny. This portrait, he claims, was for a long time in the collection of the Marquis de Ganay. At the present time there is no documentation for either the Marquis de Ganay or Mme Livingstone Sampson provenances given by Nolhac.

The date 1748, which Nolhac ascribed to a portrait of Mlle de Savigny, seems plausible for the Cleveland painting if one compares it stylistically with other portraits that Nattier exhibited in the Salon of 1748. To those suggested by Nolhac—the portraits of Queen Marie Leszczyńska and her daughters Mmes Sophie and Louise (all three portraits are in the Musée de Versailles)—one may add the portraits

of two other princesses: *Mme Victoire*, painted in 1748 (Musée de Versailles), and *Mme Henriette*, painted in 1746 (formerly private collection, Paris).

Thieme-Becker (XXV, 1931, 357) incorrectly lists a portrait of Mme de Savigny as in the collection of The Metropolitan Museum of Art; this error was repeated in E. Bénézit's *Dictionnaire critique et documentaire des peintres, sculpteurs, dessinateurs et graveurs*, VI (Paris, 1953), 315.

<div align="right">NCW</div>

EXHIBITIONS: Columbus (Ohio) Gallery of Fine Arts, 1950: Twentieth-Anniversary Celebration, cat. no. 23; University of Michigan Museum of Art (Ann Arbor), Grand Rapids (Michigan) Art Gallery, 1951/52: Italian, Spanish, and French Paintings of the 17th and 18th Centuries, cat. no. 40; Tulsa, Oklahoma, Philbrook Art Center, 1953: 18th and 19th Century French Painting (no catalogue); Art Institute of Zanesville (Ohio), 1954: Masterpieces of Paintings Owned by Ohio Museums (no catalogue).

LITERATURE: Henry S. Francis, "A Gift of the Louis Dudley Beaumont Foundation," CMA *Bulletin*, XXXV (1948), 221–25, illus. p. 225; CMA *Handbook* (1978), illus. p. 179.

JEAN-BAPTISTE OUDRY
1686–1755

Oudry was born in Paris in 1686. He studied first with his father, Jacques, a painter and art dealer, and then at age seventeen or eighteen, briefly with Michel Serre (1658–1733). From around 1707 until 1712 he studied with Nicolas de Largillière. He entered the Academy of St. Luke in 1706, was received as a master in 1708, and was appointed professor in 1717. He was accepted into the Royal Academy in 1719 as a painter of "tous les talents," with *Abundance and Her Attributes* (Versailles, Grand Trianon) as his reception piece. Early in his career he concentrated on portraits; history and still life were secondary interests. During the 1720s he painted animal and hunt subjects almost exclusively. In 1724 he painted his first royal commission, *Meleager and Atalanta Hunting the Caledonian Boar* (Versailles, Hôtel de Ville), after which he enjoyed the lifelong patronage of the Superintendent of Royal Buildings. In 1726 he was nominated painter at the Beauvais tapestry factory. During the next decade he painted mostly tapestry designs, producing cartoons for such series as the *Amusements champêtres* and the *Chasses royales*, the latter based on a hunt scene commissioned by the king in 1728 (*Louis XV Hunting the Stag in the Forest of Saint-Germain*, Toulouse, Musée des Augustins). In 1734 he was appointed director of Beauvais; in that same year he established a free school for the training of tapestry designers. He became chief inspector of the Gobelins tapestry works in 1748, though he had by that time given up active designing. He was elected assistant professor at the Royal Academy in 1739 and in 1743 became a professor. Among his patrons was Count

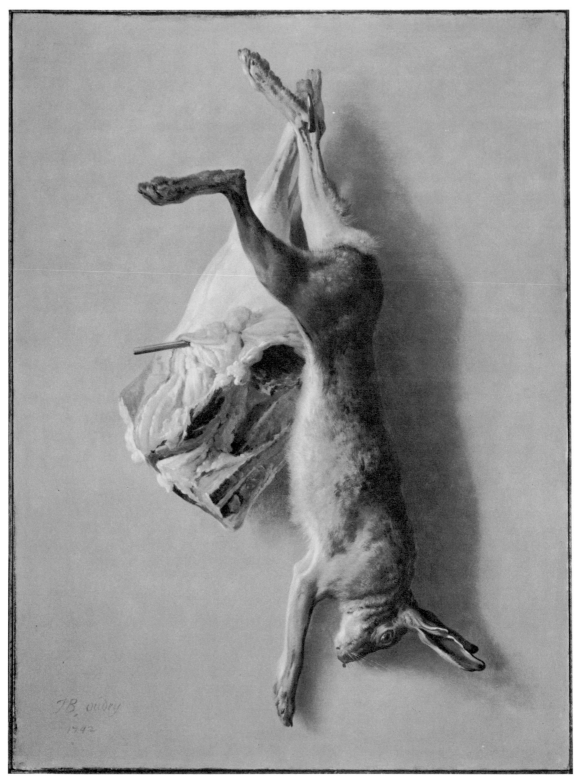

Figure 45.

Tessin of Sweden, who was acquiring pictures for the Swedish royal palace and through whom Oudry also received commissions from the king of Denmark and from Duke Christian II Ludwig of Mecklenberg-Schwerin, his most important patron after the French crown. After the death of Alexandre-François Desportes (1666–1743), Oudry was unrivaled as an animal painter. He was extremely prolific; Opperman (1977) catalogued over 650 paintings and 1,100 drawings, as well as engravings and etchings. Oudry's son Jacques-Charles (1723–1770) painted still lifes in his father's style, as did Henri-Horace Roland de la Porte (1725–1793). Oudry died in Beauvais in 1755.

45 Hare and Leg of Lamb 69.53

Canvas, 98.1 x 73.3 cm. Signed and dated at lower left: J. B. Oudry/ 1742.

Collections: M. de Vaize and the de Vaize family, until at least 1956; (sale: Paris, Galerie Charpentier, December 15–16, 1958, no. 64, as Le Lièvre, the meat as "un quartier de venaison," illus. pl. XI); (sale: Paris, Palais Galliera, December 4, 1963, no. 200, to Cailleux); private collection, New York; [Eugene V. Thaw, New York].

John L. Severance Fund, 1969.

Although the paint layer is quite thin, the painting is in excellent condition. The original canvas has been lined with a fiberglass fabric using a wax-type adhesive. Scattered minor losses have been retouched. There is evidence of old stretcher creases.

Commissioned by M. de Vaize, probably as an overmantel painting to be set into the paneling of a dining room, this painting is a *provision de cuisine* depicting food awaiting the cooking pot rather than a meal ready for eating. Dead-game still lifes were quite popular in the first half of the eighteenth century, but the particular intensity of this picture may be related to the Paris famine of 1740–41. In the Cleveland picture Oudry brought the subject to the peak of dramatic illusionism with such trompe-l'oeil, hyperrealistic details as the gleaming folds of white fat in the leg of lamb and the furry pelt of the hare. The precise rendering of the latter was probably based on the technique of Jan Weenix (1640–1719). The compelling realism is greatly heightened by the drop of blood on the animal's nose.

Unlike Oudry's earlier still lifes of the 1720s that were in the Flemish tradition of opulent diversity, his later still lifes are greatly simplified renderings with only a few objects placed against a neutral background. In the Museum picture the hare and lamb create a credible shadow against the stark wall. Paintings such as this explain the acclaim for Oudry's realism; one of his contemporaries wrote that one must touch a painting by him to see that it is not real ("Ode à M. Oudry, peintre du Roi," *Mercure de France*, December 1749).

Opperman lists a related chalk drawing (1977, cat. no. D1001), which Ph. de Chennevières ("Une collection de dessins d'artistes français," *L'Artiste*, n.s., XII, 1896, 180) said is dated 1743, one year after the Museum oil. WST

EXHIBITIONS: Paris, Salon of 1742, cat. no. 35; Paris, Musée de l'Orangerie des Tuileries, 1956: Le Cabinet de l'Amateur, cat. no. 81 (as *Lièvre et Quartier de Venaison*); CMA, January 1970: Year in Review, cat. no. 146, illus. p. 18; CMA, 1979: Chardin and the Still-Life Tradition in France, cat. no. 5, color illus. (catalogue by Gabriel P. Weisberg, with William S. Talbot).

LITERATURE: Jean Locquin, *Catalogue Raisonné de L'Oeuvre de Jean-Baptiste Oudry, Peintre du Roi* (Paris, 1912), no. 74 (as *Provisions de cuisine*); Michel Faré, *La Nature Morte en France* (Geneva, 1962), I, 142, 213; L. Dussieux, E. Souliè, Ph. de Chennevières, Paul Mantz, and A. de Montaiglon, eds., *Mémoires inédits sur la vie et les ouvrages des membres de l'Académie Royale de Peinture et de Sculpture* (reprint ed., Paris, 1968), II, 388; William S. Talbot, "Jean-Baptiste Oudry: *Hare and Leg of Lamb*," CMA *Bulletin*, LVII (1970), 149–59, illus. pp. 149 and 155 (color); Carol C. Clark, "Jean-Baptiste Siméon Chardin: *Still Life with Herring*," CMA *Bulletin*, LXI (1974), 309, 313, n. 1, fig. 1; Michel and Fabrice Faré, *La Vie Silencieuse en France—La Nature Morte au XVIIIᵉ siècle* (Fribourg, 1976), p. 125, color illus. p. 121; Hal N. Opperman, *Jean-Baptiste Oudry* (New York, 1977), I, 120, 189, 552, no. P509, and II, 839, 945, 1116, fig. 288; CMA *Handbook* (1978), illus. p. 178.

JEAN-BAPTISTE PATER
1695–1736

Pater was born in Valenciennes in 1695. His father was a sculptor and a friend of Antoine Watteau, a fellow townsman. As a youth and again just before Watteau's death in 1721, Pater was a pupil of that great painter. After Watteau's death, Pater's personal knowledge of the master's style and his access to many of Watteau's original drawings enabled him to become the most important painter of Watteau-like *fêtes galantes*, rivaled only by Lancret. Though he borrowed many themes from Watteau, Pater painted with a broader touch and less subtle sensibility. He copied himself endlessly. His figures, painted with sharp blues and irridescent roses, became modishly costumed flirts, totally given over to the pursuit of earthly pleasure, but lacking the combination of scintillating color, stately movement, and grave introspection that elevates Watteau's revelers above the common lot. Though Pater's feathery backgrounds are graceful, they lack the solidity and spatial conviction found in Watteau's compositions. Nevertheless, Pater's fame approached that of Watteau in the eighteenth century. A large number of his pictures—including the Museum's *Minuet in a Pavilion*—were acquired by Frederick the Great. Pater became a full member of the Royal Academy in 1728. He died in Paris in 1736.

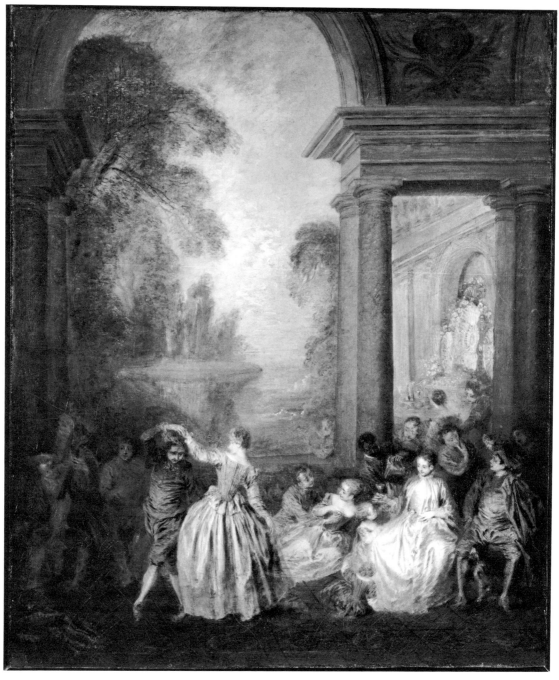

Figure 46.

Canvas, 55.3 x 47 cm.

Collections: Frederick the Great (1712–1786), Palace Sans-Souci, Potsdam, probably by 1773; German imperial family, until 1926; [Joseph Duveen, by 1931]; Commodore and Mrs. Louis Dudley Beaumont, Cap d'Antibes, France.

Gift of Commodore Louis D. Beaumont, 1938.

The painting was cleaned and relined at the Museum in 1977. There are pentimenti in the raised arms of the dancing couple and in the profile of the figure at the far right in the column and lintel opening. The paint has been generally abraded throughout by previous cleanings, which makes the delicate brushwork appear broader. An old lining canvas was inscribed "M 1696," the number given the painting in the inventory (begun in 1824) of furnishings in the Berlin State Palace, where the picture was called *Gesellschaft mit Tanz (Party with Dancing)* (letter of March 3, 1977, from the Verwaltung der Staatlichen Schlösser und Gärten). On the back of the frame there is a partly legible, four-digit number, beginning with "53"—possibly 5300, a number that appears in the 1883 general catalogue of pictures in Prussian castles. If our picture is no. 5300 from that catalogue, then it was at one time in the New Palace.

This is probably the painting that Oesterreich (1773) called *L'Agrément du Bal*, with an attribution to Watteau. *Une agréable conversation*, which Oesterreich (1773, no. 545) thought to be its pendant, was later justifiably attributed to Pater by Ingersoll-Smouse (1928, no. 6); this painting, now in the collection of Stichting Huis Doorn, bears the Berlin State Palace inventory number "M 1693."

Correspondence between Frederick the Great and his Paris agent, Count von Rothenburg, reveals that Frederick desired a pair of Watteau pictures but was unwilling to pay the high prices asked for them. His eagerness for the work of Watteau and his appreciation of musical subjects would have made the Watteau-like Cleveland picture very appealing to him.

Called *Der Tanz in der Gartenhalle*, the Cleveland painting was published as Watteau by Seidel (1900, 1905, and 1912), who (in 1905) called it an undoubted Watteau variant of *Les Plaisirs du Bal*, now at Dulwich College in England. Foerster (1923) also attributed the painting to Watteau and located it in the New Palace, Potsdam. It probably remained in Potsdam until it was acquired by Duveen before 1931.

Ingersoll-Smouse (1928) said that the Cleveland picture had been in Potsdam, and she attributed it to Pater. She also mentioned two earlier attributions which cannot be verified, one to Pater by Hübner and another to Antoine Pesne (1683–1757). She thought the picture might possibly have been begun by Watteau and, after his death, completed by Pater. Recent technical examination, however, revealed no inconsistencies in technique that would suggest more than a single hand. Ingersoll-Smouse (1928,

no. 6) proposed that *Les Comédiens Italiens* is the pendant to the Cleveland picture. She noted that the dancing couple in our painting also appears in *La Danse* (1928, no. 241A).

In addition to Seidel and Foerster, many other scholars have agreed with a Watteau attribution, including Staley (1902), Réau (1928), Valentiner (1931, where he calls it late Watteau), Francis (1939), Jaffé (1963), and Francis Watson (orally during a visit to the Museum in 1966, before the painting's 1977 cleaning). The picture, however, does not appear in the 1875 Watteau catalogue by Goncourt, nor was it accepted by X. Zimmerman or H. Adhémar in their Watteau catalogues of 1912 and 1950. Donald Posner (letter of September 29, 1977) also rejected Watteau's authorship.

While there are several passages of coloristic delicacy in the Cleveland picture—the broken color on the gown of the seated woman to the right and in the costume of the male dancer—its highlights are broader and more regular than Watteau's. The figures generally lack Watteau's assured drawing, particularly in the hands and faces, and they do not have the expected psychological depth. The source of the architectural setting is Watteau's Dulwich picture, but spatial relations between figures and architecture and among architectural elements lack his conviction. Pater is known to have painted two or three imitations of the Dulwich picture (as did Lancret also). One, in The Wallace Collection (P 420, attributed to Pater), closely follows Watteau's Dulwich composition, but its touch is broader and its highlights more restrained. The Cleveland picture is closer stylistically to the Wallace picture, not quite reaching the nervous brilliance of the Dulwich canvas. An attribution to Pater, therefore, seems most appropriate.

The royal arms of France, which appear in the upper right, undoubtedly increased the picture's desirability, but to present knowledge they do not relate to its subject or to its early history. WST

EXHIBITIONS: Berlin, 1883: Ausstellung von Gemälden älterer Meister im Berliner Privatbesitz., cat. no. 41 (as Watteau); Cambridge, Massachusetts, Fogg Art Museum, 1931: French XVIII-Century Art (as Watteau; no catalogue); London, 25 Park Lane, 1933: Three French Reigns, Louis XIV, XV, and XVI, cat. no. 101 (as Watteau), lent by Lord Duveen; New York, World's Fair, 1940: Masterpieces of Art, *Catalogue of European and American Paintings 1500–1900*, no. 211, illus. p. 145 (as Watteau); Pittsburgh, Carnegie Institute, 1951: French Painting, 1100–1900, cat. no. 77, illus. (as Watteau); Minneapolis Institute of Arts, 1954: 18th-Century French Painting (not in cat.); Art Institute of Chicago, 1955: Great French Paintings—An Exhibition in Memory of Chauncey McCormick, cat. no. 39, pl. 39 (as Watteau); Baltimore Museum of Art, 1959: Age of Elegance, The Rococo and Its Effect, cat. no. 33, illus. p. 44 (as Watteau); Seattle, World's Fair, 1962: Masterpieces of Art, cat. no. 34, illus. p. 83 (as Watteau).

LITERATURE: Matthieu Oesterreich, *Description de tout l'intérieur des deux palais de Sans-Souci, de ceux de Potsdam et de Charlottenbourg* (Potsdam, 1773), p. 107, no. 543; Paul Seidel, ed., *Französische Kunstwerke des XVIII Jahrhunderts im Besitze Seiner Majestät des Deutschen*

Kaisers (Berlin, 1900), p. 144, no. 153 (as Watteau, *Der Tanz in der Gartenhalle*); Edgcumbe Staley, *Watteau and His School* (London, 1902), p. 136; Seidel, ed., *Gemälde Alter Meister im Besitze Seiner Majestät des Deutschen Kaisers und Königs von Preussen* (Berlin, 1905–06), p. 138, illus. (as Watteau); Seidel, *Friedrich der Grosse und die französische Malerei seiner Zeit* (Berlin and Leipzig, 1912), illus. p. 41 (as Watteau); C. F. Foerster, *Das Neue Palais bei Potsdam* (1923), p. 61 (as Watteau); Florence Ingersoll-Smouse, *Pater* (Paris, 1928), p. 55, no. 241; Louis Réau, "Watteau," *Les Peintres Français du XVIII^e Siècle*, ed. Louis Dimier (Paris and Brussels, 1928), I, 40, no. 111 (as Watteau); *Fogg Art Museum Notes*, II, no. 6 (June 1931), 310, fig. 1; W. R. Valentiner, Ludwig Burchard, and Alfred Scharf, *Unknown Masterpieces* (New York, 1931) I, 77 (as Watteau); Henry Francis, "*La Danse dans un Pavillon* by Jean Antoine Watteau," CMA *Bulletin*, XXVI (1939), 16–17, illus. p. 14 and cover; *Duveen Pictures in Public Collections of America* (New York, 1941), no. 239, illus.; Michael Jaffé, "The Cleveland Museum of Art: The Figurative Arts of the West ca. 1400–1800," *Apollo* LXVIII (December 1963), 457 (as Watteau); Jean Ferré, ed., *Watteau* (Madrid, 1972), II, pl. 512, and III, 1073, no. P62 (as pastiche of Watteau); CMA *Handbook* (1978), illus. p. 176.

JEAN-BAPTISTE PATER

47A Spring (Le Printemps) 51.486

Oval canvas, mounted on masonite, 64.9 x 53.7 cm overall.
Central oval scene: 64 x 47.5 cm.

47B Summer (L'Été) 52.540

Oval canvas, 65.3 x 53.5 cm overall. Central oval scene:
63 x 51 cm.

Collections: Duc de Choiseul et Mantachef; [Wildenstein, Paris]; Henry G. Dalton, Cleveland; Harry E. Kendrick, Cleveland.

Gift of Harry D. Kendrick, 1951 and 1952.

The two landscapes were originally surrounded by a floral background, as in a decorative panel or screen. Later, the scenes and some adjacent floral pattern were cut from a larger canvas to an oval shape, which apparently proved to be too narrow. Strips cut from the original painting were then added at the sides to make the ovals wider, perhaps to fit an existing frame, and the landscape composition was extended to cover the floral design. The overpaint was removed in 1967, revealing the heavily abraded floral design. There is substantial abrasion at the right, left, and bottom edges of *Summer*, but the central oval scenes of both paintings are in generally good condition. The original canvases and added strips are mounted on canvas (*Summer*) and masonite (*Spring*). Both are attached to oval stretchers.

According to Ingersoll-Smouse (1928, nos. 578 and 579), the Museum's paintings are part of a set representing the four seasons, painted perhaps for a screen. *Autumn* and *Winter* (Figures 47a and b) are presently in the Cambó collection, Barcelona, having passed from Wildenstein to Edwin Bayer, New York (see also Francisco Javier Sánchez-Cantón, *La colección Cambó*, Barcelona, 1955,

p. 102). It is possible that these four paintings, attributed by Ingersoll-Smouse to Pater, may not all be by the same hand. The style of the figures and their placement within a setting made spatially convincing by powerful perspective relates *Spring* and *Winter*, while the figure style, genre subject matter, spatial effect, and background motifs of *Summer* and *Autumn* are similar. The woman being pushed on a sled in the foreground of *Winter* is also found in a Watteau composition known through an eighteenth-century engraving (Emile Dacier and Albert Vuaflart, *Jean de Jullienne et les Graveurs de Watteau*, Paris, 1922, III, no. 71), whereas the setting and the skating figures are reminiscent of another Watteau composition (*ibid.*, no. 142). There are, in addition, two rectangular paintings in Angers that are similar in size and quite close in content to *Winter* and *Spring*; they have been questionably attributed to Lancret but are derived from Pater by a much lesser hand.

Closely related to the Museum's *Spring* are two other works listed by Ingersoll-Smouse: one is a similar representation that is part of a four-leaf screen with ovals of the four seasons (Ingersoll-Smouse, 1928, nos. 574–77); the other is a single oval (no. 583) of a walkway, with two gardeners raking and two strolling couples. The latter painting was once attributed to Watteau, but Ingersoll-Smouse attributed it to Pater as a variant of a portion (no. 574) of the four-leaf screen. Its graceless stiffness, however, suggests it is a copy.

A related drawing by Watteau (Figure 47c) in The Hermitage, Leningrad (no. 11855; K. T. Parker and J. Mathey, *A. Watteau, Catalogue complet de son oeuvre dessiné*, Paris, 1957, I, 457, etched by Boucher before 1735)—perhaps of Crozat's garden at Montmorency—describes an arched pavilion at the end of a tree-lined pathway similar to that in *Spring* but without figures. I. Nemilova (1975) pointed out the similarity between this Hermitage drawing and the Cleveland painting. She also suggested that Pater borrowed from a Watteau drawing (Parker and Mathey, *op. cit.*, II, 606, etched by J. Audran) for one of his female figures in *Spring*. There are, in addition, three Watteau drawings closely related to the two couples in *Spring* (*ibid.*, p. 558, etched by Jeaurat; p. 587, etched by Caylus; and p. 637). The painting itself is quite close to the style of Watteau, especially in the aristocratic reserve of the strolling figures and the incisive drawing of the gardeners.

A rectangular drawing in the Berlin Kunstbibliothek (Figure 47d) is identical to the central portion of *Summer*. Its tentative attribution to Pierre-Antoine Quillard on the basis of a signed drawing in the Louvre (no. 32601) is doubtful, but it is certainly from the circle of Watteau—perhaps by Pater, perhaps even late Watteau. Another version of *Summer* extremely close to the Cleveland oil and probably by Pater exists in a private collection in Cornwall, England.

Various oval paintings of the seasons were executed by

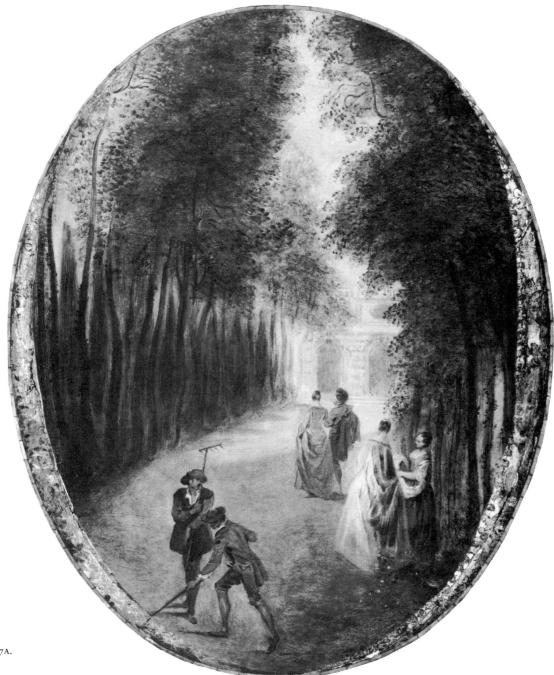

Figure 47A.

Figure 47B.

Figures 47*a* and *b*. *Autumn* and *Winter*. On canvas, each 64.5 x 53.5 cm.
Pater. Barcelona, La Colección Cambo.

Figure 47*c*. *Un Allée d'Arbres*. Red chalk, 21 x 17 cm. Antoine Watteau,
French, 1684–1721. The Hermitage, Leningrad.

Figure 47*d*. *Summer*. Red chalk and graphite, 22.7 x 36.5 cm.
Pierre-Antoine Quillard (?), French, 1701–1733. Staatliche Museen,
Stiftung Preussischer Kulturbesitz, Kunstbibliothek, Berlin.

Figure 48.

Watteau, but of these only the four engraved by Huquier—possibly after the drawings rather than the paintings (Dacier and Vuaflart, *op. cit.*, nos. 140–43)—are similar to those given to Pater. Similarities include the scale of the figures, the general activities portrayed—reaping, vintage, skating—and the manner in which the central scene is enframed by a floral or plant motif. W S T

EXHIBITIONS: None.

LITERATURE: Florence Ingersoll-Smouse, *Pater* (Paris, 1928), p. 84, nos. 578 and 579, figs. 154 and 155; Coe (1955), II, 46, nos. 6 and 7; Inna Nemilova, "Watteau's Drawing *The Allé* and Pater's *Spring*," *Soobscenija Gos*, XL (1975), 20–22.

LIE LOUIS PERIN-SALBREUX

1753–1817

Perin, the son of a cloth manufacturer, was born in Reims in 1753. In Reims he was a student of Clermont, called Ganif, and in Paris he worked with Lemonnier and Louis Marie Sicardi. He was influenced by a number of his contemporaries, including the Swedish miniature painter Pierre-Adolphe Hall (who worked in Paris after 1766); François Dumont (one of the most highly accomplished miniaturists of the last decade of the eighteenth century); and the Swedish miniaturist Alexandre Roslin, who had perhaps the greatest influence on him and is said to have advised him to specialize in miniatures. Perin exhibited at the Salon from 1793 until 1798. He had a fast-growing reputation among the Parisian aristocracy, but during the Revolution his clientele disappeared and his personal fortune diminished. Perin then returned to Reims to take over the family woolen mills. His son Alphonse Perin was also a painter.

48 *Self-Portrait* 61.334

Canvas, 64.4 x 53.3 cm.

Collections: Carrie Moss Halle, Cleveland.

Gift of Carrie Moss Halle in Memory of Salmon Portland Halle, 1961.

The painting was partially cleaned by Joseph Alvarez in 1966. At some time in the past, when the painting was lined, the original tacking margins were trimmed, but the dimensions do not appear to have been greatly reduced. There are some small spots of retouching in the face and scattered losses throughout the painting, especially along the edges.

The Museum painting is characteristic of Perin's style—somewhat derivative and not inspired but painted broadly, with assurance, with warmth in coloring, and with clarity. The pose with paintbrush in hand is typical for a self-portrait. The artist is attired in a cloth coat with velvet collar, a light silk waistcoat, and a muslin cravat; all these, together

Figure 48a. *Portrait of Lié Louis Perin-Salbreux*. On panel, 55 x 45 cm, dated 1791. Alexandre Roslin, Swedish, 1718–1793. Musée de Reims.

with his Brutus hairstyle, exemplify the Directoire fashion of the years 1795–99 and argue strongly for a dating of the portrait in that period. An earlier portrait of Perin by his friend Roslin (Figure 48a), painted in 1791 (signed and dated), shows the artist attired according to the style preceding the Directoire.

Other self-portraits by Perin—in miniature (full-scale paintings of any kind are rare for this artist)—are in the Cabinet des Dessins in the Louvre (Henri Bouchot, *La Miniature Française 1750–1825*, Paris, 1907, III, illus. opp. p. 110, and V, illus. opp. p. 212; see also Leo Schidlof, *Die Bildnisminiatur in Frankreich im XVII, XVIII, und XIX Jahrhundert*, Vienna and Leipzig, 1911, illus. pl. X).

A miniature portrait by Perin, *Noël François-Charles Caille des Fontaines*, is in the Cleveland Museum, as are two miniatures by Dumont and one by Hall, both contemporaries of Perin (*Portrait Miniatures, The Edward B. Greene Collection*, Cleveland, 1951, cat. nos. 59, 66, and 73). N C W

EXHIBITIONS: None.

LITERATURE: "Year in Review, 1962," CMA *Bulletin*, XLIX (1962), 225, no. 95; Henry S. Francis, "Report of the Departments: Paintings," CMA *Bulletin*, LII (1965), 155, no. 96; Francis, "Report of the Departments: Paintings," CMA *Bulletin*, LIII (1966), 140, illus. p. 141; CMA *Handbook* (1978), illus. p. 202.

JEAN PILLEMENT
1728–1808

Jean Pillement was born in Lyons in 1728 and died there, impoverished, in 1808. He first studied with Daniel Sarrabat (1666–1748), a painter of portraits, religious subjects, and ornaments. He finished his training in Paris, where he was employed for several years at the Gobelins factory. He spent much of his life traveling. At seventeen he went to Madrid and stayed for three years. From 1750 to 1760 he lived in London, where many of his designs were engraved and published and where his talents in landscape painting were appreciated. He was back in Paris in 1761. He then set off for Rome, Milan, and Turin. In 1763 he was in Vienna painting landscapes and working on what he hoped would be a revolutionary process for printing designs and colored flowers on textiles. He married Marie Julien at Lyons in 1768; they had three children, two of whom they abandoned. Pillement returned to London during the 1770s. On April 13, 1774, at Christie's, there was a sensational sale of seventy of his paintings. Pillement then worked for the Prince of Liechtenstein, who bought ten of his paintings. He was appointed painter to King Stanislas August of Poland. Upon completing three paintings in 1778 for the Petit Trianon, he was made court painter to Marie Antoinette. He was in Lisbon from 1780 to 1786, a city which he had visited previously. There he established a drawing school at Opporto di Olival; among his pupils were his son and a niece, Mlle Louvette, who made miniatures and etchings. In 1796 he was in Pézenas, where he invested money in an industrial enterprise. Toward the end of his life he returned to Lyons and gave lessons in decoration and design. He is considered to be one of the important French eighteenth-century decorators and painters of pastel landscapes. His

Figure 49.

chinoiserie ornament, landscapes, seascapes, and genre and flower paintings were the epitome of the French Rococo taste, which of course did not survive the French Revolution.

49 *Landscape with Figures* 73.1

Pastel on prepared fabric, 46.3 x 61 cm. Signed, dated, and inscribed at lower right in pastel: J. Pillement/pour son ami/gaviner 1779.

Collections: Albert Blum, New York; [Wildenstein & Co., New York].

Mr. and Mrs. William H. Marlatt Fund, 1973.

Except for scattered specks of discoloration from mold, this pastel is in pristine condition. Nothing is known of its early history at present, but it may be that the inscription—*Pour son ami gaviner*—refers to Pillement's friend Pierre Gaviniès (1728–1800), a famous violin virtuoso and composer.

This painting exemplifies one of Pillement's major contributions to eighteenth-century French painting—his development of the gouache and pastel technique in landscape. Though in general he followed the conventions for landscape painting in his time, Pillement added his own subtle and exquisite rendering of atmospheric distance. His irregular countrysides dotted with shepherds, flocks, and rustic buildings evince a bucolic charm which is quite different from the realism of, say, the *View of Rome* by Valenciennes (Painting 59) of about the same date. N C W

EXHIBITIONS: New York, Decorators Picture Gallery, 1938: French, Italian, and Chinese Paintings (no catalogue); New York, Wildenstein & Co., 1949: Drawings through Four Centuries, cat. no. 47; CMA, February 1974: Year in Review, cat. no. 41, illus. p. 44.

LITERATURE: CMA *Handbook* (1978), illus. p. 187; William S. Talbot, "Some French Landscapes: 1779–1842," CMA *Bulletin*, LXV (1978), 75–76, illus.

NICOLAS POUSSIN
1594–1665

Poussin was born of a peasant family in Les Andelys, Normandy. He studied briefly in Rouen and went to Paris ca. 1612. In Paris he was exposed to Renaissance art, the Mannerist style of Fontainebleau, and Italian engravings in the Royal Library. He traveled for a while in France and found his way to Florence ca. 1620–21. He acquired a theoretical knowledge of architecture, perspective, and anatomy, which he further developed in Rome, having arrived there —after a brief visit to Venice—by March 1624. He gradually earned the esteem of the intelligentsia and gained favor in the circle of the Barberini and with the Roman collector Cassiano dal Pozzo. In 1630 he married Anne Marie Dughet, the sister of Gaspard Dughet, who had nursed him through a serious

illness in the year before their marriage. At this time he turned away from official commissions, large altarpieces, and decorations and devoted himself to smaller paintings for a discriminating upper-middle-class audience. He studied theoretical treatises and enlarged his knowledge of humanistic and philosophical disciplines. His brother-in-law, Gaspard Dughet, who lived in his home from 1631 to 1635, may have helped him to sharpen his observations of landscape. He returned to Paris briefly between 1640 and 1642 at the persistent invitations of Richelieu and Louis XIII. He was unhappy there, forced to think of painting as having only a decorative function and exposed to the jealousies of other French artists. He returned to Rome, never to leave again.

Like other French painters of the seventeenth century— Claude Lorrain, for example—he produced his greatest works in Rome rather than in Paris. In the more contemplative atmosphere of Rome he began to develop a preference for New Testament subjects rather than those of the Old Testament. Likewise, he gradually gave up Ovid for the moral themes found in the philosophy of the Stoics. He was especially absorbed with the problem of the will versus the passions and used biblical and classical subjects to illustrate the drama and psychology of that struggle. Poussin had an enormous influence among his contemporaries; he was an important spirit to be reckoned with, both by those who followed his classical, highly rational and intellectual approach, and by those who rebelled against it—some even well into the twentieth century. Among his admirers were Gaspard Dughet, Giovanni Benedetto Castiglione, Pier Francesco Mola, Andrea Sacchi, Pietro Testa, Alessandro Algardi, François Girardon, and François Duquesnoy. His reputation and influence were so great that many paintings were executed in his style by followers; numerous replicas, pastiches, and copies of his work found their way into European, especially English, private collections. As a result, the attribution and dating of several paintings in the circle of Poussin have been subject to serious art-historical debate, particularly since the Louvre exhibition of 1960, when many of these works were seen together for the first time.

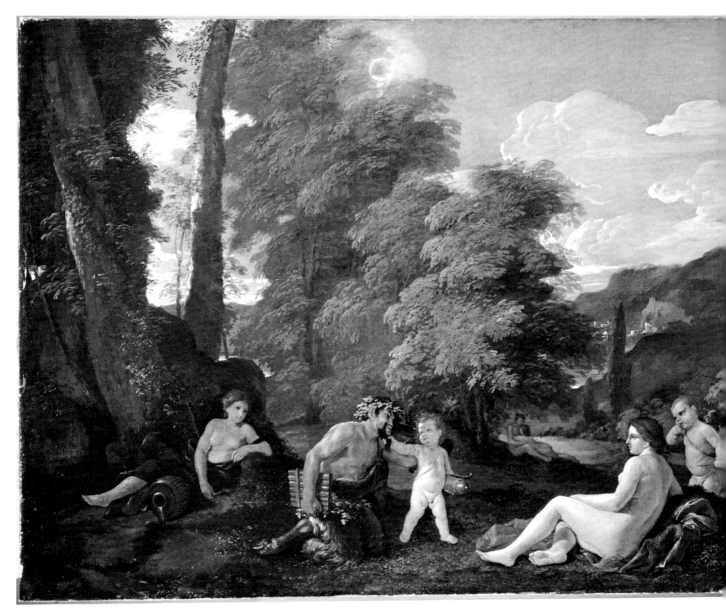

Figure 50.

118

50 *Landscape with Nymphs and Satyrs* 26.26
 (or *Pan with the Infant Bacchus,*
 or *Amor Vincit Omnia*)

Canvas, 97 x 127.5 cm.

Collections: Lord Radstock; (sale: Christie's, London, May 13, 1826, no. 27); anonymous collection; (sale: Phillips, London, 1829); Lord Northwick, Thirlestane House, near Cheltenham, by 1837 (sale: Phillips, London, August 24, 1859, no. 1809); J. S. W. S. Erle Drax, Esq., Olantigh Towers, Wye, Kent (sale: Christie's, London, February 19 and 21, 1910, no. 105, to Cohen); David Horner, London, by 1925; [Durlacher Brothers, London]; J. H. Wade, Cleveland.

Gift of J. H. Wade, 1926.

This painting was treated by William Suhr in 1951 and was lined and cleaned by Joseph Alvarez in the Museum laboratory in 1968. The tacking margins are missing, but the X radiograph indicates that the dimensions have not been greatly altered. There is considerable repaint in oil, particularly on the left thigh of the nymph at the lower right. There are scattered damages, and tonal relationships are obscured in some areas due to residues of old, yellowed varnishes.

Nymphs and satyrs were fairly popular subjects for artists in the seventeenth century. The most celebrated rendition, perhaps, is a medallion by Agostino Carracci in the Farnese Gallery, Rome (H. Tietze, *Jahrbuch des Allerhöchsten Kaiserhauses*, XXVI, 1906, illus. p. 83 ff.), in which Carracci enjoys a pun on the phrase *Omnia Vincit Amor* (from Virgil's *Eclogues*, x, i, 69) by substituting the bearded, goat-footed Pan for the word *Omnia*. Another example is in The Hermitage, Leningrad (Otto Grautoff, *Nicolas Poussin: Sein Werk und Sein Leben*, Munich and Leipzig, 1914, II, 278): a weak painting dating from the late thirties—perhaps a copy after a lost original—it shows Cupid defending the honor of his mother from the assaults of Pan. Poussin himself made three drawings of the subject, none of which is directly related to the Cleveland painting: two are in Windsor Castle (nos. 11980 and 11915) and the other is in the Louvre (no. 32427).

Until 1925, when it was lent by David Horner to the exhibition in Paris, the painting had been secluded in private English collections. In 1926 the picture was purchased by J. H. Wade, who gave it to this Museum within a year of its purchase. It was his last gift to the Museum, given two months before his death.

Jamot (1925 and 1948), Hourticq (1925), Friedlaender (1933 and 1953), and others accepted the picture as an early work of Poussin's Roman period. However, when it was exhibited side by side with the masterpieces of Poussin in the Paris exhibition in 1960, that attribution was immediately questioned. Anthony Blunt (1960) considered it a free variant of Poussin's style. He associated the painting of the trees and the treatment of the foreground and figures with *Landscape with Arcadian Shepherds* at Liverpool (Figure 50a; Grautoff, *op. cit.*, no. 36) and the *Bacchus and*

Figure 50a. *Landscape with Arcadian Shepherds.* On canvas, 102.5 x 133.3 cm. Poussin. Walker Art Gallery, Liverpool.

Ariadne in the Prado, Madrid (no. 2312), which he believed were by an Italian painter in the circle of Cassiano dal Pozzo. Jacques Thuillier (1961) also said the Cleveland painting is a free variant of Poussin's style, but he could not accept Blunt's suggestion that it is by the same artist who painted the *Bacchus and Ariadne*; the latter, he felt, was painted by Poussin about 1626.

Eckhard Schaar (1961) linked the Cleveland painting to the drawing *Amor Vincit Omnia*, in the Lugt collection

Figure 50b. *Amor Vincit Omnia* (or *Landscape with Nymphs and Satyrs*). Pen and wash, 22.6 x 32 cm. Pier Francesco Mola, Italian, 1612–1666. Fondation Custodia (Collection F. Lugt), Institut Néerlandais, Paris.

Figure 50c. *Amor*. Red chalk, 22.5 x 14.5 cm. Formerly attributed to Andrea Sacchi, Italian, 1599–1661. Musée du Louvre, Paris.

gested that Mola may have made the drawing after a painting by his friend Pietro Testa. She pointed out the similarity between the nymph on the right side of the Cleveland painting and her counterpart in the *Landscape with Figures*, now at Ancona, which has been attributed to Pietro Testa (*Catalogue of the Museo Municipale*, Ancona, 1960, no. 35). She conceded, however, that the Cleveland painting was still a problem in attribution.

Thuillier (1961) saw similarities between a red chalk drawing in the Louvre (Figure 50c; Rosenberg, 1961, no. 185; Schaar, 1961, p. 187, fig. 4) and the figures of Amor and Pan in the Cleveland painting. The drawing had been attributed to Andrea Sacchi (because of a later inscription at the lower left), but this attribution is not generally accepted. Harris (1967) thought the drawing was not by Mola or Testa.

Pierre Rosenberg (1977) objected to the almost universal and hasty rejection of Poussin's authorship. After a visit to this Museum (June 4–6, 1979), he confirmed his impressions in a letter (dated June 15, 1979), saying that the work is not only entirely Poussin's but is also an important and very beautiful work. Its authenticity is beyond a doubt, he said. Rosenberg assigned the painting to a group of warm and very lyrical paintings, such as those at Montpellier, Liverpool (see Figure 50a), Brighton, Cherbourg, and others, all of which he accepts as works by Poussin. N C W

EXHIBITIONS: Paris, Petit Palais, 1925: Exposition du Paysage Français de Poussin à Corot, cat. no. 270; CMA (1936), cat. no. 227, illus.; Rochester, New York, Memorial Art Gallery, 1936: Rebels in Art (no catalogue); New York, M. Knoedler & Co., 1939: Loan Exhibition, Pollaiuolo to Picasso—Classics of the Nude, cat. no. 12; New York, Durlacher Brothers, 1940: Exhibition of Paintings and Drawings of Nicolas Poussin (no catalogue); New York, World's Fair, 1940: Masterpieces of Art, cat. no. 58; CMA (1956), cat. no. 31, illus.; Paris, Musée du Louvre, 1960: Exposition Nicolas Poussin, cat. no. 33, illus.; Akron (Ohio) Art Institute, 1965: Our Neighboring Museums (no catalogue); Denver Art Museum, 1971: Baroque Art, Era of Elegance, cat. pp. 56, 57, illus.; Art Gallery of Hamilton (Ontario), 1980: Man and Nature, A View of the Seventeenth Century, cat. no. 30, illus.

LITERATURE: Smith (1837), VIII, 119, no. 227; Waagen (1854), III, 104; Louis Hourticq, "L'Exposition du Paysage Français de Poussin à Corot," *Revue de l'Art*, XLVIII (1925), 8; Paul Jamot, "Nouvelles Etudes sur Nicolas Poussin," *Gazette des Beaux-Arts*, XII (July–August 1925), 86, illus. opp. p. 88; *Le Bulletin de l'Art Ancien et Moderne* [suppl. to *Revue de l'Art*], L (1926), 206, illus.; William M. Milliken, "The Last Gift of J. H. Wade: *Landscape with Nymphs and Satyrs* by Nicolas Poussin," CMA *Bulletin*, XIII (1926), 86–89, illus. p. 62; Walter Friedlaender, in Thieme-Becker (1933), XXVII, 324; Regina Shoolman and Charles E. Slatkin, *The Enjoyment of Art in America* (Philadelphia and New York, 1942), pl. 474; Jamot, *Connaissance de Poussin* (Paris, 1948), p. 50, pl. 50; Giovanni Incisa Della Rocchetta, "I 'Baccanali Chigi' di Nicolas Poussin," *Paragone*, II, no. 15 (1951), 43, n. 3; Friedlaender and Anthony Blunt, *The Drawings of Nicolas Poussin: Catalogue Raisonné* (London, 1953), III, 32; John D. Morse, *Old Masters in America* (Chicago, 1955), p. 121; Henry Bardon, "Poussin et la littérature latine," *Nicolas Poussin*, ed. André Chastel, Editions du Centre National de la Recherche Scientifique (Paris, 1960), I, 130, n. 37; Blunt, "Poussin Studies XI: Some Addenda to

(Figure 50b), which had been attributed to Pier Francesco Mola (1612–1666). Schaar discussed the differences in composition, light, and style and concluded that the drawing most probably followed directly after the painting. The attribution of the drawing to Mola has not been disputed; Harris (1967) dated it in the 1640s and Cocke (1969) dated it after 1647, when Mola returned to Rome.

The attribution of the Cleveland painting, however, remained problematical. Schaar attributed it to Mola, and it has been accepted as the probable work of Mola by others as well. Thuillier (1974) attributed it to Mola; Blunt (1960) suggested the possibility of Mola or Pietro Testa (1599-d. 1661, Rome) and later (1966, II, 110, n. 15) called it close to Mola. Cocke (1972), on the other hand, rejected both the attribution to Mola and that to Testa for stylistic reasons. Ann Sutherland Harris (1964) pointed out that Mola's name did not appear in the lists of artists, both foreign and Italian, drawn up in 1633 and 1634 for the Academy of St. Luke for the purpose of collecting dues. She therefore suggests that Mola was not in Rome in those years or had not painted anything of importance before that time. If Mola did paint the picture, which she believes is very difficult to justify, he would have painted it before 1632, for after his return to Rome in 1647 he was not so strongly influenced by Poussin's early Venetian period. Harris later (1967) sug-

the Poussin Number," *Burlington Magazine*, CII (1960), 400, fig. 13; Georg Kauffmann, "Beobachtungen in der Pariser Poussin-Ausstellung Mai–Juli 1960," *Kunstchronik*, XIV (April 1961), 98; Pierre Rosenberg, in *Exposition Nicolas Poussin et son temps: Classicisme français et italien contemporain de Poussin* (Rouen, 1961), p. 84; Eckhard Schaar, "Eine Poussin-Mola-Frage," *Zeitschrift für Kunstgeschichte*, XXIV, no. 2 (1961), 184–88, fig. 2; Jacques Thuillier, "L'Année Poussin," *Art de France*, I (1961), 340; Denis Mahon, "Poussiniana: Afterthoughts Arising from the Exhibition," *Gazette des Beaux-Arts*, LX (July–August 1962), 18, n. 49; Ann B. Sutherland, "Pier Francesco Mola: His Visits to Northern Italy and His Residence in Rome," *Burlington Magazine*, CVI (1964), 367, n. 19; Blunt, *The Paintings of Nicolas Poussin: A Critical Catalogue* (London, 1966), I, 173, no. R58, pp. 174, 178; Ann Sutherland Harris, "Notes on the Chronology and Death of Pietro Testa," *Paragone*, XVIII, n.s. no. 23 (1967), 39–40, nn. 36 and 38; Richard Cocke, "A Note on Mola and Poussin," *Burlington Magazine*, CXI (1969), 712, 716; Cocke, *Pier Francesco Mola* (Oxford, 1972), pp. 65, 66; Thuillier, *L'Opera completa di Poussin*, Classici dell'Arte, vol. 72 (Milan, 1974), 125–26, no. R.124; P. Rosenberg, in *Nicolas Poussin 1594–1665* (exh. cat., Rome, 1977), p. 119 (German ed., Düsseldorf, 1978, p. 83).

NICOLAS POUSSIN

51 *The Return to Nazareth* 53.156

Canvas, 134 x 99 cm.

Collections: Princes of Liechtenstein; [Newhouse Galleries, New York]; [Rosenberg and Stiebel, New York].

Gift of Hanna Fund, 1953.

In the process of attaching the glue lining during a previous restoration, the impasto was severely flattened and the paint layer was pressed into the voids between the threads of the coarse fabric support, thereby emphasizing the fabric pattern. Before acquisition, the painting was cleaned and retouched by William Suhr. In 1963 it was examined by Richard Buck at the Intermuseum Laboratory in Oberlin, Ohio; it was examined again in 1977 by the Museum conservation staff prior to its cleaning in 1979.

The paint layer was applied over a warm-colored ground of mid-value. The dark tones in the trees, foliage, and shadows were thinly painted, allowing some ground color to show—a technique consistent with that of Poussin's known works. The round, bare head of the Christ Child was painted first, and later the thin hair was painted over it; this procedure is apparent in numerous other *putti* and children painted by Poussin, such as those in the *Baccanal before Herm* (London, National Gallery) and the *Rinaldo and Armida* (Dulwich College Picture Gallery, Dulwich, England).

During the cleaning by the Museum's Conservation Department, a grime-embedded layer directly over the paint layer was found to be insoluble using normal varnish solvents. This thin layer may be the egg-white varnish that Poussin refers to in his letter of February 4, 1646, to Chantelou ("Correspondance de Nicolas Poussin," *Archives de l'art français*, n.s., V, 1911, 331, letter 135). A most unusual varnish coating, it has been found on other Poussin paintings as well.

The coarse fabric support of the *Return to Nazareth* is similar to the supports used by Poussin for the *Triumph of Flora* (Louvre, Paris) and the *Death of Germanicus* (Minneapolis Institute of Arts).

The painting has suffered from abrasion and solvent damage, which has resulted in thinning and loss of paint, especially in the cloud forms. Many of the subtle transition tones have been lost; for example, in the blue drapery of the Madonna, where the light passages are painted over a pale blue underpaint and the shadows are painted directly over the warm ground. The strong contrast in this area was heightened by a build-up of dark varnish in the shadows—the result of removing the varnish coating only from the lighter passages of the painting. When all varnish layers were removed, the cool, rich color of the blue drapery shadows was revealed, as was the severity of abrasion in the light passages. The original thin glazes in the dark folds of the green drapery of the Christ Child were found to be well preserved. Previous restorers, having misinterpreted both design and color, matched new repaint to old varnish and retouchings. A photograph from William Suhr's archive (Getty Museum, Malibu, California) shows a seated figure next to the standing figure (on the opposite bank of the river) which was not evident at the time of acquisition. Reproductions of the Museum's painting in von Bode (Figure 51a) and Grautoff (1914, II) and an eighteenth-century monochrome copy (private collection, New York; on loan to The Brooklyn Museum) also show the seated figure. After the cleaning in 1979 the figure was again visible; it is severely abraded and the features are lost, but the blue and red-draped form is readily distinguishable, as is its reflection in the water.

The Cleveland painting is closely related to a variant by Poussin at Dulwich College, which—like the Cleveland painting—formerly had been called *Flight into Egypt*. According to Gäumann-Wild (letter of June 21, 1960), the advanced age of the Child in both paintings indicates that the subject was the Holy Family's return *from* Egypt rather than their flight *to* Egypt.

There is a long succession of works in which angels bearing the cross appear before the Christ Child (see Ronot, 1978), but the combination of this iconography with the flight to or from Egypt did not appear until the seventeenth century. Mitchell (1938, p. 340), interpreting the symbolism of the Dulwich picture, saw the cross in the sky and the passage across a river as an allusion to three events: the slaughter of infants that occasioned the flight, the flight itself, and the Passion of Christ. As a prototype of this threefold symbolism, Mitchell cited Pietro Testa's *Massacre of the Innocents* (Galleria Spada, Rome), in which the slaughter takes place as the Holy Family departs in a boat, accompanied by an ass carrying their baggage and a cross.

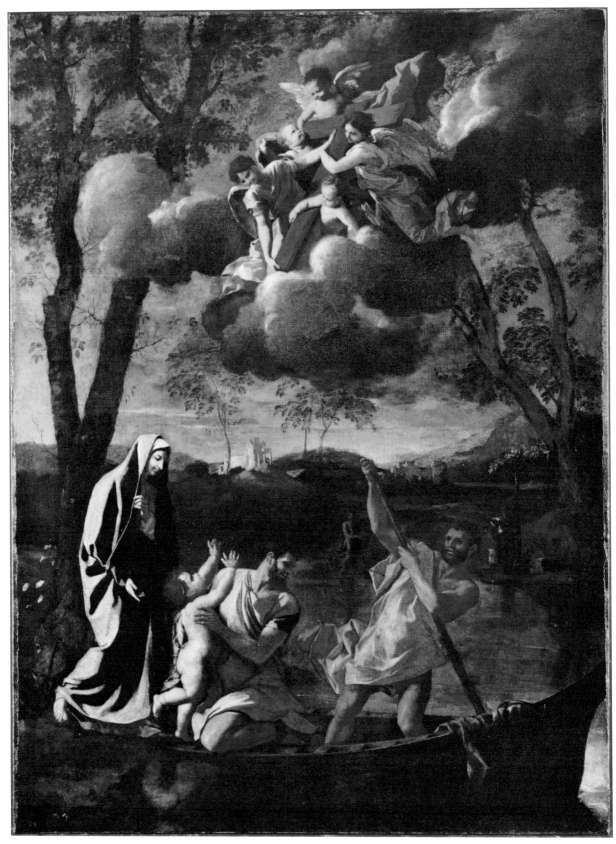

Figure 51.

122

Mitchell believed the boatman in the Dulwich picture to be the mythological Charon, who ferried dead souls across the river Styx to Hades, but Friedlaender (*Nicolas Poussin, A New Approach*, New York, 1964, p. 43) made the more plausible suggestion that he is instead St. Christopher, the patron saint of travelers.

Mitchell's theory of threefold symbolism, however, does not fully explain the Dulwich and Cleveland paintings. In both of these a vision of the cross is seen by the Holy Family on their return from Egypt, but there is in these pictures a deeper implication—a pervading sense that the return to Nazareth involved Christ's conscious and willing acceptance of his destiny. It is the Virgin's understanding of this that accounts for her pensive, sorrowful aspect.

In a poem dating from 1653 (see Literature), Hilaire Pader, a contemporary of Poussin, described a *Flight into Egypt* by Poussin, which he had obviously seen himself. He is apparently describing the Cleveland picture, for in his poem Pader speaks of the Infant reaching out toward the cross carried by the angels from heaven (the Infant in the variant at Dulwich does not reach out). In Pader's words:

> *Il élève les mains et monstre par son geste*
> *Que son coeur reconnoist la machine céleste. . . .*

These lines indicate that Pader, too, understood the central event of the painting to be the young Savior's recognition and acceptance of his fate. This painting, whose pious subject was so unusual in Poussin's oeuvre, was probably destined for an altar, an eventuality that Pader confirmed at the end of his poem.

The first known owner of the Cleveland painting was Josef Wenzel, Prince of Liechtenstein. The painting was recorded in his collection in 1733, the year in which all paintings in the Liechtenstein collection that were to remain in the hands of successive ruling princes were marked with a black or red seal on the front or the back. In the lower left corner of our canvas are remnants of a black seal which once showed the coat of arms of the princes of Liechtenstein and the date 1733 (Figure 51b). Magne (1914), and later Blunt (1966, I), suggested that the House of Liechtenstein may have acquired the painting from M. Poinsinet, who owned a *Flight to Egypt* in 1725; Poinsinet was a member of the household of the Duke of Orléans and a well-known art connoisseur and dealer. Note, however, that Magne mistakenly identified the Liechtenstein *Flight to Egypt* with the Dulwich painting.

Among the paintings listed by Comte Ernest de Ganay (*Chantilly au XVIIIᵉ siècle*, Paris, 1925, p. 23, n. 1) in the chapel at Chantilly, newly built for the Duc de Bourbon in 1718–19, was an as-yet-unidentified version entitled "un Poussin, *La Fuite en Egypte*."

Another *Flight to Egypt* by Poussin, in the Palazzo Filomarino, the palace of the Prince de la Torre, is mentioned and praised by Joseph Jérôme de la Lande in 1786 (*Voyage en Italie*, VII, 57). John Smith, in his *Catalogue Rai-*

Figure 51a. *The Return to Nazareth*. Engraving after Poussin. Reprinted from Wilhelm von Bode, *Die Graphischen Künste*, XVIII (Vienna, 1895), 111.

Figure 51b. Remnants of a black seal.

sonné (pt. 8, London, 1837, 46, no. 88) described the same painting but called it a *Rest on the Flight to Egypt*.

Until the Exposition Nicolas Poussin, held at the Louvre in 1960, scholars generally accepted our painting as an original work by Poussin. Francis (1953) published it as an original work of ca. 1638, which was also the date assigned to it in the Louvre exhibition. Acceptance had not been universal, however: Friedlaender omitted it from his book and his entry on Poussin in Thieme-Becker, and for iconographical reasons, Mitchell (1938) dismissed it as a school piece. Blunt (letter of May 27, 1960; also see Literature: 1960 and 1966), speaking for the organizers of the exhibition, expressed doubts about the attribution of our painting to Poussin. He admitted that the impression of coarse handling by the artist was partly due to carelessness on the part of restorers during lining and cleanings, but he could not reconcile the abrupt transitions from light to shadow in the robe of the Madonna which were unparalleled in Poussin's work. Blunt (1966, p. 49) found it difficult to date the painting because of stylistic inconsistencies with other works by Poussin. While the lower figures seemed comparable to those in works of the early 1630s such as *Erminia and Tancred* (Hermitage, Leningrad), the angels

Figure 51c. *Flight to Egypt*. Engraving after Poussin. Francesco Viera the Younger, Portuguese, 1765–1806. Graphische Sammlung Albertina, Vienna.

were closer in style to those in considerably later works such as the *St. Francis Xavier* (1641), the *Ecstasy of St. Paul* (1650), and the *Assumption* (1650), all in the Louvre, Paris. Their pronounced baroque religiosity, which Blunt found atypical for Poussin, obviously made the painting an ideal altarpiece for the yet-unidentified French clergyman whom Pader mentioned (1653; see also Thuillier, 1960). Blunt (1960, p. 400), pointing to the coarse Neapolitan-type canvas—and later Mahon (1962, p. 23) and Ferrari (1966, and in *Luca Giordano*, I, 1966, p. 15, n. 16)— suggested that the Cleveland painting was a copy by a Neapolitan admirer and imitator of Poussin. Ferrari suggested Nicolò de Simone, although later (letter of August 3, 1977) he saw some resemblance to the style of Andrea de Leone, also from Naples. Ferrari therefore suggested yet a third possibility: an unidentified artist whose style seems to vacillate between Nicolò de Simone and Andrea de Leone. Doris Wild (1967, pp. 22–23) assigned the *Return to Nazareth* to the French painter Charles Mellin (1620– 1649). Pierre Rosenberg (letter of December 22, 1977, and orally, during a visit to this Museum on June 5, 1979) reconsidered the possibility of Poussin's authorship, granting that the painting had suffered much damage and had been flattened in the process of lining. Thuillier (1974) also reconsidered the attribution to Poussin, saying that the painting should be considered as part of the master's oeuvre until proven to the contrary. He argued convincingly that part of the difficulty in accepting the painting stemmed from comparing it to Poussin's works of ca. 1637–38 instead of to those of ca. 1634–35, in which parallels can be found—for example, the type of Madonna, the handling of drapery, and the enlivening of the background with delicate trees. Maurizio Fagiolo Dell'Arco (1977) tacitly agreed with Thuillier when he listed the Museum painting under Poussin's Roman works of 1633, along with the *Adoration of the Magi* (Staatliche Kunstsammlungen, Dresden), another devotional painting by Poussin (Dell'Arco, however, erroneously stated that the Cleveland picture belonged to the Reinhart Institute, Winterthur).

The Cleveland painting, or one exactly like it, was reproduced in an engraving by the Portuguese Francesco Viera the Younger (1765–1806) in 1799, toward the end of his sojourn in London (Figure 51c). The engraving shows slight modifications in the background buildings and omits the dog, but includes the seated figure. A line drawing based on the engraving appeared in Anna Jameson's *Legends of the Madonna as Represented in the Fine Arts* (London, 1852, p. 255).

A pen and ink drawing (39 x 29 cm) that repeats the major part of the Cleveland composition, including the building in the background, appeared on the market in Geneva in 1968.

Another related work, the above-mentioned painted copy (ca. 84.5 x 60.3 cm) in monochrome, is unquestion-

ably after the Cleveland painting, is possibly of the eighteenth century, and was perhaps done in preparation for an engraving. ATL

EXHIBITIONS: CMA (1956), cat. no. 30, illus.; Toledo (Ohio) Museum of Art and Minneapolis Institute of Arts, 1959: Nicolas Poussin 1594–1665, cat. p. 19, fig. 14; Paris, Musée du Louvre, 1960: Exposition Nicolas Poussin, cat. no. 52, illus.; Dallas Museum of Fine Arts, 1962: The Arts of Man, cat. no. 58, illus.

LITERATURE: Hilaire Pader, *La Peinture Parlante* (Toulouse, 1653), portions reprinted in Philippe de Chennevières-Pointel, *Recherches sur la vie et les ouvrages de quelques peintres provinciaux de l'ancienne France*, IV (1862), 132–33; Vincenzio Fanti, *Descrizzione completa di tutto ciò che ritrovarsi nella Galleria di Pittura e Scultura di sua altezza Giuseppe Wenceslao del S.R.I. Principe Regnante della casa di Lichtenstein* (Vienna, 1767), no. 426; Gustav Parthey, *Deutscher Bildersaal, Verzeichnis der in Deutschland vorhandenen Oelbilder verstorbener Maler aller Schulen*, II (Berlin, 1864), 297, no. 3 (as Gaspard or Nicolas); Gustav Friedrich Waagen, *Die Vornehmsten Kunstdenkmäler in Wien* (Vienna, 1866), I, 264; *Katalog der Fürstlich Liechtensteinischen Bildergallerie im Gartenpalais der Rossau zu Wien* (Vienna, 1873), p. 38, no. 307; Wilhelm von Bode, "Die Französische Schule," *Die Graphischen Künste*, XVIII (Vienna, 1895), 112, illus. p. 111; Bode, *Die Fürstlich Liechtensteinsche Galerie in Wien* (Vienna, 1896), p. 114, illus. p. 113; Elizabeth H. Denio, *Nicolas Poussin* (London, 1899), p. 225; David Charles Preyer, *The Vienna Galleries*, The Art Galleries of Europe (Boston, 1912), p. 235; Emile Magne, *Nicolas Poussin* (Brussels, 1914), p. 210, n. 2; Otto Grautoff, *Nicolas Poussin, Sein Werk und Sein Leben* (Munich and Leipzig, 1914), I, 149, and II, no. 78, illus.; A. Kronfeld, *Führer durch die Fürstlich Liechtensteinsche Gemäldegalerie in Wien* (second ed., Vienna, 1927), no. 186; R. H. Wilenski, *French Painting* (Boston, 1931), pp. xiii, 70, pl. 21b (rev. ed., London, 1949, pp. 61, 65); Charles Mitchell, "Poussin's *Flight into Egypt*," *Journal of the Warburg Institute*, I (1938), 341, n. 5, pl. 61b; Anthony Blunt, "Poussin Studies III: The Poussins at Dulwich," *Burlington Magazine*, XC (1948), 7; *Art Treasures of the Liechtenstein Collection* (Lucerne, 1948), no. 9; Henry S. Francis, "The *Flight into Egypt* by Nicolas Poussin," *CMA Bulletin*, XL (1953), 211–13, illus. p. 209 (cover); John D. Morse, *Old Masters in America* (Chicago, 1955), p. 111; Milliken (1958), p. 38, color illus. p. 39; *In Memoriam Leonard C. Hanna, Jr.* (Cleveland, 1958), no. 70, pl. 70; Malcolm Vaughan, "Poussin in America," *Connoisseur*, CXLIII (1959), 125, fig. 8; Jacques Thuillier, "Pour un 'Corpus Pussinianum,'" *Nicolas Poussin*, ed. André Chastel, Editions du Centre National de la Recherche Scientifique (Paris, 1960), II, 101, n. 4; Blunt, "Poussin Studies XI: Some Addenda to the Poussin Number," *Burlington Magazine*, CII (1960), 400; Denis Mahon, "Poussiniana," *Gazette des Beaux-Arts*, LX (1962), 23–24; Blunt, "Poussin and His Roman Patrons," *Walter Friedlaender zum 90. Geburtstag* (Berlin, 1965), p. 73, App. II; Oreste Ferrari and Giuseppe Scavizzi, *Luca Giordano*, I (Naples, 1966), 15, n. 16; Ferrari, "Drawings by Luca Giordano in the British Museum," *Burlington Magazine*, CVIII (1966), 302, n. 13; Blunt, *The Paintings of Nicolas Poussin, A Critical Catalogue* (London, 1966), I, 48 (under no. 6); Doris Wild, "Charles Mellin ou Nicolas Poussin," *Gazette des Beaux-Arts*, LXIX (January 1967), 22, 23, 25, fig. 68; Thuillier, *L'Opera completa di Poussin*, Classici dell'Arte, vol. 72 (Milan, 1974), 92, 94–95, no. 76, illus.; Blunt, review of Thuillier's *L'Opera completa di Poussin*, in *Burlington Magazine*, CXVI (1974), 761; Christopher Wright, review of Thuillier's *L'Opera completa di Poussin*, in *Antologia di Belle Arti*, no. 1 (1977), 117; Maurizio Fagiolo Dell'Arco and Silvia Carandini, *L'Effimero Barocco, strutture della festa nella Roma del '600*, I (Rome, 1977), 86, pl. 85 (mistakenly identified as being at Winterthur, Reinhart Institute); Henry Ronot, "Le thème de l'apparition de la Croix à l'Enfant Jésus," *Archives de l'art français*, n.s., XXV (1978), 150, 155, n. 14.

HYACINTHE RIGAUD
1659–1743

Rigaud was born in Perpignan. At age fourteen he was an apprentice in the workshops of Paul Pezet and Antoine Ranc at Montpellier. At eighteen he left for Lyons, where he stayed until 1681. He then went to Paris and entered the Royal Academy, where he gained immediate recognition from Academy director Charles Lebrun. In 1682 he won the Grand Prix de Rome but declined to go to Italy. Upon the advice of Lebrun, Rigaud switched from history painting to portraiture. He received his first royal commissions in 1688 and 1689 when he painted portraits of the Duke of Orléans, brother of Louis XIV, and of the duke's son, the future regent of France. In 1694 Rigaud painted his first portrait of the king himself (Prado), followed by another—his most famous—in 1701 (Louvre). The latter epitomized the image which Louis XIV had formed of himself as the absolute ruler and head of the most magnificent court in Europe. Henceforth, commission after commission followed from courtiers and nobles in France and other countries. Rigaud's service as a court painter, which began under the rule of Louis XIV (who died in 1715), continued through the regency period (ending in 1723) into the reign of Louis XV. Rigaud died in Paris in 1743.

52 *Portrait of Cardinal Dubois* 67.17

Canvas, 146.7 x 113.7 cm. Signed and dated on base of clock: *Fait par Hyacintus Rigaus 1723.*

Provenance: Château d'Eu, 1723 (?) (see Bellier de la Chavignerie, 1864).

Collections: Mlle Violat (heiress of Cardinal Dubois), Château de Villemenon, near Brie-Comte-Robert; George, last Earl of Egremont (sale: Christie, Manson & Woods, London, May 21, 1892, no. 68); Rodolphe Kann, Paris; Edouard Kann, Berlin; [Wildenstein & Co., New York].

John L. Severance Fund, 1967.

The painting is in good condition. Viewed in ultraviolet light, retouchings can be seen in the drapery and in the sitter's wig, to the left of the parting. Retouchings are minor and few, however. There are remnants of discolored varnish in some areas. The sitter's face is in excellent condition.

Guillaume Cardinal Dubois (1656–1723), Archbishop and Duke of Cambray, Prince of the Holy Roman Empire, and Prime Minister, portrayed here in his attire as cardinal, rose to his high office from humble beginnings as the son of a small-town apothecary. He was first admitted to the court of Louis XIV as the tutor of the young Duke of Chartres, who later became Duke of Orléans, regent of France, and whom Dubois continued to serve as close confidant and statesman. The portrait commemorates the year (1723) in which Cardinal Dubois, in his new role as prime minister (since 1722), had the task of proclaiming the majority of Louis XV, who thus became king and ended the regency of

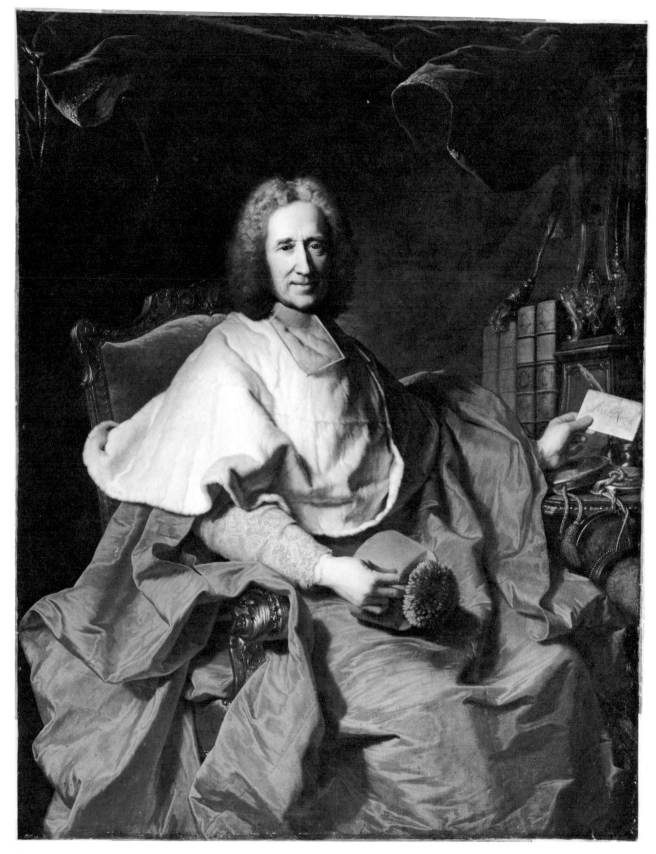

Figure 52.

126

the Duke of Orléans. The sitter ostentatiously displays a letter in his left hand bearing the inscription *Au Roi.*

According to Bellier de la Chavignerie (1864), the portrait, when it was finished in 1723, was hung in the Château d'Eu, then owned by Louis-Auguste de Bourbon, Duc du Maine. If Chavignerie is correct, the painting did not remain there very long, for after Cardinal Dubois's death in 1723 it passed into the hands of his heiress, Mlle Violat. It was still in her possession in 1764, one year before the death of the Dauphin of France (eldest son of Louis XV), who, while confined to Compiègne by illness, demanded that the Marquis de Marigny (Superintendent of Royal Buildings) bring Rigaud's portrait of Cardinal Dubois before him (see Marc Furcy-Raynaud, 1904; Lurie, 1974 and 1975). It is not known whether this actually came to pass, but the dauphin's request was so urgent that it was very likely honored.

By the time the cardinal's portrait was commissioned, Rigaud's style of courtly portraits was fully established. Without sacrificing characterization and a lively presence, he integrated his sitters with an elaborate setting which in itself expresses their high rank and image of grandeur. Thus, Cardinal Dubois's important role is emphasized in every detail of the Cleveland painting, from his pose and gesture to the sumptuousness of his red cassock; to his ermine cape; to the elaborately carved furniture; to the billowing draperies of heavy velvet; to the books and seals carefully chosen and displayed; and, last but not least, to the magnificent frame enclosing all. The painting has the air of splendor of the royal court, which both sitter and painter were proud to share (Lurie, 1967, p. 230, nn. 3 and 4).

In format and composition the portrait of Cardinal Dubois is closely related to Rigaud's portrait of Cardinal Fleury (Budapest), although the latter was painted five years later.

An engraved copy of the portrait (not in reverse), by Pierre Imbert Drevet (1697–1739) is in the Cleveland Museum (see Figure 52a). Other copies of the portrait in various media are known to have existed, though their present whereabouts are unknown: an engraving of the bust only (in reverse) by Claude Roy (1712–1792); a lithograph by Etienne Larose Baudran (1794–1866), for the publisher, Amyot; and four more, executed or recorded in 1723, known from Rigaud's own records (Roman, 1919, pp. 196, 197). The latter include two oil replicas from Rigaud's workshop, one for Dubois's nephew and one for a certain Chevalier Schaub; and two sketches by LaPenaye, one of the cardinal's head, and the other a portrait bust. (LaPenaye, also spelled La Panaye, Lapanaye, or La Penal, was Rigaud's assistant; see E. Bénézit, *Dictionnaire des Peintres* . . . , V, 1952, 407).

A nineteenth-century copy, now in the Château de Versailles, by the painter Charles Lefebvre (1805–1882), shows only the bust of the cardinal; it is probably based on one of the above copies—perhaps the sketch by LaPenaye

Figure 52a. *Portrait of Cardinal Dubois.* Engraving after Rigaud, 48.7 x 35.9 cm. Pierre-Imbert Drevet, French, 1697–1739. Gift of Mr. and Mrs. A. Dean Perry in memory of Julia Raymond, and Gift of Miss Helen B. Falter. CMA 77.50.

(Lurie, 1967, p. 233, n. 12). This painting may be the one that Alfred Sensier saw at Versailles and mentioned in his *Journal de Rosalba Carriera pendant son séjour à Paris en 1720 et 1721* (Paris, 1865, p. 268) under the name "Mazis" (Samuel or Jean-Baptiste Masse?). There is, however, no record of a copy after Rigaud's *Portrait of Cardinal Dubois* at Versailles other than that by Lefebvre.

The portrait is mounted in an exquisitely carved and gilded frame from the same period as the portrait itself. At the top, where the coat of arms is ordinarily placed, is a shell-like crown above a cartouche on which is carved a sheath of arrows crossed by a flaming torch. As he was not of nobility, Cardinal Dubois had no family coat of arms, and at the time the picture was painted he had not yet received the coat of arms to which his cardinalship entitled him (Lurie, 1967, p. 239, n. 18). ATL

EXHIBITIONS: Paris, Place Dauphine, Corpus Christi Day, 1723: L'Exposition de la Jeunesse (no catalogue); Berlin, Academy of Art, 1910: Exposition d'oeuvres de l'art français au XVIIIe siècle, cat. no. 246 (deluxe ed., Paris, 1910, pp. 36, 63, cat. no. 119, pl. 63); New York, Wildenstein & Co., 1962: The Painter as Historian, cat. no. 35; CMA, December 1967: Year in Review, cat. no. 64; Toledo (Ohio) Museum of Art, Art Institute of Chicago, and National Gallery of Canada (Ottawa), 1975/76:

The Age of Louis XV, French Painting 1710–1774, cat. no. 86, pp. 66, 67, pl. 26 (catalogue by Pierre Rosenberg; French ed., cat. no. 86, pp. 71, 72, pl. 26).

LITERATURE: Emile Bellier de la Chavignerie, "Notes pour servir a l'Histoire de l'exposition de la Jeunesse," *Revue Universelle des Arts*, XIX (1864), 61; *Journal de Rosalba Carriera pendant son séjour à Paris en 1720 et 1721*, ed. Alfred Sensier (Paris, 1865), p. 268 (1722 exhibition date incorrect; should read 1723); Wilhelm von Bode, *Gemäldesammlung des Herrn Rudolf Kann in Paris* (Vienna, 1900), no. 88, pl. 88; Emile Michel, "La galerie de M. Rodolphe Kann," *Gazette des Beaux-Arts*, XXV (1901), 503; Auguste Marguillier, "La Collection de M. Rodolphe Kann," *Les Arts*, II, no. 15 (1903), 2, illus.; Marc Furcy-Raynaud, *Nouvelles archives de l'art français*, third series, XIX (Paris, 1904), 312–15; Prosper Dorbec, "L'Exposition de la Jeunesse au XVIIIᵉ siècle," *Gazette des Beaux-Arts*, XXXIII (1905), 460; [Sedelmeyer Gallery], *Catalogue of the Rodolphe Kann Collection* II (Paris, 1907), 66, pl. 156; "Esposizione di opere d'arte francese del settecento a Berlino," *Rassegna d'arte*, X (April 1910), 59; J. Roman, *Le Livre de raison du peintre Hyacinthe Rigaud* (Paris, 1919), p. 195, n. 1, and pp. 233, 284; Ann Tzeutschler Lurie, "Hyacinthe Rigaud, *Portrait of Cardinal Dubois*," CMA *Bulletin*, LIV (1967), 230–39, figs. 1, 2, 8, and color illus. p. 229; Lurie, "Rigaud's *Portrait of Cardinal Dubois*," *Burlington Magazine*, CXVI (1974), 667–68, illus. p. 669; Lurie, "A Note on Rigaud's *Portrait of Cardinal Dubois*," CMA *Bulletin*, LXII (1975), 277–79, figs. 1, 2; CMA *Handbook* (1978), illus. p. 175.

HUBERT ROBERT

1733–1808

Hubert Robert was born in Paris in 1733. At age seventeen he entered the studio of Michel-Ange Slodtz (1705–1764), from whom he learned about Rome and the artists working there. In 1754, by virtue of his father's employment on the staff of the Comte de Stainville (the future Duc de Choiseul), he traveled to Rome in the comte's entourage. As a result of Choiseul's influence, Robert was able to study under Charles Natoire (1700–1777), then director of the French Academy in Rome. Among his early patrons were the Marquis de Marigny, Superintendent of Royal Buildings, and the Bailli de Breteuil, ambassador to Malta. As early as 1754 Robert showed a preference for painting architectural scenes. In Rome he came under the influence of Giovanni Battisti Piranesi (1720–1778) and Giovanni Paolo Panini. From 1759 to 1762, as a *pensionnaire* of the French Academy, he sketched and painted buildings and landscapes in the regions of Naples and Tivoli. During the following three years he visited Florence and other Italian cities. In 1765 he returned to Paris, and in the following year was both accepted as an architectural painter and made a full master of the Royal Academy in a single session. His reception piece was the *Port de Ripetta à Rome* (Paris, Ecole des Beaux-Arts). In 1767 he began to exhibit at the Salon, contributing regularly until 1798. He was designer of the king's gardens until 1781. He was given lodgings in the Louvre until 1806, when Napoleon evicted all of the Louvre's artist-residents. In 1784 he was nominated curator for the new installation in the *grande galerie* of the Louvre, but the project was interrupted by the Revolution. In 1795 he was appointed with his friend Fragonard and the sculptor Augustin Pajou (1730–1809) to the Conservatoire du Muséum National. In 1796 Robert devised a daring plan for the overhead lighting of the Louvre's *grande galerie*, which was eventually adopted, but not until the mid-nineteenth century.

Robert's architectural scenes are animated by his often exaggerated perspective, dramatic lighting, free brushwork, and casual disposition of figures. His extensive production, which has yet to be catalogued, included genre, landscape, occasional portraits, and etchings, as well as numerous prints after his drawings and paintings. More than a thousand drawings were recorded in his estate.

| 53A | *Interior of the Colonnade of St. Peter's at the Time of the Conclave* | 76.97 |
| 53B | *The Grotto of Posillipo with Imaginary Architecture* | 76.98 |

Canvas (oval), 43 x 34 cm (each). Inscribed on the back of original canvas (53A only): Mʳ de/Laferté.

Collections: Denis-Pierre Papillon de la Ferté; Marius Paulme (sale: Paris, Galerie Georges Petit, November 22, 1923, nos. 76 and 77, to Henri Boudonneau); Henri Boudonneau, Paris, until 1949; René Boudonneau (son of Henri), until 1961; Mme S. A. Boudonneau (wife of René), Geneva (sale: Christie's, London, December 13, 1974, no. 146 [pair], to Cailleux); [Cailleux, Paris].

Mr. and Mrs. William H. Marlatt Fund, 1976.

The *Interior of the Colonnade . . .* is in very good condition. The very thinly painted brown in the foreground arch of *The Grotto of Posillipo . . .* has been slightly abraded by prior cleanings. The pictures were lined by Cailleux and are in their original frames.

The *Interior of the Colonnade . . .* was based partly on a sanguine drawing, signed, and dated 1758 (Figure 53a), formerly in the collection of Marius Paulme (present whereabouts unknown), which the artist must have made on the spot during the conclave that elected Pope Clement XIII. Numerous elements in the lower left of the painting correspond roughly to those in the drawing. The painting shows the colonnade considerably more weathered but repeats fairly closely the wooden partition, cannon, flag, drum, and dog in the drawing. To the right in the painting a soldier and beggar cast dice. One of the onlookers is a soldier in ancient Roman armor, a figure often used by Panini and Salvator Rosa to evoke the antique.

The companion picture, *The Grotto of Posillipo . . .*, reveals the more inventive side of Robert. The actual grotto was a cavernous tunnel over two thousand feet long, cut into volcanic tufa in Roman times and since enlarged. It was repaved and reinforced with arches under Charles III

Figure 53A.

Figure 53B.

(ruled Naples 1734–59), but it never was the elegant thoroughfare with engaged columns, coffered barrel vaulting, and classical architrave that Robert created in a sanguine drawing of 1760, known from a *contre-épreuve* in Besançon (Figure 53b); nor was it ever the less elaborate but imposing passageway in the Museum painting. In another version (present whereabouts unknown; Cailleux, 1975, p. xii, illus.)—apparently executed during the artist's trip to Naples in 1760—Robert painted the grotto to look more primitive than it actually was, with no supporting arches at all; this picture includes the back view of a woman carrying a basket, which is repeated in the Museum's *Grotto*.

Another version of the *Grotto* (La Fère, Musée Jeanne d'Aboville) is from a viewpoint closer to the end of the tunnel, where figures are starkly silhouetted against the light. The figures in the Museum version, on the other hand, are modeled by a second light source, which is not revealed in the painting but can be explained by the presence of light shafts in the actual grotto.

The Museum pictures were painted in the 1760s and have always been together. They were exhibited with twelve other pictures and various drawings by Robert at the Salon of 1769, where they were sketched by Gabriel de Saint-Aubin. These cabinet pictures would have had a special appeal to a connoisseur such as Papillon de la Ferté, former owner of the paintings, enlightened collector, and compiler of a book on artists' lives. He must have recognized the subtle degree of ruin that Robert added to Bernini's colonnade, and he would have appreciated the grandly imaginative inventions of Renaissance architecture which Robert added to the grotto. W S T

EXHIBITIONS: Paris, Salon of 1769, nos. 95 and 96; Paris, Galerie Charpentier, June 1922: Hubert Robert et Louis Moreau, cat. nos. 31 and 32; Paris, Galerie Cailleux, 1975: Eloge de l'ovale, cat. nos. 26 and 27, illus.; CMA, February 1977: Year in Review, cat. nos. 41 and 42, illus.

LITERATURE: C. Gabillot, *Hubert Robert et son temps* (Paris, 1895), pp. 110, 273; Emile Dacier, *Catalogues de Ventes et Livrets de Salons illustrés par Gabriel de Saint-Aubin*, Vol. II: *Livret du Salon de 1769* (Paris, 1909), 79 (under page 19, nos. 95 and 96); Jean Cailleux, "L'Art du Dix-huitième Siècle—Hubert Robert's Submissions to the Salon of 1769," *Burlington Magazine*, XXXII (1975), suppl., pp. i–xvi, illus. figs. 2, 3, 13, colorplates I and II; CMA *Handbook* (1978), illus. p. 187 (both pictures).

Figure 53a. *The Interior of the Colonnade of St. Peter's at the Time of the Conclave*. Red chalk, dated 1758. Robert. Present whereabouts unknown.

Figure 53b. *View of a Palace in Rome*. Counter proof of red chalk drawing, 56 x 42 cm, dated 1760. Robert. Bibliothèque Municipale, Besançon, France.

PIERRE ROUSSEAU and others
1751–1829

The son of an architect from Nantes, Pierre Rousseau studied in Paris with the architect Nicolas-Marie Potain (1716/17–ca. 1790). Although unsuccessful in the Prix de Rome competition, Rousseau was nevertheless sent to Rome in 1773 on the strong recommendation of Potain. He remained at the French Academy two years, returning for reasons of health in 1775. Potain immediately took Rousseau into his architectural practice and assigned him the tasks of building a Theatine convent and fulfilling a commission for the Baron de Montmorency. Rousseau married Potain's eldest daughter in 1777. Potain was appointed controller of building at Fontainebleau in 1777; he named his son-in-law inspector there in 1784. By that time Rousseau had almost completed a private house for Prince Frédéric-Othon of Salm-Kyrbourg, commissioned in 1782 (burned during the Commune). As Potain's health declined, Rousseau became increasingly responsible for plans, contracts, and decoration at Fontainebleau. The remodeling of the king's and queen's rooms began in 1785. The decoration of what is now the emperor's bedroom and the boudoir of the queen is substantially Rousseau's design, executed by Michel-Hubert Bourgeois (died 1791) and Jacques-Louis-François Touzé (died 1806). Evidence for the role of Pierre Rousseau at Fontainebleau was advanced by Colombe Samoyault-Verlet ("Les travaux de Pierre Rousseau à Fontainebleau," *Antologia di Belle Arti*, no. 2, June 1977, pp. 157–69), who rejected the traditional attribution of the Fontainebleau decorations to Jean-Siméon Rousseau (born 1747), called Rousseau de la Rottière.

54 Decorative Paintings on Canvas (in pairs) — 42.2–42.11

A	42.2	264.2 x 85.1 cm.
B	42.3	264.2 x 85.1 cm.
C	42.4	264.2 x 52.7 cm.
D	42.7	264.2 x 48.5 cm.
E	42.5	264.2 x 55 cm.
F	42.6	264.2 x 55 cm.
G	42.8	264.2 x 26 cm.
H	42.10	264.2 x 26 cm.
I	42.9	264.2 x 33.7 cm.
J	42.11	264.2 x 34.3 cm.

55 Overdoor Paintings on Canvas — 42.18–42.20, 44.466

A	42.18	52.1 x 151.1 cm.
B	42.19	52.1 x 151.1 cm.
C	42.20	52.1 x 151.1 cm.
D	44.466	52.1 x 151.1 cm.

56 Double-leaf Doors with Painted Wood Panels — 42.12–42.17, 44.467, 44.468

A	42.12 and 13	274.3 x 62.9 cm.
		274.3 x 65.1 cm.
B	42.14 and 15	274.3 x 63.2 cm.
		274.3 x 64.1 cm.
C	42.16 and 17	274.3 x 63.8 cm.
		274.3 x 65.1 cm.
D	44.467 and 468	274.3 x 62.9 cm.
		274.3 x 65.1 cm.

Provenance: Said by Wildenstein & Co. (letter of January 19, 1942) to have come from 193 Boulevard St. Germain, Paris (known at the time as 21 and 23 rue St. Dominique), a private house, supposedly built after plans by Ange-Jacques Gabriel (1698–1782).

Collections: Comte Hippolyte Terray, owner of the house from about 1830; Marquise de Belleuf (daughter of Comte Terray); Comte de Waresquiel; Arthur Veil-Picard; [Wildenstein & Co., Paris]; Grace Rainey Rogers, purchased in 1913.

Gift of Grace Rainey Rogers in memory of her father, William J. Rainey, 1942 and 1944.

Decorative paintings: Polychrome human figures, sphinxes, and floral decorations are painted on a cream-colored background. Grisaille figures against simulated marble imitate antique relief sculpture. Details and highlights throughout are in gold leaf. There is a pronounced general craquelure, but the paint surface is in good condition, with minor scattered losses. Five of the paintings (54A, 54C, 54D, 54E, 54F) were cleaned and lined in 1977 and 1980. On two (54C and 54D), overpaint was removed that had concealed the bare legs of the polychrome winged female figures and the wings (in 54C) and bow (in 54D) of the grisaille cupids.

Overdoor paintings: Light grisaille figures are painted on a terra-cotta-colored background. There is pronounced craquelure throughout, but the paint surface is in good condition. One of the paintings (55C) was cleaned and lined in 1977.

Double-leaf door panels: Grisaille figures are on blue, terra-cotta, or marbleized backgrounds and enframed with borders in gold. The main figures and decorations are in gold over a warm reddish ground, probably at one time suggesting mahogany (as in the paintings in the queen's boudoir at Fontainebleau). This warm tone has been carefully scraped away in all areas that are free from decoration, exposing an ivory-colored lower paint layer. One pair of panels (56B) was cleaned, and areas of molding were regilded, in 1980.

The most prominent polychrome figures in the decorative paintings dance or hold objects related to wine festivals or celebrations. Many of the grisailles describe festive processions or ceremonies of sacrifice in the antique manner. The medallions in two of these tall paintings (54E and 54F) depict a musical competition; in another (54J), a cupid plays the cymbals, and the lyre and triangle appear among the decorative motifs.

Figure 54A.

Figure 54B.

Figure 54C.

Figure 54D.

Figure 54E.

Figure 54F.

Figure 54G.

Figure 54H.

Figure 54I.

Figure 54J.

135

Figure 55A.

Figure 55B.

These canvases would have been set into the wood paneling of a room in pairs, flanking such features as a fireplace, mirror, window, or door. Since there is an odd number of pairs and the pairs are of different widths, it is possible that these paintings are only part of the original decoration. The four doors, however, may well be the original number.

The decorative paintings and door panels were probably designed by Pierre Rousseau and painted by more than one artist, possibly Michel-Hubert Bourgeois and Jacques-Louis-

François Touzé, who painted the figures and arabesques in the queen's chambers at Fontainebleau about 1786. In 1787 Bourgeois also executed three double doors in gilded grisaille on false mahogany for the queen's boudoir. The Cleveland paintings are on canvas, while the paintings in the queen's boudoir are on wood, but the similarities are nonetheless striking. The doors in the boudoir and also in the *salon des jeux*, for example, were painted to imitate mahogany with gilded grisaille decorations; similarly, the

136

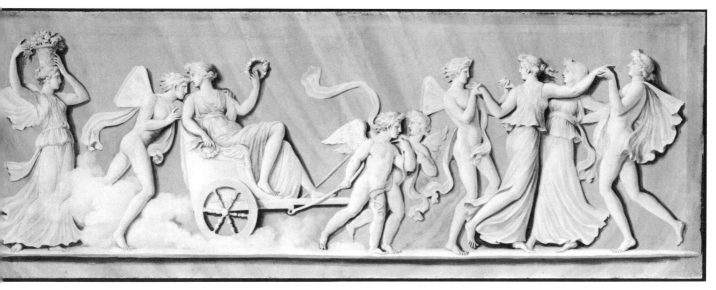

Figure 55C.

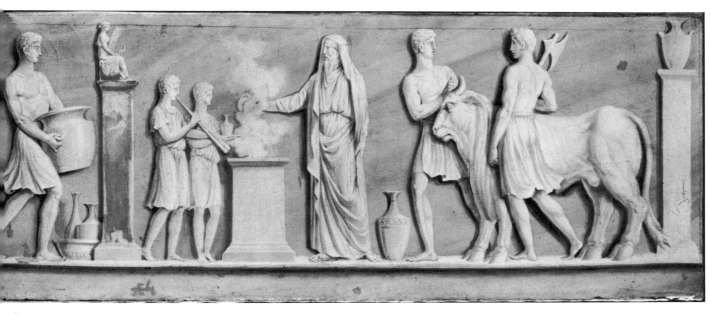

Figure 55D.

figures and decorations in the Cleveland doors were painted over a striated, warm reddish ground that was probably meant to imitate wood. At some point, however, this reddish color was carefully scraped away, leaving the polychrome design against a cream-colored ground, perhaps to give the doors a light background similar to the canvases. The grisaille figures in the Cleveland paintings are especially close to the decorations in the *salon des jeux*, but in general the Museum pictures are less playful and more restrained.

There are still closer resemblances between the Museum pictures and the decorations in the salon of the Hôtel Hostein (later Duc de Rivoli) which were painted in 1792, and those in the *petit boudoir* of the Hôtel de Brancas, 6 rue de Tournon, painted after the Revolution. The blunt-winged sphinxes; the staring, winged females; and the grisaille figures of the Cleveland pictures resemble those from the Hôtel Hostein, while the simplicity, regular composition, and lightness of the floral border are close to the Hôtel de Bran-

137

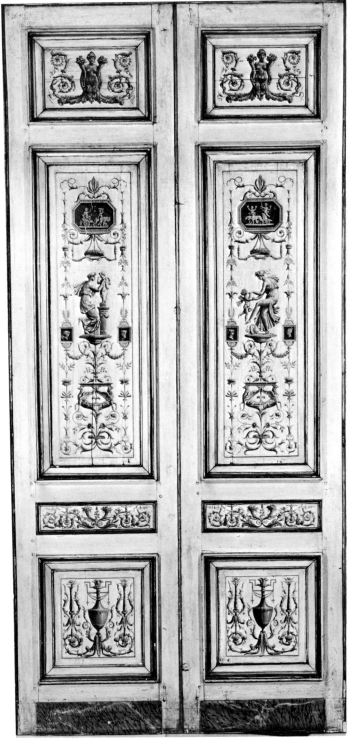

Figure 56A.

Figure 56B.

138

gure 56C.

Figure 56D.

cas decorations. The similarity of the grisaille cameo style in both the Museum and Hôtel de Brancas decorations is particularly striking.

The painter of the polychrome figures in four of the decorative paintings (54A, 54B, 54E, and 54F) may also have executed the figures on the doors of the grand salon in the house built by the architect François-Joseph Belanger (1744–1818) at 20 rue Joubert. The poses of the single female figures are comparable, as is their fluttering drapery. The original interior of this house, built in 1787, was destroyed in the Revolution and redecorated in the Directoire style in the 1790s. This more severe, post-Revolutionary, linear style is quite close to that of the Museum's decorative paintings.

The Museum's overdoor canvases, which imitate stucco relief, were inspired by the overdoors in the queen's boudoir at Fontainebleau and Compiègne, painted by Piat-Joseph Sauvage (1744–1818). The Sauvage overdoors reflect the popular fashion of grisaille imitation of terra-cotta relief sculpture, although the Cleveland overdoors are less sculptural and not as robust as those of Sauvage. The Museum overdoors may be by the same hand that painted the grisaille figures in the border of the ceiling of the *salon des jeux* at Fontainebleau. The central scene of the ceiling is signed by Jean-Simon Barthélemy (1742/3–1811), but it is not clear whether the large and small grisaille figures in the border were done by Barthélemy or by Bourgeois, assisted perhaps by Touzé. No more conclusive attribution has yet been made for the Museum canvases. WST

EXHIBITIONS: None.

LITERATURE: William M. Milliken, "The Rousseau de la Rottière Room," CMA *Bulletin*, XXIX (1942), 47–50; Colombe Samoyault-Verlet, "Les Travaux de Pierre Rousseau à Fontainebleau," *Antologia di Belle Arti*, no. 2 (June 1977), pp. 157–69.

GABRIEL DE SAINT-AUBIN
1724–1780

Gabriel de Saint-Aubin was born into a respected Parisian bourgeois family in 1724. His father was embroiderer to the king, and his five brothers, two sisters, and a sister-in-law were all successful artisans—among them, porcelain painters, craftsmen, and engravers. By 1750 Gabriel was a student at the Royal Academy, studying under Etienne Jeaurat (1700–1789), Hyacinthe Colin de Vermont (1693–1761), and François Boucher. Although he never became a member of the Royal Academy, he was a member of the less prestigious Academy of St. Luke. Three times he competed, unsuccessfully, for the Prix de Rome—in 1752, 1753, and 1754. Of the four or five thousand drawings, some eight paintings, etchings, books, and papers left in his studio at his death in 1780, the gold medal of the Academy of St. Luke was the only object he bequeathed, and that to his sister. His older brother Charles-Germain (1721–1786), the chronicler of the family history, treated him with affection and sympathy but described him as eccentric, unsociable, and untidy, adding that it was fortunate he remained a bachelor. Gabriel was one of the most versatile chroniclers and prolific illustrators of his time. Wandering through the streets of Paris, he constantly recorded in pencil or crayon the spectacle of Parisian life. He haunted art sales and filled sales catalogues with drawings in the margins. He also designed letterheads, vignettes, and decorations for books; the most notable example of the latter was a book of poems by his friend Sedaine.

57 *Laban Searching* 65.548
 for His Household Gods

Canvas, 45.6 x 57.3 cm.
Collections: [Victor D. Spark, New York]; Ruth and Sherman E. Lee, Cleveland.

Gift of Ruth and Sherman E. Lee in memory of their parents, George B. Ward, and Emery and Adelia Lee, 1965.

The original tacking margins are missing, but the fabric cusping on three sides of the canvas indicates that the dimensions have not been greatly reduced. The raised edges of paint due to cupping have been abraded throughout the design but most severely in the dark tonalities in the bottom fourth of the painting. The overall extent of retouching is moderate; the largest area is close to the left edge, near the center.

The subject as prescribed by the French Academy is taken from Genesis 31:33–35. In the picture Laban confronts his daughter Rachel, who is leaning back against her husband Jacob, concealing the house idols which she had taken with her to gain the right to her first-born. Her brother is searching through her trunk.

This painting was the preparatory sketch for a large canvas, now in the Louvre (Figure 57a), which was Saint-Au-

Figure 57.

bin's entry in the competition against Nicolas Brenet and
Antoine Renou for an opening in the Ecole Royale des
Elèves Protégés in 1753. The Cleveland sketch won him
first place in the preliminary competition, but the large
canvas did not succeed. Had he won in the final contest he
would have been able to study in Rome.

The large canvas was still in his studio when he died in
1780, at which time it was sold. It was then lost for over a
hundred years until it was recognized by Max Kann in the
collection of Alphonse Trézel, Paris, where it had been at-
tributed to Fragonard (sale: Galerie Jean Charpentier, Par-
is, May 17, 1935, no. 53). Kann recognized it because of its
relationship to the etching (Figure 57b), which exists in
three states (see Emile Dacier, *L'Oeuvre gravé de Gabriel
de Saint-Aubin*, Paris, 1914, pp. 61–62, no. 11), and to a

drawing in the Kupferstichkabinett, Staatliche Museen,
Berlin (Figure 57c). Paul Wescher, not knowing of the exis-
tence of the Cleveland sketch, wrote that the drawing was
not a preparatory drawing but a copy of the final Louvre
painting, closely following an engraving ("Les Maîtres
Français du XVIII Siècle au Cabinet des Dessins de Berlin,"
Gazette des Beaux-Arts, XX, 1934, 355).

The Cleveland sketch was discovered and purchased in
the art market in New York by Sherman E. Lee in 1964 and
was subsequently given to the Museum. With its pearly
colors and buoyant design, the Cleveland painting is more
successful than the final version in Paris in the Louvre.
Although the figures and faces in our painting are more
sketchy, the composition reads more clearly and is more
vibrant. NCW

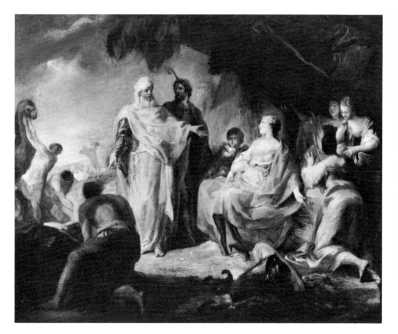

Figure 57*a*. *Laban Searching for His Household Gods*. On canvas,
111 x 144 cm. Saint-Aubin. Musée du Louvre, Paris.

Figure 57*b*. *Laban Searching for His Gods*. Etching, 19.4 x 25.6 cm.
Saint-Aubin. The Art Museum, Princeton University.

Figure 57*c*. *Laban Searching for His Gods*. Drawing, 15.2 x 21.4 cm.
Saint-Aubin. Staatliche Museen Preussischer Kulturbesitz,
Kupferstichkabinett, Berlin. Kdz no. 14719.

EXHIBITIONS: None.

LITERATURE: Henry S. Francis, "Annual Report for 1965: Paintings,"
CMA *Bulletin*, LIII (1966), 140; Wolfgang Stechow, "Bartolomé Esteban
Murillo: *Laban Searching for His Stolen Household Gods in Rachel's
Tent*," CMA *Bulletin*, LIII (1966), 374, 377 n. 27, fig. 8; Louise S. Rich-
ards, "Gabriel de Saint-Aubin: *Fête in a Park with Costumed Dancers*,"
CMA *Bulletin*, LIX (1967), 217; Victor Carlson, Ellen D'Oench, and
Richard S. Field, *Prints and Drawings by Gabriel de Saint-Aubin 1724–
1780* (exh. cat., Middletown, Connecticut, 1975), p. 39; Pierre Rosen-
berg, *The Age of Louis XV—French Painting 1710–1774* (exh. cat., To-
ledo, Ohio, 1975), p. 7 n. 12, p. 25; Rosenberg, "La Donation Herbette,"
La Revue du Louvre et des Musées de France, XXVI (1976), 96–97, 98 n.
17, fig. 8; CMA *Handbook* (1978), illus. p. 182.

JEAN-FRANÇOIS DE TROY
1679–1752

De Troy was trained by his father, François de Troy, who sent him to Rome in 1699 in spite of his failure to win the Prix de Rome (he had won the second prize in 1697). Through the patronage of the Marquis de Villacerf he received a four-year stipend at the French Academy in Rome, at that time directed by Le Brun's pupil, René-Antoine Houasse. He traveled in Italy before returning to France in 1708, the year he became a member of the Royal Academy upon submitting his *Apollo and Diana Transfixing the Children of Niobe with Arrows* (Montpellier). In 1716 he became adjunct professor and in 1719 was made full professor. He participated in the decoration of the Hôtel du Grand Maître in Versailles and, with his main rival François Lemoine, in the decoration of the royal quarters at Versailles. He entered his *Bath of Diana* (Museum, Nancy), painted in 1726, in the *concours* in competition with Lemoine; both won, sharing equally the award of five thousand livres. De Troy received a commission to design tapestries for the Manufacture des Gobelins before returning to Rome to accept the directorship of the French Academy in 1738 (replacing the late Nicolas Vleughels). In 1774 he also became head of the Academy of St. Luke in Rome. Wealthy through his marriage, de Troy played a leading role socially as well as artistically. However, in 1751 his fortunes changed; the Marquis de Marigny, brother of Mme de Pompadour, ousted him as head of the French Academy, appointing Charles Natoire in his place. De Troy returned to Paris and died shortly thereafter.

58 *Pan and Syrinx* 73.212

Canvas, 106 x 139 cm. Signed and dated on rock in foreground: De Troy 1720.

Collections: Jean-Antoine Rigoley de Juvigny (1715–1788); Alfred Beurdeley (sale: Hôtel Drouot, May 25, 1883, no. 56, "Ecole française, deux pendants," *Paysage avec baigneuses* and *Pan et Syrinx*); Gustave Chaix d'Est-Ange II (son of Gustave Chaix d'Est-Ange, 1800–1876); Mme Chaix d'Est-Ange, née Sipière (wife of Gustave Chaix d'Est-Ange II); Gustave Chaix d'Est-Ange III (sale: collection of Gustave Chaix d'Est-Ange III, with some works belonging to M. le Comte X, Galerie Charpentier, Paris, December 11, 1934, lot 46, with annotation of name "Page"); Mme G. Patino de Ortiz-Linares; George Ortiz (son of Mme Ortiz-Linares) (sale: Christie's, London, June 29, 1973, no. 93); [Herner Wengraf/Old Masters Galleries, London].

Mr. and Mrs. William H. Marlatt Fund, 1973.

The painting has been relined and is in very good condition. It was restored by Gabrielle Kopelman in 1973, prior to acquisition by the Museum. There are minor abrasions along the bottom edge, toward the left, and scattered flake losses which have been retouched.

The subject is from one of Ovid's *Metamorphoses* (I, 689–713). As the story goes, the river god Ladon saves his daughter Syrinx from the pursuit of Pan by transforming her into reeds. Dated 1720, the Cleveland painting is the earliest-known of de Troy's *Pan and Syrinx* paintings. Its composition links de Troy with the tradition of the Goltzius school and its seventeenth-century followers, such as Hendrick van Balen I.

The Cleveland *Pan and Syrinx* was engraved by Benoît-Louis Henriquez (1732–1786) in 1769. An inscription on the plate reads *peint par DeTroy en 1720* (Figure 58a). Until the rediscovery of the Cleveland painting, it had been assumed that Henriquez's engraving was after another *Pan and Syrinx* by de Troy—one sold in Paris on April 9, 1764 (no. 107), measuring 89 x 73 cm (Yves Bruand and Michèle Hébert, [*Bibliothèque Nationale*] *Inventaire des Fonds Français, Graveurs du XVIIIᵉ Siècle*, XI, Paris, 1970, 323, no. 25). As Talbot (1974, p. 259, n. 7) pointed out, the engraving, which is horizontal, could not have been after this other version, which is vertical and is substantially smaller than the horizontal Cleveland canvas.

The engraving bears the coat of arms of the painting's original owners, the family of Jean-Antoine Rigoley de Juvigny. The same coat of arms also appears on a pendant engraving by Henriquez (Bruand and Hébert, *op. cit.*, p. 323, no. 24) after *Galathée sur les eaux* (Figure 58b) painted by Jean-Baptiste Nattier the Elder (1696–1726) in 1724; this painting was thought to be a pendant to the Cleveland *Pan and Syrinx* when it appeared in the 1883 sale of the Beurdeley collection as *Paysage avec baigneuses* (see Collections above). The pendant engraving is fully dedicated to its owner, Jean-Antoine Rigoley de Juvigny, but a like dedication is missing from Henriquez's *Pan and Syrinx* engraving. M. Rigoley de Juvigny apparently had acquired both paintings before he left Paris in 1760 to become a member of the Parliament of Metz.

There is a close compositional relationship between the two paintings. They are close in size (*Galathée* measures 105 x 137 cm), and it is quite possible that they did serve as pendants. Nattier's *Galathée*, in fact, may even have been painted with de Troy's *Pan and Syrinx* in mind.

In the 1883 Beurdeley sale only the Cleveland *Pan and Syrinx* appears to have been sold. Nattier's *Galathée* reappeared in a later sale of the Beurdeley collection, on May 7, 1920 (no. 177). It is possible that the Cleveland painting entered the collection of Gustave Chaix d'Est-Ange II after the sale of 1883. It was in that collection in 1907, according to Baron Josef du Teil, who married into the family. It remained in the family's collection until 1934.

Other versions of the subject by or after de Troy differ in size and format from the vertical version listed in the Paris sale of April 9, 1764. One, commissioned with an *Apollo and Daphne* in 1741 by Christian VI of Denmark, was destroyed in a fire at Castle Christiansborg in 1794. A drawing of the Christiansborg version by Niels Eigtved, dated 1748 (kindly provided by Svend Eriksen, Museum of

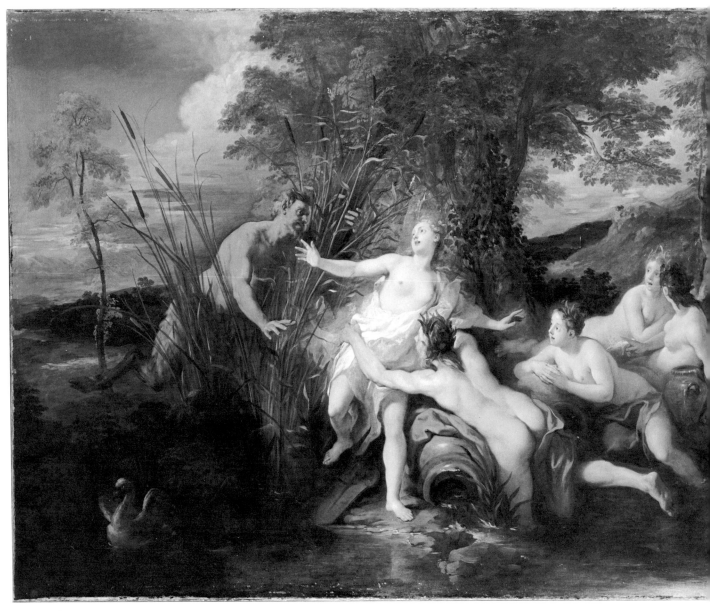

Figure 58.

Decorative Arts, Copenhagen, on March 4, 1974), shows that the composition differed from that of the Cleveland painting and of two other closely related renderings of the subject—one in a private collection in England, dated 1751 (Talbot, 1974, fig. 15), and the other in the Danish castle Frederiksdal, after an original of 1740 (*ibid.*, fig. 14). The Frederiksdal version, like the Christiansborg version, had a pendant, *Apollo and Daphne* (dated 1740), though both Frederiksdal paintings differed considerably from their Christiansborg counterparts. However, the *Pan and Syrinx* in England and the one in Frederiksdal are related; both compare closely to an engraving by François Hutin (1686–

1758) (Bruand and Hébert, *op. cit.*, p. 552, no. 11, and under no. 9).

The Cleveland *Pan and Syrinx* dates from one year after de Troy's appointment as full professor of the Royal Academy. In style and composition it is closely related to the *Bath of Diana* of 1718 (*Aspects of French Academic Art, 1680–1780*, exh. cat., London, 1977, no. 8, illus.), which, in turn, is an early precursor of the *Bath of Diana* of 1726 in Nancy.

The Cleveland Syrinx served as a model for many other related figures, like the one in *Lot and His Daughters*, dated 1722 (Orléans, Musée de Peinture et de Sculpture). Another

Figure 58a. *Pan and Syrinx*. Engraving after the painting by De Troy. Benoît-Louis Henriquez, French, 1732–1786. Bibliothèque Nationale, Paris.

Figure 58b. *Galathée sur les eaux*. Engraving after a painting by Jean-Baptiste Nattier the Elder. Henriquez. Bibliothèque Nationale, Paris.

figure, the river god Ladon (protectively reaching out for Syrinx in the Cleveland painting), only slightly altered, served as Salmacis in de Troy's *Salmacis and Hermaphrodite* of ca. 1730 (Paris, private collection; *La Revue du Louvre et des Musées de France*, XXVI, 1976, 95, fig. 5).

ATL

EXHIBITIONS: CMA, February 1974: Year in Review, cat. no. 44, illus.

LITERATURE: Baron Josef du Teil, "La Collection Chaix d'Est-Ange," *Les Arts*, VI, no. 67 (1907), 18; William S. Talbot, "Jean-François de Troy, *Pan and Syrinx*," CMA *Bulletin*, LXI (1974), 250–59, illus. pp. 249 (color), 250–51; Pierre Rosenberg, *The Age of Louis XV—French Painting 1710–1774* (exh. cat., Toledo, Ohio, 1975), p. 75 (French ed., p. 79); CMA *Handbook* (1978), illus. p. 176.

PIERRE HENRY DE VALENCIENNES

1750–1819

Valenciennes was born in Toulouse in 1750. He studied at the Royal Academy under the history painter Jean-Baptiste Despax (1709–1773) and the landscape painter Jean Pierre Rivaltz (1718–1785). While at the Academy, he was exposed to the landscape tradition of seventeenth-century France and the work of Nicolas Poussin. Valenciennes first visited Italy in 1769. By 1771 he was in Paris, where he entered the school of Gabriel François Doyen (1726–1806) and gained an understanding of perspective from Joseph Vernet (1714–1789). He worked in Rome and environs from 1777 to 1785 and visited Naples and Sicily in 1779. By way of Florence, Lombardy, Geneva, and Lyons, he returned for a brief visit to Paris in 1781. During this visit Joseph Vernet corrected Valenciennes's method of perspective, as Valenciennes himself explained in the foreword to his treatise on perspective and aesthetics entitled *Elémens de perspective pratique, à l'usage des artistes, suivis de réflexions et conseils à un élève sur la peinture et particulièrement sur le genre de paysage* (Paris, 1799–1800). In deference to public taste, he painted mostly landscapes with historical, classical, and mythological subjects, thereby abandoning the brilliant experimental compositions of his early travels. In 1787 he became a member of the Royal Academy in Paris and exhibited at the Salon for the first time. He was a highly respected teacher, who maintained that historical landscape was a distinct category of painting which demanded knowledge of history, literature, science, and nature. Among his pupils were Jean Victor Bertin (1767–1842) and Achille-Etna Michallon (1796–1822), the teachers of Corot. During the French Revolution, Valenciennes apparently took a discreet position and eventually withdrew into voluntary seclusion. He continued to exhibit regularly at the Salon. In 1812 he was appointed professor of perspective at the Ecole Impériale des Beaux-Arts. In 1815 he was made a member of the Legion of Honor. After 1810 he exhibited only one painting at the Salon—in 1814. He spent his last years preparing a revised edition of his *Elémens*, which was published in Paris in 1820, a year after his death.

Figure 59.

59 *View of Rome* 70.55

Paper mounted on pulp board, 19.5 x 38.9 cm.
Collections: Walter Pach; Raymond Pach, Canton, North Carolina.
Purchase from the J. H. Wade Fund, 1970.

The painting is on cream-colored paper which is attached
to a two-millimeter-thick pulp board. The painting had
been cleaned in the past. There are flake losses in the paint
film, especially in the foliage on the left side, and abrasions
along the edges where gummed tape was removed some-
time in the past.

Valenciennes, who was virtually ignored in the nineteenth
century largely because of the pedantic historical landscapes
he painted after his return from Italy, is now generally re-
spected for his earlier landscape studies—scenes of impor-
tant historical sites, some of them aerial perspectives, and
all studies of form as affected by light. These were the in-
novative contributions that bridged the gap between eigh-
teenth-century painters and Corot and the nineteenth-cen-
tury Romanticists and Impressionists. Indeed, former owner
Raymond Pach said (letter of November 20, 1976) that his
father, Walter Pach, originally bought the painting *View of
Rome* because it resembled a Corot.

Valenciennes proposed that a close familiarity with na-
ture was essential for the proper painting of historical land-
scape, and that preparatory studies should be made out-of-
doors, directly from the scene, and painted rapidly—within
two hours during daylight and within the half-hour near

sunrise or sunset. The Museum painting is one of the many
nature studies Valenciennes painted during his Roman so-
journ, 1777–85. Such a study was to serve as reference
while the artist painted a finished landscape with historical
figures. Half the picture is given to the sky, which Valen-
ciennes said should set the tone of a landscape. Only one-
third of the picture surface is occupied by the buildings and
massed foliage, with the principal forms defined by strong
sunlight and deep shadow—all quickly painted without
elaboration of detail. Such sparkle and immediacy of brush-
stroke appeals strongly to the modern taste for spontaneity.

Valenciennes's theories, which he clearly expressed in his
Elémens, were widely known and respected among artists.
Camille Pissarro, in a letter of December 14, 1883, to his
son Lucien (quoted by Lionello Venturi in "Pierre Henri de
Valenciennes," *Art Quarterly*, IV, 1941, 109), recommended
Valenciennes as "still the best and most practical." As a
painter, however, he has only recently been accorded the
respect he deserves. His early landscape studies were con-
sidered unfinished by eighteenth-century standards; and
they were appreciated by only a few nineteenth-century
painters, such as Odilon Redon (1840–1916), who owned
four gouaches. It was not until Vaudoyer's exhibition in
1934 (Paris, Musée des Arts Décoratifs: Artistes français en
Italie de Poussin à Renoir) that Valenciennes's work was
seriously considered by scholars and its relation to Corot
acknowledged. His work was then evaluated by Lionello
Venturi (*op. cit.*, pp. 89–100), and other exhibitions fol-

lowed: one at the Musée Paul-Dupuy, Toulouse, in 1956/57, and another at the Louvre in 1976.

Valenciennes's early drawings, gouaches, and oils from his travels in Italy were sold at a posthumous sale in Paris, Quai des Orfèvres, April 26, 1819 (an annotated copy of the sale catalogue is in The British Museum Library, London). These works apparently had been kept in his studio to be used as source material for later compositions; often he copied them exactly, a discipline he recommended in his *Elémens*. It is not known whether the Museum painting was included in this sale, nor is it known how many works were included. Geneviève Lacambre, in an excellent article, gives the most complete inventory and sources of Valenciennes's early work, which, however, does not include our painting ("Les Paysages de Pierre-Henry de Valenciennes 1750–1819," *Le Petit Journal des Grandes Expositions*, n.s., no. 30, Paris, 1976, unpaginated). Lacambre says it is impossible to determine whether the entire group at the Paris sale was acquired by M. de l'Espine, or if all the Valenciennes paintings known to have been in de l'Espine's collection were acquired at that time. In 1930 Princess Louis de Croÿ, the daughter of M. de l'Espine, gave the Louvre all but twenty of the paintings recorded by the artist himself in his notebook, "Etudes Peintes par P. de Valenciennes," folios 2, 3, and 4, recto and verso (preserved in the Cabinet des Dessins of the Louvre, inv. R.F. 12972; see Lacambre, *op. cit.*, for an inventory of the Louvre paintings). Lacambre suggests that perhaps M. de l'Espine had acquired additional Valenciennes paintings in the sale of Anne Louis Girodet-Trioson (Paris, April 11, 1825), an artist friend of Valenciennes's who lived near him in an apartment in the Louvre. About fifty oils on paper were sold from the Girodet collection, four of which were later acquired by Odilon Redon. During the second half of the nineteenth century, Lacambre points out, five paintings from the collection of M. de l'Espine entered the collection of the Bowes Museum, Barnard Castle.

The Museum painting—one of the finest of Valenciennes's early Italian studies—has not been identified with a corresponding entry in the artist's notebook, and there is no inscription on the margin, as is characteristic of many of the early works. If there is a number or any other identification on the back, it is obscured by the cardboard; the condition of the painting is stable enough at the present time that the removal of the pulp board mounting is not warranted. In any case, many of these studies were not numbered.

NCW

EXHIBITIONS: CMA, February 1971: Year in Review, cat. no. 45, illus.

LITERATURE: Paula Rea Radisich, *Eighteenth-Century Landscape Theory and the Work of Pierre Henri de Valenciennes* (Ph.D. dissertation, University of California, 1977; Ann Arbor, Michigan: University Microfilms, 1978), pp. 319, 321–22, 333 n. 98, 464, fig. 42; William S. Talbot, "Some French Landscapes: 1779–1842," *CMA Bulletin*, LXV (1978), 78–81, illus. p. 80; *CMA Handbook* (1978), illus. p. 187.

VALENTIN DE BOULOGNE (Boullogne)
1594–1632

Valentin was born in Coulommiers (Brie) in 1594. His name is at times prefaced by "Moïsé," a colloquialized version of the Italian form of Monsieur (Monsú), which was frequently given to foreign artists in Italy. According to Sandrart, Valentin settled in Rome before Vouet, who arrived in 1613. Valentin shared a studio with Douffet in 1620. He was one of the most accomplished followers of Caravaggio and his circle, being particularly close to Manfredi and Vouet. He had a strong influence on Nicolas Tournier from Toulouse, who most likely was his pupil. Valentin befriended Poussin after the latter's arrival in Rome in 1624, and the two artists shared the patronage of Cardinal Francesco Barberini. In 1629 the cardinal commissioned Valentin's most important work, *The Martyrdom of SS. Processus and Martinian*, for St. Peter's (now in the Vatican), at the same time he commissioned Poussin's *Martyrdom of St. Erasmus* (Pinacoteca Vaticana, Rome) as a companion piece. In France Valentin enjoyed the patronage of Louis XIV and Cardinal Mazarin; consequently, there are numerous works by Valentin in the Louvre and at Versailles. Valentin died at the age of thirty-eight from a fever resulting from a plunge into the Fontana del Babuino during one of his many revelries with fellow artists.

60 *Samson* 72.50

Canvas, 135.6 x 102.8 cm.

Collections: Cardinals Francesco and Antonio Barberini and heirs, Rome; Colonna di Sciarra, Rome (sale: Galleria Sangiorgi, Rome, March 28, 1899, fifth sale, no. 363, as Caroselli); Ing. Dr. Edoardo Almagià, Rome.

Mr. and Mrs. William H. Marlatt Fund, 1972.

The painting is in good condition except for some retouchings along the right and left margins and some small, scattered losses and abrasions in the red drapery of Samson. There are some residues of discolored varnish layers. Infrared photographs clearly reveal anatomical details of Samson's body beneath the blue chain mail (Figure 60a), indicating that Valentin intended to portray Samson with a bare torso, like David in a pendant painting which was recently rediscovered (Figure 60b). The blue chain mail, however, offset the red drapery and made it possible to add the golden bee clasp—the emblem of the Barberini family, who commissioned the painting—to the strap on Samson's shoulder.

The support is a moderately heavy, coarse, plain-weave fabric. A 2.5- to 4.5-centimeter-wide strip of fabric was stitched to each vertical side of the fabric before the artist attached the support to the stretcher. A selvage edge is evident along the right edge of the central piece of fabric, and the cusping is evident in the added sections. An X radiograph reveals cusping along the present top and bot-

Figure 60.

148

Figure 60a. Infrared photograph.

tom edges, which would indicate that these were the original edges. When it was purchased by the Museum, the painting had additional strips along the top and bottom edges (since removed) and measured 179 x 103 centimeters. In the 1649 inventory of Cardinal Francesco Barberini's collection (Lavin, 1975, p. 242 [III, inv. 49.676]), the measurements for *Samson* and its pendant, *David* (Collection of Michael and Jo Ellen Brunner, California), were approximately 134 x 111.5 centimeters (given as 6 x 5 palmi). In the sale in Rome in 1899 (see Exh: 1971/72, no. 72, n. 7) the measurements cited were 101 x 125 centimeters (most likely width before height). We may therefore conclude that sometime after 1899 both paintings had been enlarged, as Figure 60b demonstrates). In 1972, when Joseph Alvarez cleaned the painting, he removed the added pieces along the top (ca. 30.4 cm) and along the bottom (ca. 15.2 cm) and attached a new lining with wax-resin adhesive. A narrow wedge-shaped piece of added fabric was left along the lower edge in order to square the irregularly shaped original support. Thus, the painting was reduced to its present dimensions, 135.3 x 102.6 centimeters, which brings it closer to the measurements cited in the 1649 Barberini inventory.

Richard Spear (Exh: 1971/72; and 1972, no. 14) identified the painting as the *Samson* from the Barberini collection. The painting is mentioned in various documents from the Barberinis. The earliest, dating from December 1630, states that the first payment had been made to Valentin; and another, dating from July 1631, states that Valentin had then received the balance for his commission (Lavin, 1975, p. 43, Doc. 345). Later Barberini inventories that list the painting are somewhat confusing, however. Another inventory of Cardinal Francesco Barberini's collection taken in 1631 listed a *Samson* by "Monsú Posino" (Poussin), the description of which closely fits the Cleveland painting; it is unlike anything Poussin ever painted: "Un Sansone, che sta a sedere, con un mano che l'appoggia ad una guancia, con una pelle di leone e la mascella di cavallo" (Lavin, 1975, p. 98 [III, inv. 26–31.482] and p. 114 [III, Barb. Lat. 5635. 482]). Moreover, the *Libro Mastro* of Cardinal Francesco Barberini shows no payments of any kind to Poussin during 1631 (Vivian, 1969, p. 721). Anthony Blunt (1966), yet unaware of the *Samson* by Valentin, listed the Barberini *Samson* by "Monsú Posino" in his Poussin catalogue under "Early Records of Paintings Attributed to Poussin"; Blunt, however, referred only to the 1631 inventory and did not

Figure 60b. *David*. On canvas, approximately 134 x 111.5 cm. Valentin. Collection of Michael and Jo Ellen Brunner, California.

make reference to yet another inventory—that of Cardinal Antonio Barberini, dated January 26, 1633—in which the painting was again listed as by Poussin (Vivian, 1969, p. 722 and n. 37). Only two days later, on January 28, 1633, the *Samson* was recorded in Francesco Barberini's inventory, this time attributed to Valentin (Lavin, 1975, p. 43, Doc. 346). The discrepancy between the two January 1633 inventories cannot be explained easily, but as Vivian pointed out (in a letter dated August 23, 1976), Antonio Barberini's inventory was "a very rough draft, indeed." One may assume that the confusion between the two French artists, Poussin and Valentin, was created by the inventory keeper, and that the *Samson* referred to in all the above listings is the *Samson* by Valentin.

The *David* is first mentioned in Francesco Barberini's collection in 1627 (Lavin, 1975, p. 42, Doc. 342); it is mentioned again in the inventory of January 27, 1633, which preceded by one day the inventory that included the *Samson* (*ibid.*, p. 43, Doc. 346).

The paintings were evidently considered as pendants; they were similarly framed and are listed together in the 1649 inventory of Francesco Barberini's collection, both properly ascribed to Valentin (Lavin, 1975, p. 242 [III, inv. 49.676]). In 1738, after the death of Cardinal Francesco Barberini Giuniore, the great nephew of Cardinal Francesco Barberini (1597–1679) and son of Prince Maffeo Barberini, the *Samson* and *David* were inventoried as a pair and attributed to Andrea Camassei (1602–1649) (Arch. Barb. Ind. II, Cred. VI, Cas. 70, Maz. LXXXIX, Lett. I, No. 32; the author is grateful to Frances Vivian for this information which was related by letter of December 16, 1973). When Friedrich Wilhelm Basilius von Ramdohr saw both paintings in the Barberini Palace in 1787, he attributed *Samson* to "the Calabrese" (Preti) and *David* to Caravaggio.

During the division of the Barberini-Sciarra collection in 1812, the two paintings were separated. The *David* remained in the Barberini Palace, where it was seen by Zeri (*La Galleria Barberini*, no. 87, illus.) as late as 1954. *Samson* then became the property of the Galleria Colonna di Sciarra; it appears in an unpublished list of 1812, as fourth class, no. 73, as by Caroselli (see Exh: 1971/72, no. 72, n. 4), and again in a Sciarra inventory of 1818 (Mariotti, 1892, p. 135, no. 46, as by Caroselli). Because of the Sciarra inventory, various nineteenth-century guidebooks mention the painting with the Caroselli attribution (see Exh: 1971/72, no. 72, n. 6). The *Samson* was sold at auction in Rome in 1899 (Sangiorgi, March 28, no. 363, as Caroselli), and it entered the Almagià collection.

Stylistically the two pendants, *Samson* and *David*, belong with the *Martyrdom of SS. Processus and Martinian* (Vatican), also dating from ca. 1629 to 1630. In color, composition, and psychological depth, *Samson* is closest to *Judith with the Head of Holofernes* in the Musée des Augustins, Toulouse (Nicola Ivanoff, *Valentin de Boulogne*, I

Maestri del Colore, no. 171, Milan, 1966, pl. I), where, too, the dominant colors are Venetian red and cool blue. The compressed space in Valentin's *Judith* is characteristic of many of his single-figure compositions such as the *David*, *St. Paul* (Musée Départemental de l'Oise, Beauvais), *St. John the Baptist* (S. Maria in Via Camerino), and *Samson* (after the added-on strips were removed). Samson's slightly parted lips and his brooding melancholy, which are typical of many of Valentin's subjects, reveal the artist's understanding of comparable figures by Caravaggio.

No other versions or copies of a single-figure *Samson* are known. A *Samson and Delilah* by Valentin (now lost) is mentioned in the inventory of the Palais Mazarin taken after Cardinal Mazarin's death in 1661 (Gabriel-Jules, Comte de Cosnac, *Les Richesses du Palais Mazarin*, Paris, 1884, p. 317, no. 1094). This painting appeared in the Lauraguais sale in 1772 (Lugt 2008). ATL

EXHIBITIONS: CMA, 1971/72: Caravaggio and His Followers, cat. no. 72, pp. 184–85, color illus. (catalogue by Richard E. Spear); CMA, March 1973: Year in Review, cat. no. 128.

LITERATURE: Friedrich Wilhelm Basilius von Ramdohr, *Über Mahlerei und Bildhauerarbeit in Rom*, II (Leipzig, 1787; reprint ed., Westmead, England, 1971), p. 285 (as by Calabrese); A. Nibby, *Itinéraire de Rome*, I (Rome, 1842), 34; Erasmo Pistolesi, *Descrizione di Roma e suoi contorni* (Rome, 1846), p. 94; Filippo Mariotti, *La Legislazione delle belle arti* (Rome, 1892), p. 135, no. 46; J. A. F. Orbaan, *Documenti sul Barocco in Roma* (Rome, 1920), p. 511 (as by Poussin); Francis Haskell, *Patrons and Painters* (London, 1963), p. 45 (as by Poussin); Anthony Blunt, *The Paintings of Nicolas Poussin, A Critical Catalogue* (London, 1966), p. 158, no. L4; Frances Vivian, "Poussin and Claude Seen from the Archivio Barberini," *Burlington Magazine*, CXI (1969), 721–22; *Catalogue of European Paintings in The Minneapolis Institute of Arts* (Minneapolis, 1970), p. 163 (as by Poussin, now lost); Evelina Borea, "Considerazione sulla Mostra 'Caravaggio e i suoi seguaci' a Cleveland," *Bollettino d'Arte*, LVII (1972), 162; Julius S. Held, "Caravaggio and His Followers," *Art In America* (May–June 1972), p. 44; Benedict Nicolson, "Current and Forthcoming Exhibitions: Caravaggesques at Cleveland," *Burlington Magazine*, CXIV (1972), 113–14; D. Stephen Pepper, "Caravaggio rivedute e corretto: La Mostra di Cleveland," *Arte Illustrata*, V (1972), 171, 175, fig. 8; Richard E. Spear, *Renaissance and Baroque Paintings from the Sciarra and Fiano Collections* (University Park, Pennsylvania, 1972), p. 32, cat. no. 14, nn. 1–9; Spear, "Unknown Pictures by the Caravaggisti (with notes on Caravaggio and His Followers)," *Storia dell'arte*, no. 14 (1972), 151, 159; Robert Enggass, review of Spear's *Caravaggio and His Followers*, in *Art Bulletin*, LV (1973), 462; Jacques Thuillier, *L'Opera Completa di Nicolas Poussin*, Classici dell'Arte, vol. 72 (Milan, 1974), 119, no. R21 (attributed to Valentin); Arnauld Brejon de Lavergnée and Jean-Pierre Cuzin, *I Caravaggeschi Francesi* (exh. cat., Rome, 1974), pp. 88, 123, 126, 168; Marilyn Aronberg Lavin, *Seventeenth-Century Barberini Documents and Inventories of Art* (New York, 1975), p. 43 (Docs. 345 and 346), p. 98 (III. Inv. 26–31.482), p. 114 (III. Barb. Lat., 5635.482), p. 242 (III. Inv. 49.676), and pp. 530, 695; CMA *Handbook* (1978), illus. p. 171; Nicolson, *The International Caravaggesque Movement* (Oxford, 1979), p. 104.

ANNE VALLAYER-COSTER
1744–1818

Anne Vallayer-Coster and two of her contemporaries, Elisabeth Vigée-Lebrun (1755–1842) and Adélaide Labille-Guiard (1749–1803), were the foremost women painters in eighteenth-century France. The circumstances of Anne Vallayer's training are unknown. In 1770, at age twenty-six, she was accepted into the Royal Academy. Her reception pieces, *Attributes of the Arts*, 1769 (Louvre, Paris), and *Still Life with Musical Instruments*, 1770 (Louvre), were exhibited at the Salon of 1771 along with eight of her other paintings. In 1780 she painted a portrait of Marie Antoinette; during that same year, she was given quarters in the Louvre. After marrying Jean-Pierre Silvestre Coster she exhibited under the name Vallayer-Coster. Although her fame and position diminished after the Revolution, she exhibited regularly in the Salon until her death. A prolific artist with more than four hundred known works, Vallayer-Coster painted—in addition to still lifes—flower pictures, miniatures, and portraits. Some of her drawings and water colors served as designs for Gobelins tapestries. Eighteenth-century critics such as Diderot and Bachaumont praised her *magie d'imitation* and compared her favorably with the Dutch flower painter van Spaendonck, but she has since been classified too narrowly as a follower of Chardin. Although some of her compositions are derived directly from Chardin, Vallayer-Coster's forms and textures are more tangible and less rarefied, and a slight impasto enhances naturalistic effects. Although she never equaled Chardin's originality, she was, nevertheless, one of the most prominent still-life painters of the second half of the eighteenth century.

61 A Basket of Plums 71.47

Canvas, 38 x 46.2 cm. Signed and dated on stone sill at lower right: Melle Vallayer/1769.

Collections: Baron Herzog, Budapest; Axel Rydén, Stockholm, 1918; Osborn Kling, Stockholm, 1934 (sale: H. Bukowski, Stockholm, September 25–26, 1934, no. 323, illus. pl. 37); Thorsten Laurin, Stockholm, 1938, and his daughter Mrs. B. Stjernsward, Sakanor, Sweden (sale: Sotheby's, London, June 24, 1970, no. 4, illus.); [Old Masters Gallery, London]; [H. Shickman Gallery, New York].

Mr. and Mrs. William H. Marlatt Fund, 1971.

The painting was lined and cleaned shortly before acquisition. The signature has been abraded and slightly reinforced, but otherwise the painting is in very good condition.

During the second half of the eighteenth century, fruit still lifes were extremely popular, and a basket of plums was a common motif. In Chardin's works fruit baskets appear on stone sills, and in one case—*Basket of Plums, Walnuts, Currants, and Cherries*, of ca. 1764–65 (Daniel Wildenstein, *Chardin*, New York, 1969, no. 333, fig. 152)

—an attached string hangs over the ledge, as in Vallayer's painting here. Her interpretation, however, is quite different from Chardin's. Details, especially the plums and basket, are much crisper and emerge from deep shadows. Vivid reds and violets in the plums exploit the purely decorative qualities of the fruit, an interest not usually pursued by Chardin. A sense of immediacy is evoked by the growing moss, the cakes in their crisp papers—a rare motif in the artist's work, and the glass of water animated by scintillating highlights and reflections.

According to Marianne Roland Michel (1973), this painting may have been one of those exhibited at the Salon of 1771 with the artist's reception pieces, for a painting with similar title and dimensions was listed in the Salon entry. The painting is an early work of the artist whose later still lifes often included a greater variety of objects; *A Basket of Plums*, however, contains in itself all the essential elements of her style.

Vallayer-Coster's *Peaches and Cherries*, signed and dated 1769 (private collection, Paris; Michel, 1971, no. 127), is most probably a companion picture to the Museum painting. Michel (1973) pointed out that the paintings have similar dimensions, their compositions strikingly correspond in reverse symmetry, and their color schemes are analogous.

WST

EXHIBITIONS: Paris, Salon, 1771: cat. no. 147 (as *Un panier de prunes*); Stockholm, Nationalmuseum, 1918: English, French, Italian, Netherlandish, Spanish, and German Art, cat. no. 40; Göteborg (Sweden) Art Museum, 1938: Three Centuries of Still Life, cat. no. 52; Stockholm, Nationalmuseum, 1958: Five Centuries of French Art, cat. no. 102; CMA, January 1972: Year in Review, cat. no. 56; CMA, 1979: Chardin and the Still-Life Tradition in France, cat. no. 7, illus. (catalogue by Gabriel P. Weisberg, with William S. Talbot).

LITERATURE: *Collection des Livrets des Anciennes Expositions depuis 1673 jusqu'en 1800: Exposition de 1771* (Paris, 1870), p. 29, no. 147; Ragnar Hoppe, *Katalog över Thorsten Laurins samling av malerei och skulptur* (Stockholm, 1936), no. 399, pl. 218; Marianne Roland Michel, *Anne Vallayer-Coster* (Paris, 1970), no. 183, illus. p. 155 (as *Corbeille de prunes et gâteaux*); Michel, "A Basket of Plums," CMA *Bulletin*, LX (1973), 52–59, figs. 4, 5, 6, 10; Carol C. Clark, "Jean-Baptiste Siméon Chardin: *Still Life with Herring*," CMA *Bulletin*, LXI (1974), 309, 314, n. 2, fig. 2; Michel and Fabrice Faré, *La Vie silencieuse en France, La Nature Morte au XVIII^e siècle* (Fribourg, 1976), p. 217, fig. 332.

Figure 61.

Attributed to SIMON VOUET
1590–1649

Vouet was the son of a very minor painter in the service of the crown. He was baptized in Paris, January 9, 1590. Vouet was a prodigy; while still very young, he traveled to carry out commissions for portraits in London, Constantinople, and Venice, before going to Rome in 1613. He also visited other art centers in Italy. He attained eminent status in official circles as a painter and in 1624 was named Principe of the Accademia di San Luca. He left Italy for France in 1627 to become Premier Peintre du Roi in the court of Louis XIII. He was very successful in Paris and established a large workshop to assist with his commissions. Vouet's great contribution to French painting was the introduction of Italian styles to artists and patrons who were still tied to a late Mannerist style. In a very real sense, Vouet prepared the way for Nicolas Poussin, who returned to Paris in 1640. The overwhelming acceptance of Poussin brought about the eclipse of Vouet, who did not recover his previous ascendency in official art circles until after Poussin returned to Italy upon leaving Paris.

62 Rest on the Flight into Egypt 73.32

Panel (oak), 35.5 x 45.7 cm.
Collections: [Galerie Joseph Hahn, Paris].
Mr. and Mrs. William H. Marlatt Fund, 1973.

The painting was examined under ultraviolet light and found to be in generally good condition. There are residues of old varnish in scattered background areas. Tiny flakes of paint losses have been filled in; the figures are intact, with only scattered retouches in the draperies and the hair of the background angel. A very small area on the upper arm of the kneeling angel has been restored, and retouchings around the angel's foot obscure its outlines. The vine over the Madonna's head has been strengthened. The panel has warped slightly, and there is a tiny horizontal crack in the upper left corner.

As a painter, Vouet was not an innovator; rather, he assimilated the stylistic developments of other artists and adapted them for his own use. By the time he returned to France from his Italian sojourn, Vouet had adopted some of the classical approach of the Carracci and the color of the Venetian painters. At first he retained the firm, polished modeling that he had used in Italy; then he moved toward a looser execution with transparent light and shadow. The Cleveland painting fits in stylistically with this second phase and was probably executed between 1635 and 1640.

William R. Crelly (*The Paintings of Simon Vouet*, New Haven and London, 1962, p. 63) pointed out that Vouet evidently brought back sketches and prints of Italian works and continued to draw from these sources in the years after his return to France. In this version of *Rest on the Flight into Egypt*, Vouet rearranged elements frequently found in Italian depictions of this subject (see Hermann Voss, "Die Flucht nach Aegypten," *Saggi e Memorie di storia dell'arte*, I, 1957, 25–61). Often included in these works—as seen in the Cleveland picture—were angels helping to gather cherries and the ass being led away to graze (in some versions, by an angel; in our painting, by Joseph), all in a landscape setting.

Vouet's Italian experience coincided with that of sculptor Jacques Sarrazin (1592–1660), a frequent collaborator on important commissions after the two returned to Paris —in 1627 and 1628, respectively. (Sarrazin married Vouet's niece in 1628.) A comparison of the two artists' works confirms that they were in close contact. Sarrazin executed reliefs on subjects similar to Vouet's and, like Vouet, included in his compositions plump infants, graceful angels, and young virgins. Compare our painting, for example, with Sarrazin's *Holy Family* (known through Pierre Daret's engraving; see Marthe Digard, *Jacques Sarrazin*, Paris, 1934, pl. XI-3), which also has Joseph with the ass in the background.

To our knowledge the Cleveland panel has not been recorded in the literature, nor has it been engraved. It is, however, intimately related in composition and style to a number of Vouet's works on similar subjects painted during the 1630s and 1640s, some of which are known only through engravings; Michel Dorigny, for example, made two engravings of the *Rest on the Flight into Egypt*, one in 1636, and another in 1649 (Crelly, *op. cit.*, p. 232, nos. 164 and 165). A small painting (80.3 x 64.7 cm) in the Robert L. Manning collection is also compositionally close to our painting (Robert L. Manning, "Some Important Paintings by Simon Vouet in America," *Studies in the History of Art Dedicated to William E. Suida*, London, 1959, fig. 12, engraved by Pierre Daret, 1642). A variant of this painting (94 x 91.4 cm) is in the Philadelphia Museum of Art, and another is documented in the collection of Milton H. Adler, New York. And finally, a *Rest on the Flight into Egypt* (Crelly, *op. cit.*, pp. 232–33, no. 166) was listed by Bailly in an inventory of Versailles, but it is different from these other, more similar, compositions, and from Vouet's vertical version of 1640 in Grenoble.

Pierre Rosenberg (in a letter dated July 29, 1977) seriously questioned the attribution to Vouet, tentatively suggesting as an alternative, Charles Poërson (1609–1667), one of Vouet's close collaborators and followers, whose work is not very well known (a monograph is being prepared by Sylvie Savina). Among his best-known works is a *Rest on the Flight into Egypt*, a design for a tapestry (Brigitte Klesse, *Katalog der italienischen, französischen und spanischen Gemälde bis 1800 im Wallraf-Richartz Museum*, Cologne, 1973, pp. 103–4, no. 2311, fig. 74), which offers certain parallels in composition and details with the Cleveland panel but lacks its natural flow of movement.

Figure 62.

Admittedly, there is a somewhat closer stylistic resemblance
between our painting and a small, signed *Pietà* on panel by
Poërson (J. Patrice Marandel, *French Oil Sketches from an
English Collection, Seventeenth, Eighteenth, and Nine-
teenth Centuries*, exh. cat., Houston, 1973, cat. no. 71,
illus.). The *Pietà*, however, is not Poërson's invention; it is a
copy of a lost work which Vouet had painted for the Palais-
Royal in 1644. JKC and ATL

EXHIBITIONS: CMA, February 1974: Year in Review, cat. no. 45, illus.

LITERATURE: CMA *Handbook* (1978), illus. p. 173.

ANONYMOUS MASTER
French School(?), early eighteenth century

63 *Head and Shoulder Study* 78.125
 of a Shepherd(?) with a Staff

Paper, 54 x 42.5 cm (original support only).
Collections: [Galerie Joseph Hahn, Paris]; Mr. and Mrs. Noah L. Butkin, Cleveland, 1975.
Gift of Mr. and Mrs. Noah L. Butkin, 1978.

The painting was executed in oil on a medium-weight laid paper with vertical screen lines. A partly visible watermark (at 38.5 cm from the bottom edge and 21 cm from the left edge) closely resembles two Italian watermarks, one dating from 1639, and another from Rome dated 1640 (E. J. Labarre, ed., *Collection of Works and Documents Illustrating the History of Paper*, Vol. 1: Edward Heawood, *Watermarks, Mainly of the 17th and 18th Centuries*, Hilversum, 1950, p. 101, illus. pl. 222). The paper had been mounted on a moderately heavy, woven pulp paper, which in turn was adhered to a light weight, open-weave, gauze-like fabric, all of which had turned dry and brittle. In 1974 the two auxiliary supports—the lining fabric and inner laminate—were removed at the Intermuseum Laboratory in Oberlin, Ohio, and the original paper was attached to the top veneer of a four-ply ragboard. A sheet of Japanese paper impregnated with a thermoplastic adhesive was used as the inner laminate.

The painting is an accomplished study of a man holding a staff; his type and attire suggest that he is a shepherd. The work was attributed to an anonymous French artist of the seventeenth century when it was acquired by Mr. and Mrs. Noah L. Butkin in 1975. While on loan to this Museum from February 1975 until December 1978, the painting was labeled first Flemish and later Genoese because of the distinct Flemish handling of draperies and flesh tones. Everett Fahy suggested a comparison between the Cleveland study and the *Hermit with a Skull* attributed to Federico Bencovich (1670–1740), in the Fitzwilliam Museum, Cambridge, England. David Ditner noticed certain similarities between the Cleveland *Shepherd* and the figure of Joseph in *St. Joseph and the Christ Child* at the Royal Ontario Museum, Toronto (ROM 970.357), there tentativly attributed to Gaulli. Although Joseph appears to be considerably older, in some ways he resembles the shepherd—in physiognomy, for example, and the treatment of hair and hands, which suggest common Flemish sources. Erich Schleier (letter of February 6, 1979) proposed an attribution to a French artist of the seventeenth, more likely eighteenth, century. Pierre Rosenberg (letter of July 3, 1979) agrees that the artist was French; he added that he was probably someone of the generation of Jacques Louis David, which would date the painting in the late eighteenth century, ca. 1780. Luigi Salerno (letter of January 2, 1979) suggested a French artist

working in Rome in the early part of the eighteenth century.

The Italian watermark of the paper and the portrait's resemblance to male types found in paintings by Pietro da Cortona tend to support Salerno's proposal. But the Flemish features of the work would lead one more specifically to the milieu of an artist whose style combined Flemish, French, and Italian influences; such an artist was Nicolas Vleughels, director of the French Academy in Rome from 1725.

Although born in Paris, Vleughels grew up in a Flemish milieu—the colony of Saint-Germain des Prés. He was trained by his father, an admirer of Rubens. As the director of the Academy in Rome he insisted that his students study and copy the works of as many masters as possible, among these the works of Pietro da Cortona, whose male types are related to our shepherd. The many portrait studies by Vleughels and his circle are evidence of this common practice at the Academy (see, for example, those in the Louvre, illustrated in Bernard Hercenberg, *Nicolas Vleughels, peintre et directeur de l'Académie de France à Rome 1668–1737*, Paris, 1975, nos. 219, 220, 222, 223, 224, 226, 230, 231, and 374). One of Vleughels's students, Pierre Subleyras (1699–1749), pictured many such head and shoulder studies, apparently in oil, apparently also on paper, on the wall of an artist's studio in his painting called *The Artist and His Studio* (Vienna Academy). Other students of Vleughels—also possible candidates for the attribution of the Cleveland painting—are Jean-Charles Frontier (1701–1763), Pierre Charles Tremolières (1703–1739), and Gabriel Blanchet (1705–1772). ATL

EXHIBITIONS: CMA, January 1979: Year in Review, cat. no. 32, illus.

LITERATURE: None.

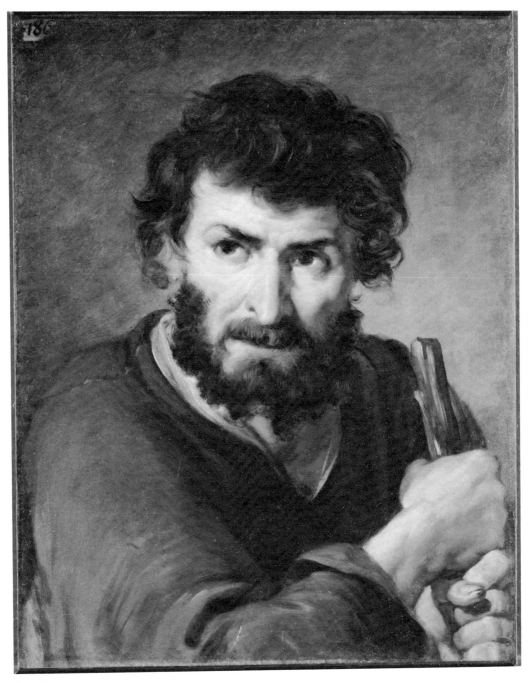

Figure 63.

ANONYMOUS MASTER
French School, eighteenth century
Formerly attributed to Fragonard

64 *Allegorical Figure of Sommeil* 63.502
 (God of Sleep)

Canvas, 97.6 x 130 cm.

Collections: (sale: Hôtel Drouot, Paris, December 2, 1910, no. 13, attributed to Fragonard); Collection Octave Linet, Tours (sale: Palais Galliera, Paris, March 23, 1963, no. 16, as *Le génie du sommeil*, attributed to Boucher); [Cailleux, Paris].

Purchase, Leonard C. Hanna Jr. Bequest, 1963.

The painting has been lined with fabric having a glue-type adhesive. A thin red ground, evenly applied, has not filled or masked the texture of the original fabric. The oil paint, which was applied as a thin fluid paste, is generally opaque. The brush marking, though apparent, has little or no relief. There are minor abrasions in the darks, shadows, and modeling tones around toes and hands. The painting was cleaned recently by Ross Merrill, the Museum conservator, who removed disturbing earlier restorations—particularly in the area of a tear (at H. 80 cm and W. 55 cm). The painting is in good condition.

The painting was acquired by this Museum from Cailleux as a work by Fragonard. It was published by Henry S. Francis as a post-Italian work by Fragonard, dating from about 1765 to 1769. Francis saw in the painting impressions from Tiepolo's Venetian drawings of reclining figures (Francis, 1966, pp. 68–69, fig. 7), but he ruled out the possibility that the figure was an *Académie d'homme* sent by Fragonard from Rome in 1759. He saw a resemblance between the Cleveland figure and the sleeping guard in Fragonard's wash drawing, *Deliverance of St. Peter* (ibid., p. 72, fig. 9), and between the Cleveland painting and another Fragonard drawing, *Reclining Figure* (ibid., p. 73, fig. 10). In addition, Francis compared the brilliant brushwork in our painting with that in Fragonard's *Diana and Cupids Sprinkling Flowers on the World and Setting It Ablaze* (ibid., p. 68, fig. 5) and the *Sleeping Cupids* (ibid., p. 69, fig. 6), both of which include poppies similar to those in the Cleveland painting (Figure 64a), and both of which share with ours strong impressions from Boucher.

The attribution to Fragonard was first challenged by Frederick Cummings (letter dated January 19, 1971) and Pierre Rosenberg (orally). Cummings suggested Noël Hallé as an alternative attribution on the basis of style. Alexandre Ananoff (orally, 1973) initially felt uncertain about the Noël Hallé attribution but recently produced a photograph (Figure 64b) of a drawing which, he felt, supported the attribution. Ananoff believed the drawing, which bore the inscription *après N. Halle à Paris en 1773* was by Saint-Aubin. (According to Ananoff, the photograph was acquired by him as part of the dossier of M. Nicolle in Paris. The

Figure 64a. Detail showing poppies.

Figure 64b. *Reclining Male Figure (Sommeil?)*. Photograph after a lost drawing presumably by Gabriel de Saint-Aubin after Noël Hallé; reproduced by permission of M. Alexandre Ananoff.

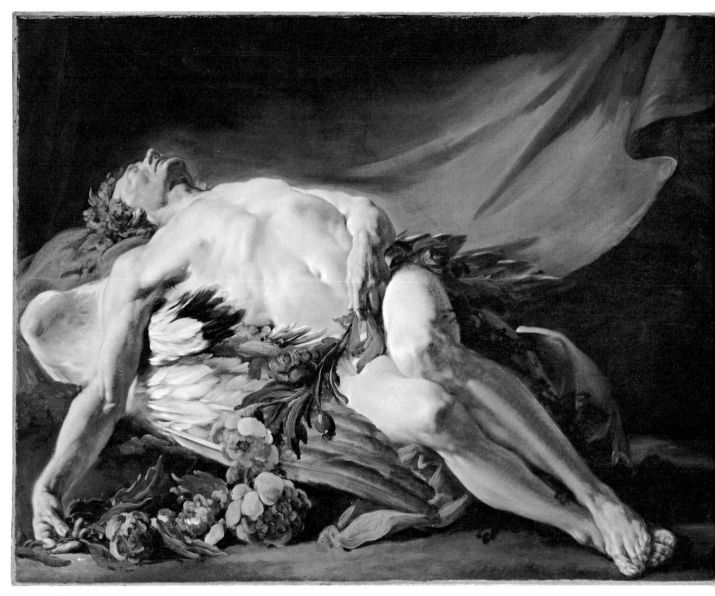

Figure 64.

drawing is lost.) Judging from the photograph, the drawing lacks the usual freedom and "loose end" character of Saint-Aubin's copies of other masters' paintings (incidentally, in none of these did the artist use the term *après*). When projected to the scale of the painting, the outlines of the figure in the photograph almost precisely match those in the painting, a feature which speaks against Saint-Aubin's authorship. No painting by Noël Hallé of this or a similar subject is known, except for his *Allegory of Night*, a *dessus-de-porte*, exhibited in the Salon of 1753. It is true, however, that paintings were exhibited in the Salons without any mention of their titles. For example, Noël Hallé's *St. Louis portant en procession de Vincennes à Paris . . .*, no. 1 in the *livret* of the Salon of 1773, was followed by a no. 2 which

was simply called *autres ouvrages sous le même numéro* ("other works under the same number"). Unfortunately, these paintings were not discussed in any Salon reviews. Diderot did not review the Salon that year because he was in Russia (Jean Seznec and Jean Adhémar, *Diderot Salons*, 1, Oxford, 1957, p. viii).

Cummings (1974) and Welu (1974), writing about Nicolas-Guy Brenet's *Sleeping Endymion* (Worcester [Massachusetts] Art Museum) suggested that Brenet may also have painted the Cleveland *Sommeil*. However, in spite of the similarity in composition, it is very different in style. Brenet's figure totally lacks the fluency of brushwork found in the Cleveland painting.

In the exhibition The Age of Louis XV (1975/76), Ro-

senberg proposed a new attribution, Jean Bernard Restout (1732–1797), which he supported by stylistic comparisons with Restout's *St. Bruno* (Louvre, Paris) of 1763, the four paintings representing the seasons (Trianon de Versailles) of 1767, and *St. Louis Landing in Egypt* (Ecole Militaire, Paris) of 1774. Rosenberg explained the plausibility of the earlier attribution to Fragonard by citing from Cochin's letter to Marigny, written in 1766, in which Cochin expressed his admiration for Restout's harmonious use of colors, comparable, he said, to Fragonard's. Rosenberg believed that the Cleveland painting could be the missing *Sommeil—figure d'étude* shown by Restout at the Salon of 1771 (no. 137), which is also very likely the *Morphée* of the Salon de la Correspondance (no. 144; Pahin de la Blancherie, *Essai d'un tableau historique des peintres de L'Ecole Française depuis Jean Cousin en 1500, jusqu'en 1783 inclusivement*, Paris, 1783; reprint ed., Geneva, 1972, p. 245).

A recently published drawing of a reclining male figure (Figure 64c), attributed by James Henry Rubin (1977) to Restout, deserves comparison with the Cleveland figure, but it is not as close stylistically as Fragonard's above-mentioned *Reclining Figure*.

Francis (1966, p. 72) and Rosenberg (Exh: 1975/76) independently recognized a resemblance between our painting and a sculpture by Houdon called *Morphée*. The plaster model of ca. 1769 is now at Gotha, Schlossmuseum (Hjorvardur H. Arnason, *The Sculptures of Houdon*, London, 1975, fig. 65); the terra-cotta version was exhibited at the Salon of 1771, the same in which Restout showed his *Som-*

meil. Francis, believing the Cleveland figure to have been painted by Fragonard shortly before or during 1769, suggested that Houdon may have known it. More likely their similarity can be explained by a common visual source, namely, an engraving by Jean Massard (Figure 64d) after a drawing of *Sommeil* of ca. 1769 by Cochin, published in 1781 in Cochin's iconological *Almanach* (Marguerite Charageat, "Le Fleuve et le Sommeil," *Musées de France*, January–February 1950, p. 114).

Apart from obvious resemblances in the poses, Houdon's sculptures, the painted figure, and the engraving by Massard, all include the large, white, swan-like wings and garland of poppies (both in blossom and in seed), and all are dated contemporaneously. Houdon's terra cotta follows the pose of the engraving very closely, even though the god no longer wears his wings, as in the plaster model, but sleeps on them. In the marble exhibited in 1777, which finally gained Houdon his long-hoped-for acceptance to the Academy, he returned to the concept of a younger, winged god that more convincingly represented Morpheus. Morpheus, according to Cochin (Charageat, *op cit.*, p. 115), was to be young and to wear butterfly wings, symbolizing his inconstancy and light-footedness. Thus, the Cleveland figure and Houdon's terra-cotta and plaster models could not represent Morpheus; instead, all three closely followed Cochin's image of Sommeil, the son of the night, brother of death, an old man with wings who presides over dreams (*ibid.*, p. 114). The wings are Cochin's invention, but otherwise he closely followed Ovid's description in his *Meta-*

Figure 64d. *Le Sommeil.* Engraving after a drawing by Charles Nicolas Cochin the Younger (1715–1790). Jean Massard, French, 1740–1822. Reprinted from Cochin, *Almanach* (1781).

Figure 64c. *Reclining Male Figure.* Black chalk and charcoal, 33.2 x 56 cm. Jean-Bernard Restout, French, 1732–1797. Private collection.

morphoses (bk. XI, trans. Frank Justus Miller, London, 1916, II, 163), which reads: ". . . in deep recess within a hollow mountain, the home of sluggish sleep . . . before the cavern's entrance abundant poppies bloom . . . and inside lies the god himself, his limbs relaxed in languorous repose. . . ." According to Ovid (*ibid.*) the cavern was entirely dark, but when Iris arrived to ask the God of Sleep for help on behalf of Juno, "the awesome house was lit up with the gleaming of her garments" (*ibid.*, p. 165). Cochin actually depicted the arrival of Iris, whereas the artist of the Cleveland picture only implied it through the luminosity of his colors.

Diderot's description of Restout's *Sommeil* in the Salon of 1771 (*Diderot Salons*, IV, 1967, 200) provides some further support for identifying that work with the painting in Cleveland. Diderot described the figure as *Dormeur ignoble, mine de supplicié* ("an ignoble sleeper, with the looks of an executed criminal"), a description that certainly applies to the rugged, muscular type in our painting—as it does also to Cochin's drawing and to Houdon's terra cotta of Morpheus (but not to Houdon's youthful Morpheus of 1777). On the other hand, Diderot's claim that the figure lacked vigor and facility of draftsmanship makes it hard to believe that he was discussing the Cleveland *Sommeil*. It was precisely its outstanding assurance in drawing and brushwork, together with the sensitivity of color, that led to the original attribution of our painting to Fragonard. A T L

EXHIBITIONS: CMA, December 1963: Year in Review, cat. no. 88, illus.; New York, Wildenstein & Co., 1968: Gods and Heroes, Baroque Images of Antiquity, cat. no. 15, pl. 38; Toledo (Ohio) Museum of Art, Art Institute of Chicago, and National Gallery of Canada (Ottawa), 1975/76: The Age of Louis XV—French Painting 1710–1774, cat. no. 123, pl. 117 (catalogue by Pierre Rosenberg).

LITERATURE: Henry S. Francis, "Jean Honoré Fragonard, *Morpheus*," CMA *Bulletin*, LIII (1966), 66–73, figs. 1 (color), 2, 3; Frederick Cummings, "La Peinture sous Louis XVI," *De David à Delacroix* (exh. cat., Paris, 1974), p. 38; James A. Welu, "*Sleeping Endymion* by Nicolas-Guy Brenet," *Worcester Art Museum Bulletin*, n.s., IV, no. 1 (1974), 7, fig. 2; James Henry Rubin and David Levine, *Eighteenth-Century French Life-Drawing* (exh. cat., Princeton, New Jersey, 1977), pp. 88–89, fig. 27; CMA *Handbook* (1978), illus. p. 186.

Germany

HANS BALDUNG (called Grien)
1484/5–1545

Hans Baldung was born in late 1484 or early 1485 in Swäbisch-Gmünd. He was from a family of scholars who came from Swabia; his father was a lawyer who settled in Strasbourg. Little is known of his early life, except that he was apprenticed to Dürer in Nuremberg (the exact dates of the apprenticeship are not known). Dürer went to Italy in 1505, at which time, it has been assumed, his association with Baldung ended; Carl Koch ("Über drei Bildnisse Baldungs als künstlerische Dokumente vor Beginn seines Spätstils," *Zeitschrift für Kunstwissenschaft*, V, 1951, 62–64), however, speculated that Baldung was put in charge of several projects until Dürer returned. In 1507 Baldung completed two altarpieces for the cathedral in Halle. In 1508 he was enrolled as a citizen of Strasbourg, and in 1510 he married Margaretha Herlin. In 1511 he received an important commission for the high altar in St. Nicholas's Church, Freiburg (now the cathedral); in 1512 he moved to Freiburg, completing the altar in 1516. He continued working in Freiburg until 1517, after which he returned to Strasbourg, where he established himself as a respected and prosperous citizen. In 1545 he was named a member of the Municipal Council; in that same year he died.

65 *The Mass of St. Gregory* 52.112

Panel (linden?), 89.2 x 124.9 cm.

Provenance: St. John's Convent, Strasbourg, as late as the eighteenth century; listed in an inventory of 1741 (Carl Koch, letter of March 9, 1955).

Collections: Private collection, France; [Rosenberg & Stiebel, Inc., New York, 1952].

Gift of Hanna Fund, 1952.

The painting was cleaned by William Suhr before it entered the Museum collection, but there are no conservation records of that treatment. Three narrow, vertical cracks on either side of the Christ figure extended the full height of the panel. Another crack extended halfway up the panel, through the kneeling figure on the left. There are numerous scattered, minor losses, especially near the edges of the panel. All the faces and costumes are very well preserved.

Baldung's painting is based on the legend surrounding the Mass of St. Gregory. According to the legend, while St. Gregory was officiating at mass, an assistant expressed skepticism about the Holy Presence, and as the saint prayed,

Figure 65.

Christ responded by appearing upon the altar surrounded by the symbols of his Passion.

Numerous paintings and prints representing the Mass of St. Gregory appeared in Germany from 1430 on (Comte J. de Borchgrave d'Altena, "La messe de St. Grégoire," *Bulletin des Musées Royaux des Beaux-Arts Brussels*, VIII, 1959, 3–34). An especially notable example is a wood engraving by Dürer, dated 1511 (*Albrecht Dürer 1471–1971*, exh. cat., Nuremberg, 1971, no. 339). Baldung, too, did a woodcut of a simplified version of the subject for the series *Hortulus animae* (see Figure 65a). The subject was not adopted in Italy.

In the Museum painting—an important early work of Baldung—the ruddy complexions and highly individualized expressions, as well as the apparently normal demeanor of

the unaware bystanders, contrast dramatically with the pallor of Christ, his agonized expression, and the tense astonishment of the witnesses. Baldung's luminous, crisp modeling of the faces lends an immediacy that heightens the impact of the subject, making it believable as an actual event.

The painting was commissioned by Erhart Künig, commander of the Strasbourg order of St. John, who stands at the far right. His identity is verified by the Maltese cross he wears (Koch, 1955). Künig died in 1511; Koch (1951) therefore dates the painting the same year.

Two other paintings which Koch (Exh: 1959, nos. 14, 15) also dates ca. 1511 are stylistically consistent with the Cleveland panel: *St. Anne with the Christ Child, the Virgin and St. John the Baptist* (Washington, National Gallery,

Figure 65a. *The Mass of St. Gregory*. Woodcut from the series *Hortulus animae*. Baldung. Bayerische Staatsbibliothek, Handschriftenabteilung, Munich.

K-350) and *St. John the Evangelist on Mt. Patmos* (Becker collection, Dortmund, West Germany). JKC

EXHIBITIONS: CMA (1958), cat. no. 43; Karlsruhe, Staatliche Kunsthalle, 1959: Hans Baldung Grien, cat. no. 16 (catalogue by Carl Koch).

LITERATURE: Carl Koch, "Über drei Bildnisse Baldungs als künstlerische Dokumente vor Beginn seines Spätstils," *Zeitschrift für Kunstwissenschaft*, V (1951), 62–64; Henry S. Francis, "*Mass of St. Gregory* by Hans Baldung Grien," CMA *Bulletin*, XXXIX (1952), 184–87, illus. p. 180; Francis, "Early German Painting in The Cleveland Museum of Art," *American-German Review*, XXI/2 (1954), 9, fig. 7; Koch, "Hans Baldung Grien 1484/5–1545," *Die Grossen Deutschen*, I (Berlin, 1955), 406; Milliken (1958), color illus. p. 33; Louis Réau, *Iconographie de l'art Chrétien*, III, pt. 2 (Paris, 1958), 615; Hans Möhle, "Hans Baldung Grien: Zur Karlsruher Baldung-Austellung 1959," *Zeitschrift für Kunstgeschichte*, XXII (1959), 128, no. 16; *Kindlers Malerei Lexikon*, I (Zurich, 1964), illus. p. 183; *Selected Works* (1966), no. 136; Arthur Burkhard, *The Freiburg Altar of Hans Baldung* (Munich, 1970), p. 6, n. 12; Robert A. Koch, *Hans Baldung Grien: Eve, the Serpent, and Death*, Masterpieces in the National Gallery of Canada, no. 2 (Ottawa, 1974), p. 7; Colin Eisler, *Paintings from the Samuel H. Kress Collection: European Schools Excluding Italian* (Oxford, 1977), p. 30; Gert von der Osten, "Ein Altar des Hans Baldung Grien aus dem Jahre 1511—und eine Frage nach verschollenen Werken des Malers," *Zeitschrift des deutschen Vereins für Kunstwissenschaft*, XXXI, no. 1/4 (Berlin, 1977), 53–61, nn. 27, 29–32, figs. 1–3, 8; CMA *Handbook* (1978), illus. p. 88; François-Georges Pariset, "Réflexions à propos de Hans Baldung Grien," *Gazette des Beaux-Arts*, XCIV (1979), 2.

LUCAS CRANACH THE ELDER
1472–1553

Lucas Cranach was born in 1472 in Kronach (from which his name is derived), in Upper Franconia. His father was Hans Maler, an artist about whom very little is known. Cranach's own early history is obscure; he was probably taught by his father, but no works from that early period before 1500 are known. The earliest painting generally accepted as the work of Lucas the Elder is the Schottenstift *Crucifixion* of ca. 1500 (now in Vienna, Kunsthistorisches Museum). This and other early works, such as the Vienna *St. Jerome* and the Munich *Crucifixion*, differ radically from Cranach's later, signed paintings. Not until Franz Rieffel ("Kleine Kunstwissenschaftliche Controversfragen II," *Repertorium für Kunstwissenschaft*, XVIII, 1895, 424–28) assigned the Munich *Crucifixion* to Cranach (previously attributed to Grünewald) did other early works come to be identified—works which precede Albrecht Altdorfer and establish Cranach as the precursor of the Danube School.

In 1504 Cranach accepted a call to Wittenberg from Frederick the Wise of Saxony, who named him court painter in 1505. The appointment encompassed many functions: illustrating books; printmaking; designing medals and coins; and painting portraits, biblical and mythological subjects, and hunt pictures. He maintained a large workshop to meet the demands of his many commissions. Although a subject was often repeated—such as the Death of Lucretia, or Adam and Eve—no paintings were ever copied exactly.

Cranach's sons, Lucas the Younger and Hans, assisted him in his workshop; both worked in a style so close to that of their father that at times it is difficult to separate the father's work from the sons' work. At first, Cranach signed his work with his monogram; from 1509, however, he used the insignia of a snake with upright wings. When Hans died in 1535, the snake's wings were lowered.

After the death of Frederick the Wise in 1525, Cranach served Frederick's brother, John the Steadfast, then his son, John Frederick the Magnanimous. Cranach died at Weimar in 1553, after which his son Lucas continued the workshop.

66 *The Stag Hunt* 58.425

Panel (lindenwood), 116.8 x 170.2 cm. Signed with insignia of winged snake and dated, lower right, on the boat, 1540.

Collections: Royal collection of Saxony; [M. H. Drey, London].

John L. Severance Fund, 1958.

When William Suhr examined the panel in 1959, he noted it had warped, forming a concave surface. He discovered numerous worm holes in the back of the panel. The horizontal join across the upper middle of the panel had opened, and there were several vertical cracks along the lower left edge. The painting was transferred to a new composite support. Under ultraviolet light earlier restorations could be seen:

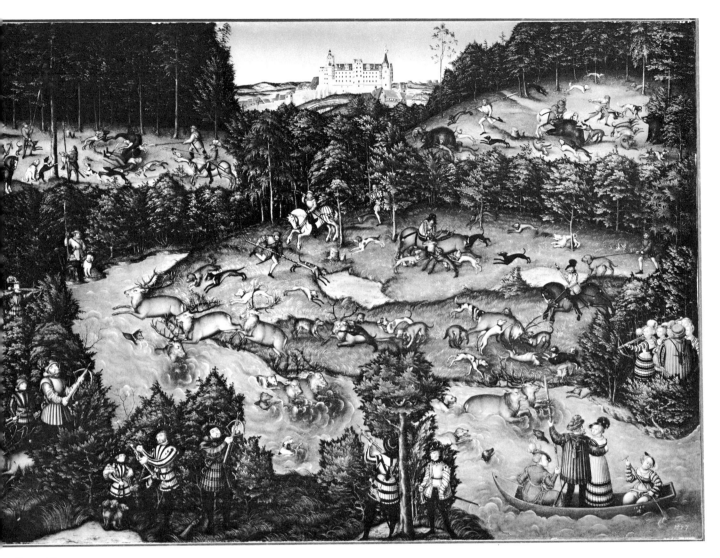

Figure 66.

small horizontal losses had been filled in on the dress of the woman seated in the front of the boat and on the boat itself. The date and insignia were intact. When Suhr cleaned the painting he uncovered tiny losses along the cracks and around the edges, the most serious intruding into the standing group at the far right. There were losses on the right side of Electress Sibylle's face, on the faces of the two ladies-in-waiting behind her, on the hat of the attendant, and in the foliage above the group. Otherwise, almost all the figures and animals are intact, and the paint surface is in good condition.

Cranach's earliest hunt pictures, *Prince Hunting a Wild Boar* and *The Stag Hunt*, were woodcuts from ca. 1506, signed with his monogram, L. C. They seem to be prototypes for his later hunt paintings, of which the earliest is *The Stag Hunt of Frederick the Wise of Saxony*, dated 1529 (Vienna, Kunsthistorisches Museum). The Cleveland panel

is dated 1540. Two others are dated 1544, one in the Prado, Madrid (Figure 66a), and one in Vienna, Kunsthistorisches Museum (Figure 66b). Another, also in the Prado, is dated 1545. A replica on canvas of the 1545 Madrid panel is in the Powerscourt collection (Herbert Furst, "Art News and Notes," *Apollo*, XII, 1930, 159). Copies of the 1529 Vienna painting are in the Glasgow Art Gallery and Museum (*Scottish Art Review*, II, no. 2, 1948, 22); in the Royal Museum of Fine Arts, Copenhagen (*Catalogue of Old Foreign Paintings*, 1951, no. 144; called a later copy by Friedländer and Rosenberg, 1932, p. 72); and in Basel, Öffentliche Kunstsammlung (*Katalog 1946*, p. 54). A fragment of a larger panel is in Ostergötland och Linkäpings (Sweden), Stads Museum.

The Cleveland panel and the three later hunt pictures all have Hartenfels Castle near Torgau in the background. According to Peter Findeisen of Halle (letter of October 12,

1972, from Werner Schade), the Cleveland version was painted before the castle was completed, and Cranach must have worked from the architectural drawings. (The same view of the castle appears in a drawing of 1540 by Cranach the Younger, *Christ and the Children*, Leipzig; see Schade, 1974, no. 208.) The completed castle is shown in the Madrid and Vienna panels of 1544 and 1545. In all four paintings Elector John Frederick stands in the foreground, and his wife, the Electress Sibylle, is toward the lower right with her cross-bow raised to make the traditional first shot. Charles V appears in the two Prado paintings and the later Vienna panel; he does not appear in the Cleveland picture. Charles was never at Torgau; he may have met John Frederick in the Reichstag at Speyer in 1544. Except for John Frederick and his wife, the only other people in the Cleveland painting who have been identified are the couple at the upper left in the foreground, Caspar I. Ritter von Minckwitz and his wife, who were identified from a pair of portraits dated 1543 ascribed to Cranach the Younger (*Katalog der Staatsgalerie Stuttgart: Alte Meister*, 1962, p. 58).

The panel of 1529 in Vienna has been generally accepted as solely the work of Cranach the Elder, despite disparate styles in different sections; for example, the horses and riders to the right through the middle section stand out as especially unlike Cranach's usual style. Most attributions of the later group of hunt pictures have been to Cranach the Younger. Schuchardt (1851) and Friedländer and Rosenberg (1932) attribute both the Cleveland and the Vienna panel of 1544 to Cranach the Younger. Francis (1959), however, published the Cleveland painting as by Cranach the Elder with the assistance of Cranach the Younger. Most recently, Schade (1974) gave the Cleveland panel and the Madrid panel of 1544 to Cranach the Younger, while giving the Vienna picture of 1529 to Cranach the Elder without question. The Prado catalogue (1972) attributes both hunt pictures to Cranach the Elder, but mentions Winkler's attribution to Lucas the Younger.

Figure 66a. *The Stag Hunt*. On panel, 114 x 175 cm, dated 1544. Cranach the Elder. Museo del Prado, Madrid.

Figure 66b. *Stag Hunt of the Elector John Frederick of Saxony*. On panel, 117 x 177 cm, dated 1544. Attr. to Cranach the Younger. Kunsthistorisches Museum, Vienna.

A careful study of the Cleveland painting leads to the conclusion that most of the figures and animals in the foreground of the picture are by Lucas Cranach the Elder, and the rest are probably by Lucas the Younger. In a comparison of the upper half of the Cleveland painting with two fragments attributed to Lucas the Younger (Dieter Koepplin and Tilman Falk, *Lukas Cranach*, I, Basel and Stuttgart, 1974, colorplate 7, fig. 109), strong similarities in the treatment of the animals and horsemen are apparent. It would seem, moreover, that the commission for this first of a series of hunt panels would be important enough for the elder Cranach himself to be involved in the project. The painting was destined for Schloss Hartenfels, where it remained for generations. An inventory number of the House of Saxony is at the extreme lower right (a record of payment in 1543 for a hunt picture very likely referred to the painting now in Cleveland; see Schade, 1974, no. 338, p. 439). The painting may have been commissioned in celebration of the construction of the castle, for the date of the painting coincides with that event.

The composition of the Cleveland panel is complex. Illustrations of many diverse activities spread across the surface in a seemingly casual arrangement, but all function together as a cohesive whole, unified by the overall rhythm and sweep. Lucas the Younger had less skill in composition than did his father—less than is evidenced in this Cleveland panel. He tended to crowd his groupings; see, for example, the herd of deer in the 1544 Vienna panel and the cluster of figures around the Electress Sibylle in the 1545 Madrid panel. The three later panels follow the same general format as the Cleveland panel, but they are less cohesive. The Prado panel of 1544 comes closest in spirit and quality.

JKC

EXHIBITIONS: Berlin, Staatliche Museen (Deutsches Museum), 1937: Lucas Cranach d. Ä. und Lucas Cranach d. J., cat. no. 122 (as Lucas Cranach the Younger); CMA, December 1959: Year in Review, p. 230; CMA, 1965: Juxtapositions (no catalogue).

LITERATURE: Christian Schuchardt, *Lucas Cranach des Älteren, Leben und Werk*, II (Leipzig, 1851), 93; Eduard Flechsig, *Cranachstudien* (Leipzig, 1900), pp. 275, 288 (as Lucas the Younger); Max J. Friedländer and Jakob Rosenberg, *Die Gemälde von Lucas Cranach* (Berlin, 1932), no. 331a, p. 91 (trans. Heinz Norden, London, 1978, pp. 152, 202, no. 421B); Jan Lauts, "Der Berliner Cranach-Austellung," *Pantheon*, XIX (1937), illus. p. 177; E. Heinrich Zimmerman, "Ein Zerstörtes Jagdbild Lukas Cranach d. J.," *Zeitschrift des deutschen Vereins für Kunstwissenschaft*, VIII (1941), p. 31; Heinrich Lilienfein, *Lukas Cranach und seine Zeit* (Leipzig, 1944), p. 86, colorplate 24; *Katalog der Gemäldegalerie: Vlamen, Holländer, Deutsche, Franzosen* (Vienna, 1958), no. 117, p. 39; Henry S. Francis, "*The Stag Hunt* by Lucas Cranach the Elder and Lucas Cranach the Younger," CMA *Bulletin*, XLVI (1959), 198–205, fig. 1; *Lucas Cranach der Ältere und seine Werkstatt* (exh. cat., Vienna, 1972), p. 32; *Museo del Prado: Catalogo de las Pinturas* (Madrid, 1972), p. 165, no. 2175; Werner Schade, *Die Malerfamilie Cranach* (Dresden, 1974), p. 91, pls. 210 and 211, no. 338, p. 439; Peter Findeisen and Heinrich Magirfus, *Die Denkmale der Stadt Torgau* (Leipzig, 1976), pp. 108–9, pls. 64 and 65; CMA *Handbook* (1978), illus. p. 128.

Assistant of LUCAS CRANACH THE ELDER
Active ca. 1515 – before 1540

67 *The Baptism* 53.143

Panel, 15.2 x 20.3 cm. Inscribed at top center: HIC EST FILIVS MEVS DILECTVS IN QVO/MICHI BEN COMPLACITVM EST.
Collections: Charles E. Roseman, Jr., Cleveland.
Gift of Mrs. Charles E. Roseman in Memory of Charles E. Roseman, Jr.

The painting was cleaned in 1960 by Joseph Alvarez, who found it to be in excellent condition. The panel was slightly warped, and there were a few retouches in the sky and in the water along the lower edge. Minor abrasions necessitated some inpainting on the red robe at the left, on some of the water below it, and in a small area above the figure of God the Father.

The painting entered the collection as the work of Lucas Cranach the Younger, an attribution that now seems unlikely. Although Lucas the Younger adopted his father's style of simplified forms, smooth modeling, and firm outlines, he was not the draftsman his father was, and therefore tended to lapse into rather routine, mechanical handling of background details. Works that are firmly attributed to him are characterized by a tight style, unlike the light touch we see in this charming, small panel.

That Cranach the Elder had an eye for natural detail can be seen in his paintings from the early 1500s in which sensitively painted landscape backgrounds are enlivened by imaginative buildings scattered among the hills. In the ensuing years, his landscape backgrounds continued to be carried out in the same spirit, mimicking his original approach quite successfully. Early in his career Cranach very likely had an assistant who worked closely with him, painting the landscape backgrounds and some minor figures (after 1535 he apparently had many more assistants, judging by the noticeable stylistic inconsistencies of his later productions). A particularly lyric touch, a departure from Cranach's own style, distinguishes works painted before ca. 1535. For example, note the fanciful, fairy-tale-like buildings and the liquid brushstrokes in trees and architecture in the *Madonna and Child* of 1518 (Karlsruhe), the *Judgment of Paris* of 1530 (Karlsruhe), and the *Venus* of 1529 (Louvre). Note also the background and some of the figures in the Vienna hunt picture of 1529 (Figure 67a). The landscape backgrounds of these works are close enough in style and handling to the Cleveland *Baptism* to suggest the same authorship, probably an early assistant who worked with Cranach in the period from ca. 1515 to ca. 1535.

JKC

EXHIBITIONS: None.

LITERATURE: Coe (1955), II, 222, no. 7, pl. XLV.

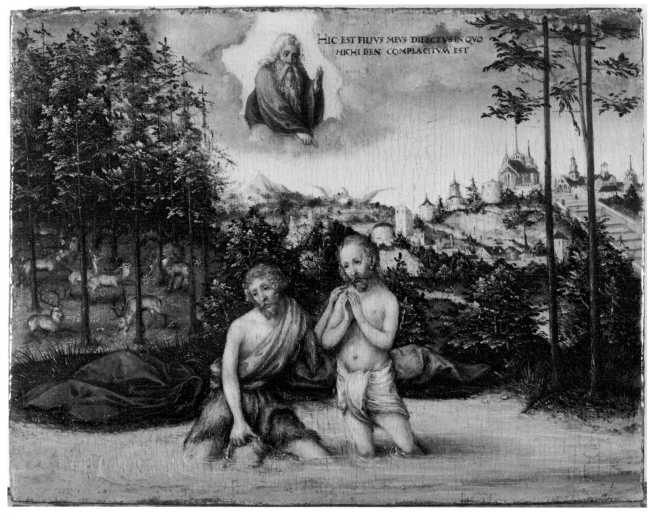

Figure 67.

Figure 67a. *The Stag Hunt of Frederick the Wise*
(detail). On panel, 80 x 114 cm, dated 1529.
Cranach the Elder. Kunsthistorisches
Museum, Vienna.

Circle of ALBRECHT DÜRER
First half of the sixteenth century

68 Adoration of the Shepherds 16.807

Panel, 58 x 56.5 cm.

Collections: James Jackson Jarves; Mrs. Liberty E. Holden,
Cleveland, 1884.

Holden Collection, 1916.

In 1930 an unsuccessful attempt was made to transfer the
painting from panel to canvas. In 1958 flaking necessitated
a second try, this time by William Suhr, who transferred the
painting to a pressed-wood panel with cradling. There were
several narrow, vertical losses the length of the panel and
along the edges, and large losses in the heads of the animals
in the stall, in Mary's robe, and in Joseph's back, as well as
scattered smaller losses and abrasions. These damages have
not completely obscured the quality of the painting, but
they make a certain attribution more difficult.

The painting entered the collection as the work of Al-
brecht Dürer (Exh: 1883), but when it was cleaned the false
monogram was removed and the attribution was then
changed to School of Dürer. Ernst Buchner (letter from
Walter Heil, July 25, 1930) assigned it to the Master of the
Ansbach Kelterbild (after the painting in the Ansbach
Gumbertus Church; Exh: 1961, cat. no. 241, pl. 41), the
attribution it was given in the Cleveland Museum exhibi-
tion of 1936. Tietze (1933) felt a more cautious attribution
to Dürer's school should be made.

Though the identity of the Master of the Ansbach Kelter-
bild is unknown, he is thought to have been one of Dürer's
followers. Strieder (Exh: 1961, cat. no. 241, p. 142) ques-
tions previous attributions of the Ansbach *Kelterbild* to
Weiditz, Hans Baldung Grien, Hans von Kulmbach, or
Dürer, while tentatively identifying the master as Hans
Springinklee. The Berlin panel, *Allegory of the Papacy and
the Law of Dispensation* (I. Kühnel-Kunze, "New 'Old
Masters' for the Picture Gallery," *Apollo*, LXXX, 1964,
112), attributed to Springinklee, seems to support that pos-
sibility. Gmelin (1966) suggested that Georg Pencz was the
master, but the artist's known works (*Jahrbuch Staatliche
Kunstsammlung Baden Württemberg*, 1967, pp. 31–84)
are not stylistically close to the Ansbach panel. More re-
cently, Oettinger and Knappe (1963) again associated the
name of Baldung with the Ansbach panel.

The Cleveland and Ansbach pictures should be consid-
ered separately. Apart from the poor condition of the Ans-
bach picture (confirmed by Strieder, orally, 1974), the ren-
dering of the figures and the composition are markedly
different from those of the Cleveland panel. It seems certain
that the Cleveland painting is by a follower who observed
Dürer carefully and was influenced by such works as the
Paumgartner *Nativity*, in Munich, and the *Adoration of the
Magi*, in the Uffizi. JKC

EXHIBITIONS: Boston (1883), no. 427; Cleveland, Hickox Building,
1894: Cleve Art Loan Exhibition, cat. no. 4; New York (1912), cat. no.
11; CMA (1936), cat. no. 197a; Nuremberg, Germanisches Nationalmu-
seum, 1961: Meister um Albrecht Dürer, cat. no. 243, pl. 42 (catalogue by
Peter Strieder).

LITERATURE: Jarves (1884), no. 51; Rubinstein (1917), no. 46; Hans
Tietze, "Dürer in Amerika," *Anzeiger des Germanischen Nationalmuse-
ums* (1932–33), pp. 107–8, fig. 70; Tietze, "Dürer in America," *Art Bulle-
tin*, XV (1933), 271, fig. 26; Charles L. Kuhn, *A Catalogue of German
Paintings of the Middle Ages and Renaissance in American Collections*
(Cambridge, Massachusetts, 1936), no. 206, pl. XXXIX; Henry S. Francis,
"Early German Painting in The Cleveland Museum of Art," *American-
German Review*, XXI/2 (1954), 9, fig. 5; Coe (1955), II, 87, no. 27; Peter
Strieder, "Masters in the Circle of Albrecht Dürer," *Connoisseur*, CXLVIII
(1961), 45, fig. 6; Friedrich Winkler, "Meister um Albrecht Dürer,"
Kunstchronik, XIV (1961), 268, 271; Karl Oettinger and Karl-Adolf
Knappe, *Hans Baldung Grien und Albrecht Dürer in Nürnberg* (Nurem-
berg, 1963), p. 118, n. 486; Hans Georg Gmelin, "Georg Pencz als
Maler," *Münchner Jahrbuch der Bildenden Kunst*, XVII (1966), 55–57,
fig. 9 (as Pencz), 74 no. 4, 123 n. 14; CMA *Handbook* (1978), illus. p. 125.

Figure 68.

168

HANS HOLBEIN THE YOUNGER
1497/8–1543

Hans Holbein the Younger was born in Augsburg. He received his early training from his father, Hans Holbein the Elder, a leading master of the late Gothic school in Augsburg. By 1515 Hans and his brother, Ambrosius, were in Basel, where they were employed to design title pages and initials for the publisher and humanist Johann Froben. Holbein enjoyed the patronage of Erasmus of Rotterdam, whom he had met through Froben, the publisher of Erasmus's *The Praise of Folly*. Holbein's reputation spread quickly in the decade he spent in Switzerland. Between 1517 and 1519 he traveled to Lucerne, and may have crossed the Alps and visited Lombardy. He journeyed to France in the spring of 1524, visiting Lyons and Avignon. In 1526 he gave up his workshop in Basel and traveled to the Netherlands, via Antwerp, where he met the important Flemish painter Quentin Massys. Commissions for religious works gradually diminished in the years leading up to the Reformation, which probably precipitated Holbein's visit to England with letters of introduction from Erasmus to Sir Thomas More and Archbishop Warham. After a brief return to Basel in 1528 and a short stay in Freiburg-im-Breisgau, he settled permanently in London in 1532. Though by this time Sir Thomas More had broken with King Henry VIII, Holbein found favor with the monarch and members of his court. During the remaining years of his life he was the leading portrait painter in England. He was dispatched to the Continent with delegations inspecting prospective brides for Henry VIII in order to bring back portraits for the king's scrutiny. He visited Basel again briefly but did not succumb to the urgent pleas of the city fathers to remain. He died of the plague raging in London in October 1543.

69 Terminus: The Device of Erasmus of Rotterdam 71.166

Panel (oak), 21.6 x 21.6 cm. Inscription at shoulder level: CONCEDO NVLLI. Inscription at bottom right of cubiform base: TERMI/NVS.

Collections: [Charlotte Frank, London]; Dr. and Mrs. Sherman E. Lee, Cleveland.

Gift of Dr. and Mrs. Sherman E. Lee in Memory of Milton S. Fox, 1971.

The earlier history of this panel is unknown. It was examined by the Intermuseum Laboratory in Oberlin, Ohio, in 1971, and then cleaned at this Museum by Joseph Alvarez. On the left side of the cubiform base, large areas have been retouched, and there are minor abrasions on the neck and abdomen of the figure. Infrared and ultraviolet examination (in 1978) showed strengthening of the profile at the chin, the jaw line, and the neck.

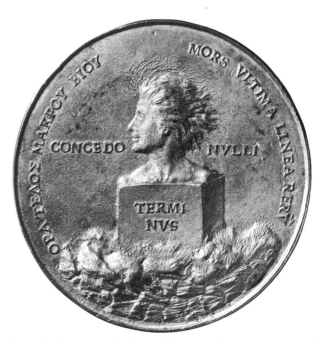

Figure 69a. *Terminus: The Device of Erasmus of Rotterdam* (reverse of *Portrait of Erasmus of Rotterdam*). Bronze medal after design by Quentin Massys. Historisches Museum, Basel.

In 1509, while traveling in Italy, Erasmus, the famous German Renaissance humanist, received from his pupil, Alexander Stewart (the illegitimate son of King James IV of Scotland), the gift of an antique gem engraved with a figure which at that time was identified as Terminus, the Roman god of boundaries (the figure is now thought to be Dionysus, the Greek god of vegetation and wine). From this image, Erasmus derived the design for his seal ring, on which the god is pictured as a younger figure than the one that inspired it, and to which are added the inscriptions *Terminus* and *Concedo Nulli* ("I give way to no one").

The device appeared thereafter on various other artifacts associated with Erasmus. One such work is the medal designed for Erasmus in 1519 by Quentin Massys; on one side is a portrait of Erasmus and on the other is the bust of a youth with flying hair (Figure 69a) and additional inscriptions translated as follows: "Death, the ultimate boundary of all things," and "Look towards the end of a long life." Later, Terminus and Erasmus were illustrated together in the well-known Holbein woodcut of 1535, in which the scholar is pictured full-length, with his hand resting on the head of the sculptured bust of the god (Figure 69b). The god and the scholar are one and the same, as in the case of another Holbein work, dating from 1525: a pen and wash drawing of Terminus (Figure 69c), in which the features of Erasmus have been substituted for those of the young god. John Rowlands (1980, p. 53) suggests that this drawing was the design for yet another Holbein work, a painting on

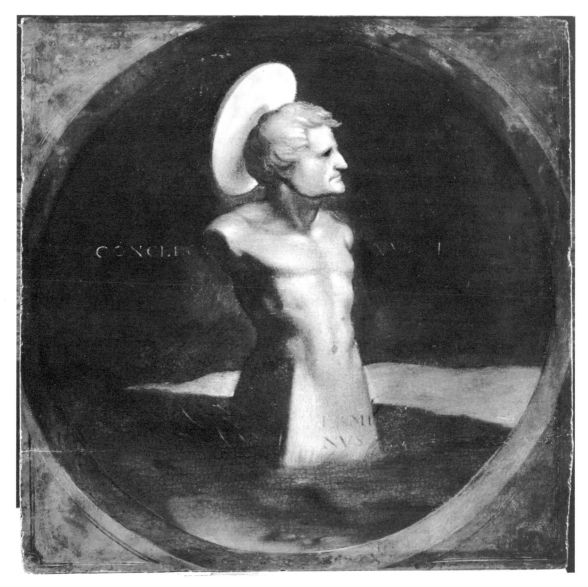

Figure 69.

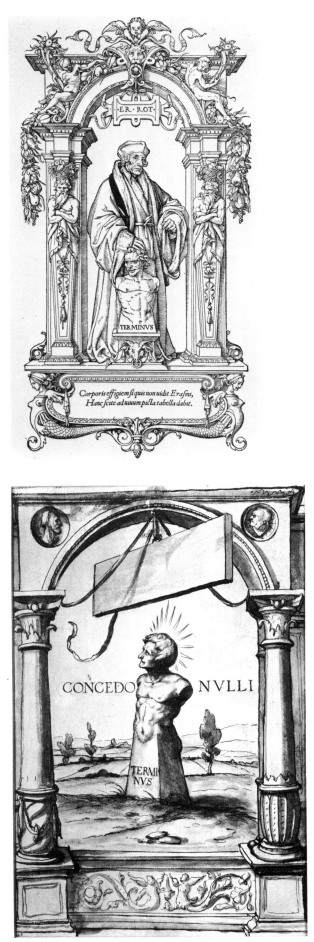

Figure 69b. *Erasmus Standing with His Hand on the Head of the Sculptured Bust of Terminus.* Woodcut, 28.6 x 14.8 cm. Holbein the Younger. Kupferstichkabinett des Kunstmuseums, Basel.

glass (now lost) which Erasmus intended to give to the University of Basel. According to a seventeenth-century source (cited *ibid.*), the glass painting was dated 1525 and bore the same inscriptions as the Massys medal of 1519. The image in our painting faces to the right, that is, in the opposite direction of the drawing for the glass painting, but otherwise they have certain features in common.

The Terminus emblem and the inscription *Concedo Nulli* are based on the Roman legend in which Terminus, alone of all the gods, refused to make way when Jupiter decided to have his sanctuary on the Capitoline Hill (Livy, *Ab urbe condita*, bk. I, chap. 55, and bk. V, chap. 54). The legend and some questions it raised were posed to scholars by the Late Classical author Aulus Gellius in his *Noctes Atticae* (bk. XII, chap. 6). Gellius described the god's refusal with the words *noluit concedere* ("he refused to give way"), from which Erasmus probably derived his own motto. Gellius's work was a subject of lively interest in humanist circles.

The device had a personal connotation for Erasmus. He claimed for himself a similar, unyielding position in the face of contemporary forces that tried to influence him in their direction, but his resistance to prevailing theological arguments and his substitution of his own features for those of the god inevitably drew charges of intellectual arrogance. In self-defense he wrote his *Epistola apologetica de termini sui inscriptione concedo nulli* (addressed to Alfonso Valdesius and dated August 1, 1528), in which he insisted that Terminus did not represent Erasmus but instead symbolized death, the boundary of life that yields to no one. Indeed, said he, the inscription *Mors ultima linea rerum* ("Death, the ultimate limit of [all] things") had often appeared on his Terminus emblems. He also said: "They see there a sculptured figure, in its lower part a stone, in its upper part a youth with flying hair. Does this look like Erasmus in any respect?" In at least two cases (the Basel drawing, Figure 69c, and the Cleveland panel), the answer to his question is yes: the facial features of the god are obviously those of Erasmus himself—visual evidence that Erasmus aspired to be as immovable as Terminus, who has been described as Erasmus's alter ego (Erwin Panofsky, "Erasmus and the Visual Arts," *Journal of the Warburg and Courtauld Institutes*, XXXII, 1969, 215).

Figure 69c. *Herma of Terminus.* Pen and wash, 31 x 21 cm. Holbein the Younger. Kupferstichkabinett des Kunstmuseums, Basel.

A comparison of our painting with other portraits of Erasmus confirms that our portrait is indeed of the scholar himself. See, for example, the series executed by Holbein in the early 1530s (Paul Ganz, *The Paintings of Hans Holbein*, London, 1950, cat. no. 56–59), which is also especially useful for stylistic comparisons. Other fine examples by Holbein, dating from 1523, when the scholar was somewhat younger than he is in our portrait, point up the undeniable physiognomic likeness: one in the collection of the Earl of Radnor at Longford Castle, Salisbury (Ganz, *op. cit.*, cat. no. 34, pl. 64); one in the Basel Öffentliche Kunstsammlung (*ibid.*, cat. no. 35, pl. 65); and the famous portrait in the Louvre, Paris (*ibid.*, cat. no. 36, pl. 66).

The Cleveland panel was discovered in 1970 in the English art market, where it had been called Flemish. David Carritt was the first to propose an attribution to Holbein, which both John Rowlands of The British Museum and Franz Meyer of the Kunstmuseum in Basel have since accepted. The attribution is supported by stylistic comparison with a series of panels that Holbein painted for a large altarpiece in Basel in the early 1520s, called *Eight Scenes of the Passion*, which are characterized by the rendering of soft, diffused light; by a similar choice of colors; and by the modeling of elongated faces and noses.

The attribution is also supported, of course, by comparison to the Holbein works discussed above, particularly the Basel drawing (Figure 69c). Furthermore, Rowlands (1980, p. 10) convincingly links the Cleveland *Terminus* to the style of a series of portraits of Erasmus produced—for the most part after 1532—not in Basel but in England. He believes that among these the one in the Robert Lehman Collection of the Metropolitan Museum is the best example. On the other hand, as Rowlands admits, this series is derivative in nature from Holbein's first and greatest portrait of Erasmus executed in 1523 in Basel (Öffentliche Kunstsammlung), which points up the difficulty in dating the Cleveland *Terminus* with any degree of certainty.

NCW

EXHIBITIONS: CMA, January 1972: Year in Review, cat. no. 52a.

LITERATURE: John Rowlands, "*Terminus, The Device of Erasmus of Rotterdam*: A Painting by Holbein," CMA *Bulletin*, LXVII (1980), 50–54, fig. 1 (color).

Follower of HANS HOLBEIN THE YOUNGER

70 *Portrait of Sir Thomas More* 57.356
 (1477/8–1525)

Panel (oak), Diam. 5.9 cm.
Collections: Private collection, New York; [Rosenberg & Stiebel, Inc., New York].
The Edward B. Greene Collection, 1957.

The early history of this portrait miniature is unknown, as is its record of restoration. It appears to be in excellent condition except for a minimum of abrasion around the border and on the neck of the sitter. There is also a thin line of reinforcement around the edges of the hat.

The Cleveland panel is one of the many paintings related to the life-size portrait of Sir Thomas More by Holbein the Younger now in The Frick Collection, New York (*The Frick Collection, An Illustrated Catalogue*, Vol. I: *Paintings: American, British, Dutch, Flemish, and German*, New York, 1968, 228–33, illus. in color opp. p. 228). The popularity of this distinguished theologian is understandable, considering his high office and his courageous refusal to take the oath of the royal succession after the marriage of Henry VIII to Anne Boleyn. More resigned as Lord Chancellor of England in 1529 and was executed for high treason in 1535.

Although the Cleveland miniature is dependent on the Frick portrait, it is not considered to be one of the copies directly derived from it. The S-chain in the Museum miniature is in reverse, which suggests that our painting may have been copied from a print made after Holbein's painting. With the exception of the Pemberton miniature in the Victoria and Albert Museum, London, most so-called Holbein miniatures are either from his studio or are later copies. It has been suggested that the Cleveland portrait is probably not sixteenth-century but may be seventeenth-century Flemish, possibly post-van Dyck. Sir Thomas More was a popular figure even into the seventeenth century when Rubens painted a portrait of him (Prado, no. 1688), probably a copy after the Frick portrait. Rubens's copy most likely dates from his first visit to England, between June 1629 and December 1630. A Netherlandish attribution for our painting seems worthy of further study.

The Cleveland miniature, though it is a fine example, is of lesser quality than the miniature portrait of More in Lincoln's Inn, London (water color on thin paper, mounted on a playing card, diam. 6 cm; ex collections: Godolphin-Quicke [related by marriage to Margaret Roper, More's eldest daughter], Newton Street, Cyres, Devon; Pierpont Morgan, New York, 1905; Sir Felix Cassell; see Paul Ganz, *The Paintings of Hans Holbein*, London, 1950, p. 227, as copy after Holbein, and Frances Paul, "Holbein and Portraits of the More Family," *Apollo*, XLVI, 1947, fig. VII, p. 21). The Lincoln's Inn miniature, formerly in the Morgan collection, was incorrectly referred to by Henry S. Francis

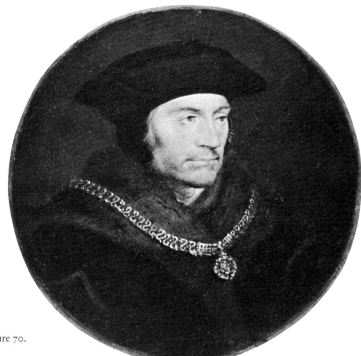

Figure 70.

(1959) as two separate paintings—a Morgan miniature and a Lincoln's Inn miniature.

There is an oval miniature portrait of More in the collection of the Duke of Buccleuch (oil on gesso ground on metal plaque; see Dudley Heath, *Connoisseur*, XVIII, 1907, illus. p. 136). Another is in the collection of the Museum of the Villa Albani in Rome (mentioned in Hans Werner Grohn and Roberto Salvani, *L'Opera pittorica completa di Holbein il Giovane*, Classici dell'Arte, vol. 50, Milan, 1971, no. 47, p. 97). These and the Lincoln's Inn miniatures show Sir Thomas as slightly older and grayer than he was in the Frick portrait, but, like the Cleveland miniature, they all show him with similar headdress, fur coat, chain of the Latin S, and pendant with double roses. They probably derive from a portrait that Holbein painted after his return to England in 1532 and before More's incarceration in the Tower of London in 1534. NCW

NOTE: For other miniatures in the Museum collection, see *Portrait Miniatures: The Edward B. Greene Collection* (Cleveland, 1951); see also Painting 79 in this catalogue.

EXHIBITIONS: None.

LITERATURE: CMA *Bulletin*, XLV (1958), illus. p. 71; Henry S. Francis, "Miniature of Sir Thomas More by Hans Holbein the Younger," CMA *Bulletin*, XLVI (1959), 53–57, illus. pp. 53–54; Malcolm Vaughn, "Attributed to Holbein: Miniature Acquired by The Cleveland Museum of Art," *Connoisseur*, CLXV (1960), 65–66, illus. p. 66; Stanley Morison, *The Likeness of Thomas More* (New York, 1963), p. 30; CMA *Handbook* (1978), illus. p. 127.

JOHANN LISS
Ca. 1597–1630/31

Johann Liss, who was also known as Jan or Giovanni Lisz, Lis, Lys, or Lijs, was born ca. 1597, presumably in Oldenburg, Holstein. Liss's biography has been tentatively reconstructed on the basis of Joachim van Sandrart's *Academie der Bau-, Bild- und Mahlerey-Künste von 1675* (ed. A. R. Peltzer, Munich, 1925, pp. 187–88). Some newly found documents substantiate Sandrart's account of the artist's life. Jörg Ehret of the North German Broadcasting Corporation, Hamburg, found the name Jan Lisz (possibly the father of Johann Liss) entered in the 1594 guild book of the sharpshooters' fraternity of St. Catherine in Oldenburg. And it is known that a certain couple, Anna and Johann Liss, both painters, resided at the ducal court of Schloss Gottorf, for two receipts were found—one, dating from 1622, made out to Johan Lissen (Landesarchiv no. 473), and the other, dating from 1650, made out to Anna Lissen (no archive number). A painting—formerly in the Cathedral of Schleswig, now lost—is described in an old guidebook (mentioned by Jörg Ehret, letter of September 17, 1976) which says it bore an inscription saying it was painted by Anna Lissen in 1651 in her seventy-fourth year. Liss himself gives Holstein as his place of origin in the inscription of two drawings, *Fighting Gobbi Musicians* (Kupferstichkabinett, Kunsthalle, Hamburg) and the *Allegory of Christian Faith* in the Cleveland Museum (acc. no. 53.6). That he was still alive in 1629 is confirmed by his listing in the fraternity of painters in Venice, where his name, "Lis Zuanne fiamengo," is followed by a notation of the year 1629 (Leone Luzzatto, "Per la Storia dell'Arte Veneziana—Lista di Nomi di Artisti Tolta dal Libri di Tanse o Luminarie della Fraglia dei Pittori," *L'Ateneo Veneto*, series 14, I, Venice, 1890, 636). New evidence has been found which, if confirmed, would establish the exact date of Liss's death from the black plague: in the archives of the city of Verona (Elisabetta Antoniazzi, "Addenda: La Data di Morte di Johann Liss," *Arte Veneta*, XXIX, 1975, 306, n. 6), the name "Gio Lis Olandese" appears, and his death on December 3, 1631, is recorded.

According to Sandrart, Liss went to Amsterdam and adapted the manner of Hendrick Goltzius, who was very likely his teacher at Haarlem. Goltzius died in 1617, after which Liss may have left for Antwerp. Although Sandrart does not mention Antwerp, Liss appears to have absorbed lasting influences from leading Antwerp painters, particularly from Jacob Jordaens. On the other hand, Sandrart does mention the possibility that Liss was in Paris, though no influence from Paris can be found in his oeuvre. Liss was in Venice at least by 1621; the inscription on the drawing *Fighting Gobbi Musicians* attests to his presence there. From Venice he went to Rome, where, as Sandrart observed, he absorbed "an entirely different manner." The inscription on his drawing *Allegory of Christian Faith* confirms that he was in Rome, but unfortunately the last two digits of the date are illegible. Liss was a member of the Schildersbent, founded in 1623, an association of Northern painters active in Rome. Sandrart arrived in Venice in 1628, at which time Liss had already painted his *Vision of St. Jerome* for the church of S. Nicolò da Tolentino. Sandrart's attempt to persuade his friend to return to Rome failed, and thus Liss met his untimely end in the plague.

71 *Amor* 71.100

Canvas, 87.7 x 65.7 cm.

Collections: Alessandro Basevi, Genoa; [Heim Gallery, London].

Purchase, Leonard C. Hanna Jr. Bequest, 1971.

The canvas is a single piece of plain-woven, brown linen fabric of moderately fine weight which has been lined with an animal-glue adhesive to a piece of medium-weight linen. Its dimensions have not been altered, and it appears to be on the original stretcher. Aside from moderate abrasions of the paint layer, especially in the background, the general condition of the painting is good. Two large vertical tears through the original support in the upper right quarter have been repaired by the glue lining. Although the painting was retouched and revarnished before it came to the Museum, fragmentary residues of yellowed varnish remained in the paint texture in some areas, altering the contrasts and minimizing the subtle, cool tones of the flesh.

Amor was first published as the work of Johann Liss by Antonio Morassi when it was exhibited in Genoa in 1947 (Exh: 1947). At that time, the painting was on loan from the Genoese collection of Alessandro Basevi, the only known previous owner.

Bloch (1955) suggested that the *Amor* had a symbolical connotation stemming from Liss's notorious Bohemian life, which earned him the nickname "Pan" among members of the Roman Schildersbent.

Stylistically, the *Amor* is proof of Liss's direct contact with Caravaggesque painting in Rome, revealing perhaps a direct inspiration from Caravaggio's own *Victorious Amor* (Berlin, Staatliche Museen Preussischer Kulturbesitz, Gemäldegalerie). But more importantly, Liss's *Amor* is a felicitous combination of Venetian *and* Roman aspects. In it we see the opulence of Venetian color; the dramatic use of light associated with the artist's important Roman works, such as *Banquet of Soldiers and Courtesans* (Germanisches Nationalmuseum, Nuremberg); and the subtle modeling in another Roman work, the drawing *Allegory of Christian Faith*, in The Cleveland Museum of Art. The style, therefore, suggests a date in the latter part of Liss's short career.

ATL

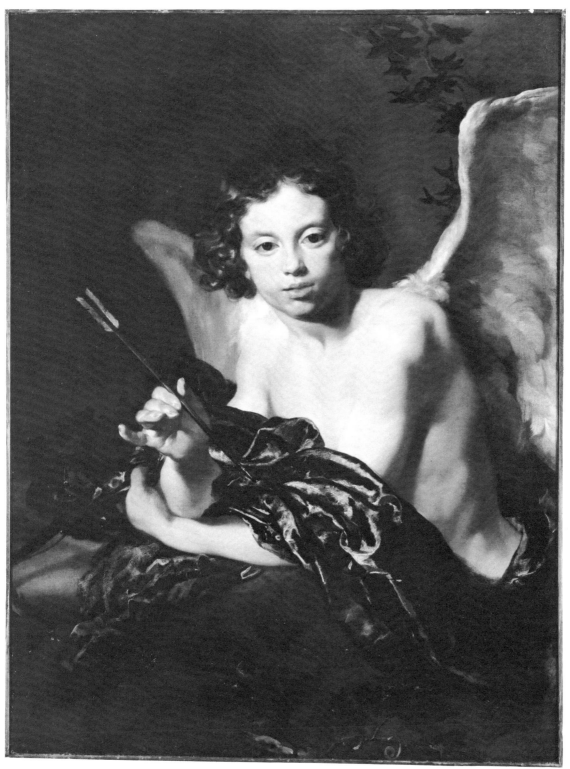

Figure 71.

EXHIBITIONS: Genoa, Palazzo Reale, 1947: Mostra della pittura del Seicento e Settecento in Liguria, cat. no. 146, illus. (catalogue by Antonio Morassi); Venice, Ca'Pesaro, 1959: La pittura del Seicento a Venezia, cat. no. 63, illus.; CMA, January 1972: Year in Review, cat. no. 54, illus.; Augsburg, Städtische Kunstsammlungen, 1975, and CMA, 1975/76: Johann Liss, cat. no. 29, pp. 23, 70, 101–3, 104, 106, 108, color frontispiece (catalogue by Rüdiger Klessmann, Ann Tzeutschler Lurie, and Louise Richards).

LITERATURE: Vitale Bloch, "Liss and His *Fall of Phaeton*," *Burlington Magazine*, XCII (1950), 282, n. 22; Bloch, "Addenda to Liss," *Burlington Magazine*, XCVII (1955), 324, n. 6, fig. 27; Donzelli and Pilo (1967), p. 241; Gode Krämer, "Johann Liss—ein deutscher Maler des Barock," *Alte und Moderne Kunst*, XX, no. 140 (1975), 17, fig. 9; Gabriele Blankenagel, "Johann Liss," *Weltkunst*, XLV (1975), 1361, illus. p. 1360; Ann Tzeutschler Lurie, "Liss and the God of Love," CMA *Bulletin*, LXII (1975), 283–90, color illus. p. 281, and figs. 1, 5, 17; Eduard A. Safarik, "La Mostra di Johann Liss," *Arte Veneta*, XXIX (1975), 301–2; Elisabetta Antoniazzi, "Addenda: La Data di Morte di Johann Liss," *Arte Veneta*, XXIX (1975), 306; Alfred Werner, "The Sphinx of Oldenburg," *Art and Artists*, XI (May 1976), 27; Rüdiger Klessmann, "Begegnung mit einem Vergessenen," *Westermanns Monatshefte* (June 1976), p. 22, and color illus. opp.; "Art across North America," *Apollo*, CIII (1976), 241; Richard E. Spear, "Johann Liss Reconsidered," *Art Bulletin*, LVIII (1976), 583, 586, 590, 592; CMA *Handbook* (1978), illus. p. 134; Rodolfo Pallucchini, *La pittura veneziana del Seicento* (Milan, 1981), I, 145, and II, 608, fig. 405.

HANS MIELICH (Müelich)

1515–1573

Hans Mielich probably got his training from his father, Wolfgang (recorded in Munich from 1509–1541). In his travels along the Danube about 1536, Mielich painted sacred pictures, such as the *St. Jerome* (Munich, Alte Pinakothek), which reflect the influence of Albrecht Altdorfer, with whom he probably collaborated in Regensburg. Mielich was active ca. 1539 in Munich; in 1541 he went to Rome. The influences he absorbed during his Italian journey are reflected in such works as the *Derision of Christ*, in the church of Solna near Stockholm, which he painted in 1543. In that same year he was a member of the Munich guild. He was active most of his life in the court of Albrecht V of Bavaria. As court painter he was commissioned to do numerous portraits for the House of Wittelsbach, and his duties included illustrating prayer books and inventories of jewels. He also illustrated two volumes of psalms by Orlando Lassus (ca. 1530–1594).

Figure 72a. *Portrait of Pankraz von Freyberg.*
On panel, 64.3 x 48.2 cm. Mielich.
Staatliche Kunsthalle, Karlsruhe, West Germany.

72 *Portrait of Maria Kitscher* 44.88
von Oelkofen, Frau Pankraz
von Freyberg zu Aschau

Panel (lindenwood), 64.1 x 47.8 cm. Signed and dated: M D XXXXV
AETATIS SVAE XXVII H. M.
Collections: Mrs. Francis F. Prentiss, Cleveland.
The Elisabeth Severance Prentiss Collection, 1944.

In 1936 William Suhr cradled the panel to support the original joints on either side of the subject's head. The cradle was positioned in such a way as to leave uncovered as much as possible of the remains of the heraldic emblem painted on the back. Along the joints there was a slight rising of the paint film, which otherwise was in excellent condition.

A companion portrait of Pankraz von Freyberg (Figure 72a), husband of Maria Kitscher von Oelkofen, was also painted by Mielich in 1545. These portraits by Mielich are much more idealized and flattering than another pair of portraits of the couple which were etched by Hans Lautensack in 1553, eight years after Mielich's paintings. The differences in the appearance of Frau Pankraz von Freyberg

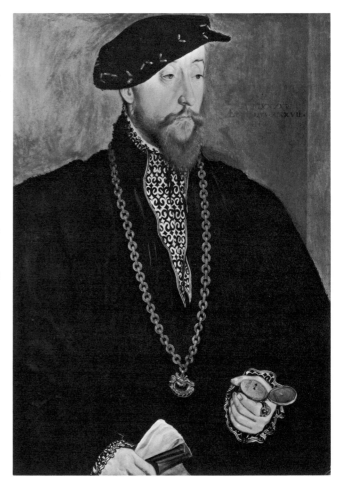

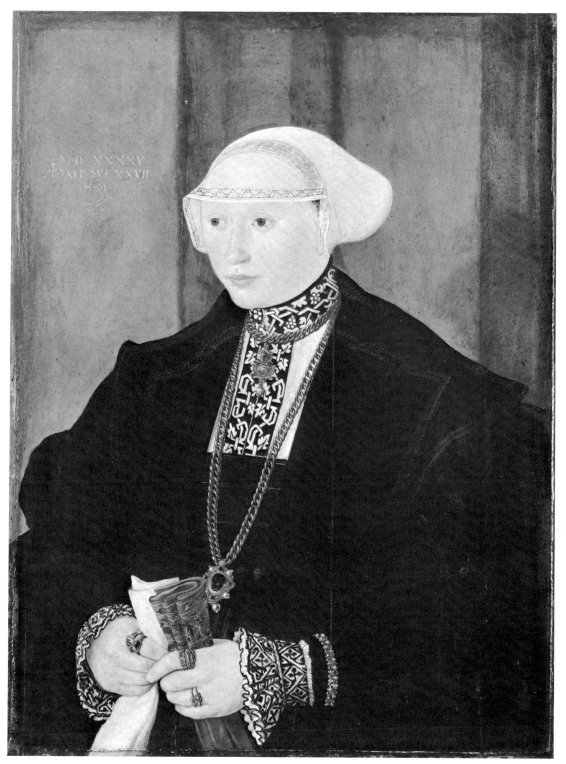

Figure 72.

Figure 72b. Detail showing hands and signet ring.

EXHIBITIONS: CMA, 1944: The Prentiss Bequest, cat. no. 10, pl. VIII (said to have been in the C. Fairfax Murray collection, apparently having been confused with the companion portrait [Figure 72a]).

LITERATURE: B. H. Röttger, *Der Maler Hans Mielich* (Munich, 1925), pp. 46, 67, no. 11, illus. p. 65; Charles Louis Kuhn, *A Catalogue of German Paintings of the Middle Ages and Renaissance in American Collections* (Cambridge, Massachusetts, 1936), p. 71, no. 305; Henry S. Francis, "Paintings in the Prentiss Bequest," CMA *Bulletin*, XXXI (1944), 88; Coe (1955), II, 213–14, pl. XLII; Annegrit Schmitt, *Hans Lautensack*, Nürnberger Forschungen, Vol. IV (Nuremberg, 1957), 9, 63; Staatliche Kunsthalle, *Katalog Alte Meister bis 1800* (Karlsruhe, 1966), p. 205, see no. 2477; CMA *Handbook* (1978), illus. p. 130.

Circle of MICHAEL OSTENDORFER (?)
Early sixteenth century

The provinces of the Danube in southeastern Germany were particularly attractive to artists of the early sixteenth century. Perhaps the most prominent painter of this so-called Danube School was Albrecht Altdorfer (ca. 1478–1538) from Regensburg. Michael Ostendorfer (born around 1490), of Swabian descent, was one of the many pupils in Altdorfer's Regensburg workshop. Ostendorfer bought a house in Regensburg in 1528 and lived there with his wife, Anna, who died in 1550. After his second marriage, he was beset with financial difficulties. In 1556 he entered the House of Brotherhood, which apparently he left before his death in 1559. The altar depicting the *Legend of St. Eligius* (Nuremberg, Germanisches Nationalmuseum, cat. no. 319), formerly ascribed to the monogrammist "I," was recognized by Pfeiffer (1965) as the remains of an altar signed by Ostendorfer (according to a statement of 1661), which was donated to the St. Rupert Church in 1520 by the goldsmiths' guild of Regensburg. Pfeiffer also identified from the fragmented predella panel of this altar an *Ecce Homo* which is signed by Ostendorfer and dated 1520. Modern scholarship has identified a number of the Danube School painters, some of them pupils of Altdorfer, and other independent masters, such as Wolf Huber (1490–1553), who undoubtedly exchanged ideas with Altdorfer.

73 *The Visitation* 50.91

Panel (fruitwood), 102.7 x 78.5 cm. Painted surface: 101 x 75 cm.
Collections: [R. Heinemann-Fleischmann]; Baron Thyssen-Bornemisza, Schloss Rohoncz, Castagnola; [Rosenberg & Stiebel, Inc., New York, 1950].
Gift of Hanna Fund, 1950.

According to Franz Winzinger (orally, during visit to this Museum, September 27, 1977), this panel may once have been part of an altarpiece depicting scenes from the life of Mary. The faces and figures are almost all intact. There are numerous small-to-moderate areas of retouching covering flake losses and abrasion. Before it entered the Museum collection, the panel had split along the vertical joint to the

are not so much due to the increment in her age or to the difference in media as to Lautensack's unsparing approach to his subject (he even included a mole on her cheek).

Mielich's work on jewel inventories and miniatures for Albrecht V was perhaps excellent preparation for the rendition of jewels and costume decoration in his portraits, which he executed with meticulous clarity. The ring on the forefinger of the sitter's right hand (Figure 72b), when examined under magnification at the suggestion of Kurt Löcher (orally, 1975), appears to bear the family coat of arms painted in complete detail, with the blue stripes of the woman's family on the left and the golden stars of the husband's family on the right. In the companion portrait the husband wears a similar ring with the same coat of arms. The woman's initials, M v F, are painted in reverse above the coat of arms, indicating that the ring was a signet ring. Also noted during the examination was a Latin inscription on the headband, which is seen through the gauzy fabric of the head cover. The narrow ribbon which winds across the central portion of the decorative border bears the words VNA (or INR) . . . and PENSA (?); these words are repeated in the same order on the next two sections of ribbon. Not all letters in the inscription are clear; they may have been rubbed in previous cleanings. JKC

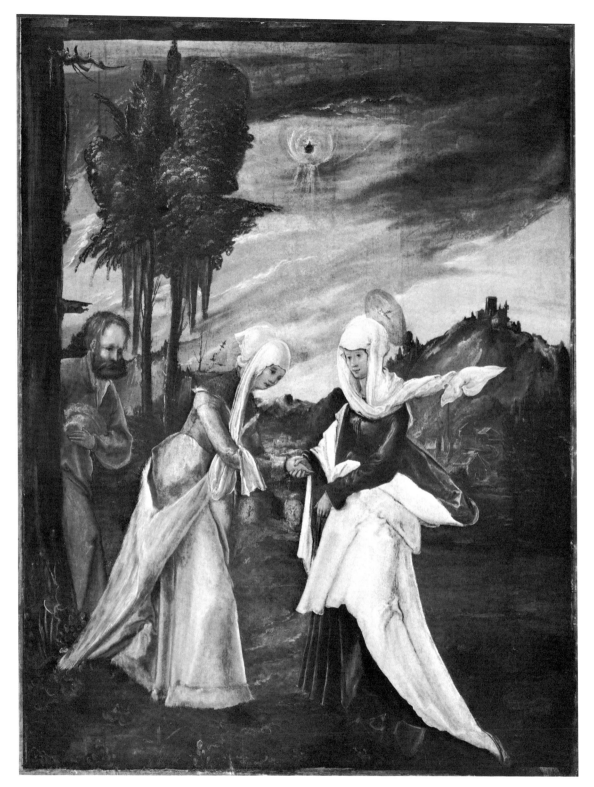

Figure 73.

179

Figure 73a. *The Assumption of Mary*. On panel, 102 x 78 cm, ca. 1520. Danube School. Collection of Georg Schäfer, Obbach, West Germany.

Eligius altar as the signed work of Ostendorfer. Franz Winzinger (letter of September 21, 1950) thought the Cleveland panel was definitely not by Altdorfer; he suggested a Bavarian or Austrian master of the Danube School (School of Altdorfer) and dated it about 1520. Later Winzinger (1975) attributed the panel to Michael Ostendorfer (?), believing it to be by the same hand as *The Lamentation* (private collection in Upper Bavaria, formerly in the collections of Kränner and Hamminger in Regensburg; see Winzinger, no. 106) because of its overall composition and some of the details, particularly in the treatment of the robes and trees.

The *Assumption of Mary* (Figure 73a) in Obbach and the Cleveland *Visitation*, having nearly the same dimensions (102 x 78 cm, and 101.6 x 77.4 cm, respectively) and having both been in the Thyssen collection, have been consistently linked together in the literature. Winzinger (1975, and orally in 1977) said that both were probably in the Kränner collection in Regensburg before they entered the Thyssen collection, and that both were by the same hand. Pfeiffer, who had given the *St. Eligius* altar to Ostendorfer, rejected an Ostendorfer attribution for the *Assumption* and the *Visitation*, making no further conjecture on their authorship. The two panels stand apart in some ways from the *St. Eligius*. There are similarities in the treatment of the landscape and trees, but the bulkiness and heavy handling of the figures, the broad facial features, and the large hands in the *St. Eligius* contrast sharply with the slender proportions, delicate features, and diminutive hands in the Cleveland and Obbach paintings.

Pfeiffer (1965) and Winzinger (1975) mention two other panels which they say are closely related: *Death of Mary* and *Mary in the Temple* (*Pantheon*, XIV, July–December 1934, 223, illus. p. 285). Both were on the art market in 1935.

Although the assignment of our panel to a master of the Ostendorfer circle seems justified, further attributions should be studied. More and more works of the Danube School are being attributed to Wolf Huber (*Die Kunst der Donauschule 1490–1540*, exh. cat., Linz, 1965, pp. 110–34; Stange, 1971, pp. 96–106), whose drawings especially might be profitably compared with the Cleveland painting. The iconography of our panel is individual, whimsical, and imaginative in its interpretation (Verheyen, 1964), and the brushwork is sure and confident. At the same time, there are awkward elements in the composition which indicate it could be an early work—for example, the bulky tree trunk flattened against the left edge of the painting; the proportions of the pair of trees that jut into the sky, belying their position in the background; and the insistent, outward sweep of the garments of the two women. Other characteristics of our painting—such as the light, sure strokes that delineate the buildings against washes of pigment, the gentle expressions of the faces, the small heads, the elongated proportions of the figures, and the abbreviated nota-

right of Mary and there were tiny losses along the split. The fruitwood panel was thinned before the cradle support was attached. The ground paint layers extend to the edge of the support along the top; on both sides and along the bottom edge there is an unprepared margin approximately 1.5 centimeters wide, indicating that the painting may have been in an engaged frame originally. Under infrared light, pentimenti are visible in the sky, in the town on the hill, and in the white garments of Mary. At present the panel is disfigured by an accumulation of surface grime, discolored varnish, and numerous areas of retouching that have darkened.

First to publish the panel was R. Heinemann-Fleischmann (Exh: 1930), who attributed the Cleveland painting to Albrecht Altdorfer and dated it ca. 1511. Hugelshofer (1930) agreed with the Altdorfer attribution and speculated that stylistic inconsistencies with Altdorfer's other works stemmed from the need to accommodate the painting to the dimly lit church interior for which it was intended. Zimmerman (1933) thought the Cleveland panel was by the monogrammist "I," to whom he had also attributed the *St. Eligius* altar because of a small "I" found on two of the panels. Wolfgang Pfeiffer (1965), however, later identified the *St.*

tions of plants and flowers in the foreground—are consistent with the style of Huber's drawings, which show a natural inclination toward abbreviation, a quick summing up of space and texture in a few lines, and a simplified composition with figures placed in the foreground. In the treatment of figures, drapery, and landscape, Huber's *Crucifixion* of 1511 (Karl Oettinger, "Zu Wolf Hubers Frühzeit," *Jahrbuch der Kunsthistorischen Sammlungen in Wien*, XVII, 1957, 71–72, fig. 116), for example, has much in common with the Cleveland painting, if one allows for the differences between ink and paint.

Unfortunately, not many early paintings by Huber—that is, before 1519—have yet been identified. Stange (1964, p. 98) accepts the Thyssen *Adoration of the Magi* as a Huber work and dates it 1512. Franz Winzinger ("Der Meister der Anbetung Thyssen," *Festschrift Karl Oettinger*, Erlangen, 1967, pp. 367–78) qualified his attribution to Huber by adding "or his workshop." *Christ's Farewell to Mary* (Vienna, Kunsthistorisches Museum), dated 1519, has many stylistic similarities to the Cleveland painting. Other firmly attributed paintings are from a later phase, after Huber's exposure to Italian works, when his own paintings reflected an interest in a more sculptural and classical approach.

<div align="right">NCW and JKC</div>

EXHIBITIONS: Munich, Neue Pinakothek, 1930: Sammlung Schloss Rohoncz (catalogue: *Ausstellung Neue Pinakothek*, ed. Rudolf Heinemann-Fleischmann, I, 1, no. 1, pl. 8); CMA (1958), no. 42.

LITERATURE: Walter Hugelshofer, "Die Altdeutschen Bilder der Sammlung Schloss Rohoncz," *Der Cicerone*, XXII (1930), 406, fig. 2; E. H. Zimmerman, "Aus Altdorfer's Umkreis," *Anzeiger des Germanischen Nationalmuseums* (1933), p. 123, pl. 83; Henry S. Francis, "A Painting and a Drawing by Albrecht Altdorfer," CMA *Bulletin*, XXXVII (1950), 115–18, illus. p. 113; Francis, "Early German Painting in The Cleveland Museum of Art," *American-German Review*, XXI/2 (1954/55), 9, fig. 8; Gisela and Karl Noehles, in *Encyclopedia of World Art* (New York, Toronto, and London, 1959), I, 222; Arnulf Wynen, "Michael Ostendorfer" (Ph.D. dissertation, Freiburg i.Br., 1961), p. 36; Alfred Stange, *Malerei der Donauschule* (Munich, 1964), p. 92, fig. 150 (rev. ed. [Munich, 1971], p. 92, fig. 169); Egon Verheyen, "An Iconographic Note on Altdorfer's *Visitation* in The Cleveland Museum of Art," *Art Bulletin*, XLVI (1964), 536–39; *Die Kunst der Donauschule 1490–1540* (exh. cat., Linz, 1965), p. 89, mentioned under nos. 206 and 207; Wolfgang Pfeiffer, "Ein Frühwerk Michael Ostendorfers (?) Die Nürnberger Tafeln des Monogrammisten I," *Alte und Moderne Kunst*, X, no. 80 (1965), 22; Pfeiffer, "Die Zeichnungen Michael Ostendorfers am Kirchenmodell der Schöenen Maria zu Regensburg," *Pantheon*, XXIV, n.s. (1966), 378, fig. 10; Franz Winzinger, *Albrecht Altdorfer, Die Gemälde* (Munich and Zurich, 1975), pp. 129–30, 154, no. 108, fig. 108; CMA *Handbook* (1978), illus. p. 131.

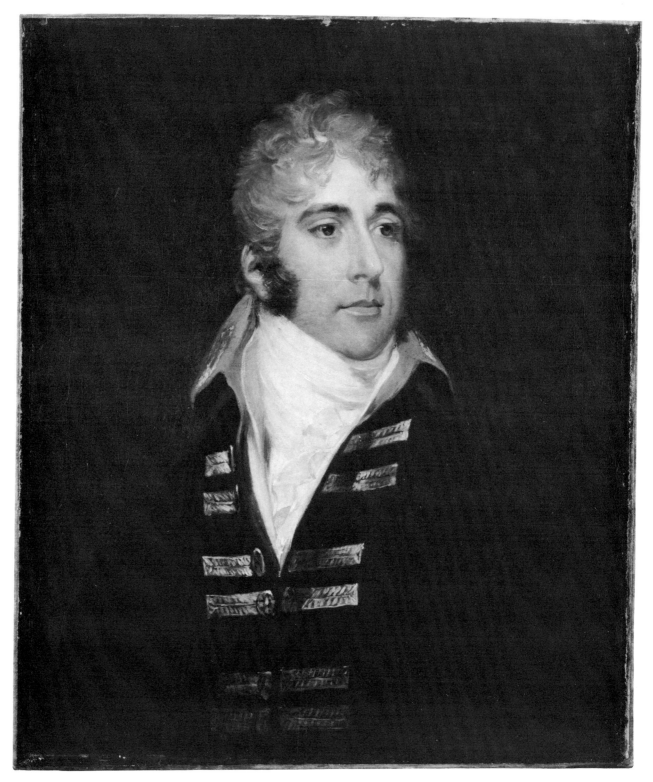

Figure 74.

Great Britain

SIR WILLIAM BEECHEY
1753–1839

William Beechey was born in Burford, Oxfordshire, in 1753. He studied under the expatriate German painter Johann Zoffany, and at the Royal Academy School. It is doubtful that he was tutored by Sir Joshua Reynolds, as has sometimes been stated; in later life, however, he did count Reynolds as a friend. His reputation rested almost entirely upon his portraits of the fashionable and famous, including Queen Charlotte and the royal family. Although Thomas Lawrence and Sir Joshua Reynolds were more eminent portraitists, Beechey remained popular throughout his career. He exhibited more than 350 paintings at the Royal Academy over a period of sixty-two years. He became a member of the Academy in 1798 and was knighted by George III in the same year. The critics of his time frequently compared his work with Reynolds', but later opinion has tended to assign Beechey a less prominent place in the history of English portraiture.

74 *Portrait of a Man* 78.75

Fabric, 76.7 x 64.3 cm.
Collections: Family of Mrs. Myron E. Merry.
Gift of Mrs. Myron E. Merry, 1978.

Before it entered the Museum collection, the painting had been enlarged by letting out the tacking margins, which resulted in an increase of slightly more than one centimeter in each dimension. There is a uniform crackle overall. Paint losses along all edges of the painting have been overpainted.

This painting of an unidentified officer has been traditionally attributed to Beechey. The subject's elongated, slightly softened facial features and vaguely detached air are typical of this artist's portraits of male subjects. The jacket worn by the sitter is probably an undress naval uniform, but the insignia and markings are too generalized to permit positive identification. The cut of the jacket suggests that the portrait was done very near the end of the eighteenth century, a date which coordinates well with the style of the painting. Beechey's earlier style, in the seventies and eighties, tended to be somewhat harder and crisper, with less obvious brushwork. The style of the present work, with its more liquid, painterly modeling, relates it to Beechey's work at the turn of the century and later, when he seems to have assimilated some of the style of Lawrence, who was then very much in vogue. The handling of color, especially in the flesh tones, was thought in Beechey's day to be his greatest strength, and this facility is indeed one of the most appealing qualities of the Museum's painting. W S T

EXHIBITIONS: None.

LITERATURE: None.

FRANCIS COTES
1726–1770

Francis Cotes's father, Robert Cotes, was from an old English family which had emigrated to Ireland. Robert Cotes returned to England after an altercation with the Irish Parliament, and there he became a well-to-do apothecary in the parish of Saint-Mary-le-Strand in London, where Francis Cotes was born in 1726.

Little is known about the life of this artist, one of the founders of English portraiture in pastel or crayon, the graceful art that had become fashionable in England in the eighteenth century. Its popularity was due largely to the work of prominent artists on the Continent, such as Swiss-born Jean-Etienne Liotard (see Paintings 226 and 227), the French pastel painter, Maurice Quentin de La Tour (see Painting 38), and the Venetian, Rosalba Carriera (Francis Cotes was often referred to as "the Rosalba of England"). About 1740 Francis Cotes studied both pastel and oil in the studio of the conservative George Knapton (1698–1778). He soon decided on portraiture as a career. Through the 1750s he usually worked in pastel, but after he settled in his comfortable house on Cavendish Square in 1763, he occasionally painted in oils. The draperies in many of his portraits were executed by Peter Toms, a student of Cotes's, who worked in his studio. Another of Cotes's pupils, with whom he had a lifelong friendship, was the prominent John Russell of Guildford. Cotes's signature is on a petition to George III to form the Royal Academy, of which he became a founding member. Cotes was the most fashionable painter of portraits in the 1760s, aside from Gainsborough and Reynolds. His popularity and commissions, as well as his fine house on Cavendish Square, were taken over after his untimely death by George Romney. His younger brother, Samuel Cotes (1734–1818), was a prominent miniature painter.

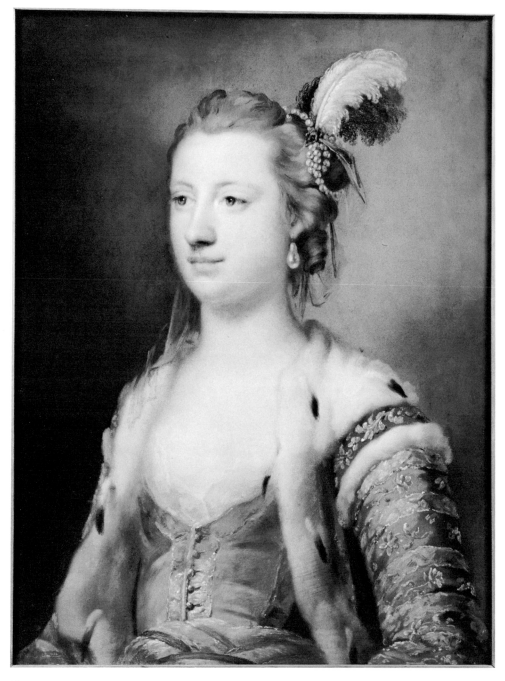

Figure 75.

184

75 *The Right Honorable Lady Mary* 46.463
 Radcliffe (1732–1798),
 Wife of Francis Eyre, Esq.

Pastel on paper glued on canvas, 60.7 x 45.7 cm. Signed below left center: Cotes pₓᵗ /1755.

Collections: Colonel H. H. Mulliner, Clifton Court, Rugby, Warwickshire (sale: Christie's, London, July 18, 1924, lot 2); [P. and D. Colnaghi, London]; (sale: Mensing & Fils, Amsterdam, April 27, 1937, no. 148, illus.); [Arnold Seligmann & Rey, Paris]; Edward B. Greene, Cleveland, 1937.

Gift of Edward B. Greene, 1946.

The paper, which is now glued to canvas, was originally adhered to linen and attached to the stretcher. There is abrasion of the surface in the lower right quadrant, extending through the lady's vest and the adjacent fur; the dark feather also appears to be abraded. There are serious mold stains in the mounting fabric; these have not penetrated the pastel except for small dark spots at the right edge of the sitter's fur collar. The pastel was treated by Ann Clapp at the Henry Francis Dupont Winterthur Museum, Paper Conservation Laboratory in 1978.

The signature is untouched. The date indicates that the work is a product of Cotes's maturity as an artist, though not of his full development. The pose of the sitter seems contrived and perhaps not as graceful as those of his later subjects, but the draftsmanship is skillful, and there is a fresh directness in the rendering of the lady's peacock-blue jacket fringed with ermine, her scarlet bodice, and her headdress surmounted by feathers and bound with pearls.

The sitter was identified only by a pencil notation on the back of the stretcher. Francis Radcliffe (letter of March 10, 1977), a relative of Lady Mary Radcliffe, informed us that Lady Mary was born in 1732, the daughter of Charlotte Maria, Countess of Newburgh, by her second husband, Charles Radcliffe, Earl of Derwentwater. Lady Mary was related to some notorious Englishmen: her uncle, James Radcliffe, Third Earl of Derwentwater, was beheaded for high treason in 1716, and her father was decapitated for the same reason in 1746. She married Francis Eyre of Warkworth, Northamptonshire, afterwards (1792) of Hassop, Derbyshire, in 1755 at St. George's, Hanover Square, London (H. A. Doubleday and Lord Howard de Walden, eds., *The Complete Peerage of a History of the House of Lords and All Its Members from the Earliest Times*, IX, London, 1936, 516). Francis Radcliffe suggested that the Museum portrait may be a wedding portrait of Lady Mary Radcliffe.

Another pastel of the Right Honorable Lady Mary Radcliffe was sold at auction by Messrs. Hampton & Sons, April 29, 1919, from the estate of the Eyre family at Hassop Hall, Hassop, Derbyshire. It is definitely not of the same woman who is represented in the Museum portrait (Walter Heil, "Portraits of Francis Cotes," *Art in America*, XX, December 1931, 5, and *Connoisseur*, XLIV, 1919, color illus. p. 205), but it may represent a different Lady Mary Rad-

cliffe—the daughter of James Radcliffe, the Third Earl of Derwentwater, who married Robert James Petre, Eighth Baron Petre, in 1732, and died in 1760. This Lady Mary would have been much older than the sitter in the Museum portrait, which was painted in 1755. N C W

EXHIBITIONS: None.

LITERATURE: Henry S. Francis, "Three Eighteenth-Century Pastel Portraits," CMA *Bulletin*, XXXIV (1947), 213–15; Coe (1955), II, 64, no. 5; Edward Mead Johnson, *Francis Cotes: Complete Edition with a Critical Essay and a Catalogue* (Oxford, 1976), cat. no. 57, p. 58.

GAINSBOROUGH DUPONT

1754–1797

Gainsborough Dupont was the son of Thomas Gainsborough's sister, Sarah. He lived in Thomas Gainsborough's house from childhood, was apprenticed to him in 1772, and in later years was his assistant. He engraved mezzotints after a number of his uncle's later works and finished the series of portraits of members of the Whitbread's Brewery (now at Southill) which Thomas Gainsborough had begun. E. K. Waterhouse (*Painting in Britain 1530 to 1790*, London, 1953, p. 191) remarked that without Dupont's signature, it would be difficult to determine that some of the portraits are not by Thomas Gainsborough. After his uncle's death in 1788, Dupont set up his own independent studio and exhibited at the Royal Academy between 1790 and 1795. His chief work is a group portrait of the Merchant Elder Brethren Corporation, now in the courtroom at Trinity House, painted in 1793–95 (John Hayes, "The Trinity House Group Portrait," *Burlington Magazine*, CVI, July 1964, 309–16). Dupont has not yet been studied adequately; it is difficult to separate his single portrait heads from the average work of his uncle's later years (for further information, see M. H. Spielmann, "A Note on Gainsborough and Gainsborough Dupont," *The Walpole Society*, V, 1915–17, 91 ff.; Waterhouse, *Gainsborough*, London, 1958, pp. 41–42; and J. Hayes, "Thomas Harris, Gainsborough Dupont and the Theatrical Gallery at Belmont," *Connoisseur*, CLXIX, December 1968, 221–27). He died at his house in Fitzroy Square in London in 1797. His death date is known from a memorial inscription that states he was forty-two years of age at the time of his death. He is buried at Kew at the same grave site as his uncle.

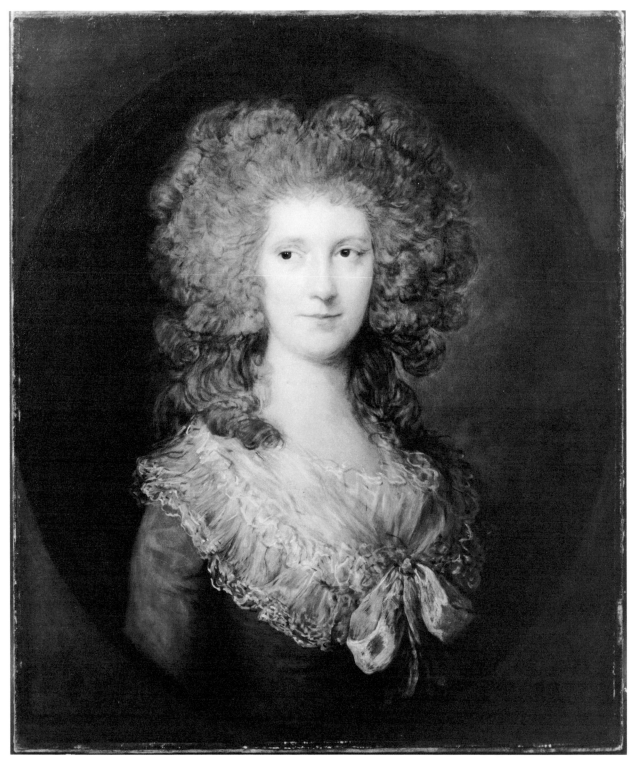

Figure 76.

76 *Portrait of Mrs. Thomas Samuel* 42.640
Joliffe (1756–1802)

Canvas, 76.8 x 63.7 cm.
Collections: William Joliffe, Esq.; Lord Hylton, Ammerdown Park, Radstock, Beth, Somerset; [M. Knoedler & Co., New York, 1911]; John L. Severance, Cleveland.
Bequest of John L. Severance, 1942.

William Suhr examined the painting in 1942 and gave it a light surface cleaning. The paint film is in satisfactory condition except for some slightly darkened retouching that conceals an old U-shaped tear on the right side of the sitter's face, just above the upper lip. There is also some minor damage to the left of the mouth: a tear, beginning under the nose, extends downward to the left, and at the end of the tear the paint surface is abraded. William Suhr noted that the shadowed parts of the face appeared to have been scratched with a fine needle after the paint was applied to achieve a certain peculiar texture. Suhr removed the disfiguring, yellowed varnish in these fine horizontal interstices, but the varnish has yellowed again.

The sitter was Anne, daughter and heir of Reverend Robert Twyford of Kilmersdon, Somersetshire. In 1778 Anne married Thomas Samuel Joliffe (1746–1824), younger brother of William and the second son of John Joliffe. None of their children had issue. The painting became the property of William Joliffe, whose wife, Eleanor, Lady Hylton, had been wrongly identified as the sitter until E. K. Waterhouse (1948–50) pointed out that Lady Hylton died in 1764, and the style of the painting dates it as a work of the 1780s. In 1788 Thomas Samuel Joliffe commissioned James Wyatt to build Ammerdown House in Somerset, where this painting long resided and where the companion, *Portrait of Mrs. Samuel Joliffe*, by Thomas Gainsborough (canvas, 76.2 x 63.5 cm, ca. 1780), still hangs (Waterhouse, 1958, no. 404, p. 76).

The Museum's portrait was attributed to Thomas Gainsborough until 1963, when it was changed to his nephew Gainsborough Dupont at the suggestion of E. K. Waterhouse. Scholars in general have supported the attribution to Dupont. NCW

EXHIBITIONS: New York, M. Knoedler & Co., 1914: Exhibition of Paintings by Thomas Gainsborough, R.A., and J. M. W. Turner, R.A., cat. no. 17; CMA (1936), cat. no. 216; CMA (1942), cat. no. 6, pl. v; CMA (1963), cat. no. 33, illus.

LITERATURE: *Description of the Mansion, Marbles, and Pictures at Ammerdown in Somerset* (London, 1857); William M. Milliken, "The Twentieth-Anniversary Exhibition of The Cleveland Museum of Art," *Art News*, XXXIV (June 1936), illus. p. 14; Francis (1942), p. 136; Helen Comstock, "The John L. Severance Collection at Cleveland," *Connoisseur*, CXI (1943), 61; Ellis K. Waterhouse, "Preliminary Check List of Portraits by Thomas Gainsborough," *The Walpole Society*, XXXIII (1948–50), 63; Coe (1955), II, 232, no. 6 (as Thomas Gainsborough, *Portrait of Eleanor, Lady Hylton*); Waterhouse, *Gainsborough* (London, 1958), p. 76, no. 405; *A Portrait of Lady Hylton by Thomas Gainsborough, R.A., 1727–1788* (London, New York, and Paris, n.d.), illus. and discussed.

THOMAS GAINSBOROUGH
1727–1788

Thomas Gainsborough was born in 1727 in Sudbury, Suffolk; he was the youngest son of a cloth merchant. In 1740 he went to London, where he became the assistant to the French engraver and book illustrator, Hubert Gravelot. He learned a delicate, fluent style of draftsmanship that more than compensated for his lack of academic training. His painting technique was influenced by Dutch landscape paintings, which he copied and also restored for local collectors. He painted landscapes for pleasure and portraits for a living. He lived in Suffolk from 1746, when he married Margaret Burr (the illegitimate daughter of Henry, Duke of Beaufort), until he moved to Ipswich in 1752. In Ipswich he painted landscapes and portraits of the local gentry. In 1757 he moved to the fashionable spa of Bath, where his style acquired the more sophisticated elegance of his new patrons. By 1768 his reputation was established. He became a founding member of the Royal Academy and was elected to their council, but he eventually severed connections with them. In 1774 he settled in London, where he died in 1788.

Unlike most of his contemporaries and his main rival, Sir Joshua Reynolds, Gainsborough never used drapery painters, nor did he maintain a large studio. His one faithful assistant was his nephew, Gainsborough Dupont (see Painting 76). His many portrait commissions, largely of the lesser gentry, left him little time for painting his so-called fancy pictures—idyllic landscapes with figures. In contrast to Reynolds, who painted the social and intellectual elite in a manner based on a thorough study of Italian Renaissance and Baroque art, Gainsborough relied on his own inspired brushwork, his sense of vibrant color and dramatic depth, and his empathy with humanity to create his brilliant portraits—accomplishments that were eventually acknowledged by Reynolds in his *Discourse Fourteen* (1790).

77 *Portrait of Mrs. Wise* 44.82

Canvas, 76.2 x 63.5 cm.
Collections: Sir Wathen Arthur Waller, Bart. (descendant of Mrs. S. Wathen, the mother of the sitter); [New York, The F. Kleinberger Galleries]; [Duveen Brothers, 1913]; Mrs. Francis F. Prentiss, Cleveland.
The Elisabeth Severance Prentiss Collection, 1944.

The painting had been lined and restored in the past. There are some paint flakings, particularly in the hand. The condition is generally good, but the varnish is very dirty and discolored, and the painting is in need of cleaning at present.

Mrs. Mary Wise, the subject of this Gainsborough portrait, was married in 1776 to Henry Christopher Wise (1738–1805), the High Sheriff of Warwickshire and presumably the grandson of the Henry Wise who was in charge of the Royal Gardens under William II and Queen Anne,

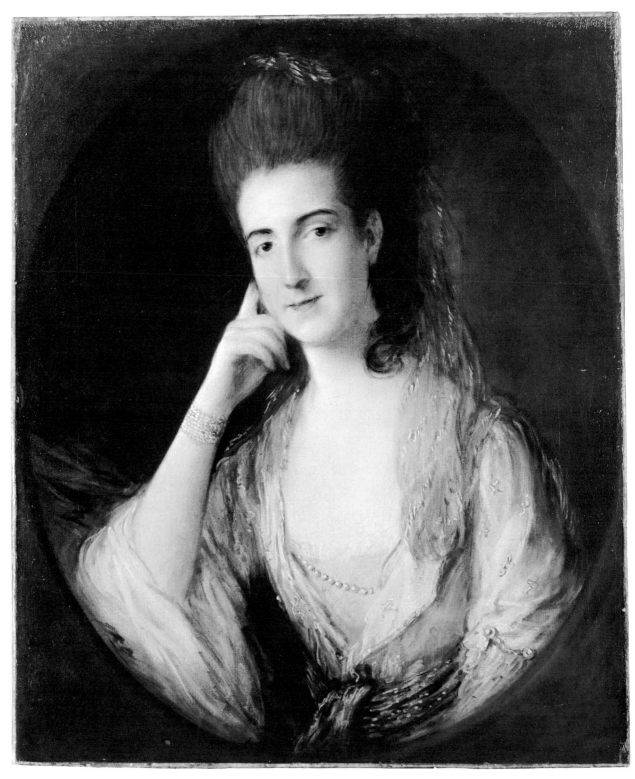

Figure 77.

and who was, in partnership with George London, a prominent landscape designer of the period. The Museum portrait was inherited by Sir Wathen Arthur Waller, whose collection also contained sketches by Henry Wise for Windsor, Hampton Court Palace and Gardens, and Kensington Gardens and Plantation (sale: Christie's, London, December 12, 1947, nos. 126–28). In addition, the Waller collection included Gainsborough's portraits of Henry Wise's son, also called Henry Wise (1706–1778), said to have been painted in Bath in 1760 (E. K. Waterhouse, "Bath and Gainsborough," Apollo, XCVIII, 1973, illus. p. 361), of his wife, née Patricia Banks (Waterhouse, 1948–50, p. 114, says "inscrutably repainted"), and of his son, Henry Christopher Wise, the husband of the sitter for the Cleveland portrait (Waterhouse, 1958, no. 728). The present whereabouts of these portraits is unknown.

The Waller collection also included a *Portrait of Mrs. Mary Wise* (73.6 x 61 cm; signed and dated 1794; sale: Christie's, London, December 12, 1947, no. 150) by Thomas Hickey (1741–1824), an Irish painter who copied portraits by Gainsborough and traveled extensively in India and China. Hickey's style is very different from Gainsborough's, however, and it is difficult to identify his pictures with specific works by Gainsborough.

William T. Whitley (1915, p. 157) apparently originated the tradition that the Museum portrait was exhibited at the Royal Academy in 1778 (no. 118).

The portrait has been consistently accepted as a typical late Gainsborough by Waterhouse (1948–50, 1958, and orally in 1963). NCW

EXHIBITIONS: London, Royal Academy, Burlington House, 1778, cat. no. 118; London, Grosvenor Gallery, 1913/14: Second National Exhibition, Woman and Child in Art; Flint, Michigan Institute of Arts, 1949: Master Works from Giotto to Impressionists; Cedar Rapids, Iowa, Coe College Art Gallery, 1952: Centennial Exhibition, cat. no. 12; Montgomery, Alabama, Museum of Fine Arts, 1955: Festival of the Arts.

LITERATURE: Algernon Graves, *The Royal Academy of Arts: A Complete Dictionary of Contributors & Their Works from Its Foundation in 1769 to 1904*, III (London, 1905), 192; *Portrait of Mrs. Wise by Thomas Gainsborough, R.A., 1722–1788* (New York and Paris: The F. Kleinberger Galleries, n.d.), discussed and illus.; William T. Whitley, *Thomas Gainsborough* (London, 1915), p. 157; Henry S. Francis, "Paintings in the Prentiss Bequest," CMA *Bulletin*, XXXI (1944), 89; *Catalogue of the Prentiss Collection* (CMA, 1944), cat. no. 5, p. 22, pl. VIII; Ellis K. Waterhouse, "Preliminary Check List of Portraits by Thomas Gainsborough," *The Walpole Society*, XXXIII (1948–50), 114; Waterhouse, *Gainsborough* (London, 1958), no. 729, p. 96.

THOMAS GAINSBOROUGH

78 George Pitt, First Lord Rivers (1721–1803)

71.2

Canvas, 234.3 x 154.3 cm.

Collections: George Pitt, First Lord Rivers, Stratfield Saye House, Hampshire; George Pitt, Second Lord Rivers, Stratfield Saye House, Hampshire; Third Lord Rivers (nephew of Second Lord Rivers), Rushmoor House, Dorset; Lieutenant General Pitt-Rivers; Alfred Pitt-Rivers, Rushmoor House, Dorset; George Henry Lane Fox Pitt-Rivers, Hinton St. Mary, Dorset; Stella Pitt-Rivers; [E. V. Thaw, New York].

Gift of The John Huntington Art and Polytechnic Trust, 1971.

The portrait was cleaned by Joseph Alvarez in 1971. There are no records of earlier cleaning and restoration, but small areas of old restoration were found in the waistcoat, in the sky to the right of the subject, and above the head. Otherwise, the painting is in excellent condition.

George Pitt, who was born in Geneva in 1720, was a descendant of John Pitt, a clerk of the Exchequer under Elizabeth I, and of Sir William Pitt, whose arms were granted in 1604. He attended Magdalen College, Oxford, receiving higher degrees in 1739 and 1745. In 1746 he married the beautiful Penelope Atkins of Clapham, Surrey, who bore him three daughters and a son. Lady Rivers received lavish praise from Horace Walpole in his correspondence with Sir Horace Mann, but Walpole was caustic in his opinion of her husband (W. S. Lewis, ed., *Horace Walpole's Correspondence*, New Haven, 1948, XX, 58; XXIII, 451). Pitt was elected to the House of Commons for Shaftesbury in 1742, and for Dorset from 1747 until 1774, and was a member of the House of Lords from 1776. He was appointed colonel of the Dorset militia at its founding in 1757, and it is in the uniform of this militia that he is represented in the Museum portrait (correspondence from John Hewett, London, dated May 2, 1971). Between 1761 and 1768 he served as envoy-extraordinary and minister-plenipotentiary to Turin and in 1770–71 was ambassador to Madrid; it was between these two appointments that the Museum portrait was painted at Stratfield Saye. Pitt was made first Baron of Stratfield Saye in the county of Southampton in 1776; in 1780 he was appointed Lord Lieutenant of Hampshire; in 1782 he was made a Lord of the Bedchamber; in 1793 he became Lord Lieutenant of Dorset; and in 1802 he became Baron Rivers of Sudeley Castle. He died May 7, 1802, and is buried in the family vault at Stratfield Saye.

The portrait does not include Gainsborough's customary accessories—pedestals, curtain, or sculpture. Instead, all attention is focused on the image of Lord Rivers, a forceful, dramatic, and self-contained figure set against a pastoral landscape with a distant, low horizon. The portrait, painted in late 1768 or 1769, appeared with a companion, *Lady Molyneux* (Waterhouse, 1958, no. 606), in the first exhibition of the Royal Academy in 1769. As Waterhouse (1973,

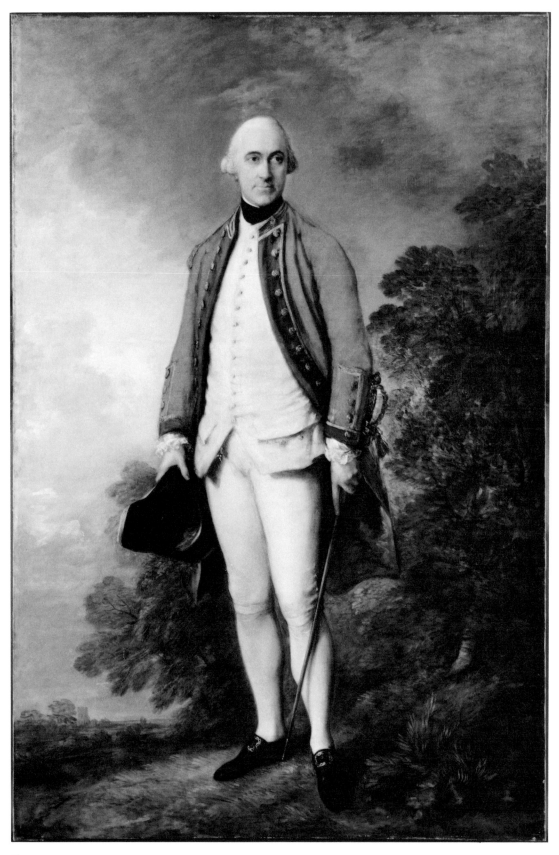

Figure 78.

p. 365) so eloquently stated, these paintings "represent the moment of perfect balance in Gainsborough's art."

NCW

EXHIBITIONS: London, Royal Academy, 1769, cat. no. 36; London, Royal Academy, 1881: Works by Old Masters (Winter Exhibition), cat. no. 20; London, Royal Academy, 1951/52: The First Hundred Years of the Royal Academy (Winter Exhibition), cat. no. 91; CMA, January 1972: Year in Review, cat. no. 51, illus.

LITERATURE: George M. Brock-Arnold, Gainsborough (London, 1889), p. 31; George Fisher Russell Barker, Dictionary of National Biography (London, 1895–96), XV, 1230; William Armstrong, Gainsborough (London and New York, 1898), I, 110–11, and II, 117, 201; Lord Ronald Sutherland Gower, Thomas Gainsborough (London, 1903), p. 53; William Armstrong, Gainsborough and His Place in English Art (London, 1904), pp. 116, 147, 155, 277; William B. Boulton, Thomas Gainsborough, His Life, Work, Friends and Sitters (London, 1905), p. 165; Algernon Graves, The Royal Academy: A Complete Dictionary of Contributors & Their Works from Its Foundation in 1769 to 1904 (London, 1905), III, 191 (incorrectly called George Pitt, eldest son of Lord Rivers); Mortimer Menpes and James Greig, Gainsborough (London, 1909), pp. 79–80; Graves (1913), I, 384; William T. Whitley, Artists and Their Friends in England 1700–1799 (London, 1928), II, 66 (wrongly identified as George Pitt, eldest son of Lord Rivers), 378; Ellis K. Waterhouse, "Preliminary Check List of Portraits by Thomas Gainsborough," The Walpole Society, XXXIII (1948–50), 91; Waterhouse, "The Exhibition 'The First Hundred Years of the Royal Academy,'" Burlington Magazine, XCIV (1952), 51, illus.; Waterhouse, Gainsborough (London, 1958), p. 21, no. 577, pl. 110; William S. Talbot, "Thomas Gainsborough, George Pitt, First Lord Rivers," CMA Bulletin, LVIII (1971), 258–68, illus. p. 257 and figs. 1, 7, 8 (details); Waterhouse, "Bath and Gainsborough," Apollo, XCVIII (1973), 365, and colorplate II on p. 363; CMA Handbook (1978), illus. p. 193.

NICHOLAS HILLIARD
Ca. 1547–1619

Hilliard is one of the earliest English painters about whom there is enough documentary information on which to base at least a brief biography. He was born about 1547, at the end of the reign of Henry VIII. He was the son of the Exeter goldsmith Richard Hilliard, and was trained as a goldsmith and jeweler by Robert Brandon, a leading goldsmith who later became his father-in-law. Two self-portraits, both dated 1560, when Hilliard was about thirteen, show his early ability as a miniature painter—an ability that was undoubtedly reinforced by his training as a goldsmith and jeweler. He was appointed limner and goldsmith to Queen Elizabeth, probably in 1572, the date of his earliest-known portrait of the queen (now in the National Portrait Gallery, London; Foskett, 1979, p. 49). Hilliard had a monopoly on the painting of miniature portraits of the queen. He was also patronized by James I. In 1578 Hilliard was in France. Between 1598 and 1603 he composed the Treatise Concerning the Arte of Limning, which provides more insight into his character and life. He apparently enjoyed the special favor of Sir Robert Cecil, to whom all his remaining correspondence is addressed. He was married twice. There is less information about the later part of his life. He is known to have suffered financial problems which resulted in his imprisonment at Ludgate in 1617, two years before his death. He died January 7, 1619, and was buried in his parish church, St. Martin-in-the-Fields.

79 Sir Anthony Mildmay 26.554

Water color on vellum, 23.5 x 17.5 cm.

Collections: Sir Miles Stapleton, Bart. (a descendant of Sir Anthony Mildmay; sale: Christie, Manson & Woods, London, May 11, 1926, no. 79, illus); [S. J. Phillips, London]; [Durlacher Brothers]. Purchase from the J. H. Wade Fund, 1926.

This miniature has been rubbed slightly and has suffered some flaking of the paint film, particularly in the subject's white stockings. Its condition has remained stable since it entered the Museum in 1926.

Until the exhibition at the Victoria and Albert Museum in 1947, when it came under the discerning eye of Graham Reynolds, this full-length miniature had been attributed to Sir Isaac Oliver. It had been passed down through the Mildmay family in England until it was bought by this Museum.

As the son of Sir Walter Mildmay, Chancellor of the Exchequer, Anthony Mildmay had been connected with the court of Queen Elizabeth since his childhood. He was a personal friend of Nicholas Hilliard. In 1596 he was appointed ambassador to Henry IV of France, and knighthood was conferred upon him. He died at his family estate, Apethorpe, in Northamptonshire in 1617.

This miniature must have been painted during or after the year 1596, for Sir Anthony is represented with his ar-

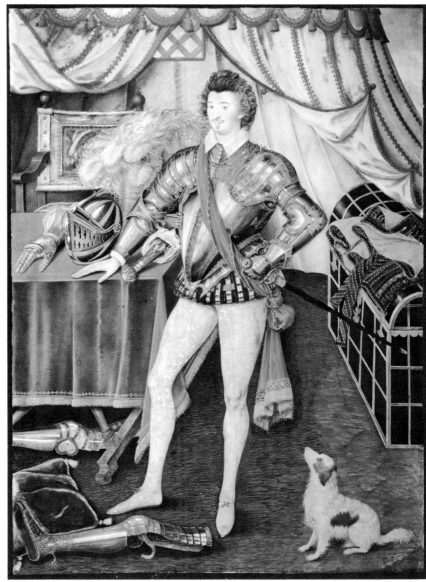

Figure 79.

mor after he had been knighted. He is standing before his tent, which forms an elaborate baldachino in the upper background. The armor he wears can be identified on the basis of style as the work of the Greenwich School. Some elements of the armor lie scattered on the floor in the fore-ground and on a table covered with a gold-fringed blue cloth. A pistol, inlaid with ivory, also lies on the table, next to Sir Anthony's helmet, which is elaborately bedecked with a plume of blue ostrich feathers that covers the side of a Renaissance chair behind the table. At the right is a late

sixteenth-century London chest, covered with black leather and having silvered iron straps, which apparently held Sir Anthony's armor (Thornton, 1971).

This Mannerist court portrait, with its symbols of rank, and decorative jewelry and costume, is one of the most important in the Museum's miniature collection. John Pope-Hennessy (1949) cites this miniature as an example of the influence of French court painting on the art of Nicholas Hilliard. Pope-Hennessy compares the miniature with François Clouet's drawing of Henry III as Duc d'Anjou, in the Cabinet des Estampes, Paris. He suggests that this composition, with its imperfectly understood linear perspective, demonstrates that Hilliard borrowed from the French. Pope-Hennessy further claims that this French influence lasted for twenty-five years, until 1585, when it began to wane. Eric Mercer (1962) contests the theory of a French influence. NCW

NOTE: For other miniatures in the Museum collection, see *Portrait Miniatures: The Edward B. Greene Collection* (Cleveland, 1951); see also painting 70 in this catalogue.

EXHIBITIONS: New York World's Fair, 1939: Masterpieces of Art, cat. no. 267; CMA, 1940: Masterpieces of Art from the New York and San Francisco World's Fairs, cat. no. 49, illus.; London, Victoria and Albert Museum, 1947: Nicholas Hilliard and Isaac Oliver: An Exhibition to Commemorate the 400th Anniversary of the Birth of Nicholas Hilliard, cat. no. 57; CMA, 1956: The International Language (no catalogue).

LITERATURE: William M. Milliken, "A Miniature by Isaac Oliver," CMA *Bulletin*, XIV (1927), 19–21, illus. p. 17; Thieme-Becker, XXV (1931), 599; R. H. Wilenski, *Masters of English Painting* (Boston and New York, 1933), p. 48, pl. 7; F. M. Kelly, "A Portrait of a Warrior," *Connoisseur*, C (1937), 28, fig. III; John Pope-Hennessy, "Elizabethan Psychologist: Nicholas Hilliard's Quadricentennial," *Art News*, XLVI (July 1947), 20; Carl Winter, "Hilliard and Elizabethan Miniatures," *Burlington Magazine*, LXXXIX (1947), 176, 180; Pope-Hennessy, *A Lecture on Nicholas Hilliard* (London, 1949), p. 19, pl. XIII; Alexander C. Judson, *Sidney's Appearance: A Study in Elizabethan Portraiture* (Bloomington, Indiana, 1958), p. 34; Erna Auerbach, *Nicholas Hilliard* (London, 1961), pp. 116, 119, 303, no. 93, pl. 93; Roy Strong, *The English Icon: Elizabethan and Jacobean Portraiture* (London and New Haven, 1961), p. 14, fig. 13; Eric Mercer, *English Art 1553–1625* (Oxford, 1962), p. 204, pl. 70; *Selected Works* (1966), no. 147; Peter Thornton, "Two Problems," *Furniture History: The Journal of the Furniture History Society*, VII (1971), 68–69, illus. pl. 18; Daphne Foskett, *A Dictionary of British Miniature Painters* (London, 1972), I, 330, and II, 51, no. 412, pl. 161; Strong, *Nicholas Hilliard* (London, 1975), no. 11, p. 31, color illus. p. 43, pl. 11; CMA *Handbook* (1978), illus. p. 123; Thornton, *Seventeenth-Century Interior Decoration in England, France, and Holland* (New Haven and London, 1978), pp. 226–27, 411 n. 211, fig. 211.

JULIUS CAESAR IBBETSON
1759–1817

Julius Caesar Ibbetson was called the Nicholas Berchem of England by Benjamin West. He was born in 1759 in Yorkshire. After his apprenticeship as a ship painter at Hull, he went to London in 1777. He worked as a scene painter, a restorer, and then a dealer's assistant. He produced numerous copies and fakes in the style of seventeenth-century Dutch landscape painters, ascribing them to Berchem, Poelenburgh, and Teniers; he also copied the works of English painters such as Gainsborough and Wilson. In 1787–88 he made a voyage to the East Indies and China. In 1791 he traveled to the Isle of Wight and in the following year went to Wales. He had serious financial problems and ate and drank excessively, particularly after the death of his first wife in 1794 and the loss of eight of their eleven children. He exhibited at the Royal Academy frequently throughout his life. He published *Painting in Oil* in 1803. He retired to paint in Ambleside and later in Masham, the village where he was born and where, in 1817, he died. Working in a style similar to that of George Moreland, he was also influenced by Richard Wilson and seventeenth-century Dutch landscape painters.

80 *A Storm behind the Isle* 48.461
 of Wight

> Oil on canvas, 50.8 x 67.6 cm. Signed at lower left: Julius Ibbetson 179[?]. (There is illegible writing below the signature.)
> Collections: Henry W. Kent.
> Bequest of Henry W. Kent, 1948.

This lined canvas is in generally good condition. It was cleaned most recently by Joseph Alvarez in 1972. There is some rubbing of the paint surface and some minor retouching.

The scene depicts a family's distress upon finding that one of its members had drowned off the rocky shore of the Isle of Wight during a storm. A ship founders in the wild sea, amidst swirling dark clouds and lightning flashes. A cluster of houses is seen in the distance, behind a large rock in the middle ground. The topography and highly descriptive style of this painting are typical of Ibbetson's works during his visit in 1791 to the Isle of Wight.

The painting is apparently not listed in the scanty literature on the painter. Most of the paintings executed on the Isle of Wight and exhibited at the Royal Academy in 1792 have not been traced (Rotha Mary Clay, *Julius Caesar Ibbetson 1759–1817*, London, 1948, pp. 29–30). Our painting might be identified with the *Storm, Back of the Isle of Wight* that was exhibited at the Royal Academy in 1794 (no. 299), or *Shipwrecked Figures on a Sea-Shore*, formerly in the Sykes Collection (in 1824). NCW

Figure 80.

EXHIBITIONS: Milwaukee, Wisconsin, War Memorial Building (for Children's Arts Program), 1958: Man's Concept of Outer Space; Pough-keepsie, New York, Vassar College Art Gallery, 1964: Nature and Natural Phenomena in Art of The Eighteenth Century, cat. no. 6; London, Royal Academy of Arts, Burlington House, December 1968 – February 1969: Winter Exhibition.

LITERATURE: CMA *Handbook* (1978), illus. p. 194.

CORNELIS JOHNSON (Jonson)
1593–1661

The family of Cornelis Johnson came from Cologne originally, settled in Antwerp, and from there went to London, where, in 1593, Cornelis was born and was baptized in the Dutch Reformed Church in Austin Friars. Nothing is known of his early training. He may well have been apprenticed to an artist in The Hague or in Delft. His early work reflects an Anglo-Netherlandish style, with influences from the early work of Gheeraerts and the later work of Nicholas Hilliard (see painting 79). He may have studied with a miniature painter, but his earliest-known miniature on copper bears the date 1625, when he was already thirty-two years old. He was court painter for James I and Charles I, but he never seemed to enjoy as much royal patronage as did his contemporary, Daniel Mytens. His popularity must have suffered upon the arrival in London of the brilliant Anthony van Dyck from Flanders. In 1636 Johnson left London and went to live in Kent. Numerous portraits dated from 1617 to 1643 show the artist's development year by year (E. K. Waterhouse, *Painting in Britain 1530–1790*, London, 1953, p. 38, n. 13). In 1643, at the outbreak of the Civil War, his wife, Elizabeth Beke of Colchester, whom he married in 1622, persuaded him to move to Holland. After he left England he signed his portraits "Jonson van Ceulen" (Jonson of Cologne). His name has often been erroneously given as Janssen. He had a son (ca. 1622–1689), with the same name, who was also a portrait painter. Cornelis Johnson died in Utrecht in 1661.

81 *Portrait of a Lady* 73.185

Panel (oak), 65.7 x 56 cm. Signed with monogram, and dated at lower right: CJ fec/1619.

Collections: E. C. Knight (sale: Christie's, London, January 29, 1917, no. 45, bought in by the family); Colonel G. M. Knight (sale: Christie's, London, October 17, 1947, no. 47); [Central Picture Galleries, New York]; Mr. and Mrs. Noah L. Butkin, Cleveland.

Gift of Mr. and Mrs. Noah L. Butkin, 1973.

The painting had been re-varnished by the Central Picture Galleries before it entered the Butkin collection. No earlier restoration records are known. The painting is in pristine condition, with only a few very minor abrasions and strengthenings.

This portrait on panel is a very early work by Cornelis Johnson, whose later portraits were executed on canvas. The surface quality of the paint and the bright glossiness of the color are typical of the artist's early works. Also typical of Johnson was his inclination to feign oval portraits, probably a carry-over from miniature painting. Spandrels of the rectangular panel have been painted to simulate marble and grained wood, with the edge of the oval painted in shadow, as if recessed behind the frame. This portrait exemplifies Johnson's meticulous draftsmanship and his Dutch pre

occupation with detail and texture; there is also a curiously personal and perhaps English sensitivity to the sitter. Though it is an early work, it shows Johnson's potential to become the most important of the English Stuart portrait painters before the generation of van Dyck.

Unfortunately, the early history of the painting is unknown. A suggestion from Ellis K. Waterhouse, however, may prove helpful in establishing the identity of the sitter and in reconstructing the history of the painting. Waterhouse (letter of January 17, 1976) brought to our attention another oval portrait by Johnson (Figure 81a) of a slightly older woman, who, he suggests, might be the older sister or mother of the sitter in our painting. This second oval portrait appeared in two Christie's sales of the collection of Mrs. M. D. Harris (November 22, 1974, no. 165, and June 20, 1975, no. 81; ex collections: George Rochfort-Clarke; his widow, Mrs. I. Spain) in which it was called *Portrait of a Lady, Said to Be Lady Corbett* [*sic*] (one Lady Corbet living in 1619 was Judith Austen, wife of Sir Richard Corbet; see Burke's *Peerage*, London, 1970, 105th ed., p. 641). Regardless of this identification, Waterhouse believes that either this portrait or the one in Cleveland was the picture recorded by Vertue in 1740 ("Vertue Notebooks," IV, 179,

Figure 81a. *Portrait of a Lady, Said to be Lady Corbett*. On panel, 65 x 49.5 cm. Johnson. Private collection, England.

Figure 81.

as published in *The Walpole Society*, XXIV, 1935) as a portrait of Miss Hyde, later Mrs. Young (who was connected with the family of the Earl of Clarendon of the first creation). The painting described by Vertue was signed and dated exactly as the two paintings under consideration.

As paintings of this date by Johnson are rare, it is tempting to consider Waterhouse's suggestion. If it is true, as he says, that the sitters in the two paintings are related and that one may be identified as "Miss Hyde," then it is possible that the elder sitter was Mary Langford Hyde, and the other, in the Museum portrait, was her daughter who was baptized in 1598. Another possibility is that the elder sitter was Miss Joan Hyde, daughter of Laurence Hyde, of the elder branch of Chancellor Hyde, who married Edward Young of Durnford, Wiltshire, and the Museum portrait is of one of her four daughters who were baptized between 1588 and 1599 (see *Landed Gentry*, III, 269). Miss Joan Hyde is the only Hyde who married a Young; as far as can be determined, she had no connection with the family of Lady Corbet.

The subject of the painting mentioned in the Vertue Notebooks was described as follows: ". . . the face fair and clear, strong colord.—lace about the head, and breast, very curious & exact,"—a description that could apply to either the painting sold at Christie's or the Cleveland portrait. The costumes and headdresses of the two sitters are nearly identical. As Mesdames M. E. Tiethoff-Spliethoff and Lia de Bruyn of the Stichting Iconographisch Bureau in The Hague (letter of June 8, 1979) pointed out, the lace ruff and the headdress topped by an aigrette were quite common in the early days of Charles I. Other paintings in which these fashions appear are: Michiel van Mierevelt's portrait of Elisabeth Stuart, daughter of James I and wife of Frederick V, painted in 1623 (Henry Havard, *Les Artistes Célèbres—Michiel van Mierevelt et son Gendre*, Paris, 1892, illus. p. 27); Daniel Mytens's *Martha Cranfield, Countess of Monmouth* (collection Lord Sackville) and *Lady Mary Feilding, Later Duchess of Hamilton* (collection of the Duke of Hamilton and Brandon), one painted ca. 1620, and the other 1622 (Oliver Millar, *The Age of Charles I*, exh. cat., London, 1972, nos. 19 and 20, illus. p. 26).

Unfortunately, until further documentation can be found, the sitters in both the Cleveland portrait and the closely related painting sold at Christie's will remain without positive identification. NCW

EXHIBITIONS: CMA, February, 1974: Year in Review, cat. no. 38, illus.

LITERATURE: Alexander J. Finberg, "A Chronological List of Portraits by Cornelis Johnson or Jonson," *The Walpole Society*, X (1921–22), 7, pl. III; *Important English Pictures* (sale cat., Christie's, London, November 22, 1974), p. 56, mentioned under no. 165; *Important English Pictures* (sale cat., Christie's, London, June 20, 1975), p. 32, under no. 81; *The Age of Shakespeare* (exh. cat., Manchester, 1964), p. 24, mentioned under no. 11; CMA *Handbook* (1978), illus. p. 169.

SIR THOMAS LAWRENCE
1769–1830

Thomas Lawrence was born in Bristol in 1769, the fourteenth of sixteen children. His impractical but gifted father was the owner of the Black Bear, a famous inn at Devizes on the Bath road to London. Lawrence at a very early age showed superior gifts in portraiture as he sketched profiles of his father's customers. At Bath he may have learned about pastel painting from William Hoare, but what is more important is that Bath was a place to meet visiting members of London society, and Lawrence apparently took advantage of his opportunities. By 1786 he was established in London. At twenty he was accepted in social circles far above his own. At the age of twenty-one he was summoned to paint Queen Charlotte, and at twenty-five he was a full Academician. He succeeded Sir Joshua Reynolds as a Painter in Ordinary to the King in 1792 and eventually, in 1820, attained the highest honor his profession could offer, the presidency of the Royal Academy, succeeding Benjamin West. Between 1797 and 1806 Lawrence was involved in the theatrical world in London, and this was the period of his famous entanglement with the Siddons daughters. He never married. His financial difficulties grew with his reputation. He consistently lived beyond his means, taking on more commissions than he could reasonably expect to complete, which annoyed his sitters. The uneven quality of his work suggests that he never reached his fullest potential despite his facile draftsmanship and serious intent. He was invited by the Prince Regent to attend the Vienna conference after the defeat of Napoleon in order to paint portraits of military leaders and heads of state. After three months in Vienna and most of a year in Rome, he returned to England in 1820. Until his death in 1830 he continued to be overwhelmed with commissions. He also continued to develop his abilities, endeavoring to deserve the respect he enjoyed as the first portrait painter of Europe and the inheritor of the tradition of Sir Joshua Reynolds.

Figure 82.

82 The Daughters of Colonel 42.642
Thomas Carteret Hardy

Canvas, 129 x 103 cm.

Collections: Daniel L. Lysons, Hempstead Court, Gloucestershire
(sale: Bruton, Knowles & Co., Gloucester, April 21, 1887, no.
284); Camillo Roth, Esq., 1888; Charles T. D. Crews (sale:
Christie's, London, July 1, 1915, no. 105, to Colnaghi); John L.
Severance, Cleveland.

Bequest of John L. Severance, 1942.

The canvas, which is lined, was cleaned in 1968 by Joseph
Alvarez; the yellowed varnish was removed and the paint-
ing was found to be in good condition.

Colonel Thomas Carteret Hardy was an officer of the
York Fusiliers. His daughters, shown in this painting, were
Charlotte Savery (1782–1850), who became Mrs. Ralph
Price, and Sarah (1780–1808), who married the Reverend
Daniel Lysons (1762–1834) of Hempstead Court, Glouces-
tershire, in 1801 at Bath. Daniel Lysons was a well-known
topographer, who also sat for a portrait by Lawrence. The
painting of the Hardy daughters remained in the family
until 1887.

Joseph Farington wrote in his diary on October 9, 1806
(published 1922; see Literature) that Lawrence had not
finished the picture of Mrs. Lysons and Mrs. Price which
was begun in 1801. Nevertheless, the picture must have
been virtually completed the year it was begun, for in that
same year Henry Bone (1755–1834) painted a miniature
(on enamel, 21.3 x 17 cm) directly after the Lawrence por-
trait, with only minor changes in the landscape at the far
left. The miniature is signed in the lower right, inscribed by
the artist on the back with the sitter's identity and address,
and is dated 1801 (Lindsay Fleming, *Memoir and Select
Letters of Samuel Lysons*, 1934, reproduced in color, col-
lection of Mrs. Teresa Pattinson). NCW

EXHIBITIONS: London, Royal Academy, Burlington House, 1888: Ex-
hibition of the Works of the Old Masters, cat. no. 21; London, Agnew
Gallery, 1897: 20 Masterpieces of the English School (third series), cat.
no. 9; Paris, Jeu de Paume, 1909: Exposition de cent portraits des femmes
anglaises et françaises du XVIIIème siècle, cat. no. 23, illus. p. xxvi and p.
22; CMA (1936), cat. no. 225, illus. pl. LVII; CMA (1942), cat. no. 8, p.
22, pl. VII; Worcester (Massachusetts) Art Museum, 1960: Sir Thomas
Lawrence, Regency Painter, cat. no. 10; CMA (1963), cat. no. 44, illus.;
Indianapolis, John Herron Art Museum, 1965: The Romantic Era, Birth
and Flowering, 1750–1850, cat. no. 16, illus.

LITERATURE: Lord Ronald Sutherland Gower, *Sir Thomas Lawrence*
(London, 1900), p. 135; Timothy Cole and John C. VanDyck, *Old Eng-
lish Masters* (New York, 1902), illus. as woodcut by Timothy Cole facing
p. 167; Charles Saunier, "Exposition de cent portraits des femmes des
écoles anglaise et française du XVIII^e siècle," *Les Arts*, VIII (July 1909), 18,
illus.; Walter Armstrong, *Lawrence* (London, 1913), pp. 138, 149;
Graves (1914), II, 656; H. C. Marillier, "*Christie's*" 1766 to 1925 (Lon-
don, 1926), p. 160; *Art News*, XXXIV, pt. 2 (June 13, 1936), 11; Francis
(1942), p. 136, illus. p. 133; Helen Comstock, "The John L. Severance
Collection," *Connoisseur*, CL (1943), 41, 87; Kenneth Garlick, "A Cata-
logue of the Paintings, Drawings, and Pastels of Sir Thomas Lawrence,"
The Walpole Society, XXXIX (1962–64), p. 102; CMA *Handbook* (1978),
illus. p. 195.

SIR THOMAS LAWRENCE

83 *Lady Louisa (Tollemache) Manners* 61.220
 (1745–1840), Later Countess of Dysart,
 as Juno

Canvas, 255.3 x 158 cm.

Collections: Sir Thomas Lawrence (sale: Christie's, London, June 18, 1831, no. 147); Samuel Woodburn; Frederick John, Fifth Baron Monson (died 1841), and his heirs, Gatton Park, Surrey (sale: Christie's, London, May 12, 1888, no. 21, to Davis; correspondence among the Monson papers now deposited in the Lincoln County archives); William, Fifth Earl of Carysfort, 1888; Lady Carysfort; Colonel Douglas James Proby (nephew of Lady Carysfort), Elton Hall, Huntingdonshire; [Duveen Brothers, 1919]; Jules S. Bache, New York, 1924; John D. Rockefeller, Jr.

Bequest of John D. Rockefeller, Jr., 1961.

The painting is in excellent condition. Undoubtedly it was cleaned shortly before it entered the Museum collection, but there are no records.

Lady Louisa Manners was the daughter of Lionel Tollemache (1708–1770), Fourth Earl of Dysart. In 1765 she married John Manners of Hanby Hall (County of Lincoln and Buckminster), who died in 1792. In 1821, upon the death of her brother, Wilbraham, the Sixth Earl of Dysart, Lady Louisa became Countess of Dysart. She lived to the age of ninety-five.

There has been some confusion about the subject of this portrait. When it was first exhibited at the Royal Academy in 1794, Pasquin (1796) confused it with another painting in the same exhibition, the full-length *Portrait of Lady Emily Hobart in the Character of Juno* (no. 168). In newspaper criticism Lawrence's portrait was described both as Lady Manners and Lady Milner, a confusion that carried over to the literature (Gower, 1900; Graves, 1906; and Armstrong, 1913). A diary entry written by Lawrence's friend, Joseph Farington, on April 3, 1794 (published 1922; see Literature), clarified the matter as follows: "Lawrence is desirous to have the whole length of Lady Manners hung in the centre at the head of the room."

Although it is an early work, the painting has all the monumental elegance and brilliance of Lawrence at his best.

NCW

EXHIBITIONS: London, Royal Academy, 1794, cat. no. 160; London, National Gallery, 1913/14: Woman and Child in Art, Second National Loan Exhibition, cat. no. XXIX, p. 53, illus. (catalogue by Francis Howard); CMA, November 1961: Year in Review, cat. no. 63a, illus.; CMA, (1963), cat. no. 43, illus.; CMA, 1965: Juxtapositions (no catalogue).

LITERATURE: John Williams (pseudonym Anthony Pasquin), *Memoirs of the Royal Academicians* (London, 1796), no. 173, p. 28; George Redford, *Art Sales* (London, 1888), I, 454; Lord Ronald Sutherland Gower, *Sir Thomas Lawrence* (New York, 1900), p. 150; Algernon Graves, *The Royal Academy of Art: A Complete Dictionary of Contributors & Their Works from Its Foundation in 1769 to 1904*, V (London, 1906), 3; Sir Walter Armstrong, *Lawrence* (New York, 1913), pp. 129, 150, pl. XIV; Graves, *Art Sales* (London, 1921), II, 128; Joseph Farington, *The Farington Diary*, ed. James Greig (London, 1922), I, entry dated April 3, 1794, p. 44 and n.; Tancred Borenius and Reverend J. V. Hodgson, *A Catalogue of the Pictures at Elton Hall . . .* (London, 1924), pp. ix, 117; Kenneth Garlick, *Sir Thomas Lawrence* (London, 1954), pp. 49, 88, pl. 32; Aline B. Saarinen, *The Proud Possessors* (New York, 1958), p. 349; Garlick, "A Catalogue of the Paintings, Drawings, and Pastels of Sir Thomas Lawrence," *The Walpole Society*, XXXIX (1962–64), 138; CMA *Handbook* (1978), illus. p. 195.

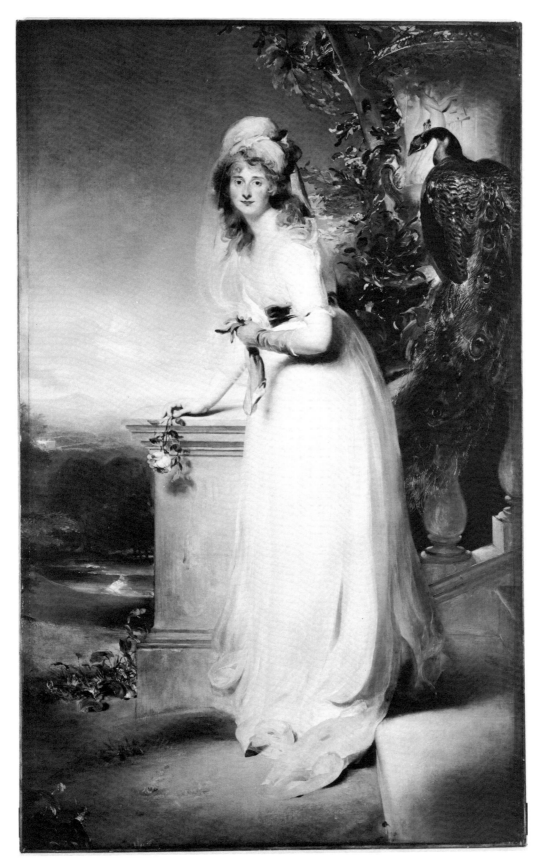

Figure 83.

Studio of SIR THOMAS LAWRENCE

84 *Portrait of Benjamin West* 16.2059

Canvas, 76.2 x 63.5 cm.

Collections: James Matthews, London; Louis Kronberg, Chelsea, purchased from Matthews in 1908.

Gift of The John Huntington Art and Polytechnic Trust, 1916.

The painting was cleaned by H. Hammond Smith in 1916 and again by Joseph Alvarez in 1960. It is marred by a deep gouge in the paint surface in the upper left corner, a tear in the left shoulder of the sitter, and minor abrasions in his forehead.

In a letter of November 8, 1916, Louis Kronberg, former owner of the Cleveland painting, informed the Museum that he had bought the painting from James Matthews in 1908 (enclosed with the letter was a copy of the sales agreement, dated June 27, 1908). Matthews, an eccentric, elderly gentleman who spent his time studying, collecting, and dealing in English paintings, had presumably acquired the painting about thirty years earlier.

Kenneth Garlick, in a letter of August 1, 1952, said he felt that the Cleveland portrait was a sketch after, not for, Lawrence's portrait of Benjamin West that was commissioned by John Trumbull, then president of the American Academy of Fine Arts, New York; this portrait, now in the Wadsworth Atheneum, was exhibited at the Royal Academy in 1821 (Garlick, *Sir Thomas Lawrence*, London, 1954, p. 62). Garlick also said in his letter that many small sketches similar to the Cleveland painting and attributed to Lawrence were in reality studio copies. Lawrence's own sketches or unfinished portraits usually show the body of the sitter very roughly laid in, and the face carried out with precision and detail. An example is Lawrence's sketch for a *Portrait of Benjamin West*, in the collection of Amherst College, Amherst, Massachusetts (on oval panel, 73.3 x 60.6 cm, within a rectangle, 74.3 x 60.9 cm; exhibited at the Royal Academy, 1877, no. 255, lent by J. A. Anderson; Garlick, *op. cit.*, p. 62, pl. 73).

There are several other documented portraits by Lawrence of this prominent painter, Benjamin West, as well as engravings after the portraits. A full-length version was painted for George IV and presented by William IV to the National Gallery, London, in 1836; it is presently owned by the Tate Gallery, London (*Catalogue of British School*, London, 1947, p. 152, no. 144; Garlick, *op. cit.*, p. 62, as replica; C. C. Cunningham, "Letter to the Editor," *Art in America*, XXXIX, February 1951, 96). A half-length portrait, present whereabouts unknown, was given by Lawrence to West; this portrait was exhibited at the Royal Academy in 1811 (Garlick, *op. cit.*, p. 62; ex collections: Benjamin West; Castle Smith, West's solicitor [sale: Paris, July 21, 1913]; anonymous collection [sale: April 27, 1928, no. 130]; John Levy Galleries, New York; see Cunning-

ham, *op. cit.*, p. 96, and Farington, *The Farington Diary*, ed. James Greig, London, 1922, VI, entries dated March 31 and April 3, 1811, pp. 255–57). Another painting, a weaker version of the Wadsworth Atheneum portrait, was owned by Thomas J. Gannon, Inc., New York, in 1961.

Notable among portraits of Benjamin West by other artists is a half-length copy of a Lawrence portrait by Charles R. Leslie (English, 1794–1859), now in the Museum of Fine Arts, Boston (acc. no. 36354), which could easily be after the same portrait as the Cleveland picture, but is stronger and more complete. Another related portrait of Benjamin West is by the American painter, Washington Allston (canvas, 76.2 x 63.5 cm, head painted in 1814, background in 1837; Edgar P. Richardson, *Washington Allston: A Study of the Romantic Artist in America*, Chicago, 1948, no. 82, p. 199, pl. XXXI).

Because Lawrence painted several portraits of Benjamin West in the same pose, it is difficult to determine which portrait served as the model for the Cleveland copy and the copy by Leslie. It seems likely, however, that it would have been one that was exhibited at the Royal Academy; that is, either the portrait given to West or the portrait now in the Wadsworth Atheneum. NCW

EXHIBITIONS: CMA (1956).

LITERATURE: None.

Figure 84.

Figure 85.

204

SIR PETER LELY
1618–1680

Sir Peter Lely, who was originally named Pieter van der Faes, was born in 1618 in Soest, Westphalia, where his Dutch father's regiment was stationed. Most of what we know about Lely is based on somewhat doubtful information in the second volume of *De Groote Schouburgh*, written by Arnold Houbraken and published in Amsterdam in 1719, some thirty-nine years after Lely's death. It is known that Lely studied in the studio of Frans Pietersz. de Grebber in Haarlem in 1637, and that about 1641 he went to England, where he was influenced by the work of Sir Anthony van Dyck, and where he eventually became the country's principal portrait painter. He was knighted in 1680 and died that same year.

85 *Portrait of Mrs. Leneve,*　　　　42.247
　　 Wife of Mr. P. Leneve,
　　 Alderman of Norwich

　　Canvas, 126.7 x 101.3 cm.

　　Collections: Mr. and Mrs. P. Leneve, Norwich; Horace Walpole, Strawberry Hill, Middlesex, England; the Earls Waldegrave (sale: Strawberry Hill, May 18, 1842, no. 61); Mr. Downe; Sir Hugh Hume Campbell, Bart. (sale: Christie's, London, June 16, 1894, no. 26); (possibly) General William Earle Bulwer, Heydon Hall, Norfolk, England; [R. C. Vose and N. M. Vose, Boston]; Mrs. Otto Miller, Cleveland, purchased from Vose in 1915.

　　Gift of Mrs. Otto Miller, 1942.

Figure 85a. *Portrait of Mr. P. Leneve, Alderman of Norwich.* On canvas, 126.1 x 101.5 cm. Lely. Walters Art Gallery, Baltimore.

This painting was cleaned in 1942. There was an extensive amount of "beautification" in the face, added, apparently, when honesty in portraiture was no longer fashionable or desirable. The overpaint was removed, and the original paint surface was found to be in excellent condition.

　　The portrait has been dated ca. 1656 to 1658 because of the sitter's hair style—with the single curl in the center of the forehead—which was in fashion at that time.

　　When the portrait entered the Museum collection, and before the repaint was removed, the sitter was thought to be Lady Denham, an identification that proved incorrect after cleaning and when the picture was compared with an authentic portrait of Lady Denham of ca. 1663, now at Hampton Court (Oliver Millar, *The Tudor, Stuart, and Early Georgian Pictures in the Collection of Her Majesty the Queen*, London, 1963, no. 264, fig. 111).

　　According to Henry Francis (1944, p. 180), Finley Foster suggested that the sitter was Sarah Earle, wife of John Earle, who acquired Heydon Hall in 1650 (Heydon Hall was the provenance given the portrait by the dealer Robert C. Vose when the picture was purchased by Mrs. Otto Miller). R. B. Beckett (letter of August 18, 1949) doubted this identification after having seen the signed double portrait of Sarah Earle and her husband, John, by Lely, at Heydon Hall. Believing the subject to be another member of the Earle

family, Beckett published (1955) the portrait under the title *A Lady of the Earle Family* in his monograph on Lely.

　　The identity of the sitter was established only recently. A water color by Thomas Sandby (1721–1798) illustrating Horace Walpole's Gallery of Strawberry Hill, Middlesex (John Cornforth, *English Interiors 1790–1848*, London, 1978, fig. 129, p. 106)—brought to the author's attention by Henry Hawley of this Museum—even though small in scale shows an accurate reproduction of what appears to be the present portrait. A description of the Gallery (see Literature, 1784) lists the paintings, along with the basalt bust of Vespasian below them, to the right of the chimney, and refers to our painting and that of the lady's husband as follows: ". . . Leneve, alderman of Norwich. . . . The best picture Sir Peter Lely ever painted. . . . His wife, in blue; ditto." The blue of the sitter's stole is, indeed, one of our portrait's most striking features. As shown in Sandby's water color, both portraits are of three-quarter-length figures. The portrait of Mr. Leneve (Figure 85a), now in the Walters Art Gallery, Baltimore, had long been known to have come from Strawberry Hill, but heretofore had not been recognized as a pendant to the Cleveland portrait. The similarity in poses and in the drapery on the left in both pictures (even though in one it is patterned, and in the other

205

it is not), together with the official attire of the alderman and the complementary formal dress of the lady, are certainly undeniable indications that the two portraits were meant to be pendants.

Beckett (1955, p. 50, no. 296) lists the portrait of Mr. Leneve, assigning a date of ca. 1660, but makes no mention of a missing pendant portrait of a woman, in spite of the fact that both pictures were sold together in the Strawberry Hill sale of May 18, 1842 (no. 60, Mr. Leneve, ". . . considered to be the best picture ever painted by Sir Peter Lely"; and no. 61, Mrs. Leneve, ". . . an equally clever picture"). Both pictures were bought by a Mr. Downe, after which they belonged to Sir Hugh Hume Campbell, Bart., who sold them at Christie's, London, on June 16, 1894 (lot 26, Mrs. Leneve; and lot 34, Mr. Leneve). The subsequent whereabouts of the portrait of the man are all known, but traces of the Cleveland portrait were lost after the 1894 sale, until it appeared at the Robert C. Vose Gallery in Boston.

NCW

EXHIBITIONS: Seattle, 1909: Alaska-Yukon Exposition; CMA (1973).

LITERATURE: *A Description of the Villa of Mr. Horace Walpole Youngest Son of Sir Robert Walpole Earl of Orford, at Strawberry-Hill near Twickenham, Middlesex* (1784), p. 50; *A Historical Catalogue of the Pictures, Herse-Cloths and Tapestry at Merchant Taylors' Hall with a List of the Sculptures and Engravings by Frederick M. Fry, Master of the Company for 1895–6* (London, 1907), p. 103; Henry S. Francis, "The Portrait of Sarah Earle by Sir Peter Lely," CMA *Bulletin*, XXXI (1944), 177–80, illus. p. 175; Ronald Brymer Beckett, *Lely* (Boston, 1955), p. 44, no. 176, pl. 61; CMA *Handbook* (1978), illus. p. 169.

JOHN OPIE
1761–1807

John Opie was the son of a mine carpenter. He was born in 1761 in St. Agnes, near Truro, in the Cornish tin- and copper-mining district. Discouraged from doing so by his father, but encouraged by Dr. John Wolcot (pen name Peter Pindar, a poet, amateur musician, and painter), Opie started his career as an itinerant portrait painter. He traveled along the coast and, patronized by the local aristocracy as he went, painted some of his most famous portraits. In 1781 he left Cornwall and traveled to Exeter with Wolcot; that same year the two went to London, where Wolcot launched his protégé, the "Cornish Wonder," with great success. During the next few years Opie's sympathetic paintings of peasants, children, and old people appeared at the Royal Academy exhibitions. Familiar with the work of Rembrandt and Reynolds, he described his own work as a combination of Caravaggio and Velázquez. By 1789 Opie had become independent of Wolcot, although they remained friends. His first marriage, to Mary Bunn in 1782, ended in divorce in 1796. In 1798 he married the novelist Amelia Alderson of Norwich. He became a full member of the Academy in

1788. In addition to portraits, he painted many subject pictures, including a series of seven paintings for Alderman Boydell's Shakespeare Gallery. In 1805 he was elected professor of painting at the Royal Academy. Shortly before his death in 1807, he delivered four scholarly lectures on painting to Royal Academy students which were published after his death with a memoir by his widow.

86 *Street Singer and Child* 16.1030

Canvas, 76.5 x 64.3 cm. Inscribed across book: LOVE/CLOW[N or R].

Collections: Reverend Thomas Collyer of Gislingham, near Eye, Suffolk (sale: Christie's, London, July 26, 1890, no. 181, to Smith); Lord Bateman, Kelmarsh Hall, Northamptonshire (sale: Christie's, London, April 11, 1896, no. 115); [Blakeslee Galleries, New York]; R. Hall McCormick, Chicago; [Blakeslee Galleries, New York, 1900]; Mr. and Mrs. Jeptha H. Wade, Cleveland.

Gift of Mr. and Mrs. J. H. Wade, 1916.

The painting has a repaired tear extending diagonally across the lower part of the canvas, from the elbow to the wrist of the street singer. The painting was partially cleaned by Joseph Alvarez in 1961. Residues of old varnishes remain in most areas.

The subject of this painting was drawn from the ragged underworld of Cornish society which Opie knew intimately even though his family was of more substantial, but still modest, means. His oeuvre includes portraits of the local aristocracy in Cornwall and prominent patrons in London, as well as paintings of simple people and genre scenes. His colors are the earthy, somber browns and blacks that recall his early exposure to the mines. His rustic tones, relieved by highlights of white, frequently describe a melancholy or lugubrious mood, such as that of the Cleveland painting.

NCW

EXHIBITIONS: Pittsburgh, Carnegie Institute, 1898: Collection of Pictures Principally of the English School Loaned to the Carnegie Institute by R. Hall McCormick, Esq., Chicago, cat. no. 36, p. 25; Cleveland (1913), cat. no. 133b; William Rockhill Nelson Gallery, Kansas City, Missouri, 1937: Survey of English Painting (no catalogue).

LITERATURE: Ada Earland, *John Opie and His Circle* (London, 1911), p. 339, illus. opp. p. 248; Gertrude Underhill, "Some Recent Acquisitions of The Cleveland Museum of Art," *Art and Archeology*, VI (1917), 41; Coe (1955), II, 253, no. 27.

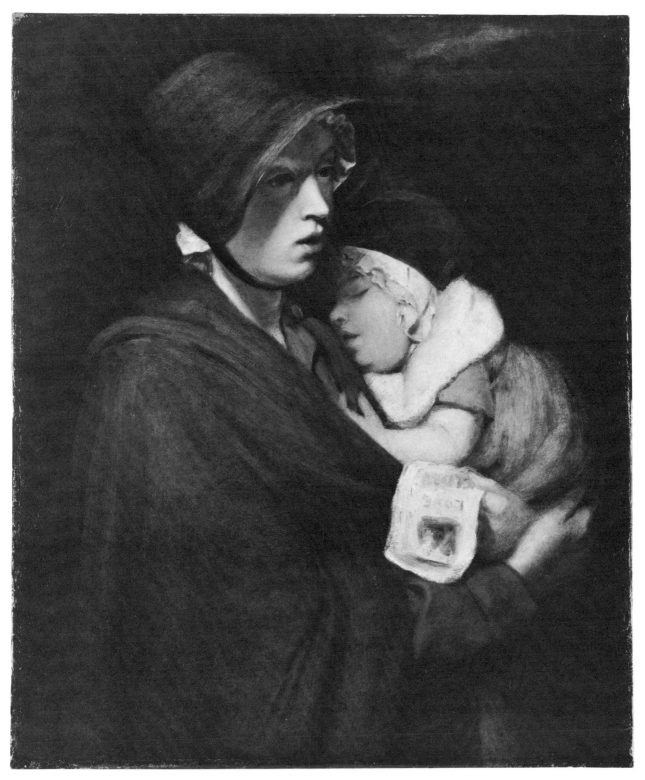

Figure 86.

SIR HENRY RAEBURN
1756–1823

Raeburn was born in 1756 at Stockridge, Edinburgh. He was the son of a manufacturer. About 1771 he was apprenticed to Gilliland, a goldsmith. He apparently met the seal engraver David Deuchar about 1773 and the painter David Martin about 1775, but he was largely self-taught. He began by painting miniatures, and progressed to full-scale portraits. About 1785 he went to London, where he met Sir Joshua Reynolds, whose work he had already studied through engravings. He traveled in Italy between 1785 and 1787 and then returned to settle in Edinburgh. He married Ann Edgar Leslie, a wealthy widow twelve years his senior. His portraits were mainly of the rising professional classes in Edinburgh and members of old Highland families. He became an associate of the Royal Academy in 1812 and an Academician in 1815. He was knighted and appointed His Majesty's limner for Scotland in 1822. He died the following year.

87 General Duncan Campbell 47.266
of Lochnell (1763–1837)

Canvas, 75.5 x 63.3 cm.

Collections: Mrs. Thomas Riddell (sister of General Campbell); Sir Thomas Riddell (grandson of Mrs. Thomas Riddell); [Spink & Co., London]; Leonard C. Hanna, Cleveland, purchased through Harold Parsons in 1925.

Gift of Leonard C. Hanna Jr., 1947.

Harold Parsons (correspondence dated March 13 and 27, 1925) reported that the painting was cleaned by a Mr. Thompson at the Boston Museum in 1925 and that it was impossible to remove all the darkened varnish from the background. Ross Merrill, conservator at the Cleveland Museum, examined the painting in September 1976 and concluded that it probably had been cut down because there was no evidence of cusping in the original twill canvas. There are numerous pentimenti—in the collar and a button, for example, and elsewhere. The painting is badly abraded and heavily overpainted; its condition would account perhaps for the sitter's blurred, receding hairline. There is evidence of blue paint in the background, below the brown glazes applied later. Unfortunately, because of the varnish glazes, it would be inadvisable to clean the painting.

The Museum painting may be a study for a larger, three-quarter-length portrait, one formerly in the collection of James Campbell of Barbreck (Richard Phillipson Dunn-Pattison, *The History of the 91st Argyllshire Highlanders*, Edinburgh and London, 1910, where the engraving after the portrait is reproduced opposite p. 12), or the one mentioned by James Greig (*Sir Henry Raeburn, R.A., His Life and Works*, London, 1911, p. 40) in the collection of the Duke of Argyll (engraved by J. B. Bird, R.S.A., 1863).

Another Raeburn portrait of General Duncan Campbell, in a different position, holding his bearskin hat in his right hand and standing in a landscape with trees (121.9 x 99.1 cm), is mentioned in the literature (see, among others, Greig, *op. cit.*).

Still another Raeburn portrait of the general (122.5 x 99.5 cm), with his arms crossed, leaning against a tree, was formerly in the collection of Sir Rodney Riddell (sales: Paris, 1913; Christie's, London, 1917; and Gluckstadt sale, Copenhagen, June 2–5, 1924).

General Duncan Campbell, Eighth Lochnell, was the son of Colonel Dugald Campbell of Ballimore. While still a child, he succeeded his great-uncle, Sir Duncan Campbell, in the estate of Lochnell; later he succeeded another great-uncle, Major General John Campbell, in the estate of Barbreck. In 1794 he was promoted from Captain 1st Foot Guards to Lieutenant Colonel, commandant. In 1795 he participated in the battle for the Cape in South Africa, including the Battle of Wynberg. He became a colonel in 1796, a major general in 1802, a lieutenant general in 1808, and a general in 1819. He held the position of Colonel of the 91st Regiment of the Argyllshire Highlanders from 1796 until his death in Edinburgh in 1837 (Dunn-Pattison, *op. cit.*, pp. 1–11, 383–84). The Museum painting probably dates from ca. 1808, when the sitter was a lieutenant general.

A portrait by Raeburn of Sir Duncan Campbell, Bart., Scots Guards, a cousin of General Campbell who acted as aide-de-camp for the general at the battle of Talavera in Portugal in 1809, is in the collection of the M. H. de Young Memorial Museum, San Francisco (*The Romantic Era: Birth and Flowering 1750–1850*, exh. cat., Indianapolis, 1965, no. 15).

An expertise, written by William Roberts (London, November 11, 1924), accompanied the painting when it entered the Museum collection. NCW

EXHIBITIONS: None.

LITERATURE: *In Memoriam Leonard C. Hanna, Jr.* (Cleveland, 1958), no. 89; CMA *Handbook* (1978), illus. p. 195.

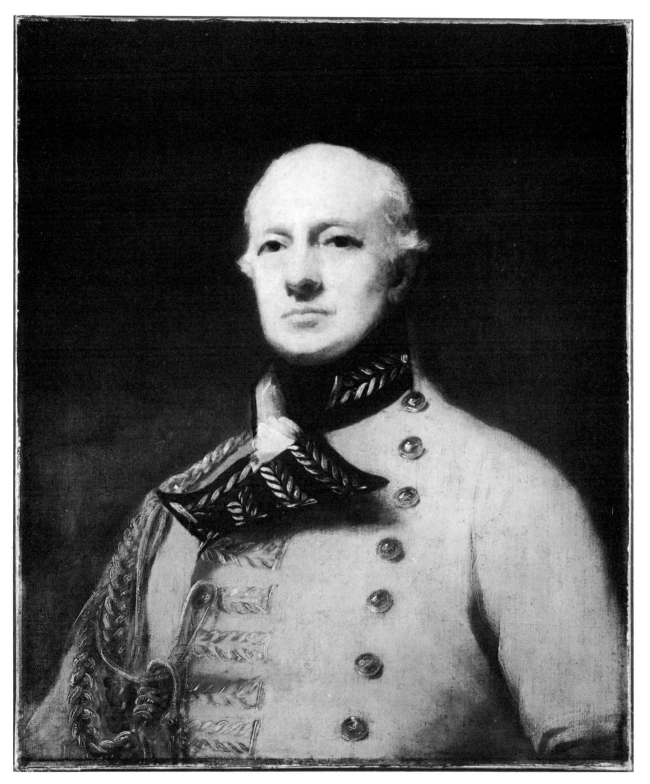

Figure 87.

SIR JOSHUA REYNOLDS

1723–1792

Sir Joshua Reynolds was born at Plympton St. Maurice in Devon (near Plymouth) in 1723. His father was the Reverend Samuel Reynolds, headmaster of the Plympton Grammar School. Reynolds grew up in an educated family environment, surrounded by intelligent people, and having access to his father's considerable library—advantages that set him apart from most other English painters of his day. In 1740 his father sent him to London to apprentice with the fashionable and competent portrait painter, Thomas Hudson. Reynolds returned to Devonshire intermittently until 1749, when he set off for a tour of Europe, visiting Rome for two years and then Florence, Parma, Bologna, and Paris. He settled in London in 1753 and lived there for the rest of his life. From Rome he brought back Giuseppe Marchi (1735–1808), a drapery painter, who worked in his studio along with a number of other assistants until Reynolds's death. In 1755, the first year Reynolds kept records of his studio, he had over a hundred sitters, enough to employ himself and several assistants (James Northcote was the only assistant whose work can be identified today; see John Steegman, *Art Quarterly*, XXI, Autumn 1958, pp. 247 ff.). Reynolds became president of the Royal Academy in 1768. In 1781 he journeyed to Flanders and Holland. In 1784 he became the king's principal painter upon the death of Alan Ramsey. He was determined to improve the social position of the artist in English society; that he was knighted in 1769 shows the extent to which he was able to achieve this goal. He was also determined to raise the art of portraiture to the level of history painting by the addition of narration and classical allusion. To keep abreast of creative ideas in all the arts, in 1764 he formed the "Club," to which his friends, Dr. Johnson, Edmund Burke, and Oliver Goldsmith, belonged, and through which they challenged each other's wit and intelligence. His *Discourses* were a vital contribution to the literature of art criticism and still are of interest today. Throughout the *Discourses* Reynolds maintained that English painting must be measured by universal standards and that English painters should not be parochial and isolated. In 1782, at the age of fifty-nine, he had a paralytic stroke, but he continued to paint for several more years, until 1789, when he began to lose his eyesight. He delivered the last of his *Discourses* at the Academy in December 1790. He died in February 1792.

88 The Ladies Amabel and Mary Jemima Yorke 42.645

Canvas, 195 x 170 cm.

Collections: Philip Yorke, Viscount Royston, later Second Earl of Hardwicke, St. James Square, London; Amabel Yorke, Baroness Lucas (in 1797), Countess de Grey (in 1816); Anne Florence, Baroness Lucas (m. 1833 to the Sixth Earl Cowper); Francis Thomas de Grey, Seventh Earl Cowper, Seventh Baron Lucas and Tenth Baron Dingwall; Auberon Thomas Herbert, Eighth Baron Lucas and Eleventh Baron Dingwall; Nan Ino, Ninth Baroness Lucas and Twelfth Baroness Dingwall (sale: Christie's, London, May 26, 1922, lot 78); [Agnew, London]; [M. Knoedler & Co., New York]; John L. Severance, Cleveland.

Bequest of John L. Severance, 1942.

The painting was cleaned and the disfiguring, yellowed varnish was removed by Roy Vallence in London in 1966. The painting has a tear at the right edge and some scattered areas of damage to the paint surface. Spots in the foreheads of both young ladies were retouched.

The young ladies were the daughters of Philip Yorke and Lady Jemima Campbell. Philip Yorke was Viscount Royston and later Second Earl of Hardwicke, and his wife was the only daughter of John Campbell, Third Earl of Breadalbane, and Amabel, eldest daughter and co-heir of Henry de Grey (last Duke of Kent of that line). Lady Amabel Yorke was born January 22, 1751; on July 16, 1772, she married Alexander Hume Campbell, Lord Polwarth (only surviving son of Hugh, Third Earl of Marchmont, created Lord Hume of Berwick, May 20, 1776), who died without issue, before his father, March 9, 1781. Lady Amabel Yorke succeeded her mother as Baroness Lucas (January 10, 1797); she became Countess de Grey, October 25, 1816; she died May 4, 1833. Lady Mary Jemima Yorke was born February 9, 1756; she was married on August 17, 1780, to Thomas, Second Baron Grantham, who died in 1786; she died at Whitehall on January 7, 1830. Lady Mary Jemima's eldest son, Thomas Philip, succeeded his aunt, becoming Second Earl de Grey and Fourth Baron Lucas in 1833. The painting was inherited through the de Grey-Lucas branch of the family.

Apparently there is no record of sittings for the painting; but according to Graves and Cronin (1899) and Cormack (1968–70), a payment of £84 was entered in Reynolds's ledger on January 13, 1761, for the portrait of Lady Grey's children.

Horace Walpole (see Toynbee, 1927–28) said that he saw the painting hanging on the first floor of the home of Lord Royston in St. James Square in 1761; Waterhouse (1973), however, pointed out that the year must have been 1762, for Walpole also mentioned a mezzotint engraved by Edward Fisher in 1762 which he saw on the same occasion.

The painting was engraved in mezzotint by Samuel William Reynolds I. The elder girl appeared in an engraving by Valentine Green (in reverse), and the younger daughter, in an engraving by J. Ogborne (Hamilton, 1884, p. 130).

NCW

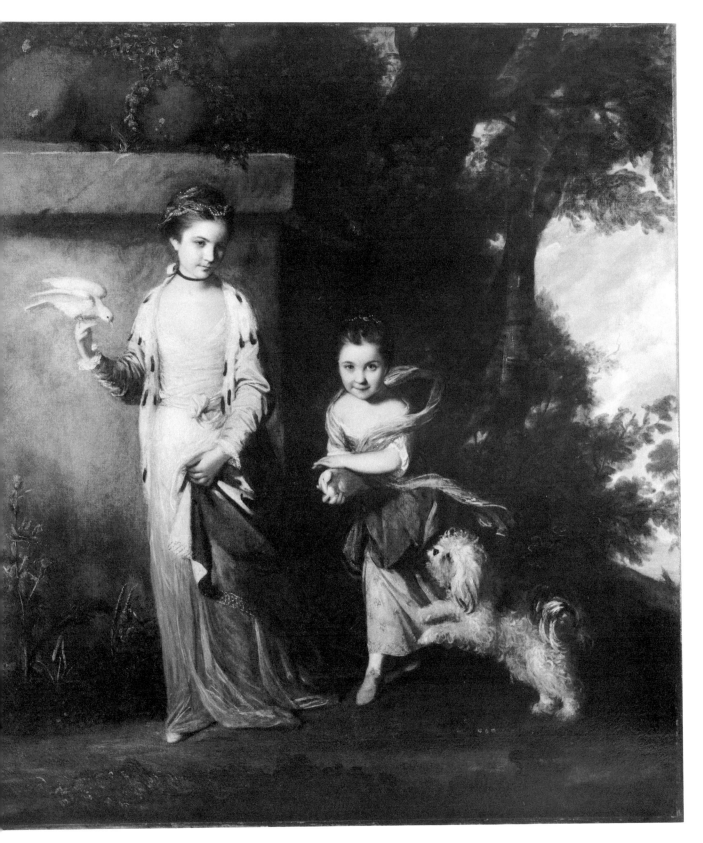

Figure 88.

EXHIBITIONS: London, British Institution, 1813, cat. no. 21 (as *Lady Lucas and Lady Grantham*); London, Suffolk Street, 1833: Family Portraits, cat. no. 73; London, Royal Academy, Burlington House, 1875: Old Masters Exhibition, cat. no. 139; London, Grafton Gallery, 1895: Fair Children Exhibition, cat. no. 154; London, Grosvenor Gallery, 1913/14: Second National Exhibition, Woman and Child in Art, cat. no. 90, illus. opp. p. 138; CMA (1936), cat. no. 233, pl. LVII; CMA (1942), cat. no. 14, p. 22, pl. VI; Detroit Institute of Arts, 1948: Exhibition of English Conversation Pieces, cat. no. 23, illus.; CMA, 1956: The Venetian Tradition, cat. no. 38, p. 30; CMA (1963), cat. no. 34, illus.

LITERATURE: *The Graphic Works of Sir Joshua Reynolds*, by Samuel William Reynolds (London, 1820–36), IV, no. 64 (as *Protection, Misses Hardwicke*); William Cotton, *Sir Joshua Reynolds and His Works* (London, 1856), p. 36; Edward Hamilton, *The Engraved Works of Sir Joshua Reynolds: A Catalogue Raisonné of the Engravings Made after His Paintings from 1755–1822* (London, 1884), p. 105 (reprint ed., Amsterdam, 1973, p. 139); Clarence Cook, *Art and Artists of Our Time*, III (New York, ca. 1888), 37–38, illus. p. 37; Algernon Graves and William V. Cronin, *History of the Works of Sir Joshua Reynolds P.R.A.*, III (London, 1899), 1084; Sir Walter Armstrong, *Sir Joshua Reynolds* (London, 1900), p. 237; *Bryan's Dictionary of Painters and Engravers*, IV (London, 1904), 219; [Alfred Lys Baldry], *Sir Joshua Reynolds* (London, 1905), p. XXXII; Graves (1914), III, 1020, 1041, 1054, 1085, 1091; *American Art News*, XX (May 1922), illus. p. 4; Henry Currie Marillier, *"Christie's" 1766 to 1925* (London, 1926), p. 196; Paget Toynbee, "Horace Walpole's Journals of Visits to Country Seats, etc.," *The Walpole Society*, XVI (1927–28), 40; Ellis K. Waterhouse, *Reynolds* (London, 1941), pp. 117, 121, pl. 70; Francis (1942), p. 136, illus. p. 133; Edgar P. Richardson, "Recent Acquisitions: *Ladies Amabel and Mary Jemima Yorke*, by Reynolds," *Art Quarterly*, VI, no. 2 (Spring 1943), 146–49, illus. p. 146; James Thomas Flexner, *John Singleton Copley* (Boston and Cambridge, 1948), pp. 32, 132, pl. 3; Coe (1955), II, 234–35, no. 14, pl. XLVIII; Milliken (1958), repr. p. 47; René Gimpel, *Journal d'un collectionneur, marchand de tableaux* (Paris, 1963), p. 236; Giulio Carlo Argan, in *Encyclopedia of World Art*, XII (New York, Toronto, and London, 1966); *Selected Works* (1966), no. 194, illus.; Malcolm Cormack, "The Ledgers of Sir Joshua Reynolds," *The Walpole Society*, XLII (1968–70), 121; William S. Talbot, "Thomas Gainsborough: *George Pitt, First Lord Rivers*," CMA *Bulletin*, LVIII (1971), 259, illus. fig. 2; Waterhouse, *Reynolds* (London, 1973), pl. 26; CMA *Handbook* (1978), illus. p. 192.

Studio of SIR JOSHUA REYNOLDS

89 Mrs. Collyear (Collier) as Lesbia and Her Dead Bird 20.514

Canvas, 80 x 67.2 cm.

Collections: Mrs. Gwynn, wife of General Gwynn; Sir William Wellesley Knighton, Blendworth Lodge, Hampshire (sale: Christie's, London, May 21, 1885, no. 457); Mrs. Adelaide Ross; Mr. and Mrs. Jeptha H. Wade, Cleveland.

Gift of J. H. Wade, 1920.

In 1963 Roy Vallence of London cleaned the painting, secured the blistering paint film, and removed discolored varnish and unnecessary repainting.

The subject of the painting, Lady Christiana Collyear (Collier), was the wife of Captain, and later Admiral, Sir George Collyear. She was the sister of General Gwynn, who married Mary Horneck, an intimate friend of Reynolds. This picture, according to Leslie and Taylor (1865) and also Graves and Cronin (1899), was painted in February 1764.

A portrait of Mrs. Collyear was exhibited by Reynolds in 1764 at the Society of Artists exhibition (Algernon Graves, *The Society of Artists of Great Britain 1760–1791: The Free Society of Artists 1761–1783*, Bath, 1907, p. 211, no. 93; reprint ed., 1970). It is not known, however, which of the several versions of the portrait was exhibited.

The only portrait of Mrs. Collyear that E. K. Waterhouse included in his monograph (*Reynolds*, London, 1941, pp. 53, 86, 108) was formerly in the collection of the Honorable Ernest Guinness, London (canvas, 76 x 63 cm). This may be the portrait that was owned by Malcolm Sands Wilson of Ridgefield, Connecticut, in 1942 (canvas, 63.5 x 76.2 cm; ex collections: Mr. Banfylde (?); Sir Edmund Francis Hayes), which, judging from a photograph provided by Mr. Wilson, appears to be more sensitive in execution and mood than the Cleveland painting.

Other replicas are: the portrait exhibited in Chefs-d'Oeuvres des Collections Parisiennes, at the Musée Carnavalet, Paris, in 1950 (cat. no. 58, pl. XIX; canvas 78 x 60 cm; ex collections: E. W. Beckett, London; Sedelmeyer Gallery, Paris, cat. 1905, no. 92, p. 114, illus.); and an oval replica of the portrait owned by the P. Jackson Higgs Gallery, New York, in 1927.

A drawing (black chalk heightened in white, 18.4 x 13.9 cm) for this portrait, attributed to Reynolds, appeared at auction at Batsford, London, in 1941 (cat. no. 105, illus.).

The painting was apparently popular among later artists. James Watson, Richard Houston, and G. Graham all made engravings in mezzotint after the portrait (Edward Hamilton, *The Engraved Works of Sir Joshua Reynolds: A Catalogue Raisonné of the Engravings Made after His Paintings from 1755–1822*, Amsterdam, 1973 [reprint of London, 1884, ed.], p. 91). There is also a painting of Mrs. Collyear, after the Reynolds portrait, on glass, attributed to J. Watson

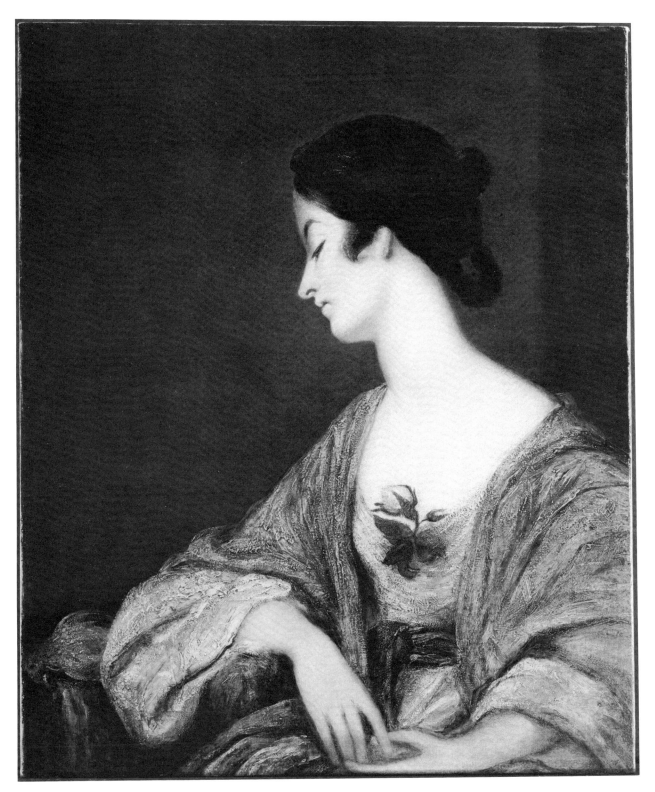

Figure 89.

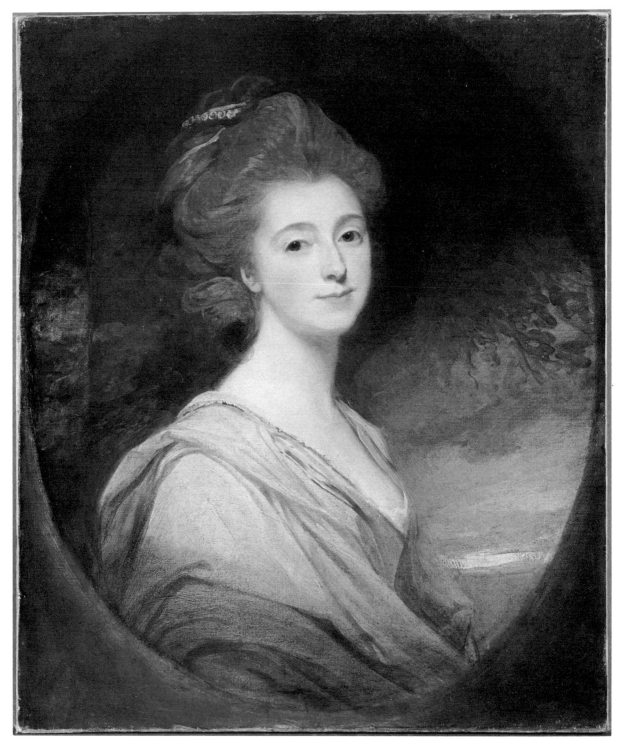

Figure 90.

(Egan Mew, "Old Glass Pictures," *Connoisseur*, LXXXVII, June 1931, illus. p. 343).

Because Reynolds had a large studio with many assistants, scholars have long questioned whether or not he himself had any hand in the Museum portrait. Waterhouse did not include our painting in his listing of Reynolds's works. Other scholars have suggested possible attributions to Stuart Newton, Osias Humphrey, or James Northcote.

<div align="right">NCW</div>

EXHIBITIONS: London, British Institution, 1823, cat. no. 50; London, British Institution, 1864, cat. no. 148; London, Grosvenor Gallery, 1884, cat. no. 134; Cleveland (1913), cat. no. 145B; CMA (1936), cat. no. 234; Pittsburgh, Carnegie Institute, 1938: Survey of English Painting, cat. no. 19.

LITERATURE: *Engravings from the Works of Sir Joshua Reynolds*, I (London: Moon, Boys & Graves, n.d.), pl. 71; Charles R. Leslie and Tom Taylor, *Life and Times of Sir Joshua Reynolds*, I (London, 1865), 239, n. 2; [Alfred Lys Baldry], *Sir Joshua Reynolds* (London, 1905), p. XXXIX; Algernon Graves and William V. Cronin, *History of the Works of Sir Joshua Reynolds, P.R.A.*, I (London, 1899), 186; Sir William Armstrong, *Sir Joshua Reynolds* (London and New York, 1900), p. 200; Graves (1914), III, 1039, 1075; Gertrude Underhill, "Some Recent Acquisitions of The Cleveland Museum of Art," *Art and Archeology*, VI (1917), 41; F. M. H. and L. M. [Leila Mechlin], "The Cleveland Convention," *American Magazine of Art*, XVI (July 1925), illus. p. 353; Coe (1955), II, 254, no. 30.

GEORGE ROMNEY

1734–1802

George Romney was born at Dalton-in-Furness, Lancashire. The son of a cabinetmaker, he apprenticed in his father's shop. In 1755 he began two years of study with Christopher Steele at Kendal and York. He moved to London in 1762. The following year he visited Paris, where he was fascinated with the work of Eustache Le Sueur. He was most interested in classical antiquity, but his dreams of doing historical paintings never materialized. From 1773 to 1775 he traveled in Italy; in Rome and Venice he studied the classical world and the works of Titian and Raphael. Upon his return to London he bought the house of the pastel portraitist Sir Francis Cotes. He was primarily known as a portrait painter. Of a shy and retiring nature, he rarely exhibited his work—until 1773, and then not at the Academy. In the mid-eighties he began to fail physically. He retired to Kendal, and died an invalid in 1802.

90 *Portrait of Lady Jane Reade* 16.1041

Canvas, 69.8 x 59 cm.

Collections: Sir John Chandos Reade, Seventh Bart. (1785–1868), Shipton Court, Axon, England (sale: Christie's, London, July 13, 1895, no. 14, to Tooth and Sons, London); Mr. and Mrs. J. H. Wade, Cleveland, purchased in 1895.

Gift of Mr. and Mrs. J. H. Wade, 1916.

There is evidence of an earlier, partial cleaning. The painting appears to be structurally sound. At present the paint film is covered with a disfiguring, yellowed varnish.

Jane Hoskyns was the only daughter of Sir Charles Hoskyns, Bart. Romney's sittings-book records numerous appointments with a Miss Hoskings, Hoskins, and Mrs. Hoskings, in three groups, in the years 1778, 1779, and 1780 (Ward and Roberts, 1904, I, 86 ff.). A receipt entered in Romney's cash-book for 1785 records payment for "Miss Hoskins' picture" (*ibid.*, II, 81). Sir John Reade, sixth baronet (1762–1789), who became Jane Hoskyns' husband in 1784, sat to Romney in 1788, at which time Lady Reade appears in the sittings-book for one appointment only (*ibid.*, I, 114–15). From this it seems certain that the Cleveland portrait dates from the years 1778 to 1780. NCW

EXHIBITIONS: Cleveland (1913), cat. no. 148B; CMA (1936), cat. no. 236.

LITERATURE: Humphry Ward and William Roberts, *Romney: A Biographical and Critical Essay with a Catalogue Raisonné of His Work* (London and New York, 1904), I, 86–88, 90–91, 114, and II, 81; Gertrude Underhill, "Some Recent Acquisitions of The Cleveland Museum of Art," *Art and Archeology*, XVI (1923), illus. p. 130; Coe (1955), II, 254, no. 31.

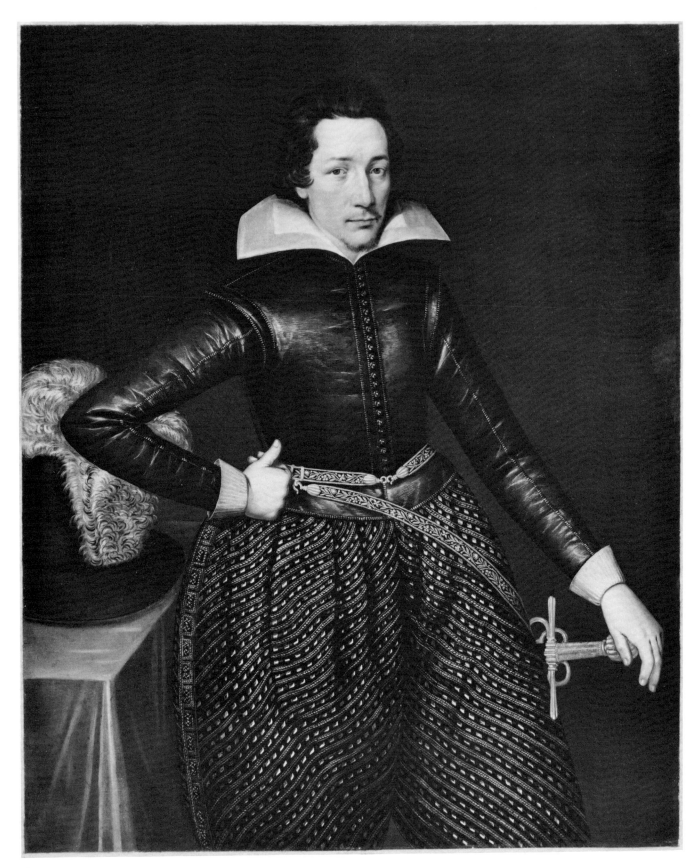

Figure 91.

ANONYMOUS MASTER
Anglo-Netherlandish
First quarter of the seventeenth century

91 *Portrait of a Man* 46.161

Canvas, 123.2 x 99.8 cm.

Collections: Viscount Ednam (sale: Christie's, London, July 17, 1925, no. 63); S. A. Hecht; Mr. and Mrs. Samuel D. Wise, Cleveland.

Gift of Samuel D. Wise, 1946.

In 1946, before it entered the Museum collection, William Suhr lined the canvas. All the tacking margins are missing, and, Suhr noted, a strip 6.4 centimeters wide had been added across the entire top of the canvas. There are scattered paint losses and numerous areas of retouching overall, but particularly along the right edge. There is cracking and flaking of paint along folds in the lower right. The paint film is in generally good condition except for losses in the lower part of the man's green waistcoat and some abrasion on his face and hands and in the background.

A photograph taken when the painting was stripped down accompanied the work when it entered the collection. The back of the photograph was stamped by Duveen Brothers, indicating that perhaps this was the dealer from whom Samuel Wise acquired the painting.

In 1925, when this Jacobean portrait was sold by Christie's, the subject was thought to be Sir Philip Sidney (1554–1588), and the attribution was to Federico Zuccaro. Zuccaro, a Roman painter, was in England for only a few months, sometime toward the end of 1574 until sometime before October 1575. The style of the painting and the costume appear to be English. In the opinion of K. Corey Keeble, Royal Ontario Museum, Toronto (letter of March 8, 1979), details of costume and the hilt of the sword strongly suggest a date between 1610 and 1615, which would negate the Zuccaro attribution and the Sir Philip Sidney identification.

The portrait is most likely of an Englishman, painted in England, probably by an immigrant Netherlander. The two Gheeraerts have been suggested as the painters of the Museum portrait, but Marcus Gheeraerts the Elder died before 1604, and the few signed works of Gheeraerts the Younger (1561–1635), the most important painter in England between roughly 1590 and 1620, have few stylistic similarities to our painting.

In 1968 E. K. Waterhouse said the Museum picture was similar in style to the works of Abraham van Blyenberch of about 1610. Though little is known about this artist, one can be reasonably sure that he paid a visit to England, probably about 1618, because he painted a portrait of Charles, Prince of Wales, and a portrait of Robert Ker, Earl of Ancrum (Marquess of Lothian's trustees), the latter dated 1618. Since he is known to have had pupils in Ant-

werp in 1621–22, he had obviously returned from England at least by that time (for further information on van Blyenberch, see E. K. Waterhouse, *Painting in Britain 1530 to 1790*, London, 1953, p. 34). Van Blyenberch's style is very close to that of Daniel Mytens (ca. 1590–1647) and Paul von Somer (ca. 1576–1621/2), both of whom painted extensively in England; unlike the artist of the Cleveland portrait, however, these artists painted in a manner that was more robust and more typically Dutch.

There is a large group of portraits once thought to have been of Sir Philip Sidney, but art-historical criticism has gradually ruled out this identification for most of these works, including the Museum's portrait. Though it is dangerous to try to identify a portrait of an unknown subject without some documentation, it has been very tentatively suggested by J. W. Goodison (letter of October 31, 1949) that a relationship exists between the Museum's portrait and one of Sir Thomas Overbury (1581–1613) in the Bodleian Library, Oxford; doubt is cast on this assumption, however, by a comparison of our picture with another possible portrait of Overbury in London, National Portrait Gallery (NPG 2613; Roy Strong, *Tudor and Jacobean Portraits*, London, 1969, I, 238–39, and II, pls. 474 and 476).

The Museum portrait is very similar in style to a full-length portrait of Sir Thomas Dale, by an anonymous seventeenth-century painter, in the Virginia Museum of Fine Arts, Richmond (*The Virginia Museum of Fine Arts Members' Bulletin*, XII, no. 9, May 1952). N C W

EXHIBITIONS: Virginia Museum of Fine Arts (Richmond) and Detroit Institute of Arts, 1964: The World of Shakespeare, 1564–1616, cat. no. 22, illus. p. 29.

LITERATURE: Berta Siebeck, *Das Bild Sir Philip Sidneys in der Englischen Renaissance* (Weimar, 1939), p. 169, no. VII; Alexander C. Judson, *Sidney's Appearance: A Study in Elizabethan Portraiture* (Bloomington, Indiana, 1958), pp. 72, 86.

Holland

NICOLAES BERCHEM
1620–1683

Nicolaes Berchem was born in Haarlem in 1620. He received his first training from his father, Pieter Claesz., a still-life painter. Nicolaes entered the Haarlem guild in 1642 and in the same year went to Italy. By 1646 he was back in Haarlem, where for a time Pieter de Hooch studied with him. By 1677 Berchem had settled in Amsterdam, where he lived until his death in 1683.

His style was formed during the short time he was in Italy, and the Italian influence continued throughout his career. His subject matter included biblical and mythological themes, battles, genre, and harbor views. He did many landscapes peopled with bucolic workers or travelers. He also painted figures in the landscapes of other artists—for example, Ruisdael and Hobbema. Few of his works are dated, making a chronology of his paintings difficult to establish accurately.

92 *The Rush Gatherers* 68.239

> Canvas, 101.6 x 137.2 cm. Signed and dated on rock at lower left: Berchem 1657.
>
> Collections: Jacob Odon, Amsterdam (sale: van der Schley . . . Yver, Amsterdam, September 6, 1784, no. 1); M. Lapeyrière, Paris (sale: Henry, Paris, April 19, 1825); imported to England in 1830 and sold by Mr. O'Neil to Edward Lloyd, Manchester (see Smith, 1834); Lewis Lloyd of Beckenham; E. N. F. Lloyd (sale: Christie's, London, April 30, 1937); [Bernard Houthakker, Amsterdam, 1957]; Dr. and Mrs. Paul J. Vignos, Jr., Cleveland, 1960.
>
> Gift of Dr. and Mrs. Paul J. Vignos, Jr., 1968.

The painting is in very good condition. It was cleaned in 1968 by Joseph Alvarez.

In another work by Berchem, the *Itinerant Musician*, also dated 1657 (Indianapolis, private collection; Wolfgang Stechow, *Dutch Landscape Painting of the Seventeenth Century*, London, 1966, fig. 307), there is a figure on horseback seen from the back which is similar to that in the Cleveland painting, except that in the former the rider plays a bagpipe and in the latter he carries a staff. Both paintings feature rather rugged, mountainous settings instead of the open, hilly vistas with Roman ruins which more often characterize Berchem's work.

Hofstede de Groot (1926) confused some of the history of the Cleveland painting with that of another work with slightly different measurements (107 x 135 cm) in the J.

Hage collection in Nivaa, Denmark (no. 6 in the catalogue of 1922). The provenance given by Hofstede de Groot is that of the Cleveland painting except for his inclusion of the Hage collection. JKC

EXHIBITIONS: CMA, January 1969: Year in Review, cat. no. 59; CMA (1973).

LITERATURE: Smith (1834), V, no. 193, pp. 64–65; Hofstede de Groot (1926), IX, no. 337, p. 149; Eckhard Schaar, "Studien zu Nicolaes Berchem" (Ph.D. dissertation, University of Cologne, 1958), p. 63.

ABRAHAM VAN BEYEREN
1620/21–1690

Abraham van Beyeren was born in 1620 or 1621 in The Hague. Traditionally he has been called the pupil of Pieter de Putter, to whom he became related by his second marriage in 1647. He was active in Leyden in 1639. From 1640 to 1657 he was in The Hague, where in 1656 he helped found the painters' confraternity, Pictura. From 1657 to 1663 he was in Delft, and from 1663 to 1669 he was again in The Hague. From there he moved to Amsterdam, where he stayed until 1674. In 1674 he was recorded in the guild in Alkmaar. From 1678 he was in Overschie, where he died in 1690.

He was a prolific still-life painter who also did some seascapes. Notable among his still-life paintings were his fish pieces and banquet pieces, full of sumptuous items that reflect rich living, but also with subtle *memento mori*. Van Beyeren ranks among the most important Dutch still-life painters, but he did not enjoy success in his lifetime, nor did he attract many followers or imitators.

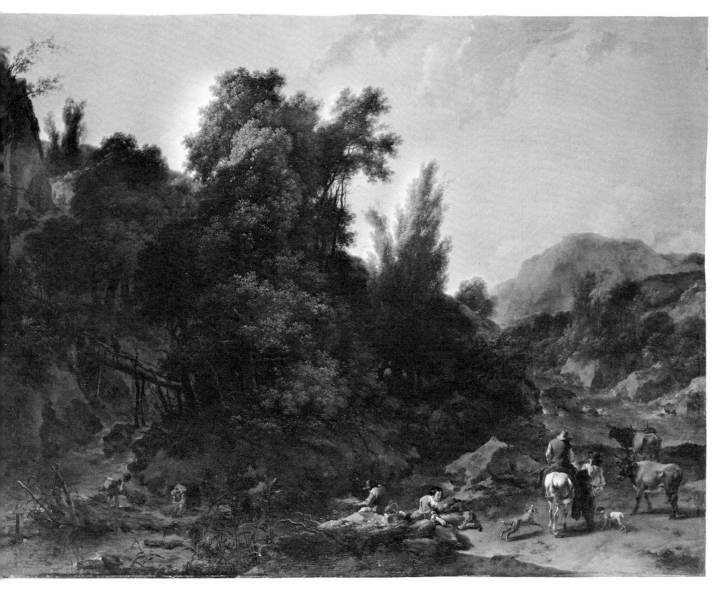

Figure 92.

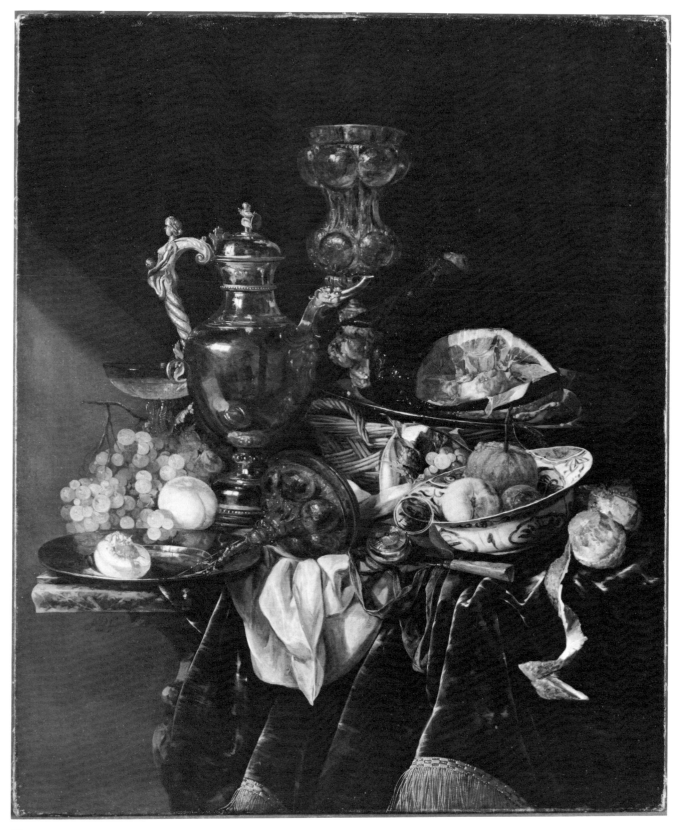

Figure 93.

93 *Still Life with a Silver Wine Jar* 60.80
and a Reflected Portrait of the Artist

Canvas, 99.7 x 82.6 cm. Signed at lower left with monogram: AB f.
Collections: [H. Terry-Engell Gallery, London].
Mr. and Mrs. William H. Marlatt Fund, 1960.

A lightweight, plain, tightly woven fabric (estimated to be linen) is lined to a heavy herringbone twill fabric (estimated to be cotton). A patch of the lining material measuring 67 x 21.5 centimeters covers a tear. The painting is generally well-preserved. Old losses—in the lemon peel and peach on the right, in the marbelized table, chalice, and cover on the left, and in some of the background—have been restored. Losses along the edges have been retouched. There is reinforcing in the wine jar and in the background above the wine glass.

On the wine jar there is a reflection of the artist working at his easel (Figure 93*a*), a device that appears in several other still lifes by van Beyeren in the following collections: Oxford, Ashmolean Museum (*Catalogue of the Collection of Dutch and Flemish Still-Life Pictures Bequeathed by Daisy Linda Ward*, Oxford, 1950, p. 45, no. 10, illus.); Rotterdam, Museum Boymans-van Beuningen (*Old Paintings 1400–1900*, cat., 1972, illus. p. 99, vdV2); Toledo (Ohio) Museum of Art (*Museum News*, January 1953, no. 141, illus.); private collection in South Africa (illus. in *Vier Generaties Nystad, 1862–1962*, Lochem, 1962, unpaginated); Amsterdam, Rijksmuseum (no. 505 A3, dating from ca. 1655; R. van Luttervelt, *Masterpieces from the Great Dutch Museums*, New York, 1961, p. 227, illus.); and Champaign (Illinois), Krannert Art Museum, University of Illinois.

The Cleveland picture is stylistically related to, but certainly later than, the still life of 1655 in Worcester, Massachusetts (Ingvar Bergström, *Dutch Still-Life Painting in the Seventeenth Century*, London, 1956, fig. 198). Van Beyeren's earliest-known banquet piece is from 1651 (Huldschinsky collection; sale: Lepke, Berlin, March 20, 1900, cat. no. 67; Sullivan, 1974, n. 9). Since van Beyeren seldom dated his paintings, it is difficult to document his development. Among works dated 1653 to 1666, however, one finds a stylistic growth toward greater unity and clarity in composition (*European Works of Art in the M. H. de Young Memorial Museum*, San Francisco, 1966, p. 141). In such a progression, the Cleveland painting would seem to belong within a few years after 1655.

At the time it entered the collection, the Cleveland painting was thought to have been formerly in the Huldschinsky collection in Berlin (Francis, 1960, p. 214), an erroneous assumption based on a reference to another work in Wilhelm von Bode's catalogue, *Die Sammlung Oscar Huldschinsky* (Frankfurt, 1909). WS

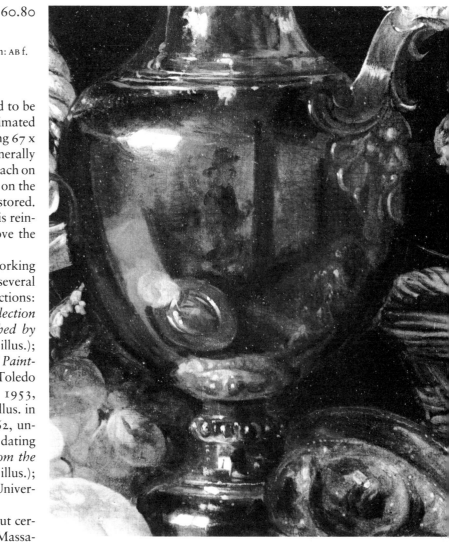

Figure 93*a*. Detail showing artist's reflection.

EXHIBITIONS: CMA, December 1960: Year in Review, cat. no. 55; CMA, 1979: Chardin and the Still-Life Tradition in France, cat. no. 1, illus. (catalogue by Gabriel P. Weisberg, with William S. Talbot).

LITERATURE: Henry S. Francis, "Abraham van Beyeren: *Still Life with a Silver Wine Jar and Reflected Portrait of the Artist*," CMA *Bulletin*, XLVII (1960), 213–14, illus. p. 212; *Catalogue of Paintings*, Vol. 1: *Foreign Schools, 1350–1800* (York, England, 1961), p. 48; Scott A. Sullivan, "A Banquet-Piece with Vanitas Implications," CMA *Bulletin*, LXI (1974), 271–82, figs. 1 and 8; Janet Gaylord Moore, *The Eastern Gate* (Cleveland and New York, 1979), p. 83, color illus. p. 85, listed p. 26.

GERARD TER BORCH (Terborch)
1617–1681

Gerard ter Borch, the son of the painter Gerard ter Borch the Elder (1584–1662), was born in Zwolle in 1617. From 1633–34 he was in Haarlem, where he studied with Pieter Molijn (1595–1661), a painter of landscapes and genre. Ter Borch entered the Haarlem guild in 1635. In the same year, he began to travel—first to England, then to France, Italy, Germany, and Spain—returning ca. 1640–41. He was also active in Münster (1646–48), where he painted the group portrait *Signing of the Peace of Münster, 15 May 1648* (London, National Gallery), the work which established his reputation. After Münster he was in Zwolle and Kampen. His earlier paintings were mostly guardroom scenes. After he settled in Amsterdam, around 1650, he began to paint small, full-length portraits. His craftsmanship and subtle characterizations were of a consistently high quality throughout his career. After 1654 ter Borch moved to Deventer, where he remained until his death in 1681.

94 *Portrait of a Lady Standing* 44.93

Canvas, 63.3 x 52.7 cm.

Collections: Cardinal Jean Jacques de Faesch, Rome (sale: de Vries … Roos, Amsterdam, July 3, 1833, no. 56; see Gudlaugsson, 1960, II, 190); F. Austen, London, 1877; [M. Knoedler & Co., New York]; Elisabeth Severance Prentiss, Cleveland, 1923.

The Elisabeth Severance Prentiss Collection, 1944.

In 1947 William Suhr examined the painting and reported that the surface condition was faultless. When the cover of yellow varnish was removed, the paint film was found to be in very good condition. There were retouches covering tiny abrasions above the sitter's upper lip, at the right.

This portrait was probably the companion piece of a slightly larger painting, the *Portrait of a Gentleman* (Figure 94*a*), which was painted ca. 1663–64. Gudlaugsson (1959) assumed that the Cleveland painting was done a little later, perhaps ca. 1665.

The identity of the sitter in our painting is not known; an early identification as the Princess of Condé (Exh: 1877) cannot be justified. W S

EXHIBITIONS: London, Royal Academy, 1877: Winter Exhibition, cat. no. 277; CMA (1936), cat. no. 245, pl. LIII; CMA, 1944: The Prentiss Bequest, cat. no. 15; Grand Rapids (Michigan) Art Gallery, 1949: Old Masters from Midwestern Museums; Minneapolis Institute of Arts, 1952: Great Portraits by Famous Painters; Metropolitan Museum of Art, Toledo (Ohio) Museum of Art, and Toronto Art Gallery, 1954/55: Dutch Painting: The Golden Age, cat. no. 11; Akron (Ohio) Art Institute, 1956: Seventeenth-Century Dutch Paintings and Drawings; New York, Wildenstein & Co., 1962: Masters of Seven Centuries, cat. no. 21; CMA (1973); Sarasota, Florida, The John and Mable Ringling Museum of Art, 1980/81: Dutch Seventeenth-Century Portraiture, The Golden Age, cat. no. 10, illus.

LITERATURE: Hofstede de Groot (1913), V, 78, no. 220, and p. 128, no. 416f; Graves (1914), III, 1301; F. Hannema, *Gerard Terborch* (Amsterdam, 1943), p. 101, illus. p. 163; Henry S. Francis, "Paintings in the Prentiss Bequest," CMA *Bulletin*, XXXI (1944), 88–89, illus. p. 86; Coe (1955), II, 217, no. 22, pl. XLIII; S. J. Gudlaugsson, *Gerard Ter Borch*, I (The Hague, 1959), 140, 337, and II (1960), 190, fig. 194; René Gimpel, *Journal d'un collectionneur, marchand de tableaux* (Paris, 1963), p. 236; Blanche Payne, *History of Costume* (New York, 1965), p. 398; CMA *Handbook* (1978), illus. p. 162.

Figure 94*a*. *Portrait of a Gentleman*. On canvas, 67.3 x 54.3 cm. Ter Borch. The National Gallery, London.

Figure 94.

AMBROSIUS BOSSCHAERT THE ELDER
Ca. 1573–1621

Bosschaert was born in Antwerp in 1573. When he was fourteen his family moved to Middelburg, the provincial capital of Zeeland. There he evidently established himself as a successful dealer in paintings and a painter. By 1593 he was listed as a member of the guild in Middelburg. He lived and worked there until 1613. By 1615 he resided in Bergen-op-Zoom (in northern Brabant); in the following year he moved to Utrecht; and in 1619 he was in Breda. In 1621, while in The Hague to personally deliver a flower piece, he fell ill and died.

95 *Still Life* 60.108

On copper, 35.6 x 29.3 cm. Signed at lower left with monogram, and dated 1606.

Collections: Carrie Moss Halle, Cleveland.

Gift of Carrie Moss Halle in Memory of Salmon Portland Halle, 1960.

In 1966 the painting was cleaned and restored by Joseph Alvarez. The old varnish was removed, and the painting was found to be in good condition. There were small losses of paint along the top edge of the panel, in a few scattered spots in the background, diagonally across the tips of the top left tulip, in the lower left carnation, and in two spots on the rose at the lower right. On the lower portion of the panel there were losses across the top part of the dragonfly wing and in a small area beside the butterfly.

Dated 1606, the Cleveland panel is the earliest-known, dated work by Bosschaert. L. J. Bol, in *The Bosschaert Dynasty* (Leigh-on-Sea, England, 1960, p. 19), cited a still life with a dish of fruit, signed by Bosschaert the Elder, which he thought dated from ca. 1600; at the time of his publication, Bol knew of no dated work from before 1607.

Judging from the known works of Bosschaert, the Cleveland painting is fairly typical of his oeuvre. Each flower appears with the same shadowless clarity; each petal and leaf was painted with glistening freshness. The flowers included are similar to some that appear in other Bosschaert paintings. The careful arrangements of both colors and shapes, and the fact that the blooms do not all appear in the same season indicate that these arrangements are composed from separate studies, a common practice among still-life painters of the time.

The flowers have been identified by Margaret F. Marcus as follows: four tulips, two yellow Turk's Caps (*Lilium Martagon*, upper right center), a gray fritillary (checkered lily, to the right of center), a large Ismene (*Hymenocallis*, at the bottom), a deep blue *Iris plicata* (upper right), narcissus (upper left center), various roses, carnations, crocus, columbines, a wild violet, and forget-me-nots. A white rose and a French anemone lie on the table. JKC

EXHIBITIONS: CMA, November 1965: Year in Review, cat. no. 91, illus. p. 130.

LITERATURE: Wolfgang Stechow, "Ambrosius Bosschaert *Still Life*," CMA *Bulletin*, LIII (1966), 60–65, color illus. p. 59.

Figure 95.

PIETER CODDE

1599–1678

Pieter Codde was born in 1599 in Amsterdam, where he apparently lived all his life. His work included genre paintings of drinking scenes and conversation pieces, as well as portraits and historical, mythological, and biblical subjects. The dates on his pictures range from 1625 to 1651. In 1637 he was commissioned to complete the group portrait left unfinished by Frans Hals, the *Officers of the Militia Company of St. Hadrian* (Haarlem, Frans Halsmuseum).

96 *Interior of an Inn* 48.462

Panel (oak), 37.2 x 48.3 cm.
Collections: Henry W. Kent, Cleveland.
Bequest of Henry W. Kent, 1948.

The thinned and cradled panel was cleaned by William Suhr in 1949. A horizontal crack, starting from the right edge and extending through the two seated figures on the right, was filled with white gesso. Losses at the top center and small losses at the two lower corners were filled. Paint film on the whole was found to be in good condition. Dark,

Figure 96.

discolored varnish was removed, and losses were attenuated.

This painting is a characteristic work of Codde's later period, namely after the 1640s when his style became looser and when he frequently used tavern scenes for subject matter. Dates for his genre paintings of that period are lacking, but stylistically comparable (though slightly earlier) works such as *Conversation* (*Trésors des musées du Nord de la France*, Vol. 1: *Peinture Hollandaise*, exh. cat., Lille, 1972, no. 12) or *La Toilette* (Paris, Louvre, no. 2339A; A. P. de Mirimonde, "La Musique dans les Oeuvres Hollandaises du Louvre," *La Revue du Louvre et des Musées de France*, XII, 1962, 133) show a clear departure from the artist's earlier style in which he painted with a much more formal arrangement of his subjects and with careful attention to details such as lace and the surface of satin (Neil MacLaren, *Dutch School*, I, London, 1958, pls. 64 and 65). WS

EXHIBITIONS: Pittsburgh, Carnegie Institute of Art, 1954: Pictures of Everyday Life, Genre Painting in Europe, 1500–1900, cat. no. 32; Akron (Ohio) Art Institute, 1956: Seventeenth-Century Paintings and Drawings; Raleigh, North Carolina Museum of Art, 1960: Tobacco and Smoking in Art, cat. no. XVIII.

LITERATURE: None.

AELBERT CUYP

1620–1691

Aelbert Cuyp was born in Dordrecht in 1620. He was the son and pupil of Jacob Gerritsz. Cuyp, a painter of landscapes and portraits. He remained in Dordrecht all his life and held several high offices in that community. Since few of his works were dated, it is difficult to reconstruct his development. He produced a considerable variety of paintings, mainly landscapes and animal pictures but also seascapes, still lifes, and numerous portraits. His early landscapes show the influence of Jan van Goyen. Cuyp, who apparently never went to Italy, later absorbed the influences of Dutch painters who did travel there, particularly Jan Both. He painted many portraits in the latter part of his career, but he seems to have painted little, if at all, after ca. 1655 to 1670.

97 Travelers in a Hilly Landscape 42.637
 with a River

Panel (oak), 48.1 x 74.8 cm. Signed at lower right: A Cuyp.

Collections: Johan van der Linden van Slingeland, Dordrecht (sale: Yver, Dordrecht, August 22, 1785, no. 87); Sir Simon Clarke, London (sale: Christie's, London, May 14, 1802); George Hibbert, London (sale: Christie's, London, June 13, 1829, no. 66); Richard Foster, London (sale: Christie's, November 14, 1835); Henry Bevan, London, 1842; Sir John Dean Paul (grandson of Henry Bevan); [A. Wertheimer, London]; Alfred de Rothschild, London; [Galerie Charles Brunner, Paris, 1912, no. 7]; John L. Severance, Cleveland, 1923.

Bequest of John L. Severance, 1936.

When William Suhr cleaned the painting in 1943 he found that the surface condition was nearly perfect and the paint film was well-preserved. There were some slight abrasions at the farthest left edge of the clouds and a few faint scratches in the sky. The original horizontal join at the center had opened at the left, causing small losses along the edges, about 5.7 centimeters into the picture.

A similar but smaller picture by Cuyp in the Mauritshuis, The Hague (Figure 97a), was engraved in reverse by J. C. Maillet in Lebrun's *Galerie des Peintres Flamands, Hollandais et Allemands* (Paris and Amsterdam, 1792, I, 94). The woman in the Mauritshuis painting sits on the second mule instead of the first, and the structure of the landscape differs from the Cleveland landscape; nevertheless, the picture was once erroneously identified by Hofstede de Groot (1909, no. 465) as the picture presently in the Cleveland Museum (the description in the first part of Hofstede de Groot's entry refers to the Mauritshuis picture, but the measure-

Figure 97a. *Travelers in a Southern Landscape.* On canvas, 38.6 x 52.2 cm. Cuyp. Mauritshuis, The Hague.

ments and the ex collections are those of the Cleveland painting).

A copy of the Cleveland picture is in the museum in Wroclaw (Breslau) (Steinborn, 1973). This panel, which measures 44.5 x 73 centimeters, has somewhat larger figures and a lower horizon.

Hans-Ulrich Beck (letter of June 26, 1955) mentioned what may be a larger replica or copy (signed and dated 1651, 51.2 x 61.3 cm) that was in the Berlin trade in 1947 and is now in The Hague.

The Cleveland painting probably dates from ca. 1650 to 1655. It is closely related in style to the *View of Nijmegen* in the Indianapolis Museum of Art, which has been dated in the 1650s (*John Herron Art Museum Bulletin*, XLVII, no. 1, 1960, 10, color illus. p. 1). W S

EXHIBITIONS: London, British Institution, 1818, cat. no. 110; CMA (1936), cat. no. 214; CMA (1942), cat. no. 3; CMA (1956); Ann Arbor, University of Michigan Museum of Art, 1964: Italy through Dutch Eyes, cat. no. 29, pl. XII; CMA (1973).

LITERATURE: Smith (1834), V, 294, no. 27; Smith (1842), IX, *Supplement*, 667, no. 56; Hofstede de Groot (1909), II, 143, no. 465; Graves (1913), I, 240; Francis (1942), p. 136; Coe (1955), II, 230–31, no. 3; Horst Gerson, "Italy through Dutch Eyes," *Art Quarterly*, XXVII (1964), 347, fig. 4; Wolfgang Stechow, *Dutch Landscape Painting of the Seventeenth Century* (London, 1966), pp. 161–62, fig. 326; S. J. Gudlaugsson, *Vijfentwintig jaar aanwinsten Mauritshuis 1945–1970* (cat., The Hague, 1970), no. 47; Bozena Steinborn, *Katalog Zbiorów Malarstwa Niderlandzkiego* (Wroclaw, 1973), no. 11, p. 34; Stephen Reiss, *Aelbert Cuyp* (Boston, 1975), no. 46, p. 79, colorplate VI; CMA *Handbook* (1978), illus. p. 161.

Figure 97.

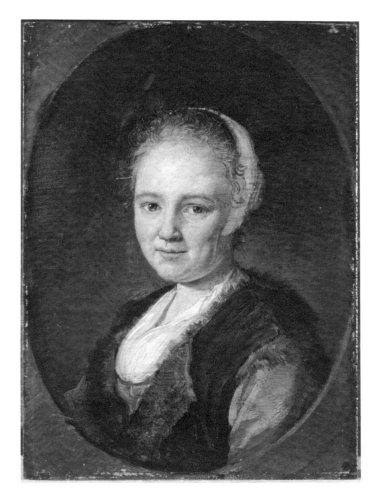

Figure 98.

GERARD (Gerrit) DOU
1613–1675

Gerard Dou, the son of the glass painter Douwe Jansz., was born in Leyden in 1613. His first training was in his father's profession. From 1628 to 1631 Dou was the pupil of Rembrandt, who lived near Dou's father's workshop. For a time Dou's works reflected the surface qualities of Rembrandt's paintings, but although Dou borrowed from the themes of the master, he never probed for as deep an interpretation of the subjects. He painted numerous portraits of Rembrandt's mother as well as biblical subjects. In 1648 he became co-founder of the painters' guild. He lived in Leyden until his death in 1675.

His work, which consisted primarily of portraits and genre, in later years became very meticulous. He was the initiator of the Leyden tradition of small, minutely finished pictures. Dou's paintings were very much in demand and even as late as the nineteenth century commanded higher prices than Rembrandt's.

98 *Portrait of a Woman* 51.325

Panel, 16.4 x 12.2 cm. Signed at left center: GDOV [G and D in ligature].

Collections: Comte d'Oultremont, Brussels, 1842; [Henry Reinhardt, New York]; William G. Mather, Cleveland, 1912.

Bequest of William G. Mather, 1951.

Small losses, including a tiny dot in the center of the forehead, a jagged scratch across the right cheek, and a spot under the ear, have been filled. Retouches occur under the chin, to the right; on the right nostril; in the sleeve, at the bottom of the picture; and on the vest, near the armhole. The edge of fur along the neckline has also been touched up. Under ultraviolet light the signature appears to be intact.

A companion piece (oval, 17.8 x 14 cm), a portrait of a man, has not been traced since 1882 (Smith, 1842, no. 66; Martin, 1901, no. 148, and 1902, no. 18; Hofstede de Groot, 1907, no. 332).

Dating Dou's portraits is difficult because of a dearth of exact dates. Because it is close in style to a drawing of 1638

229

in the Louvre (Roseline Bacou, *Great Drawings of the Louvre Museum*, New York, 1968, no. 91), it seems appropriate to place this portrait before 1640. On the other hand, Lia de Bruyer (letter of March 29, 1973), basing her opinion on a photograph of the Cleveland portrait, challenged the attribution by suggesting it may be a later copy in reverse of the *Portrait of a Woman* now in the Montreal Museum of Fine Arts (956.1150; oval, 14 x 11.4 cm). W S

EXHIBITIONS: Brussels, 1882: Exposition Néerlandaise de Beaux-Arts, cat. no. 50; CMA (1973).

LITERATURE: Smith (1842), IX, *Supplement*, 21, no. 67; Wilhelm Martin, *Het Leven en de Werken van Gerrit Dou* (Leyden, 1901), no. 199; Martin, *Gerard Dou*, trans. Clara Bell (London, 1902), no. 19, p. 106; Hofstede de Groot (1907), I, no. 362, p. 456; Henry S. Francis, "Bequest of William G. Mather, Paintings," CMA *Bulletin*, XXXVIII (1951), 197–98; Coe (1955), II, 162, no. 7.

JACOB DUCK
Ca. 1600–ca. 1660

Jacob Duck spent most of his life in Utrecht, where he was a member of the painters' guild. He died in The Hague about 1660. Little else is known of his life. He is one of those lesser-known Dutch painters of the first half of the seventeenth century—among them, Anthony Palamedes, Pieter Codde, Dirck Hals, and Willem Cornelisz. Duyster—who lived in the shadow of the more famous Frans Hals. Duck was influenced by the pictorial devices of the older generation of Caravaggesque painters in Utrecht—Hendrick Terbrugghen, Gerard Honthorst, and Dirck van Baburen—and painted many of their favorite subjects, such as musicians, drinkers, and card players. After the Thirty Years' War, Duck concentrated on describing the off-duty occupations of the soldier. His paintings have a hard, enamel-like finish and a marked realism that appealed to the prosperous middle classes for whom they were painted.

99 *Salome with the Head of* 75.79
 St. John the Baptist

Panel (oak), 71.1 x 54.6 cm.

Collections: Raedt van Oldenbarneveldt (sale: Muller, Amsterdam, November 6, 1900); Mrs. W. E. Gatacre' Jonkvrouwe de Stuers, Castle Wiersse, Vorden, Holland (sale: Christie's, London, November 26, 1965, no. 42); Socolow collection (sale: Sotheby's, London, December 6, 1972, no. 54); [The Arcade Gallery, London]; Mr. and Mrs. Noah L. Butkin, Cleveland.

Gift of Mr. and Mrs. Noah L. Butkin, 1975.

The oak panel consists of three members. Minor retouching has been done along the edges of the joined members. There is a small area of restoration in the background, between the executioner and the hand of the maidservant. In the lower left of the panel there is some very minor flaking of the paint surface and an old split, about five centimeters from the left edge, extending vertically some thirty-six centimeters upward from the bottom edge. Otherwise, the painting is in excellent condition. It was cradled in 1973 by Kenneth Malcolm in London. At some unknown time prior to that, it had been cleaned.

The ascription to Hendrick Gerritsz. Pots in the sale of 1965 (see Collections) is not acceptable. The attribution to Jacob Duck has been questioned because of the high quality of the work compared with other paintings in Duck's oeuvre and because the biblical subject matter is virtually unknown for this artist. Genre subjects are more characteristic of his work, although a moral lesson is usually implied. In the Cleveland panel the artist has deliberately isolated the paunchy, vulgar executioner at the left, with his hand on his scabbard, who stares with bold indifference at the spectator; the old woman, with subservient delight, holds the platter with the head of St. John before her mistress; and the richly garbed Salome, with raised hands, turns toward the spectator with an expression of subdued but poignant horror, unable to face the sight of the accomplished deed.

Other characteristics of Duck's work found in our panel are the painting style, the color, and the handling of surfaces and rich textures. The open door and the ambiguous floor line are typical of Jacob Duck's interest in, and rather naive experimentation with, the illusion of space. (For a representative painting by Duck and a recent evaluation of the artist, see James A. Welu, "'Card Players and Merrymakers': A Moral Lesson," *Worcester Art Museum Bulletin*, IV, May 1975, 8–16. In a letter of March 26, 1976, Welu concurred with the Duck attribution for the Cleveland painting, basing his judgment on a photograph of the painting.)

The subject had appeared in Dutch art long before Duck painted his version: in an engraving of 1513, to cite one example, by Lucas van Leyden, whose tall figures with small heads are echoed in Duck's painting.

Quite clearly, however, Duck depended more upon a Caravaggesque model for his rendition of the subject. Perhaps he was familiar with the *Beheading of St. John the Baptist* by Caravaggio himself (there are two extant versions of the *Beheading* ascribed to Caravaggio: one in the National Gallery, London, no. 172; and another in the Brera, Milan). It is even more likely that Duck was familiar with the *Beheading* now in the Herzog Anton Ulrich-Museum, Braunschweig. For many years this latter painting has been attributed to Ludovicus Finsonius (Louis Finson), but recently Maurice Pettex-Sabarot (*La Peinture en Provence au XVIIᵉ siècle*, exh. cat., Marseilles, 1978, cat. no. 84, pp. 57–58, and letter of July 1, 1979) suggested attributing it to the Friesian painter Martin Faber, another contemporary of Duck. Both Finson and Faber spent time in

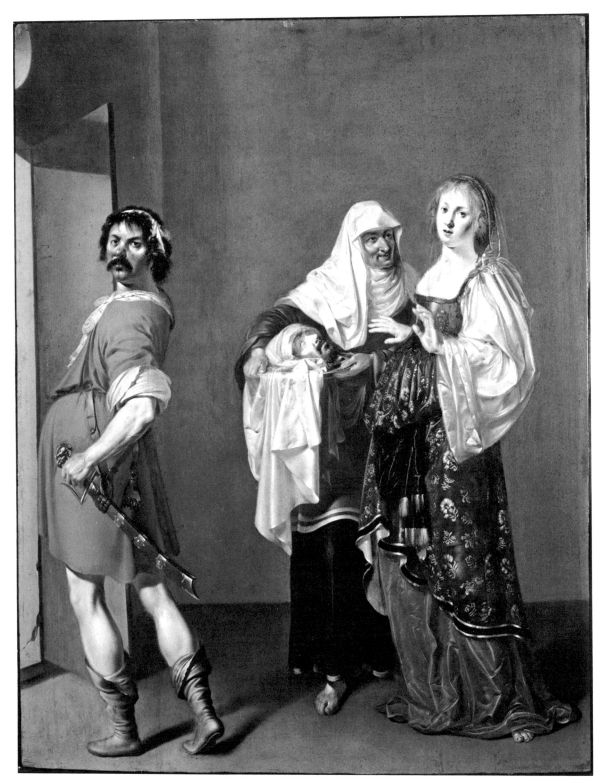

Figure 99.

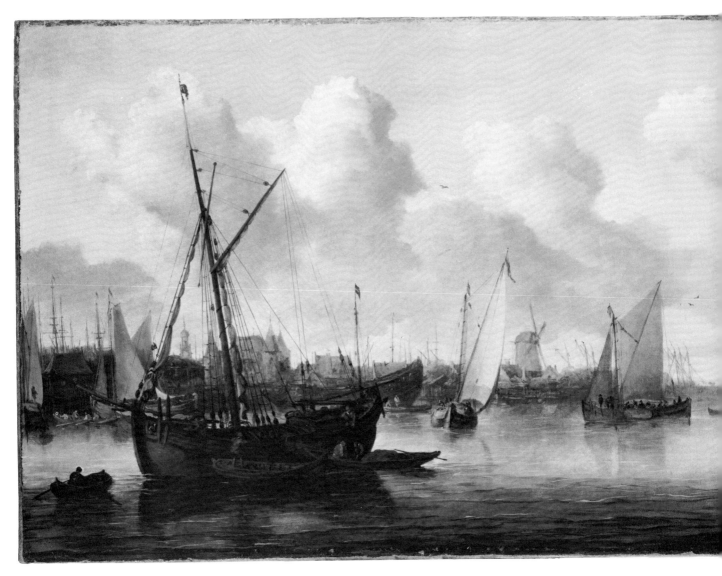

Figure 100.

Italy and were strongly influenced by Caravaggio. They became friends and traveled together on their return journey to the North between 1614 and 1616. Finson returned to Amsterdam (where he died in 1617); Faber settled in Emden, a German town in East Friesia near the Dutch border, and apparently carried on an active practice throughout the Low Countries until his death in 1648. No matter which of the two artists executed the Braunschweig painting, its Caravaggesque elements are clear, and it may well have been this work which served as the immediate inspiration for Duck's treatment of the subject. N C W

EXHIBITIONS: CMA, February 1976: Year in Review, cat. no. 58, illus. p. 41.

LITERATURE: "Notable Works of Art Now on the Market," *Burlington Magazine*, CXV (1973), pl. XXX.

ALLART van EVERDINGEN
1621–1675

Everdingen was born in Alkmaar in 1621. According to Houbraken, he was the pupil of Roelant Savery in Utrecht and of Pieter Molijn in Haarlem; traces of influence from both can be seen in his work. After 1645 the influence of Cornelis Vroom's work may also be noted. About 1643–44 Everdingen traveled to Scandinavia, and then introduced into Dutch painting the motifs of the rugged Northern landscape, with pines and waterfalls, which Ruisdael (see Painting 115) and others were also to adopt. He continued to use Northern motifs in his paintings long after he returned to his homeland. He lived in Haarlem until 1651, having become a master in the Haarlem guild in 1645. He moved to Amsterdam in 1652, and records show that he became a citizen in 1657. He died in Amsterdam in 1675.

100 *Fishing Boats in a Harbor* 74.105

> Canvas, 68.5 x 96.8 cm. Signed on boat in right foreground: A. v. Everdingen.
>
> Collections: [B. Cohen & Sons, London]; Mr. and Mrs. Noah L. Butkin, Cleveland, 1972.
>
> Gift of Mr. and Mrs. Noah L. Butkin, 1974.

The original support is a piece of lightweight, plain-woven linen, which in the past had been lined with a wax adhesive to a piece of linen of similar weight and weave. All original tacking margins have been removed. Examinations using infrared and ultraviolet light revealed broad areas of abrasion and restorer's paint but did not produce evidence that the signature was inconsistent with the construction of the painting.

Everdingen's earliest signed and dated work is a marine painting of 1640. After 1650 he rarely dated his paintings, making it difficult to establish a convincing chronology of his work. He is best known for his rugged Scandinavian landscapes and for his paintings of ships tossed about in rough seas. He also did town views. This harbor view with a calm sea is less common in his oeuvre, though not unique; Everdingen's *View of Alkmaar* (collection Frits Lugt, Institut Néerlandais, Paris) similarly shows a sea harbor with only a light breeze rippling the water.

At the present time the identity of the harbor is not known. Before the painting entered the collection it was, for a time, called the *Harbor at Muiden*. It has also been suggested that it might be Medenblik Harbor (Frits J. Duparc, letter of April 24, 1975). F. H. C. Weytens, Keeper of the Topographical Collection at Utrecht, has indicated, however, that both suggestions are unlikely. JKC

EXHIBITIONS: CMA, March 1975: Year in Review, cat. no. 47.

LITERATURE: CMA *Handbook* (1978), illus. p. 157.

GOVAERT FLINCK
1615–1660

Of Rembrandt's many followers—Nicolaes Maes, Aert van Gelder, Ferdinand Bol, and Carel Fabritius, to name a few—Govaert Flinck was the closest to the master and the most successful. He was born in Cleve on January 25, 1615. Although his parents were opposed to his artistic career, they sent him to the Mennonite painter and preacher Lambert Jacobsz. in Leeuwarden, Friesland, when he was about fifteen. Flinck shared quarters with the slightly older Jacob Backer, who also had an apprenticeship and with whom he went to Amsterdam at the end of his term. From 1632 to 1635 Flinck was Rembrandt's student; subsequently he entered into a business relationship with his master. Through his second marriage with the well-to-do Sophia van der Hoeven, and because of his own sizable income from his many important commissions, he, like Rubens in Antwerp, was able to maintain a stately home in Amsterdam. He assembled a distinguished collection of antique statuary, tapestries, and many other art objects. He numbered among his friends stadtholders, burgomasters, and fellow collectors (including Jan and Pieter Six), as well as fellow artists (among them, his great admirer, the poet Joost van Vondel, who eulogized Flinck as the "Kleefsche Apelles"). Flinck was to have executed twelve paintings in celebration of the glory of Rome for the main hall of the new city hall in Amsterdam, but after preparing the sketches for them, he died suddenly in his forty-fourth year. The commission was then carried out by several other artists, including Jacob Jordaens.

Having worked in a pre-Rembrandtesque style before he became Rembrandt's pupil (Egbert Haverkamp-Begemann, "Rembrandt as Teacher," *Evolution générale et développments régionaux en histoire de l'art*, Actes du XXIIe Congrès International d'Histoire, Budapest, 1972, p. 108), Flinck adapted the master's manner so perfectly that his work was frequently mistaken for Rembrandt's. In Flinck's life-size portraits and in his late works his style showed influences from Bartholomew van der Elst, who tended to brush on paint somewhat thinly and to use colors that were lighter and cooler than Rembrandt's. Houbraken attributes the changes in Flinck's and other Dutch artists' work to the great number of Italian paintings that were being introduced in Holland at the time (Seymour Slive, *Rembrandt and His Critics*, The Hague, 1953, p. 184).

101 *Portrait of a Woman* 77.117
(traditionally said to be Anna Maria
van Schurman, 1607–1678)

Panel (oak), 71.3 x 59.5 cm. Signed and dated: G. Flinck 1646.

Collections: Private collection, Amsterdam (sale: P. Methorst, Amersfoort, and others, March 14, 1882, no. 27); Dirksen (?); Raedt van Oldenbarnevelt (sale: Frederik Muller, Amsterdam, November 6–9, 1900, no. 35); Chevalier de Stuers (sale: Frederik Muller, Amsterdam, December 11, 1923, no. 473, illus.); Hoschek, Prague; Farrar (sale: Sotheby's, London, July 8, 1925, no. 42); Rothstein; Kenyon-Slaney (sale: Sotheby's, London, December 10, 1925, no. 44); (sale: Gebr. Douwes, Amsterdam, 1926); Victor de Stuers, Utrecht (on loan to Rijksmuseum); Dr. C. J. K. van Aalst, Hoevelaken; heirs of Dr. C. J. K. van Aalst; [Cramer, The Hague]; Mr. and Mrs. Noah L. Butkin, Cleveland.

Gift of Mr. and Mrs. Noah L. Butkin, 1977.

The oak panel consists of three vertical pieces, joined so that the wood grain is parallel. The panel is thin and fragile, and has split from the center (29.6 cm from the left vertical edge) to about 27 centimeters from the top edge. There are retouchings along this split and along the vertical joins. There is some abrasion in the paint layer, and the chin of the sitter has been reinforced. Surface grime and slightly discolored varnish have dulled the colors.

Figure 101a. *Anna Maria van Schurman with Rembrandt and Jacob Backer.* Engraving. Arnold(?) Houbraken, Dutch, 1660–1719. Reproduced by permission of the Iconographic Bureau, The Hague.

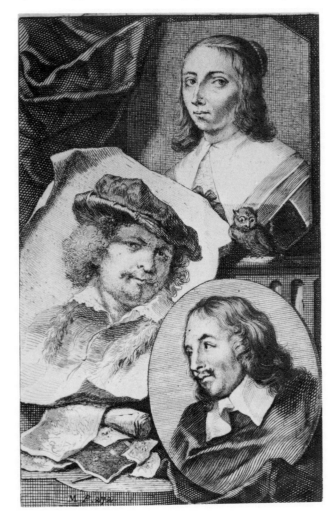

This portrait is eloquent proof that Flinck had absorbed much from Rembrandt's style, particularly from the time he was his student. Rembrandt's *Young Woman* of ca. 1635–36 in Kassel (Staatliche Kunstsammlungen), especially, comes to mind. Omitting all decorum, Flinck, like Rembrandt, concentrated on the sitter's face and its reflection of underlying psychological nuances; the woman in the Cleveland picture, for example, looks directly at the viewer, but her eyes betray that she is lost in thought.

There is some uncertainty concerning the traditional identification of the sitter. A handwritten inscription on the back of the panel, obviously added considerably later, reads: "Anna Maria Schuurmans AE XXXXII." Anna Maria van Schurman (or Schuurmans, or Schürmann), a famous Dutch scholar, artist, and religious leader, was born in Cologne in 1607 and died in Franeker, Holland, in 1678. (There is a discrepancy about her place of death. Paul Tschackert, in *Anna Maria von Schürmann, der Stern von Altrecht, die Jüngerin Labadie's*, Gotha, 1876, p. 24, said it was Wiewert, near Leuwarden.) The sitter's age—forty-two—given in the inscription is in error, for in 1646, the date of the painting, Anna Maria van Schurman would have been only thirty-nine years old. Nevertheless, since the sale of 1882, she has been presumed to be the subject of this portrait by former owners and scholars alike, including Hofstede de Groot (in Thieme-Becker, 1916), who mentions the Cleveland painting (without giving a provenance) among other portraits which Flinck painted of poets and scholars. A certain resemblance exists between this and other portraits of Anna Maria van Schurman, though most were painted when she was younger. Among portraits that resemble ours are Houbraken's engraving showing Anna Maria van Schurman with Rembrandt and Jacob Backer (Figure 101a), and her own *Self-Portrait*, at the Stedelijk Museum in Franeker, that was painted when she was much younger. Other portraits, however, make the identification highly doubtful. Her *Self-Portrait* of 1649 (present whereabouts unknown; sale: Lempertz, Cologne, November 8, 1898, no. 105), painted three years after the Cleveland portrait, is of a much younger woman than Flinck painted. Other painters' portraits of Anna Maria van Schurman—such as M. van Miereveld's (Stedelijk Museum, Franeker) and Cornelis Johnson's (Lille, Musée des Beaux-Arts)—seem to be of entirely different persons than the sitter in Flinck's portrait. Not only do Miereveld's and Johnson's representations differ from Flinck's, but they also differ from each other.

F. G. L. O. van Kretschmar, Director of the Stichting Iconographish Bureau (in a letter dated August 8, 1978) and B. J. A. Renckens of the Rijksbureau voor Kunsthistorische Documentatie (in a letter dated January 26, 1978), do not accept the identification of the sitter as Anna Maria van Schurman, but both consider the painting to be an attractive work by Govaert Flinck. ATL

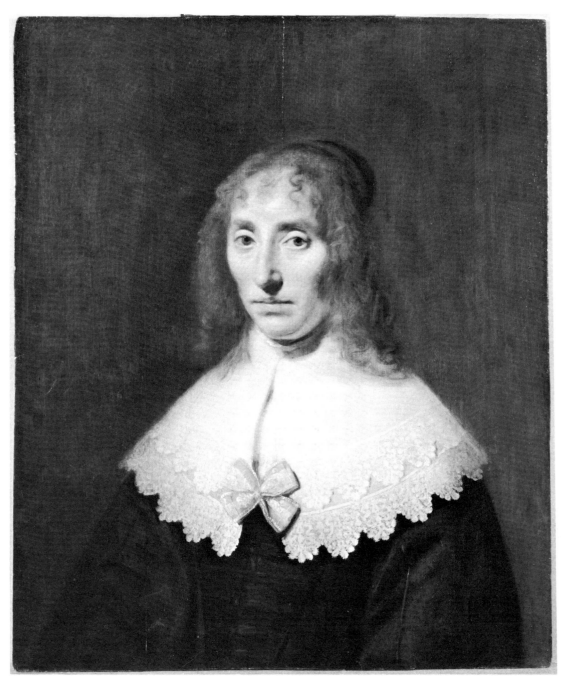

Figure 101.

EXHIBITIONS: Paris, Galerie du Jeu de Paume, 1911: Exposition des Grands et Petits Maîtres Hollandais du XVIIe siècle, cat. no. 34; Utrecht, Centraal Museum, 1956: Lustrumtentoonstelling uit hed kunstbezit van Reünisten van het Utrechtsch Studenten Corps, cat. no. 6; CMA, January 1978: Year in Review, cat. no. 37, illus.

LITERATURE: E. W. Moes, *Iconographia Batava*, pt. 2 (Amsterdam, 1905), p. 362, no. 7069/6; C. Hofstede de Groot, in Thieme-Becker, XII (1916), 98; W. R. Valentiner and J. W. von Moltke, *Dutch and Flemish Old Masters in the Collection of Dr. C. J. K. van Aalst* (Verona, 1939), p. 138, fig. XXXII; von Moltke, *Govaert Flinck* (Amsterdam, 1965), p. 137, no. 344.

JAN VAN GOYEN
1596–1656

Van Goyen was born in Leyden, where from 1606 to about 1608 he studied with minor masters. In Hoorn, ca. 1608–10, he studied with Willem Gerritsz. He was in France ca. 1615, returning to Leyden after 1616. He then was in Haarlem studying with Esaias van de Velde, who was the only teacher to have a decisive influence on him. He became a master in the Leyden guild in 1618. In 1631 he moved to The Hague, where he obtained the rights of citizenship in 1634 (records show that he was in Haarlem for part of that same year). He became head of the painters' guild in The Hague in 1640. He died in The Hague in 1656.

The works of both van Goyen and Salomon van Ruysdael (see Painting 119) are characterized by a tonal style which had a far-reaching impact on Dutch landscape painting. In van Goyen's mature works his color range was limited—almost monochromatic—with paint applied in thin, transparent washes. The Cleveland painting, which is dated 1645, is a product of the artist's maturity, when his tonal style had reached a climax and after which his paintings began to take on stronger contrasts and more pronounced color (Wolfgang Stechow, *Dutch Landscape Painting of the Seventeenth Century*, London, 1966, pp. 40–41, 54–56).

102 *A View of Emmerich* 59.351
across the Rhine

Panel (oak), 66 x 95.3 cm. Signed on edge of the ferryboat: VGOYEN 1645.

Collections: Robert, Earl Grosvenor (1820), later Marquess of Westminster, London; Duke of Westminster, London; (sale: Sotheby's, London, June 24, 1959, no. 7); [Leonard F. Koetser, London, 1959 Autumn Exhibition, no. 4].

Purchase, John L. Severance Fund, 1959.

The picture was cleaned and restored in 1955 by Horace Buttery in London. It had split horizontally along the glued join of the original two pieces of the panel. The panel was rejoined; a cradle was attached either at that time or earlier by a previous restorer. A coat of dirty varnish was removed by Buttery, who noted losses along the join and in the sky. In the period between the 1955 restoration and before the Museum purchased the painting, the horizontal join was repaired again by Thomas Wickens in London, and a few damages in the sky were attenuated. At present, examination of the painting under ultraviolet illumination reveals extensive retouching in the sky; the extent of actual damage is unknown.

The tower in the center of this view of Emmerich belongs to the late thirteenth-century church of St. Aldegundis. (Once considered the highest tower on the Lower Rhine, it was gutted in 1651, collapsed in 1660, was restored in 1661 and again in 1854 in a nineteenth-century interpretation of its original form.) The church on the left is St. Martin's.

The only other extensive view of this Nether-Rhenish German town attributed to van Goyen, but listed as a probable copy by Beck (1973, II, 537), was formerly in the Friedrich Lachmann collection in Berlin (signed and dated 1648, Hofstede de Groot, no. 104; in the London trade in 1965, *Apollo*, LXXXII, November 1965, xxxix). In his catalogue Beck also includes a fantasy view of Emmerich, which is more a close-up view of the church on the left (1973, I, 69, and II, no. 730).

The composition of the *View of Emmerich* is similar to the composition in van Goyen's series of views of the town of Rhenen. One picture from approximately the same period as the Cleveland painting is the *View of Rhenen*, dated 1646, in the Corcoran Gallery (Figure 102a). WS

EXHIBITIONS: London, British Institution, 1841, cat. no. 211 (called Nimiguen); London, Burlington Fine Arts Club, 1871, cat. no. 20; London, Royal Academy, 1871, cat. no. 251; CMA (1973).

LITERATURE: John A. Young, *A Catalogue of the Pictures at Grosvenor House, London; With Etchings from the Whole Collection* (London, 1820), p. 37, no. 112; Waagen (1854), II, 167; *Catalogue of the Collection of the Duke of Westminster at Grosvenor House, London* (London, 1888), no. 15; *Catalogue of the Collection of Pictures at Grosvenor House* (London, 1913), Dining Room, no. 26; Graves (1914), IV, 1539–41; Max J. Friedländer, *Die niederländische Malerei des 17. Jahrhunderts* (Berlin, 1926), p. 172; Hofstede de Groot (1927), VIII, no. 105; Hans Volhard, "Die Grundtypen der Landschaftsbilder Jan van Goyens und ihre Entwicklung" (Ph.D. dissertation, Halle, 1927), pp. 138, 184; Henry S. Francis, "Jan van Goyen, *View of Emmerich from across the Rhine*," CMA *Bulletin*, XLVII (1960), 215–18, fig. 1; Rémy Saisselin, "Art Is Imitation of Nature," CMA *Bulletin*, LII (1965), 38, fig. 3; Anna Dobrzycka, *Jan van Goyen 1596–1656* (Poznan, 1966), p. 54, no. 149, pl. 96; Michael Kitson, *The Age of Baroque* (London, 1966), color illus. p. 110; *Selected Works* (1966), no. 168; Heinrich Dattenberg, *Niederrheinansichten holländischer Künstler des 17. Jahrhunderts* (Düsseldorf, 1967), no. 153, illus. p. 147; William D. Wixom, "Twelve Additions to the Medieval Treasury," CMA *Bulletin*, LIX (1972), 110, n. 8; Hans-Ulrich Beck, *Jan van Goyen 1596–1656*, Vol. II: *Katalog der Gemälde* (Amsterdam, 1973), no. 405; Wolfgang Stechow, "A River Landscape by Salomon van Ruysdael," CMA *Bulletin*, LX (1973), 223, fig. 4; CMA *Handbook* (1978), illus. p. 156.

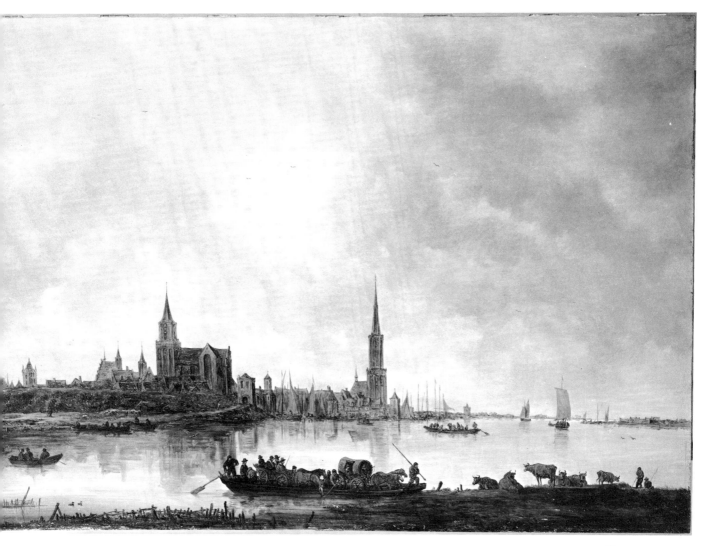

Figure 102.

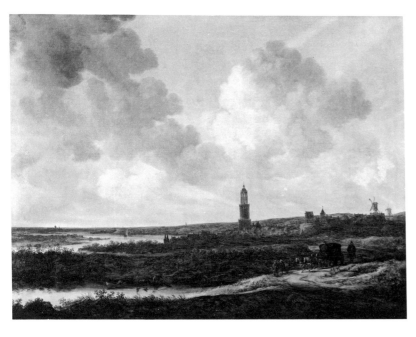

Figure 102a. *View of Rhenen*. On canvas,
101.5 x 136 cm, dated 1646. Van Goyen.
The Corcoran Gallery of Art, Washington,
W. A. Clark Collection.

237

FRANS HALS
Ca. 1581 to 1585–1666

In the absence of documentary evidence, but from what is known of his family's background, it seems reasonable to assume that Frans Hals was born in Antwerp between 1581 and 1585. By 1591 he was living in Haarlem, where from 1600 to 1603 he was a pupil of Carel van Mander. He became a member of the Haarlem guild in 1610 and was made an officer in 1644. He received many commissions for portraits, including large group portraits, the first of which was the *Banquet of the Officers of the St. George Militia Company*, of 1616, his earliest dated work (Seymour Slive, *Frans Hals*, II, London, New York, 1970, pl. 19). Hals introduced a new approach to the composition of group portraits, arranging his sitters informally, each member caught as it were in a gesture or fleeting expression, instead of in the traditional format with sitters in stiff, formal poses (*ibid.*, pp. 43–49). The majority of Hals's extant works are portraits—many of them husband-wife pendants—of well-to-do, middle-class citizens; the royal and aristocratic were not his clientele. His last important commission, a pair of group portraits of the regents and regentesses for the Haarlem Old Men's Alms House, came in 1664, at a time when he was destitute and his only source of income was a subsidy of two hundred guilders from the city of Haarlem. He died in Haarlem two years later, in 1666.

Many of Hals's paintings from the 1620s and early thirties —especially his genre works—are characterized by a bright tonality, slashing brushwork, and a somewhat gay mood. In his portraits, however, we find a more straightforward manner and greater attention to detail. The restraint and the economy of means which are typified by the Cleveland painting are in direct contrast to the style of the more popularly known *Laughing Cavalier* of 1624 (London, National Gallery) or the *Gypsy Girl* of 1628–30 (Paris, Louvre).

A single portrait, *Jean de la Chambre* (London, National Gallery, no. 6411), and three pairs of portraits (one in the São Paulo Museum; one in Stockholm, collection of the King of Sweden; and another in Frankfurt, Städelsches Kunstinstitut) bear the same date as the Cleveland painting. Each painting is a perceptive and sensitive portrayal of its sitter. Seen together (Slive, 1970, II, figs. 182–94), they show Hals's ability to produce remarkably individual impressions of different personalities.

In a closely related painting by Hals of ca. 1635–38 (Figure 103a), the costume is almost the same as the one in the Cleveland portrait, but the attitude and mood of the sitter differ completely. JKC

Figure 103a. *Portrait of a Woman*. On canvas. Hals. Collection of the Countess Mountbatten of Burma.

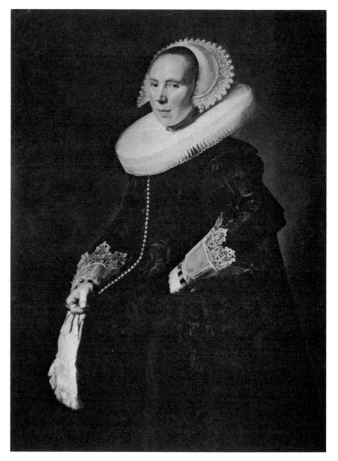

103 *Portrait of a Lady in a Ruff* 48.137

> Canvas, 69.7 x 54.1 cm. Inscribed at upper left: AETAT SUAE 41 ANNO 1638.
>
> Collections: Baron Anselm von Rothschild, Vienna, 1873; Baron Albert von Rothschild, Vienna, 1909; Baron Alphonse von Rothschild, Vienna (see note); [Rosenberg & Stiebel, New York].
>
> Note: During World War II, when it belonged to Baron Alphonse von Rothschild, this painting, along with many others, was confiscated by the Germans, stored in an Austrian salt mine, ultimately destined for the Gemäldegalerie, Vienna. After the war it was returned to Baron von Rothschild (see Francis, 1948, pp. 163–64).
>
> Purchase from the J. H. Wade Fund, 1948.

An X radiograph indicates that the painting had been cut down on all sides; the amount of reduction is not known. Slight fabric cusping, which is most pronounced along the bottom edge, may be seen in the X radiograph. The medium-weight fabric is glue-lined. There is general overall abrasion of the paint layer, especially in the background, and scattered retouching had been done by a previous restorer. The entire background may have been overpainted, but this is unconfirmed by the recent, limited, technical examination. The background is glazed up to the edges of the figure, but a thick varnish coating makes it difficult to determine if the glaze was applied to cover abrasion, is part of the original construction, or is a later alteration.

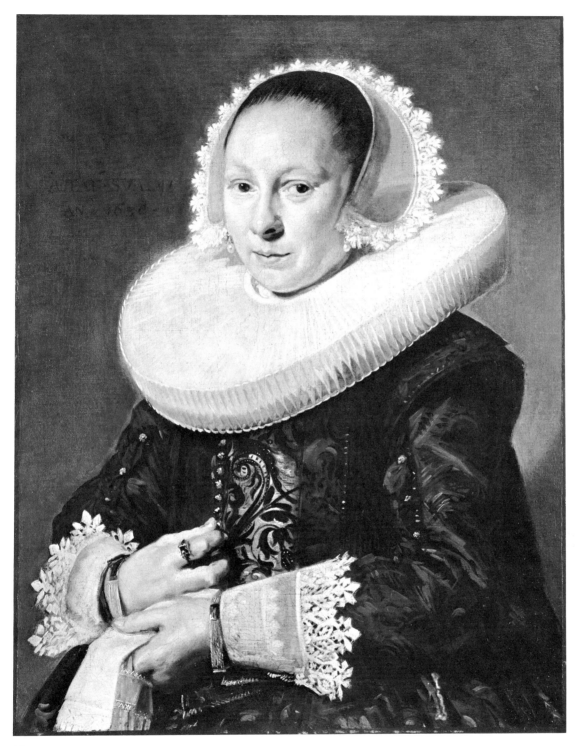

Figure 103.

EXHIBITIONS: Vienna, Oesterreichisches Museum für Kunst und Industrie, 1873: Ausstellung alter Gemälde aus Wiener Privatbesitz, cat. no. 124; CMA (1963), cat. no. 21; CMA (1973).

LITERATURE: E. W. Moes, *Frans Hals, sa vie et son oeuvre* (Brussels, 1909), p. 108, no. 190; Hofstede de Groot (1910), III, no. 398; Henry S. Francis, "*Portrait of a Lady in a Ruff* by Frans Hals," CMA *Bulletin*, XXXV (1948), 163–70, color illus. opp. p. 164; Milliken (1958), color illus. p. 43; *Selected Works* (1966), no. 165, illus.; Seymour Slive, *Frans Hals*, 3 vols. (London and New York, 1970–74), II, pls. 191, 193, and III, no. 121; Claus Grimm, *Frans Hals* (Berlin, 1972), p. 98, no. 91; Grimm and E. C. Montagni, *L'Opera completa di Frans Hals*, Classici dell'Arte, vol. 76 (Milan, 1974), pp. 100–101, no. 129, fig. 129; CMA *Handbook* (1978), illus. p. 157.

MEINDERT HOBBEMA
1638–1709

Meindert Hobbema was born in Amsterdam, where he lived all his life, and where he died in 1709 at the age of seventy-one. He was a painter of landscapes. His earliest extant work, *River Scene*, in The Detroit Institute of Arts, is dated 1658. Hobbema was the pupil of Jacob van Ruisdael sometime before 1660 (for an account of his early career, see Wolfgang Stechow, "The Early Years of Hobbema," *Art Quarterly*, XXII, 1959, 14), but only in the works after 1662 is the influence of Ruisdael's woodland scenes evident. Hobbema's mature works, dating from 1663 to 1668, show an individual quality, with a lightness of touch, feathery trees, and a lighter tonality. After 1668, when Hobbema was appointed to a city position as sealer of weights and measures (of wine shipments), his output diminished. Nevertheless, during this time he produced his best-known work, *The Avenue, Middelharnis* (London, National Gallery, no. 830), which is dated 1689. No paintings after 1689 can be attributed to him with any degree of certainty.

104 *A Wooded Landscape with Figures* 42.641

Canvas, 84.1 x 111.8 cm. Signed at lower right center: M. Hobbema.

Collections: Mrs. W. Atherton, 1823; Judge Sir James Alan Park (1763–1838), who was married to a daughter of Richard Atherton of Preston; Colonel H. M. Clark, London, 1919; [Colnaghi & Co., London, 1920]; [M. Knoedler & Co., New York]; John L. Severance, Cleveland.

John L. Severance Collection, 1942.

The painting was cleaned and retouched by William Suhr in 1942, and the paint film was found to be in good condition. There were a few small, darkened retouchings in the sky, which was covered by thick varnish; the varnish was removed, revealing only a few thin areas in an otherwise well-preserved sky. The right edge of the painting is irregular, indicating that it had been cropped on that side. A few fills were found to the right of the windmill and just below the man and boy walking on the road. At the bottom edge, about thirteen centimeters from the left, an old filling obscures the original color.

Unlike most landscape painters in Hobbema's time who employed other artists to paint the figures in their landscapes, Hobbema painted his own in the Cleveland work. The picture was probably painted in 1662, but certainly after 1660, when Hobbema began signing his works with his first initial separated from the last name (Wolfgang Stechow, "The Early Years of Hobbema," *Art Quarterly*, XXII, 1959, 18). The heavy trees with their compact contours, and the rather closed composition are reminiscent of several works dated 1662, particularly a painting in the Philadelphia Museum (Broulhiet, 1938, no. 197, wrongly dated 1665). The Cleveland and Philadelphia works probably can be placed at the end of a Ruisdael-like series with watermills (Hofstede de Groot, *Catalogue Raisonné*, IV, 1912, nos. 88, 108; Broulhiet, 1938, pp. 33–34), dated 1662, and before some paintings that anticipated the freer trend of 1663 (Stechow, *op. cit.*, p. 10).

A copy was formerly in the collection of Dr. Richter, London (Broulhiet, 1938, no. 413; sale: New York, Anderson Gallery, January 22, 1931, no. 55). WS

EXHIBITIONS: Liverpool, Royal Institute, 1823: cat. no. 49; CMA (1936), cat. no. 223; CMA (1942), cat. no. 7; Montreal Art Association, 1944: Five Centuries of Dutch Art, cat. no. 87; Akron (Ohio) Art Institute, 1951/52: Painting of the Month; CMA (1973).

LITERATURE: Georges Broulhiet, *Meindert Hobbema* (Paris, 1938), p. 433, no. 419, illus. p. 311 (wrong data on size and signature); Francis (1942), p. 136; Coe (1955), II, 232, no. 7, pl. XLVII; Milliken (1958), illus. p. 42; CMA *Handbook* (1978), illus. p. 163.

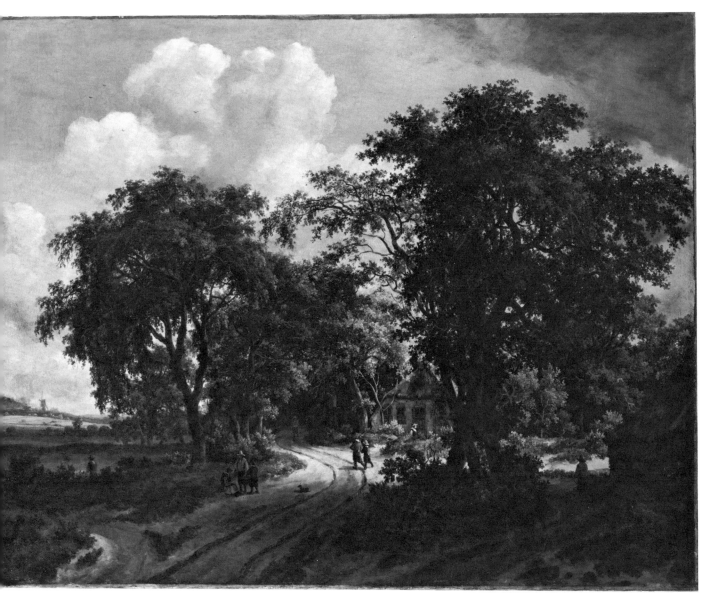

Figure 104.

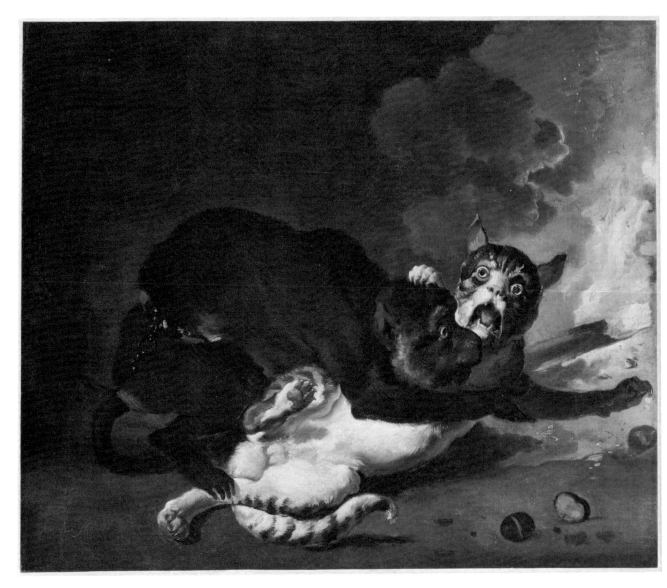

Figure 105.

ABRAHAM HONDIUS
1625 to 1630–ca. 1695

Hondius was born in Rotterdam; his father, according to Alfred von Wurzbach (*Niederländisches Künstler-Lexikon*, Vienna and Leipzig, 1906, I, 705) was a stonemason. Nothing is known of his artistic training, and little is known of his career. He is recorded as having worked in both Rotterdam and Amsterdam. He is best known for his animal and hunt subjects; he also produced some lesser-known religious and mythological paintings and a few topographical landscapes late in his career. In 1666 he moved to London, where he died in 1695 (Horace Walpole, *Anecdotes of Painting*, London, 1782, III, 24).

105 *The Monkey and the Cat* 79.82

 Canvas, 62.2 x 73.7 cm. Signed at lower left: Abraham Hondius.
 Collections: [Judson Art Galleries, Kenilworth, Illinois]; The Butkin Foundation, Cleveland, 1974.
 Gift of The Butkin Foundation, 1979.

The painting is in good condition and has no obvious conservation problems.

There are very general similarities in style between Hondius's animal paintings and those of his contemporaries, such as Jan Fyt (1611–1661) and Melchior d'Hondecoeter (1636–1695). Hondius's works, however, are noted for some special qualities, all of which are well represented in the Cleveland painting: animated drawing, close-up framing of the composition, crisp silhouettes, and lively, glowing color. Alfred Hentzen ("Abraham Hondius," *Jahrbuch der Hamburger Kunsthalle*, VIII, 1963, 39–40) particularly associates these qualities with Hondius's works of the 1670s.

The subject of the painting is a fable that was sometimes included in collections of Aesop's fables, especially those recensions based on the Latin work of Phaedrus. In this fable the monkey cajoles the cat into retrieving the chestnuts that are roasting on the hearth; while the cat is thus engaged, the monkey consumes the chestnuts, leaving the cat with nothing. The moral warns against becoming the unwitting dupe of flattery.

Hondius may have taken the inspiration for his painting from any of a large number of fable-books that were widely published in the latter half of the seventeenth century. Such books were especially popular in both Amsterdam and London, where Hondius worked. It is quite possible that Hondius was inspired by the most famous version of the tale, that of La Fontaine (*Fables*, bk. IX, fable XVII), first published in Paris in 1671 and soon thereafter in many editions all over Europe. Since many editions of Aesop and La Fontaine were illustrated, Hondius may even have found a direct visual source for his painting in an engraved edition.

Although Hondius is not known to have illustrated any comparable literary subject, a painting by him with subject matter somewhat similar to that of the Cleveland painting appeared in the sale of the collection of Lady North, in London, at Sotheby's, July 11, 1945 (no. 151). Described as "Abraham Hondius, *Still Life with a Cat Attacking a Monkey*, signed and dated 1690, 29 in. by 24 in.," this painting can no longer be traced. Though it may have resembled the Cleveland painting, at least in composition, the two might not be identical, because Hentzen (*op. cit.*, p. 54, no. 73) described it as "Monkey and Cat Fighting over Dead Fowl."

 ATL

EXHIBITIONS: None.

LITERATURE: None.

GERRIT VAN HONTHORST
1590–1656

Honthorst was trained under the Utrecht Mannerist Abraham Bloemaert. Following the example of two other Utrecht masters, Hendrick Terbrugghen and Dirck van Baburen, Honthorst too went to Rome, where he stayed from 1610 to 1620. He became one of the leading Northern followers of Caravaggio. In Rome he was patronized by the Giustiniani and Borghese families and in Florence by the Grand Dukes of Tuscany. His frequent use of candlelight and torches in dark interiors earned him the Italian nickname "Gherardo della Notte." Honthorst returned to Utrecht in 1620 and remained there until 1627, after which, in 1628, he worked briefly in London for Charles I. He succeeded Miereveld as court painter at The Hague in 1637. In 1652 he returned to his native Utrecht.

Canvas, 129 x 94 cm.

Collections: (Possibly) Marchése Tommaso Raggi, Genoa and Rome (1595/6–1676), and descendants; anonymous collection, Rome; [Hazlitt Gallery, London].

Mr. and Mrs. William H. Marlatt Fund, 1968.

The painting was glue-lined previously. It is in good condition. The original tacking margins have been cropped, but fabric cusping indicates that the painting is close to its original dimensions. The paint layer is cracked and edges of cupped paint are abraded.

In a letter of December 20, 1977, Thomas Kren pointed out that an exhibition held at San Salvatore in Lauro in 1701 included, according to an unpublished list of paintings in the exhibition, a "Dalida" by "Monsù Gerardo," on loan from a member of the family of the Marchése Tommaso Raggi (G. Ghezzi, "Quadri delle Case dei Principi in Roma," manuscript in Museo di Roma, Rome; see also Kren, *Jan Miel, 1599–1664, a Flemish Painter in Rome*, 3 vols., New Haven, 1978). Since the Cleveland *Samson and Delilah* belongs stylistically among Honthorst's Roman works, and because it is known to have been in Italy until as late as 1967, it could well have been the painting exhibited at San Salvatore in 1701 as "Dalida" by "Monsù Gerardo." It is quite possible that a member of the family of the Marchése Tommaso Raggi, who died in Rome in 1679, inherited the painting and made it available for the exhibition in 1701. Raggi was an ardent collector; a native of Genoa, he moved his collection to Rome in 1629 when Urban VIII appointed him head of the papal galleries.

Though it belongs among Honthorst's Roman works, the Cleveland painting is a synthesis of Dutch and Italian influences. The Samson and Delilah of the Cleveland painting are reminiscent of their counterparts in Lucas van Leyden's engraving (Bartsch 25) after Andrea Mantegna's monochrome painting, *Samson and Delilah* (National Gallery, London). And Honthorst's old woman, who holds her index finger to her lips, recalls Jan Müller's engraving (Lurie, 1969, fig. 11) of the Greek god Harpocrates, whose primary function was to admonish for silence at religious rites (Cesare Ripa, *Iconologia*, V, Perugia, 1767, pp. 163–64). She also bears a stylistic relationship to Carlo Saraceni's old woman in *The Miracle of St. Benon*, which he painted in 1618 for the Church of S. Maria dell'Anima in Rome. The relationship is not surprising, for in that same year, 1618, both Saraceni and Honthorst were engaged in commissions for the Church of S. Maria della Scala in Rome: Saraceni to paint a replacement for *Death of the Virgin* by Caravaggio, and Honthorst to do the *Beheading of St. John*.

There is a close stylistic correspondence between Honthorst's *Beheading* of 1618 and his *Samson and Delilah* in Cleveland. The three protagonists in each have their counterparts in the other—all brought into focus by light from a candle or torch. Delilah and Salome wear similar claret-colored dresses and headgear topped by delicate aigrettes. Because they both anticipate the young hostess in the Uffizi *Banquet*, painted in Florence ca. 1620, it is reasonable to date the Cleveland painting just prior to that, in Honthorst's late Roman period, between 1618 and 1620.

Other versions include: a *Samson and Delilah* that appeared in the H. Ten Kate sale on June 10, 1801, in Amsterdam, sold to Mensart (cat. no. 86, measuring 41 x 50 duims, or 105.4 x 128.6 cm, using the equivalent 2.57 cm per duim which was customary before 1823 in Amsterdam); another version, in the E. Seward sale of March 22, 1926, in London (Christie's, cat. no. 105, measuring 114.2 x 102.9 cm, as by G. Honthorst), sold to an Amsterdam dealer named Wolff; and a close replica of the Cleveland painting sold April 11, 1967, at Messrs. Brandt in Amsterdam (cat. no. 25, measuring 116 x 104 cm, as by Honthorst).

It will be noted that the measurements of the version sold to Wolff at Christie's in 1926 are very close to those of the version sold in 1967 at Brandt's. Because of this, and because in each case the painting had been in the hands of an Amsterdam dealer, van de Watering (letter of August 15, 1969) suggested that these two versions may in reality be one and the same.

G. Parthey (*Deutscher Bildersaal*, Berlin, 1863, I, 619, no. 1) listed a *Samson and Delilah* from Schloss Schwedt among Honthorst's questionable works.

Another *Samson and Delilah*, which has been attributed to Honthorst, is in the Dordrecht Town Hall (Godefridus Joannes Hoogewerff, *Honthorst*, The Hague, 1924, p. 12). According to J. Richard Judson (*Gerrit van Honthorst: A Discussion of His Position in Dutch Art*, The Hague, 1959, p. 147, no. 8), this picture was painted by Christiaen van Couwenbergh. **ATL**

EXHIBITIONS: (Possibly) San Salvatore in Lauro, in 1701 (on loan from the family of the Marchése Tommaso Raggi, as "Dalida" by "Monsù Gerardo"); CMA, January 1969: Year in Review, cat. no. 66; CMA, 1971/72: Caravaggio and His Followers, cat. no. 35, illus. (catalogue by Richard E. Spear); CMA (1973).

LITERATURE: Ann Tzeutschler Lurie, "Gerard van Honthorst: *Samson and Delilah*," CMA Bulletin, LVI (1969), 332–44, figs. 8, 16, and color illus. opp. p. 334; Benedict Nicolson, "Caravaggesques at Cleveland," Current and Forthcoming Exhibitions, *Burlington Magazine*, CXIV, pt. 1 (1972), 114; Madlyn Kahr, "Rembrandt and Delilah," *Art Bulletin*, LV (1973), 241, n. 8, and 243, fig. 4; CMA *Handbook* (1978), illus. p. 153; Nicolson, *The International Caravaggesque Movement; Lists of Pictures by Caravaggio and His Followers throughout Europe from 1590 to 1650* (Oxford, 1979), p. 58, pl. 155 (detail).

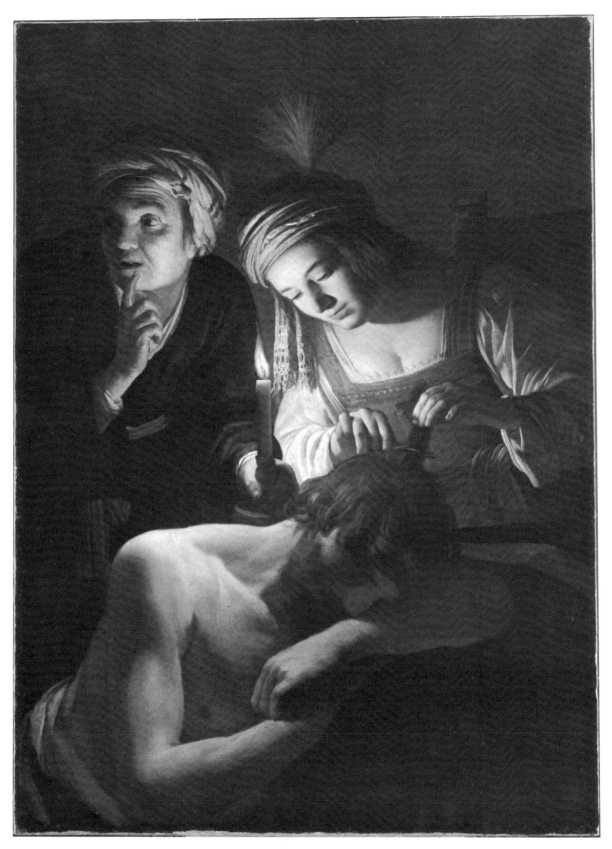

Figure 106.

Figure 107.

PIETER DE HOOCH
1629–1684

Pieter de Hooch was born in Rotterdam. He studied in Haarlem with Nicolaes Berchem. In the beginning he painted genre scenes of military life. From 1654 until ca. 1662 he was active in Delft, where in 1655 he was registered as a member of the painters' guild (Jacques Foucart, "Un troisième Pieter de Hooch au Louvre," *La Revue du Louvre*, XXVI, 1976, 34, n. 4). He was influenced by Vermeer, and like Vermeer, painted scenes of middle-class life —though de Hooch placed more emphasis on the architectural setting. From Delft he moved to Amsterdam, and for a time the influence of Vermeer continued. In the late sixties his work suffered a decline; elaborate scenes in palatial settings were then in demand in Amsterdam, and this apparently did not suit his more modest approach. He died in an insane asylum in Amsterdam and was buried in the Sint Anthonis Kerkhof on March 24, 1684 (this information was discovered by S. A. C. Dudok van Heel, archivist in Amsterdam; it was first published by Christopher Brown in *Art in Seventeenth-Century Holland*, exh. cat., London, 1976).

107 *The Music Party* 51.355
 (Family Portrait)

Canvas, 100.3 x 119.4 cm. Signed and dated in left-hand corner in the space below seat of the chair: P D HOOCH [16]63. (See Figure 107a.)

Collections: James A. Stuart-Wortley-Mackenzie, First Baron Wharncliffe (1776–1845), 1833; John Smith, London; William Theobald, London, 1842 (sale: Christie's, London, May 10, 1851, no. 76); private collection, Yorkshire; E. E. Cook, Bath; [Scott & Fowles, New York].

Gift of Hanna Fund, 1951.

In 1962 Joseph Alvarez cleaned the painting, removing old, dirty varnish. The paint surface is in good condition. Only a few small areas required retouching: parts of the tiles in the foreground near the dog; on the hand and clothing of the violinist; on the left hand of the lady; on the left side of the lady's dress, below the waist; and a few scattered spots in the background.

The painting above the mantelpiece probably represents the Sacrifice of Isaac (William H. Gerdts, Jr., letter of November 22, 1955) rather than the Descent from the Cross (Burchfield, 1952). The tapestry may contain an as-yet-undiscovered clue concerning the identity of the family represented in the picture. The large wardrobe is the light color of unstained oak furniture, which was popular in the mid-seventeenth century. On top of the wardrobe are two vases of the K'ang-hsi type and two lacquer boxes. The box toward the front may be Chinese, the other Japanese, perhaps imported from the island of Deshima, which was ceded to the Netherlands in 1641 (Staring, 1956); it is also possible

that both pieces are at least partly Amsterdam work (lacquer work of a similar kind was done in Amsterdam from ca. 1600 on). The chandelier is a type frequently found in Dutch pictures of the period. The musical instruments are: a viola da gamba, an alto recorder, a small cittern, and a violin.

A. B. de Vries, in a letter of April 26, 1952, dated the painting ca. 1663–65, which proved to be correct, for when Peter C. Sutton visited this Museum on July 9, 1976, he discovered a signature and the date [16]63 on the painting. At that time, de Hooch had begun to paint less like Vermeer, who preferred one or two figures in an intimate interior, and had turned to more elaborately dressed groups in sumptuous surroundings. Shortly afterward, his style and treatment deteriorated; note, for example, the indifferent composition and treatment of the *Music Party* of ca. 1666–68, in the Leipzig Museum (W. R. Valentiner, *Pieter de Hooch*, Stuttgart and New York, 1930, pl. 176).

In his monograph, Peter Sutton compares stylistically the Museum painting with two other family portraits by de Hooch—the well-known and earlier *Family in a Delft Courtyard* (Academie, Vienna), and the later portrait of the *Jacott-Hoppesack Family* of ca. 1670 (private collection, Bath, England). He suggests that the family portrayed in the Cleveland painting may be the family of Adam Oortmans (owner of the Zwaan Brewery in Amsterdam), because the ages of the children represented correspond closely to those of four of the six Oortmans children in 1663: Nicolaes, age twelve; Maria, eleven; Anna Clara, five; and Adam, one year or less. W S

Figure 107a. Detail showing signature.

EXHIBITIONS: London, British Institution, 1829: cat. no. 165; Newark (New Jersey) Museum, 1955: Old Masters; Omaha (Nebraska), Joslyn Art Museum, 1957: Twenty-Fifth Anniversary Exhibition; CMA (1958), cat. no. 58; Kansas City (Missouri), Nelson Gallery-Atkins Museum, 1968: Seventeenth-Century Dutch Interiors, cat. no. 5, illus. p. 13; CMA (1973).

LITERATURE: Smith (1833), IV, 239, no. 63; Smith (1842), IX, *Supplement*, 571, no. 27; Hofstede de Groot (1907), I, 518, no. 157; Arthur de Rudder, *Pieter de Hooch et son oeuvre* (Brussels, 1914), p. 101; Louise H. Burchfield, "*The Music Party* by de Hooch," CMA *Bulletin*, XXXIX (1952), 121–23, illus. p. 118; A. Staring, *De Hollanders thuis, Gezelschapstukken uit drie eeuwen* (The Hague, 1956), p. 86, pl. X; Mario Praz, *Conversation Pieces: A Survey of the Informal Group Portrait in Europe and America* (University Park, Pa., and London, 1971), pp. 184, 190, pl. 151; Peter Eikemeier, "Das Familienbildnis des Emanuel de Witte in der Alten Pinakothek," *Pantheon*, XXXII (September 1974), 260, n. 6; CMA *Handbook* (1978), illus. p. 162; Peter C. Sutton, "Pieter de Hooch" (Ph.D. dissertation, Yale University, 1978; Ann Arbor, Michigan: University Microfilms, 1978), I: 51–54, 57, 196 n. 121, 197 n. 122, and II: 71–74, cat. no. 54, and III: 20, fig. 54; Peter Thornton, *Seventeenth-Century Interior Decoration in England, France, and Holland* (New Haven and London, 1978), pp. 42, 405 n. 48, fig. 48; Sutton, *Pieter de Hooch* (Oxford, 1980), pp. 28–30, 92, cat. no. 53, color pl. XII and fig. 57.

JORDANUS HOORN

1753–1833

Jordanus Hoorn was born at Amersfoort in 1753. He was an apprentice of Gerrit Torenburg, who worked in the manner of Jan van der Heyden (1637–1712). Hoorn studied in the drawing school in Haarlem. He settled in Haarlem in 1772 and stayed until 1795. His style was close to that of Isaak Ouwater (1750–1793) in the rendering of detail and in the precise, even lighting of his scenes. In 1795 he was appointed official drawing master of Amersfoort, a position he held until his death in 1833. He was a prolific artist whose oeuvre includes portraits and family groups as well as many paintings and drawings of scenes and views.

108 *View of the Village of Eemnes* 462.15

Canvas, 31.6 x 41.9 cm. Signed on wooden fence at lower right: J: Hoorn fi/1778.

Collections: Hinman B. Hurlbut (1819–1884), Cleveland.

Hinman B. Hurlbut Collection, 1915.

The painting had been lined before it entered the Museum collection. Joseph Alvarez cleaned it in 1958. All the blue in the sky had been repainted and is somewhat discolored. Otherwise, the painting appears to be in good condition.

Hinman B. Hurlbut may have purchased this painting on one of his travels through Italy, France, and Holland, which he undertook with some frequency after 1875.

Dutch eighteenth-century painting has long been overshadowed by the splendors of the Golden Age of the seventeenth century. Gradually, more information has been gathered on many of the later and often very competent masters of the eighteenth century. The Museum's painting is a delightful example from that time and place. Typically, it shows the Dutchman's uncompromising love for his own land. In Italy topographical views were painted largely for tourists, but in Holland they were painted for the domestic collector, the wealthy burgher class. The scenes were rendered with devoted attention to details, as in the Museum picture, which presents with clarity of description the architecture and trees that line a small village street, enlivened here and there with figures of townspeople engaged in their daily routine.

The view is of the village of Eemnes-Binnes, which with Eemnes-Buiten (the two villages are separated by a dike that controls the water of the river Eem) make up the municipality of Eemnes, northwest of Amersfoort, near Ijselmeer, once known as Zuiderzee (according to F. H. C. Weijtens, Keeper of Topographical Collection of Utrecht, in a letter dated November 26, 1973; and W. L. van de Watering from the Rijksbureau voor Kunsthistorische Documentatie, in a letter dated June 9, 1976). The church is identifiable, according to W. L. van de Watering, because of its unusually short spire. The rest of the buildings cannot be identified because of a scarcity of eighteenth-century illustrations and descriptions of this particular area. Although Jordanus Hoorn had his residence in Haarlem when he painted this view, he apparently made several trips back to Amersfoort, the town of his birth, just south of Eemnes. From 1775 on he produced many drawings of the environs of Amersfoort. NCW

EXHIBITIONS: CMA, 1917: The Hinman B. Hurlbut Collection, cat. no. 37; CMA (1973).

LITERATURE: None.

Figure 108.

WILLEM KALF
1619–1693

Willem Kalf was born in Rotterdam in 1619. According to Houbraken, he was the pupil of Hendrick Gerritsz. Pot in Haarlem. From ca. 1640 to 1646 Kalf was in France, where he painted the genre pictures of kitchen interiors that were so greatly admired and imitated by French eighteenth-century painters. After 1646 he was active in Rotterdam and Hoorn; after 1653 he settled in Amsterdam, where he died in 1693.

There is a mysterious quality in Kalf's chiaroscuro, which is reminiscent of Rembrandt. Kalf was a dealer in antiques as well as a painter and probably used his stock as subject matter; the same objects were used in more than one of his still lifes.

109 *Still Life* 62.292

Canvas, 60.3 x 50.2 cm. Signed at lower left: W. Kalf 1663.
Collections: G. Vegting, Amsterdam; [Frederick Mont, New York].
Purchase, Leonard C. Hanna Jr. Bequest, 1962.

Before the painting entered the collection, it was examined by William Suhr, who found it to be in an excellent state of preservation.

The composition is very similar to that of another picture from the same year, 1663, and of approximately the same size, now in Schwerin (no. 81; *Holländische Maler des XVII Jahrhunderts*, Staatliches Museum Schwerin, 1962, cat. no. 171, pl. 56). Practically the same objects appear in both paintings but with slight variations in arrangement and details throughout; the Schwerin painting has an additional half-peeled orange in the bowl—a late Ming-type—which is the same in both pictures and appears again, with the same silver tray, in another painting of 1663 in Schwerin (no. 71; *op. cit.*, cat. no. 170), in a similar picture in the Amherst College collection, in a picture of 1659 that was once in the Nemes collection (H. E. van Gelder, "W. C. Heda, A. van Beyeren, W. Kalf," *Palet-serie*, II, Amsterdam, 1941, 45), and elsewhere.

The center vessel in the Cleveland painting, particularly the foot and stem and supporting *putto*, recalls the style of Christiaen van Vianen (J. W. Fredericks, *Dutch Silver*, I, The Hague, 1952, 262, no. 169; see also p. 263, a view of the same bowl showing some similarities to the lower part of the foot of Kalf's vessel). W S

EXHIBITIONS: Oslo, National Gallery, 1959: Fra Rembrandt til Vermeer, cat. no. 36; CMA, December 1963: Year in Review, cat. no. 90; CMA (1973).

LITERATURE: *Selected Works* (1966), no. 167, illus.; "Dutch Art and Life in the Seventeenth Century," *Connoisseur*, CLXXXIV (1973), 136, no. 13, illus.; J. M. Nash, *The Age of Rembrandt and Vermeer, Dutch Painting in the Seventeenth Century* (London, 1973), p. 27, pl. 73; Lucius Grisebach, *Willem Kalf, 1619–1693* (Berlin, 1974), p. 272, no. 126, fig. 134; CMA *Handbook* (1978), illus. p. 160.

Figure 109.

JAN ANTHONISZ. VAN RAVESTEYN
Ca. 1570–1657

Ravesteyn was born in The Hague. He is known to have been in Delft in 1597, perhaps studying there with Michiel van Miereveld (1567–1641). In 1598 Ravesteyn became a member of the guild of St. Luke in The Hague, where he was also co-founder of the new painters' association, Pictura, in 1654. He specialized in group and single portraits. After a long life of about eighty-seven years, he died in The Hague in 1657.

Figure 110a. *Portrait of a Young Woman.* On panel, 64.2 x 51.8 cm. Paulus Moreelse, Dutch, 1571–1638. Staatliches Museum Schwerin, East Germany.

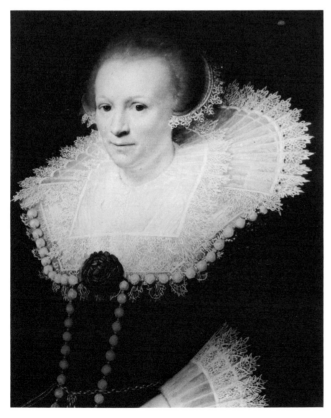

110 *Portrait of a Lady* 16.1055

Panel (oak), oval, 53.2 x 45 cm.

Collections: Dowdeswell, London; [Durand-Ruel, Paris and New York]; Mr. and Mrs. J. H. Wade, Cleveland, 1902.

Gift of Mr. and Mrs. J. H. Wade, 1916.

In 1973 Joseph Alvarez cleaned the painting. Narrow areas of paint were lifting in spots along the vertical grain of the wood. Tiny blisters were put down and losses were filled. Similar repairs were found under the old varnish in the middle of the sitter's forehead, on her right temple, in the hair, and in tiny spots scattered throughout the dress and background. Otherwise, the paint surface is in good condition.

In the early part of the seventeenth century Delft and The Hague were centers of portraiture, and the leading practitioners of the art were Ravesteyn and Michiel van Miereveld. Miereveld had a large following of foreign as well as local patrons, and he maintained a workshop with assistants who helped him turn out commissions for numerous families of wealth and nobility. Paulus Jansz. Moreelse (1571–1638), a student of Miereveld, was also active at this time. Attributions to these portraitists have been confused, because the artists utilized a common style of sober, straightforward presentations, with meticulous attention to detail, and they often left the painting of clothing and other accessories to assistants.

The Cleveland painting was attributed to Moreelse when it entered the collection; de Jonge (1938) affirmed that attribution. F. Lugt (orally) was the first to attribute the picture to Ravesteyn, an attribution that now seems a certainty. Parallels may be observed in the faces of other subjects by Ravesteyn: a portrait signed and dated 1629, in the Mniszech sale, Galerie Georges Petit, Paris (April 9, 1902, no. 166, illus.); *Portrait of a Lady*, signed and dated 1631, in London, Courtauld Institute; *Portrait of Anna van Lockhorst*, signed and dated 1634, in Paris, the Louvre (K. Langedijk, "Portretten van Nicolaas Pauw en Anna van Lockhorst door J. A. van Ravesteyn," *Oud Holland*, LXXVI, 1961, 110); *Portrait of a Lady*, signed and dated 1635, Metropolitan Museum of Art (no. 12.202). Another comparable work is an unsigned portrait in the Schwerin Museum (Figure 110a) that can be attributed to Ravesteyn, although the present owner and some scholars prefer a Moreelse attribution (de Jonge, p. 133; and *Holländische Maler des XVII Jahrhunderts*, Staatliches Museum Schwerin, 1962, no. 253). WS

EXHIBITIONS: CMA (1936), cat. no. 226; Indianapolis, John Herron Art Museum, 1937: Dutch Paintings, Etchings, Drawings, Delftware of the Seventeenth Century, cat. no. 46; Grand Rapids (Michigan) Art Gallery, 1940: Masterpieces of Dutch Art, cat. no. 55.

LITERATURE: "The Wade Collection," CMA *Bulletin*, IV (1917), 4, illus. p. 1; C. H. de Jonge, *Paulus Moreelse, Portret-en Genreschilder te Utrecht 1571–1638* (Assen, 1938), p. 30, no. 213, pl. 129 (accepted as by Moreelse, ca. 1625–30).

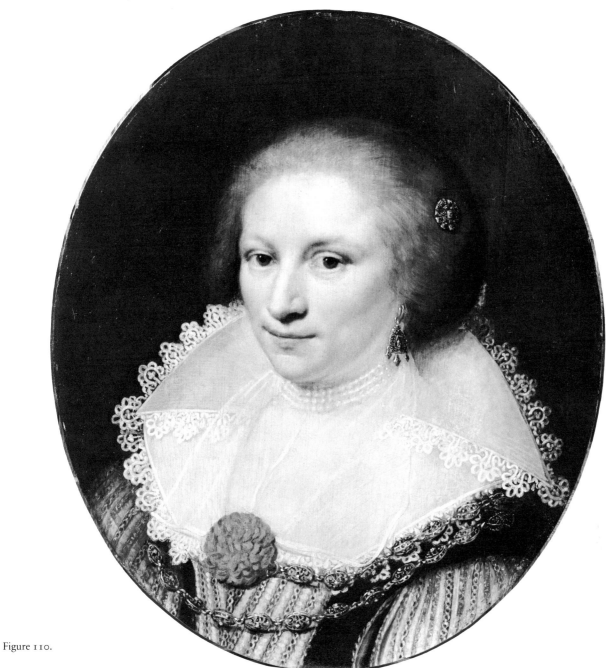

Figure 110.

REMBRANDT HARMENSZ. VAN RIJN
1606–1669

Rembrandt, the son of a miller, was born in Leyden in 1606. From the age of seven he studied in a Latin school. At age fourteen he enrolled at the University of Leyden, but after about a year his parents decided that he should be an artist. His first teacher is not known. He was apprenticed for three years to Jacob Isaacksz. Swanenburgh, though a much more important influence was Pieter Lastman, a history painter, with whom he studied in Amsterdam for a short time. In 1625 he returned to Leyden, where he set himself up as an independent master. He attracted numerous pupils and continued to be a much-sought-after teacher as well as an important influence on other artists who never entered his studio. His earliest-known, dated work is from the year 1625 (*The Stoning of St. Stephen*, Lyons, Musée des Beaux-Arts). He continued to paint biblical and mythological subjects throughout his career. He moved to Amsterdam in 1631, at which time he began to receive commissions for portraits. In 1632 he painted the *Anatomy Lesson of Dr. Tulp*, which gained considerable notice. After that, he received many commissions for both single and group portraits, although he did not devote himself exclusively to that métier. In 1634 he married Saskia van Uylenborch, of a well-to-do Amsterdam family. Saskia died in 1642, the year Rembrandt painted the *Night Watch*. Soon afterward his fortunes began to decline. His preference for chiaroscuro and subdued color did not correspond to the new taste for a less introspective mood and a brighter palette. He was not a good business manager; he had to declare his insolvency in 1656 and liquidate his property to pay his debts. After that he arranged to be "employed" by his son Titus in order to retain something from his creditors. Although the 1660s were for Rembrandt a time of adversity and misfortune, he still had important commissions (*Syndics of the Cloth Drapers Guild*, 1661; *Conspiracy of Julius Civilis*, 1661–62). Some of his most expressive and moving portraits date from this period. He died in Amsterdam in 1669.

111 *Portrait of a Youth* 42.644

Panel (oak), oval, 57.8 x 43.8 cm. Signed at right center: RHL [in ligature] van Rijn 1632.

Collections: M. de Gaignat (sale: Remy, Paris, February 14, 1769, no. 20, one of a pair, bought by Abbé Renoir); François Théodore Rochard (sale: LeRoy, Brussels, April 7, 1858, no. 33, illus., erroneously listed as dated 1652 and from the De Julienne collection); Rochard (sale: Febvre, Paris, December 13, 1866, no. 113); Alphonse Oudry (sale: Febvre, Paris, April 16, 1869, no. 54); Max Kann (sale: Féral, Paris, March 3, 1879, no. 3); Senator M. Mir, Paris; [M. Knoedler & Co., London]; John L. Severance, Cleveland, 1921.

John L. Severance Bequest, 1936.

The painting was cleaned by William Suhr in 1942. The paint film was found to be in excellent condition except for a few small areas. In the left background there were small, darkened retouchings over earlier spots of flaking. Heavy, discolored varnish and some overpaint on the right side were removed; spots of flaking were retouched in dry color; and tiny blisters in the face near the right ear were put down.

At one time this painting was wrongly considered to be a self-portrait (Bredius, 1936; see no. 17 for a documented self-portrait from the same year). The sitter has since been tentatively identified as Ferdinand Bol (Bauch, 1966).

The history of this painting has been confused by a series of mistaken assumptions on the parts of both Smith (1836) and Hofstede de Groot (1916) regarding our painting and the companion piece with which it was sold in 1769. A careful check of the records clarified the ex collections of the Cleveland portrait, but the companion piece has disappeared from available listings. It is certainly not the *Saskia* now in the National Gallery in Washington (Bredius, 1936, p. 96), as Hofstede de Groot assumed (1916, no. 615), for the *Saskia* is rectangular (54 x 45.5 cm) and our portrait is oval. Moreover, Saskia was not yet married to Rembrandt in 1632, the date specifically given in the Gaignat catalogue. Nor could the companion piece be the so-called *Sister of Rembrandt* in the Clifford collection in Minneapolis (Bredius, 1936, p. 88), as Valentiner first proposed, for the measurements are not the same. Bode (1906) assumed it was a portrait of the same girl, formerly in the Robinson collection (Bredius, 1936, p. 90), but this portrait is on canvas and is dated 1633. Later Valentiner (1931) suggested a portrait now in Stockholm (Bredius, 1936, p. 91), and one in Boston, Paine collection (*ibid.*, p. 89), neither of which is a convincing pendant, though the latter corresponds reasonably well in size, date, and attitude.

Both Smith (1836, no. 502) and Hofstede de Groot (1916, no. 588) correctly identified our portrait as the one in the Gaignat sale (Paris, December, 1768; the sale was rescheduled and actually took place February 14, 1769); both, however, incorrectly added that it was also in the C. A. de Calonne sale (Paris, April 21, 1788, no. 41) and the Choiseul-Praslin sale (February 18, 1793, no. 38), each

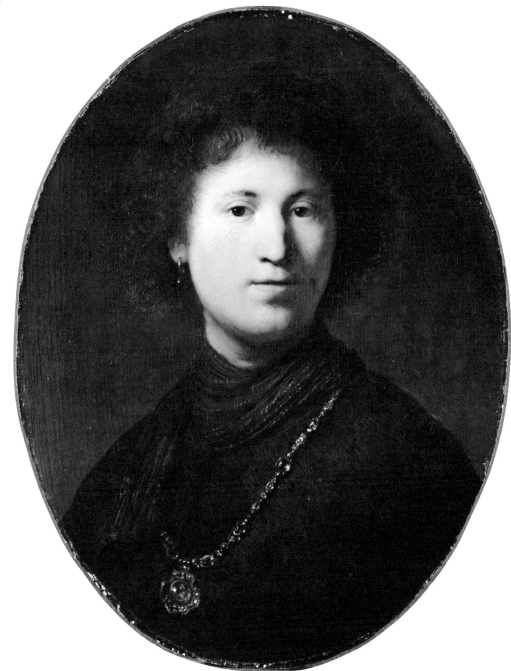

Figure 111.

time noting it was sold with a pendant which they identified as a portrait of Saskia (Smith, 1836, no. 502; Hofstede de Groot, 1916, no. 615). Judging from the descriptions in the sales catalogues, the apparently undated pairs in the C. A. de Calonne and Duc de Choiseul-Praslin sales differed greatly from the Gaignat pair and, evidently, even from each other. Smith listed the Cleveland portrait a second time as no. 233 (without a pendant); to add to the confusion, he also again listed the Choiseul-Praslin portrait of a male (without a pendant) as no. 221.

Both Smith (1836, no. 502) and Hofstede de Groot (1916, no. 615) identified the female pendant as the subject of a mezzotint called *The Artist's Wife*, by Richard Read (published 1776, no owner given; John Chaloner Smith, *British Mezzotint Portraits*, III, London, 1884, 1032). Though the print seems close to the description of the female in the Gaignat catalogue, it does not correspond to the one in the de Calonne catalogue. On the other hand, except for its oval stone frame, it does correspond exactly to the Washington *Saskia* (Bredius, 1936, p. 96) with which Bode (1906, no. 153) and Hofstede de Groot (1916, no. 615) identified it. John Chaloner Smith (*op. cit.*) stated that the Read mezzotint was from an original painting, but he did not identify the picture from which it was taken.

According to an old label on the back of the Cleveland portrait, it was once in the collection of Isaac Pereire, Paris, but this is erroneous and probably stems from confusion with another Rembrandt portrait, also dated 1632, that was in the Henri Pereire sale of 1872.

In the Rochard sale catalogue of 1858 the Cleveland picture was reproduced in an etching after a drawing by Rochard. Another etching was made by Léopold Lowenstam (1842–1898) when the painting was in the Kann collection (reproduced by Bode and Hofstede de Groot, 1906; and Rosenberg and Valentiner, 1908).

The golden chain around the neck of the sitter was fancifully identified as the "Chain of the Order of St. Michael" in the Gaignat sale catalogue. A similar chain appears in many early portraits by Rembrandt. WS

EXHIBITIONS: Amsterdam, Frederick Muller & Co., 1913/14: Rembrandt Exhibition; Detroit Institute of Arts, 1930: Loan Exhibition of Paintings by Rembrandt, cat. no. 11; CMA (1936), cat. no. 232; CMA (1942), cat. no. 13, pl. v; CMA (1973).

LITERATURE: Smith (1836), VII, no. 233; E. Dutuit, *Tableaux et dessins de Rembrandt: Supplément de L'Oeuvre Complet de Rembrandt* (Paris, 1885), pp. 20–21; Wilhelm von Bode and C. Hofstede de Groot, *The Complete Work of Rembrandt*, VIII, trans. Florence Simmonds (Paris, 1906), 156, no. VII; Adolf Rosenberg and W. R. Valentiner, *Rembrandt: Des Meisters Gemälde*, Klassiker der Kunst (Stuttgart and Berlin, 1908), p. 522; Rosenberg, *The Work of Rembrandt* (New York, 1913), p. 522; Gerard Knuttel, "De Lucretia en andere werken van Rembrandt bij de Firma Fred. Muller & Co. te Amsterdam," *Elsevier's geïllustreerd maandschrift*, XXIV (1914), 137, 142; Hofstede de Groot (1916), VI, nos. 557, 588; Valentiner, *Rembrandt, Wiedergefundene Gemälde*, Klassiker der Kunst (Stuttgart and Berlin, 1921), p. 23 (second ed. rev., Berlin, 1923, p.

26); Valentiner, *Rembrandt Paintings in America* (New York, 1931), no. 16; A. Bredius, *The Paintings of Rembrandt* (Vienna, 1936), p. 7, no. 156; Francis (1942), p. 135; Coe (1955), II, 234, no. 13, pl. XLVIII; Jaffé (1963), p. 467; Kurt Bauch, *Rembrandt, Gemälde* (Berlin, 1966), p. 9, no. 142; Fritz Erpel, *Die Selbstbildnisse Rembrandts* (Munich, 1967), no. 124, illus. p. 202; Horst Gerson, *Rembrandt Paintings*, ed. Gary Schwartz, trans. Heinz Norden (Amsterdam, 1968), pp. 256, 493, fig. 101; Giovanni Arpino, *L'Opera pittorica completa di Rembrandt*, Classici dell'Arte, vol. 33 (Milan, 1969), p. 67, no. 73; Bredius (revised by H. Gerson), *Rembrandt, The Complete Edition of the Paintings* (London, 1969), p. 135, no. 156; CMA *Handbook* (1978), illus. p. 158.

REMBRANDT HARMENSZ. VAN RIJN

112 *Portrait of a Lady* 44.90

Panel (oak), oval, 77.5 x 64.8 cm. Signed at right center: Rembrandt f. 1635.

Collections: Capo di Lista family (?), Padua; Barbini-Breganze, Venice, 1847, cat. no. 204; Städelsches Kunstinstitut, Frankfurt am Main (inv. no. 927), 1847 to 1882; (sale: Paris, May 5, 1882, no. 30); [Charles Sedelmeyer, Paris]; Karl von der Heydt, Berlin; [M. Knoedler & Co., New York]; Elisabeth Severance Prentiss, Cleveland, 1919.

The Elisabeth Severance Prentiss Collection, 1944.

Before it was given to the Museum, the painting was known to have been damaged and restored. In 1877 Angilbert Goebel in Frankfurt removed the overpaint and reported that he found no original pigment underneath the restored eyes; he also noted other paint losses in the face (files of the Städelsches Kunstinstitut; see also Bode, 1883). In 1973 the painting was cleaned and examined at the Intermuseum Laboratory at Oberlin College under the direction of Richard Buck. Most of the overpaint was removed. It was found that the distinction between the original pigment and later additions was quite clear in many areas. It was also determined that, even though damage was fairly extensive, the losses in the eyes had been overstated by Goebel. Scattered areas of abrasion in the face, hair, and background were restored as coherently as possible; earlier repaint in the lace, dress, and rosette was left intact.

According to a handwritten notation in the listing of the exhibited art objects of the Städelsches Kunstinstitut in Frankfurt in 1858, the portrait supposedly represents a Netherlandish lady who was married to a member of the Capo di Lista family in Padua, in whose collection the portrait formerly resided.

Bode (1897) and Hofstede de Groot (1916) have identified the Cleveland portrait with the picture in the F. Kalkbrenner sale in Orléans (not Paris) on January 14, 1850 (no. 22), but this is unacceptable since the Cleveland picture was in the Frankfurt Museum from 1847 to 1882. The Kalk-

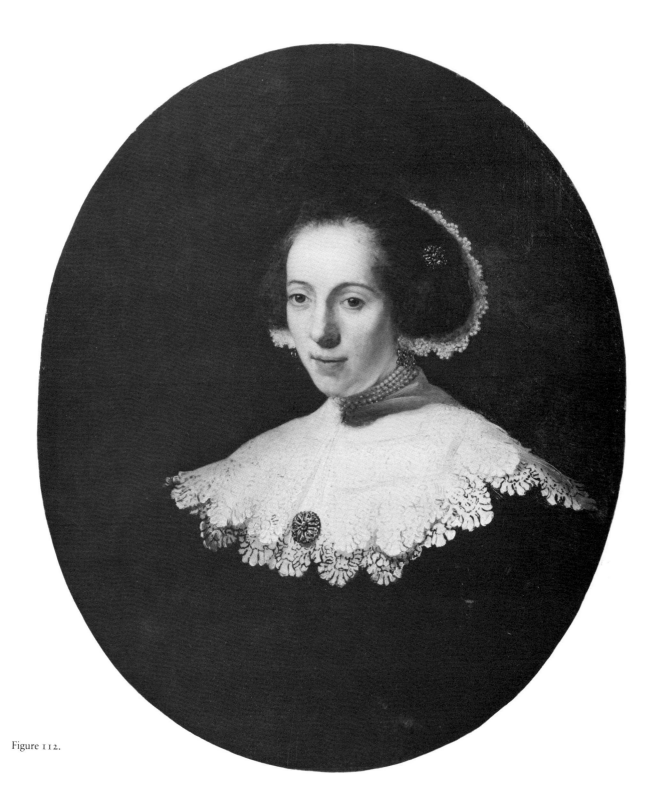

Figure 112.

brenner painting (oval, signed, and dated 1635) may be the one now in the André Meyer collection, New York (Hofstede de Groot, 1916, no. 661; Bredius, 1936, p. 349).

Valentiner (1931) suggested, and Bauch (1966) agreed, that the Cleveland picture is the companion piece of the portrait of a man now in the Earl C. Townsend, Jr., collection in Indianapolis (Hofstede de Groot, 1916, no. 730; Bredius, 1936, p. 201). Although the Townsend painting has exactly the same measurements (the size given in the exhibition catalogue *The Young Rembrandt and His Times*, Indianapolis and San Diego, 1958, no. 11, is not correct), it lacks convincing similarities with the Cleveland picture, particularly in the pose of the sitter and the placement of the signature. **WS**

EXHIBITIONS: Amsterdam, Stedelijk Museum, 1898; Rembrandt Schilderijen, cat. no. 33; Berlin, Kaiser-Friedrich Museum, 1906: Werke alter Kunst aus dem Privatbesitz der Mitglieder des Kaiser-Friedrich-Museum-Vereins, cat. no. 108; Berlin, Kaiser-Friedrich Museum, 1909: Bildnisse des XV. bis XVIII. Jahrhunderts aus dem Privatbesitz der Mitglieder des Kaiser-Friedrich-Museum-Vereins, cat. no. 106; CMA (1936), cat. no. 229, pl. XLIX; CMA, 1944: The Prentiss Bequest, cat. no. 12; Los Angeles County Museum, 1947/48: Frans Hals, Rembrandt, cat. no. XII; Stockton, California, Haggin Memorial Galleries, 1948; Dayton (Ohio) Art Institute, 1948: Old Masters; New York, Wildenstein & Co., 1950: Benefit Exhibition of Paintings by Rembrandt; Akron (Ohio) Art Institute, 1953: Masterpiece Series; Baltimore Museum of Art, 1954: Man and His Years, cat. no. 15; CMA (1963), cat. no. 16.

LITERATURE: *Verzeichnis der öffentlich ausgestellten Kunst-Gegenstände des Städel'schen Kunst-Institutes* (Frankfurt a/M., 1858), no. 146; Gustav Parthey, *Deutscher Bildersaal*, II (Berlin, 1864), 339, no. 183; Count L. Clément de Ris, "Le Musée de Frankfort-sur-le-Mein," *Revue Universelle des Arts*, XIX (1864), 347; C. Vosmaer, *Rembrandt* (The Hague, 1877), p. 508; Wilhelm von Bode, *Studien zur Geschichte der holländischen Malerei* (Braunschweig, 1883), p. 405; E. Dutuit, *Tableaux et dessins de Rembrandt: Supplément de L'Oeuvre Complet de Rembrandt* (Paris, 1885), p. 29; E. Michel, *Rembrandt*, II (London, 1894), 243; Bode and C. Hofstede de Groot, *The Complete Work of Rembrandt*, II, trans. Florence Simmonds (Paris, 1897), 11, no. 117; *Three Hundred Paintings by Old Masters of the Dutch, Flemish, Italian, French, and English Schools* (Sedelmeyer Gallery cat., Paris, 1898), no. 125; Adolf Rosenberg and W. R. Valentiner, *Rembrandt: Des Meisters Gemälde*, Klassiker der Kunst (Stuttgart and Berlin, 1908), no. 207; Hermann Voss, "Ausstellung von Bildnissen aus dem Privatbesitz der Mitglieder des Kaiser-Friedrich-Museum-Vereines zu Berlin," *Cicerone*, I (1909), 287; Alfred von Wurzbach, *Niederländisches Künstler-Lexikon*, II (Vienna and Leipzig, 1910), 413; Rosenberg, *The Work of Rembrandt* (New York, 1913), p. 207; Hofstede de Groot (1916), VI, 387, no. 846; David Storrar Meldrum, *Rembrandt's Paintings* (London, 1923), p. 190, pl. CLX; Valentiner, *Rembrandt Paintings in America* (New York, 1931), no. 56; A. Bredius, *The Paintings of Rembrandt* (Vienna, 1936), no. 350; Henry S. Francis, "Paintings in the Prentiss Bequest," CMA *Bulletin*, XXXI (1944), 88, illus. p. 95; Coe (1955), II, 215, no. 18, pl. XLIII; Kurt Bauch, *Rembrandt, Gemälde* (Berlin, 1966), p. 25, no. 485; Horst Gerson, *Rembrandt Paintings*, ed. Gary Schwartz, trans. Heinz Norden (Amsterdam, 1968), pp. 294–95, 495, fig. 181; Giovanni Arpino, *L'Opera pittorica completa di Rembrandt*, Classici dell'Arte, vol. 33 (Milan, 1969), no. 169; Bredius (revised by H. Gerson), *Rembrandt, The Complete Edition of the Paintings* (London, 1969), p. 274, no. 350; *Rembrandt after Three Hundred Years* (exh. cat., Chicago, 1969), pp. 34–35; CMA *Handbook* (1978), illus. p. 158.

REMBRANDT HARMENSZ. VAN RIJN

113 Portrait of a Jewish Student 50.252

Canvas, 84.5 x 69.2 cm. Signed above shoulder at right: Rembrandt 16[?].

Collections: Paul Delaroff, St. Petersburg (Leningrad), 1906; [Thomas Agnew & Sons, London]; [Scott & Fowles, New York]; Otto H. Kahn, New York, 1910, presented by his children to the Metropolitan Opera Association, New York, 1950; [M. Knoedler & Co., New York].

Gift of Hanna Fund, 1950.

When examined under ultraviolet light, the signature, beneath a darkened triangular area of varnish, seemed to be intact. The craquelure is consistent over all the painting, including the signature. Ultraviolet light reveals some imbalances in tone, apparently caused by old varnishes left by past restorers. Retouchings show in very few places.

The picture has been variously dated from 1645 to 1646 and from 1657 to 1660. The early dates must be ruled out on the bases of color (the more luminous brown-red combination appears in later works) and interpretation (deeper introspection than in the earlier portraits). The brushstroke (smoother now, after being ironed over by restorers, and therefore somewhat misleading) is comparable to that in works of the late 1650s (Bredius, 1969, nos. 282–83) in

Figure 113a. *Portrait of Spinoza*. On canvas, 77 x 62 cm. Anonymous. Herzog-August-Bibliothek, Wolfenbüttel, West Germany.

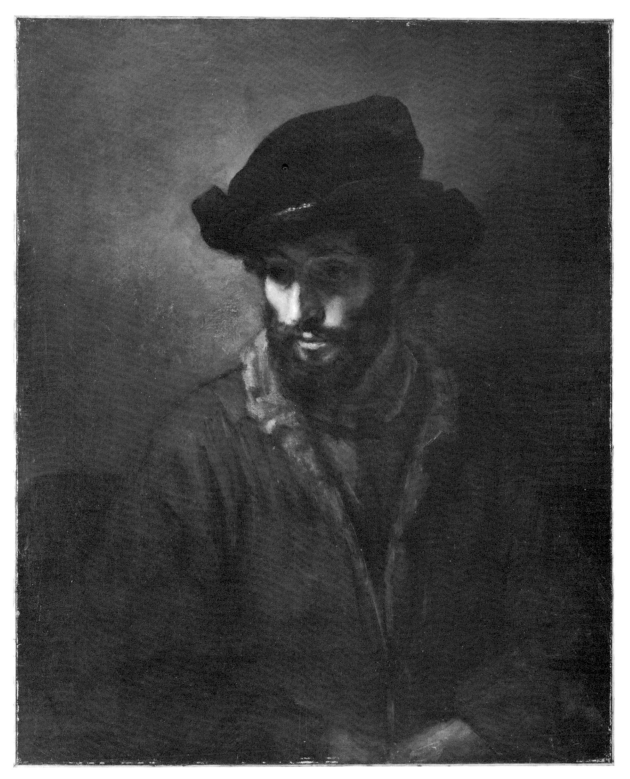

Figure 113.

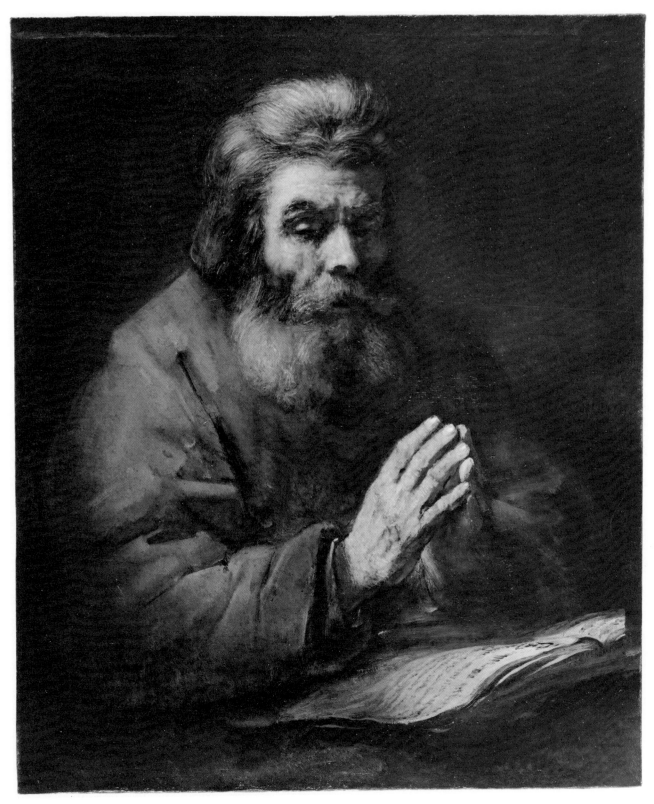

Figure 114.

which the effect of the dark cap against the light background also occurs. Referring to the *Jewish Student* in the Cleveland Museum, Valentiner (1957) suggested its subject could possibly be Spinoza. In the late 1650s Spinoza, who was born in 1632, would have been about twenty-five to twenty-eight years old. A comparison of our portrait with the only authenticated portrait of Spinoza, in the Herzog-August Library in Wolfenbüttel (Figure 113a), does not rule out this possibility.

The suggestion by Bauch (1966) that the picture may be the work of Carel Fabritius is unacceptable. Gerson (in Bredius, 1969) questioned the signature, feeling that an attribution to Rembrandt was probably incorrect. Since the signature is genuine, Gerson's doubts are unfounded; moreover, his suggested alternatives, early Aert de Gelder or Barent Fabritius, have nothing to recommend them. W S

EXHIBITIONS: The Hague, Royal Gallery, 1908/09; New York, Scott & Fowles, 1914: Loan Exhibition of Paintings by the Great Dutch Masters of the 17th Century, cat. no. 13; Raleigh, North Carolina Museum of Art, 1956: Rembrandt and His Pupils, cat. no. 28; Buffalo (New York), Albright Art Gallery, 1957: Trends in Painting 1600–1800, cat. no. 24; CMA (1958), cat. no. 71; Raleigh, North Carolina Museum of Art, 1959: Masterpieces of Art: In Memory of William R. Valentiner, 1880–1958, cat. no. 74; CMA (1963), cat. no. 16; CMA (1973).

LITERATURE: Wilhelm von Bode and C. Hofstede de Groot, *The Complete Work of Rembrandt*, VIII, trans. Florence Simmonds (Paris, 1906), 39, no. 586; Adolf Rosenberg and W. R. Valentiner, *Rembrandt: Des Meisters Gemälde*, Klassiker der Kunst (Stuttgart, 1908), pp. 362, 561; Alfred von Wurzbach, *Niederländisches Künstler-Lexikon*, II (Vienna and Leipzig, 1910), 410; Hofstede de Groot (1916), VI, 222, no. 414; Valentiner, *Rembrandt Paintings in America* (New York, 1931), no. 130; A. Bredius, *Rembrandt Gemälde* (Innsbruck, 1935), p. 11, no. 246, pl. 246; Bredius, *The Paintings of Rembrandt* (Vienna, 1936), no. 246; W. Martin, *Paintings by Rembrandt* (New York, 1947), no. 70; Henry S. Francis, "Rembrandt's *Portrait of a Young Student*," CMA *Bulletin*, XXXVII (1950), 191–93, illus. p. 189; Margaretta Salinger, "Eight Rembrandts in American Collections," *Connoisseur*, CXXXVIII (1956), 67, illus. p. 69; Valentiner, *Rembrandt and Spinoza: A Study of the Spiritual Conflicts in Seventeenth-Century Holland* (London, 1957), pp. 16–19, pl. 6; Milliken (1958), illus. p. 42; Jaffé (1963), p. 467; Kurt Bauch, *Rembrandt, Gemälde* (Berlin, 1966), p. 47, no. 246; Giovanni Arpino, *L'Opera completa di Rembrandt*, Classici dell'Arte, vol. 33 (Milan, 1969), p. 2 of attributed works; Bredius (revised by H. Gerson), *Rembrandt, The Complete Edition of the Paintings* (London, 1969), p. 195, no. 246; Peter de Mendelssohn, "Did Spinoza Ever Sit for Rembrandt? Speculations in Amsterdam," *Encounter*, XLIX (September 1977), 57, 61–62, illus. p. 58; CMA *Handbook* (1978), illus. p. 158.

REMBRANDT HARMENSZ. VAN RIJN

114 *Old Man Praying* 67.16

Canvas, 87.3 x 72.1 cm. Signed and dated at middle right: Rembrand[t]/ f. 166[1]. (The last letter of the name and the last digit of the date are no longer visible).

Collections: The Counts von Harrach, Schloss Rohrau and Vienna (inventories of 1889 and 1897, no. 218); Frau Charlotte Barreiss, Zurich; (sale: Sotheby's, London, June 24, 1964, lot no. 5, illus. opp. p. 6); [Pinakos Inc., New York].

Purchase, Leonard C. Hanna Jr. Bequest, 1967.

The painting was cleaned by Mario Modestini in 1967. A layer of dark varnish was removed from a surface that was in unusually fine condition, with textures of the artist's brush still intact. A second set of stretcher marks uncovered in the cleaning shows clearly that after its completion Rembrandt himself reduced the size of the canvas to approximately 82.6 x 68 centimeters, cutting off part of the signature and date. X radiographs show that he then repainted the book, enlarging it and slightly changing its position. Lee (1967, p. 297) reasoned that Rembrandt finished the painting, signed and dated it, and then decided that reducing the scale would make the proportions and tone progressions more effective. At a later date the canvas was remounted and its dimensions expanded to almost the original size—probably in an effort to expose more of the signature and date, though the last letter and digit are still not visible. The canvas is presently mounted according to these larger dimensions, showing that the reworked version of the book stops short of the edge of the canvas and the underlying first version protrudes into the extreme right margin.

The painting was first published in 1890 while still in the Harrach collection. It has been generally accepted as Rembrandt's work. Since its emergence into the public view in 1967, when it was purchased by this Museum, only Gerson (Bredius and Gerson, 1969, p. 613) has expressed doubts about its authenticity, saying, "It has a kind of looseness of surface texture that I have not observed in other works by Rembrandt." On the other hand, Eva Benesch (letter of January 12, 1968) quotes from a letter of June 4, 1964, written by her husband to a Swiss collector, urging him to buy the painting "in which every stroke is by the master himself."

The deep personal piety which marked the work of Rembrandt throughout his career became increasingly evident in his later years when he suffered great hardships and losses. He sought out subjects among the poor and dispossessed, perhaps because they embodied for him the triumph of faith over personal adversity. Some of his studies of Jewish students (Bredius, 1969, p. 300) and of poor, elderly men (*ibid.*, pp. 302–5) appeared again in paintings of Christ (*ibid.*, pp. 627–30) and the Apostles (*ibid.*, p. 614), with much of the individual, portrait-like qualities of the studies still remaining. Russian pilgrims passing through

Amsterdam seem also to have furnished inspiration for the artist. Bode speculated that the praying old man, with his broad, Slavic features, may have been drawn from such a group. The same model may also have been used in two drawings from 1661 (Lee, 1967, p. 301, n. 4).

The intensely spiritual quality of the Cleveland portrait aligns it with a group of fifteen paintings—eleven of saints and four of Christ—which Rembrandt painted between 1657 and 1661. Of these, *Matthew Inspired by the Angel* (Bredius, 1969, p. 614), *The Apostle Bartholomew* (ibid., p. 615), *The Apostle Simon* (ibid., p. 616A), and *The Apostle James* (ibid., p. 617) also date from 1661. Usually assigned this same date is the *Evangelist Writing* (Bredius, 1969, p. 619), which, like the Cleveland painting, has no last digit in its date.

The Cleveland picture shares with these paintings a number of stylistic similarities. The rough and scratching brushwork which describes the wrinkled, aging skin of St. Matthew and St. James is remarkably similar to that in the *Old Man*. The praying posture of the strong, worn hands that barely touch is seen in both the *St. James* and the *Old Man*. (Throughout his life Rembrandt studied this gesture, just as thoroughly as he explored the use of facial expressions of piety; the last painting he worked on, apparently, *Simeon with the Christ Child in the Temple* [Bredius, 1969, p. 600], is an illuminating comparison.) The broad, firm planes of the heavy fabric of the old man's garment, painted in soft, chromatic hues, is very close to similar textures in the *Evangelist Writing*. On the basis of the stylistic continuity within this group, it seems likely that the *Old Man Praying* was also painted in 1661, the date traditionally assigned to it.

The placement of our painting among this larger group is also supportable iconographically. It has long been thought, based on our knowledge of Rembrandt's personal contacts and commissions, that the artist became a Mennonite in his late years. But whether or not he was influenced by Mennonite theology, it is clear that he was preoccupied by the idea that each individual must relate to his God in a direct and personal way, without human mediation, drawing inspiration only from the all-powerful Word itself. It is this great theme of personal faith and piety that unites this series of half-length figures, rather than any traditional, formal, iconographic program. Each painting has as its subject the highly individualized image of a man responding to the spirit of Grace, exalted and monumentalized not by the trappings of worldly wealth or glory, but rather by the indwelling spirit of faith. J K C and A T L

EXHIBITIONS: Vienna, Harrach Gallery, on exhibition from before 1904 to 1939, cat. no. 218; Schaffhausen, Museum zu Allerheiligen, 1949: Rembrandt und seine Zeit, cat. no. 141; Schaffhausen, Museum zu Allerheiligen, 1952: Thirty-One Paintings of the 15th–18th Centuries from a Private Collection, cat. no. 22, illus.; Rijksmuseum (Amsterdam) and Museum Boymans (Rotterdam), 1956: Rembrandt Tentoonstelling, cat. no. 89, illus. p. 182 (as A Praying Apostle); Munich, Alte Pinakothek,

1963; CMA, December 1967: Year in Review, cat. no. 63; Art Institute of Chicago, 1969: Rembrandt after Three Hundred Years, cat. no. 19, illus.; CMA (1973).

LITERATURE: Wilhelm Suida, *Wien*, Vol. II: *Die Gemäldegalerie der K. K. Akademie der Bildenden Künste-Die Sammlungen Liechtenstein, Czernin, Harrach und Schönborn-Buchheim* (Stuttgart, Berlin, and Leipzig, 1890), pp. 171–72; Theodor von Frimmel, "Ausgewählte Bilder aus Wiener Sammlungen," *Blätter für Gemäldekunde*, I, no. 6 (1904), 106, illus. p. 105; Wilhelm von Bode and C. Hofstede de Groot, *The Complete Work of Rembrandt*, VIII, trans. Florence Simmonds (Paris, 1906), no. 594, illus.; Karl Baedeker, *Österreich-Ungarn* (Leipzig, 1907), p. 39 (second ed., Leipzig, 1929, p. 55); Hofstede de Groot, *Beschreibendes und kritisches Verzeichnis der Werke der hervorragendsten holländischen Maler des XVII Jahrhunderts*, VI (Esslingen and Paris, 1907–28), no. 194, illus.; Adolf Rosenberg and W. R. Valentiner, *Rembrandt: Des Meisters Gemälde*, Klassiker der Kunst (Stuttgart and Berlin, 1908), illus. p. 459; Alfred von Wurzbach, *Niederländisches Künstler-Lexikon*, II (Vienna and Leipzig, 1910), 412; A. Rosenberg, *The Work of Rembrandt* (New York, 1913), p. 459; Hofstede de Groot (1916), VI, 131, no. 194, illus.; Bode, "Ein Studienkopf aus Rembrandts Spätzeit im Berliner Schloss und seine Beziehung zu den slawischen Pilger- und Mönchsbildnissen des Meisters aus dem Jahre 1661," *Jahrbuch der Königlich Preussischen Kunstsammlungen*, XXXVII (Berlin, 1917), 108–9, illus.; Isabella Errera, *Répertoire des Peintures Datées*, I (Brussels and Paris, 1921), 302; H. Ritschl, *Katalog der Erlaucht Gräflich Harrachschen Gemälde-Galerie in Wien* (Vienna, 1926), pp. 110–11, no. 218, illus.; A. Bredius, *The Paintings of Rembrandt* (Vienna, 1936), fig. 616, p. 26 of notes; Ludwig Munz, "A Newly Discovered Late Rembrandt," *Burlington Magazine*, XC (1948), 64; Jakob Rosenberg, *Rembrandt* (Cambridge, 1948), I, 63, 219 n. 3, and II, fig. 107; F. Grossman, "The Rembrandt Exhibition of Schaffhausen," *Burlington Magazine*, XCII (1950), 11; Otto Benesch, "Worldly and Religious Portraits in Rembrandt's Late Art," *Art Quarterly*, XIX (1956), 346; J. Rosenberg, "The Rembrandt Exhibition in Amsterdam," *Art Quarterly*, XIX (1956), 387; W. R. Valentiner, "The Rembrandt Exhibition in Holland, 1956," *Art Quarterly*, XIX (1956), 391, 400, fig. 1; Benesch, *Rembrandt* (New York, 1957), p. 118; Seymour Slive, "Frans Hals Studies," *Oud Holland*, LXXVI (1961), 176, illus. p. 187; Wolfgang Christlieb, "Ein neuer Rembrandt in der Alten Pinakothek" (Feuilleton), *Münchener Abendzeitung* (January 9, 1963), p. 8; J. Rosenberg, *Rembrandt: Life and Work* (London, 1964), pp. 118–19, fig. 107; Kurt Bauch, *Rembrandt, Gemälde* (Berlin, 1966), pp. 13, 44, no. 234 illus.; Magdalen Haberstock, *Hundert Bilder aus der Galerie Haberstock, Berlin* (Munich, 1967), pl. 28; Sherman E. Lee, "Old Man Praying," *CMA Bulletin*, LIV (1967), 295–301, figs. 1–3; *Art Quarterly*, XXX (1967), 264, illus. p. 274; *Gazette des Beaux-Arts*, LXXI (February, 1968: Supplément), 61, fig. 237; Horst Gerson, *Rembrandt Paintings*, ed. Gary Schwartz, trans. Heinz Norden (Amsterdam, 1968), pp. 426–27, 502, no. 365 illus.; Giovanni Arpino, *L'Opera pittorica completa di Rembrandt*, Classici dell'Arte, vol. 33 (Milan, 1969), pp. 120–21, no. 403, illus.; Bredius (revised by H. Gerson), *Rembrandt, The Complete Edition of the Paintings* (London, 1969), p. 613, no. 616, illus. p. 519; Gerson, "The Rembrandt Exhibitions of 1969," *Burlington Magazine*, CXI (1969), 782; Bob Haak, *Rembrandt: His Life, His Work, His Time* (New York, 1969), pp. 298–99, fig. 502; Benesch, *Collected Writings*, Vol. I: *Rembrandt* (London, 1970), p. 198, no. 166 illus.; Burton B. Fredericksen, *Catalogue of the Paintings in the J. Paul Getty Museum* (Malibu, California, 1972), p. 89; Erich Schleier, "Die Erwerbungen der Gemäldegalerie," *Jahrbuch der Stiftung Preussischer Kulturbesitz*, X (1972), 252; *The Cleveland Museum of Art*, The Little Art Book, ed. Berthold Fricke (Hannover, 1975), p. 48, fig. 21 (color); CMA *Handbook* (1978), illus. p. 159; Ann T. Lurie, "The *Weeping Heraclitus* by Hendrick Terbrugghen in The Cleveland Museum of Art," *Burlington Magazine*, CXXI (1979), 287.

JACOB van RUISDAEL
1628/29–1682

Jacob van Ruisdael was born in Haarlem in 1628 or 1629, according to a document that declares him to have been thirty-two years old by June 9, 1661 (A. Bredius, "Het Geboortejaar van Jacob van Ruisdael," *Oud Holland*, VI, 1888, 21). Ruisdael's early works show the influence of his uncle, Salomon van Ruysdael, and Cornelis Vroom. Ruisdael was active in Haarlem from 1645. He became a member of the guild in 1648. In the early 1650s he traveled in the eastern Netherlands and western Germany, where the mountainous landscape stimulated his vision and enlarged his concepts. During this period he was in contact with some of the Italianate Dutch painters who were familiar with the poetic, idyllic landscapes of Claude Lorrain. All this was preparation for his greatest artistic production, after ca. 1655, when he settled in Amsterdam. Ruisdael was also influenced by the work of Allart van Everdingen (see Painting 100), who had traveled in Scandinavia and had popularized Northern motifs in Holland. Ruisdael's earliest-dated Northern landscape is from 1659 (Jakob Rosenberg, *Jacob van Ruisdael*, Berlin, 1928, no. 93). In the sixties waterfalls were an important motif for him. In his later years, after the seventies, his work suffered a decline. He died in Amsterdam in 1682 and was buried in his native Haarlem.

Previously it had been thought that Ruisdael took a medical degree at Caen in 1676 and actually practiced medicine while continuing his painting career. Seymour Slive and Jakob Rosenberg (*Dutch Art and Architecture 1600–1800*, Middlesex, England, 1966, p. 154) suggested that the "Jacobus Ruÿsdael" who received a medical degree from the university at Caen was not the painter. Ruisdael's output, they argue, was enormous, and it seems unlikely that he could have produced so many works while studying and practicing medicine.

115 Landscape with a Church by a Torrent 62.256

Canvas, 71.1 x 55.2 cm. Signed at lower right: JvRuisdael [JvR in ligature].

Collections: Etienne Le Roy (seal and inscription on back); Marquis de La Rochebousseau (sale: Pillet, Paris, May 5–8, 1873, no. 198, illus.); Baron Anselm von Rothschild, Vienna, 1873; Baron Nathaniel von Rothschild, Vienna; Baron Alphonse von Rothschild, Vienna; [Rosenberg & Stiebel, New York]; Jane Taft Ingalls, Cleveland, 1949.

Bequest of Jane Taft Ingalls, 1962.

The painting is in excellent condition.

The influence of Allart van Everdingen is evident in this work, though less so than in Ruisdael's earlier Scandinavian views, which are more vigorous renderings, with tall pines and rugged rocks surrounding cascading waterfalls. These Northern motifs, which Ruisdael borrowed from Everdingen and observed himself in his travels through northern Germany, were combined with more familiar Dutch landscape elements to arrive at a fresh and resourceful synthesis. Ruisdael's creative energies diminished in the years around the 1670s, presaging an even more marked decline in his last phase of activity. *Landscape with a Church by a Torrent*, because of its more vertical format and because it lacks the characteristic vigor of earlier works, may be dated around 1670 to 1675.

The same chapel appears in very similar but less romanticized surroundings in a painting by Jan van Kessel (Stechow, 1968, fig. 9).

Two other undated paintings by Ruisdael are similar in composition, with a waterfall in the foreground and a building (or buildings) set against the sky (reproduced in Jakob Rosenberg, *Jacob van Ruisdael*, Berlin, 1928, figs. 134 and 147). JKC

EXHIBITIONS: Vienna, Oesterreichisches Museum für Kunst und Industrie, 1873: Ausstellung alter Gemälde aus Wiener Privatbesitz, cat. no. 122; CMA November 1962: Year in Review, cat. no. 96, illus. p. 212; CMA (1973).

LITERATURE: Hofstede de Groot (1912), IV, 128, no. 399 (with incorrect size); Coe (1955), II, 102, no. 18, pl. XXIII; Wolfgang Stechow, "Ruisdael in the Cleveland Museum," CMA *Bulletin*, LV (1968), 259, fig. 8.

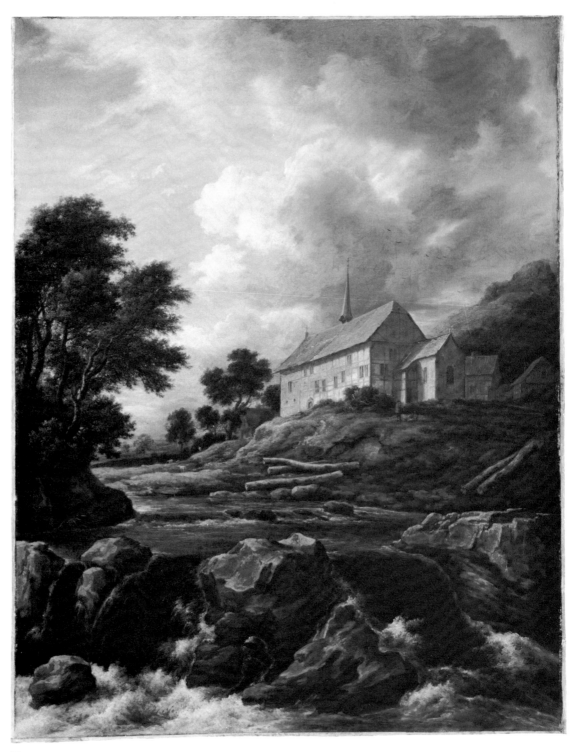

Figure 115.

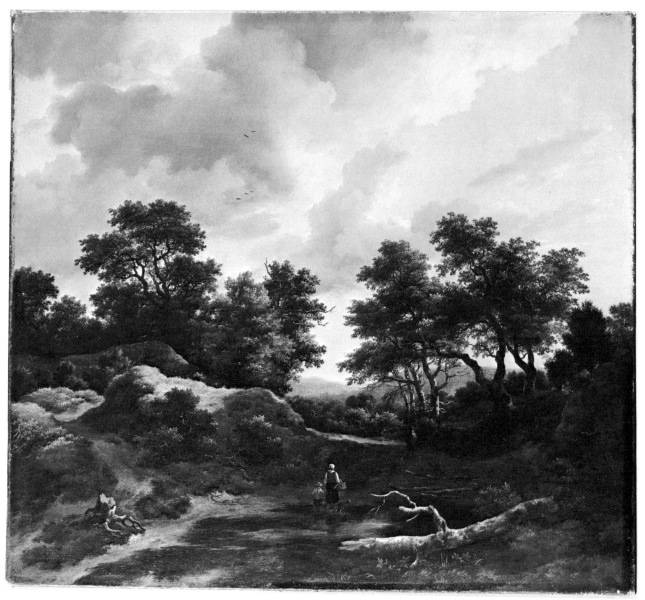

Figure 116.

JACOB van RUISDAEL

116 *A Wooded and Hilly Landscape,* 63.575
 Evening

 Canvas, 51.6 x 59.4 cm. Signed at lower left: JvRuisdael
 [JvR in ligature].
 Collections: Johann Matthias de Neufville Gontard, Frankfurt,
 1794; acquired in 1817 from his widow for the Städelsches
 Kunstinstitut, Frankfurt am Main (no. 270 in the catalogue of
 1900); August Berg, Portland, Oregon, 1921; [Frederick Mont,
 New York]; Walter P. Chrysler, Jr., New York; [Frederick Mont,
 New York].
 Purchase, Leonard C. Hanna Jr. Bequest, 1963.

The painting was cleaned in 1968 by Joseph Alvarez. It is in
excellent condition.

 In most of Ruisdael's works, trees rather than human
figures form one of the most important expressive elements.
In this painting the figures act as a compositional device to
lead the eye into the picture. (An identical figure group
appears in another work by Ruisdael, a landscape with
waterfall, in Washington, National Gallery, no. K-462.)

 Contrasts are modest: a fallen, dead tree and a twisted
stump in the foreground quietly complement trees in full
foliage in the middle ground; the glowing light of evening
highlights crisply painted details of the foliage, so thoroughly
Dutch in character.

A Wooded and Hilly Landscape, Evening was probably painted in the early to middle sixties, about fifteen to eighteen years later than the *Landscape with a Windmill* (Painting 117), and before the *Landscape with a Dead Tree* (Painting 118). JKC

EXHIBITIONS: CMA, December 1964: Year in Review, cat. no. 86; CMA (1973).

LITERATURE: Smith (1835), VI, 52, no. 167; E. Michel, *Jacob van Ruisdael et les paysagistes de l'école de Haarlem* (Paris, 1890), p. 84; Hofstede de Groot, (1912), IV, 147, no. 460; Jakob Rosenberg, *Jacob van Ruisdael* (Berlin, 1928), p. 96, no. 395; Rémy G. Saisselin, "Art Is an Imitation of Nature," CMA *Bulletin*, LII (1965), 38, color illus. pp. 36–37; *Selected Works* (1966), no. 169, illus.; Wolfgang Stechow, "Ruisdael in the Cleveland Museum," CMA *Bulletin*, LV (1968), 252–53, fig. 5; Alvey L. Jones, "Jacob van Ruisdael's Ford in the Woods," *The Bulletin* (Krannert Art Museum), II, no. 2 (1978), 19, 22 n. 37, illus. fig. 11; CMA *Handbook* (1978), illus. p. 161.

Figure 117a. *Landscape with a Farmhouse near a Village*. On panel, 34.3 x 46.4 cm. Ruisdael. Present whereabouts unknown.

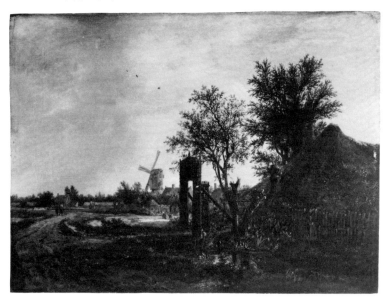

266

JACOB van RUISDAEL

117 *Landscape with a Windmill* 67.19

Panel, 49.5 x 68.5 cm. Signed at lower right: JvR 1646.

Collections: Sir Francis Cook; Sir Frederick Cook; Sir Herbert Cook, Doughty House, Richmond; Sir Francis Cook, Le Coin, Jersey, Channel Islands; Trustees of the Cook Collection (sale: Christie's, London, November 25, 1966, no. 55, listed as Follower of Ruisdael); [F. Kleinberger & Co., New York].

Mr. and Mrs. William H. Marlatt Fund, 1967.

The painting was cleaned in 1967 by Joseph Alvarez. Old, dirty varnish was removed, and the paint surface was found to be in excellent condition.

Painted in 1646, when Ruisdael was about eighteen years old, this picture, though it lacks the refinement and clarity of the artist's later works, foreshadows some aspects of his later development. The sombre moodiness and dramatic expression of Ruisdael's mature vision are already present in this work, a remarkably strong and original statement by a precocious young artist.

Ruisdael painted another panel (Figure 117a), also dated 1646, of the same subject viewed from a different vantage point, with another fenced-in cottage in the foreground (sale: Sotheby's, London, July 9, 1975, no. 71C). A few years later he painted still another version of the same scene (*Landscape with a Windmill*, ca. 1650, London, Buckingham Palace), which reflects the artist's change and growth from the time of the first version (Stechow, 1968, fig. 4).

Another work dated 1646, in Leningrad (Hermitage, no. 1143, 105.5 x 163 cm; Rosenberg, 1928, fig. 2), though it is much larger, is close in composition to the Cleveland painting, with a group of trees filling the space given to the windmill in the latter work. Because the handling of the composition in the Leningrad painting seems more accomplished, it most likely followed the Cleveland painting.

Two other works dated 1646 serve to emphasize the pivotal nature of this year in Ruisdael's development. *The Cottage* (Hamburg, Kunsthalle) has many similarities to *Landscape with a Windmill*, while another landscape (Rosenberg, 1928, fig. 5) shows the lingering influence of Salomon van Ruysdael. JKC

EXHIBITIONS: Manchester, City Art Gallery, 1964–66 (on extended loan); CMA, December 1967: Year in Review, cat. no. 66, illus. p. 315; CMA (1973).

LITERATURE: Hofstede de Groot (1912), IV, 62, no. 180; J. O. Kronig, *A Catalogue of the Paintings at Doughty House Richmond and Elsewhere in the Collection of Sir Frederick Cook, Bt.*, II (London, 1914), 94, no. 350; Kurt Erich Simon, *Jacob van Ruisdael* (Berlin, 1927), pp. 20–21, no. 28; Jakob Rosenberg, *Jacob van Ruisdael* (Berlin, 1928), p. 79, no. 119; *Abridged Catalogue of the Pictures at Doughty House, Richmond, Surrey, in the Collection of Sir Herbert Cook, Bart.* (London, 1932), p. 40, no. 350; J. P. Ballegeer, "Aus der Arbeit der Museen, Amerika," *Pantheon*, II (1968), 138; Wolfgang Stechow, "Ruisdael in the Cleveland Museum," CMA *Bulletin*, LV (1968), 250, 252, color illus. pp. 256–57; CMA *Handbook* (1978), illus. p. 160.

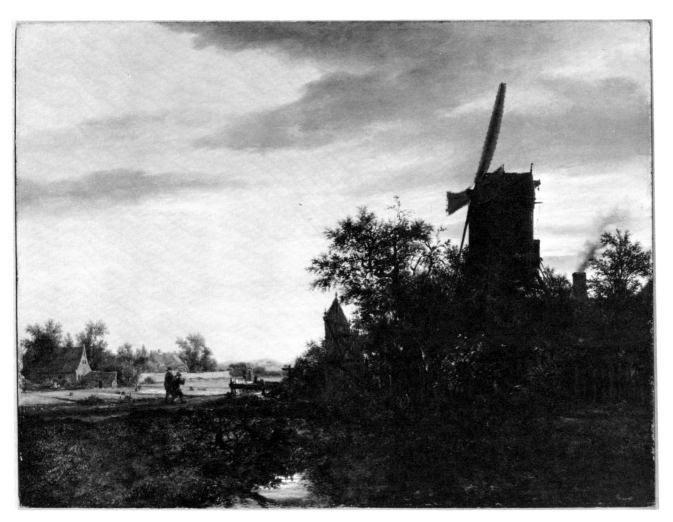

Figure 117.

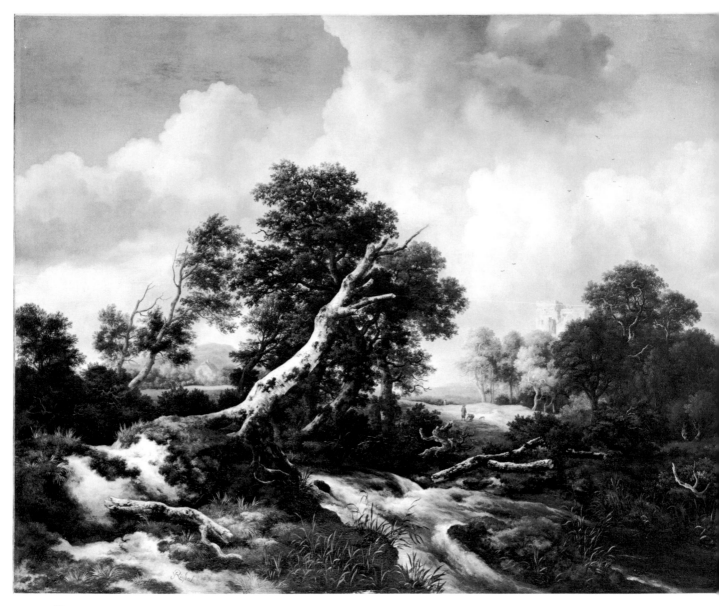

Figure 118.

268

JACOB van RUISDAEL

118 *Landscape with a Dead Tree* 67.63

Canvas, 99.2 x 131 cm. Signed at lower left: JvRuisdael
[JvR in ligature].

Collections: Freiherren von Ketteler (first at Schloss Harkotten
near Warendorf, probably by mid-eighteenth century; later at
Schloss Ehringerfeld near Büren, Westphalia, 1904); J. J. van
Leeuwen Boomkamp, Naarden, Holland, 1929; (sale: Sotheby's,
London, November 30, 1966, no. 21; to Legatt); [Frederick
Mont, New York].

Mr. and Mrs. William H. Marlatt Fund, 1967.

The canvas has been lined. The paint surface is in excellent
condition, with only a few retouchings, including several
small irregular spots in the trees and ground to the left of
the figures in the middle distance, a small area in the water
to the left of the clump of grass in the lower left corner, and
a triangular spot in the tree trunk below the broken-off
branch at the top. The rock in the stream has been strength-
ened. There are some minor abrasions along the stretcher
edge in an otherwise well-preserved sky.

Stechow (1968) dated this work ca. 1665 to 1668, fitting
it into Ruisdael's general stylistic development. Closely
comparable works are also undated. The liquid manner of
painting distant buildings and landscape reflects some con-
tact with the Italianizing influence which came after the
1650s. Ruisdael, however, never completely adopted any
given style; he utilized only what he found useful for his
own personal vision.

In this work we see a move toward a grander, more
dramatic concept of landscape, marking a change from the
more intimate approach of Ruisdael's earlier works, such
as *A Wooded and Hilly Landscape, Evening* (Painting
116). Crisply defined trees beside a turbulent stream are
contrasted with the soft effects of a sun-drenched distant
view. A dead tree—a motif that Ruisdael used in a number
of other works of this period, such as *Marsh in the Woods*,
from ca. 1665 (Leningrad, Hermitage; Rosenberg, 1928,
pl. LXVII), and *A Pool Surrounded by Trees*, second half of
the sixties (London, National Gallery, no. 854)—stands
out against a dense clump of live trees. The dynamic com-
position is masterfully executed and is typical of Ruisdael's
best work in the years after ca. 1665. JKC

EXHIBITIONS: Düsseldorf, Kunsthistorische Ausstellung, 1904, cat. no.
372; Rotterdam, Museum Boymans, 1929/30, cat. no. 11, pl. VIII; CMA,
December 1967: Year in Review, cat. no. 65; CMA (1973); National
Museum of Western Art (Tokyo) and Kyoto National Museum, 1976:
Masterpieces of World Art from American Museums, cat. no. 34, color
illus.

LITERATURE: Hofstede de Groot (1912), IV, no. 220; Kurt Simon, *Jacob
van Ruisdael* (Berlin, 1927), p. 74; Jakob Rosenberg, *Jacob van Ruisdael*
(Berlin, 1928), p. 81, no. 140; Wolfgang Stechow, "Ruisdael in the Cleve-
land Museum," CMA *Bulletin*, LV (1968), 254, 259, fig. 7; CMA *Hand-
book* (1978), illus. p. 161.

SALOMON van RUYSDAEL

Ca. 1602–1670

Ruysdael was born in Naarden in Gooiland. In his early
years he was known as Salomon de Gooyer (Salomon from
Gooiland), the name he gave in 1623 when he entered the
Haarlem guild. Though it is not known who his teacher
was, the influence of Esaias van de Velde is evident in his
earliest-dated painting, *Horse Market at Valkenburg near
Leiden*, 1626 (The Hague, N. van Bohemen collection). He
was apparently influenced by Pieter de Molyn, who also
was in the Haarlem guild. In the 1630s he arrived at his own
style of landscape in which he used a tonal approach similar
to that of Jan van Goyen (Wolfgang Stechow, *Dutch Land-
scape Painting of the Seventeenth Century*, London, 1966,
pp. 54–56). His work after the mid-forties reflects the im-
pact of a contemporary development toward more monu-
mental landscapes, as exemplified by the paintings of his
nephew, Jacob van Ruisdael (for example, a landscape in
Hamburg, Kunsthalle, dated 1645, and one in Amsterdam,
J. Goudstikker collection, dated 1649; Stechow, *Salomon
von Ruysdael eine Einführung in seine Kunst*, Berlin, 1938,
cat. no. 514, pl. 15, and cat. no. 355, pl. 19), although he
never gave up the feathery, airy effects that were character-
istic of his mature style. He died in 1670 in Haarlem, where
he had spent most of his life.

119 *River Landscape with Castle* 73.2

Panel (hardwood, oak?), 39.3 x 60.5 cm. Signed and dated on side
of the boat: SVR 1644.

Collections: Paul Oppenheimer, Littleborough, Lancashire; M.
B. Asscher, London, 1946; J. Singer, London, 1948; [Leonard
Koetser, London, 1962 to 1967]; [E. Speelman, London]; (sale:
Sotheby's, London, March 24, 1971, no. 104); [Bruno Meissner,
Zurich]; [Schaeffer Galleries, New York, 1972].

Mr. and Mrs. William H. Marlatt Fund, 1973.

The slightly thinned, cradled panel consists of two pieces
joined horizontally at 18.2 centimeters from the bottom. A
six-centimeter-wide, unpainted wood strip has been added
to all sides, increasing the overall dimensions. The painting
is in good condition, with only minor, scattered paint losses,
mostly along the horizontal join; the losses have been re-
touched. In some places the white ground is visible where
the paint has been abraded.

The buildings are a free variation of Castle Loevenstein,
where the scholar Hugo Grotius (1583–1645) was held
prisoner after his trial in 1619 until his dramatic escape.
The castle, located at the confluence of the Maas and Waal
Rivers, opposite the town of Woudrichem, was altered some-
what during restorations in the nineteenth century. Com-
parison of Ruysdael's painting with an engraving (Stechow,
1973, fig. 11) of ca. 1621 by Claes Jansz. Visscher, a view
from the north, shows that Ruysdael's castle was more a
motif drawn from his imagination than a specific rendering

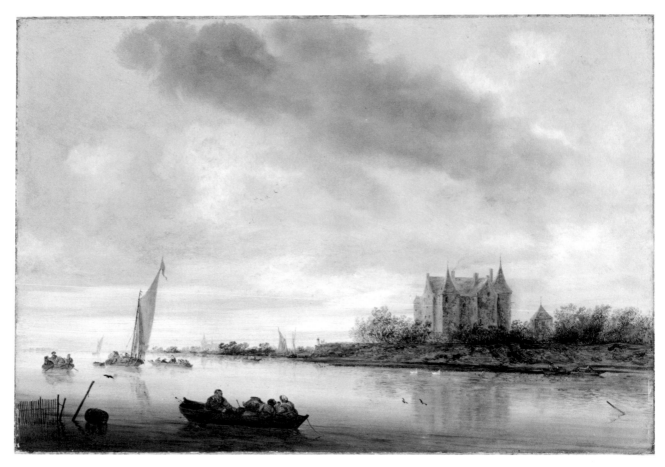

Figure 119.

of the scene. Photographs taken in 1972 by Gerrit Noordzij (in Museum files) show a bridge leading to the castle (visible in the engraving but not in Ruysdael's painting); the bridge is obscured from some vantage points by a drop in the land toward the River Maas. A photograph taken from the east side of the castle—the side from which Ruysdael's view is taken—shows many of the details seen in the painting. Apparently for the sake of the composition, Ruysdael placed the castle about a kilometer to the west of its actual location.

According to Stechow (1973), the painting is one of the finest examples of Ruysdael's transition stage in the early 1640s. The translucent yellow, brown, and rose glow of his earlier works lingers on, but the green-gray tree and water colors predominate. This superb painting dates from around 1643–45, when Ruysdael began to de-emphasize tone, using greater contrasts of light and shade and color for the sake of structural clarity.

Castle Loevenstein appears in two other works by Ruysdael, one dated 1643 and the other dated 1644 (Stechow, 1975, nos. 283 and 453A). JKC and NCW

EXHIBITIONS: London, Leonard Koetser Gallery, 1962: Spring Exhibition of Fine Flemish, Dutch, and Italian Old Masters, cat. no. 2, color illus.; London, Leonard Koetser Gallery, 1967: Spring Exhibition of Fine Flemish, Dutch, and Italian Old Masters, cat. no. 15; CMA (1973); CMA, February 1974: Year in Review, cat. no. 43, illus.

LITERATURE: Wolfgang Stechow, "A River Landscape by Salomon van Ruysdael," CMA *Bulletin*, LX (1973), 222–30, figs. 1–3; Stechow, *Salomon van Ruysdael* (second ed. rev., Berlin, 1975), p. 138, no. 452A, fig. 26; CMA *Handbook* (1978), illus. p. 157.

DIRCK van SANTVOORT
1610/11–1680

Dirck van Santvoort was born in Amsterdam in late 1610 or early 1611. He remained there all his life and died there in 1680. He probably was a pupil of his father, Dirck Pietersz., called Bontepaert, who was also a painter. He and his brothers adopted the surname Santvoort. Santvoort became a master in the guild in 1636 and was made chairman in 1658. A contemporary of Rembrandt, he was one of the most sought-after portrait painters among the fashionable upper middle class in Amsterdam. His paintings of adults are conventional and conservative in style, an influence of Cornelis van der Voort and Nicolaes Eliasz. He followed in the footsteps of such successful portraitists as Paulus Moreelse (1571–1638) and Thomas de Keyser (1596/7–1668) and adopted the same straightforward approach to his subjects. Occasionally the influence of Rembrandt showed in his works; for example, in the somewhat looser brushwork and the chiaroscuro effects in the *Portrait of a Girl with a Finch*, signed, and dated 163(?), in the National Gallery, London (Neil Maclaren, *The Dutch School*, London, 1958–60, I, no. 3154, p. 384, and II, illus. p. 313), and in the pair of portraits of children dated 1644 in the Rijksmuseum (*Catalogue of Paintings*, Amsterdam, 1960, nos. 2132–33). In general, his portraits of children had a special charm and intensity that was lacking in his representations of adults.

120 *Portrait of a Young Girl* 75.81
 with a Flute

Panel, 62.9 x 49.8 cm.

Collections: M. Muyser, The Hague (sale: Nahuys-Hodgson, Royer-Kerst and Muyser, Amsterdam, November 11, 1883, no. 142, MS addition to sales catalogue by Victor de Stuers); [William Macbeth, New York, by 1895 (sale: Anderson Galleries, New York, April 3–5, 1916, no. 152, illus. opp. p. 42]); [M. Knoedler & Co., New York]; private collection (sale: Parke-Bernet, New York, November 3, 1972, no. 38); Mr. and Mrs. Noah L. Butkin, Cleveland.

Gift of Mr. and Mrs. Noah L. Butkin, 1975.

There are several small worm holes on the reverse side of the panel and two small splits, one at the top and another at the lower left. Extensive abrasion in the dark background was retouched sometime in the past. Except for some minor strengthening in the dress of the sitter, the rest of the painting is in good condition.

William Macbeth, in the foreword to the Anderson sales catalogue (1916), says that the Cleveland painting was purchased by him in 1895 from M. Muyser, a prominent collector of Dutch paintings in The Hague.

Figure 120a. *Young Girl with a Dog before a Mirror*. On panel, 64.1 x 48.9 cm. Santvoort. Private collection.

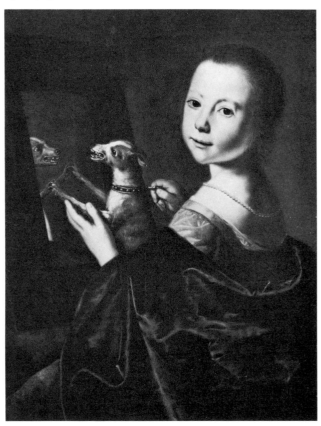

Figure 120b. Detail of Figure 120a.

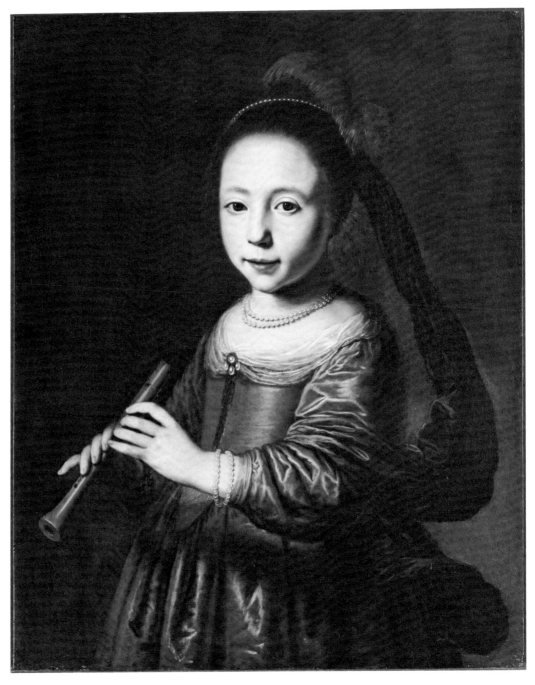

Figure 120.

A handwritten inscription on the back center of the painting identifies the sitter as Elisabet Spiegel. She was so identified in the Macbeth sale (which included an expertise by C. Hofstede de Groot from 1908), but there is no documentation to support that identification. Victor D. Spark, in an appraisal of the painting dated August 10, 1975, says tentatively that the sitter was Agathe Geelvinck, but that seems highly improbable, for a portrait of Agathe Geelvinck as an adult (now in the Rijksmuseum, Amsterdam, no. 2131), was painted in 1640, about the same time or only slightly later than the Museum painting.

The young sitter faces the viewer, her body turned slightly to the left. She wears a satin dress with a low, round neckline, clasped with a jeweled pin; around her neck and around her left wrist she wears a double row of pearls. She holds a flute with both hands in front of her as if she had been interrupted in the act of playing. She bears a striking resemblance to the *Young Girl with a Dog before a Mirror* (Figure 120a), signed and dated in the upper left corner (Figure 120b), and also to the *Portrait of a Young Girl Holding Fruit* (Figure 120c), owned by Arthur Tooth and Sons in 1975 (ex collections: Edward George Coles, Esq.,

Figure 120c. *Portrait of a Young Girl Holding Fruit*. On panel, 61 x 48.9 cm. Santvoort. Present whereabouts unknown.

Headley, Epsom; sale: Christie's, London, November 11, 1926, no. 30; Captain E. G. Spencer-Churchill, Northwick Park; sale: Christie's, London, October 29, 1965, no. 43).

M. E. Tiethoff-Spliethoff (letter dated April 4, 1978) suggested that if the Cleveland portrait is indeed of Elisabet Spiegel, who was born in 1628 and looks about eleven years old in the portrait, the other two portraits could well be of her two sisters. NCW

EXHIBITIONS: CMA, February 1976: Year in Review, cat. no. 62; CMA (1973).

LITERATURE: *New York Herald*, March 26, 1915, illus.

JAN STEEN
1626–1679

Jan Steen was born in Leyden, where he grew up and later attended the university. He joined the newly founded St. Luke's Guild in 1648. Steen moved to The Hague in 1649, the year he married Jan van Goyen's daughter, Margaret. He lived in Delft from 1654 to 1656; in Warmind (near Leyden) from 1656 to 1660; and in Haarlem from 1661 until 1669, the year both his father and his wife died. His remaining years were spent in Leyden, where he married Maria von Egmont in 1673, and where he died in 1679.

Certain stylistic resemblances to the works of Nicolaus Knüpfer led Arnold Houbraken (*De Groote Schouburgh der Nederlantsche Konstschilders en Schilderessen*, I, 1719, reprint ed., Maastricht, 1943, 340) and, later, Jacob C. Weyerman (*De Levens-beschryvingen der nederlandsche konst-schilders en konstschilderessen*, II, The Hague, 1729, 348) to believe that Steen was Knüpfer's pupil. No documents support this theory, however. The few landscapes that Steen painted reveal influences from his father-in-law, van Goyen. Like many Dutch artists of his time, Jan Steen combined his career as a painter with a trade. His occupation as a brewer and innkeeper provided the subject matter for many of his scenes of merrymaking.

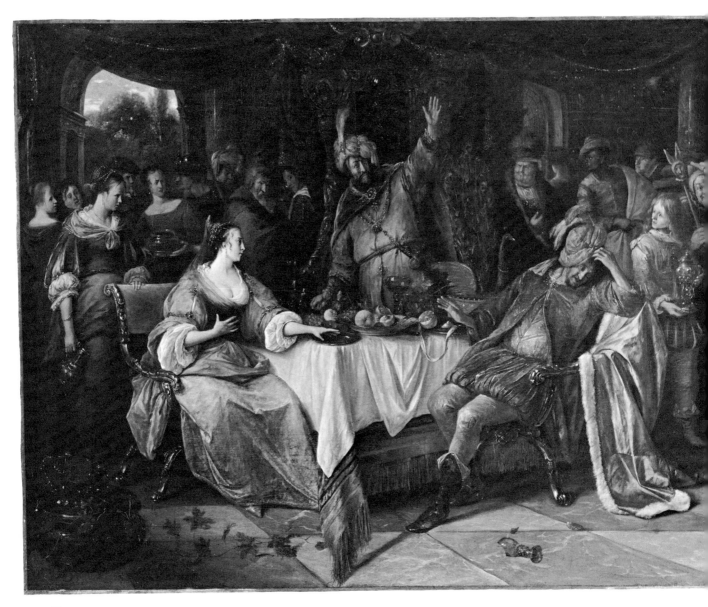

Figure 121.

121 *Esther, Ahasuerus, and Haman* 64.153

Canvas, 70 x 92.9 cm.

Collections: [Jolle Albertus Jolles and Hendrik de Winter] (sale: May 23, 1764, no. 30); Pieter Yver, Amsterdam; [Douwes Brothers, Amsterdam, prior to 1926]; W. J. R. Dreesmann (sale: Frederick Muller, Amsterdam, March 22–25, 1960, no. 15); [Douwes Brothers, Amsterdam]; W. J. R. Dreesmann, Jr., Wassenaar; [G. Cramer, The Hague, 1963].

John L. Severance Fund, 1964.

The painting is in relatively good condition. There are some abrasions and extensive retouching in the skirt of Esther, in the costume of Haman, and in the dark tones of the background. The varnish coating has developed a wrinkled texture which somewhat reduces its transparent quality. Some residues of darkened varnish are found in the interstices of the paint texture.

An X radiograph reveals that Jan Steen's picture is painted over another painting—a vertical composition containing several figures, apparently cherubs—which fills the entire format of the canvas.

The subject of our painting, taken from the Book of Esther, 7:6–7, was repeated by Steen numerous times. Hofstede de Groot lists versions in his *Catalogue Raisonné of the Works of the Most Eminent Dutch Painters of the Seventeenth Century* (I, London, 1907, 13, nos. 17–20, 20a and b, and 21). In a typewritten supplement (preserved at the Rijksbureau voor Kunsthistorische Documentatie, The Hague), he added others (nos. 19a, 21a and b, 22a and b).

No. 17 in Hofstede de Groot's catalogue belongs to The Hermitage, Leningrad.

No. 18—which is a close and brilliant variant of the Cleveland composition, though in reverse—is at the Barber Institute of Fine Arts, Birmingham, England.

No. 19, according to Hofstede de Groot's supplement, is probably the painting sold in the Goldsmith sale in Paris on February 27, 1869 (Drouot, no. 74C), which was then with the art dealer Sulley in 1909. It has been identified as the painting that went through the 537th auction at the Dorotheum, Vienna, on September 12, 1957 (no. 106); through Christie's, London, July 17, 1970 (no. 177, illus.); and through Brandt's, Amsterdam, November 14, 1972 (no. 13). Its present location is unknown. The painting, which, according to the sales catalogue, bears traces of a signature on the column at the right, is a close copy or replica of the Cleveland painting, in which no traces of a signature have been found (the catalogue of the 1955 exhibition in Amsterdam erroneously mentions that it was signed). No. 19 varies slightly from the Cleveland painting in some details of composition (e.g., it does not include the broken glass in the foreground); its execution is not as refined, nor are the facial features and expressions as subtle as those in our painting.

The Cleveland painting can be identified as no. 19a of the typewritten supplement, even though there are slight differences in the measurements given there (71.5 x 94 cm).

No. 20, which is signed with a monogram, has been identified as the painting sold at Christie's on July 7, 1972 (no. 95), to Alan Jacob, who in turn sold it to a private collector in London (see *Connoisseur*, October 1972, p. 3, color illus.). In this smaller variant of the Cleveland composition Steen added to the foreground a young page who is seen from the back (Lurie, 1965, p. 100, n. 6, fig. 7, originally believed this painting to be the copy from the London sale of 1919 to which Hofstede de Groot refers under no. 20 of his supplement).

Nos. 20a, 20b, and 21 in Hofstede de Groot's *Catalogue*, and 21a, 21b, 22a, and 22b in his supplement have not been identified.

Steen's figure of King Ahasuerus reflects comparable figures by Rembrandt, such as King Belshazzar in *Belshazzar's Feast*, from the 1630s (National Gallery, London). Stylistically, our painting is closely related to others of Steen's late Haarlem period, such as his *Banquet of Anthony and Cleopatra* (Rolsaal, Binnenhof, The Hague, on loan from Dienst voor's Rijks Verspreide Kunstvoorwerpen), his smaller version of *Belshazzar's Feast* at Göttingen (Gemäldesammlung der Universität), dated 1667, and his *Samson and Delilah* (private collection, the Netherlands), dated 1668. In all these, Steen lavishes opulent colors and textures on his main figures, which he contrasts with the somber browns of shadowed backgrounds. In nearly all of them, Steen singles out a few still-life props for careful description, often displaying them in the immediate foreground. A T L

EXHIBITIONS: Leyden, Museum de Lakenhal, 1926: Jan Steen, cat. no. 37; Amsterdam, Rijksmuseum, 1929: Tentoonstelling van Oude Kunst, cat. no. 140; Amsterdam, Rijksmuseum, 1939: Bijbelse Kunst, cat. no. 60f; Delft, Prinsenhof, 1952: Prisma der Bijbelse Kunst, cat. no. 88, pl. 50; Amsterdam, Douwes Brothers, 1955: Jubileum Tentoonstelling, cat. no. 59; Tel-Aviv Museum, 1959: Holland's Golden Age, cat. no. 106; Amsterdam, Douwes Brothers, 1962: The Hundred Best Works of Jan Steen, cat. no. 7; CMA (1973); Milwaukee Art Center, 1976: The Bible through Dutch Eyes, cat. no. 59, illus.; Washington, National Gallery, 1980, Detroit Institute of Arts, and Amsterdam, Rijksmuseum, 1981: Gods, Saints, and Heroes: Dutch Painting in the Age of Rembrandt, cat. no. 85, illus.

LITERATURE: Abraham Bredius, *Jan Steen* (Amsterdam, 1927), p. 29, pl. 7; Willem Martin, "Neues über Jan Steen," *Zeitschrift für Bildende Kunst*, LXI (1927–28), 325; Thieme-Becker, XXXI (1937), 511; Albert Heppner, "The Popular Theater of the Rederijkers in the Work of Jan Steen," *Journal of the Warburg and Courtauld Institutes*, III (1939–40), 42, pl. 4d; *Catalogue of the Paintings, Drawings, and Miniatures in the Barber Institute of Fine Arts, University of Birmingham* (Cambridge, 1952), p. 102; Pigler (1956), p. 203; Fred A. van Braam, ed., *World Collectors Annuary*, XII (1960), 440, no. 4961; *Weltkunst*, XXXII (April 1962), 17; "Notable Works of Art Now on the Market," *Burlington Magazine*, CVI (1964), 303, color pl. I; Ann Tzeutschler Lurie, "*Esther, Ahasuerus, and Haman*," CMA *Bulletin*, LII (1965), 94–100, color illus. p. 93, and fig. 9; *Selected Works* (1966), no. 166, illus.; Baruch D. Kirschenbaum, *The Religious and Historical Paintings of Jan Steen* (New York, 1977), pp. 13, 48, 50, 66, 70, 78, 80, 88, 119 cat. no. 19a, 252, and fig. 74; CMA *Handbook* (1978), illus. p. 162.

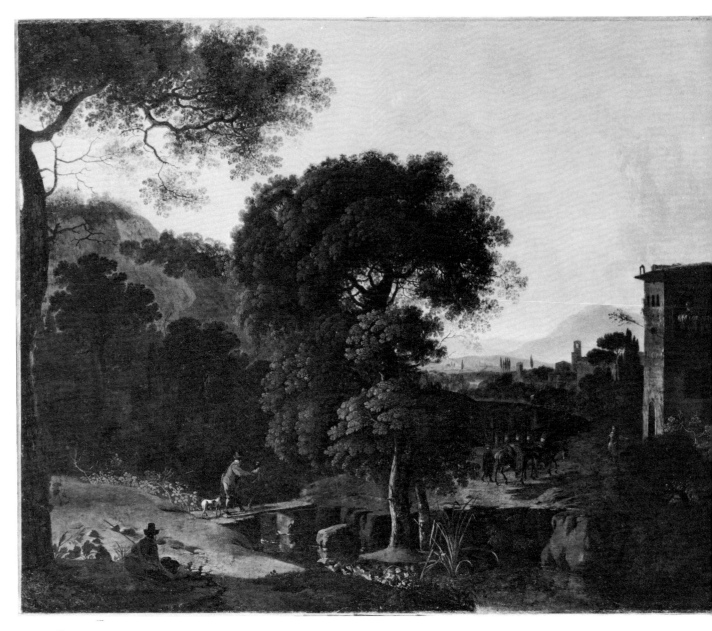

Figure 122.

HERMAN van SWANEVELT
Ca. 1600–1655

Swanevelt was born in Woerden, near Utrecht, ca. 1600. In 1623 he was in Paris. By 1624 he was in Rome with a number of other artists from the North who had come to live and work there. In 1627 he and Claude Lorrain were living in the same house. He moved in 1629, but remained in Rome until ca. 1640. He visited Woerden repeatedly during the 1640s. From 1644 on, he was active mainly in Paris. In 1651 he was named Peintre Ordinaire du Roy and a member of the Academy. Swanevelt died in Paris in 1655.

Swanevelt and Claude Lorrain seem to have influenced each other: one painting by Swanevelt, *Campo Vaccino*, of 1631 (Cambridge, Fitzwilliam Museum), served as a model for the same subject by Claude; and Swanevelt's *The Departure of Jacob*, of 1630 (The Hague, Bredius Museum), anticipates some features of Claude's mature style. Swanevelt's work was uneven in quality, but it was influential in the development of classical landscape painting in the North.

122 *Landscape with Travelers* 16.823

Canvas, 74.9 x 94.8 cm.

Collections: James Jackson Jarves, Florence, after 1872; Mrs. Liberty E. Holden, Cleveland, 1884.

Holden Collection, 1916.

The picture was cleaned by William Suhr in 1938. The paint film was found to be in excellent condition, and many of the fine details were revealed when the dirt was removed. In 1973 Joseph Alvarez cleaned the painting again, removing dirty varnish and overpaint on the sky and distant mountains. Small losses around the edges were attenuated.

At some time in the past the false signature of Claude Lorrain was put on this painting, and it was purchased as the work of that artist by Jarves (Exh: 1883). Though some scholars had questioned the attribution to Claude, it was generally accepted until Henry S. Francis (1946) published the painting as by Swanevelt.

A very similar composition in the Glasgow Art Gallery (no. 428) is listed in their catalogue of 1961 (I, p. 133) as by an imitator of Swanevelt, a "variant, and quite possibly a later adaptation" of the Cleveland picture, which was probably painted in the early 1630s. W S

EXHIBITIONS: Boston (1883), cat. no. 413; Cleveland (1894), section A, cat. no. 1; CMA (1916), cat. no. 45; CMA (1936), cat. no. 217 (as Claude); Ann Arbor, University of Michigan Museum of Art, 1964: Italy through Dutch Eyes, cat. no. 55; CMA (1973).

LITERATURE: Jarves (1884), cat. no. 42 (as Claude); Rubinstein (1917), cat. no. 45, p. 40 (as Claude); René Brimo, *L'Evolution du goût aux Etats-Unis d'après l'histoire des collections: Art et goût* (Paris, 1938), p. 67 (as Claude); Henry S. Francis, "*Roman Campagna near Tivoli* by Claude Gellée de Lorrain," CMA *Bulletin*, XXXIII (1946), 179– 80, illus. p. 191 (as Swanevelt); Coe (1955), II, 91, no. 36; *Dutch and Flemish, Netherlandish and German Paintings* [Glasgow Art Gallery and Museum], I (Glasgow, 1961), 133.

HENDRICK TERBRUGGHEN
1588–1629

Terbrugghen was born to a wealthy Catholic family in the province of Overijssel, near Deventer, in 1588. During his infancy the family moved to Utrecht. Terbrugghen was apprenticed to Abraham Bloemaert. In 1604, at little over fifteen years of age, he left for Italy, arriving there when Caravaggio was still in Rome. Ten years later, in 1614, he returned to the Netherlands and established his permanent home in Utrecht. He became a member of the guild of St. Luke between 1616 and 1617. Nothing is known of his artistic career in Rome, except that he was affiliated there with the Marchése Giustiniani (Roberto Longhi, "Ter-Brugghen e la parte nostra," *Vita artistica*, June 1927, p. 11). In a letter written to the marchése, Teodor Amideni refers to the artist as Enrico, possibly the Enrico d'Anversa who is mentioned in Vincenzo Giustiniani's inventory of 1638 (under nos. 150 and 151) as the author of two large, similar paintings, one of *St. Peter* (at night, warming himself by a fire), and the other of *Christ at the Column* (Luigi Salerno, "The Picture Gallery of Vincenzo Giustiniani, II: The Inventory, Part I," *Burlington Magazine*, CII, 1960, 101).

Terbrugghen's works, particularly during the early 1620s, show decisive impressions from Caravaggio's style and subjects, although his predilection for daylight and luminous colors sets him apart from the other Northern Caravaggisti. His paintings also reflect the influence of his teacher, Bloemaert, through whom he was exposed to the works of Lucas van Leyden and Albrecht Dürer. His style and colors confirm a personal contact with other masters who were active in Rome at the time of his sojourn, among them Carlo Saraceni, Adam Elsheimer, and Orazio Gentileschi. Because there are certain affinities between Terbrugghen's and Serodine's work after 1620, a second journey to Italy has been postulated, but scholars do not agree on its date or circumstances.

Canvas, 125 x 101.6 cm. Signed and dated upside down on open book: H TBrugghen 1621.

Collections: Sir Watkin Williams-Wynn, Wynnstay, Denbighshire, Wales (sale: Wyngetts Auction Galleries, Wrexem, Wales, May 12, 1971, cat. no. 489, as "Anonymous: *Man Reading with Human Skull at Side*"); [Trafalgar Galleries, London].

Mr. and Mrs. William H. Marlatt Fund, 1977.

The general condition of the painting at present is good. The original fabric with tacking margins let out has been strip-lined along all edges; there is no overall lining fabric. X radiographs and infrared photographs reveal no areas of major loss or damage. There are no pentimenti.

In composition and style the picture is closely related to the paintings of the four Evangelists at Deventer (City Hall), which Terbrugghen also painted in 1621 (Nicolson, 1958, pp. 61–62, cat. nos. A 21–A 24, pls. 16–19); these, in turn, are strongly influenced by similar figures by Caravaggio. Of the four paintings, the *St. Mark* is closest in composition to *Heraclitus*, and even includes a skull on the table. Like Caravaggio, Terbrugghen made use of light in a darkened room to accentuate gestures, forms, and textures, and, like Caravaggio, he draped his figures in ample folds of heavy cloth which spill into the spectator's space. Each of the four Evangelists and Heraclitus are seated at a table before an open book, but Heraclitus, unlike the others, neither reads nor writes. He meditates. Unlike the others, he is separated from the spectator by a pronounced table edge. The silence

of the setting is disturbed only by the emphatic gesture of the hand pointing to the skull.

While the *Weeping Heraclitus* combines echoes from Caravaggio's *St. Jerome*, in the Borghese Gallery, and impressions from the artist's Flemish heritage, Terbrugghen was especially indebted to Dürer for his depictions of St. Jerome in the engravings of 1511 and 1514, and particularly in the powerful painting of 1521 (National Museum, Lisbon). The painting was a product of Dürer's sojourn to the Netherlands, and it, too, depended on Flemish examples (such as Quentin Massys's *St. Jerome*, Kunsthistorisches Museum, Vienna). Though Terbrugghen was also familiar with Marinus van Roymerswaele's transcription of the Dürer painting, his Heraclitus seems much closer to Dürer's original, precisely because of the Flemish aspects of the two works— the emphatic gestures and the blemishes of old age in hands and faces (Lurie, 1979, p. 283).

The painting was first published by Benedict Nicolson in 1973 as a signed and dated work by Terbrugghen. At that time, the painting belonged to the Trafalgar Galleries, London, having been acquired from the sale of the famous Watkin Williams-Wynn collection in Wales. It is most certainly the painting that was listed in a Wynnstay inventory as *Translating the Bible*, a title that indicates the subject was thought to be St. Jerome, the earliest translator of the Bible into Latin. Nicolson, however, identified the painting as the *Weeping Heraclitus*, believing that the artist consciously intended to associate Heraclitus with St. Jerome, for he shows him here with a skull, the traditional attribute of St. Jerome, instead of the globe with which Heraclitus and his laughing counterpart, Democritus, are more familiarly associated.

There is support for Nicolson's identification in another painting by Terbrugghen, an autograph double portrait of Heraclitus and Democritus (Figure 123a) that was formerly in the Ole Olson collection and is now in the Ginsberg collection, South Africa. In this double portrait Heraclitus appears exactly as in the Cleveland picture, except that he is shown with a terrestrial globe instead of a skull. But even though the images are duplicates, the Cleveland picture, as Nicolson (1973) observed, is certainly not a truncated copy of the double portrait, for there are no pentimenti to indicate the switch from a globe to a skull.

Portrayals of the two philosophers—one laughing, one weeping, representing two opposite world views—began to emerge during the Italian Renaissance, and in the early part of the seventeenth century became very popular in the North, where religious, humanistic moralizers exploited the subject for lessons on the folly and vanity of mankind. In Terbrugghen's double portrait, the *vanitas* idea is emphasized by scenes of carousing couples shown in simulated polychrome high relief on the globe. (For further discussion of the moralistic uses of the two philosophers, see Werner Weisbach, "Der sogenannte Geograph von Velazquez und

Figure 123a. *Double Portrait of Heraclitus and Democritus.* On canvas, 93 x 111 cm. Terbrugghen. Ginsberg Collection, South Africa.

Figure 123.

die Darstellungen des Demokrit und Heraklit," *Jahrbuch der Preussischen Kunstsammlungen*, XLIX, 1928, and A. Blankert, "Heraclitus en Democritus," *Nederlands Kunsthistorisch Jaarboek*, XVIII, 1967). Dutch artists usually portrayed the two philosophers in genre-like fashion, treating the two extremes of mirth and dejection as equally foolish. While Terbrugghen himself painted them in a similar manner in his pendant portraits of 1628 (Rijksmuseum, Amsterdam), his St. Jerome-like Heraclitus is strikingly different from such representations.

Undoubtedly, Terbrugghen's figure was inspired by an image suggested to the artist through the book *The Christian Heraclitus* by Pierre de Besse (published in 1612 in Lyons and translated into Latin in Cologne in 1614 by Enricus Cuckius). Written in defense of the Sacrament of Penitence, which had been criticized by Luther and was later rejected by Calvin, the book was naturally of great interest to Terbrugghen, a Catholic. De Besse, like many other religious moralizers of the time, made use of an analogy between an ancient and a modern image, namely, the ancient Greek philosopher Heraclitus, who wept over the follies of the world, and the Christian St. Jerome, who wept over his own sins. De Besse's two protagonists were both eminent scholars who retreated from the mundane world, one in search of enlightenment about the nature of knowledge, the other seeking the knowledge of the ancients for use in his defense of Christian morals. Two engravings by Léonard Gaultier (1561-ca. 1630 to 1641) in de Besse's book visually reinforce the association of Heraclitus with St. Jerome: in one, the ancient philosopher is shown weeping, the globe at his feet; in the other, the penitent, weeping St. Jerome is shown with his female counterpart, St. Mary Magdalene. In Terbrugghen's *Weeping Heraclitus* St. Jerome and Heraclitus become one. Certainly de Besse could not have wished for a better single embodiment of the ancient, gloomy philosopher and the scholarly saint. A T L

EXHIBITIONS: London, Trafalgar Galleries, 1976: In the Light of Caravaggio, cat. no. 6 (as *St. Jerome in Contemplation, a Skull, Book, and Bone on the Table before Him*); CMA, January 1978: Year in Review, cat. no. 45, illus.

LITERATURE: Unpublished inventory of the ancestral home of Sir Watkin Williams-Wynn, no. 72, under the Turnery, as anonymous portrait bust entitled *Translating the Bible* (National Library of Wales, Dyfed, Wynnstay W/37); Benedict Nicolson, *Terbrugghen since 1960*, in *Album Amicorum J. G. van Gelder* (The Hague, 1973), pp. 240–41 n. 20, fig. 14; *Trafalgar Galleries at the Royal Academy, London: Old Master Paintings* (exh. cat., London, 1977), under no. 29, fig. 7; CMA *Handbook* (1978), illus. p. 153; Ann Tzeutschler Lurie, "*The Weeping Heraclitus* by Hendrick Terbrugghen in The Cleveland Museum of Art," *Burlington Magazine*, CXXI (1979), 279–87, figs. 1 (color cover) and 2; Nicolson, *The International Caravaggesque Movement; Lists of Pictures by Caravaggio and His Followers throughout Europe from 1590 to 1650* (Oxford, 1979), pp. 98–99 (as *St. Jerome Contemplating a Skull*).

ADRIAEN VAN DE VELDE
1636–1672

Adriaen van de Velde was born in Amsterdam in 1636. He was the son of the ship designer and draftsman of ships and sea battles Willem van de Velde the Elder (1611–1693) and the brother of the marine painter Willem van de Velde the Younger (see Painting 125). He is reported to have been a pupil of Jan Wijnants in Haarlem, although he owed a greater debt to Philips Wouwerman (see Painting 130) and Paulus Potter. He probably never visited Italy, but his pastorals of about 1656 contain a number of Italianate motifs. He was frequently employed by other artists—including Jacob van Ruisdael, Meindert Hobbema, Jan Wijnants, and Jan van der Heyden—to add figures to their landscape paintings. He died in 1672 at the age of thirty-five.

124 *Landscape with Sleeping Shepherdess* 66.12

Panel (oak), 22.7 x 27.5 cm. Signed at lower right: A.V. Velde 1663.

Collections: F. W. Lippman, London (sale: July 8, 1911; information from Henry McIlhenny); John Dexter McIlhenny, Philadelphia (sale: Parke-Bernet, New York, June 5, 1946, no. 500); Arthur C. Tate; [Schaeffer Galleries, New York].

Mr. and Mrs. William H. Marlatt Fund, 1966.

There are slight pentimenti on the drapery edge, at the left of the tree. The paint is in good condition except for some retouching in the blue sky at the upper left and a slight reinforcement of the shadow on the skirt, above the knee.

Dated 1663, the Cleveland painting is a fine example of the artist's work. A close parallel of the same date is the *Noonday Rest*, in The Wallace Collection, London (Figure 124a), which has many of the same elements—sleeping figures; resting animals; and even the figure of a sower in the background, outlined against the sky. Unlike the Cleveland painting, the Wallace painting has a somewhat Italianate distant view. J K C

EXHIBITIONS: Philadelphia, Pennsylvania Academy of Fine Art, 1917: Loan Exhibition of the John D. McIlhenny Collection, cat. no. 51; CMA (1966), cat. no. 67, illus. p. 211.

LITERATURE: Wolfgang Stechow, "A Painting and a Drawing by Adriaen van de Velde," CMA *Bulletin*, LIV (1967), 31–33, color illus. p. 29; CMA *Handbook* (1978), illus. p. 162.

Figure 124.

Figure 124a. *Noonday Rest*. On panel,
30.5 x 41 cm. Adriaen van de Velde.
Reproduced by permission of the Trustees
of The Wallace Collection, London.

281

WILLEM van de VELDE II
1633–1707

Willem was born in Leyden in 1633. His father was Willem van de Velde I, a marine painter, and his younger brother was Adriaen, also a painter (see Painting 124). Willem studied in Weesp with Simon de Vlieger, whose influence can be seen in subsequent works. He returned to Amsterdam in 1652. He and his father left Amsterdam after the French invasion of 1672 and moved to England, where both were taken into the service of Charles II, the father specifically appointed to do drawings of ships, and the son to do paintings (*The Walpole Society*, XXVI, 1938, 75). The two remained in England, making only brief visits to Holland. They lived in Greenwich until 1691, when they moved to Westminster. Willem the Elder died at Westminster in 1693, and Willem the Younger died there in 1707.

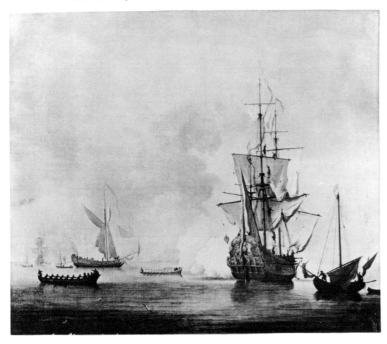

Figure 125a. *Seascape with Man-of-War Firing a Salute.* 62.2 x 75 cm. Peter Monamy or his studio. Present whereabouts unknown.

125 Seascape with Man-of-War 75.80
Firing a Salute

Canvas, 63.7 x 77.5 cm. Signed and dated at bottom left center: W. V. Velde J. 1690.

Collections: Charles Calvert, Fifth Lord Baltimore (1699–1751); Frederick Calvert, Sixth Lord Baltimore (1731–1771); Henry Harford, 1771; Frederick Paul Harford, Down Place, Windsor, 1835; Colonel Frederick Harford, Down Place, Windsor, 1860 (sale: Christie's, London, June 27, 1885); Rufus L. Patterson, New York; [Norton Galleries, New York]; Mr. and Mrs. Noah L. Butkin, Cleveland, 1968.

Gift of Mr. and Mrs. Noah L. Butkin, 1975.

The painting is in generally good condition. There are small retouchings in the sky, and there is some strengthening of details on the bow of the boat at the lower left, on the bowsprit of the yellow boat, on the figure in the yellow boat, and on the masts of the distant boats at the lower left.

In this scene a small English ship, becalmed at anchor, fires a salute as a state barge sails away. M. S. Robinson of the National Maritime Museum in London (letter of July 29, 1970) speculated that the ship in the Cleveland picture was one of three sixth-rate English ships built in the 1670s: the "Lark," the "Greyhound," or the "Saudadoes." He pointed out the similarity between the stern of the ship in the painting and the stern of the "Saudadoes" in a drawing in the collection of the National Maritime Museum, although there are also notable differences. Robinson also cited another version of the scene (Figure 125a), formerly in the Devitt collection (sale: Christie's, London, May 16, 1924, no. 167), which he believes to be inferior to our painting. He pointed to the unconvincing way the boat sits on the water and to the spidery figures that are typical of works by Peter Monamy (1689 [or 1670?]–1749) or his studio (draft for proposed catalogue of paintings by the van de Veldes, courtesy of M. S. Robinson).

In addition to the Cleveland painting, there are two others by Willem the Younger dated as late as 1690; both are in the Vienna Akademie (nos. 788 and 792; Robert Eigenberger, *Die Gemäldegalerie der Akademie der Bildenden Künste in Wien*, Vienna and Leipzig, 1927, II, 155–56, illus.). JKC

EXHIBITIONS: CMA (1973); CMA, February 1976: Year in Review, cat. no. 63, illus. p. 40.

LITERATURE: None.

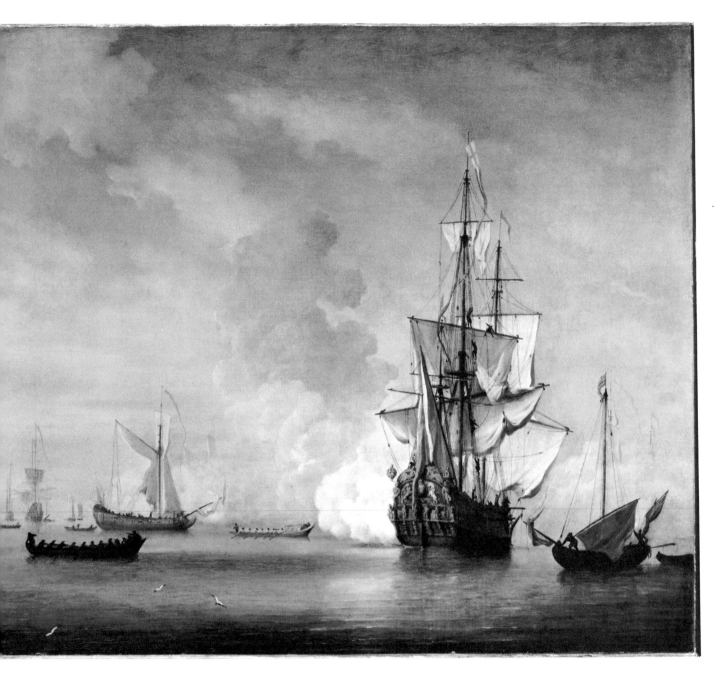

Figure 125.

SIMON DE VLIEGER
Ca. 1600–1653

De Vlieger was born in Rotterdam; the year of his birth is not known. He was married in 1627 (P. Haverhorn van Rijsewijk, "Simon Jacobsz. de Vlieger," *Oud Holland*, XI, 1893, 229). In 1634 he became a member of St. Luke's Guild in Delft. Records show that he lived in Amsterdam from 1638 to 1648 and that he became a citizen in 1643. From 1649 he resided in the town of Weesp, about ten miles from Amsterdam. Willem van de Velde II was his pupil. De Vlieger died in Weesp in 1653.

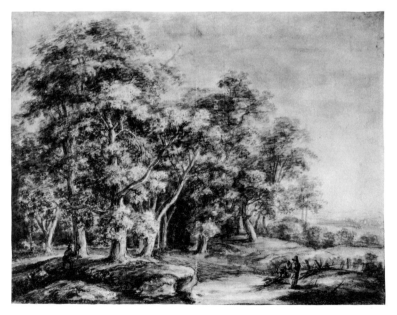

Figure 126a. *Wooded Landscape.* Black chalk, brush, heightened with white, 29 x 39.5 cm. De Vlieger. Staatliche Museen Preussischer Kulturbesitz, Kupferstichkabinett, Berlin.

126 Wooded Landscape with Sleeping Peasants (Parable of the Sower)
75.76

Canvas, 90.4 x 130.4 cm. Signed and dated at lower left on the plow: S. DE VLIEGER 165[?].

Collections: Honorable Frederick George Lindley Meynell; Captain Charles Meynell, R. N. (sale: Sotheby's, London, March 27, 1974, no. 7, pl. 7); [Frederick Mont, New York].

Mr. and Mrs. William H. Marlatt Fund, 1975.

The painting was cleaned and retouched by a Dr. Blummel in 1974. It was also lined recently. A vertical tear in the canvas at the top left center has been repaired. Numerous small, scattered losses and one larger loss (about four centimeters in diameter, on the lower part of the tree trunk) were filled and inpainted. Otherwise, the surface is in excellent condition.

Not many of de Vlieger's paintings are dated. His earliest-dated work is a stormy seascape, *Rescue*, of 1630 (present whereabouts unknown; Wolfgang Stechow, *Dutch Landscape Painting of the Seventeenth Century*, London, 1966, fig. 204), and the latest is a genre scene, *Falconer's Homecoming* (Amsterdam, Rijksmuseum), painted in 1653, the year he died. The *Falconer's Return*, dated 1637 (Rijksmuseum), shows some borrowing from Rembrandt, but this was not a lasting influence. Most of de Vlieger's paintings are seascapes or river scenes. The early paintings show the influence of Jan Porcellis (1584–1632); the later works, of Jan van de Cappelle (ca. 1624–1679).

Only a few wooded landscapes by de Vlieger are known: *Entrance to a Forest*, Rotterdam, Museum Boymans-van Beuningen (Stechow, *op. cit.*, fig. 133); *Landscape with River and Trees*, Budapest, Museum of Fine Arts (Agnes Czobor, *Dutch Landscapes*, Budapest, 1967, pl. 33); and *Wooded Landscape*, Stockholm, Nationalmuseum. The Cleveland painting is the only one of this group with a date, but unfortunately the last digit cannot be read.

A wooded landscape in the Liechtenstein collection (no. 414; listed in Alfred von Wurzbach, *Niederländisches Künstler-Lexikon*, Vienna and Leipzig, 1910, II, 803) had a false de Vlieger signature and date painted over the signature of another artist (Stechow, *op. cit.*, p. 199, n. 20).

The subject of the Cleveland painting is taken from Matthew 13:24–30, which tells how bad seed is sown with the good while the sowers sleep. The painting is quiet in mood and offers a harmonious vision of nature—quite different from the turbulence of many of de Vlieger's sea pictures.

De Vlieger also used landscape as a subject in a series of etchings and some drawings, none of which is dated. Two of the drawings, one in Berlin (Figure 126a) and another in Hamburg (Kunsthalle, no. 22657), are especially close in style to his landscape paintings. JKC

EXHIBITIONS: CMA, February 1976: Year in Review, cat. no. 64, illus. p. 40.

LITERATURE: CMA *Handbook* (1978), illus. p. 156.

284

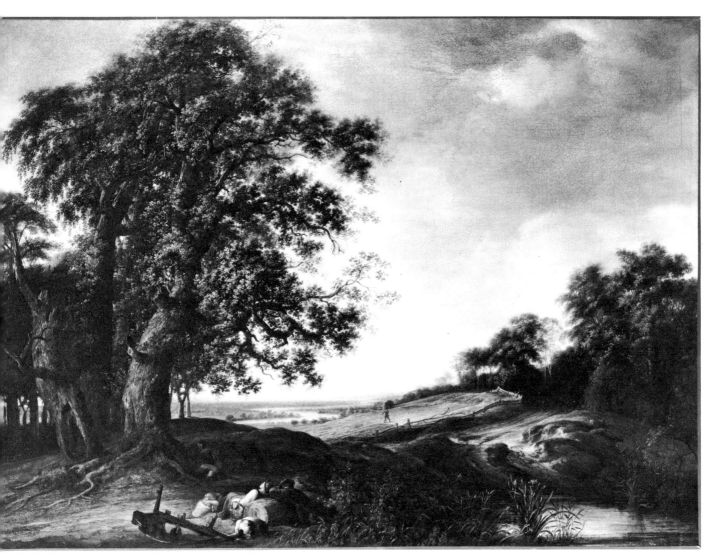

Figure 126.

JAN BAPTIST WEENIX
1621–1660

Weenix was born in Amsterdam in 1621; he was the son of an architect. According to Houbraken, he studied with Jan Micker (ca. 1598–1664) in Amsterdam, with Abraham Bloemaert (1564–1651) in Utrecht, and with Nicolaes Moeyaert (1592/3–1655) in Amsterdam (A. Houbraken, *De Groote Schouburgh der Nederlantsche Konstschilders en Schilderessen*, II, reprint ed., Maastricht, 1943, 61–65). About 1639 he married Josina d'Hondecoeter, who bore him two sons; Jan, the elder son, born in 1642, became a painter, best known for his still lifes. From 1643 to 1647 Weenix was in Rome. He received the patronage of Cardinal Giovanni Battista Pamphili, who became Pope Innocent X in 1644. In Rome Weenix belonged to the Dutch Schildersbent, or painters' guild, a notoriously boisterous social and professional organization that attracted Dutch artists who specialized in Italian landscape paintings. By 1647 he had returned to Amsterdam, where he began to produce the Italianate coastal scenes that form the bulk of his oeuvre, as well as still lifes and occasional portraits. He appeared in Utrecht in 1649 and was elected a director of the Utrecht painters' guild along with Cornelis Poelenburgh (ca. 1595–1667) and Jan Both (1618–1652), both of whom had also been prominent in the painters' guild in Rome. Weenix remained in Utrecht for the rest of his life. He died at his home, Huys ter Mey, near Utrecht, at the age of thirty-nine.

127 *Hunting Party Resting among Ruins on the Italian Coast* 64.294

Canvas, 98.8 x 129.2 cm. Signed and dated at bottom left: Gio. Batt. Weenix 164[6 or 8].

Collections: Duc de Choiseul-Praslin, Paris (sale: Paillet, Paris, February 18–25, 1793, no. 102); Marquis of Montcalm, Montpellier (sale: Laneuville, Paris, March 25, 1850, no. 28); Piérard collection, Paris (sale: Laneuville, Paris, March 20–21, 1860, no. 95); Bourlon de Sarty collection, Paris (sale: Hôtel Drouot, Paris, March 9–11, 1868, no. 20); (sale: Hôtel Drouot, Paris, February 2, 1883, no. 25); [Galerie Heim, Paris]; Mr. and Mrs. Severance Millikin, Cleveland, 1964.

Severance and Greta Millikin Collection, 1964.

The painting is marked by damage in a number of areas. X radiographs reveal major losses at the bottom right, along all the edges, and in scattered spots throughout. There is considerable overpaint, especially in the sky, which is disturbingly mottled in appearance. Visual and technical evidence indicates that the painting was transferred from its original support at some point.

The painting almost certainly dates from 1648, immediately after Weenix's return from Rome, and not 1646, when he was still in Rome. Almost no work survives from Weenix's years in Rome. The Cleveland painting is related to others he painted in Amsterdam following his return.

The theme and setting are typical of the Italian subjects painted by Dutch artists at this time, usually from drawings and sketches made during an Italian sojourn.

Motifs and still-life elements occur again and again in Weenix's paintings, as if drawn from a single source; for example, the architrave corner and three columns seen in our picture also appear in *Mother and Child on the Italian Seashore* (Staatlichen Gemäldegalerie, Kassel, no. 376) and, viewed from another angle, in *On the Seashore* (The Wallace Collection, London).

The figure group in the Cleveland painting is enlivened by exotic costuming and suggestions of narrative action, such as the gesticulations of the groom behind the lead rider, and the figure in Levantine garb who is about to be drawn into a discussion. There was considerable interest in Middle Eastern and North African costume in Rome in the 1640s. Such garb is frequently seen in the work of the Dutch Italianate landscapists close to Weenix and in the genre paintings of the Bamboccianti and artists influenced by them, such as G. B. Castiglione (see Painting 144).

The low vantage point, the relatively shallow foreground space, and the dramatic, asymmetrical recession into a vacant background vista are all characteristic of Weenix's compositions. The pale blonde-rose tonality and thin, clear glazes are also typical of Weenix and unlike most of the other Dutch Italianate painters who, inspired by the Campagna paintings of Claude Lorrain (see Painting 31), tended to create a golden, hazy atmosphere in their landscapes.

NCW

EXHIBITIONS: Utrecht, Centraal Museum, 1965: Nederlandse 17e Eeuwse Italianiserende Landschapschilders, no. 97, illus. fig. 100.

LITERATURE: E. Haverkamp-Begemann, et al., *Wadsworth Atheneum Paintings, Catalogue I: The Netherlands and the German-Speaking Countries, Fifteenth–Nineteenth Centuries* (Hartford, Connecticut, 1978), p. 202, n. 3.

Figure 127.

JAN WIJNANTS (Wynants)
Ca. 1630–1684

There is little concrete information on Wijnants's life. Even
his birthdate remains a matter of conjecture based on the
dates of his earliest-known paintings, the chronology of
which is confused by unreliable dates in Hofstede de Groot's
Catalogue Raisonné (VIII). No reasonably sure date before
1654 is known (Wolfgang Stechow, "Jan Wijnants, *View
of the Heerengracht, Amsterdam*," CMA *Bulletin*, LII,
1965, 166). Wijnants was born in Haarlem, probably ca.
1630. He was active in that city from ca. 1650 to 1660.
From there he went to Amsterdam, where he remained until
his death in 1684.

128 *View of the Heerengracht,* 64.419
 Amsterdam

Canvas, 67.6 x 81.9 cm. Signed at lower left: J. Wijnants [with
illegible remains of a date].

Collections: Mrs. Derek Fitzgerald, Heathfield Park, Sussex (sale:
Sotheby's, London, July 3, 1963, no. 17); [Frederick Mont, New
York].

Gift of Harry D. Kendrick, 1964.

The painting is in generally good condition, with only a few
very small losses: two in the sky in the upper right corner,
two tiny losses in the cloud towards the center, one very
small spot above the trees at the left; two small losses in the
middle group of trees; and minor losses along the edges of
the canvas. There are a few, very minor, later additions:
along the left side of the skirt of the bending woman, along
the prow of the boat and in the nearby shadows in the
water, and in the figure standing next to the tree. The can-
vas is lined.

This is the first inner-city view painted by any artist of the
Golden Age; it also seems to be a unique work for Wijnants,
whose subjects were more often dune landscapes or Italian-
ate scenes. The view, from a point near the present Leidsche-
gracht towards the north, shows the Huidenstraat, Wol-
venstraat, and Hartenstraat bridges (according to the Mu-
nicipal Archives of Amsterdam, through A. van Schendel,
Director of the Rijksmuseum). The two houses on the left
are presently numbered Heerengracht 374 and 372; the
fenced-off lot is now occupied by four houses built in 1662
by Philipps Vingboons for Jacob Cromhout (present nos.
370, 368, 366, 364; J. G. Wattkes and F. A. Warners,
Amsterdams Bouwkunst en Stadschoon, 1306–1942, Am-
sterdam, 1944, p. 225, fig. 492).

This work can be dated between 1660, when Wijnants
arrived in Amsterdam, and 1662, when the four houses
were erected. It is highly improbable that the figures are by
Wijnants's hand, since his staffage was customarily painted
by other artists—among them, Johannes Lingelbach and
Adriaen van de Velde. W S

EXHIBITIONS: CMA, December 1964: Year in Review, cat. no. 100;
CMA (1973); Amsterdams Historisch Museum (Amsterdam) and Art
Gallery of Ontario (Toronto), 1977: The Dutch Cityscape in the 17th
Century and Its Sources, cat. no. 136, p. 244.

LITERATURE: Wolfgang Stechow, "Jan Wijnants, *View of the Heeren-
gracht, Amsterdam*," CMA *Bulletin*, LII (1965), 164–73, color illus. pp.
168–69; I. H. v. E[eghen], "De vier huizen van Cromhoult," *Amstelo-
damum*, LIII (1966), 52–59, illus. p. 58; Stechow, *Dutch Landscape Paint-
ing of the Seventeenth Century* (London, 1966), p. 127, fig. 254A; Helga
Wagner, *Jan van der Heyden 1637–1712* (Amsterdam and Haarlem,
1971), pp. 23–24, n. 55; H. de la Fontaine, I. H. van Eeghen, et al., *Vier
Eeuwen Herengracht* (Amsterdam, 1976), p. 134, fig. 22; CMA *Hand-
book* (1978), illus. p. 161.

Figure 128.

EMANUEL DE WITTE
1617–1692

Emanuel de Witte entered the guild in Alkmaar, the city of his birth, in the year 1636. By July 1639 he was in Rotterdam. It is presumed that by 1641 he was living in Delft, for records show his daughter was baptized there in that year. He became a member of the Delft guild in 1642. He moved to Amsterdam sometime between 1650 and 1654. It is not known who his teacher was. He began as a painter of mythological subjects. Later he painted portraits (a pair dated 1648 is in Rotterdam, Museum Boymans-van Beuningen, nos. 517a, b), and from 1650 on, he painted church interiors, some market scenes, domestic interiors, and harbor views. By the time de Witte entered the field of architectural painting, it was a well-established tradition, based on works of Pieter Saenredam (1597–1665). De Witte's contribution was to move away from the cool, objective architectural portraits of his predecessors and to paint convincing representations of church interiors endowed with a unique mystery and tranquility. The peace and quiet warmth of these paintings seem incongruous against the background of his personal life. De Witte was an atheist, disputatious in temperament, and disorganized in financial matters. He lived in precarious circumstances, burdened with financial and family problems. After 1660, separated from his second wife and stepdaughter, he contracted to exchange his art work for his keep plus an allowance. He lived in Amsterdam until the winter of 1692, when he committed suicide.

129 *Protestant Gothic Church* 71.1
with Motifs of the Oude Kerk in Amsterdam

Canvas, 62 x 54 cm.

Collections: Theodor Stroefer, Nuremberg (sale: Julius Böhler, Munich, October 28, 1937, no. 122, pl. 51); private collection, Berlin; Eduard Plietzsch, Berlin; Curt Bohnewand, Rottach-Egern; [Steinmeyer, Munich, 1953]; [Schaeffer Galleries, New York].

Mr. and Mrs. William H. Marlatt Fund, 1971.

Ultraviolet light revealed several areas of later paint: a vertical strip over a crack in the paint on the left column of the central pier, extending from the middle hatchment down the column; at the top of the center column of the same pier; over the left capital of the arch before the north transept; and in the ceiling of the transept. Otherwise, the paint layer is intact under layers of varnish.

The church in the Cleveland painting has some features of the Oude Kerk in Amsterdam—the compound piers, the vaults, and the broad window of the north transept—but all are rearranged. A more exact rendering of the same church by de Witte, dated 1659, is in Hamburg (Stechow, 1972, fig. 6). The Hamburg painting typifies de Witte's earlier church interiors in which actual architectural features were followed closely and shown in a clear, even light that cast few shadows. After the 1660s light became increasingly prominent in his compositions, and architectural exactitude became less important. From the late 1670s to the early 1680s de Witte simplified his compositions somewhat by taking in less depth, with fewer architectural elements. He then concentrated on interplaying shafts of light which form complex patterns over the surfaces. The Cleveland painting has stylistic characteristics in common with other works from ca. 1680 (Manke, 1963, especially figs. 92, 103; and Stechow, 1972, pp. 232, 234), and should be placed among them. JKC

EXHIBITIONS: CMA, January 1972: Year in Review, cat. no. 57; CMA (1973).

LITERATURE: *Weltkunst*, VIII (September 12, 1937), 3; Eduard Trautscholdt, in Thieme-Becker, XXXVI (1947), 125; Ilse Manke, *Emanuel de Witte* (Amsterdam, 1963), p. 105, no. 114, fig. 84; Wolfgang Stechow, "A Church Interior by Emanuel de Witte," CMA *Bulletin*, LIX (1972), 228–35, fig. 1; CMA *Handbook* (1978), illus. p. 157.

Figure 129.

Figure 130.

PHILIPS WOUWERMAN
1619–1668

Philips Wouwerman was the son of a painter, who was also his first teacher. He was born in Haarlem and later studied there with Pieter van Laer and Pieter Verbeecq, a painter of horses. In 1638 Wouwerman went to Hamburg, where he married a Catholic. He returned to Haarlem in 1640 and that same year entered the Haarlem painters' guild. As far as is known, he never traveled to Italy; the hints of Italianate style in his work must be the influence of other Dutch painters who had—Pieter van Laer, for one. He is credited with hundreds of works. He is also known to have collaborated with other artists, such as Ruisdael, Cornelius Decker, and Jan Wijnants, painting figures in their landscapes. Wouwerman died in his native Haarlem in 1668.

130　*Dune Landscape with Figures*　67.124

Panel (oak), 41.5 x 31.5 cm. Signed at lower left with monogram.

Collections: Gerard Braamcamp, Amsterdam (sale: Van der Schley ... Yver, Amsterdam, July 31, 1771, no. 287); Carlos Adler, Buenos Aires; [Frederick Mont, New York].

Mr. and Mrs. William H. Marlatt Fund, 1967.

There are small, very light abrasions along the upper right edge of the painting. Except for three minor retouches in the sky, the picture is in excellent condition.

Wouwerman's work consists primarily of genre scenes in landscape settings, most of them with horses and horsemen —engaged in battles, at encampments, on hunts, in smithies, or in riding schools. Hofstede de Groot listed more than a thousand such pictures, as well as about two hundred landscapes. The latter are the more memorable works, some of them evoking a mood of loneliness which sets them apart from his boisterous genre works. See, for example, the quietly expressive *Dunes and Horsemen*, dated 1652 (London, Koetser collection; Wolfgang Stechow, *Dutch Landscape Painting of the Seventeenth Century*, London, 1966, fig. 41), and *The White Horse* (Amsterdam, Rijksmuseum); both are close in style to the Cleveland picture.　　JKC

EXHIBITIONS: CMA, December 1967: Year in Review, cat. no. 70; CMA (1973).

LITERATURE: Smith (1829), I, no. 91; Hofstede de Groot (1909), II, no. 1010; René Brimo, *L'Evolution du goût aux Etats-Unis d'après l'histoire des collections: Art et goût* (Paris, 1938), p. 67; Horst Gerson, *De Schoonheid van ons Land*, II (Amsterdam, 1952), 49, fig. 144; CMA *Handbook* (1978), illus. p. 156.

Attributed to JOACHIM ANTHONISZ. WTEWAEL (Uytewael, Wtenwael)
Ca. 1566–1638

Joachim Wtewael was born ca. 1566 in Utrecht. The son of a glass painter, he worked with his father as a draftsman and designer of cartoons for stained glass until the age of eighteen. He studied for two years with Abraham Bloemaert and Joos de Beer, who introduced him to the style of the Fontainebleau Mannerist school. He traveled with Charles de Bourvigneuf, Bishop of St. Malo, spending two years in France and Padua. In Utrecht, from 1592, he belonged to the saddlers' guild, to which artists were relegated. He helped to establish a separate guild for artists, which was founded in 1611. Although probably born a Catholic, he must have become a Protestant by 1595, when he executed his blatantly Protestant and patriotic stained-glass window for the Cathedral of Gouda (C. M. A. A. Lindeman, *Joachim Anthonisz. Wtewael*, Utrecht, 1929, pp. 142–50, pls. lxii, lxv). In 1610 he was briefly a member of the town council and was active in the overthrow of the Remonstrant magistery of Utrecht in 1618. (For a more detailed review of Wtewael's complex religious and political involvements in Utrecht, see Elizabeth McGrath, "Netherlandish History of Wtewael," *Journal of the Warburg and Courtauld Institutes*, XXXVIII, 1975, 209–11). His oeuvre until recently was thought to include works now attributed to his son Peter (see Painting 132; see also Anne Walter Lowenthal, "Some Paintings by Peter Wtewael [1596–1660]," *Burlington Magazine*, CXVI, August 1974, 458–66). Joachim apparently gave up painting about 1630. He died in Utrecht in 1638, a wealthy merchant in the flax-trading business.

131　*Diana and Callisto*　74.106

Canvas, 50 x 70.2 cm.

Collections: [Victor Spark, New York, by 1958]; Mr. and Mrs. Noah L. Butkin, Cleveland, 1972.

Gift of Mr. and Mrs. Noah L. Butkin, 1974.

This painting was partially cleaned by Joseph Alvarez in 1974. The canvas is in generally good condition. A piece of canvas about .6 centimeters wide was cut from the lower horizontal edge sometime in the past, and about 2.5 centimeters of the present lower margin has been repainted. There is scattered repaint in the landscape.

When it was exhibited in 1958, this painting was attributed to Joachim Wtewael, except for the landscape, which was attributed to an unidentified collaborator who worked in the Flemish tradition and was influenced by Gillis van Coninxloo.

Figure 131.

294

In a letter dated January 26, 1973, Anne Lowenthal questioned the attribution to Joachim, pointing out that the small scale of the figures in relation to the landscape was uncharacteristic of his work. She felt, moreover, that the figures were less fluently rendered and appeared to be more muscular than those in Wtewael's signed and dated *Diana and Actaeon* in Vienna, Kunsthistorisches Museum (Figure 131*a*). Later, in a letter of July 6, 1974, Lowenthal revised her opinion, accepting the attribution to Joachim. She compared the Cleveland painting to a *Diana and Actaeon* (Figure 131*b*) in the Bearsted Collection (no. 152) at Upton House, Warwickshire, in which figures that are characteristic of Joachim Wtewael were set in an expansive landscape after the manner of Coninxloo and Vinckboons and in a style very similar to that of the Cleveland painting. Though the figures in the Cleveland painting are somewhat crude, she thought, they are not uncharacteristic in type and pose. She noted also that the dogs, the hunting implements of Diana, and the wispy figures in the background were painted with the artist's usual delicacy. Lowenthal dated the Cleveland painting at the end of the first decade of the seventeenth century. In another letter, dated January 9, 1978, she again revised her opinion, saying that the landscape and the awkward, muscular figures are not typical of Wtewael's style. She then suggested an attribution to Joachim's studio.

Lowenthal's earlier argument in favor of the attribution to Joachim Wtewael seems most convincing and finds further support in a comparison of our painting with Joachim's *Judgment of Paris*, in which there is a similar treatment of figures and landscape (17.2 x 21.9 cm, collection of Major W. P. Kincaid Lennox, Downton Castle, Shropshire; a copy is in the Fitzwilliam Museum, Cambridge, no. 427—see C. M. A. A. Lindeman, *Joachim Anthonisz. Wtewael*, Utrecht, 1929, pl. XXIV). Wolfgang Stechow (letter dated November 29, 1972) also argued for the attribution to Joachim, saying he believed the figures and probably the landscape as well were by Wtewael.

A *Diana and Callisto* by Joachim Wtewael is listed in the inventory of the collection of Seger Tierens, dated 1743 (no. 115; Gerard Hoet, ed., *Catalogus of Naamlyst van Schilderyen, met derzelver pryzen zedert een langen reeks van Jaaren zoo in Holland als op andere Plaatzen in het openbaar verkogt . . .*, The Hague, 1752, II, 104). Other illustrations of poor Callisto's plight were executed by Wtewael's contemporaries, such as Hendrick de Clerck, Paulus Moreelse, Hendrick Goltzius, and Cornelisz. van Haarlem. The theme of Diana and Callisto was very popular from Venice to the Netherlands in the late sixteenth and early seventeenth centuries.

A copy of the Museum painting, without the change at the bottom edge, was in the exhibition The Art of Mannerism at the Arcade Gallery, London, in June 1950 (52.1 x 59.7 cm; cat. no. 29, illus.). NCW

EXHIBITIONS: John Herron Art Museum (Indianapolis) and (San Diego) Fine Arts Gallery, 1958: The Young Rembrandt and His Times, cat. no. 93, illus.; CMA, March 1975: Year in Review, cat. no. 52, illus.

LITERATURE: Anne Walter Lowenthal, "The Paintings of Joachim Anthonisz. Wtewael 1566–1638" (Ph.D. dissertation, Columbia University, 1975; Ann Arbor, Michigan: University Microfilms, 1975), p. 383, no. C-28; CMA *Handbook* (1978), illus. p. 123.

Figure 131*a*. *Diana and Actaeon*. On panel, 58 x 79 cm. Joachim Wtewael. Kunsthistorisches Museum, Vienna.

Figure 131*b*. *Diana and Actaeon*. On panel, 28.6 x 39.4 cm. Joachim Wtewael. Bearsted Collection, Upton House, Edgehill, Warwickshire, England.

PETER WTEWAEL
1596–1660

Peter Wtewael was born in Utrecht in 1596. He was the oldest child of a prominent painter of the Utrecht Mannerist school, Joachim Wtewael (see Painting 131) and his wife, Christina van Halen. Very little is known about his life—there is no evidence that he ever married or traveled beyond his native city. He succeeded his father on the town council in 1636 and later served as an alderman. His name appears frequently in notarial records concerning his family's affairs, and family inventories mention his name. However, it is not known whether any of his paintings in the family collection have survived; if any did, it is possible that they have been confused with his father's works, for not many works by the younger Wtewael are known to us. There is a signed and dated *Caritas* (present whereabouts unknown) which has been published by Poul Gammelbo ("Some Paintings in Danish Collections: An Allegory from 1628 by Peter van Wtewael," *Artes*, II, 1966, 75–76, figs. XXXIV–XXXV). At the present time four signed works and eleven unsigned paintings constitute his known oeuvre (Lowenthal, 1974). His earliest work is the *Adoration of the Shepherds*, dated 1624, now in the Wallraf-Richartz-Museum in Cologne. His style reflects the influence of Caravaggio, through Hendrick Terbrugghen, Gerrit van Honthorst, and Dirck van Baburen, all of whom had returned to Utrecht from Italy by 1624. His known paintings date from the early 1620s to the early 1630s. No later works have been identified as yet. It is possible that he gave up painting for the family business in flax trading, which as Carel van Mander and Joachim von Sandrart both noted, was one of his absorbing interests. He died in Utrecht in 1660, leaving a sizable estate that included many paintings.

132 *The Denial of St. Peter* 72.169

Panel, 28.4 x 45.6 cm. Traces of illegible signature at upper right.

Collections: [L. A. Houthakker, Amsterdam, 1970]; Mr. and Mrs. Noah L. Butkin, Cleveland.

Gift of Mr. and Mrs. Noah L. Butkin, 1972.

This panel was cleaned by Joseph Alvarez in 1972, and in 1976 a new balsa-wood backing was attached by Ross Merrill. Scattered over the surface were horizontal lines of blisters that ran along the wood grain. Tiny losses occurred where paint had flaked off, mostly in the lower left and right corners and around the edges of the panel.

When this painting entered the Museum collection, it was attributed to Joachim Wtewael. The attribution to Peter was made in an important article by Anne Lowenthal (1974) in which she identified Peter's work, apparently for the first time. The concealed light source and the resulting sensitive dramatization shows Peter's awareness of the potential of Caravaggesque chiaroscuro, a clear departure from his father's works.

In another work, his signed and dated (1628) *Last Supper* in Uppsala, Sweden (Figure 132a), Peter also used an open flame for a light source. Other similarities are also observed: upraised hands with spreading fingers are silhouetted against the light, and the dark back of a figure in the center foreground dramatically establishes the picture plane, behind which highlighted figures take their place in an enigmatic space. As Lowenthal (1974) suggested, Peter may have known one of the several versions of the *Denial of St. Peter* by the Antwerp Caravaggist Gerard Seghers, dated about 1620 to 1628 (Richard E. Spear, *Caravaggio and His Followers*, exh. cat., Cleveland, 1971, no. 61), in which half-length figures are arranged around a central figure that serves as a *repoussoir* outlined against the light.

Peter's focus on expressions and gestures and his daring use of nocturnal lighting effects lends a psychological intensity to his works, setting them apart from those of his far more conservative father, who was under the influence of French Mannerism in Utrecht and preoccupied with meticulous brushwork. NCW

EXHIBITIONS: CMA, March 1973: Year in Review, cat. no. 127, illus.

LITERATURE: Anne Walter Lowenthal, "Some Paintings by Peter Wtewael (1596–1660)," *Burlington Magazine*, CXVI (1974), 465, n. 34, fig. 66; Lowenthal, "The Paintings of Joachim Anthonisz. Wtewael 1566–1638" (Ph.D. dissertation, Columbia University, 1975; Ann Arbor, Michigan: University Microfilms, 1975), p. 386, no. C-51 (as Peter Wtewael), illus.; CMA *Handbook* (1978), illus. p. 123.

Figure 132.

Figure 132a. *The Last Supper*. On panel, 40.5 x 68.5 cm. Peter Wtewael. Uppsala Universitets Konstsamling, Uppsala, Sweden.

Italy

GIOVANNI FRANCESCO BARBIERI
(called Il Guercino)

1591–1666

Il Guercino ("the squint-eyed") was born in Cento, a small town in the Emilia, between Ferrara and Bologna. Records show that he visited Venice and Mantua. From 1617 to 1618 he was in Bologna, called there by the cardinal archbishop of Bologna, Alessandro Ludovisi, whom he followed to Rome in 1621 when Ludovisi became Pope Gregory XV. His most important commissions in Rome were the Aurora ceiling fresco in the Casino Ludovisi and the large altarpiece *St. Petronilla* for St. Peter's (now at the Galleria Capitolina). After the death of Pope Gregory XV in 1623, Guercino left Rome for Cento. He settled permanently in Bologna after Guido Reni's death in 1642, succeeding Reni as Bologna's leading painter.

Guercino's style was predominantly painterly, having developed largely under the influence of North Italian masters—above all, the Ferrarese painter Scarsellino and the Bolognese Ludovico Carracci. During his sojourn in Rome, when his work was exposed to and criticized by artists of the classical baroque, such as Domenichino, Annibale Carracci, and Guido Reni, his style underwent decisive changes. Restraining his capricious use of chiaroscuro, which tended to obscure the structure of objects and diminish the clarity of composition, he increasingly stressed solidity of forms and balance of design. In his late style, strongly influenced by the works of Guido Reni, his initial classicism grew less subtle and personal and became increasingly academic.

133 *Rest on the Flight to Egypt* 67.123
with an Angel Playing the Violin

Canvas tondo, diam. 68.5 cm.

Collections: Sig. Tiberio Lancellotti, Palazzo Lancellotti, Rome; [W. Buchanan, London, purchased by his agent, Mr. Irvine, in 1804]; Jeremiah Harman, Esq., in 1824 (sale: Christie's, London, May 17, 1844, no. 18); Duke of Cleveland; private collection, London (sale: Sotheby's, London, May 19, 1965, no. 100); [Julius Weitzner, London].

Mr. and Mrs. William H. Marlatt Fund, 1967.

The canvas was lined, probably in the nineteenth century; the stretcher, dating from the same period as the painting, is of the French type. There are scattered areas of repaint, particularly in the drapery furrows of the Madonna's skirt. Old varnishes remain in the area of the Madonna's right knee, in the figure of Joseph, and in the trees behind him. There are retouchings in the angel's face and left arm, and parts of the sky have been restored.

In reference to a tondo in the Lancellotti collection that was painted by Guercino in 1624, Malvasia (1678) wrote: "... avendo anco nel medemo tempo lavorati altri quadri, e particolarmente un tondo per il Sig. Tiberio Lancellotti Romano, una Madonna col puttino, ed un S. Gioseffo, con an'Angelo, che suona." According to this, the tondo was painted after Guercino's return to the Emilia but while he was still working for his Roman patron Lancellotti. Mr. Irvine, who purchased the painting for Buchanan, stated that the tondo was still in the Lancellotti palace in 1804 (Buchanan, 1824). (It was not included, however, in von Ramdohr's *Ueber Mahlerei und Bildhauerarbeit in Rom*, Leipzig, 1787). By 1824 it belonged to Jeremiah Harman, Esq., at whose death in 1844, according to a handwritten annotation in the sales catalogue, it went to the Duke of Cleveland, bought for him through Lloyd's of London (Buchanan, 1824). Since the duke's title became extinct in 1891, it is difficult to trace the tondo's subsequent history of ownership. Its whereabouts were unknown from that time until 1965, when it reappeared in a private collection in London.

The Walters Art Gallery, Baltimore, owns an exact copy, 71.4 centimeters in diameter, attributed by Zeri (1976) to the workshop of Guercino. It was purchased in 1899 by Henry Walters from Don Marcello Massarenti, Rome (Edouard van Esbroeck, *Supplément au Catalogue du Musée de Peinture, Sculpture et Archéologie au Palais Accoramboni*, Rome, 1900, no. 39, as by Gennari). The his-

Figure 133.

Figure 133a. *Madonna and Child and St. Lawrence* (detail). On canvas, 266 x 145 cm, dated 1624. Guercino. Chiesa del Seminario Arcivescovile in Finale, Emilio, Italy.

tory of this tondo before 1898 is unknown; in 1898 it was in the possession of Marchése Filippo Marignoli, Rome and Spoleto, and from then until 1899 in the collection of Marchése Francesco Marignoli.

A tondo of approximately the same size, which fits the description of the Cleveland and Baltimore tondi, went through a succession of sales in Paris during the nineteenth century (in 1819, 1826, and 1865; Lurie, 1970, p. 102, nn.

11 and 12). It has been suggested that this may be the tondo that is now in Baltimore, but since the known history of the much-sold tondo ends in 1865 and that of the Baltimore tondo does not begin until 1898, the question remains open. It is certain, however, that this tondo of the Paris sales was continuously present in France in the nineteenth century and therefore cannot be confused with the tondo in Cleveland, which is known to have been in England during the same period. It is clear that there were at least two tondi of the same size and description, by or attributed to Guercino or his workshop.

The Cleveland tondo, which dates from 1624, is typical of Guercino's post-Roman style (see Exh: 1968, pp. 140–41). The tondo compares closely to the *Madonna and Child and St. Lawrence* (Figure 133a) in the Chiesa del Seminario Arcivescovile in Finale, also dated 1624. Both paintings show influences from classical baroque and Renaissance works which Guercino studied in Rome. The choice of a circular, and therefore centralized, composition is indicative of Guercino's stylistic preferences at this point in his development. So too is his frequent use of one figure seen in profile, such as the angel playing the violin in the Cleveland tondo, the messenger in the *Semiramis* (Boston, Museum of Fine Arts), and Samson in the *Samson Bringing Honey to His Parents* (Norfolk, Virginia, Chrysler Museum), all of about the same date. Also typical of his post-Roman period was his tendency toward more subtle compositions in which figures are linked together by quiet gestures and glances instead of through lively interplays of light and shade.

Guercino painted other versions of the *Rest on the Flight to Egypt*, including a composition similar to that of the Cleveland tondo in a lunette for the dome of the cathedral at Piacenza in 1627–28 (Malvasia, 1678). Another version was commissioned by the Duke of Savoy and painted in 1634–35 (*ibid.*, 369; 1841 ed., 263); this painting is known through two copies (Lurie, 1970, pp. 93–95). Still another version was mentioned (no measurements given) in Serge Grandjean's *Inventaire après décès de l'Impératrice Joséphine à Malmaison* (Paris, 1964, p. 140, no. 959). ATL

EXHIBITIONS: CMA, December 1967: Year in Review, cat. no. 55, illus.; Bologna, Palazzo dell'Archiginnasio, 1968: Il Guercino (Giovanni Francesco Barbieri, 1591–1666), cat. no. 56, illus., pp. XL, XLI, 128 n. 13, 130, 143, 228 (catalogue by Denis Mahon).

LITERATURE: Carlo Cesare Malvasia, *Felsina Pittrice, Vite de'pittori bolognesi* (Bologna, 1678), II, 366 (reprint, 1841, Giampietro Zanotti, ed., II, 261); W. Buchanan, *Memoirs of Painting, with a Chronological History of the Importation of Pictures by the Great Masters into England since the French Revolution*, II (London, 1824), 155; Donald Posner, "The Guercino Exhibition at Bologna," *Burlington Magazine*, CX (1968), 599; Ann Tzeutschler Lurie, "Guercino's Versions of the *Rest on the Flight to Egypt* and the Lancellotti Tondo," CMA *Bulletin*, LVII (1970), 93–102, figs. 1 and 11; Fredericksen and Zeri (1972), listed pp. 98, 351, 574; *Dizionario* (1974), VI, 215; Federico Zeri, *Italian Paintings in the Walters Art Gallery*, II (Baltimore, 1976), 480, no. 361; CMA *Handbook* (1978), illus. p. 136.

PIETRO BARDELLINO

1728–ca. 1806

Pietro Michele Antonio Pasquale Bardellino was baptized in Naples on February 17, 1728. In 1755 he married D. Anna Maria Ravasco of Naples (Ulisse Prota-Giurleo, "Notizie inedite su alcuni pittore napolitani del '700," *Partenope*, II, no. 1, 1961, 43). In 1806 Bardellino was still listed among the "Maestri del Nudo" at the Neapolitan Accademia del Disegno, a position which he had held since 1779 (Angelo Borzelli, "L'Accademia del Disegno," *Napoli Nobilissima*, IX, August 1900, 125, and X, January 1901, 4, 23).

Bardellino, like other Neapolitan painters of his generation, lived in the shadow of his more famous predecessors or older contemporaries—Luca Giordano, Francesco Solimena, Corrado Giaquinto, and Francesco de Mura—the strongest influences being the last two. Recent studies of his work revealed that Bardellino was one of the most talented Neapolitan painters of the second half of the eighteenth

century. He was obviously recognized as such by the Spanish rulers of Naples—Charles III; Charles's third son, Ferdinand IV of Bourbon; and Ferdinand's wife, Maria Caroline (daughter of Empress Maria Theresa of Austria).

134 *Bozzetto* for an *Apotheosis* 68.208
 of Ferdinand IV of Bourbon and Maria
 Caroline of Austria

Oval canvas, 172.4 x 122.5 cm.

Collections: Florence art market; [Dr. Kurt Rossacher, Salzburg, Austria].

John L. Severance Fund, 1968.

The original fabric and the lining fabric are both very dry and brittle. The stretch is poor and the painting is slack, with bulges, draws, and a dished conformation. There is general, irregular crackle in the ridges of paint, and cupping has developed. Although there are signs of embrittlement, paint and ground layers show no evidence of cleavage or flaking.

Figure 134a. *Apotheosis of Ferdinand IV of Bourbon and Maria Caroline of Austria*. Fresco, dated 1781. Bardellino. Museo Archeologico Nazionale, Naples.

Figure 134b. *Bozzetto* for an *Apotheosis of Ferdinand IV of Bourbon and Maria Caroline of Austria*. On canvas, 154 x 77 cm. Bardellino. Collection of Professor Carlo Volpe, Bologna.

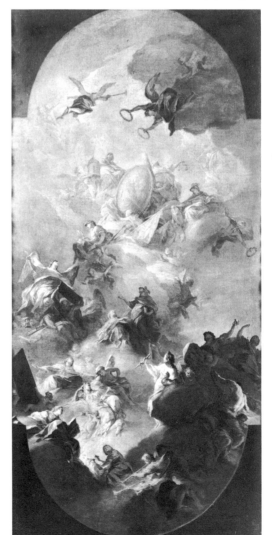

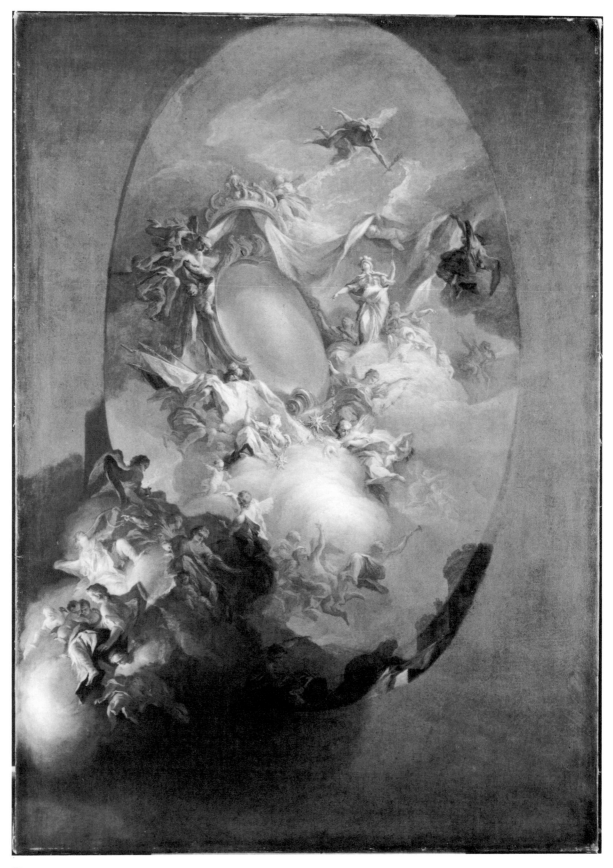

Figure 134.

Figure 134c. Detail of 134 showing the orders of Ferdinand IV.

When the *bozzetto* was acquired, it was thought to be the work of Corrado Giaquinto (1700–1776), but Federico Zeri (letter of June 9, 1969) dismissed that attribution, pointing out the strong influence from Francesco de Mura. Zeri suggested that the two towers in the lower right of our painting resembled those of Castel Nuovo at Naples. Erich Schleier also rejected the attribution to Giaquinto (letters of May 11, 1969, and May 8, 1970), tentatively suggesting Giacomo del Po.

Schleier was the first to recognize the stylistic closeness between the Cleveland *bozzetto* and one acquired by the Gemäldegalerie, Berlin-Dahlem, in 1972, which Schleier, Ferdinando Bologna, Raffaello Causa, and Nicola Spinosa all attributed to Bardellino. In 1973 Spinosa published the two *bozzetti* as works by Bardellino, suggesting that the Cleveland *bozzetto* was an extremely inventive first idea for the *Apotheosis of Ferdinand IV of Bourbon and Maria Caroline of Austria* of 1781 for the ceiling of the Salone della biblioteca antica in the Palazzo degli Studi in Naples (Figure 134a). This was also the opinion of Carlo Volpe (letter of June 7, 1977), who had acquired another *bozzetto* (Figure 134b) of the same subject by Bardellino (sale: Finarte, Milan, November 25, 1976, no. 242). The close correspondence of the Volpe *bozzetto* to the final painting suggests that it may have been Bardellino's *modello*, which followed his first rough sketch, the Cleveland *bozzetto*.

In our *bozzetto* the main feature is the cartouche, on which the artist has depicted regal paraphernalia—the crown on top and the orders below—which he omitted in the final work. The orders (identified by A. W. C. Phelps) are those of Ferdinand IV (Figure 134c). From left to right they are: the Order of San Januarius and the Order of the Holy Spirit of France; and below, the Order of the Golden Fleece and the Order of St. George of Constantine.

Because it can be reasonably assumed that the Cleveland *bozzetto* preceded the one owned by Carlo Volpe and that both were executed in preparation for the *Apotheosis* completed in 1781, we may safely date our *bozzetto* no later than 1781. The earliest possible date is 1768, the year in which Ferdinand IV of Bourbon and Maria Caroline of Austria were married. ATL

EXHIBITIONS: CMA, January 1969: Year in Review, cat. no. 64, illus.

LITERATURE: Erich Schleier, "Die Erwerbungen der Gemäldegalerie," *Jahrbuch Preussischer Kulturbesitz*, X (1972), 257; Nicola Spinosa, "Pietro Bardellino, Un Pittore poco noto del Settecento Napoletano," *Pantheon*, XXXI (1973), 271, fig. 12, 272–73, 280–81 n. 14, 284 n. 49, 286; *Berlin, Staatliche Museen, Gemäldegalerie, Catalogue of Paintings, 13th–18th Century*, trans. Linda B. Parshall (second ed. rev., Berlin-Dahlem, 1978), p. 44.

JACOPO BASSANO (Jacopo da Ponte)
1510–1592

Jacopo Bassano, the son of Francesco and the most prominent artist of a large family of painters, was born in Bassano, a little town in the province of Vicenza, about thirty miles northwest of Venice. He was an assistant to his father in his youth. In 1535 he was in Venice, where he studied with Bonifazio di Pitati. He returned home about 1540 and was married. Bassano town records show his activities there in the years 1551–58, 1560–63, 1565–69, 1571–72, and 1577–84. Jacopo's vast workshop included his sons Francesco, Leandro, Giovanni Battista, and Girolamo. Jacopo died in Bassano in 1592.

135 *Lazarus and the Rich Man* 39.68

Canvas, 146 x 221 cm.

Collections: [Simonetti, Rome, 1905]; Mr. and Mrs. Dan Fellows Platt, Englewood, New Jersey.

Delia E. and L. E. Holden Funds, 1939.

The painting was cleaned in 1939 by William Suhr. The support, a moderately heavy, herringbone-twill fabric, is in two pieces, with a horizontal seam at 47 centimeters from the bottom. The support is lined, and all tacking margins are missing. The original fabric and the lining fabric are both dry and brittle. The paint surface has developed a marked irregular net crackle and concentric crackle pattern. Some flake losses have occurred along lines of crackle

Figure 135.

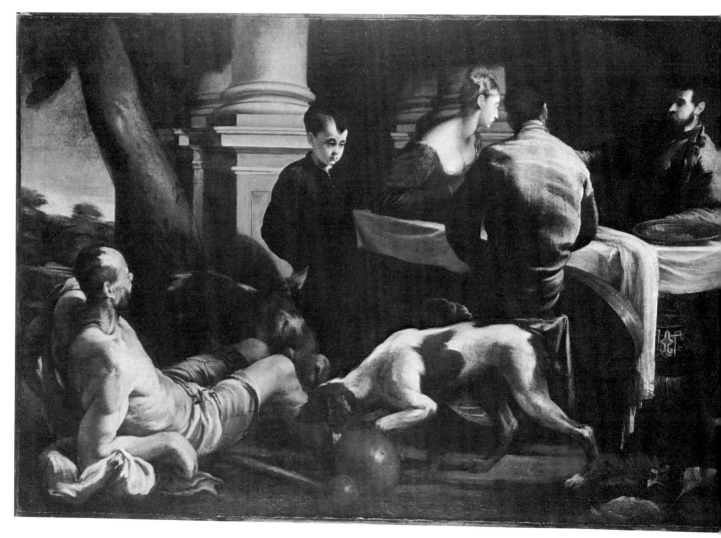

and along the edges. There are spots of discolored restorer's paint in scattered areas, including the area along the seam. The surface coating is dark and discolored and has caused considerable color changes throughout, except where the coating was removed during selective cleaning of the flesh tones and other light areas.

The painting was acquired in Rome in 1905 by Dan Fellows Platt, whose traveling companion, F. Mason Perkins, was the first to publish it (in 1911). Most art historians agree that this is one of the important works of Jacopo Bassano.

An inventory of Jacopo Bassano's workshop, taken April 27, 1592, after Bassano's death, includes two versions of *Lazarus and the Rich Man* listed under no. 184, one of which belonged to Giacomo Vittorelli in Bassano and the other to the Palazzo Contarini in S. Samuele in Venice (Giambattista Verci, *Notizie intorno alla vita e alle opere de'pittori . . . della Città di Bassano*, Venice, 1775, p. 85). There are so many extant versions of the subject, however, that it is impossible to positively identify any of the known versions with those in the Bassano workshop inventory.

The Palazzo Contarini version is recorded by Carlo Ridolfi (in *Le Meraviglie dell'Arte*, ed. Detlev von Hadeln, Berlin, 1914, p. 395) along with two others in Venice belonging to Signor Pighetti and to Signori Contarini di San Felice. Many other versions are listed by Arslan (*I Bassano*, 1960). Neither these nor others by the Bassani and their workshop seem to bear a close relationship to the Cleveland picture. There is, however, a drawing in the British Museum (1920–11–16–1) that is a variant in reverse and is considered to be a late study of a lost version of the subject (Hadeln, *Venezianische Zeichnungen der Spätrenaissance*, Berlin, 1926, pl. 80). A drawing in Darmstadt (Ridolfi, *op. cit.*, pl. 77) of a reclining man—also in reverse —could be connected with the Cleveland painting.

Fiocco (1929) attributed the painting to Pietro de'Marescalchi (called Lo Spada), an opinion that apparently was once supported by Berenson (Arslan, 1931, p. 343). Berenson, however, later changed his mind and included it under Jacopo's work in his lists (Berenson, 1957). Arslan (1931) listed it under the workshop of Jacopo. W. A. Rearick (orally, see Exh: 1957, p. 90) thought it was later than Bassano. Fiocco (1957) continued to maintain that it is not by Jacopo (and perhaps not Italian) but must be a seventeenth-century copy, which would place it after, rather than before, Caravaggio. With the exception of Fiocco, Arslan, and Rearick, scholars have accepted the attribution to Jacopo without question. Most agree that it dates between ca. 1545 (Arslan, *I Bassano*, 1960), and ca. 1555 (Ballarin, 1971), during Jacopo's middle period.

The quiet, pensive mood and the dramatic use of light and dark in several of Bassano's paintings of this period seem to derive from works by Savoldo, such as the *Archangel and Tobias* in Rome, Borghese Gallery; the *St. Mat-thew and the Angel* in New York, Metropolitan Museum; and the *Adoration of the Shepherds* in Washington, National Gallery. Savoldo was fascinated with strong light sources and dramatic contrasts of light and dark. These "Caravaggesque" aspects of a few of Bassano's paintings, which predate Caravaggio's own experimentations by nearly half a century, have disturbed some art historians; most, however, view the works as prophetic masterpieces in cinquecento Italian painting.

Other paintings of this period frequently associated with the *Lazarus* are: *Beheading of St. John the Baptist*, in Copenhagen; *Adoration of the Shepherds*, in Rome, Borghese Gallery; *Adoration of the Shepherds* and the *Good Samaritan*, both at Hampton Court; and *Veronica before the Fallen Christ*, in Budapest. The Copenhagen *St. John*, like the *Lazarus*, has a thrusting diagonal composition and uses many of the same details, such as the Oriental rug, the folds of a white tablecloth, and the profile of a woman. (The latter is an influence from the style of Parmigianino, whose mannerisms show up frequently in Bassano's work.)

The Cleveland painting is an illustration of the parable of Lazarus and the Rich Man (Luke 16:19–31). It is generally considered to be a pendant to *The Miracle of Quails and Manna* in a private collection in Florence (see Exh: 1957, fig. 5).

N C W

EXHIBITIONS: San Francisco, Panama Pacific International Exposition, 1915, deluxe cat., I, no. 4009, and II, 456; New York, The Metropolitan Museum of Art, 1920–28; Los Angeles, 1929: American Art Dealers Association Exhibition (no catalogue); CMA (1936), cat. no. 176, pl. XXVII; Columbus (Ohio) Gallery of Fine Arts, 1938: Exhibition of Four Outstanding Venetian Canvases (no catalogue); San Francisco, California Palace of the Legion of Honor, 1938: Venetian Paintings from the Fifteenth through the Eighteenth Century, cat. no. 5, illus.; New York, World's Fair, 1939: Masterpieces of Art, cat. no. 4; Columbus (Ohio) Gallery of Fine Arts, 1946: The Age of Titian (no catalogue); CMA (1956), cat. no. 1, pl. XXXIII; Venice, Palazzo Ducale, 1957: Jacopo Bassano, cat. no. 34, illus. pp. 91–93 (catalogue by Pietro Zampetti); New York, Wildenstein Gallery, 1967: The Italian Heritage, An Exhibition of Works of Art Lent from American Collections for the Benefit of CRIA (Committee to Rescue Italian Art), cat. no. 27, illus.

LITERATURE: F. Mason Perkins, "Dipinti Italiani nella Raccolta Platt," *Rassegna d'Arte*, XI (1911), 147, n. 2; Alice van Vechten Brown and William Rankin, *A Short History of Italian Painting* (London, Toronto, and New York, 1914), p. 343; Perkins, "Miscellanea," *Rassegna d'Arte Antica e Moderna*, I (1915), 122, illus. p. 121; Matteo Marangoni, *Arte Barocca* (Florence, 1927), p. 27; Giuseppe Fiocco, "Pietro de'Marescalchi detto lo Spada," *Belvedere*, VIII (1929), 214; A. Venturi (1929), IX, part 4, 1147, 1252, fig. 812; A. Venturi, "Jacopo Bassano," *L'Arte*, XXXII (1929), 117–21, fig. 8; Edoardo (Wart) Arslan, *I Bassano* (Bologna, 1931), p. 343 (as a Bassanesque work); Henry S. Francis, "*Lazarus and the Rich Man* by Jacopo Bassano," *CMA Bulletin*, XXVI (1939), 155–58, illus. p. 154; L. Fröhlich-Bume, "Some Sketches by Jacopo Bassano," *Burlington Magazine*, XC (1948), 169; Roberto Longhi, "Calepino Veneziano," *Arte Veneta*, II (1948), 54; Licisco Magagnato, "In margine alla mostra dei Bassano," *Arte Veneta*, VI (1952), 226, fig. 240; Magagnato, "Jacopo Bassano intorno al 1540," *Critica d'Arte*, no. 13–14 (1956), 103–6, pls. 110 and 111; Pigler (1956), I, 369; Berenson (1957), I, 17, and II, pl. 1197; Fiocco, "Francesco Vecellio e Jacopo Bassano," *Arte Veneta*, XI (1957), 96; Mi-

chelangelo Muraro, "The Jacopo Bassano Exhibition," *Burlington Magazine*, XCIX (1957), 295–96, fig. 1; Attilio Podesta, "La Mostra di Jacopo Bassano," *Emporium*, CXXVI (1957), 12, illus. p. 14; Ulrich Weissten, "Jacopo Bassano in Venice," *Arts*, XXXI (September 1957), 16, illus. p. 14; Benedict Nicolson, *Hendrick Terbrugghen* (London, 1958), p. 102; Pietro Zampetti, *Jacopo Bassano* (Rome, 1958), p. 36, pls. XLII–XLIV (color); Arslan, *I Bassano* (Milan, 1960), I, 65–66, 84, 90, 95 n. 48, 96 n. 57, 97, 166, 168, 317, and II, pls. 94–98; Arslan, in *Encyclopedia of World Art*, II (Toronto and London, 1960), 403; Pamela Askew, "The Parable Paintings of Domenico Fetti," *Art Bulletin*, XLIII (1961), 32; Jaffé (1963), p. 467; Alessandro Ballarin, "L'orto del Bassano," *Arte Veneta*, XVIII (1964), 66–67, fig. 72; *Selected Works* (1966), no. 141, illus.; P. A. Tomory, "Profane Love in Italian Early and High Baroque Painting, The Transmission of Emotive Experience," *Essays in the History of Art Presented to Rudolf Wittkower* (New York, 1967), p. 185, fig. 3; Ballarin, "Introduzione ad un catalogo dei disegni di Jacopo Bassano," *Arte Veneta*, XXIII (1969), 104, 106; Ballarin, "Un ritratto inedito del Bassano," *Arte Veneta*, XXV (1971), 270–71, fig. 372; *Dizionario* (1972), I, 402–3, fig. 397; Fredericksen and Zeri (1972), pp. 18, 279, 573; Jan Bialostocki, "Le Vocabulaire visuel de Jacopo Bassano et son *stilus humilis*," *Arte Veneta*, XXXI (1978), 170–71, fig. 1; CMA *Handbook* (1978), illus. p. 114.

LEANDRO BASSANO

1557–1622

Leandro was one of the sons of Jacopo Bassano (Jacopo da Ponte, see Painting 135). He accompanied his father to Venice in 1577 and in 1582 settled there. He is known to have been in Bassano in 1587. Leandro was very much influenced by the style of his father; he worked closely with his father until at least 1580 and was still painting in his style in 1590. A painting dated 1580, now in the Prefettura in Vicenza, formerly in a small church in Montecchio Precalcino, is signed by both father and son. From 1588 until his death, Leandro lived in Venice, painting canvases for the doge's palace, altarpieces, genre pictures, portraits of doges and their wives, and portraits of private citizens. He died in Venice in 1622, a very popular painter, laden with honors.

136 *The Entombment* 16.806

Canvas, 123.8 x 76.2 cm.

Collections: James Jackson Jarves; Mrs. Liberty E. Holden, Cleveland, 1884.

Holden Collection, 1916.

It is possible that the picture was painted on an irregularly shaped canvas with truncated corners. The corners are now filled with triangular pieces of fabric (each approximately 12.7 x 7.6 cm) to form a vertical rectangle, and these additions have been inpainted. Some time prior to acquisition the painting was lined. William Suhr cleaned it in 1949. There is overall abrasion of the paint and ground at the crest of the fabric threads, and there are losses along all edges and at the corners.

This is one of four paintings of the subject executed by the Bassani between 1560 and 1590. The paintings, which differ in size but are very close in figure composition, undoubtedly derive from a composition by Jacopo. Arslan (1960) said that the Cleveland version is by Leandro, is early, and is the most brilliant in color; but he felt that another—a horizontal version—now in the convent of the Franciscans in Zadar, Yugoslavia, was the finest (published as about 1560, in the manner of Jacopo, by I. Petricioli, in "Nepoznata slika Radionice Jacopa Bassana u Zadru," *Zbornik Instituta za historijske nauke u Zadru*, Zara, 1955, pp. 114–24). A version in the Museum of Bassano is given to Leandro by Magagnato and Passamani (1978), who call the Cleveland painting a replica by Leandro. Another version, in the Museo di Castelvecchio in Verona, is attributed to Francesco the younger by Magagnato and Passamani (1978, p. 32). NCW

EXHIBITIONS: Boston (1883), cat. no. 429; New York (1912), cat. no. 2; CMA (1916), cat. no. 3; CMA (1936), cat. no. 75; CMA (1956), cat. no. 3, pl. XXIX.

LITERATURE: Jarves (1884), no. 22 (as Jacobo [*sic*] Bassano); M. L. Berenson (1907), p. 3; Rubinstein (1917), no. 3; Underhill, (1917), p. 20; B. Berenson (1932), p. 60; Edoardo (Wart) Arslan, *I Bassano*, I (Milan, 1960), 260, 275; Donzelli and Pilo (1967), p. 76; Fredericksen and Zeri (1972), pp. 19, 358, 573; CMA *Handbook* (1978), illus. p. 114; Licisco Magagnato and Bruno Passamani, *Il Museo Civico di Bassano del Grappa, Dipinti dal XIV al XX Secolo* (Bassano, 1978), p. 32.

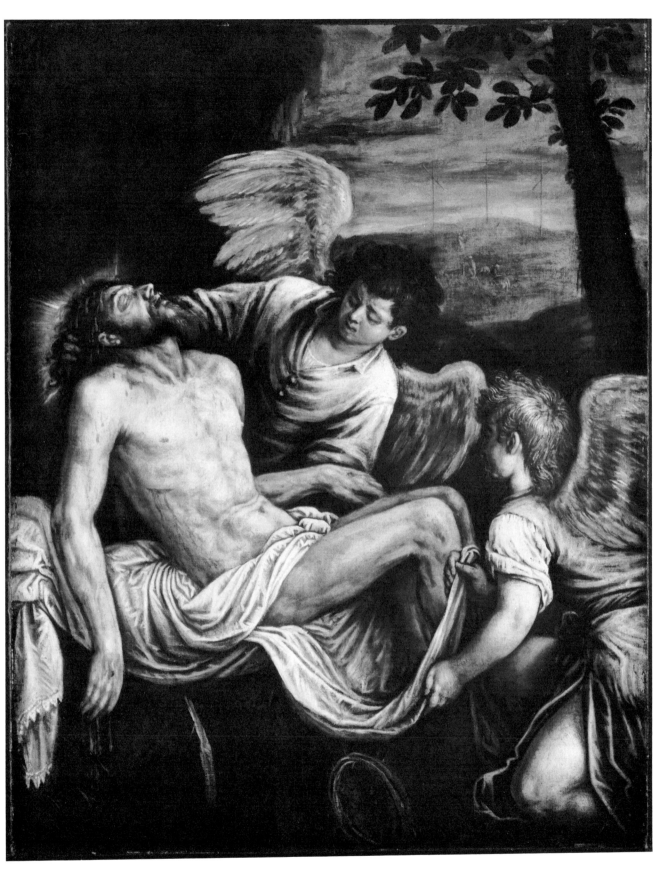

Figure 136.

GIUSEPPE BAZZANI
1690–1769

Giuseppe Bazzani was born in Mantua in 1690; he re-
mained there all his life and died there in 1769. His early
training came from two minor painters, Giovanni Canti
(1653–1716) of Parma and Giovanni Cadioli (1710–1767)
of Mantua; the latter was co-founder and director of the
Academy of Fine Arts (Mantua) in 1752. He was surrounded
by a wealth of stylistic influences; in the duchy of Mantua
were the frescoes of Andrea Mantegna, Giulio Romano,
and Paolo Veronese, and the paintings that Rubens exe-
cuted during his trips early in the 1600s. Bazzani was also
familiar with the work of contemporaries such as Antonio
Balestra and Gianbettino Cignaroli and with artists of the
preceding generation, such as Francesco Maffei. He may
have derived his nervous, rapid style from Magnasco. Baz-
zani executed both small-scale paintings and many large-
scale decorative cycles in fresco and oil for churches in
Mantua. He remained a bachelor all his life, making his
home with his brother and sister. In 1753 he was made a
professor at the Academy of Fine Arts and in 1767 became
director, succeeding his master, Cadioli.

137 *Pietà with Mary Magdalene* 55.682

Canvas, 94.5 x 141.7 cm.

Collections: [Italico Brass, Venice].

Gift of Mr. and Mrs. Severance A. Millikin, 1955.

In general, the painting is structurally sound. It has been
lined with a glue-type adhesive to a coarse twill fabric. In
addition to the rather considerable damage along the bot-
tom edge of the canvas, there is a horizontal tear through
the Magdalene's profile and an old damage at the left of the
Virgin's head. Major retouching was necessary near the leg
of Christ and in the Magdalene's left hand. The painting
was cleaned by Joseph Alvarez in the Museum laboratory
in 1961.

The mystical humility and religious fervor in this paint-
ing are intensified by the artist's use of color and his expres-
sive and dramatic foreshortening of figures—qualities that
would place the work late in Bazzani's oeuvre. Ivanoff
(1950) dated the painting after 1750, an idea that had been
expressed as early as 1837 by Luigi Coddè when he as-
signed all Bazzani's nocturnal scenes to his late period
(*Memorie biografiche poste in forma di dizionario dei pit-
tori, scultori, architetti ed incisori Mantovani per la più
parte finora sconosciuti raccolte dal fu dottore Pasquale
Coddè segretario delle belle arti in Mantova aumentate a
scritte dal Dottor Fisico Luigi Coddè*, Mantua, 1837). An
earlier, less intense interpretation of the subject by Bazzani,
executed in a larger format (Figure 137a), is in the Duomo
in Mantua (Ivanoff, 1950, no. 45, fig. 39).

Ivanoff suggested that the Cleveland painting is the pen-
dant to the *Entombment* (canvas, 94 x 144 cm) in a private
collection in Venice (Ivanoff, 1950, fig. 108; and Benesch,
1924, fig. 114).

A weak replica of the Museum painting was formerly in
the Attilio Staffanoni collection in Bergamo (Ivanoff, 1949,
fig. 4, as by Bazzani).

The early history of the painting is unknown. NCW

EXHIBITIONS: CMA (1956), cat. no. 4, pl. XXV.

LITERATURE: Otto Benesch, "Maulbertsch zu den Quellen seines ma-
lerischen Stils," *Städel-Jahrbuch*, III–IV (1924), 139–41, fig. 113; Nicola
Ivanoff, "Tre 'Pietà' di Giuseppe Bazzani," *Emporium*, CIX (April 1949),
162–66, fig. 3; Ivanoff, *Bazzani: Saggio critico e catalogo delle opere*
(Mantua, 1950), pp. 20, 78, fig. 107; Henry S. Francis, "A Pietà by Giu-
seppe Bazzani: Gift of Mr. and Mrs. Severance Millikin," CMA *Bulletin*,
XLIII (1956), 44–46, illus. p. 42; Ivanoff, in *Kindlers Malerei Lexikon*, I
(Zurich, 1964), illus. p. 251; Fredericksen and Zeri (1972), pp. 21, 296,
574; CMA *Handbook* (1978), illus. p. 148.

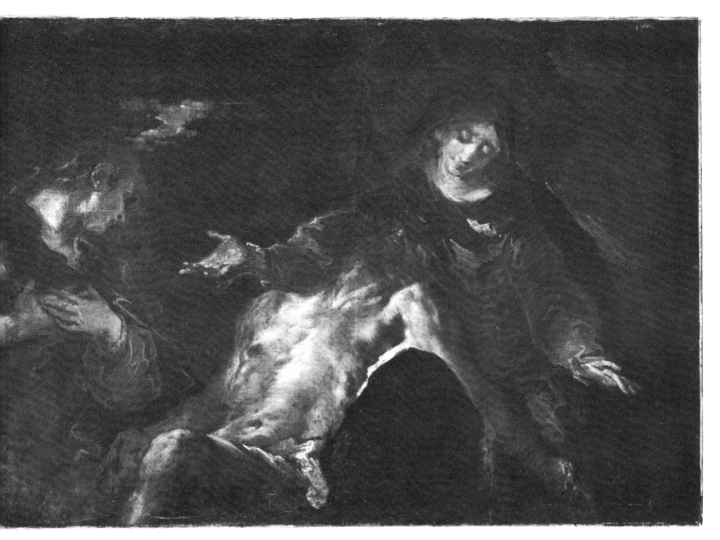

Figure 137.

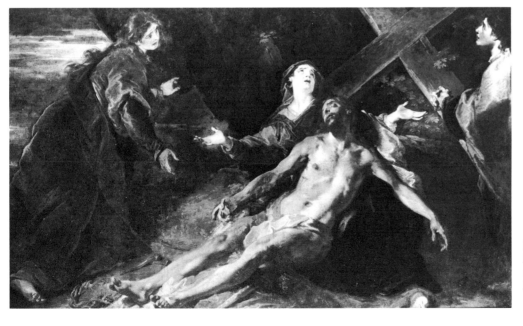

Figure 137a. *Pietà with Mary Magdalene.* On canvas, 187 x 330 cm. Bazzani. Mantua Cathedral, Italy.

AGNOLO BRONZINO
(Agnolo di Cosimo di Mariano)
1503–1572

Bronzino was born in Monticelli, a suburb of Florence. His paintings are representative of the culminating phase of Florentine Mannerism. According to Vasari, Bronzino received his early training under Raffaellino del Garbo. It is not certain when he became Pontormo's pupil—most likely not before 1519 (Craig Hugh Smyth, "The Earliest Works of Bronzino," *Art Bulletin*, XXXI, 1949, 186)—but from 1523 on he was the master's sole pupil and assistant. In 1530 Bronzino was called to the court of Duke Guidobaldo II at Pesaro, returning to Florence in 1532 to assist Pontormo with commissions for the Medici family. After the marriage of Cosimo I to Eleanora of Toledo in 1539, Bronzino became the couple's leading portraitist. He was appointed official court painter in 1548, a position he held until his death.

Figure 138a. Detail showing necklace.

138 *Portrait of a Young Lady* 72.121

Panel (poplar), 60 x 48.3 cm.

Collections: Städelscher Museums-Verein, Frankfurt, in 1882; Freifrau Mumm von Schwarzenstein, Frankfurt; Baron Max von Grunelius, Frankfurt; [David M. Koetser, Zürich].

Purchase, Leonard C. Hanna Jr. Bequest, 1972.

The panel is in very good condition. When Mario Modestini cleaned it in 1973, he removed a thin wash of brownish water color, revealing the original light purple background and pentimenti along the contours of the figure. There were small, scattered losses (mostly in the background) and a small vertical loss (approximately 3.7 x 1.3 cm) below the sitter's right eye.

In 1925 the portrait was exhibited at the Städelsches Institut with other paintings from Frankfurt private collections. It was lent by Max von Grunelius, who inherited it from his mother-in-law, the widow of Peter Arnold Gottlieb Hermann Mumm von Schwarzenstein (died in 1904). It is known that the Frankfurter Kunstverein purchased the painting in 1882 (letter from the city of Frankfurt am Main, dated October 15, 1973). Freiherr Hermann Mumm von Schwarzenstein was the president of the Frankfurter Kunstverein in the 1880s. An earlier provenance is difficult, if not impossible, to establish, for too many pertinent records in Frankfurt were lost during World War II. A seal on the back of the panel—showing a winged Eros riding a lion, the emblem of *omnia amor vincit*—may be that of the original owner (Lurie, 1974, p. 3, fig. 2, and n. 4).

The young woman of the portrait is unknown, but her elegant attire, including the precious cap and jewelry and the exquisite golden collar (Figure 138a), which is unique in Bronzino's oeuvre, and the very fact that Bronzino painted her indicates that she was affiliated with or known to the Medici court or its entourage. The black and white of her costume may be the principal colors of her family's blazon of arms, representing the first color (black) and the first metal (silver), and this may be a clue to her identity. A similar suggestion applies to Bronzino's portrait of *Ludovico Capponi*, in The Frick Collection, in which the predominant black and white are indeed the Capponi family's basic armorial colors (Lurie, 1974, p. 13, n. 15). Ludovico was married to Maddalena Vettori, whose identification as the subject of our painting is worthy of consideration; a descendant of the Florentine Vettoris, her family's armorial colors were also black and white. Ludovico Capponi was a page at the court of Cosimo I at the time Bronzino was official court painter.

Lada Nikolenko (letters of November 22 and December 22, 1975) suggested that the subject might be Eleonora degli Albizzi (1544–1634), mistress to Cosimo I in the early 1560s. Nikolenko has informed the author of an inventory of the jewels and treasures bestowed upon Eleonora by Cosimo; if the jewels match any in the Cleveland portrait, we shall have proof of the sitter's identity. Cosimo actually

Figure 138.

intended to marry Eleonora degli Albizzi—she bore him a son, whom he officially acknowledged as his—but instead, she married Carlo de Panciatichi (son of Lucrezia and Bartolommeo, whom Bronzino painted in ca. 1540). If the portrait is of Eleonora, Bronzino could have painted her as Cosimo's mistress between 1564 and 1566, or as the wife of Carlo de Panciatichi whom she married in 1567. After a few years of marriage, three sons, and another love affair—with Cosimo's son, Piero de'Medici—Eleonora was forced into a Franciscan convent, San Onofrio da Foligno, where she died in 1634.

The erect, rigid pose of the lady in our portrait and the emphasis on nobility are anticipated in Bronzino's portraits of Bartolommeo and Lucrezia Panciatichi, of ca. 1540 (Uffizi, Florence). As Bronzino's style matured, he focused more intently on the face of the sitter, eliminating all illusion of space. Sitters were set against a uniform background of evanescent tonalities (grayish lavender in the Cleveland portrait) that emphasized the sharp contours of their faces. Stylistically the Cleveland portrait resembles Bronzino's *Ludovico Capponi* of ca. 1550 to 1555 and a series of portraits of the Medici children—Maria, Ferdinando (both portraits in the Uffizi), and Isabella (Nationalmuseum, Stockholm)—painted in the early 1550s. In refinement of color, firmness of definition, and subtlety of expression—all indicative of Bronzino's mature style—the Cleveland portrait is particularly close to the *Girl with a Missal* in the Uffizi. Even though dates suggested for the latter have ranged over a period of thirty years, from ca. 1540 (Andrea Emiliani, *Il Bronzino, Gusto Arsizio*, 1960, opp. pl. 26; Craig Hugh Smyth, *Bronzino Studies* [Ph.D. dissertation, Princeton University, 1955; University Microfilms, Ann Arbor, Michigan, 1973], p. 169) to ca. 1560–70 (McComb, 1928, and Schulze, 1911), it is this author's opinion that the stylistic sophistication of both the Cleveland portrait and the *Girl with a Missal* suggests a date between 1555 and 1565. ATL

EXHIBITIONS: Frankfurt, Städelsches Kunstinstitut, 1925: Meisterwerke alter Malerei aus Frankfurter Privatbesitz, cat. no. 28, pl. XXVII; CMA, February 1974: Year in Review, cat. no. 34.

LITERATURE: Emil Schaeffer, *Das Florentiner Bildnis* (Munich, 1904), p. 185, illus.; Hanns Schulze, *Die Werke Angelo Bronzinos* (Strassburg, 1911), p. xix; Thieme-Becker, v (1911), p. 62; Arthur McComb, *Angelo Bronzino, His Life and Works* (Cambridge, Massachusetts, 1928), pp. 67–68; Coe (1955), II, 80, no. 2; Ann Tzeutschler Lurie, "Agnolo Bronzino: *Portrait of a Young Lady*," CMA *Bulletin*, LXI (1974), 1–13, figs. 1–5, 7, 9, and color cover; CMA *Handbook* (1978), illus. p. 112.

Follower of AGNOLO BRONZINO

139 *Portrait of a Lady as* 16.825
 St. Catherine

Panel (walnut), 95.3 x 71.4 cm.
Collections: [Riccardi Gallery, Florence]; James Jackson Jarves; Mrs. Liberty E. Holden, Cleveland, 1884.
Holden Collection, 1916.

The painting is in poor condition. The background is almost completely overpainted. The shadows on the sitter's face and dress have been strengthened, and there are scattered losses on her right wrist, left hand, neck, forehead, nose, and cheeks. The painting was cleaned by William Suhr in April 1930 and restored by Joseph Alvarez in January 1960.

The sitter is portrayed with the attributes of St. Catherine—the palm and a broken wheel. The figure is in profile, the head turned for a three-quarter view. Light enters from the upper left, and the right side of the figure is in shadow. The lady's transparent veil is mustard-yellow; her dress, a cherry-red; her collar and cuffs, a tannish-brown. In her right hand is an olive-green cloth.

None of the attributions thus far proposed for this fine, but badly damaged, portrait has proved convincing. Jarves (1884) ascribed the picture to Bronzino. Mary Berenson (1907) rejected the Bronzino attribution and suggested the picture was by Cristofano Allori (1577–1621), a follower of Bronzino. Berenson's attribution is unacceptable, because stylistically the painting seems earlier than Allori. Longhi's attribution to Sicciolante da Sermoneta (ca. 1521–ca. 1580), the Roman follower of Perino del Vaga, is based on the assumption that a painting attributed to Sicciolante (collection of Lord Methuen, Corsham Court) was the prototype for the Cleveland picture. The Methuen version, however—with its reduced size, the summary treatment of drapery, and the diffuse modeling of forms—is probably a replica after a yet-unidentified original.

In all likelihood the Cleveland portrait was painted in Florence about 1575 in the circle of Bronzino, but its poor condition makes it difficult to assign it to one of Bronzino's known followers. NCW

EXHIBITIONS: Boston (1883), cat. no. 440; New York (1912), cat. no. 1 (as Cristofano Allori); CMA (1916), cat. no. 1; CMA (1936), cat. no. 73.

LITERATURE: Jarves (1884), cat. no. 30 (as Angelo Bronzino); M. L. Berenson (1907), p. 3 (as Cristofano Allori); Rubinstein (1917), p. 11, no. 1 (as Cristofano Allori); Coe (1955), II, 80, no. 2; Roberto Longhi, "Uno sguardo alle fotografie della Mostra: 'Italian Art and Britain' alla Royal Academy di Londra," *Paragone*, XI, no. 125 (1960), 60 (under *Appunti*); Edmund P. Pillsbury, *Florence and the Arts, Five Centuries of Patronage* (exh. cat., Cleveland, 1971), p. 55; Fredericksen and Zeri (1972), pp. 237, 384, 531, 573 (as Roman 18th century).

Figure 139.

Attributed to GIULIO CAMPI
Ca. 1502–1572

Giulio Campi was born in Cremona and spent most of his life there. He was the son of the painter Galeazzo Campi, from whom he received his early training. Other members of the Campi family who distinguished themselves as painters are: Antonio Campi (1520/25–ca. 1591), the much younger (half?) brother of Giulio, who studied with him and was probably the most inventive; Bernardino Campi (1522–1591), a distant relative who studied in Giulio's workshop but worked more in Mantua and Parma; and Vincenzo Campi (1530–1591), Antonio's younger brother, who specialized in very popular genre scenes and still lifes with figures. Numerous documents record Giulio's activities as painter, architect, and decorator in Cremona. Though he is not known to have traveled, he was exposed to influences from many directions—from Brescia, Venice, Emilia, Bologna, and Rome—because of Cremona's centralized location in the north of Italy. His work is eclectic, mannered, and highly precise, with obvious debts to Pordenone, Parmigianino, Giulio Romano, Correggio, and Michelangelo, among others.

140 *Portrait of an Old Man* 16.794

> Panel (poplar) transferred to masonite pressboard, 92.4 x 63.8 cm.
>
> Collections: [Gino Capponi Gallery, Florence]; James Jackson Jarves; Mrs. Liberty E. Holden, Cleveland, 1884.
>
> Holden Collection, 1916.

In 1947 William Suhr transferred this painting from the original poplar panel to a veneered and cradled masonite board. The dimensions of the original panel are not known. On the reverse side of the old poplar panel was an illegible signature with the numeral "4" below it. The face of the gentleman is in good condition, but there are minor, scattered losses and a slender vertical loss in the forehead due to a split in the original panel. The robe of the sitter and the background have suffered extensive damage due to blisters and the loss of adhesion between the paint film and gesso, and between the gesso and the panel. A strip 2.5 centimeters wide was added at the bottom, and the fingers of the gentleman's left hand were then reconstructed with simulated crackle. The painting is disturbingly weak in the hands, particularly the right hand, and there has been some minor strengthening. The left hand may have been painted later in the studio or left unfinished.

The attribution of this painting is problematic. Jarves (1884) purchased and published the portrait as by Titian. Lionello Venturi (orally, during a visit to the Museum in 1933) suggested it was painted by the Fleming Giovanni Calcar (ca. 1499–1546/50), who worked in Titian's workshop ca. 1540 and distinguished himself as a portraitist in

Naples. Adolfo Venturi (1934) attributed the painting to Scipione Pulzone da Gaeta (ca. 1550–1598), a draftsman of clarity and accuracy, who was influenced by Raphael, Sicciolante da Sermoneta, and Roman painting in general; Venturi noted a similarity to Scipione's so-called portrait of Cardinal Gravella in the museum of Besançon. William E. Suida (letter of September 4, 1944) said it was by a Netherlandish painter under decisive Venetian influence. Philip Pouncey, on a visit to the Museum on March 31, 1958, said that although Giulio Campi was a reasonable attribution, Girolamo Sicciolante da Sermoneta ought also to be considered. Berenson (1932, 1968) and Perotti (n.d.) attributed the portrait to Giulio Campi. Silla Zamboni (letter of June 20, 1960) suggested, and Adolfo Venturi agreed, that it is close in style to others attributed to Giulio Campi: the *Portrait of an Old Man* in the Casa Gaslini in Milan (Perotti, n.d., illus. p. 18) and the *Portrait of a Man* in the Galleria Estense in Modena (R. Pallucchini, *I Dipinti della Galleria Estense di Modena*, 1945, fig. 178). Fritz Heinemann (letter of February 16, 1961) pointed out a stylistic similarity in the treatment of the robe and glove to those in the so-called portrait of Galeazzo Campi of ca. 1535 in the Uffizi (no. 1628) also attributed to Giulio; more recently, Heinemann (letter of September 29, 1974) suggested the possibility that Antonio Campi, the younger brother of Giulio, was the painter. Mina Gregori (letter of March 19, 1956, and orally, during a visit to the Museum in January 1969) felt that the portrait had nothing to do with Cremona and is definitely not by Campi; she suggested a Netherlandish painter who was influenced by Venetian portraits from the circle of Titian. Fredericksen and Zeri (1972) list this portrait under the work of Giulio Campi but as an uncertain attribution.

NCW

EXHIBITIONS: Boston (1883), cat. no. 426; Cleveland, Hickox Building, 1894: The Cleveland Art Loan Exhibition, cat. no. 13; CMA (1916), cat. no. 39; CMA (1936), cat. no. 79.

LITERATURE: Jarves (1884), p. 12, no. 23; M. L. Berenson (1907), p. 5; Rubinstein (1917), no. 39; B. Berenson (1932), p. 123; A. Venturi (1934), IX, pt. 7, 766; Aurelia Perotti, *I Pittori Campi da Cremona* (Milan, n.d.), p. 95; Coe (1955), II, 82, no. 9; B. Berenson (1968), I, 73; Fredericksen and Zeri (1972), pp. 41, 528, 573.

Figure 140.

GIOVANNI ANTONIO CANAL
(Canaletto)

1697–1768

Canaletto was born in Venice; he was the son of Bernardo Canal, a scene painter. Canaletto began his career as a stage designer, working with his father and his brother Cristofo. In 1719–20 he and his father were in Rome designing stage scenery for Alessandro Scarlatti's operas that were performed during the carnival of 1720. Aside from the influence of his father, the chief impressions upon his work were made by Lucas Carlevaris (1663–1731). In 1720 Canaletto returned to Venice, where he remained for the next twenty-five years, working as a landscape painter. His two most important patrons were Owen McSwiney, an agent for collectors in England, and Joseph Smith, merchant, banker, amateur collector, and later British Consul in Venice. Smith was responsible for introducing the painter to important English visitors. Most of the paintings and drawings commissioned by Smith were later acquired by George III and are now in the Royal Collection at Windsor. Canaletto went to England to establish his identity because his works were so popular there that British artists were imitating his style. With the exception of two brief trips back to Venice, he remained in England from 1746 until 1755. He then returned to Venice, where he stayed for the rest of his life.

Canaletto was a prolific painter. The art historian's task of cataloguing his enormous output is complicated by the existence of many studio versions of his designs and by numerous copies and pastiches. Both Francesco Guardi and Michiel Giovanni Marieschi (1710–1743) copied his work, and to further complicate the task, there is the early work of Bernardo Bellotto (1720–1780), Canaletto's nephew, who trained under him.

141 *View of the Piazza San Marco* 62.169
 and the Piazzetta Looking toward
 San Giorgio Maggiore

Canvas, 136.2 x 232.5 cm.

Collections: Earl of Craven, Combe Abbey, Warwickshire, before 1833; Cornelia, Lady Craven, Hamstead Marshall, Berkshire (sale: Sotheby's, London, November 29, 1961, no. 42); [M. H. Drey, London].

Purchase, Leonard C. Hanna Jr. Bequest, 1962.

Sometime in the past, when the canvas was lined, the tacking margins were extended and painted, increasing the painted surface by about 2.5 centimeters in height and width. Infrared and ultraviolet illumination reveal scattered areas of repaint in the sky and along the edges. Visible under the very thinly painted sky are the outlines of an earlier study, with an enigmatic mass of tall architectural shapes on the left and a series of domes extending from the upper middle to the right edge of the original canvas (before

the tacking margins were extended). These shapes have been partially painted over but still appear as pinkish pentimenti. The dark paint in the foreground of the piazza was applied directly on a pinkish ground, after which the drawing, highlights, details, and figures were laid upon it.

Although aware that most critics believe in the attribution to Canaletto, Valcanover (1980) claims that the painting is an early work and one of the extremely rare *vedute* of the piazza by Canaletto's nephew, Bernardo Bellotto. This author, on the other hand, believes in the traditional attribution and considers the painting to be one of Canaletto's earlier works from the 1730s. Lionelli Puppi (1968) dates it about 1732–33 because of its similarities to the series of views of Venice that Canaletto painted for the Duke of Bedford during the latter's tour of the Continent before 1731–32. The Cleveland painting is a view of the Piazza San Marco and the piazzetta. It includes the façade of the Cathedral of San Marco (one dome of which is visible) and the Doge's Palace on the left, the San Marco Library by Sansovino on the opposite side of the piazzetta, San Giorgio Maggiore in the distance, and at the far right (or west end) of the piazza, the Procuratie Nuove and the façade of San Geminiano (destroyed by Napoleon).

Martin Linsey of the Museum's Department of Art History and Education made a careful study of the perspective of the painting (see Figure 141*a*) and concluded that it would be impossible to see the façade of the Cathedral of San Marco, the Doge's Palace, and the San Marco Library all from a single vantage point. In order to make the scene visually convincing, Canaletto established two vanishing points, only 3.8 centimeters apart. As Linsey has shown, the artist must have stood against the southwest corner of the Torre dell'Orologia to see the façade of the library and then have moved about 30 to 35 feet west, up against the Procuratie Vecchie, to include the view of the Doge's Palace. Martin Linsey's diagrams also show that while Canaletto painted the outlines of the façade of the Procuratie Nuove in parallel perspective, he systematically shaved off the width of each bay in increasing, but almost imperceptible, degrees as he progressed toward the right of the canvas, thus employing the principles of two-point perspective in order to reduce the length of the façade.

A smaller version of this painting (58.4 x 95.2 cm), which has fewer and less varied figures, is in the collection of Captain Cecil Samuel, London. Constable (1962, II, 445) first suggested that this painting was by Bellotto but later (1976, II, 209) recognized it as the work of Canaletto.

Another version (69 x 108 cm), in the Musée des Beaux-Arts at Lille, is from a viewpoint slightly to the left; this version has been attributed to Bellotto and Canaletto (Constable, 1976, II, 209). Constable cited a drawing derived from the Lille painting, which is from Canaletto's studio and is now in the print room of the Rijksmuseum, Amsterdam (z 25).

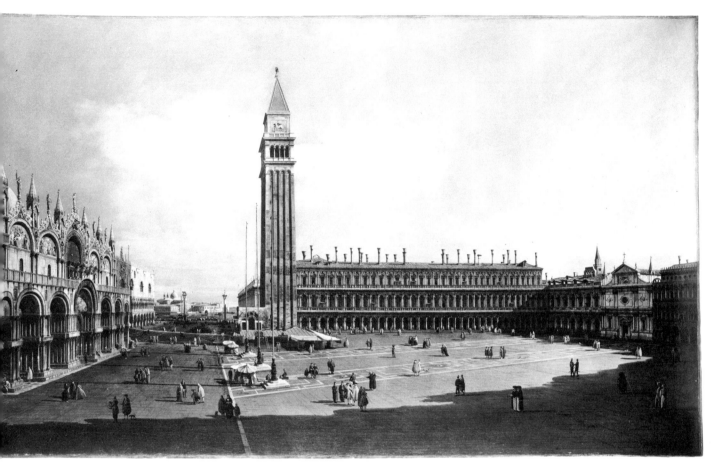

Figure 141.

Figure 141a. Study of the construction of the painting, by Martin Linsey.

Other variants of the Cleveland painting are as follows: one in the collection of Maron di Brugnera, Udine, Italy, which has a slightly different viewpoint and more figures (Constable, 1976, II, no. 53*); another, painted from a viewpoint slightly more to the east, in the Wadsworth Atheneum, Hartford (Constable, 1962 and 1976, II, no. 54); and several variants painted by followers of Canaletto.

The Cleveland painting is a pendant to the *Grand Canal: The Salute and Dogana from the Campo Sta Maria Zobenigo* (Constable, 1962 and 1976, I, pl. 38, fig. 180, and II, no. 180), formerly in the same collections as the Museum's painting and now in the Robert Lehman Collection of the Metropolitan Museum of Art.

Windsor Castle has a drawing by Canaletto (no. 7422) that is very closely related to the Museum painting (Constable, 1962 and 1976, I, pl. 97, fig. 537, and II, no. 537), although the flagpoles are in slightly different positions, slightly more is included on the right, and there are more figures in the piazza. Another drawing, directly after this but without the shading, given to Bernardo Bellotto, is in the Darmstadt print room (A. E. 2211; Detlev von Hadeln, *The Drawings of Antonio Canal Called Canaletto*, London, 1929, pl. 69). N C W

EXHIBITIONS: Birmingham (England) Society of Arts, 1833: Catalogue of Pictures, Chiefly by the Old Masters of the Italian, Flemish, and Spanish Schools, cat. no. 112; Manchester, 1857: Art Treasures of the United Kingdom, cat. no. 827; London, British Institution, 1863, cat. no. 63; Art Institute of Chicago, Minneapolis Institute of Art, and Toledo (Ohio) Museum of Art, 1970–71: Painting in Italy in the Eighteenth Century, Rococo to Romanticism, cat. no. 16, illus.

LITERATURE: Waagen (1854), p. 219; English Homes, I (1907), illus. p. 302; "Combe Abbey, I: Warwickshire, A Seat of the Earl of Craven," Country Life, XXVI (1909), 794–804, illus.; William George Constable, Canaletto, Giovanni Antonio Canal 1697–1768 (Oxford, 1962), I, pl. 20, fig. 53, and II, 204 no. 53, 445 (second ed. rev., ed. J. G. Links, Oxford, 1976, I, pl. 20, fig. 53, and II, 208–9 no. 53, 273, 486); Henry S. Francis, "Canaletto: Piazza San Marco, Venice," CMA Bulletin, XLIX (1962), 186–90, fig. 1; Rodolfo Pallucchini, "A proposito della mostra bergamasca del Marieschi," Arte Veneta, XX (1966), 319–20, fig. 381; Selected Works (1966), no. 174, illus.; David Bindman and Lionello Puppi, The Complete Paintings of Canaletto, Classics of the World's Great Art (New York, 1968), p. 102, no. 133A; Pallucchini, "La Pittura veneta del settecento alla mostra itinerante di Chicago-Minneapolis-Toledo," Arte Veneta, XXIV (1970), 289, fig. 415; Dizionario (1972), II, 445; Fredericksen and Zeri (1972), pp. 42, 574; William D. Wixom, Renaissance Bronzes from Ohio Collections (Cleveland, 1975), p. 3, and under cat. no. 104, fig. 1; CMA Handbook (1978), illus. p. 147; Francesco Valcanover, "The Horses of San Marco in Venetian Painting," The Horses of San Marco, Venice (exh. cat., New York, 1980), pp. 99, 101, figs. 136 and 137.

MICHELANGELO MERISI DA CARAVAGGIO
1573–1610

Michelangelo Merisi da Caravaggio was born in Caravaggio, near Bergamo, on September 28, 1573. He served a four-year apprenticeship in Milan under the painter Simone Peterzano. According to Giovanni Pietro Bellori (*Le Vite de'pittore, scultori, et architetti moderni*, Rome, 1672) Caravaggio went to Rome ca. 1592–93, visiting Venice on his way. In Rome he worked in, or was in touch with, the studios of a variety of painters, most important among them Giuseppe Cesari, the Cavaliere d'Arpino. By 1597 Caravaggio was attached to the household of Cardinal Francesco Maria del Monte, whose admiration for the master was shared by other important Roman families, among them the Barberinis, the Borgheses, and the Marchése Vincenzo Giustiniani.

Caravaggio's first important church commission in Rome was for the Contarelli chapel of S. Luigi dei Francesi; called *St. Matthew and the Angel* and dating from 1599–1602, it was rejected, then followed by a second version and another painting, the *Calling of St. Matthew*. By 1601 Caravaggio had received final payment for two other altarpieces, the *Crucifixion of St. Peter* and the *Conversion of St. Paul*, for the Cerasi chapel of S. Maria del Popolo. These were followed by *Death of the Virgin*, for S. Maria della Scala, painted between 1605 and 1606 and subsequently rejected.

In 1604 Caravaggio left for a brief visit to the Marches, and in 1605 he visited Genoa. His restless and hot temper led to various involvements with the Roman police. In one instance he fatally wounded his opponent, Ranuccio Tommasoni, in a ball game, and as a result was forced to flee from Rome at the end of May 1606, seeking refuge with the Colonna family east of Rome. By 1607 he was working in Naples, where he painted four major altarpieces. One, the *Resurrection*, was destroyed. The other three are: *Seven Works of Mercy*, for Pio Monte della Misericordia; *The Flagellation*, for San Domenico Maggiore (now on deposit at the Museo di Capodimonte); and *The Crucifixion of St. Andrew*, for the Spanish viceroy, the Conde de Benavente, which is now in this Museum.

Still without pardon from Rome for killing his friend, in 1608 he proceeded to Malta, where he painted *Execution of John the Baptist* for the Cathedral of St. John in Valletta. In that same year he was made Knight of the Order of St. John of Jerusalem, but was soon expelled. Before returning to Naples in October 1609, he went to Syracuse, where he painted *The Burial of St. Lucy* (1608). He then proceeded to Messina in 1609, where he painted the *Raising of Lazarus* and *Adoration of the Shepherds*. Next he went to Palermo, where he painted the *Nativity with SS. Francis and Lawrence* for the Church of S. Lorenzo. In July 1610 Caravaggio left Naples, northbound, probably still hoping for

an eventual pardon from Rome. He never arrived in Rome; struck by a fever in the Spanish enclave Port Ercole, Caravaggio died on July 18, 1610 (Richard E. Spear, *Caravaggio and His Followers*, exh. cat., Cleveland, 1971, pp. 1–27, 67–68).

142 *The Crucifixion of St. Andrew* 76.2

Canvas, 202.5 x 152.7 cm.

Collections: Don Juan Alonso Pimentel y Herrera, Eighth Conde de Benavente, Spanish viceroy in Naples from 1603 until July 1610; (his grandson) Don Juan Francisco Alonso Pimentel y Ponce de Léon, Tenth Conde de Benavente, Valladolid; an unidentified convent in Castilla, Spain; A. Tors, Madrid; José Manuel Arnaiz, Madrid, 1973.

Purchase, Leonard C. Hanna Jr. Bequest, 1976.

The previous owner, José Manuel Arnaiz, had the painting x-rayed in his Instituto Tecnico in Madrid; it was then cleaned and restored by Jan Dik in Switzerland in 1974, in close consultation with Luigi Salerno and Denis Mahon. The cleaning revealed that the original paint is remarkably well preserved in practically all essential areas; scattered losses were no more than expected (Lurie and Mahon, 1977, fig. 21). The head of the man in armor was completely overpainted because of a slashing cut through the eye (*ibid.*, figs. 17 and 18). The throat of the woman had become obscured because of a pentimento that was showing through—namely, the clasped hands which Caravaggio had placed under her chin to partially conceal her enormous goiter. The left arm (in shadow) of the executioner on the ladder was found in a summary state; it is impossible to determine to what extent this is due to loss by abrasion or to lack of finish. This area was slightly restored.

According to Bellori (1672), the *Crossifissione di Santo Andrea* was painted by Michelangelo Merisi da Caravaggio for Don Juan Alonso Pimentel y Herrera, the Eighth Conde de Benavente, who took it with him to Spain at the end of his seven-year term as viceroy of Naples. The Conde de Benavente—like Caravaggio—left Naples in July 1610. The painting was then installed in the Benavente family palace in Valladolid. Considerably later, in 1653, it was appraised the best of all the paintings in the Benavente collection in two inventory listings made shortly after the death of the viceroy's grandson, the Tenth Conde de Benavente. For over two centuries after these inventories, the painting was not heard of.

At its first public showing, in the Seville exhibition of 1973, the painting was given the title *San Felipe(?)*. Shortly after the exhibition, Benedict Nicolson ("Caravaggio and the Caravaggesques," 1974, p. 608) published his opinion that this was Caravaggio's missing *St. Andrew*. After it was restored in 1974 and acquired by this Museum in 1976, the painting was published by Ann Tzeutschler Lurie in collaboration with Denis Mahon (1977), who firmly identified it as the missing original from Valladolid, based on stylistic and iconographical considerations.

One of the reasons for doubting the identification was the description of Caravaggio's original in the second of the Benavente inventories at Valladolid, dated February 20, 1653, in which only three executioners are mentioned, although there are four in the Cleveland painting. The recently discovered earlier inventory, dated January 3, 1653, however, made it clear that the number pertained only to the executioners standing at the foot of the cross (Lurie and Mahon, 1977, figs. 14 and 15).

Further doubts were revealed in the title given the painting in the catalogue of the Seville exhibition—*San Felipe(?)*, instead of *St. Andrew*. The confusion was caused by the form of the cross—an upright Latin cross instead of the diagonal *crux decussata* with which St. Andrew is commonly associated. It was precisely at the time of Caravaggio that leading theologians declared the diagonal form to be in error (Lurie and Mahon, 1977, p. 13); nevertheless, both forms continued to be utilized (*ibid.*, nn. 35, 39). By inconspicuously crossing St. Andrew's legs, Caravaggio managed, in a very subtle way, to convey an impression of the diagonal and, in Nicolson's words, "to have it both ways" ("Caravaggio and the Caravaggesques," 1974, p. 608).

Even more conclusive for identifying the subject as Andrew is the incident which the painting depicts and which pertains only to this saint. After St. Andrew was crucified, he remained alive for two more days, preaching to the crowds gathered under the cross. He so moved them that they demanded his release, but in fulfillment of St. Andrew's ardent wish to die on the cross, a supernatural paralysis immobilized the executioners who were trying to untie him under the eyes of the perplexed onlookers (see the *Golden Legend* [*Legendario delle Vite de'Santi, Composto dal R. P. F. Giacobo di Voragine dell'Ordine de' Predicatori e Tradotto già per il R. D. Nicolò Manerbio Venetiano,* . . .], Venice, 1600, p. 14; and Lurie and Mahon, 1977, nn. 43, 44). This is the moment the painting portrays, in spite of the mistaken claim of the inventories that it was the moment St. Andrew was placed on the cross.

Perhaps the main obstacle to accepting the painting's authenticity was its poor condition at the time of its exhibition in Seville. Confusion resulting from distorting overpaint, grime, and partially protruding pentimenti caused Pérez-Sánchez to place a question mark after Caravaggio's name in the catalogue, although he clearly recognized some of the potential qualities of the work that pointed to Caravaggio (Lurie and Mahon, 1977, pp. 9, 10). X radiographs and restoration have since confirmed Caravaggio's authorship and clarified the relationship of the three other, known repetitions dependent on the Cleveland painting.

One of these versions (Figure 142a)—a painting severely damaged during the Spanish Civil War—belongs to the Museo Provincial de Santa Cruz, Toledo (Lurie and Ma-

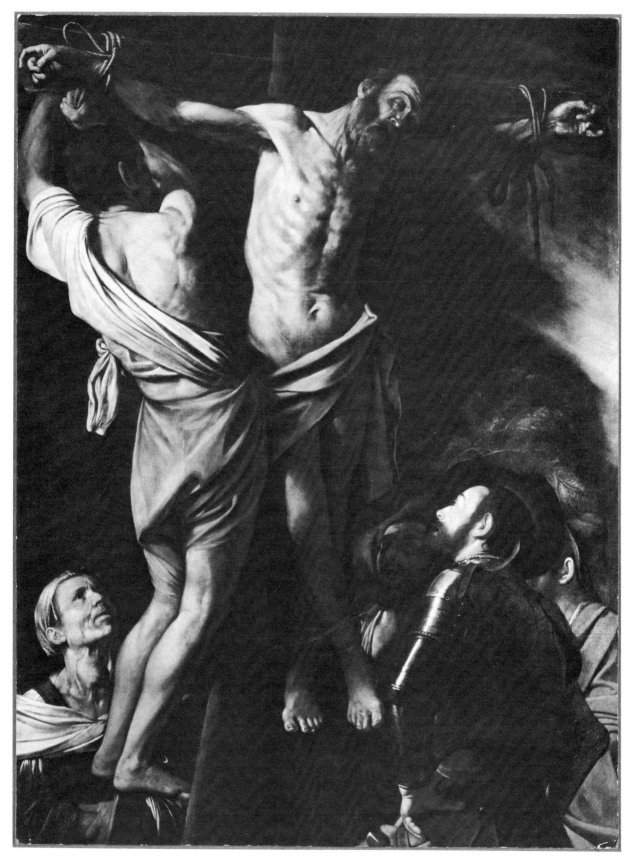

Figure 142.

hon, 1977, fig. 3). This painting was attributed to Ribera by Roberto Longhi (1943) when he first saw it in 1920, but Longhi then recognized it as a copy after a lost original by Caravaggio. Because of the greater height of this version (232.5 cm instead of the 202.5 cm of the Cleveland painting), the figures were placed lower, below the cross, thus sacrificing the dramatic effect of the more compact composition by Caravaggio.

Another version (Figure 142*b*), now in a private collection in Switzerland and formerly in the Back-Vega collection, was exhibited in Bordeaux in 1955 (in the exhibition L'âge d'or espagnol). In 1958 it was published by its owners, Emmerich and Christa Back-Vega, as the lost original ("A Lost Masterpiece by Caravaggio," *Art Bulletin*, XL, 1958, 65–66). In their article, however, the Back-Vegas did not resolve the problem presented by documents of 1617 and 1619, which mentioned a version by Caravaggio then belonging to the painter Louis Finson, an early Northern follower of the master (Lurie and Mahon, 1977, n. 18). A comparison of the Back-Vega painting with Finson's documented works (such as the *Crucifixion of La Calade* or

The Incredulity of St. Thomas, at Aix-en-Provence) and with the Cleveland painting leads to the conclusion that the Back-Vega painting and Finson's "Caravaggio" are one and the same and that the author is Finson himself. This had long been suspected, even though until recently Finson had been documented in Naples only once—in 1612, two years after the Caravaggio painting had left Naples for Spain (*ibid.*, nn. 19–21, 24–25; Moir, 1967, p. 19, no. 28; and Nicolson, "Caravaggio and the Caravaggesques," 1974, p. 607, n. 11). In 1977 Pacelli (p. 829, n. 35) published a document which confirmed Finson's earlier presence in Naples from 1608 onwards, in Pacelli's words, "thus making his execution of the copy of Caravaggio's painting perfectly feasible."

A third version (Figure 142*c*) in the Musée des Beaux-Arts, Dijon, formerly in the Cathedral of Saint-Bénigne (Lurie and Mahon, 1977, figs. 4, 13), has been alternately attributed to, or after, Caravaggio or Ribera, and its subject variously identified as St. Simeon, St. Philip, or St. Peter. Mahon suggested that it had been copied not after the original but after the former Back-Vega version, perhaps by

Figure 142*a*. *The Crucifixion of St. Andrew*. On canvas, 232.5 x 160 cm. Follower of Caravaggio, Spanish, 17th century. Museo Provincial de Santa Cruz, Toledo.

Figure 142*b*. *The Crucifixion of St. Andrew*. On canvas, 200 x 150 cm. Louis Finson(?), Flemish, after 1580–1617. Private Collection, Switzerland.

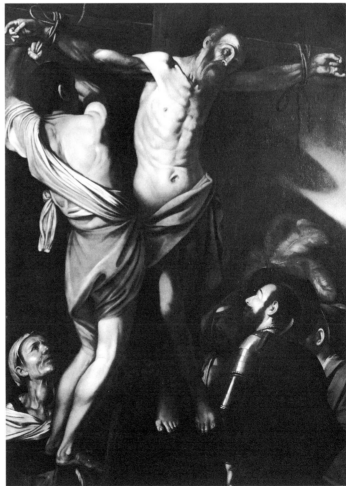

Abraham Vinck, who was known to have carried on a practice as a copyist in Amsterdam and who was Finson's friend (*ibid.*, n. 23). Perhaps this painting is Vinck's "copie van een St. Andries," which was offered for sale by his son-in-law, Simon Glaude (or Glauwe), around 1621 (*ibid.*, n. 27).

Even before the rediscovery of the Cleveland painting, scholars generally agreed that the composition and concept of the existing versions of the *Crucifixion of St. Andrew* reflected Caravaggio's style of ca. 1607—during his first Neapolitan period. As pointed out by Lurie and Mahon (1977, pp. 15–18 and n. 51) and Pacelli (1977, pp. 826, 829), the Cleveland painting confirms this theory in every way when compared with Caravaggio's three major works of late 1606/7: *Seven Works of Mercy* (Pio Monte della Misericordia, Naples), *The Flagellation of Christ* (Figure 142d); and *St. Jerome* (St. John's Museum, Valletta, Malta), the latter believed by Nicolson to have been painted in Naples in 1607 ("Caravaggio and the Caravaggesques," 1974, p. 608). Caravaggio's works of this period are characterized by varied and evocative brushwork; restraint in

color; and striking accents of brightly lit white drapery, pulled in taut, diagonal folds. In these works he tends to pack his figures into space. The handling of anatomy in *Seven Works of Mercy* (presumably the earliest of the three; Lurie and Mahon, 1977, pp. 16, 17), *The Flagellation*, and the Cleveland painting is also remarkably similar, becoming more subtle in the last two. *The Flagellation* and the Cleveland painting are believed to be close in date; they correspond closely in composition, and the central figures —Christ in one, St. Andrew in the other—seem to convey Caravaggio's own humble acceptance of human suffering (*ibid.*, pp. 16–17, figs. 28–31).

Caravaggio's choice of St. Andrew as the subject of our painting further supports the claim of a Neapolitan origin. St. Andrew's remains are preserved in the cathedral at Amalfi, which is very near to Naples. An inscription in the burial crypt confirms the Conde de Benavente's direct involvement in the veneration of St. Andrew in the tradition of the Burgundian and Hapsburg dynasties that had adopted Andrew as their patron saint (Lurie and Mahon, 1977, pp. 18–20, fig. 34). We also learn from the inscription that the

Figure 142c. *The Crucifixion of St. Andrew.* On canvas, 208 x 159 cm. Copy after Caravaggio. Musée des Beaux-Arts, Dijon.

Figure 142d. *The Flagellation of Christ.* On canvas, 286 x 213 cm. Caravaggio. S. Domenico Maggiore, Naples. On deposit at the Museo Nazionale di Capodimonte.

Conde de Benavente and his predecessor were engaged in the renovation of St. Andrew's crypt, but this does not imply that our painting was destined to hang there or in any chapel of the Amalfi cathedral. The viceroy had it painted for his own palace in Naples, with a view to taking it with him to Valladolid as the gem of his collection and a fitting memento of his viceroyship in Naples. ATL

EXHIBITIONS: Seville, Sala de Armas de los Reales Alcazares, 1973: Caravaggio y el naturalismo español, cat. no. 4, as *Martirio de San Felipe (?)*, illus.; CMA, February 1977: Year in Review, cat. no. 39, illus.

LITERATURE: Giovanni Pietro Bellori, *Le Vite de'pittori, scultori, et architetti moderni* (Rome, 1672), p. 214; Leopold Zahn, *Caravaggio* (Berlin, 1928), p. 55; Roberto Longhi, "Ultimi studi sul Caravaggio e la sua cerchia," *Proporzioni*, I (1943), 17–18; *Boletín de la Real Academia de Bellas Artes de Puríisma Concepción*, IX (Valladolid, 1946), nn. 18, 13–30; "El Palacio del Conde de Benavente," *Solidariedad Nacional [Barcelona]*, April 7, 1946; Esteban García Chico, *Documentos para el estudio del arte en Castilla*, Vol. III: *Primera parte: Pintores* (Valladolid, 1946), 393; Juan Ainaud de Lasarte, "Ribalta y Caravaggio," *Anales y Boletín de los Museos de Arte de Barcelona*, V (1947), 366, 380, 381 n. 59, 382, 406; Constantini Baroni, *Tutta la pittura del Caravaggio* (Milan, 1951), p. 24; O. H. Green and Denis Mahon, "Caravaggio's Death: A New Document," *Burlington Magazine*, XCIII (1951), 203, n. 5; Lionello Venturi, *Caravaggio* (Novara, 1951; rev. ed., 1963), p. 31; Denis Mahon, "Addenda to Caravaggio," *Burlington Magazine*, XCIV (1952), 19; Roger Hinks, *Michelangelo Merisi da Caravaggio, His Life, His Legend, His Works* (London, 1953), p. 120; Frits Baumgart, *Caravaggio, Kunst und Wirklichkeit* (Berlin, 1955), pp. 44, 108, under no. 61; "Ein Hauptwerk Caravaggios wiederentdeckt," *Weltkunst*, XXV (July 15, 1955), 9; Walter Friedlaender, *Caravaggio Studies* (Princeton, New Jersey, and London, 1955), pp. xxvii, 210, 254, illus.; Friedlaender, "Réflections sur les problèmes posés par l'exposition (de Bordeaux)," *Cahiers de Bordeaux*, II (1955), 27–30; René Jullian, "Caravage à Naples," *Revue des Arts*, V (1955), 84 n. 11, 86, 88, 90 n. 21; Ainaud de Lasarte, "Le Caravagisme en Espagne," *Cahiers de Bordeaux*, II (1955), 22; Halldohr Soehner, "Die Malerei in Spanien und Frankreich um Caravaggio," *Kunstchronik*, VIII (1955), 250; Sergio Samek Ludovici, *Vita del Caravaggio dalle testimonianze del suo tempo* (Milan, 1956), p. 69, n. 105; Emmerich and Christa Back-Vega, "A Lost Masterpiece by Caravaggio," *Art Bulletin*, XL (1958), 65, 66 n. 4; Louis Réau, *Iconographie de l'art Chrétien*, III, pt. 1 (1958), 80, 83; Hugo Wagner, *Michelangelo da Caravaggio* (Bern, 1958), p. 233; A. Berne Joffroy, *Le Dossier Caravage* (Paris, 1959), pp. 344–45; Longhi, "Un'Opera estrema del Caravaggio," *Paragone*, IX, no. 111 (March 1959), 27–29; Paul Guinard, *Zurbarán et les peintres espagnols de la vie monastique* (Paris, 1960), p. 19; Longhi, "Un originale del Caravaggio a Rouen e il problema delle copie Caravaggesche," *Paragone*, XI, no. 121 (1960), 35; Jullian, *Caravage* (Lyons and Paris, 1961), pp. 174, 181, n. 37; Giuseppe Delogu, *Caravaggio* (Milan, 1962), p. 158; Michael Kitson, *The Complete Paintings of Caravaggio*, Classics of the World's Great Art (New York, 1967), p. 105, under no. 77; Alfred Moir, *The Italian Followers of Caravaggio*, I (Cambridge, Massachusetts, 1967), 158; Didier Bodart, *Louis Finson (Bruges, avant 1580—Amsterdam, 1617)* (Brussels, 1970), pp. 15, 137; Raffaello Causa, *Opere d'arte nel Pio Monte della Misericordia a Napoli* (Naples, 1970), p. 29; Gian Alberto Dell'Acqua, *Il Caravaggio e le sue grandi opere de San Luigi dei Francesi* (Milan, 1971), pp. 136, 199 n. 512; Enrique Valdivieso Gonzales, *La Pintura en Valladolid en siglo XVII* (Valladolid, 1971), p. 19, n. 2; Maurizio Marini, "Tre proposte per il Caravaggio Meridionale," *Arte Illustrata*, XLIII–XLIV (1971), 56–58 and n. 17; Richard E. Spear, *Caravaggio and His Followers* (exh. cat., Cleveland, 1971), p. 93; Causa, "La Pittura del seicento a Napoli dal naturalismo al barocco" [offprint from *Storia di Napoli*, V (1972)]; Valerio Mariani, *Caravaggio* (Rome, 1973), p. 112; Evelina Borea, "Caravaggio e la Spagna: Osservazioni su una mostra a Siviglia," *Bollettino d'Arte*, LIX (1974), series V, 44, n. 2; Enriqueta Harris, "Caravaggio e il naturalismo spagnolo," *Arte Illustrata*, VII (1974), 238, fig. 3; Marini, *Io Michelangelo da Caravaggio* (Rome, 1974), pp. 235 (illus.), 433–35; Benedict Nicolson, "Caravaggio and the Caravaggesques: Some Recent Research," *Burlington Magazine*, CXVI (1974), 604, 607–8, figs. 54 and 55; Nicolson, "Recent Caravaggio Studies," *Burlington Magazine*, CXVI (1974), 625, n. 1; Mina Gregori, "Significato delle mostre caravaggesche dal 1951 a oggi," *Novità sul Caravaggio*, ed. Mia Cinotti (Milan, 1975), pp. 43–44, nn. 52 and 53; Joseph T. Butler, "Recent Major Museum Acquisitions," *Connoisseur*, CXCII (1976), 312–13; "The Cleveland Caravaggio," *New Lugano Review*, VIII–IX (1976), 36–37, 65; Briony Llewellyn and Charles McCorquodale, "In the Light of Caravaggio," *Connoisseur*, CXCII (1976), 113; Moir, *Caravaggio and His Copyists* (New York, 1976), pp. 113, 151; Ann Tzeutschler Lurie in collaboration with Denis Mahon, "Caravaggio's *Crucifixion of Saint Andrew* from Valladolid," CMA *Bulletin*, LXIV (1977), 3–24, illus. pp. 1 and 2 (color), and figs. 1, 5, 7, 9, 11, 16–21, 26, 31, 35–37; Vicenzo Pacelli, "New Documents Concerning Caravaggio in Naples," *Burlington Magazine*, CXIX, pt. 3 (1977), 826 n. 33, 829; CMA *Handbook* (1978), illus. p. 135; Françoise Bardon, *Caravage ou l'experience de la matière*, Publications de l'université de Poitiers, Lettres et Sciences humaines, Vol. XIX (Paris, 1978), 208–9, n. 25; Marini, *Michael Angelus Caravaggio Romanus*, Studi Barocchi/1 (Rome, 1978), pp. 16, 18–19, 22, 36, 38 nn. 40–41, 39 n. 45, 43; José López-Rey, *Velazquez, the Artist as a Maker* (Lausanne and Paris, 1979), pp. 24, 156 n. 48; Nicolson, *The International Caravaggesque Movement* (Oxford, 1979), p. 32, pl. 4; Marguerite Guillaume, *Catalogue raisonné du Musée des Beaux-Arts de Dijon: Peintures italiennes* (Dijon, 1980), pp. 17–18, under no. 27.

Attributed to GIROLAMO SELLARI DA CARPI
1501–ca. 1556/57

Girolamo studied first with his father, Tommaso, then with Garofalo. Later he worked in Bologna, where, according to Giorgio Vasari (*Lives of the Most Eminent Painters, Sculptors & Architects*, VIII, trans. Gaston du C. de Vere, London, 1914, 30) he painted some portraits that were "passing good likenesses." He visited Modena and Parma and was introduced to the Ferrarese court by Titian, probably in the 1530s. He worked for Ercole II d'Este and then for Cardinal Ippolito II, whom he accompanied to Rome. In Rome Girolamo worked as architect and designer for the cardinal and Pope Julius III. He was in close touch with some of the famous humanists of his day (including the emblematist, Alciatus). This eclectic painter was influenced by Raphael and Correggio, Dosso, Titian, and especially Parmigianino. Vasari (*op. cit.*, p. 33) says he copied some of Titian's portraits; one such copy may be the *Alfonso I d'Este* in the Pitti Palace, Florence, after the one by Titian in the Metropolitan Museum. Among his surest works are the documented Muzzarelli altarpiece, *Assumption of the Virgin* (Kress Collection, National Gallery, Washington), and the generally accepted portrait of the Archbishop Bartolini-Salimbeni in the Pitti Palace (no. 7834). In addition, there are numerous other portraits (Hermann Voss, "Girolamo da Carpi als Bildnismaler," *Städel-Jahrbuch*, III, 1924, 97–

Figure 143.

106; F. Antal, "Observations on Girolamo da Carpi," *Art Bulletin*, XXX, 1948, 81–102; Roberto Longhi, *Officina Ferrarese*, Florence, 1956, p. 222; E. H. Ramsden, "Further Evidence on a Problem Picture," *Burlington Magazine*, CVII, 1965, 185–92 [for a withdrawn attribution]).

143 *Portrait of a Prelate* 47.210

Canvas, 140.4 x 108 cm. Inscription on the book: MUNDOS LIBENTER ASPICIT ("She [the moon] regards with pleasure those that are clean").
Collections: [Italico Brass, Venice]; [Alessandro Brass].
Mr. and Mrs. William H. Marlatt Fund, 1947.

The painting had been lined, restored, and coated with a natural resin varnish before coming to the Museum. A cleaning in 1950 by William Suhr revealed pentimenti in the chair, in the curtain behind the sitter, and in the left contour of the sitter's shoulder and arm (which effectively broadened his torso). There are losses in the cap where it touches the head, and its design is not clear. The shadows under the right eye had been strengthened, the eyebrow had been repainted too large, and the mustache had been heavily overpainted; when these additions were removed, the face appeared younger. There were losses in the transition from light to shadow on the right side of the face, in the mouth, and along the edges of the book; and there were minor losses and abrasions in the sleeves. The left hand, the shadow of the right hand, the shadow thrown on the book, and the white vestment are all abraded and retouched. At present the picture is obscured by a varnish that is impenetrable by ultraviolet rays.

The painting was formerly attributed to Titian by the Museum upon the advice of Bernard Berenson (letter of March 15, 1949), who later published it (1957) with a question mark. By now, however, the attribution to Titian has been generally rejected. Scipione Pulzone was tentatively proposed by Hans Tietze (letter of June 1, 1951). Henry Francis (1951) rightly disagreed with this attribution, suggesting the possibility of Paris Bordone. Philip Pouncey (orally, March 31, 1958) suggested investigating the Bassano family. E. K. Waterhouse (orally, June 6, 1963) thought this portrait a seventeenth-century work, probably Bolognese, and perhaps a copy after a lost Sebastiano del Piombo. Francis (letter to Tietze, June 29, 1951) said that it was unquestionably sixteenth-century. More recently, Fredericksen and Zeri (1972) attributed the painting to Denis Calvaert. Pallucchini (1969) and Wethey (1971) gave more cautious attributions to "circle of collaborators and pupils of Titian" and "school of Parma-Modena," respectively.

Given the poor condition and eclectic nature of the painting, any attribution must be tentative. The Museum now attributes it to Girolamo da Carpi, not because it appears to be by the same hand as the Muzzarelli (one is not at all convinced that it is!), but because of resemblances to a group of portraits attributed to Girolamo da Carpi. A portrait of a *Lady with a Dog* from the collection of Mrs. Brandagee (which once hung in the Museum of Fine Arts, Boston [693.18], as by Parmigianino) seems to be by the same hand as our prelate; it was attributed to Girolamo da Carpi by F. Harck ("Berichte und Mittheilungen aus Sammlungen und Museen, über Kunstpflege und Restaurationen, neue Funde," *Repertorium für Kunstwissenschaft*, XI, 1888, 78). Other portraits attributed to Girolamo with which our prelate may be compared are the two portraits (in the Pitti Palace, Florence) mentioned earlier—one of Alfonso I and one of the Archbishop Bartolini-Salimbeni.

The sitter was at one time mistakenly identified as Antonio Galeazzo Bevilacqua da Verona (B. Berenson, letter of March 15, 1949; and Francis, 1951, p. 24). Although no more certain identification has been proposed, the emblem and the motto on the book held by the sitter might provide a clue to his identity and in turn might help solve the problem of authorship. The emblem of the elephant in water regarding the moon, however, was rather commonly used as a symbol of purity (Arthur Henkel and Albrecht Schöne, *Emblemata: Handbuch zur Sinnbildkunst des XVI. und XVII. Jahrhunderts*, Stuttgart, 1967, pp. 410–11). Among those who adopted the symbol was Cesare Ripa's patron Cardinal Gregorius (Petrochini) de Montelbero (Ripa, *Iconologia*, 1767, V, 12, as Montelpare), who became a cardinal in 1590 and died in 1612 (Conrad Eubel, *Hierarchia Catholica medii aevi, cive summorum pontificum S.R.E. cardinalium ecclesiarum antistitum series ab anno 1198 usque ad annum [1605] perducta e documentis tabularii praesertim Vaticani*, Regensburg, 1898–1910, III, 531). At this writing, nothing further has come to light concerning the motto or its use in an emblem. EFG

EXHIBITIONS: CMA (1956), cat. no. 55 (note: the second part of the inscription given in the catalogue is non-existent).

LITERATURE: Henry S. Francis, "Venetian Art and Its Field of Influence: *Prelate* by Titian," CMA *Bulletin*, XXXVIII (1951), 23, 24, illus. p. 27; B. Berenson (1957), p. 184; Rodolfo Pallucchini, *Tiziano*, I (Florence, 1969), 223; Harold E. Wethey, *The Paintings of Titian*, Vol. II: *The Portraits* (London, 1971), 155, no. X-12, pl. 227; Fredericksen and Zeri (1972), pp. 40, 511.

GIOVANNI BENEDETTO CASTIGLIONE
Ca. 1610–1663/65

Castiglione, who was often called "il Grechetto," was born about 1610 in Genoa; he died in Mantua between 1663 and 1665. In Genoa Castiglione studied with two minor, local painters and with Sinibaldo Scorza (1589–1631), a prominent painter specializing in animal studies. It is said that he later studied with Anthony van Dyck at his studio in Genoa. Castiglione was in Rome in 1632. In 1634 he became a member of the Accademia di San Luca. In 1635 he visited Naples, after which he seems to have traveled almost continuously. He returned to Genoa in 1641 and again in 1645. Castiglione stayed in Rome from 1647 to 1651 except for the periods when he apparently worked at the Court of Mantua. From 1659 to 1663 he was in Venice and Genoa and made trips to Mantua and Parma. He apparently also visited Florence, Modena, and Bologna at various times. He absorbed many influences. In Rome he was in contact with the circle of Poussin. The paintings of the Venetian Bassani had a discernible influence on his early style, as did the works of the Flemish painter Jan Roos (1591–1638). He produced a sizable number of religious works, which show the influence of the Venetians and fellow Genoese artists such as Bernardo Strozzi and Andrea de Ferrari. His later works show an affinity for the style of Domenico Fetti.

Castiglione was a prolific painter, whose oeuvre includes drawings, pen sketches, etchings, and monotypes—many of animal and still-life subjects. It was his technical virtuosity and need to experiment with new media that led him to invent the monotype. His son Francesco (ca. 1641–1716) studied with him and succeeded him in the service of the Duke of Mantua. (For additional information on the artist, see G. Delogu, *G. B. Castiglione*, Bologna, 1928; A. Blunt, "The Drawings of Giovanni Benedetto Castiglione," *Journal of Warburg and Courtauld Institutes*, VIII, 1945, 161–74; Blunt, *The Drawings of G. B. Castiglione and Stefano della Bella . . . at Windsor Castle*, London, 1954; and Ann Percy, *Giovanni Benedetto Castiglione: Master Draughtsman of the Italian Baroque*, Philadelphia, 1971).

144 *Journey of a Patriarch* 69.1

Canvas, 56 x 78.4 cm.
Collections: [Pinakos, New York].
Mr. and Mrs. William H. Marlatt Fund, 1969.

Pressure applied in lining the painting in the past has flattened the impasto. Residues of darkened varnish remain from the last cleaning, and there is evidence of inpainting along all edges and in other, scattered areas. Otherwise, the painting is in good condition.

Castiglione chose his subjects from the pastoral world of mythology or from Old Testament accounts of patriarchs in the course of their migrations, frequently with family, servants, possessions, and animals. The exact subject cannot always be identified.

The Cleveland painting has the main elements on which Castiglione's popularity as a painter rested: his Flemish-like, realistic portrayal of animals and a richness of material and sensuous color, as seen in the robes, ceramics, wicker basket, and other objects. The picture is also a variation on a theme he repeated many times, usually basing the variation on the desires of his patron. According to Louise Richards (1971), it is a distillation of other works, such as *Journey of the Family of Abraham* in the Palazzo Rosso in Genoa, *Jacob's Descent into Egypt* in the collection of the Earl of Derby at Knowsley, *Journey into the Promised Land* in the Pinacoteca di Brera in Milan, and *Journey of Jacob* in the Staatliche Kunstsammlungen in Dresden.

It is particularly difficult to date works such as the Museum painting because the artist executed so many versions of the same subject, each slightly different from the others. Little is known of Castiglione's early style, and none of his paintings from before the mid-forties has been securely dated. His style was quite personal, but usually the dating of his work has been based on the discernment of stylistic influences from other painters. Some art historians, seeing in the Cleveland painting the influence of Castiglione's teacher Scorza, have suggested that our painting is an early work from the 1630s. Ann Percy (1971) dated it as late as the 1650s. N C W

EXHIBITIONS: CMA, January 1970: Year in Review, cat. no. 140.

LITERATURE: Louise S. Richards, "A Painting and Two Drawings by Castiglione," CMA *Bulletin*, LVIII (1970), 274–80, color illus. p. 272–73; Ann Percy, *Giovanni Benedetto Castiglione, Master Draughtsman of the Italian Baroque* (exh. cat., Philadelphia, 1971), p. 40; Richards, "A Painting and Two Drawings by Castiglione," *Connoisseur*, CLXXVII (July 1971), 204–10, illus. pp. 204–5, figs. 1 and 2; CMA *Handbook* (1978), illus. p. 141.

Figure 144.

Figure 145.

BERNARDO CAVALLINO
1616–ca. 1656

Bernardo Cavallino was baptized at S. Nicola alla Carotà in Naples on August 25, 1616. He was trained by Andrea Vaccaro and Massimo Stanzione. Cavallino combined Caravaggio's light and the realism of the Bamboccianti with the lyrical classicism typical of the Neapolitan School. In spite of his highly individualistic style and manner, his works have long been hidden under names of better-known artists, and only recently have they emerged from obscurity. Cavallino may have died in the great plague in Naples in 1656; Baldinucci and A. F. Marni, writing about 1674–78, claimed that he had died "some twenty years ago" (*Notizie de' vite . . . di diversi pittori*, Biblioteca Nazionale, Florence; and G. Ceci, *Napoli Nobilissima*, VIII, 1899, 163–68).

Figure 145a. Detail showing monogram.

145 *Adoration of the Shepherds* 68.100

Canvas, 126.8 x 148.3 cm. Inscribed with monogram on rump of ox (see Figure 145a).

Collections: Marquis de Villette, Château de Villette, Oise; Jean Baptiste Angiot, Paris (sale: Hôtel Drouot, Paris, March 1–2, 1875, cat. no. 41, as Benedetto Castiglione); private collection, Buenos Aires; [Frederick Mont, New York].

Mr. and Mrs. William H. Marlatt Fund, 1968.

The original canvas has been lined with two fabrics; the outer fabric is in two pieces with a horizontal seam at 55 centimeters from the bottom edge. The painting is in satisfactory condition, except for old, repaired damages to the original support. Some minor reinforcements and a number of tears are evident in the following areas: in the face of Joseph and in front of it (on the extreme left); in the group of angels, running parallel with the top margin; another running diagonally from the angel on the left down to the neck of the full-length shepherd standing behind the one who kneels at the manger. The tears have been repaired, but there have been losses along their edges.

This painting is one of five known works by Cavallino which bear his monogram. The "BC" was recently discovered on the rump of a horse in the *Expulsion of Heliodorus* (Pushkin Museum, Moscow), while in our painting it is inscribed on the rump of an ox (Figure 145a). The monogram on our painting and on *Judith with the Head of Holofernes* (Nationalmuseum, Stockholm) was once taken for the monogram of the better-known artist Benedetto Castiglione.

It is difficult to establish a reliable chronology for Cavallino's oeuvre. Only one of his works is dated, his *St. Cecilia* of 1645 (Palazzo Vecchio, Florence). The Madonna in the Cleveland *Adoration* seems directly related to St. Cecilia, although the composition of the painting seems to have been inspired by two other works on the same subject: one by Jusepe de Ribera (Louvre, Paris) and another by Andrea Vaccaro (Kunsthistorisches Museum, Vienna). Some of its qualities—the extremely refined tonal variations, light effects, and composition—would place the Cleveland painting after Cavallino's work of 1645.

Our painting is close to the *Esther and Ahasuerus* (Uffizi) and probably precedes the following works by Cavallino: *Expulsion of the Money-Changers from the Temple* (National Gallery, London), dated by Michael Levey between 1645 and 1650; *Finding of Moses* (Herzog Anton-Ulrich Museum, Braunschweig); and *St. Peter and the Centurion Cornelius* (Galleria d'Arte Antica, Palazzo Corsini, Rome). In all these works, figures are increasingly mannered in proportions, stances, and movements. ATL

EXHIBITIONS: CMA, January 1969: Year in Review, cat. no. 60.

LITERATURE: Ann Tzeutschler Lurie, "*Adoration of the Shepherds*," CMA *Bulletin*, LVI (1969), 136–50, figs. 4, 10, 12b, and colorplate on pp. 148–49; Michael Levey, *The Seventeenth and Eighteenth Century Italian Schools* (London, 1971), p. 85; CMA *Handbook* (1978), illus. p. 137.

Attributed to ANTONIO DEL CERAIOLO
(Antonio di Arcangelo)
Active by 1520

Giorgio Vasari, in his *Le Vite de' più eccelenti pittori, scultori ed architettori* (Florence, 1906, IV, 462, and VI, 542), identified Antonio del Ceraiolo as a pupil of Lorenzo di Credi and later an assistant of Ridolfo Ghirlandaio. As an example of Ceraiolo's work, Vasari cited *St. Michael Weighing Souls*, which is now in the Galleria dell'Accademia, Florence. The artist was discussed at length by Carlo Gamba ("Ridolfo e Michele di Ridolfo del Ghirlandaio-II," *Dedalo*, IX, 1929, 544–61) and was recently the subject of a penetrating article, with additional attributions, by Federico Zeri ("Antonio del Ceraiolo," *Gazette des Beaux-Arts*, LXX, 1967, 139–53). Ceraiolo was influenced by Fra Bartolommeo. In 1520 he was inscribed in the Florentine *Libro Rosso dei Debitori e Creditori*.

Figure 146a. Photograph showing previous restoration.

146 *Madonna and Child in a Niche* 16.813

Panel (poplar), 59.5 x 43.9 cm.

Collections: James Jackson Jarves; Mrs. Liberty E. Holden, Cleveland, 1884.

Holden Collection, 1916.

The panel is slightly warped and worm-eaten. Three knot-holes have been filled. The original paint surface had sustained severe damages, and the painting had been extensively altered by restoration in the past (see Figure 146a). William Suhr removed the old repaint in 1941.

The painting was described as Italian, sixteenth-century, when it entered the collection. Frank W. Mather (notes in Museum files dated May 17, 1921) thought it close to the style of Andrea del Brescianino, "possibly a copy after an original by him." L. Venturi (orally, May 1929) attributed it to Brescianino himself. George Richter (letter of November 3, 1940) pointed out the similarities between the Cleveland painting and another in the Philadelphia Museum of Art, Johnson Collection (no. 79), attributed to Fra Bartolommeo's pupil, Leonardo da Pistoia.

Our painting reproduces quite closely the central portion of Ridolfo Ghirlandaio's fresco, *Madonna with SS. Benedict and Dominic*, at the Villa Agostini, Florence, painted 1515–16. According to Everett Fahy (letter of June 18, 1966), there are several close variants of this composition: in the Galleria Borghese (Paola della Pergola, *Galleria Borghese: I Dipinti*, II, Rome, 1959, no. 50, fig. 49); in the Bode Museum, Berlin (inv. no. 1261); at S. Martino a Gangalandi; and in The Hermitage, Leningrad (inv. no. 4738).

Christian von Holst (orally, 1966) said that our picture was close to the circle of Ridolfo Ghirlandaio. He compared it with an unpublished painting, *Madonna and Child with St. John*, in Florence in the Uffizi storeroom (1890 inv. no. 7250), which, he said, looks as though it could be by the same hand.

Fahy (letter of June 18, 1966) was the first to associate our painting with Antonio del Ceraiolo. Independently, Burton Fredericksen of the J. Paul Getty Museum (letter of January 6, 1968) arrived at the same conclusion, although—perhaps because of the condition of the painting—he felt the quality of workmanship was very poor.

If our picture is by Ceraiolo, it most likely would belong to the works dating from 1520 and later, a period which Zeri ("Antonio del Ceraiolo," *Gazette des Beaux-Arts*, LXX, 1967, 151) describes as one of decline, characterized by a stronger tendency toward simplification and toward the manner of Fra Bartolommeo and his circle. E F G

EXHIBITIONS: CMA (1916), cat. no. 21 (Italian School, first half of sixteenth century, "idealized in the manner of Fra Bartolommeo and Raphael"); CMA (1936), cat. no. 94.

LITERATURE: Rubinstein (1917), p. 25, no. 21; Fredericksen and Zeri (1972), pp. 11, 336, 573; Edmund P. Pillsbury, *Florence and the Arts, Five Centuries of Patronage* (exh. cat., Cleveland, 1971), p. 55.

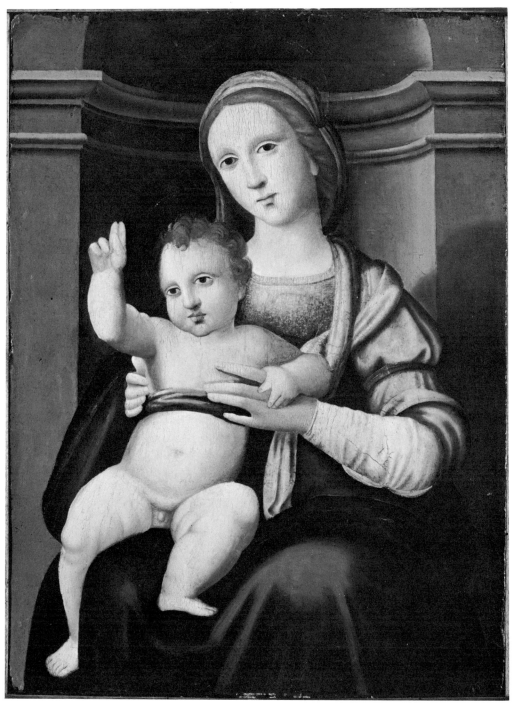

Figure 146.

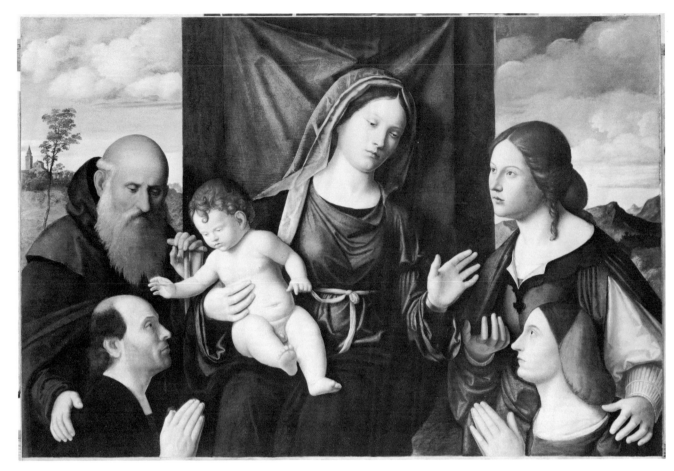

Figure 147.

GIOVANNI BATTISTA CIMA DA CONEGLIANO
1459–1517/18

Cima da Conegliano was born in 1459 in Conegliano, where he lived until 1489. From 1489 until 1516 he was active in Venice. He was probably a pupil of Alvise Vivarini but was also influenced by Antonello da Messina, Giovanni Bellini, and Giorgione. Of many documented works, the earliest is an altarpiece in Vicenza that is signed and dated 1489. His style changed very little throughout his career. Some of his compositions, or figures within compositions, are repeated in several versions, both by himself and by his followers.

147 *Sacred Conversation: The Virgin* 42.636
 and Child with St. Anthony Abbot and
 St. Lucy (?) with Donors

Panel (poplar), transferred, 57.1 x 80 cm.

Collections: H. L. Bischoffsheim, Bute House, London (sale: Christie's, London, May 7, 1926, no. 105); [Durlacher Brothers, London]; John L. Severance, Cleveland, 1926.

John L. Severance Collection, 1942.

In 1964 William Suhr transferred the painting from the original poplar panel and remounted it on tempered masonite with a poplar veneer on the reverse and along the edges. A cradle was added for additional support.

In the sale of the Bischoffsheim Collection in 1926, the painting was attributed to Liberale da Verona, but Lionello Venturi, in a letter of June 18, 1926, attributed it to Cima da Conegliano and dated it about 1505. Van Marle (1935) dated it at least ten years later and called it the last production of Cima. Berenson (1957) dated it after 1509.

It would seem to be a very late work that was left unfinished. The glazes on the head of the male donor are not carried out to the same extent as in the rest of the panel, and the hand of the female saint is in an enigmatic position, apparently poised to hold an object that was never painted in—presumably a light, if she were intended to be St. Lucy; or a jar, if she were Mary Magdalene.

The female saint has been identified as St. Lucy, probably because of her close similarity to the St. Lucy in Cima's *Rest on the Flight into Egypt* in the Gulbenkian Collection in Lisbon. The same model appears again as St. Catherine in the *Sacred Conversation* (Pierpont Morgan Library, New York), a painting which is closely related to the Museum's in composition and date. NCW

EXHIBITIONS: CMA (1936), cat. no. 119; CMA (1942), cat. no. 2, pl. IV.

LITERATURE: *Connoisseur*, LXXV (1926), 173; van Marle (1935), XVII, 449, 451, fig. 269; Francis (1942), p. 132; Coe (1955), II, 230, no. 2; B. Berenson (1957), I, 64; Luigi Coletti, *Cima da Conegliano* (Venice, 1959), p. 94, no. 134, illus.; Fredericksen and Zeri (1972), pp. 53, 333, 372, 426, 536, 573 (as studio of); CMA *Handbook* (1978), illus. p. 102.

GIUSEPPE MARIA CRESPI
(called Spagnuolo)
1665–1747

Crespi was born in Bologna in 1665. During the 1680s he studied with Angelo Michele Toni and then with Domenico Maria Canuti (1620–1684) and Carlo Cignani (1629–1719), although he was more influenced by the style of the Carracci, Guercino (early), Correggio, Barocci, and the Venetians. Before 1690, at the expense of his protector Giovanni Ricci, he traveled to Venice, Modena, Parma, Pesaro, and Urbino. He worked largely in Venice, but his reputation spread and brought him the patronage of Prince Eugene of Savoy and Ferdinando of Tuscany, among others. He was one of the most prominent painters of the Late Bolognese School. He had a lifelong interest in chiaroscuro. With pious sincerity he sought to describe the psychological depths of his subject matter, using genre scenes and a variety of subjects, including religious, for this endeavor. He had an influence on eighteenth-century Venetian painters such as Pietro Longhi, Tiepolo, and Piazzetta; the latter was a pupil in his studio in 1703. Crespi died in Bologna in 1747, surrounded by his four faithful sons, three of whom had worked in his studio and had joined religious orders.

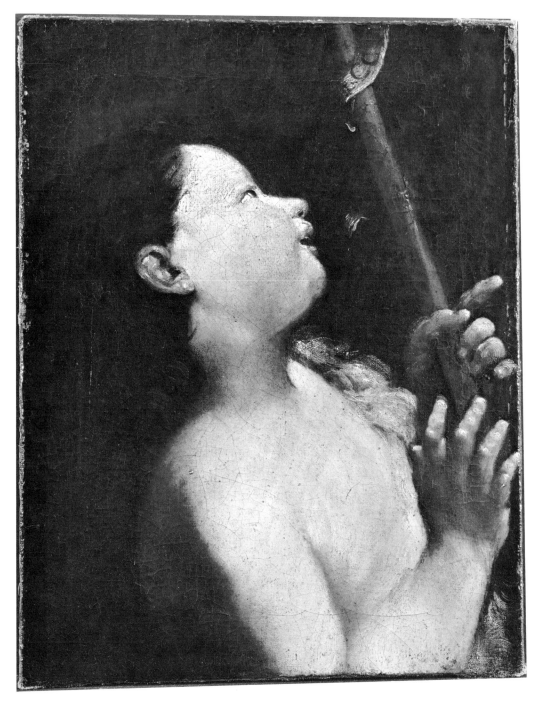

Figure 148.

148 *St. John as a Child* 36.350

Canvas, 44.5 x 34.5 cm. Signed on ribbon entwining flag staff:
GC.
Collections: Amadore Porcella.
Gift of Amadore Porcella, 1936.

In 1936 William Suhr retouched areas where the paint had
chipped off and revarnished the painting. Whether or not
the painting had been cut down from a larger composition
is unknown. There are numerous small-to-moderate losses
in scattered areas and substantial losses to the left of the ear
and to the right of the nose and mouth. X radiographs
(Figure 148a) show that St. John's hand was reworked by
Crespi himself. Paint layers have been badly abraded, and
the background has been heavily overpainted.

This sketch is a study for the large canvas of the *Holy
Family*, now in the Pushkin Museum, Moscow (Merriman,
1968, no. 67, pp. 196–98, fig. 146), which was painted for
Cardinal Ottoboni in Rome about 1715–20 along with a
companion piece, the *Death of St. Joseph*, now in The
Hermitage, Leningrad. The young St. John of the Cleveland
fragment is identical to the St. John in the Moscow *Holy
Family*.

Crespi and his workshop executed a number of versions
of the *Holy Family* which vary in composition and quality.
The closest in quality to the Pushkin Museum painting is
the version in the Capodimonte in Naples (Figure 148b).

NCW

Figure 148a. X radiograph showing pentimenti.

EXHIBITIONS: Bologna, Palazzo Communale, 1935: Mostra del Sette-
cento Bolognese, cat. no. 14; CMA (1936), cat. no. 153; New York,
Durlacher Brothers, 1937: Paintings by Giuseppe Crespi, cat. no. 3; Las
Vegas, Tallyho, 1963: Masterpieces of European Art, cat. no. 19, p. 152,
illus. opp. (catalogue by Amadore Porcella).

LITERATURE: Henry S. Francis, "A Sketch of St. John the Baptist by
Giuseppe Maria Crespi," CMA *Bulletin*, XXIII (1936), 107–9, illus. p.
105; "Cleveland: A Crespi for the Museum," *Art News*, XXXIV (September
12, 1936), 12; Alfred M. Frankfurter, "The Neglected Importance of
Crespi," *Art News*, XXXV (January 16, 1937), 12, illus. p. 11; Mira Pajes
Merriman, "The Paintings of Giuseppe Maria Crespi" (Ph.D. dissertation,
Columbia University, 1968; Ann Arbor, Michigan: University Microfilms,
1972), no. 79, pp. 202–3; fig. 147; Fredericksen and Zeri (1972), pp. 59,
415, 573; Merriman, *Giuseppe Maria Crespi* (Milan, 1980), p. 248, cat.
no. 44, fig. 44.

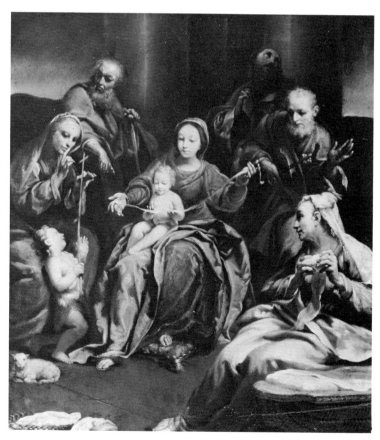

Figure 148b. *Holy Family*. On copper, 39.5 x 35 cm. Crespi.
Museo e Galleria Nazionale di Capodimonte, Naples.

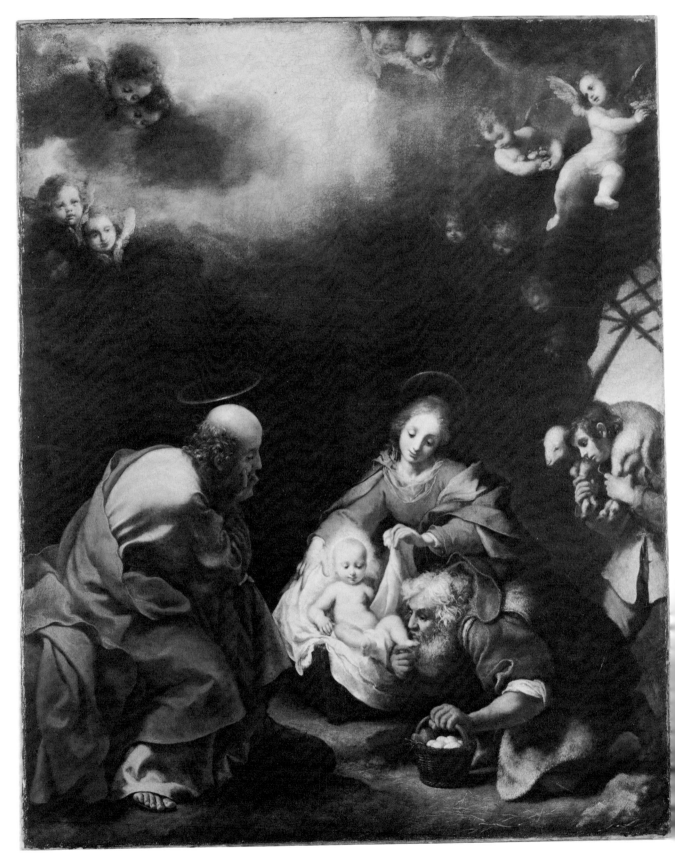

Figure 149.

CARLO DOLCI
1616–1686

Dolci's life and work are described in a biography by his close friend Filippo Baldinucci, who was aided by Dolci's practice of noting saints' days and years on the backs of his paintings (F. Ranalli, ed., *Notizie dei professori del disegno da Cimabue in qua*, v, Florence, 1847, 335–64). In 1625 Dolci entered the workshop of the Florentine master Jacopo Vignali (1592–1664). By 1627, at the age of eleven, his paintings had already attracted the attention of Pietro de'Medici and other leading Florentine, as well as visiting English, nobles. In 1648 he was admitted to the Accademia del Disegno. He left Italy only once, in 1672, when he was to paint the portrait of Claudia Felice, daughter of Archduchess Anna de'Medici and Archduke Ferdinand Carl of Austria, before her marriage to Emperor Leopold I. Dolci was a slow but prolific painter. His Florentine affinity for line was subtly fused with a soft sfumato, an influence of Correggio through the Florentine Ludovico Cigoli (Lurie, 1968, pp. 224–25). Dolci specialized in small devotional paintings. Among his few large altarpieces are the *Martyrdom of St. Andrew*, ca. 1646, and the *Martyrdom of St. Dominic*, ca. 1651–52, both in the Pitti Palace, and the unfinished *Guardian Angel with a Child*, ca. 1675, in the Prato cathedral.

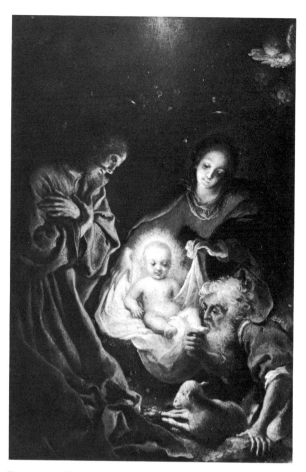

Figure 149a. *Nativity*. On canvas, 17.2 x 11.4 cm. Dolci. The Marquess of Exeter, Burghley House, Stamford, England.

149 *Adoration of the Shepherds* 68.22

> Canvas, 88.6 x 70.5 cm.
>
> Collections: Gerini family, Florence; the Earls of Cowper, Panshanger, Hertford, Hertfordshire; Lady Desborough, Taplow Court, Buckinghamshire (sale: Christie's, London, October 16, 1953, no. 37); [David M. Koetser Gallery, Zurich].
>
> Mr. and Mrs. William H. Marlatt Fund, 1968.

The canvas has been glue-lined and is close to its original size, with perhaps minor reduction along the edges. The painting is in very good condition, with small, scattered losses and some abrasions in the raised ridges of its crackle. The varnish layer is somewhat darkened and discolored where residues of dirt and varnish in the recesses of the paint had not been completely removed during an earlier restoration.

The composition of the Cleveland painting is closely related to two *Adoration of the Magi* paintings: one in the Glasgow Art Gallery and Museum, dated by George Buchanan mid- to late 1630s ("Carlo Dolci's *Adoration of the Magi*," *Scottish Art Review*, x, no. 3, 1966, 14–16); the

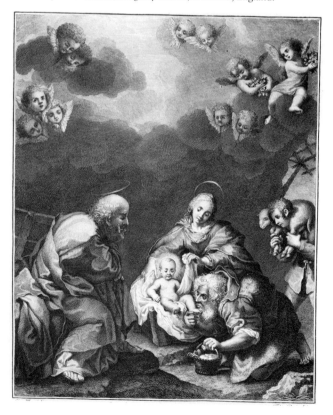

Figure 149b. *Adoration of the Shepherds*. Engraving after the painting by Dolci. Giuseppe Magni, Italian, 18th century (?). Reprinted from *Raccolta di ottanta stampe rappresentati i quadri più scelti de' Sigg^ri March^si Gerini di Firenze*, II (Florence, 1786), pl. II.

337

other in the collection of the Marquess of Exeter at Burghley House, dating from some time between 1648 and 1654, according to Baldinucci in his biography of the artist (F. Ranalli, ed., *Notizie dei professori del disegno da Cimabue in qua*, V, Florence, 1847, 347). Carlo Volpe (letter of June 7, 1977) and this author agree that the Cleveland painting probably dates from ca. 1640, that is, after the Glasgow painting and before the Burghley House version. The Glasgow and Cleveland paintings have the same bright opening in the sky with *putti* and the grotto-like entrance on the right. In the Burghley House version a bright star appears above the scene (Lurie, 1968, fig. 12) and figures enter through an open doorway, but otherwise the composition and style are similar.

Also at Burghley House is a very small, abbreviated replica (Figure 149*a*) listed in their inventory of 1688 as *Nativity*, no. 456 (Lurie, 1968, fig. 11), which Busse (1913, pp. 386–87) claims is the original. (Busse erroneously referred to another replica of the *Nativity*, illustrated in *Illustrazione Italiane*, xxv, December 1892, 1, that is in fact the *Madonna and Child* by Dolci in the Galleria Nazionale, Rome.)

Baldinucci (*op. cit.*, pp. 341, 359, 361) specifically mentioned three *Adoration of the Magi* paintings but did not mention an *Adoration of the Shepherds* or a *Nativity*. He did mention (p. 341) a painting, title unspecified, measuring about *due braccia* (100–120 cm) in height, which had developed from a small rendering (*quadretto*) of an *Adoration of the Magi* commissioned by Cardinal Leopold in or after 1625. The unnamed painting, according to Baldinucci, belonged to the Gerinis in Florence, former owners of the Cleveland *Adoration*.

The Cleveland painting was engraved by G. Magni (Figure 149*b*) for the catalogue of the Gerini family collection (*Raccolta di ottanta stampe rappresentati i quadri piu scelti de 'Sigg^ri March^si Gerini di Firenze, divisa in due Parti*, II, Florence, 1786, pl. II; brought to this author's attention by Dr. Marco Chiarini in a letter of June 1969). Most probably the painting was acquired in Florence by an earl of Cowper—perhaps the third earl (d. 1789), or the fifth earl, who traveled on the Continent extensively between 1800 and 1805. It was in the house of the fifth earl, in Panshanger, that Waagen (1854) saw our *Adoration of the Shepherds* in 1835. ATL

EXHIBITIONS: London, Royal Academy Winter Exhibition, 1881: Exhibition of Works by the Old Masters and by Deceased Masters of the British School, cat. no. 198; CMA, January 1969: Year in Review, cat. no. 62, illus.; CMA, 1971: Florence and the Arts, Five Centuries of Patronage, cat. no. 16 (catalogue by Edmund P. Pillsbury).

LITERATURE: Waagen (1854), III, 15–16; Graves (1913), I, 292; K. Busse, in Thieme-Becker, IX (1913), 387; Ann Tzeutschler Lurie, "Two Devotional Paintings by Sassoferrato and Carlo Dolci," CMA *Bulletin*, LV (1968), 219–29, color illus. p. 217, figs. 7, 8, 14, 16 (details); *Dizionario* (1973), IV, 166; CMA *Handbook* (1978), illus. p. 140.

PIETRO DEL DONZELLO
1452–1509

Pietro del Donzello was the son of Francesco d'Antonio di Jacopo, who was "donzello della Signoria," a municipal servant for the republic of Florence. Born in Florence in 1452, Pietro worked in the workshop of Giusto d'Andrea di Giusto. He and his brother Ippolito accompanied the sculptor Benedetto da Maiano to Naples after 1481 to work for King Ferdinand in the palace of Poggio Reale (Sir Dominic Ellis Colnaghi, *A Dictionary of Florentine Painters*, London, 1928, p. 94). Pietro was back in Florence in 1498, when he received a payment for his main work in Santo Spirito (published with documentation by Mario Bori, "*L'Annunziazione* di Pietro di Donzello in una Cappella Frescobaldi nella chiesa di Santo Spirito," *Rivista d'Arte*, V, 1906, 117 ff.) Pietro died in Florence in 1509.

Everett Fahy (1976) convincingly attributed a group of nineteen works to this little-known painter, a minor follower of Domenico Ghirlandaio. Among these were the tondo *Madonna Enthroned with Six Angels* in the Corsini Collection in Rome; another tondo, formerly in the collection of R. Somervell, Haverbrack, Westmorland; a tondo of the *Virgin and Child*, formerly in the Kaiser Friedrich Museum, Berlin (no. 90a, now destroyed); and a *Virgin and Child* in the Philadelphia Museum of Art (Johnson Collection, no. 76). Fahy also suggested that Pietro was the painter whom Roberto Longhi called the "Master of 1487" (*Officina ferrarese, 1934, seguita dagli Ampliamenti, 1940, e dai nuovi Ampliamenti, 1940–1955*, Florence, 1956, p. 134).

150	*Virgin and Child with St. John and Angels*	16.792

Tondo panel (probably poplar), 95.2 x 92.8 cm.

Collections: James Jackson Jarves; Mrs. Liberty E. Holden, Cleveland, 1884.

Holden Collection, 1916.

This tondo was cleaned in 1919 by H. A. Hammond Smith. It was cleaned again in 1930 by William Suhr, who removed a great deal of pre-Raphaelite-style repaint. The painting has suffered considerable damage: the joints of the two side panels have separated, leaving cracks running vertically through the faces of the two accompanying angels; large portions of the Christ Child are lost down to the gesso; and scratches in the gesso still show evidence of a loin cloth on the Child, which was added by a later hand and removed by William Suhr in 1930. The face of the Child and the figure and face of the Madonna are still in relatively good condition, as are the landscape background and the face of John. At this writing, the painting is in need of further conservation.

Originally attributed to Piero di Cosimo (Jarves, 1884) and later to Bartolommeo di Giovanni (van Marle, 1931),

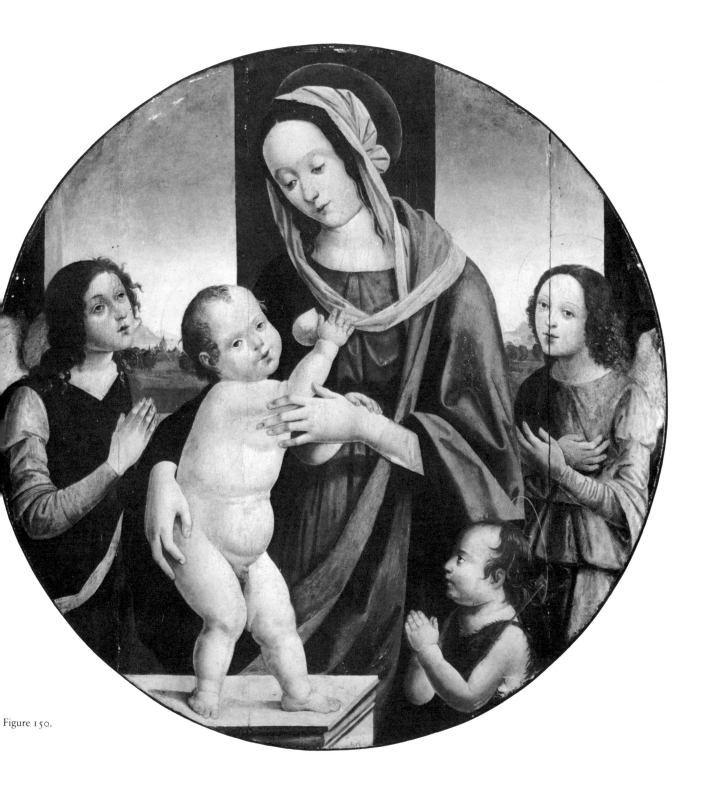

Figure 150.

the painting has since been firmly attributed to Pietro del Donzello by Everett Fahy (letter of October 19, 1966, and publication of 1976), who has generously supplied information and photographs.

Among the numerous works by Donzello which lend themselves for comparison with the Cleveland tondo are two works previously mentioned: *The Annunciation* in the Frescobaldi Chapel of the church of Santo Spirito in Florence and *Madonna Enthroned with Six Angels* in the Palazzo Corsini, Rome. NCW

EXHIBITIONS: Boston (1883), cat. no. 450; New York (1912), cat. no. 23.

LITERATURE: Jarves (1884), no. 11, p. 9; M. L. Berenson (1907), p. 3; Rubinstein (1917), no. 11; van Marle (1931), XIII, 250; Coe (1955), II, 85, no. 17; Mina Bacci, *Piero di Cosimo* (Milan, 1966), p. 116; J. W. Goodison and G. H. Robertson, *Catalogue of Paintings*, Vol. II: *Italian Schools* (Cambridge, 1967), p. 50; Edmund P. Pillsbury, *Florence and the Arts, Five Centuries of Patronage* (exh. cat., Cleveland, 1971), p. 55; Fredericksen and Zeri (1972), pp. 67, 573; Everett Fahy, *Some Followers of Domenico Ghirlandajo* (New York and London, 1976), p. 220.

DOSSO DOSSI (Giovanni di Lutero)
Active 1512, died 1542

Although Dosso's family came from Trent, he apparently was named for a small town—Dosso—in the vicinity of Mantua, where his father had a small property. The family eventually settled in Ferrara, where Dosso's father became an estate agent of the duke. There is no documentation for his birthdate; the year 1479 given in Baruffaldi (*Vite de' pittori e scultori ferraresi*, Ferrara, 1844, I, 250, n. 3; reprint, Bologna, 1971) is unconfirmed. Dosso's first recorded work, a painting he executed at Mantua, is dated 1512. His style reflects the influence of Giorgione, Titian, and Raphael. He died in Ferrara in 1542 after serving the dukes of Ferrara, Alfonso and Ercole d'Este, in various capacities with his brother Battista.

151 *Holy Family with a Shepherd* 49.185

Canvas, 38.7 x 32 cm.
Collections: Private collection, Bologna; [Giuseppe Cellini, Rome].
Delia E. and L. E. Holden Funds, 1949.

This lined canvas is in fair condition. There are disturbing retouches in the sky and in the robe and leg of the shepherd.

This work is related stylistically to numerous small paintings executed between 1520 and 1530, when Dosso, still influenced by Venetian painters—particularly Giorgione and Titian—began to incorporate Ferrarese elements in his work while still reflecting influences from the North in his composition and figures. This painting probably dates from the earlier part of the decade. It is closely related to the *Nativity* in the Galleria Borghese, Rome (Mezzetti, 1965, pl. III); to two paintings of the *Rest on the Flight into Egypt*, one in the Uffizi, Florence (*ibid.*, fig. 17), and another in the Worcester (Massachusetts) Art Museum; and to two of the *Holy Family*, one in The Detroit Institute of Arts (*ibid.*, fig. 11), and another in the Saibene collection, Milan (*ibid.*, fig. 20).

Felton Gibbons gives this small painting to Battista Dossi, relating it to an *Adoration* in a London private collection, a *Madonna with Two Saints* in Bergamo, and a *Holy Family with the Infant St. John the Baptist* (1968, nos. 100, 83, and 110, respectively). On stylistic grounds, Gibbons tentatively dated the Cleveland picture shortly after 1520—later than the aforementioned three paintings.

A sixteenth-century copy of the Museum picture is in the collection of the Galleria Spada, Rome (Zeri, 1954, fig. 82). NCW

EXHIBITIONS: CMA (1956), cat. no. 11, pl. VII.

LITERATURE: Henry S. Francis, "An Oil by Dosso Dossi in the Holden Collection," CMA *Bulletin*, XXXVII (1950), 63–65, illus. p. 61; Federico Zeri, *La Galleria Spada in Rome* (Rome, 1954), p. 74; Edoardo (Wart) Arslan, "Una Natività di Dosso Dossi," *Commentari: Rivista di critica e storia*, VIII, no. 4 (1957), 259; Maria Grazia Antonelli Trenti, "Notizie e precisazioni sul Dosso giovane," *Arte Antica e Moderna*, XXVIII (1964), 413; Amalia Mezzetti, *Il Dosso e Battista Ferraresi* (Milan, 1965), p. 17, no. 27, p. 76; Lionello Puppi, *Dosso Dossi*, I Maestri del colore, no. 78 (Milan, 1965), unpaginated (third page of text); B. Berenson (1968), I, 111 (as Giovanni Lutero); Felton Gibbons, *Dosso and Battista Dossi, Court Painters at Ferrara* (Princeton, 1968), no. 87, pp. 126 and 219, fig. 123; Fredericksen and Zeri (1972), pp. 67, 350, 574.

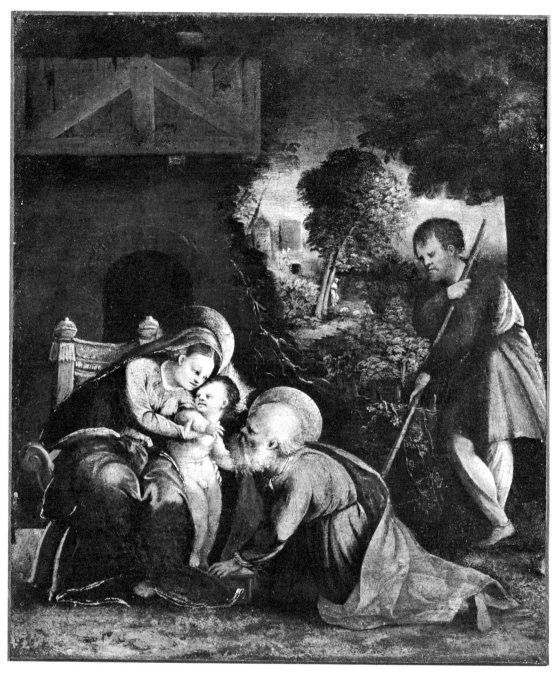

Figure 151.

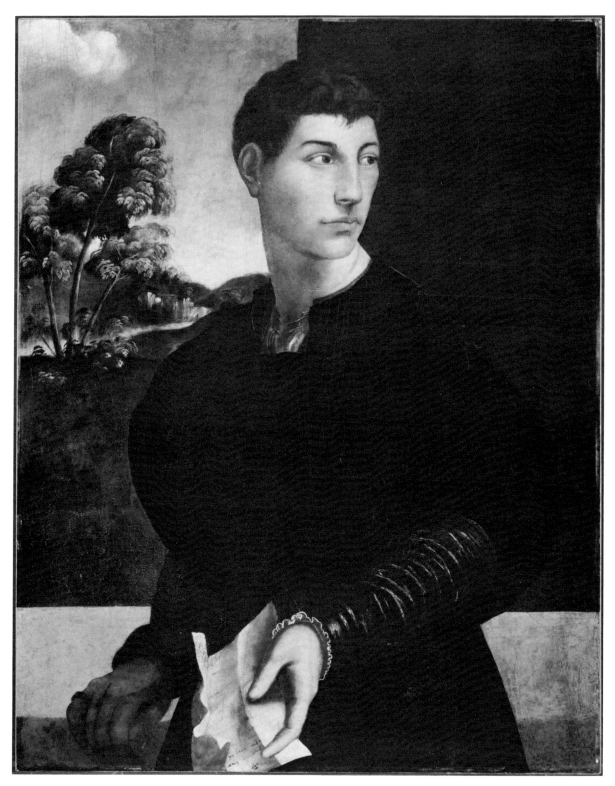

Figure 152.

342

DOSSO DOSSI and

BATTISTA DOSSI (Battista di Lutero)
Died 1548

Battista Dossi collaborated with his brother Dosso (see Painting 151) in Ferrara, where they were employed by the dukes of Ferrara. The brothers were mentioned by Ariosto in his *Orlando Furioso*, and both painters were indebted to the poet for subjects. Battista was influenced principally by Raphael; it is probable that he spent the years from 1517 to 1524—years when his name disappears from the ducal accounts of Ferrara—in Rome and there became familiar with Raphael's work. In addition to paintings for palaces and churches executed under the patronage of the dukes of Ferrara, the brothers made cartoons for tapestries and designs for Ferrarese majolica. They are also recorded as sculptors, and both were employed occasionally in making festival decorations. Battista designed coins.

152 *Portrait of a Young Man* 16.803

Panel (transferred), 97.2 x 77.5 cm.
Collections: James Jackson Jarves; Mrs. Liberty E. Holden, Cleveland, 1884.
Holden Collection, 1916.

Before it entered the Museum collection this painting was transferred to the present panel. There were paint losses along the vertical cracks of the original panel and at the sides of the sitter's face.

This painting was formerly called *Portrait of Giuliano de' Medici*. It has been attributed to Sebastiano del Piombo (Exh: 1883; Jarves, 1884), to Salviati (M. L. Berenson, 1907), and more recently to Battista and Dosso Dossi (Francis, 1950). Francis based his attribution to the Dossi brothers on the close relationship of this painting to others by the Dossis: *St. Sebastian* in Milan, Brera (Mezzetti, 1965, no. 95, pl. 79), and *Portrait of a Warrior in Rome*, Galleria Colonna (*ibid.*, no. 169). The facial types in all of these are similar, and in each the figure is placed against a parapet or a window looking out upon a leafy, romantic landscape—all typical of works by the Dossi brothers.

Roberto Longhi ("L'amico friulano del Dosso," *Paragone*, XI, no. 131, 1960, 3–9, figs. 1–10) attributed several paintings to an artist he described as "un friulano amico del Dosso," a painter from Friuli (in north Italy, close to Venice) who was born in the last decade of the fifteenth century, had friends in Ferrara and contacts with Tuscany, was influenced by Giorgione, and worked ca. 1510 to 1530 or a little later. Mina Gregori (1960) added two more paintings to the oeuvre which Longhi proposed for this artist: an *Allegory* in Pistoia, Palazzo Communale (under the patronage of the Uffizi), and the Museum portrait. Gibbons (1968) found the ingenious Longhi-Gregori construction of the

"amico friulano del Dosso" acceptable until further research uncovers more information.

Of all the provincial paintings that have been associated with the unnamed painter from Friuli, the portrait in Cleveland, with its undeniably Ferrarese landscape, seems to be set apart; it is the most reflective of the influence of Michelangelo and Parmigianino—particularly in the bold stance of the figure and the structural modeling of the face. These qualities and others also link the portrait to the abovementioned works by the Dossi brothers. Because the painting reflects the concepts that Michelangelo utilized in his portrait of Giuliano from the Medici tombs in Florence, S. Lorenzo, it seems most likely that it dates from the time the tombs were erected, between 1523 and 1534, or later.

NCW

EXHIBITIONS: Boston (1883), cat. no. 405 (as *Portrait of Giuliano di Medici*, attributed to Sebastiano del Piombo); New York (1912), cat. no. 25; CMA (1916), cat. no. 32; CMA (1936), cat. no. 103.

LITERATURE: Jarves (1884), no. 29 (measurements given include the frame); M. L. Berenson (1907), illus. p. 3 (as *Portrait of Giuliano de'Medici* by Salviati ?); Oskar Fischel, "Porträts des Giuliano de'Medici, Herzogs von Nemours," *Jahrbuch der Königlich Preussischen Kunstsammlungen*, XXVIII (1907), 129; Rubinstein (1917), p. 32, no. 33, illus. p. 62; Underhill (1917), p. 20, illus. p. 40; Henry S. Francis, "An Oil by Dosso Dossi in the Holden Collection," CMA *Bulletin*, XXXVII (1950), 66, illus. p. 71; Coe (1955), II, 83, no. 12; Mina Gregori, "Ancora due traccie dell' 'Amico friulano del Dosso,'" *Paragone*, XI, no. 131 (1960), 49–50, fig. 33; Amalia Mezzetti, *Il Dosso e Battista Ferraresi* (Milan, 1965), no. 26, p. 76; Jean Alazard, *The Florentine Portrait* (New York, 1968), p. 163; B. Berenson (1968), I, 111 (titled *Young Man Holding Letter*, listed as Giovanni Lutero); Felton Gibbons, *Dosso and Battista Dossi: Court Painters at Ferrara* (Princeton, 1968), no. 146, p. 251 (under "Works wrongly attributed to the Dossi"), fig. 194; Fredericksen and Zeri (1972), pp. 128, 526, 573 (as Master Amico Friulano del Dosso).

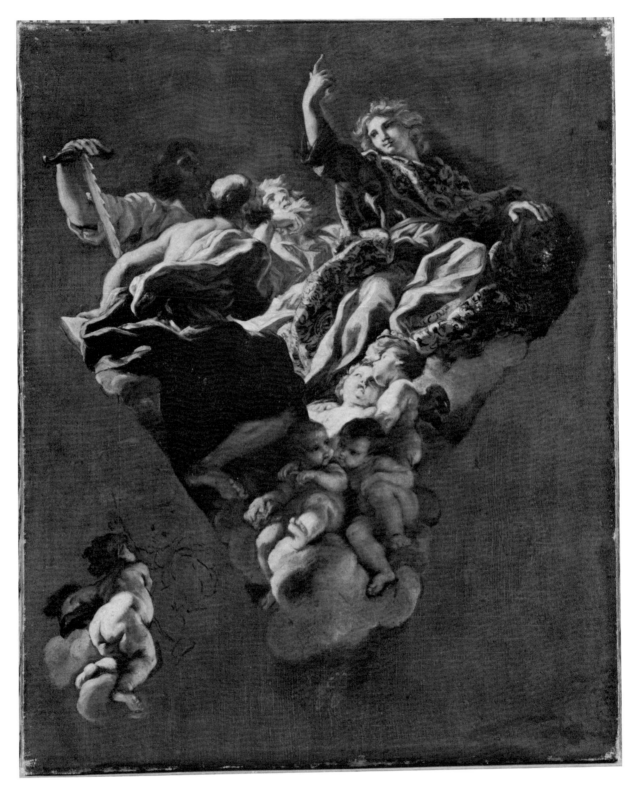

Figure 153.

GIOVANNI BATTISTA GAULLI
(called Il Baciccio or Baciccia)

1639–1709

As early as 1653 or 1657 Gaulli left Genoa for Rome (Robert Enggass, *The Painting of Baciccio, Giovanni Battista Gaulli 1639–1709*, University Park, Pennsylvania, 1964, p. 1), where Bernini became his teacher and introduced him to the leading patrons of the city. His style and colors reflect his Genoese heritage and the influence of Rubens, who had visited Genoa in 1607. Gaulli's impressions of Correggio's frescoes, which he saw during a visit to the cathedral in Parma in 1669, inspired his own climactic achievement—the decorations of Gesù Church in Rome. The four pendentives that Gaulli painted for the Gesù marked him as one of the leading and most daring of the baroque decorators.

153 The Four Prophets of Israel 69.131

Canvas, 67.3 x 55 cm.

Collections: Wilhelm Reuschel, Munich; [Dr. Kurt Rossacher, Salzburg].

John L. Severance Fund, 1969.

The painting is in excellent condition, with only a few minor retouchings along the painted edge.

The Four Prophets of Israel, representing Isaiah, Jeremiah, Ezekiel, and Daniel, may be the final sketch for the pendentive at the southeast pier, below the dome of Gesù Church in Rome (Figure 153*a*). It is one of seven oil sketches known to date which Gaulli painted in preparation for the four pendentives (Lurie, 1972, figs. 36–52). The other three pendentives are: *The Four Lawgivers and Leaders*, at the northeast pier, opposite the *Four Prophets*; *The Four Evangelists*, at the southeast pier; and *The Four Doctors of the Latin Church*, at the northwest pier. All four pendentives were painted between ca. 1675 and ca. 1677 (Enggass, 1964, p. 136).

Although there is no known preliminary drawing for *The Four Prophets*, there are studies for the other pendentives which contain compositional ideas that could have served for the *Prophets* as well.

Julius Held (1965) considers the Cleveland sketch a companion piece to the sketch for the *Four Doctors of the Church* in Ponce. ATL

EXHIBITIONS: CMA, January 1970: Year in Review, cat. no. 144, illus. p. 17; Amherst, Massachusetts, Amherst College, 1974: Major Themes in Roman Baroque Art from Regional Collections, cat. no. 10.

LITERATURE: Wilhelm Reuschel, *Die Sammlung Wilhelm Reuschel* (Munich, 1963), no. 17, pp. 42–44, color illus. p. 43; Robert Enggass, *The*

Figure 153*a*. *The Four Prophets of Israel*. Gaulli. Church of Il Gesù, Rome.

Painting of Baciccio, Giovanni Battista Gaulli 1639–1709 (University Park, Pennsylvania, 1964), p. 160; Julius S. Held, *Catalogue I: Paintings of the European and American Schools* (Ponce, 1965), p. 71; Ann Tzeutschler Lurie, "A Bozzetto for *The Four Prophets* by Gaulli," CMA *Bulletin*, LVIII (1971), 99–106, color illus. p. 97, figs. 2 and 10; Lurie, "A Short Note on Baciccio's Pendentives in the Gesù à propos a New Bozzetto in Cleveland," *Burlington Magazine*, CXIV (1972), 170–73, fig. 36; CMA, 1980: Idea to Image, cat. no. 83 illus. (catalogue by Mark Johnson).

ORAZIO GENTILESCHI
1563–1639

Although he was born in Pisa, Gentileschi considered himself a Florentine (his *Repentant Magdalen*, Kunsthistorisches Museum, Vienna, is signed HORATIUS . GEN/FLOREN-TINUS). He was trained in Tuscany, after which he settled in Rome in 1576 or 1578. In Rome he worked for three successive popes (Sixtus V, Clement VIII, and Paul V). Orazio befriended Caravaggio after he arrived in Rome, probably late in 1592 or early 1593, and became one of the master's early followers. In 1621 Orazio left Rome for Genoa at the invitation of the Genoese noble Giovanni Antonio Sauli (Saoli). In Genoa he received numerous commissions from other Genoese nobles. In Turin he worked for Duke Carl Emanuel of Savoy. In ca. 1623–24 he departed for Paris, where he received commissions from Marie de'Medici. At the invitation of Charles I he went to London in 1626; he remained there until his death in 1639. His daughter Artemisia (ca. 1593–1652) was also a notable painter.

154 *Danaë* 71.101

> Canvas, 161.9 x 228.6 cm.
>
> Collections: (Possibly) Charles Spencer, Fifth Earl of Sunderland (1706–1758); Private collection, England; [Hazlitt Gallery, London].
>
> Purchase, Leonard C. Hanna Jr. Bequest, 1971.

The support is a moderately heavy twill fabric in two pieces with a vertical join at 115 centimeters from the left edge. The painting was cleaned and relined by Herbert Lank in 1971, before it came to this Museum. At that time, the old glue lining was removed and the painting was wax-lined to a plain-weave linen fabric. Before being relined, the two sections of the picture were brought together as closely as possible, meeting at the top and bottom, but with an unavoidable gap of 1.3 centimeters in the center. Extensive overpaint was removed, and the painting was found to be reasonably well preserved. In addition to scattered flake losses, the raised edges of the crackle were found to be generally abraded. The painting was x-rayed at the Museum in 1978 and pentimenti were observed in Danaë's neck and in her loin scarf.

According to Genoese historians Raffaello Soprani and Carlo Ratti (*Vite de'pittori, scultori, ed architetti genovese*, Genoa, 1768, I, 452; also Ratti, *Guida di Genova*, Genoa, 1780, pp. 111–12), in 1621 Giovanni Antonio Sauli commissioned three large paintings from Orazio Gentileschi for his palace in Genoa. The subjects were the *Penitent Magdalene*, *Lot's Family Fleeing Sodom*, and *Danaë with Jove in a Shower of Gold*. The latter, described by Soprani as the most beautiful of the three, was mentioned again by da Morrona in 1792, at which time it was still in the palace (A.

da Morrona and P. Pisano, *Pisa illustrata delle arti del disegno*, Pisa, 1792, II, 258).

When *Danaë* was acquired by this Museum and shown in the exhibition Caravaggio and His Followers in 1971/72, it was the only known version of the subject (discussion of a later discovery follows). There are, on the other hand, five known versions of *Lot* (R. Ward Bissell, "Orazio Gentileschi and the Theme of 'Lot and His Daughters,'" *National Gallery of Canada Bulletin*, XIV, 1969, 20, fig. 5) and four versions of *Magdalene* (Charles Sterling, "Gentileschi in France," *Burlington Magazine*, C, 1958, 112–20; Benedict Nicolson, "Some Little-Known Pictures in the Royal Academy," *Burlington Magazine*, CII, 1960, 76–79; and Bissell, *op. cit.*, pp. 16–33).

Wilhelm Suida (*Genua*, Leipzig, 1906, pp. 156 and 203), Roberto Longhi quoting Suida (*Scritti Giovanili: 1912–1922*, Florence, 1961, p. 275, n. 34), and Hermann Voss (*Malerei des Barock in Rom*, 1924, p. 460) all mentioned a *Magdalene* in the palace of the Marchése Pierino Negrotto Cambiaso in the Via Corsica—the marchése's residence before his marriage in 1924. Although Voss may not have actually seen the *Magdalene*, he suggested it may be the original Genoese version of 1621. Voss may be correct, for the owners of the *Magdalene*, the Marchéses Negrotto Cambiaso, were linked with the Sauli family, the original owners, through marriage into the Genoese branch of the Palavicini family.

Nevertheless, at the time of the Cleveland exhibition (1971/72), none of the existing versions of *Lot*, *Magdalene*, or *Danaë* could be positively identified as the ones from the Sauli palace. In the absence of documentation, candidates could be chosen only on stylistic grounds. Carlo Volpe (1972), basing his opinion on such considerations, actually believed that none of the known versions could be identified as those Soprani saw in the Sauli palace in 1787. Richard Spear (Exh: 1971/72), on the other hand, believed that the *Danaë* distinctly qualified for the Sauli provenance, not only because of its outstanding quality but also because it closely matches Orazio's Genoese style of ca. 1621–23. Spear compared the patiently rendered folds of the bedsheet wrapped around the mattress in the *Danaë* with those in the *Annunciation* in Turin, which we know was painted for the Duke of Savoy ca. 1623. In Spear's mind the painting perfectly summarizes Orazio's Italian years, combining the master's inherent Florentine affinity for line, his strong impressions from Carracci's classicism (Lurie, 1975, pp. 80–81, fig. 10), and Caravaggio's potential mystery of light.

In 1973–74 there appeared on the international art market three heretofore unidentified versions of the three subjects, whose history traces back to the family of Giovanni Antonio Sauli. Of these, *Lot and His Daughters* (formerly in the Genoese collection of T[h]eophilatos) is now in the collection of Baron Thyssen-Bornemisza, Lugano, Switzerland (Bissell, letter dated June 3, 1980, in

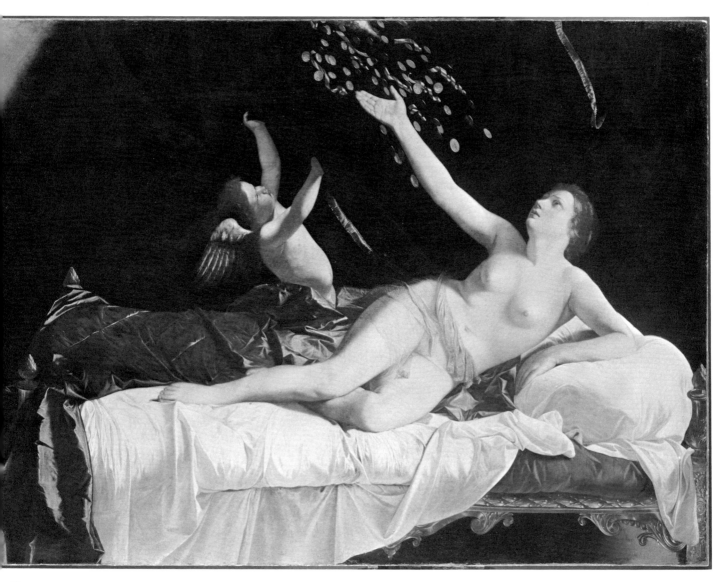

Figure 154.

Museum files), and *Danaë and the Shower of Gold* (Figure 154*a*) is in the collection of Richard L. Feigen & Co., New York. The latter is a close counterpart to the Cleveland painting in style, details, color, and scale. Neither painting shows any significant pentimenti. It is of some interest to note that in the New York *Danaë* the artist painted the red upholstery before covering it with bedsheets, and that he did not do so in the Cleveland version. The close stylistic resemblance between the *Danaë* from the Sauli palace and Gentileschi's second version in Cleveland leaves no doubt that the Cleveland painting followed the original within a short time.

347

In addition to Soprani's testimony written in the eighteenth century, another, earlier, source mentions a *Danaë* by Gentileschi in a Genoese collection. The inventory of the collection of Q. Camillo Gavotti, dated July 15, 1679, describes the painting as follows: "Danae receiving Jupiter in a shower of gold, by Gentileschi, about 15 or 16 *palmi* wide, 8 *palmi* high" (Venanzio Belloni, *Penne, pennelli e quadrerie: Cultura e pittura genovese del Seicento*, Genoa, 1973, p. 64). These figures translate to approximately 178 centimeters high by 333 centimeters wide—somewhat larger than either of the currently known versions, which are almost identical in size. The figures given in the inventory, however, may represent a casual approximation on the part of the cataloguer.

As Soprani (*op. cit.*, p. 452) remarked, the Sauli commission naturally generated interest in Orazio's artistic achievements, and other commissions followed; among them, two for the Duke of Savoy—the above-mentioned *Annunciation* and a *Flight of Lot*, both painted ca. 1623. Other Genoese works include: the now-lost decorations for a casino at San Pier d'Arena, near Genoa, painted for Marc'Antonio Doria (*ibid.*), four allegorical pictures, also lost (Bissell, *op. cit.*, p. 29, n. 6); *Judith*, in the library of the Palazzo Rosso (mentioned by Suida, *op. cit.*, p. 156); and an *Annunciation*, in the church of S. Siro, (according to Suida, it is close to the *Annunciation* painted for the Duke of Savoy).

Without specifying the subject, Soprani (*op. cit.*, p. 453)

wrote of a painting that was sent by the artist to Marie de'Medici of France. The queen, who appears to have favored the Florentine School (Sterling, *op. cit.*, p. 113, n. 13), liked the painting so much that she invited Orazio to Paris—an invitation he accepted in ca. 1624 (*ibid.*). Sterling made two suggestions regarding the painting: one, that it may have been the *Public Felicity*, which was painted for the Luxembourg Palace; and the other, that it may have been a *Penitent Magdalene*. Sterling argues more strongly for the latter because of the existence of an exact copy (now in the Pinacoteca at Lucca) by Jean Tassel (ca. 1608–ca. 1667) after one of Orazio's versions. Sterling believes that Tassel's copy was made in Paris after an original painted by Orazio in Genoa and then sent to Paris to impress Marie de'Medici (*op. cit.*, p. 117), but he does not entirely rule out the possibility that Tassel could have seen one of Orazio's versions in Italy, where he is documented in 1634 and 1635 (*ibid.*). For that matter, his copy also could have been made after yet another version which Orazio painted after arriving in Paris.

It is therefore by no means a certainty that it was a *Penitent Magdalene* that introduced Orazio to the court of France. One must still number among the possibilities the *Danaë* in Cleveland. Indeed, as Richard Spear observed (Exh: 1971/72, p. 104), the weighty monumentality and the clarity of narrative conception, verging on histrionic drama, in this Genoese figure composition could have been relied on to touch the French sensibility.

R. Ward Bissell (in the manuscript for his forthcoming book, cat. no. 50) convincingly suggests that two notations from George Vertue's records of paintings dating from sometime between 1742 and 1752 (see Literature) may pertain to the Cleveland painting, since upon completion it was acquired by Lord Sunderland, and we know for certain that the *Danaë* came from England. ATL

Figure 154a. *Danaë and the Shower of Gold*. On canvas, 152 x 228 cm. Gentileschi. Richard L. Feigen & Co., New York.

EXHIBITIONS: CMA, 1971/72: Caravaggio and His Followers, cat. no. 32, pp. 103–5, colorplate 32 (catalogue by Richard E. Spear); CMA, January 1972: Year in Review, cat. no. 52.

LITERATURE: George Vertue, "Note Books (1713–1756)," *Walpole Society*, XXVI (1937–38), 55–56; Richard E. Spear, "The Pseudo-Caravaggisti," *Art News*, LXX (November 1971), illus. p. 5 and color cover; Benedict Nicolson, "Caravaggesques at Cleveland," *Burlington Magazine*, CXIV (1972), 114, fig. 71; Julius S. Held, "Caravaggio and His Followers," *Art in America*, LX (1972), 44, color illus.; Carlo Volpe, "Annotazioni sulla mostra Caravaggesca di Cleveland," *Paragone*, XXIII, no. 263 (1972), 67–68, pl. 20; D. Stephen Pepper, "Caravaggio riveduto e corretto: La Mostra di Cleveland," *Arte Illustrata*, v, no. 48 (1972), 170, fig. 12 p. 177; Spear, "Unknown Pictures by the Carravaggisti (with notes on Caravaggio and His Followers)," *Storia dell'Arte*, XIV (1972), 158; Ann Tzeutschler Lurie, "Pictorial Ties between Rembrandt's *Danaë* in The Hermitage and Orazio Gentileschi's *Danaë* in The Cleveland Museum of Art," *Acta Historiae Artium*, XXI (1975), 75–81, figs. 2, 4, 5; CMA Handbook (1978), illus. p. 135; Charles McCorquodale, *The Baroque Painters of Italy* (Oxford, 1979), p. 28, pl. 18 (color); Nicolson, *The International Caravaggesque Movement* (Oxford, 1979), p. 52, pl. 13; R. Ward Bissell, *Orazio Gentileschi* (forthcoming), cat. no. 50.

LUCA GIORDANO
1634–1705

Agostino Francesco Giordano was baptized in Naples on October 19, 1634; later, he was called Luca by his father, Antonio Giordano. He received his initial lessons and impressions from his father and from Jusepe Ribera, but his style developed largely under the influence of Pietro da Cortona. Giordano came in contact with Cortona's works when he visited Rome ca. 1650 and when he was active in Florence for extensive periods during the 1680s. Like Cortona, he particularly admired the works of Paolo Veronese. Giordano most likely went to Venice in the mid-1660s, when he received commissions from the church of S. Maria della Salute. In 1692 he was summoned to Madrid to the court of Charles II of Spain. He returned to Naples in 1702, only three years before he died. He was one of the most influential and prolific baroque painters in Naples. His notorious speed of execution earned him the nickname "Luca fa presto."

155 *The Apparition of the Virgin* 66.125
 to St. Francis of Assisi

Canvas, 240 x 196.2 cm. Signed at lower center: Jordanus F.
Collections: Private collection, Florence; [Heim Gallery, Paris].
Mr. and Mrs. William H. Marlatt Fund, 1966.

Recent restorations with water colors have affected the glazes in some areas: in the foreground, around the head of the child whose back is turned, and between the saint's hands and the Madonna and Child. According to Heim, the restorer covered two additional pairs of hands because they disturbed the composition. The hands and other pentimenti —the corrected profile of the woman and the extra foot of the saint—with time probably have become more visible than they had been originally. The additional hands may indicate that the artist toyed with the idea of showing St. Francis reaching for the Christ Child, somewhat as in Pietro da Cortona's rendering of the subject in the Pushkin Museum, Moscow (Lurie, 1968, fig. 9).

Stylistically, our painting belongs to Giordano's Florentine period—from the 1680s. During this time he also painted the cupola of the Corsini family chapel in the S. Maria del Carmine; the frescoes in the Palazzo Medici-Riccardi; and some paintings for the Grandduke of Tuscany, for Cosimo II de'Medici, and for other Florentine nobles. Our painting is particularly close to the *Miracle of the Partridges* (Galleria Corsini, Florence); the *Vision of St. Bernard* (church of SS. Annunziata, Capella di San Luca, Florence; formerly in the church of Madonna della Pace, Florence); and two altarpieces, *Immaculate Conception* and *Stigmatization of St. Francis*, which the grandduke commissioned for the church of S. Pietro d'Alcantara (now SS. Quirico e Lucia all'Ambrogiana), a church attached to the Villa Me-

dicea dell'Ambrogiana at Montelupo. The two altarpieces date from 1687–89, not ca. 1680–81, as previously suggested (Ferrari and Scavizzi, 1966, I, 91–92; Lurie, 1968, pp. 39–41). The commission for the altarpieces was mentioned in a letter written by the grandduke to Luca Giordano on December 26, 1687 (Mara Visonà, "La via crucis del convento di San Pietro d'Alcantara presso la villa L'Ambrogiana a Montelupo Fiorentino," *Kunst des Barock in der Toskana*, Munich, 1976, p. 58, n. 10). According to Visonà (*op. cit.*, p. 58), both are *in situ*. (Earlier, Lurie, 1968, pp. 39–40, n. 8, had suggested that the altarpieces were copies by Francesco Petrucci, and that the original *Immaculate Conception* was in the Pitti Palace.)

Erich Schleier discovered an identical copy after our painting in a private residence in Rome, which does not have the numerous pentimenti of the original, of course, nor does it have the small red cross faintly visible in front of our St. Francis. Ferrari and Scavizzi (1966, p. 104) mention another copy after the Cleveland painting, formerly in the Sofio collection in Naples (present whereabouts unknown). A link between these two copies has not yet been established.

The composition of Giordano's *St. Francis* in Cleveland is related to Guido Reni's composition on the same subject —though it is in reverse—in the Palazzo Hercolani di Castelmaggiore in Bologna (Nora Clerici Bagozzi, "Antologia di Artisti," *Paragone*, XXI, no. 247, 1970, illus. fig. 54).

ATL

EXHIBITIONS: CMA (1966), Golden Anniversary Acquisitions, cat. no. 59, illus. (catalogue: *Bulletin*, LIII, September 1966); CMA, 1971: Florence and the Arts, Five Centuries of Patronage, cat. no. 17 (catalogue by Edmund P. Pillsbury).

LITERATURE: Oreste Ferrari and Giuseppe Scavizzi, *Luca Giordano* (Naples, 1966), I, 91–92, 94, and II, 104, and III, figs. 181–83; Ann Tzeutschler Lurie, "Luca Giordano: *The Apparition of the Virgin to Saint Francis of Assisi*," CMA *Bulletin*, LV (1968), 39–52, figs. 1, 17, and color cover; Fredericksen and Zeri (1972), pp. 85, 398, 574; Silvia Meloni Trkulja, "Luca Giordano a Firenze," *Paragone*, XXIII (1), no. 267 (1972), n. 51; CMA *Handbook* (1978), illus. p. 140.

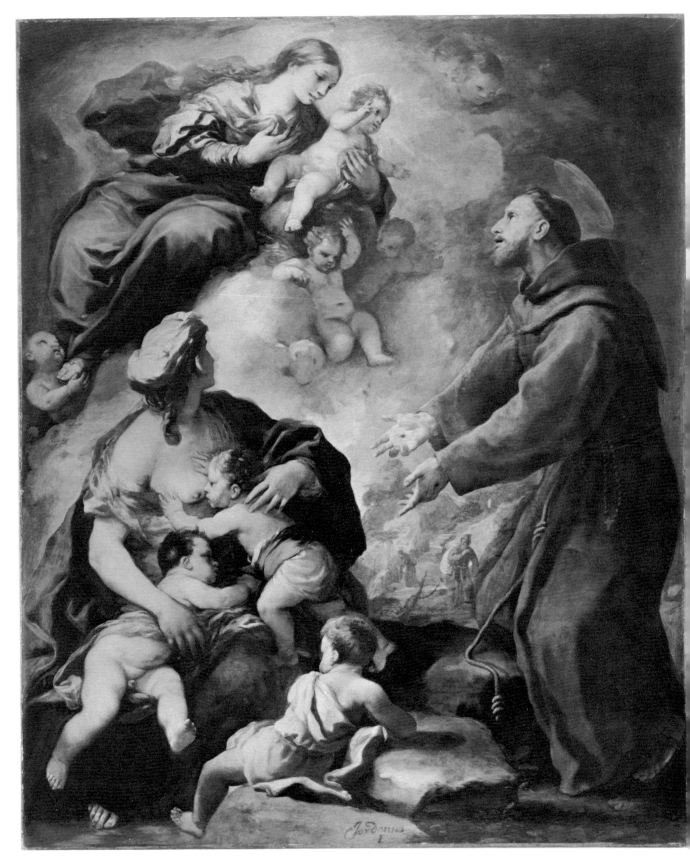

Figure 155.

School of FRANCESCO D'ANDREA DI MARCO GRANACCI

1469–1543

Francesco Granacci was trained in the studio of Domenico Ghirlandaio, with whom he later collaborated on such works as the decoration of the Duomo in Pisa and the main altarpiece in the church of Santa Maria Novella in Florence. In his youth he worked alongside Michelangelo and Fra Bartolommeo, both of whom had a lasting influence on him. Among his best-known works are the *Entry of Charles VIII into Florence* and *Madonna of the Girdle* (both in the Uffizi), and *Scenes from the Life of St. Appolonia* (Academy, Florence). He is perhaps even better known for his paintings on the life of Joseph, executed for a room in the house of Pierfrancesco Borgherini (the series also included panels by Andrea del Sarto, Pontormo, Bacchiacca, and others). Granacci was assisted in the completion of the Borgherini commission by an unknown artist now identified as the Master of the Spiridon Story of St. Joseph, so called because some of the St. Joseph panels were later in the Spiridon collection in Paris. Roberto Longhi added to the master's oeuvre the tondo *Virgin and Child with an Angel*, formerly in the collection of J. Altri, Paris (in 1937). The Master of the Spiridon Story of St. Joseph was a prolific painter; his work has often been attributed to Granacci and is still the subject of much art-historical debate.

156 St. John the Baptist Being Carried by a Maid to His Father Zacharias

44.91

Panel, 78.2 x 33.7 cm.

Collections: Marchése Giovanni Gerini, Palazzo Gerini, Florence; Reverend John Sanford, Florence and London, purchased from Marchése Gerini between 1830 and 1837; Lord Frederick Paul Methuen (married John Sanford's daughter, Anna Horatia Caroline Sanford, 1844), Corsham Court, Chippenham, England (sale: Christie's, London, May 13, 1899, no. 85); C. Davis; Mrs. Murray Guthrie (sale: Christie's, London, March 11, 1911, no. 25); [Partridge and Co.]; [Duveen Brothers, 1917]; Mrs. Francis F. Prentiss, Cleveland.

The Elisabeth Severance Prentiss Collection, 1944.

The panel is cradled and heavily repainted. A past restorer added a painted strip along the edges; this—as well as the cradling—makes it difficult to determine whether the panel has been cut down. The contours of the figures on the right, the hand and profile of the second figure from the left, and the faces of the two companions have been strengthened. The clumps of grass at the right also show traces of repainting. The painting was cleaned by Joseph Alvarez in 1961. Its condition is generally sound.

When it was in the Sanford and Methuen collections at Corsham Court, the panel was called *The Dismissal of Hagar* by Pintoricchio. A water-color copy (Figure 156a) of the painting, by Gozzini, is still at Corsham Court. Waagen (1857) saw the painting when it was in the Methuen collection; from what he could see in dim light and through glass, he thought it was probably by Ubertini (Bacchiacca). Van Marle (1931) attributed the panel to Jacopo del Sellaio and called it *Pharoah's Daughter and Moses as a Child Carried by a Servant and Other Figures in a Landscape*. Bernard Berenson (1932, 1963, and in a letter to Messrs. Duveen

Figure 156a. *Maidservant with the Infant St. John.* Water color. Vincenzo Gozzini, Italian, first quarter 19th century. Methuen Collection, Corsham Court, Chippenham, England. Reproduced by permission of Lord Methuen and by courtesy of the Courtauld Institute of Art, London.

Figure 156.

Figure 156*b*. *Scenes from the Life of St. John the Baptist.*
On panel, 80 x 152 cm. Granacci. The Metropolitan
Museum of Art, New York. Purchase from the Andrews,
Dick, Dodge, Fletcher, and Rogers Funds; funds from
various donors; Depeyster Gift, Oenslager Gift, and Gifts
in Memory of Robert Lehman, 1970.

Figure 156*c*. *Scenes from the Life of St. John the Baptist.*
On panel, 77.4 x 228.6 cm. Granacci. Walker Art Gallery,
Liverpool.

Figure 156*d*. *St. John the Baptist Preaching in the
Wilderness.* On panel, 75.5 x 210 cm. Granacci. The
Metropolitan Museum of Art, New York. Purchase from
the Andrews, Dick , Dodge, Fletcher, and Roger Funds;
funds from various donors; Depeyster Gift, Oenslager
Gift, and Gifts in Memory of Robert Lehman, 1970.

dated May 10, 1917) attributed the picture to Cosimo Ros-
selli. The Cleveland Museum accepted this latter attribu-
tion for a time, until Roberto Longhi saw the painting in
1949 and suggested the attribution to the young Francesco
Granacci. Everett Fahy, also doubting the Rosselli attribu-
tion (letters dated October 5, 1965; June 18, 1966; and
November 15, 1967), suspected it was early Granacci but
then published it (1968 and 1976) as the Master of the

Spiridon Story of St. Joseph. Federico Zeri (who studied the
Master of the Spiridon Story in detail and is planning to
publish his findings) in 1971 published the Museum panel
(with E. E. Gardner) as by a pupil or assistant of Granacci,
and later, in 1972 (with B. B. Fredericksen), published it as
by a master known as the pseudo-Granacci, who was active
in the late fifteenth and early sixteenth centuries.

Christian von Holst (1968 and 1970–71) established

353

that the Cleveland panel is part of a series of scenes on the life of John the Baptist which once decorated a room in a private house or palace. Following the biblical narrative and arranging the panels iconographically and chronologically, the first panel in such a series, according to Holst, would be the Metropolitan Museum's *Scenes from the Life of St. John the Baptist* (Figure 156*b*), which includes the Annunciation, the Visitation, and the birth of St. John. This would have been followed by the Cleveland panel, with the unusual scene of the maid bringing the infant John to Zacharias. After this would come the panel (Figure 156*c*) now in the Walker Art Gallery, Liverpool, in which Zacharias appears on the left, writing the name of his son. Next, according to Holst, would be the *St. John the Baptist Preaching in the Wilderness* (Figure 156*d*) now in the Metropolitan Museum. The series probably included at least two more panels which are now lost: most likely a baptism of Christ and other episodes such as the arrest of the Baptist, the dance of Salome, and John's beheading.

There has been some speculation that the Cleveland panel originally may have been part of the Metropolitan panel *Scenes from the Life of St. John*. The grass at the bottom and the two-stepped platform in the two paintings are in contiguous alignment with each other, and the four women in the Cleveland panel are nearly identical to those in the Metropolitan panel.

Scholars are not in general agreement concerning attributions of various portions of this series. C. J. Ffoulkes ("Le Esposizioni d'Arte Italiana a Londra," *Archivio Storico dell'Arte*, VII, 1894, 166) gave only *St. John the Baptist Preaching* to Granacci himself, and the others to his school. Berenson (*Florentine Painters of the Renaissance*, London and New York, 1896, p. 115) attributed the Metropolitan's *Scenes from the Life of St. John the Baptist* to Granacci; later (1932, p. 266), he also gave the Liverpool painting, *Scenes from the Life of St. John the Baptist*, to Granacci. Alfred Scharf ("The Robinson Collection," *Burlington Magazine*, C, 1958, 299–304) attributed only the *Scenes* in the Metropolitan Museum to Granacci. To explain the slightly different styles of painting in the panels, it was suggested in the catalogue of the Walker Art Gallery (*Foreign Schools*, I, Liverpool, 1963, 83–84) that several assistants were employed in the project. Christian von Holst (1968, 1970–71, and 1974) said that the Liverpool painting and *St. John the Baptist Preaching* in the Metropolitan Museum are by unknown contemporaries of Granacci, and that only the Metropolitan's *Scenes* and the Cleveland panel can be considered the early work of the master himself. While no consensus has yet emerged, all the attributions suggested in recent years derive from the very clear imprint of Granacci's style in the Cleveland painting.

Three of these panels were thought to have been together, first in the Tornabuoni collection, Florence, and then in the Samuel Woodburn collection, London. The Cleveland painting, however, was known to be in the collection of John Sanford, who had purchased it in Florence by 1837. Our painting was listed among a group of pictures from the Sanford collection offered for sale by G. Yates and Son, London, in 1838 (no month or day given; the sale is documented in "Catalogue of Paintings Belonging to the Rev. J. Sanford, Collected in Italy from 1815 to 1837, Entrusted to G. Yates and Son, to be partially disposed of by private contract at 209 Regent Street, London" [1838], p. 23, no. 130). The painting was not sold in 1838, however; it remained with Sanford's daughter and her husband until the sale in 1899.

The Cleveland panel probably dates from the first decade of the sixteenth century. N C W

EXHIBITIONS: London, British Institution, 1855, cat. no. 55; London, Royal Academy, Burlington House, 1877: Winter Exhibition of Old Masters, cat. no. 172; CMA (1971), cat. no. 12.

LITERATURE: Album of water-color copies painted in Florence ca. 1833–36 after pictures acquired in Florence by Reverend John Sanford, preserved at Corsham Court, Chippenham, England, no. 152; "Catalogue of Paintings Purchased by the Reverend John Sanford During His Residence in Italy, 1830 and Following Years," preserved at Corsham Court, Chippenham, England; "Catalogue raisonné of Pictures, etc., the Property of the Rev. John Sanford" (London, 1847), no. 2; Gustav Friedrich Waagen, *Galleries and Cabinets of Art in Great Britain* (London, 1857), IV, 396; van Marle (1931), XII, 410; Berenson (1932), p. 491; Henry S. Francis, "Paintings in the Prentiss Bequest," CMA *Bulletin*, XXXI (1944), 87; *Catalogue of the Elisabeth Severance Prentiss Collection* (Cleveland, 1944), pp. 10, 27, cat. no. 13, pl. IV; Benedict Nicolson, "The Sanford Collection," *Burlington Magazine*, XCVII (1955), 209, 213, no. 33; Berenson, *Italian Pictures of the Renaissance: Florentine School* (London, 1963), I, 189; Christian von Holst, "Francesco Granacci als Maler," pt. 2: "Catalogue raisonné," (Ph.D. dissertation, Kunsthistorisches Institut der Freien Universität [Berlin], 1968), pp. 118, 120–22, no. K6; Holst, "Three Panels of a Renaissance Room Decoration at Liverpool and a New Work by Granacci," *Bulletin of Walker Art Gallery*, I (1970–71), 34–35, 37, figs. 14, 15; Federico Zeri, with assistance of Elizabeth E. Gardner, *Italian Paintings: A Catalogue of the Collection of the Metropolitan Museum of Art* (New York, 1971), pp. 181–83; Fredericksen and Zeri (1972), pp. 130, 545, 574; Holst, *Francesco Granacci*, Italienische Forschungen, VIII (Munich, 1974), 11, 18, 24 ff., 136–37, cat. no. 8, figs. 16, 25, and 26; Everett Fahy, *Some Followers of Domenico Ghirlandajo* (New York and London, 1976), p. 189; [Walker Art Gallery], *Foreign Catalogue: Paintings, Drawings, Watercolours, etc.* (Liverpool, 1977), I, 86; Luciano Berti, et al., *Il Primato del disegno* (exh. cat., Florence, 1980), p. 124 (entry written by Silvia Meloni Trkulja).

FRANCESCO GUARDI
1712–1793

Francesco Guardi was born in Venice in 1712. He was the son of Domenico Guardi, a minor church painter from Austria who, with another member of the Guardi family, Stefano, had been granted a patent of nobility in 1643 by Emperor Ferdinand III for services rendered. Francesco's early work was primarily as a figure painter in collaboration with his brother Giovanni Antonio (see Painting 158). From about 1764 Francesco apparently painted mostly view paintings, but there is very little documentary evidence on which to base a chronology of his work. In 1784 Francesco was elected to the Venetian Academy. He died in Venice on January 1, 1793.

157A *Visit of Pope Pius VI in Venice:* 49.188
 Te Deum in the Church of
 SS. Giovanni e Paolo

157B *Visit of Pope Pius VI in Venice:* 49.187
 The Reception of the Doge and Senate
 in the Audience Hall of the Convent
 of SS. Giovanni e Paolo

Canvas, 51.5 x 69 cm (each).

Collections: Jakob Goldschmidt, Berlin, 1929, and New York; [Galerie Matthiessen, Berlin, 1944]; [Jacques Seligmann & Co., New York].

Gift of Hanna Fund, 1949.

These two paintings were lined and cleaned by William Suhr in 1934, when they were in the collection of Jakob Goldschmidt. There are losses around the edges of both canvases, and surface abrasion has revealed some of the red ground.

Francesco Guardi was commissioned by Pietro Edwards, Inspector of Belle Arti in Venice, to paint four pictures to commemorate the visit of Pope Pius VI to Venice, May 15–19, 1782. Two documents pertaining to this commission are in the library of the Seminario Patriarcale, Venice (L. Coggiola Pittoni, "Il Viaggio di Pio VI negli stati veneti e nella Dominante," *Archivio Veneto*, n.s. XXIX, 1915, 172–73; and George A. Simonson, *Francesco Guardi 1712–1793*, London, 1904, pp. 42–44, and Appendix XI, p. 82). Although the dimensions were not given in either of the documents, the consensus among art historians is that the four paintings commissioned by Edwards, and described in one of the documents, dated May 21, 1782 (Simonson, 1904, p. 82), were the following:

1. "Arrivo di S. Santità a S. Giorgio in Alga, ed incontro col Serenissimo": *Arrival of His Holiness at S. Giorgi in Alga, Where He Is Met by the Serene Prince.* Presumably lost.

2. "Pontificale nella Chiesa dei SS.^ti Giovanni e Paolo": *Pontifical Ceremony in the Church of SS. Giovanni e Paolo.*

72 x 82 cm, private collection, New York (Figure 157a) (formerly Cavendish-Bentinck collection, London; C. Groult collection, Paris; private collection, Milan; private collection, Paris; see Morassi, 1973, I, no. 265, and II, fig. 294).

3. "Sua Santità in atto di scendere dal Trono nella Sala d'udienza per incontrare il Serenissimo nell'ultima visita di congedo": *On the Occasion of His Farewell Visit His Holiness Descends from the Throne in the State Room to Meet the Serene Prince.* 71 x 82 cm, A. Meyer collection, Milan (formerly Cavendish-Bentinck collection, London; Mond collection, London; Lord Melchett collection; [Matthiesen, London]; see Morassi, 1973, I, no. 267, and II, fig. 296).

4. "La Benedizione al Popolo nella finita loggia alla Scuola di S. Marco": *His Holiness Blesses the Assembled People in front of the Scuola di S. Marco.* 63.5 x 78.5 cm, Ashmolean Museum, Oxford (see Morassi, 1973, I, no. 269, and II, fig. 300).

Because of the importance of the event, Guardi was evidently commissioned to repeat these subjects for other patrons—thereby accounting for other versions. It is believed that a second set of the same four scenes was also commissioned by Edwards (Erdmann, 1929). Presumably, the two Cleveland paintings belonged to that set. The following are the known versions by Guardi (measurements are taken from Morassi's catalogue—except for the Cleveland paintings, which were measured at the Museum):

Figure 157a. *The Visit of Pope Pius VI in Venice: Pontifical Ceremony in the Church of SS. Giovanni e Paolo.* On canvas, 72 x 82.2 cm. F. Guardi. Private collection, New York.

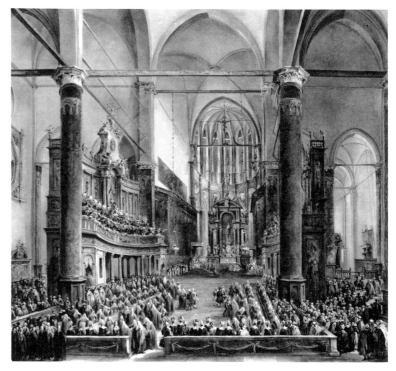

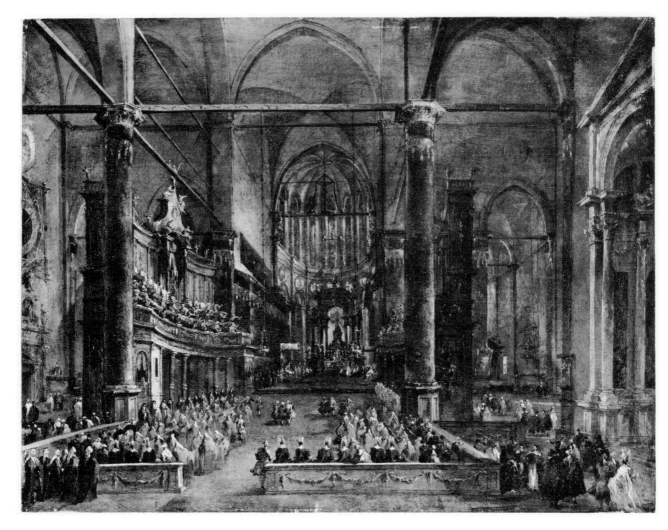

Figure 157A.

1. *Arrival of His Holiness at S. Giorgi in Alga, Where He Is Met by the Serene Prince.*
a) 52 x 68 cm, Rossello collection, Milan (see Morassi, 1973, I, no. 262, and II, fig. 291).
b) 72 x 81.5 cm, Philadelphia Museum of Art (see Morassi, 1973, I, no. 263, and II, fig. 292).
2. *Pontifical Ceremony in the Church of SS. Giovanni e Paolo [Te Deum in the Church of SS. Giovanni e Paolo].*
a) 51.5 x 69 cm, The Cleveland Museum of Art (Painting 157A).
3. *On the Occasion of His Farewell Visit His Holiness Descends from the Throne in the State Room to Meet the Serene Prince [Reception of the Doge and Senate in the Audience Hall of the Convent of SS. Giovanni e Paolo].*
a) 51.5 x 69 cm, The Cleveland Museum of Art (Painting 157B).
4. *His Holiness Blesses the Assembled People in front of the Scuola di S. Marco.*
a) 50 x 66 cm, Bearsted Collection, The National Trust, Upton House, Warwickshire (formerly Walter Burns collection, North Mymms Park, Hatfield, England) (see Morassi, 1973, I, no. 268, and II, fig. 299).
b) 51.5 x 68 cm, Dresden, Gemäldegalerie (see Morassi, 1973, I, no. 275, and II, fig. 301).

356

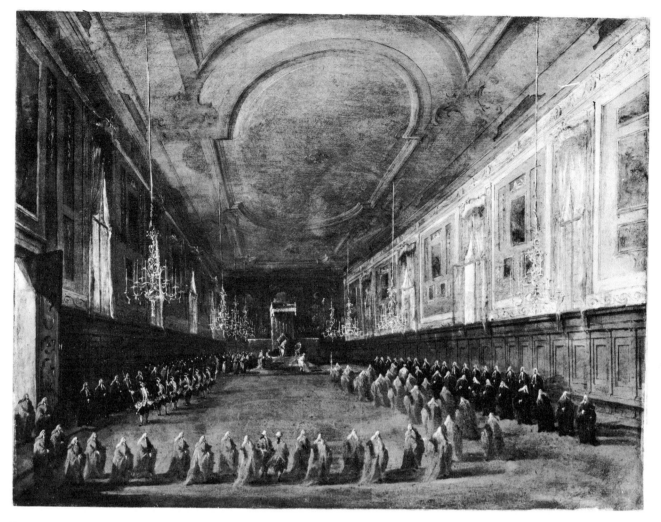

Figure 157B.

c) 53 x 70 cm, G. Schiff-Giorgini collection, Paris (formerly Barbini-Braganze collection, Venice; Staatsgalerie, Stuttgart) (see Morassi, 1973, I, no. 274).

For a thorough discussion of the Pope's visit and the Guardi paintings, sketches, and drawings related to it, see Watson (1968), pp. 114–41.

The Cleveland paintings are accepted as autograph works by most authorities, but there is some difference of opinion as to which of the versions came first and which is the finest in quality. Pallucchini (1960) believed that the painting in Milan of the *Reception of the Doge* was a replica after the painting in Cleveland; Zampetti (1965), Mo-

rassi (1973, I, 185, under no. 267), and others say the Cleveland version is a replica of the Milan painting.

There are various changes in composition and scale from the initial set of four paintings to the subsequent versions. In both Cleveland paintings, Guardi changed the right side of the picture. To the *Reception of the Doge* he added part of a tabernacle and a pedimented side altar off the nave—elements not found in the initial, documented painting, or in the drawing in the Victoria and Albert Museum (Erdmann, 1929, p. 510), or in the watercolor study in a private collection in Monza, Italy (Morassi, 1973, I, no. 264). In order to adapt the *Te Deum* to a proportionately smaller

canvas, Guardi apparently moved farther back and to the left, which resulted in some distortion in the perspective, particularly in the wall panel at the extreme right. The row of senators does not touch the picture edge at the right front; there is a looser handling of paint; and the slightly subdued darks and lights result in increased depth. In spite of the distortions, however, this smaller version in Cleveland seems both more successful and more precise in documenting the occasion. NCW

EXHIBITIONS (both paintings except where noted): Springfield (Massachusetts) Museum of Fine Arts, 1937: Francesco Guardi, 1712–1793, cat. nos. 5 and 6, illus.; San Francisco, California Palace of the Legion of Honor, 1938: Venetian Paintings from the Fifteenth through the Eighteenth Century, cat. nos. 35 and 36, illus.; New York, World's Fair, 1939: Masterpieces of Art, cat. nos. 171 and 172; Detroit Institute of Arts and John Herron Art Museum (Indianapolis), 1952: Venice 1700–1800: An Exhibition of Venice and the Eighteenth Century, cat. no. 29, illus. p. 32 (*Reception* only); Sarasota, Florida, John and Mable Ringling Museum of Art, 1955: Director's Choice, cat. no. 16, illus. (*Reception* only); Venice, Palazzo Grassi, 1965: Mostra dei Guardi, cat. no. 142, illus. (*Te Deum* only, with incorrect dimensions) (catalogue by Pietro Zampetti).

LITERATURE (both paintings except where noted): Kurt Erdmann, "Zwei Neue Historienbilder von Francesco Guardi," *Pantheon*, IV (1929), 506–10, illus. opp. pp. 506 and 508; Rodolfo Pallucchini, *I Disegni del Guardi al Museo Correr di Venezia* (Venice, 1943), p. 20 (*Te Deum* only); Max Goering, *Francesco Guardi* (Vienna, 1944), pp. 61, 75 n. 59, 85 n. 138, pls. 137 and 138; Henry S. Francis, "Two Historical Pictures by Francesco Guardi," CMA *Bulletin*, XXXVII (1950), 48–54, illus. pp. 50 and 51 (incorrectly lists ex collection Marczell von Nemes); Jean Cailleux, *Tiepolo et Guardi* (Paris, 1952), p. 78 n. 89, nos. 2 and 3; Vittorio Moschini, *Francesco Guardi* (Milan, 1952), p. 25; Morassi (1953), VII, 62; Pallucchini, "Il Settecento Veneziano a Milano," *Arte Veneta*, IX (1955), 267 (*Reception* only); Milliken (1958), illus. p. 46; Pallucchini, *La Pittura Veneziana del Settecento* (Venice, 1960), p. 249, fig. 655; K. T. Parker and J. Byam Shaw, *Canaletto e Guardi: Catalogo della Mostra dei Disegni* (Venice, 1962), p. 69 (*Te Deum* only); Pietro Zampetti, *Mostra dei Guardi* (exh. cat., Venice, 1965), p. 276 (*Reception* only); Guido Perocco, *I Guardi: Gian Antonio 1699–1760, Francesco 1712–1793* (Padua and Rovigo, 1966), p. 12, fig. 12 (color) (*Te Deum* only); Zampetti, *I Vedusti Veneziani del Settecento* (Venice, 1967), p. 344; Ross Watson, "Guardi and the Visit of Pius VI to Venice in 1782," *Report and Studies in the History of Art* (Washington, D.C., 1968), II, 128 (incorrectly lists ex collection Marczell von Nemes); Pallucchini, "Il Settecento veneziano a l'Orangerie," *Arte Veneta*, XXV (1971), 332 (*Te Deum* only); Fredericksen and Zeri (1972), 96, 485, 574 (*Te Deum* only); Alvise Piero Zorzi, *Venezia scomparsa* (Milan, 1972), pp. 603–4, fig. 536 (*Reception* only); Morassi (1973), I, 138, 185, 359, nos. 264 and 266, and II, figs. 293, 295, 297, 298; Rossi Bortolatto (1974), nos. 693 and 695, p. 131, illus. p. 129; *Dizionario* (1974), VI, 198 (*Te Deum* only); CMA *Handbook* (1978), illus. p. 146.

GIOVANNI ANTONIO GUARDI
1698–1760

Giovanni Antonio was the first son of Domenico Guardi and Maria Claudia Pichler. Shortly after his birth, the family moved from Vienna to Venice. Giovanni Antonio had two brothers, Francesco (see Paintings 157 A, B), who became perhaps the most famous painter of the family, and Nicolo, who was also a painter. Their only sister, Cecilia, married Giovanni Battista Tiepolo. Giovanni Antonio studied painting with his father in the family workshop at the Santi Apostoli parish; in later years, he took over the workshop. According to Morassi (*Guardi—Antonio e Francesco*, Venice, 1973, I, 47–55), between 1730 and 1746 Giovanni Antonio was in the service of Austrian Field Marshall Johann von der Schulenburg, for whom he executed copies of paintings. Guardi was invited to join the Venetian Academy in 1756. He died in January 1760.

The problem of sorting out the works of Francesco and Giovanni Antonio Guardi is considerable because of their frequent and extensive collaboration. In addition to their works, there are the paintings of Nicolo, who also probably collaborated in the studio, and of Francesco's son Giacomo (1764–1835), another probable assistant. In the almost complete absence of documentation about the Guardis' lives or works, a considerable difference of opinion concerning their respective oeuvres is inevitable.

158 *A Woman of Venice* 47.71

Canvas, 45 x 38 cm.

Collections: Toschi, Ravenna and Forli; Professor A. M. Mucchi, Sals (near Bologna), 1929; [Saville Gallery, Ltd., London]; J. S. Oliver, Pembroke Lodge, Richmond, Surrey (sale: Sotheby's, London, February 13, 1946, no. 20); [David M. Koetser Gallery, Zurich].

Mr. and Mrs. William H. Marlatt Fund, 1947.

This small, lined canvas is in good condition.

Over the years the painting has been variously attributed to Sebastiano Ricci, Gian Battista Pittoni, Giuseppe Bazzani, and Tranquillo Cremona. Morassi (1929) at first ascribed it to Francesco Guardi, but later (1953, 1973)—and most convincingly—attributed it to Giovanni Antonio. Morassi dated the painting between 1740 and 1745.

There is another, slightly larger, portrait, possibly of the same sitter, which is stylistically related to the Museum portrait (Cambridge, England, Fitzwilliam Museum; Goodison and Robertson, 1967, II, pl. 33). NCW

EXHIBITIONS: Bologna, 1922: Mostra fiorentina della pittura Italiana del 600–700, cat. no. 40 bis; Venice, Palazzo delle Bienale of the Public Gardens, 1929: Mostra del Settecento, cat. no. 17; London, Saville Gallery Ltd., 1930: Exhibition of Paintings by Canaletto and Guardi, cat. no. 7, illus.; London, Tómas Harris Gallery, 1932: Venetian Artists, XVI and the XVIII Centuries, cat. no. 6; London, Matthiesen Gallery, 1939: Venetian Paintings and Drawings, cat. no. 73.

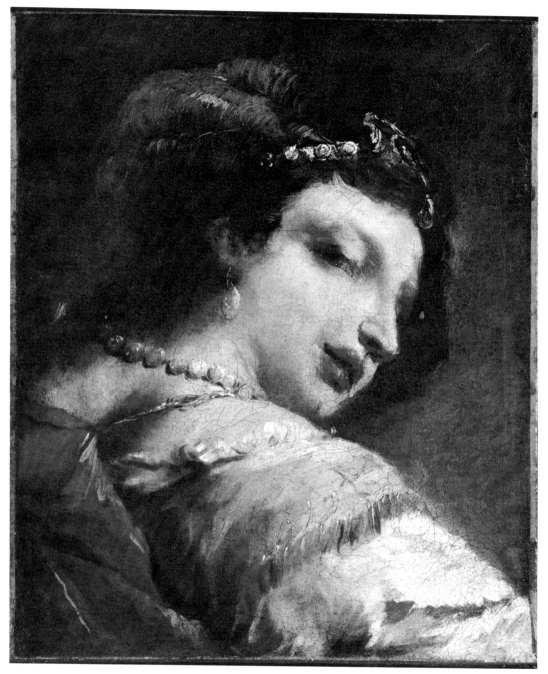

Figure 158.

Figure 159A.

LITERATURE: Antonio Morassi, "Francesco Guardi as a Figure Painter," *Burlington Magazine*, LXV (1929), 294, 299, pl. IIa; Henry S. Francis, "Francesco Guardi's *Head of a Woman*," CMA *Bulletin*, XXXIV (1947), 237–39, illus. p. 243; Morassi (1953), VII, 62; J. W. Goodison and G. H. Robertson, *Fitzwilliam Museum, Cambridge: Catalogue of Paintings*, Vol. II: *Italian Schools* (Cambridge, 1967), p. 75; Morassi (1973), I, 112, 332, no. 133, and II, fig. 151.

GIOVANNI ANTONIO GUARDI

159A	*The Sacrifice of Isaac*	52.235
159B	*Tobias and the Angel*	52.236
159C	*The Angels Appearing to Abraham*	52.237
159D	*Abraham Welcoming the Three Angels*	52.238

Canvas, 56.2 x 75.5 cm (each).

Collections: (Possibly) Count Giovanni Benedetto Giovanelli, Venice, 1731; Baroness Valerie Groedel, Budapest; [Neumann Gallery, Vienna, 1937]; Pospisil, Venice; [Alessandro Brass, Venice].

Mr. and Mrs. William H. Marlatt Fund, 1952.

The paint surface of each of these four lined canvases is somewhat rubbed. Where the thinner colors and transition tones are abraded, the red underpainting shows through

Figure 159B.

more than was originally intended, resulting in a heightened contrast of color and a more dramatic effect. Aside from minor retouchings, the canvases are in good condition; they were cleaned by Joseph Alvarez in 1962.

Documentation concerning the Guardi brothers is rare, but one document provides a clue that may someday yield further information. The will of Count Giovanni Benedetto Giovanelli, dated December 15, 1731 (Venice, Archivio di Stato; atti Marcello Girolamo, Testamenti 612, n. 345), mentions certain copies of paintings executed by the Guardis. The inventories of the Giovanelli collection, which apparently list some of these copies, are not available to this author at the present time, but Pallucchini (1934) cited a work mentioned in the inventories (Registrar Record "A" of the General Administration in Venice for 1723; 1732; 1800; and January 10, 1880), which Levey (1956) suggested is the Museum's *Sacrifice of Isaac*. Unfortunately, this possibility cannot be verified without access to the inventories themselves.

The attribution of the four Museum paintings is based on their stylistic closeness to the series of the *Story of the Archangel Raphael*, on the parapet of the organ in San Raffaele, Venice (Morassi, 1973, 1, 76–83, 309–11, nos. 15–21). The figure composition of the Museum's *Tobias and the Angel*, for example, is identical to that in one of the San Raffaele scenes. Another close variant of our *Tobias*, but with the San Raffaele landscape background, is in the Pazzagli collection, Florence; it was tentatively attributed to Francesco by Denis Mahon (letter of October 26, 1957). The San Raffaele paintings have been extensively published, both as Francesco and as Giovanni Antonio, and variously dated.

When the Cleveland paintings were at the Neumann Gallery, Antonio Morassi assigned them to Francesco Guardi (letter to Mr. Neumann, November 24, 1937), but since then (1951, 1953, 1958, 1973) he has consistently published them as the work of Giovanni Antonio. Zampetti (1965) and Watson (letter of September 28, 1966) ques-

Figure 159C.

tioned the Giovanni Antonio attribution and assigned the pictures to Francesco. Mahon (1967) also attributes them to the young Francesco because he thinks they could not be by the same hand as the *Alexander and Darius* by Giovanni Antonio in Moscow, Pushkin Museum, or the San Raffaele frescoes in Venice.

The subjects of the Museum paintings are taken from the Apocrypha and the Old Testament. Compositional sources for three of the four have been identified. Morassi (letter of November 24, 1937) associated *Tobias and the Angel* (Book of Tobit 6:4) with a painting by Domenico Feti at Dresden; and he identified a *Sacrifice of Isaac* (Genesis 22: 10–12) by Giovanni Battista Piazzetta, also in Dresden, as the source of the Museum painting of that subject. *Angels Appearing to Abraham* (Genesis 18:2) is based on an engraving after a painting by Antonio Balestra (1666–1740), according to Morassi (1958, pp. 205, 209) and Michael Levey (letter of April 11, 1958). The source of the remain-

ing work in the Museum series, *Abraham Welcoming the Three Angels* (Genesis 18:8), is unknown at present, but the Giovanelli inventories or engravings may eventually reveal that information.

A large replica (195 x 145 cm) of *Abraham Welcoming the Three Angels* is owned by Mme R. M. Quirini Mariani, Paris. NCW

EXHIBITIONS—*The Sacrifice of Isaac*: Jerusalem, Bezelel National Museum, 1965: Old Masters and the Bible, cat. no. 14, illus.

EXHIBITIONS—*Abraham Welcoming the Three Angels* and *Tobias and the Angel*: Venice, Palazzo Grassi, 1965: Mostra dei Guardi, cat. nos. 59 and 60, p. 412 (as Francesco) (catalogue by Pietro Zampetti).

LITERATURE: Rodolfo Pallucchini, *L'Arte di G. B. Piazzetta* (Bologna, 1934), pp. 34–35, n. 9 (*The Sacrifice of Isaac* only); Antonio Morassi, "Conclusioni su Antonio e Francesco Guardi," *Emporium*, XLIV (1951), 201, 208, figs. 7 and 8; Morassi (1953), VII, 62; Morassi, "A Signed Drawing by Antonio Guardi and the Problem of the Guardi Brothers," *Burlington Magazine*, XCV (1953), 267, figs. 27 and 29; Michael Levey,

Figure 159D.

The Eighteenth-Century Italian Schools (London, 1956), p. 88 (*The Sacrifice of Isaac* only); Nancy Coe, "Four Paintings by Giovanni Antonio Guardi," CMA *Bulletin*, XLIV (1957), 198–99, 202–3, illus. pp. 200 and 201; Morassi, "Pellegrini e Guardi," *Emporium*, CXXVIII (1958), 205, 209, figs. 16–19; Francis J. B. Watson, "A Series of 'Turqueries' by Francesco Guardi," *The Baltimore Museum of Art News Quarterly*, XXIV (Fall 1960), 4; Michelangelo Muraro, "The Guardi Problem and the Statutes of the Venetian Guilds," *Burlington Magazine*, CII (1960), 428, n. 25; Francesco Valcanover, *G. Guardi, le storie di Tobiolo nella Chiesa di San Raffaele Arcangelo in Venezia* (Milan, 1964), opp. pl. III (*The Sacrifice of Isaac* and *Tobias and the Angel* only); Fritz Heinemann, "Mostra dei Guardi, Ausstellung in Venedig, Juni bis September 1965," *Kunstchronik*, XVIII (1965), 238 (*Tobias and the Angel* and *Abraham Welcoming the Three Angels* only); Pallucchini, "Note alla Mostra dei Guardi," *Arte Veneta*, XIX (1965), 228 (*Abraham Welcoming the Three Angels* only); Kurt Rossacher, *Visionen des Barock: Entwürfe aus der Sammlung Kurt Rossacher* (Darmstadt, 1965), p. 66 (*The Sacrifice of Isaac* only); Pietro Zampetti, *Mostra dei Guardi* (exh. cat., Venice, 1965), p. 120 (*The Sacrifice of Isaac* and *The Angels Appearing to Abraham* only); Denis Mahon, "The Brothers of the Mostra dei Guardi," *Problemi Guardeschi* (Venice, 1967), pp. 82–84 (all except *Abraham Welcoming the Three Angels*); Fredericksen and Zeri (1972), pp. 97–98, 255–56, 265, 574; Morassi (1973), I, 83, 309, nos. 11–14, and II, figs. 6–9; Rossi Bortolatto (1974), cat. nos. 4–7, p. 88, illus.; Rüdiger Klessmann, Ann T. Lurie, and Louise S. Richards, *Johann Liss* (exh. cat., Cleveland, 1975), pp. 116 n. 6, 176 (E97), and fig. 168 (German ed., pp. 118 n. 6, 181 [(E97)], and fig. 168); CMA *Handbook* (1978), illus. p. 143.

GIOVANNI BATTISTA LANGETTI
1625–1676

Langetti was born in Genoa in 1625. He studied first with Gioacchino Assereto (1600–1649), a younger contemporary of Bernardo Strozzi, and then went to Rome, where he was a student of Pietro da Cortona (1596–1669). About 1650 Langetti arrived in Venice, where he studied with Giovanni Francesco Cassana (1611–1690), a pupil of Strozzi during Strozzi's Venetian years. Like Strozzi, Langetti was of Genoese birth but worked most of his life in Venice. By 1660 he was well established and respected as an independent master—a rejuvenating influence in Venice in the mid-seventeenth century. Langetti's style shows many different influences: the brushwork and impasto of Strozzi, the color of the Venetians, the Caravaggesque realism of the Spaniard Jusepe de Ribera, and the baroque scale and movement of Pietro da Cortona. His contemporary, M. Boschini, praised him for his ability as a colorist and for his naturalism (*Carta del Navegar Pitoresco*, Venice, 1660, pp. 538–40, 596).

Figure 160a. *The Vision of St. Jerome.* Charcoal, 25.7 x 19.4 cm. Jean-Honoré Fragonard, French, 1732–1806. Norton Simon Foundation, Pasadena, California.

160 *The Vision of St. Jerome* 51.334

Canvas, 200.2 x 149.2 cm. Signed at lower left: LANGETTI FAC.[at]

Collections: Palazzo Conti, Vicenza; [Italico Brass, Venice].

Delia E. and L. E. Holden Funds, 1951.

The restoration history of this painting is unknown. Its structural condition is poor, and it is covered with grime and yellowed varnish. There are numerous scattered losses throughout, particularly at the bottom left and along all edges. Abrasion is most noticeable in the blue drapery and dark shadow tones. It had been suggested that the signature was a later addition, but careful examination in the Cleveland laboratory in 1978 revealed that the signature, though damaged, appeared to be original: It was applied directly on the painted surface; its crackle lines are continuous; and the paint has the same solubility characteristic as that in the rest of the painting. The only evidence of overpaint in the signature was in areas where losses were bridged to complete the letter.

The early history of the painting is unknown. Giuseppe Fiocco (1922) suggested that perhaps this is the painting from the Palazzo Conti in Vicenza which F. Vendramini Mosca (*Descrizione delle architetture, pitture e sculture di Vicenza*, 1778, pp. 59–60, 114) described as "Joseph revealing his dream." An earlier and more certain reference appears in Charles Nicolas Cochin's *Voyage d'Italie* (1758), in which Cochin correctly described the painting as the *St. Jerome* by Langetti in the Palazzo Conti in Vicenza and praised its fresh color, veracity, and character of composition. But the most significant evidence linking our painting with the Vicentine collection is Fragonard's drawing of 1760 or 1761 (Figure 160a), which is inscribed "Langetti/Palazzo Vecchia/Vicence" (now in the Norton Simon Museum, Pasadena; see Ananoff, 1963). The Palazzo dei Conti Vecchia at Vicenza, according to eighteenth-century accounts, must have housed a very distinguished collection, but unfortunately the contents of the collection are unknown to us except for the painting now in Cleveland and a fragment of the salon ceiling fresco by Tiepolo that was transferred to canvas and is now in the Cini collection in Venice (Antonio Morassi, *A Complete Catalogue of the Paintings of G. B. Tiepolo*, London, 1962, p. 65).

One of the fascinations of Langetti's work is that he assimilated influences from many sources but maintained his own individuality. One influence was his admiration for the Caravaggesque realism of the Spanish painter Jusepe de Ribera, which can be seen in the Museum painting if one compares it with Ribera's *St. Jerome* in the Pinacoteca del Museo Nazionale, Naples (Trapier, 1952, fig. 33), with another version by Ribera (in reverse) in The Hermitage, Leningrad (*ibid.*, fig. 17), and with two Ribera etchings in New York at the Hispanic Society of America (*ibid.*, figs. 5 and 7). The Cleveland painting also shows the influence of

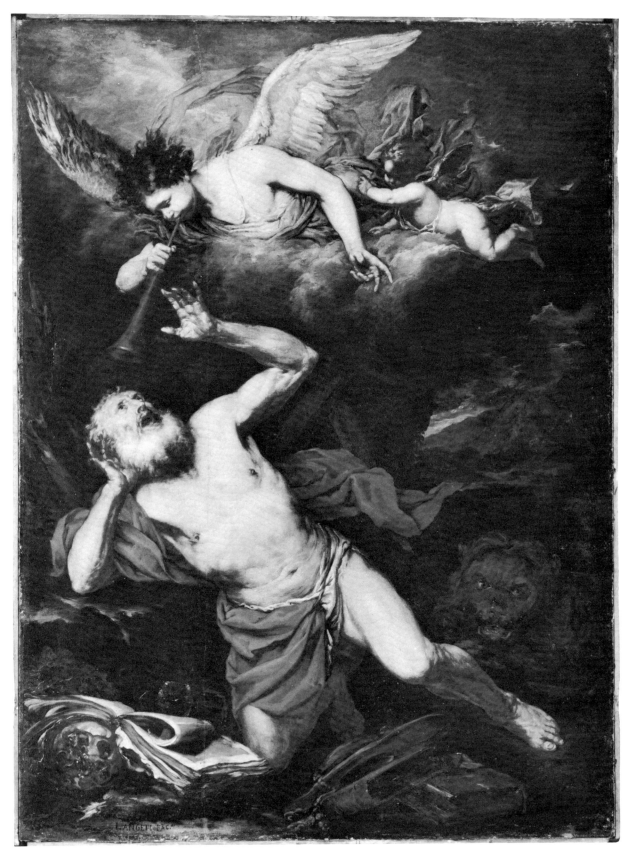

Figure 160.

Guercino's *St. Jerome and the Angel*, painted in 1641 for the church of S. Gerolamo in Rimini (Nefta Grimaldi, *Il Guercino*, Bologna, 1958, fig. 110). In spite of Langetti's dependence on other artists, his own creative spirit made his work much more than just a pastiche.

A smaller sketch (88 x 60 cm) for the Cleveland painting was in the Costa collection, Geneva (Stefani, 1966, fig. 243, p. 201).

A copy by Michael Willmann (born in Königsberg, 1630; died in Prague, 1706) of either the Geneva sketch or the Cleveland painting is in the National Gallery of Prague. Stefani (1966) suggested that one of the Langetti paintings of this subject might once have been in Prague in the collection of Count Cernin, a collector of important Venetian Baroque paintings, and that Willmann might have seen it there. N C W

EXHIBITIONS: Florence, Pitti Palace, 1922: Mostra della pittura italiana, sei- e settecento italiano, cat. no. 559, p. 112; Dayton (Ohio) Art Institute, John and Mable Ringling Museum of Art (Sarasota, Florida), and Wadsworth Atheneum (Hartford, Connecticut), 1962/63: Genoese Masters, Cambiaso to Magnasco, 1550–1750, cat. no. 40, illus.; Detroit Institute of Arts, 1965: Art in Italy, 1600–1700, cat. no. 208, illus. p. 182.

LITERATURE: Charles Nicolas Cochin, *Voyage d'Italie* (Paris, 1758), III, 182; Giuseppe Fiocco, "Giambattista Langetti e il naturalismo a Venezia," *Dedalo*, III (1922), 286, color illus. p. 274; Ugo Ojetti, L. Dami, and N. Tarchiani, *La Pittura italiana del seicento e del settecento alla mostra di Palazzo Pitti* (Milan and Rome, 1924), pl. 177; Thieme-Becker, XXII (1928), 341; F. Baumgart, "Contributi alla conoscenza di G. B. Langetti," *Bollettino d'Arte*, XXV (1931), 104; Edward M. O'Rorke Dickey, *A Picture Book of British Art* (London, 1931), p. 32, pl. 35; Henry S. Francis, "St. Jerome by Giovanni Battista Langetti," CMA *Bulletin*, XXXIX (1952), 24–26, illus. p. 22; Elizabeth du Gué Trapier, *Ribera* (New York, 1952), p. 260; Pigler (1956), p. 430; Louis Réau, *Iconographie de l'art chrétien*, III, pt. 2 (Paris, 1958), 748; Alexandre Ananoff, *L'Oeuvre dessiné de Jean-Honoré Fragonard*, II (Paris, 1963), 182, cat. no. 1079; Marina Stefani, "Nuovi contributi alla conoscenza di Giambattista Langetti," *Arte Veneta*, XX (1966), 198; Donzelli and Pilo (1967), p. 214; Alfred Moir, *The Italian Followers of Caravaggio* (Cambridge, Massachusetts, 1967), I, 289, n. 52, and II, fig. 398, p. 82; Fredericksen and Zeri (1972), pp. 103, 410, 574; Luis de Moura Sobral, "The Guercino Acquisition: A Singular Achievement in Drawing," *M: A Quarterly Review of The Montreal Museum of Fine Arts*, VI (1974), 17, fig. 13; Mary Newcombe, "Genoese Baroque Painting" (Ph.D. dissertation, State University of New York at Binghamton, 1975), p. 38, fig. 21; CMA *Handbook* (1978), illus. p. 139; Rodolfo Pallucchini, *La pittura veneziana del Seicento* (Milan, 1981), I, 248, and II, 783, fig. 796.

LORENZO LOTTO
1480–1556

A Venetian by birth, Lotto was a contemporary of Titian, a pupil of Alvise Vivarini, and a follower of Giovanni Bellini. He was also influenced by Giorgione and possibly Albrecht Dürer. Most of his life was spent in the relative obscurity of the provinces, chiefly in Bergamo and the Marches. He went to Rome in 1508 and stayed four years. He worked intermittently in Venice, principally between 1540 and 1549.

161 *Portrait of a Nobleman* 50.250

Canvas, 109 x 101.5 cm. Signed at lower right: L. Lotus 15(?).
Collections: Imperial collection, Vienna; Kunsthistorisches Museum, Vienna; [Moritz Lindemann, Vienna, 1923]; Wilhelm von Ofenheim, Vienna; Bruikleen von Ofenheim; [Rosenberg & Stiebel, New York].
Gift of Hanna Fund, 1950.

Because the original tacking margins are missing, the original size of this canvas is impossible to determine. The lining fabric and stretcher are one centimeter larger all around than the edge of the canvas. The painting has suffered considerably. There is extensive inpainting in scattered and abraded areas throughout. There are major losses in the left sleeve, left hand, and the chin and beard of the sitter. There are other losses along the edge of the canvas, with a large area of loss at the lower left. In many areas black lines have been painted in to simulate crackle. At present the painting is disfigured with yellow varnish and surface grime. Pentimenti are visible in the hat and hair of the nobleman.

The painting is signed and dated, but the last two digits of the date are not clear. Scholars in general—Freedberg (letter of June 22, 1979) and Pallucchini (letter of July 25, 1979, in particular—have dated it about 1525, before Lotto left Bergamo. Pignatti (1953), however, dated it ca. 1545, and Zeri (letter of July 19, 1979) dated it in the first half of the 1540s because of the "style, color, and the psychological approach to the sitter."

C. Douglas Lewis (letter of May 30, 1979) of the National Gallery, Washington, has suggested that the sitter might be Marc'Antonio Giustinian (1500–1579), one of the four sons of Agnesina and Girolamo Giustinian. Lewis based his opinion on the similarity he observed between our portrait and a bronze bust in Paris—supposedly of Marc'Antonio—by Sansovino or his workshop (Louvre, inv. no. RF 942). Marc'Antonio had documented business dealings with Sansovino and was even one of the executors of Sansovino's will (Lewis, review of Deborah Howard's *Jacopo Sansovino: Architecture and Patronage in Renaissance Venice* in *Burlington Magazine*, CXXI, 1979, 38–41). The portrait bust of Marc'Antonio is close in date to Sansovino's portrait bust of Agnesina, Marc'Antonio's aged mother. Sansovino's works date from about 1542.

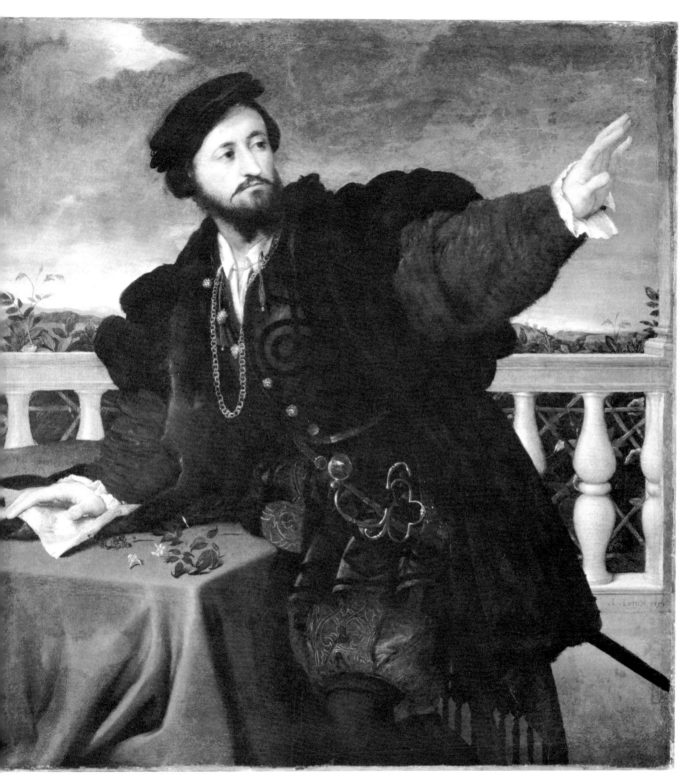

Figure 161.

Berenson (1956) compared the foliage in our portrait with that in Lotto's altarpiece of the *Madonna and St. Joseph*, 1526, in the Biblioteca Communale, Iesi, and showed that the two clusters are identical. He also convincingly suggested that Lotto's black chalk drawing of a *Bearded Man* in the Albertina, Vienna (Figure 161a), might possibly be of the same sitter and of about the same date, which he supposed to be ca. 1525. The Museum portrait can also be compared with the *Portrait of a Man as St. Wenceslaus* in the Galleria Tadini in Lovere (Berenson, 1955, pl. 172B). Both are dated about 1525, and each shows the sitter in similar poses.

Carolyn K. Lewis (*Villa Giustinian at Roncade*, New York, 1977) made the interesting suggestion that the loggia in the Museum painting bears a close resemblance to that in the Villa Giustinian, near Treviso, which was commissioned by Agnesina Badoer Giustinian and built by Tullio Lombardo in 1511–13. NCW

Figure 161a. *Portrait of a Bearded Man*. Chalk, 40.4 x 30.6 cm. Lotto. Graphische Sammlung Albertina, Vienna.

EXHIBITIONS: Amsterdam, Rijksmuseum, 1933–39 (lent by Bruikleen von Ofenheim); Amsterdam, Stedelijk Museum, 1934: Italiaansche Kunst in Nederlandsche bezit, cat. no. 197, p. 79, pl. 197; Venice, Palazzo Ducale, 1953: Mostra di Lorenzo Lotto, p. 110, pl. 69 (catalogue by Pietro Zampetti); CMA (1956), cat. no. 24, p. 26, pl. I; Columbus (Ohio) Gallery of Fine Arts, 1961: The Renaissance Image of Man and the World, cat. no. 29, illus.; Waltham (Massachusetts), Brandeis University, Institute of Fine Arts, 1963: Major Masters of the Renaissance: A Loan Exhibition of the Poses, cat. no. 11, p. 18, illus.; CMA (1963), cat. no. 1, color frontispiece.

LITERATURE: Erich von der Bercken, in Thieme-Becker (1929), XXIII, 412; Stephan Poglayen-Neuwall, "Einige Meisterwerke Italienischer Malerei der Sammlung Wilhelm von Ofenheim," *Pantheon*, III (1929), 271, illus. p. 270; B. Berenson (1932), p. 312; Henry S. Francis, "*Portrait of a Nobleman* by Lorenzo Lotto," CMA *Bulletin*, XXXVIII (1951), 22–23, illus. pp. 38, 46; Anna Banti and Antonio Boschetto, *Lorenzo Lotto* (Florence, 1953), pp. 39, 82, pl. 159; Luigi Coletti, *Lorenzo Lotto* (Bergamo, 1953), p. 45, pl. 117; Luitpold Dussler, "Die Lotto-Ausstellung in Venedig," *Kunstchronik*, VI (1953), 308; Terisio Pignatti, *Lorenzo Lotto* (Venice, 1953), p. 120, pl. 93; B. Berenson, *Lotto* (Milan, 1955), p. 126, pl. 172; B. Berenson, *Lorenzo Lotto* (London, 1956), p. 94, pls. 172, 172a; B. Berenson (1957), 1, p. 101; Francis, "Portraits by Lorenzo Lotto," CMA *Bulletin*, XLIV (1957), 44; Milliken (1958), illus., p. 34; Ferruccia Cappi Bentivegna, *Abbigliamento e costume nella pittura italiana*, 1 (Rome, 1962), 236, fig. 333; Jaffé (1963), p. 467; Margaret F. Marcus, "The Excellent Beauties of Nature in Art," *The Herbalist*, XXXI (1965), 17, illus. p. 19; Fredericksen and Zeri (1972), pp. 112, 521, 526 (wrong acc. no.), 574; Rodolfo Pallucchini and Giordana Mariani Canova, *L'Opera completa del Lotto*, Classici dell'Arte, vol. 79 (Milan, 1975), no. 163, p. 108, color illus. p. 107; CMA *Handbook* (1978), illus. p. 106; Flavio Caroli, *Lorenzo Lotto e la nascita della psicologia moderna* (Milan, 1980), 264, illus. p. 265.

Attributed to LORENZO LOTTO

162 *Portrait of a Man* 55.683

Canvas, 110.5 x 90 cm. Traces of illegible signature right of center and traces of illegible date at lower right.

Collections: [Durlacher Gallery, New York, ca. 1926]; Arthur Sachs, Paris and New York.

Gift of Arthur Sachs, 1955.

According to August Mayer (1926), this painting was dirty and overpainted when it first appeared in England. A largely illegible signature and date were uncovered during the subsequent cleaning. The paint surface has suffered extensive abrasions, and the flesh tones and hair have lost much of their original character.

Mayer interpreted the badly rubbed signature and the remains of the date as "Titian" and "1538." L. Venturi (1933) and Richard Offner (orally; see Bouchage, 1946) supported Mayer's interpretation. Berenson, however, felt that the signature had been reworked; he saw in it the letters "zo," which he thought to be the last part of Lotto's first name, exactly as they appear in his signature on the altar at S. Maria della Piazza (of 1546) in Ancona.

Wethey (1971) has given the painting to Girolamo Savoldo on the basis of its stylistic similarity to the *Portrait of a Knight* by Savoldo in the National Gallery of Art, Wash-

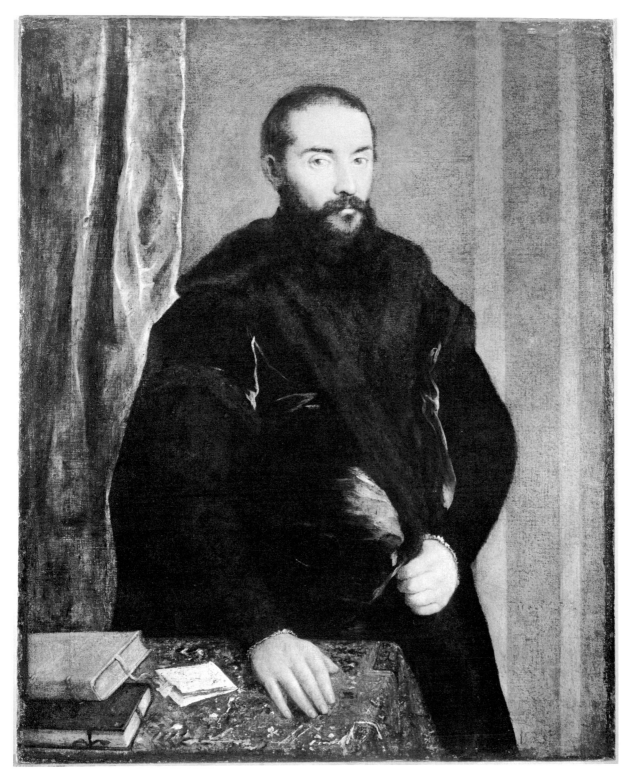

Figure 162.

ington (Fern Rusk Shapley, *Paintings from the Samuel H. Kress Collections*, Vol. II: *Italian Schools XV–XVI Century*, London and New York, 1968, fig. 215). Wethey also suggested that the painting might be the one said to have been signed by Titian that was formerly in the collection of the Infante Sebastián Gabriel de Borbón at Pau (*Catalogue*, Pau, 1876, p. 76, no. 678). Fredericksen and Zeri (1972) attribute the painting to Lotto.

The condition of the picture makes a precise attribution difficult, if not impossible. It is safest therefore to generalize that it seems Titianesque and has a stylistic affinity to other Lotto portraits of the period when Lotto was influenced by Titian (cf. Berenson, 1956, pls. 315, 336, 338, 339).

<div align="right">NCW</div>

EXHIBITIONS: Cambridge (Massachusetts), Fogg Art Museum, 1927 and 1931/32; Santa Barbara (California) Museum of Art, 1946: Exhibition of the Collection of Arthur Sachs; CMA (1956), cat. no. 23, pl. XI.

LITERATURE: August L. Mayer, "An Unknown Portrait of Titian's Middle Period," *Apollo*, III (1926), 63–64, illus. p. 63; L. Venturi (1931), pl. CCCLXXXI; L. Venturi (1933), III, pl. 514; Luc Bouchage, "Louvre to California, Today's Collections: Arthur Sachs," *Art News*, XLV (October 1946), 75; Thomas C. Howe, Jr., "Two Paintings by Titian," *California Palace of the Legion of Honor Bulletin*, V (September 1947), 34–39, illus. p. 34; Bernard Berenson, *Lotto* (Milan, 1954), p. 140, pls. 3, 6; B. Berenson, *Lorenzo Lotto* (London, 1956), p. 105, pl. 316; B. Berenson (1957), I, 101; Henry S. Francis, "Portraits by Lorenzo Lotto," CMA *Bulletin*, XLIV (1957), 44–45, illus. p. 41; CMA *Handbook* (1958), no. 418; Harold E. Wethey, *The Paintings of Titian*, Vol. II: *The Portraits* (London and New York, 1971), no. X-48, p. 167 (erroneously listed as still in the Arthur Sachs collection); Fredericksen and Zeri (1972), pp. 112, 521, 574; Rodolfo Pallucchini and Giordana Mariani Canova, *L'Opera completa del Lotto*, Classici dell'Arte, vol. 79 (Milan, 1975), no. 352, p. 124 (under attributed works).

BERNARDINO LUINI
Active ca. 1512–32

Almost nothing is known about the life of Bernardino Luini except that he worked in Milan and Lugano and died in 1532. Early in his life, while in Milan, he seems to have followed the non-Leonardesque tradition of Bramantino, Solari, and Borgognone. Later he became very much influenced by Leonardo da Vinci. His work is well documented, and there are numerous school pieces and copies. The earliest-known work by Luini is a fresco at Chiaravalle (Milan), dated 1512.

163 Madonna and Child 16.812

Panel (probably poplar), 55.5 x 42.7 cm.
Collections: [Woosley Moreau, Paris, 1865]; James Jackson Jarves; Mrs. Liberty E. Holden, Cleveland, 1884.
Holden Collection, 1916.

This panel was partially cleaned in 1936 by William Suhr. In 1976 Ross Merrill cleaned it again, removing the inpainting from previous restorations. For a painting of this period (early sixteenth century), the damage, which is extensive, is not unusual. Mary's right hand is almost completely repainted and there are considerable flake losses in the faces of the Christ Child and the Virgin.

James Jackson Jarves purchased the Luini *Madonna* in Paris in 1865 (Jarves, 1870, p. 354), having earlier, in 1857–58, in Florence, purchased another *Madonna and Child*, by Francesco Napolitano (see Painting 168). Francis Steegmuller (1951) referred to only one *Madonna* in the Jarves collection—that of Francesco Napolitano. That there were two Madonna paintings has been documented, however (see letter of November 12, 1868, from Holman Hunt to Jarves, in Jarves, 1870, pp. 361–62). The two Madonnas and an Italo-Flemish double portrait (see Painting 200) which Jarves attributed to Holbein were the only paintings from Jarves's earlier collection of twenty-five pictures that were withheld when the group was deposited at Yale University in 1870 as collateral for a loan (the twenty-two paintings were subsequently forfeited). The three paintings kept by Jarves were purchased by Mrs. Liberty E. Holden in

Figure 163a. *Head of a Young Girl (La Scapiliata)*. On panel, 24.6 x 21 cm. Attributed to Leonardo da Vinci, Italian, 1452–1519. Galleria Nazionale, Palazzo Pilotta, Parma.

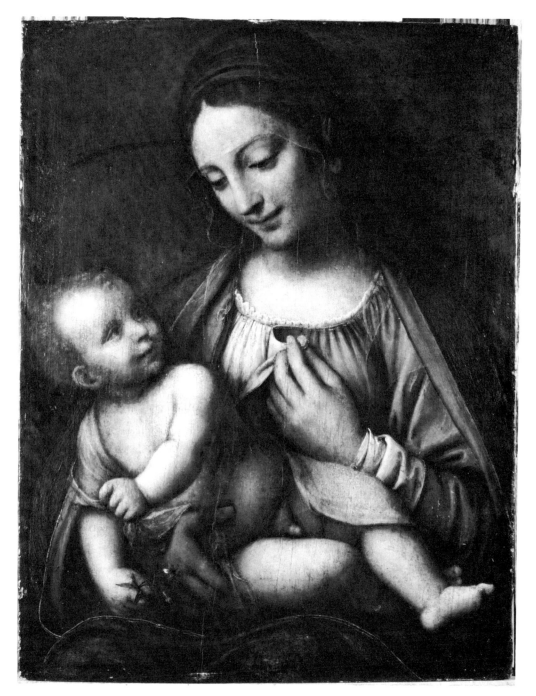

Figure 163.

1884 along with other pictures Jarves had collected in the meantime.

Bernard Berenson (1932) attributed the painting to Luini, and most scholars agree, although Fredericksen and Zeri (1972) call it School of Luini. Angelo Ottino della Chiesa (1956), who accepted the attribution to Luini, incorrectly states that the painting was exhibited in New York in 1860 and 1863.

Carlo Pedretti (1974) believes that the Museum painting is typical of the somewhat insipid style of Luini, and that it is a faithful but less animated study deriving from one of the lost paintings of Mary painted by Leonardo in 1507/8. Pedretti thought that the tilt of the head of the Madonna, the drawing of her nose, the treatment of her eyelids, and the slight smile derive directly from Leonardo. He pointed to a relationship between the Museum painting and *Head of a Young Girl* (*La Scapiliata*) in the Galleria Nazionale in Parma (Figure 163a); Pedretti thinks this latter is a sketch for a lost painting by Leonardo, but scholars in general do not accept his theory.

The Luini *Madonna and Child* dates from ca. 1515.

NCW

EXHIBITIONS: Boston (1883), cat. no. 427; Cleveland (1894), cat. no. 10; New York (1912), cat. no. 19; CMA (1916), cat. no. 25; CMA (1936), cat. no. 96.

LITERATURE: James Jackson Jarves, *Art Thoughts* (New York, 1870), p. 354; Jarves (1884), no. 52; M. L. Berenson (1907), p. 5; Rubinstein (1917), no. 26; B. Berenson (1932), p. 314; Francis Steegmuller, *The Two Lives of James Jackson Jarves* (New Haven, 1951), p. 223 and n. 28; Angelo Ottino della Chiesa, *Bernardino Luini* (Novara, 1956), no. 38, pp. 34, 72, fig. 91; B. Berenson (1968), I, 227; Fredericksen and Zeri (1972), pp. 114, 337, 573; Carlo Pedretti, "La *Femme échevelée* de Léonard de Vinci," *Revue de l'Art*, no. 25 (1974), p. 31, fig. 15; Piero Chiara et al., *Sacro e profano nella pittura di Bernardino Luini* (exh. cat., Luino, 1975), p. 102, fig. 115 (catalogue entry by Luisa Tognoli).

Circle of BERNARDINO LUINI

164 *Salome with the Head of* 16.824
 St. John the Baptist

Canvas, 46.6 x 59.7 cm.

Collections: [Baron Persi, Paris, 1810]; Count Eric Bentzel-Sternau, Mariahalden Gallery, Erlenbach, Switzerland, until after 1847; Miner K. Kellogg, Paris, by 1855; Mr. and Mrs. Liberty E. Holden, Cleveland, 1889.

Holden Collection, 1916.

An inscription on the back of the lining reads: "Taken from wood and put on canvas by Hacquin in Paris in the year 1810" (verified by Hacquin's son-in-law, Mortmard, a restorer of paintings for the Imperial Museum, Paris, in a letter dated June 2, 1857). Although x radiographs show that the painting was originally on canvas, not wood, quite possibly the canvas had been attached to wood—which would explain the apparent discrepancy. Another inscription, noted by F. R. Füssli in 1819, was added later on the border of Salome's blouse: "Leonardo da Vinci 1494." This inscription was removed by a Cleveland Museum restorer sometime after 1917, but traces of it are still visible. The losses of paint film are most extensive along the edges of the canvas, on the wrist of the executioner, and on the face of Herodias. Some old areas of repaint that may not be necessary still remain.

Miner K. Kellogg tried to prove that this painting was once in the possession of the Barberini family in Rome (letters of October 10, 1875, November 10, 1875, and February 17, 1876). Kellogg also claimed that a painting of the same subject in the Uffizi (Figure 164a) was a copy by Luini after the painting now in Cleveland, which Kellogg (1864 and 1879) and others (F. R. Füssli, 1819; W. Füssli, 1846; and Bentzel-Sternau, 1847) thought was by Leonardo. Kellogg may have been correct concerning the Barberini ownership, for none of the other versions could have appeared in the Barberini sale at Christie's, London, March 30, 1805 (lot 38).

Quite possibly the Cleveland and Uffizi paintings both derive from a lost Leonardo. The facial type of Salome and the pose of her head are derived from Leonardo's lost *Leda*, known by later copies and by Leonardo's drawings at Windsor. The salver in the Cleveland painting is elaborately chased at the top and on the base; the salver in the Uffizi painting has no chasing. The pictures seem to be nearly contemporary, with perhaps the Cleveland picture the earlier of the two.

Figure 164a. *Salome with the Head of St. John the Baptist.* On panel, 51 x 58 cm. Luini. Galleria Uffizi, Florence.

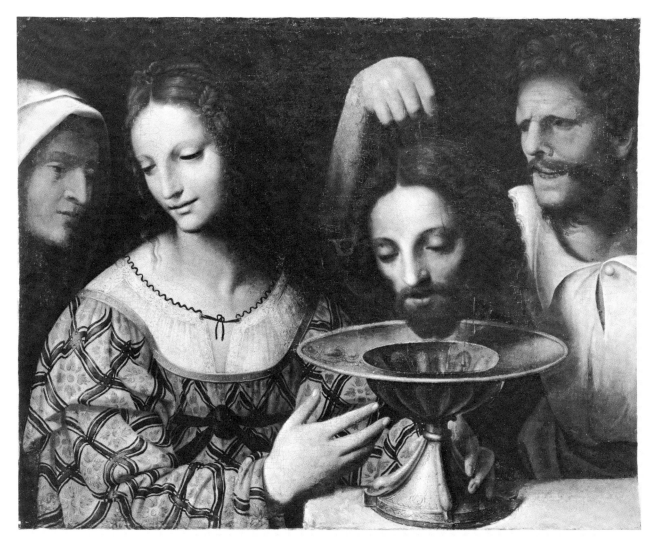

Figure 164.

Ottino della Chiesa (1956, p. 75, no. 50) called the Cleveland painting a faithful but later copy of Luini's painting in the Uffizi, but suggested that possibly it was by the Lombard painter Giovanni Paolo Lomazzo (1538–1600).

Several other variations of the subject are attributed to various contemporaries of Luini, but none of these versions includes Herodias, the mother of Salome, nor in any is there a base to the salver. Known variations are in the following collections: Museum of Fine Arts, Boston (formerly collection of the Duke d'Ascoli, Naples), Galleria Borromeo (Milan), the Prado, the Louvre, and the Galleria Imperiale in Vienna (Ottino della Chiesa, 1956, nos. 16, 64, 103, 206, 244, respectively).

A study of Salome wearing an identical costume is in the Ball State Teacher's College, Muncie, Indiana (canvas, 43.8 x 35.6 cm; Ottino della Chiesa, 1956, no. 182, and Wilbur D. Peat, "Important Paintings in the W. H. Thompson Collection at Muncie, Indiana," *Art Quarterly*, IV, 1941, 265).

N C W

EXHIBITIONS: Cleveland (1894), cat. no. 5; CMA (1916), cat. no. 26; CMA (1936), cat. no. 97.

LITERATURE: F. R. Füssli, *Allgemeines Künstlerlexikon*, II (Zurich, 1819), 3062; Wilhelm Füssli, *Zürich und die wichtigsten Städte am Rhein*, I (Zurich, 1842), 244; W. Füssli, *Kunstwerke* (Leipzig, 1846), pp. 219 ff.; Eric Bentzel-Sternau, *Catalogue des tableaux peints à l'huile de la collection de Mariahalden près Zurich* (Zurich, 1847), cat. no. 38; Sanford Gifford, *Journal*, I (Paris, 1856); Miner K. Kellogg, *Documents Relating to a Picture by Leonardo da Vinci Entitled "Herodias" from the Mariahalden Gallery* (London, 1864) (in CMA archives); Kellogg, *Observations on the History and Qualities of a Painting Entitled "Herodias" by Leonardo da Vinci* (London, 1879) (in CMA archives); Rubinstein (1917), cat. no. 27; Angela Ottino della Chiesa, *Bernardino Luini*, I (Novara, 1956), no. 39, p. 72; E. P. Richardson, "Archives of American Art Records of Art Collectors and Dealers, I: Miner K. Kellogg," *Art Quarterly*, XXIII, no. 3 (1960), 273, 280, fig. 5, p. 279.

ALESSANDRO MAGNASCO
1667–1749

The life of Magnasco has been described in a picturesque biography by Carlo Giuseppe Ratti (*Vita di Alessandro Magnasco, pittore, 1667–1749*, from *Delle vite de' pittori, scultori, ed architetti . . .*, Genoa, 1769). Alessandro, who was nicknamed Lissandrino because of his small stature and affectionate nature, was born in Genoa, where he worked with his father, who was also a painter. Between 1680 and 1682 he went to live in Milan with a rich patron who apprenticed him to the Venetian painter Filippo Abbiati. Portraits executed during this period are now lost. While in Milan he met and became a friend of the Venetian painter Sebastiano Ricci. In 1705 he went to Genoa. From there he went on to Florence, where he established himself as court painter to the Grand Duke Gian Gastone of Tuscany. He made short trips to Tuscany and Emilia, then left

Florence in 1711 to return to Milan, where he remained until 1735, collaborating occasionally with Clemente Spera. He returned to Genoa at the insistence of his only daughter and lived there until his death in 1749.

Magnasco's reputation rested primarily on originality of subject matter and his mystical, imaginative style. Although he had no students, his influence can be seen in the work of Sebastiano Ricci and his nephew Marco, and perhaps even more significantly in the work of Francesco Guardi and Giovanni Antonio Guardi. Magnasco's work was largely forgotten until the early twentieth century when he was rediscovered by the painter Italico Brass and art historians Benno Geiger, Mario Salmi, and W. R. Valentiner, among others.

165 The Synagogue 30.22

Canvas, 129 x 149 cm.

Collections: Anonymous collection (sale: Hôtel Drouot, Paris, 1928); [D'Atri, Paris]; Benno Geiger; [Italico Brass, Venice; purchased for the Cleveland Museum through Harold Parsons].

Purchase from the J. H. Wade Fund, 1930.

The painting is covered with yellow varnish. The paint film is in generally good condition.

In 1769 Carlo Giuseppe Ratti said of Magnasco: "But his favorite subject which he liked most often to repeat, was that of the Synagogue of the Jews—miniatures of most specious conception. . . ." Of the many paintings of this subject mentioned by Ratti, only four have been identified. The earliest, probably dating from before 1720, is a small version (68 x 97 cm) in Florence in the Uffizi (no. 5059), which seems to have been based on the interior of the old synagogue in Leghorn, built in 1603 (its attribution to Magnasco has been questioned by Pospisil, 1944, p. xxix; see also Delogu, 1931, pl. 120). Another painting mentioned by Ratti was commissioned by Count Giacomo di Colloredo, the Governor of Milan between 1719 and 1725. Called *Sermon of the Hebrews in the Synagogue of Livorno* (116–144 cm), it was painted from memory by Magnasco, who had traveled throughout Tuscany between 1704 and 1710. This painting and its companion, the *Interior of the Duomo*, was later donated by Count Colloredo to the Abbey of Seitenstetten in Austria, where both are presently located (Morassi, 1949, no. 57).

Two other synagogue paintings, of later date, were on the art market in Paris in the late 1920s. One came to Cleveland after a brief sojourn in the collection of Italico Brass of Venice. The other was in the Bessand collection in Paris and later entered the same Venetian collection, where it replaced the version that had been sold to Cleveland (Geiger, 1949, pp. 30–31; Arthur Sambon, *Alessandro Magnasco: Catalogue des oeuvres de ce maître exposées à la Galerie Sambon*, Paris, 1929, suppl. cat. no. 24, suppl. pl. 1, incorrectly states that the Bessand version was once in

Figure 165.

the Colloredo collection). Of these two versions, the Cleveland painting is probably the later. All four synagogue paintings, however, are closely related.

The Museum painting has generally been dated between 1725 and 1730, although Marcenaro (1958) and Morassi (1949) both suggested that it was painted after 1735, when Magnasco returned to Genoa. The painting exemplifies the artist's most mature and full-blown, fantastic imagery. In all four synagogue paintings space is prolonged and expansive, but nowhere more so than in the Cleveland painting. This limitless expanse, with its careful arrangement of flickering caricature-like figures on either side, is held together compositionally by the *almemar* (the pulpit for the rabbi), which is supported by four twisting columns. The satirical profiles of the congregation reflect both the high quality of Magnasco's late work and his commentary on the decay of Italian life in the eighteenth century. N C W

EXHIBITIONS: Venice, 1929: Il Settecento Italiano, cat. no. 14; CMA (1936), cat. no. 158, pl. xxxviii; Springfield (Massachusetts) Museum of Fine Arts, 1938: Alessandro Magnasco, ca. 1677-ca. 1749, cat. no. 3; New York, Metropolitan Museum of Art, 1938: Tiepolo and His Contemporaries, cat. no. 6; New York, World's Fair, 1939: Masterpieces of Art, cat. no. 230; San Francisco, M. H. de Young Memorial Museum, 1940: Seven Centuries of Painting, cat. no. Y-86; CMA, 1940: Masterpieces of Art, cat. no. 47, pl. xvi; Genoa, Palazzo Bianco, 1949: Mostra del Magnasco, cat. no. 72, pls. 80, 81; Philadelphia Museum of Art, 1950/51: Diamond Jubilee Exhibition, Masterpieces of Painting, cat. no. 32; CMA, 1956: The International Language (no catalogue); CMA, 1960: Paths of Abstract Art, cat. no. 7.

LITERATURE: Giuseppe Fiocco, "La Pittura Veneziana alla Mostra del Settecento," Rivista della Città di Venezia, viii–ix (1929), 501; William M. Milliken, "The Synagogue, by Alessandro Magnasco," CMA Bulletin, xvii (1930), 66–68, 73, illus. p. 70; Giuseppe Delogu, Pittori Minori Liguri Lombardi Piemontesi del Seicento e del Settecento (Venice, 1931), pp. 81, 128, pl. 127; Ugo Ojetti, Il Settecento Italiano, I (Milan and Rome, 1932), no. 85, pl. lviii; L. Venturi (1933), iii, pl. 583; Hans Tietze, Meisterwerke Europäischer Malerei in Amerika (Vienna, 1935), no. 116, p. 332, pl. 116; Ernst Scheyer, "Alessandro Magnasco," Apollo, xxviii (1938), 69, fig. ii; Maria Pospisil, Magnasco (Florence, 1944), no. 26, pp. xxxvii, lxxv, pl. 26; Benno Geiger, Magnasco (Bergamo, 1949), pp. 31, 80, pl. 201; Caterina Marcenaro, "Magnasco," Genova: Rivista del Comune, xxvi (1949), 16; Antonio Morassi, Mostra del Magnasco (Genoa, 1949), no. 72, figs. 80, 81; Pietro Zampetti, "La Mostra del Magnasco, a Genova," Emporium, cix (1949), 167, illus. p. 169; Rudolf Wittkower, Art and Architecture in Italy 1600 to 1750 (Harmondsworth, England, 1958), pl. 180; Marcenaro, "Alessandro Magnasco," Encyclopedia of World Art, ix (New York, Toronto, and London, 1958), pp. 397–98; Milliken (1958), illus. p. 40; Selected Works (1966), no. 160, illus.; Hans Durst, Alessandro Magnasco (Zurich, 1966), p. 30, no. 4; Fredericksen and Zeri (1972), pp. 116, 507, 573; CMA Handbook (1978), illus. p. 141; Fausta Franchini Guelfi, Alessandro Magnasco (Genoa, 1978), pp. 217–18, fig. 241.

School of ALESSANDRO MORETTO
(called Moretto da Brescia)

Ca. 1498–1554

Alessandro Moretto, whose family name was Bonvicino, was born about 1498, an approximate date deduced from his tax form of 1548. He may have been a pupil of the Brescian painter Floriano Ferramola, with whom he worked on the organ shutters of the cathedral in Brescia in 1516. The idea that he was a pupil of Titian has no other foundation than in Carlo Ridolfi's *Le Meraviglie dell'arte ovvero le vite degli illustri pittori veneti e dello stato* (ed. Detlev von Hadeln, Berlin, 1914–24, I, 262 ff.). He certainly was strongly influenced by Titian as well as Savoldo, Romanino, and Lotto. His activity centered around the area of Brescia, where he painted a few portraits, some religious paintings, and many altarpieces. The variation in the quality of works and the enormous quantity suggest that Moretto had an active studio. He died in Brescia in 1554.

| 166 | *Virgin Mary with Infants Christ and St. John* | 51.329 |

Canvas, 50.9 x 63.5 cm.

Collections: Lotmar, Bern, Switzerland; (Theodor Fischer, Lucerne]; William G. Mather, Cleveland, 1928.

Bequest of William G. Mather, 1951.

The painting was cleaned by Joseph Alvarez in 1963. The repainting is fairly extensive, and the paint surface is badly abraded.

This painting is similar in some ways to Moretto's *Madonna and Child and St. Joseph* in the Accademia Carrara, Bergamo (György Gombosi, *Moretto da Brescia*, Basel, 1943, cat. no. 14, pl. 67). The Cleveland painting is of far less quality than the Bergamo *Madonna* but nevertheless typifies the composition and style of Moretto.

Wilhelm Suida, in an expertise written at Lucerne in June 1928 (CMA archives), said he thought that our painting was by the hand of the master himself. Other scholars, however, agree that it is a school piece (e.g., Ellis Waterhouse, orally, during a visit to the Museum, June 6, 1963). N C W

EXHIBITIONS: None.

LITERATURE: Coe (1955), II, 164, no. 25; Fredericksen and Zeri (1972), pp. 144, 336, 574 (as Studio of Moretto).

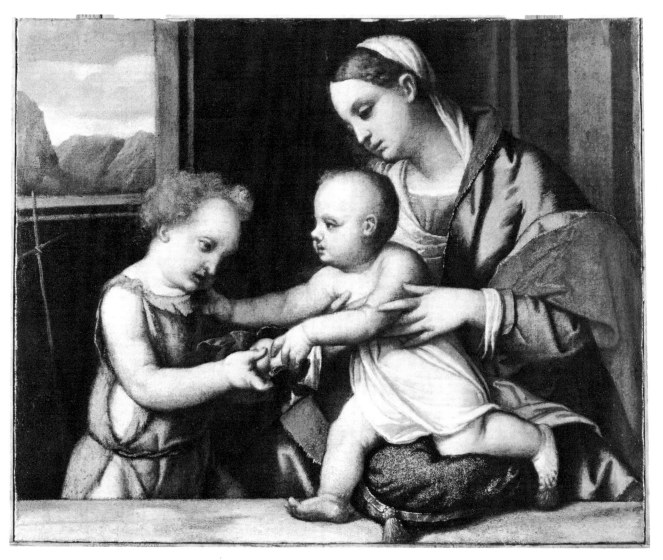

Figure 166.

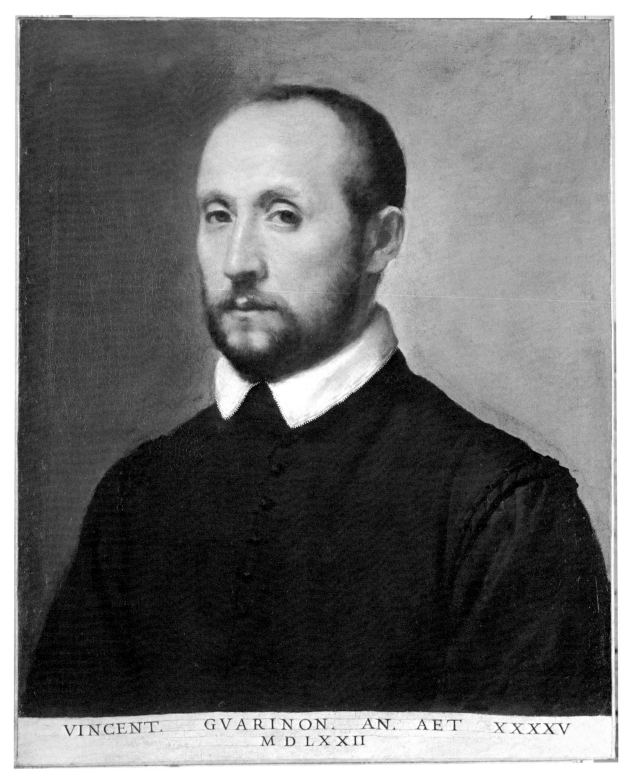

VINCENT. GVARINON. AN. AET XXXXV
M D LXXII

Figure 167.

GIOVANNI BATTISTA MORONI
Ca. 1520/25–1578

Moroni, a North Italian painter of the High Renaissance, was born probably in Albino, which is twelve kilometers northeast of Bergamo. He was a pupil of Moretto da Brescia (see Painting 166). After Moretto's death in 1554, Moroni was no longer active in Brescia but worked in the area of Bergamo. By 1568 he was in Trento, where he spent his remaining years. He was influenced by the work of Lotto and Titian. His reputation is based on his admirable portraits. His religious paintings date from the last few years of his life and follow, in an uninspired manner, Moretto's religious paintings.

167 *Portrait of Vincenzo Guarignoni* 62.1

Canvas, 63 x 50.8 cm. Inscription across bottom of the canvas: VINCENT. GVARINON. AN. AET XXXXV / MDLXXII.

Collections: Count Leon Miniszech (sale: Galerie Georges Petit, Paris, April 9–11, 1902, no. 23); [Agnew, London]; C. Fairfax Murray, London; [Julius Böhler, Munich, 1908]; Mr. and Mrs. Howard P. Eells, Cleveland, 1913; Maude Stager Eells, Cleveland (sale: Parke Bernet, New York, November 29, 1961, no. 10, illus.).

Gift of Adele C. and Howard P. Eells, Jr., in memory of Howard Parmelee Eells, 1962.

This painting was lined and cleaned in 1948 by William Suhr; it was cleaned again in 1960. It is in excellent condition except for scattered minor losses on the painted surface. Pentimenti show that the artist reduced the back of the sitter's head and his left shoulder.

Though the early history of the painting is unknown, enough is known about the family of the sitter to suggest that he was a prominent personage in Bergamo. Francesco Maria Tassi, in *Vite de'pittori, scultori, e architetti bergamaschi* (Bergamo, 1793; reprint ed., Milan, 1969–70, pp. 141–42, 164–65), mentioned two members of the Guarignoni family in sixteenth-century Bergamo: Giambattista, who painted the Sala de'Signori Giurista in 1577; and Orlando, who is named in a contract in 1596. An archival notation in Bergamo by Giuseppe Ercole Mozzi in "Antiquitates Bergomi" mentions a Don Vincenzo Guarinoni as being alive in 1680. This is most certainly identical to the reference in the Parke Bernet sales catalogue of November 29, 1961 (no. 10), there given as "Angelo Mazzi, Antiquities of Bergamo."

It is known that Moroni was engaged in a project near Bergamo two years before the Museum portrait was painted. The date—1572—inscribed with the sitter's name across the parapet at the bottom of the canvas, places this sober portrait in the artist's later and more mature period.

NCW

EXHIBITIONS: London, Royal Academy of Art, 1908: Winter Exhibition, cat. no. 38; Cleveland, Kinney and Levan Building, 1913: Cleveland Art Loan Exposition, cat. no. 138D; CMA, 1928: Representative Art through the Ages (no catalogue); CMA, November 1962: Year in Review, cat. no. 94, illus.

LITERATURE: Graves (1913), II, 823; Isabella Errera, *Répertoire des peintures datées*, I (Paris, 1920), 134; Coe (1955), II, 53, no. 8; Edmund P. Pillsbury, "Two Portraits by Giovanni Battista Moroni," CMA *Bulletin*, LVIII (1971), 75–82, figs. 1 and 2; Fredericksen and Zeri (1972), pp. 145, 514, 574; *Dizionario*, VIII (1975), 40; CMA *Handbook* (1978), illus. p. 112; Mina Gregori, "Giovan Battista Moroni," *I Pittori Bergamaschi dal XIII al XIX secolo: Il Cinquecento*, III, no. 93 (1975), 119, 253–54, illus. p. 366.

FRANCESCO NAPOLITANO
Active ca. 1500

Napolitano came from Naples to Milan, where he worked in the tradition of Leonardo da Vinci and Boltraffio. He was unknown until his signature was discovered by Giovanni Morelli ([Ivan Lermolieff], *Kunstkritische Studien über italienische Malerei*, I, Leipzig, 1891, 203, n.) on the painting *Madonna and Child with St. Sebastian and St. John the Baptist*, now in Zurich, Kunsthaus. Napolitano had been confused with the Master of the Pala Sforzesca (Emil Jacobsen, "Un Quadro e un disegno del Maestro della Pala Sforzesca," *Rassegna d'Arte*, X, 1910, 53–55) and with a Neapolitan fresco painter, Francesco Pagano, but by 1907 Emile Bertaux had firmly established Napolitano's separate identity ("Le Retable monumental de la Cathédrale de Valence," *Gazette des Beaux-Arts*, XXXVIII, 1907, 103–30). In 1910 Seymour Ricci ("New Pictures by Francesco Napolitano," *Burlington Magazine*, XVIII, 1910, 24–27) attributed five paintings to the master, and in 1932 Bernard Berenson added others, bringing Napolitano's oeuvre to twelve paintings.

Panel (walnut), 41.7 x 30.9 cm. Painted surface: 41.5 x 30.3 cm.

Collections: Leopoldo Franceschi, San Miniatello, Italy; after · Franceschi's death, acquired by a carpenter named Monta, whose heirs sold it to Vincenzo Corsi, Florence, 1857; James Jackson Jarves, 1858; Mrs. Liberty E. Holden, Cleveland, 1884.

Holden Collection, 1916.

The painting is in good condition; damage is minor, with some loss in the sky above the village and in the forehead and left knee of the Christ Child. Jarves stated that the painting was cleaned by Torcello Bacci in 1857, when it was in the possession of Vincenzo Corsi. It was cleaned again by William Suhr in 1939 and repaint was removed, principally in the landscape in the upper right corner.

This painting was in the first collection of James Jackson Jarves, acquired in Europe before 1860. The collection (with the exception of this painting and two others—Paintings 163, 200) was deposited at Yale University in 1868 as collateral for a loan and was forfeited three years later. The three paintings kept by Jarves became the basis for a second collection, which he later sold to Mrs. Liberty E. Holden.

Jarves (1860, 1884) attributed Napolitano's painting to Leonardo da Vinci—an attribution which he believed was justified by the provenance of the work and supporting opinions of the following critics: Holman Hunt; Monsieur Rio (a French author of the life of Leonardo); William Michael Rossetti, who visited Jarves in Florence in the spring of 1869 and offered his opinion in a letter to the London *Athenaeum* of June 5, 1869; Charles Heath Wilson in the *Academy* of March 1876; Professor Miglirini, Director of the Uffizi, in a letter to Jarves dated October 15, 1858 (which first mentions Jarves as the owner of the painting); Baron Gariod of the Turin Gallery; Giudici, Professor of Aesthetics at the Academy of Fine Arts, Florence; and Baron Edward de Liphart, in a letter from Florence dated June 7, 1877.

Verga (1901), in a discourse on the landscape to the right of the Madonna, which he describes as "Leonardesque school," identified the castle in the scene as Castello di Milano. The castle's Torre del Filarete, seen in this painting, was destroyed by lightning in 1521 and was rebuilt under Francesco Sforza. The destruction of the Torre establishes a *terminus ad quem* for the dating of our picture, which is thought to have been painted ca. 1500. Two other pictorial representations of the castle substantiate Verga's identification: a graffito in the Abbazia di Chiaravalle (Carlo Fumagalli, Diego Sant Ambrogio, and Luca Beltrami, *Reminiscenza di Storia ed arte nel suburbia e nella Città*, Milan, 1891, I, pl. XLI) and a drawing in the Royal Accademia di Belle Arti, Venice (Luca Beltrami, *Il Castello di Milano*, Milan, 1894, illus. between pp. 608–9).

Mary Logan Berenson (1907) suggested a modest attribution to School of Leonardo and mentioned the possibility that Ambrogio de Predis was the artist. Bryson Burroughs (Exh: 1912) attributed the painting to Francesco Napolitano. Bernard Berenson (1932 and 1968) and Fredericksen and Zeri (1972) agreed with the Napolitano attribution. Pedretti (1974) suggested that because of the oblique position of the Child the Cleveland painting may be related to a lost Leonardo; the head of the Virgin, he says, derives from Leonardo's *Madonna of the Rocks* in the Louvre.

William Suida (letter of December 17, 1949) compared the Cleveland panel with the *Madonna and Child* in Zurich, Kunsthaus, and attributed both paintings to the Valencian painter Fernando de Llanos. Suida based his opinion on his interpretation of the abbreviated signature on the Zurich painting (*Leonardo und sein Kreis*, Munich, 1929, pp. 251–52, fig. 54). While a Spanish attribution is not acceptable, there is no question that these two paintings are by the same hand. Similarities in composition, in treatment of windows and landscape, in facial types, and in treatment of highlights that graduate into somber black shadows attest to a single authorship. Suida's opinion was repudiated by Sánchez-Cantón (*Archivo español de arte y arqueologia*, V, 1929, 127) and later by Chandler Post (*A History of Spanish Painting*, Cambridge, Massachusetts, 1953, XI, 275).

Professor Federico Zeri (letter of April 23, 1980) has informed the author that he saw an almost-exact replica of the Museum painting (with only minor differences in the pattern of the haloes) in a French private collection. NCW

EXHIBITIONS: New York, Institute of Fine Arts, 1860, cat. no. 93; Boston (1883), cat. no. 428; Cleveland (1894), cat. no. 11; New York (1912), cat. no. 17; CMA (1916), cat. no. 43; CMA (1936), cat. no. 99; Los Angeles County Museum, 1949: Leonardo da Vinci, cat. no. 64, pl. 64 (as pupil of Leonardo).

LITERATURE: James Jackson Jarves, *Descriptive Catalogue of "Old Masters" Collected by James J. Jarves to Illustrate The History of Painting from A.D. 1200 to the Best Periods of Italian Art* (Cambridge, Massachusetts, 1860), no. 93, pp. 19, 21, 24–25, 27–30, 36, 38; Jarves, *Art Studies: The "Old Masters" of Italy*, II (New York and London, 1861), pl. N, opp. p. 388; Jarves (1884), no. 53, pp. 17–22; Ettore Verga, "L'esposizione cartografica di Milano," *Emporium*, XIV (1901), 57, illus. p. 54; Luca Beltrami, *Indagini e Documenti: riguardanti la Torre Principale del Castello di Milano ricostrutta in Memoria di Umberto I* (Milan, 1905), pp. 43–44, 70–71, illus. p. 42; M. L. Berenson (1907), p. 4, illus. p. 5; Thieme-Becker (1916), XII, 308; Francesco Malaguzzi-Valeri, *La Corte di Ludovico il Moro: Gli Artisti Lombardi* (Milan, 1917), p. 44, n. 1; Rubenstein (1917), pp. 38–39, no. 43, illus. p. 67; B. Berenson (1932), p. 205; Theodore Sizer, "James Jackson Jarves: A Forgotten New Englander," *New England Quarterly*, VI (1933), 348, n. 46; Henry S. Francis, "The Holden Francesco Napolitano," CMA *Bulletin*, XXII (1935), 156–59, illus. p. 153; Leandro de Saralegui, "Sobre Algunas Tablas Españolas," *Archivo Español de Arte*, XVIII (1946), 137, n. 1; Francis Steegmüller, *The Two Lives of James Jackson Jarves* (New Haven 1951), pp. 223–24, illus. p. 285; B. Berenson (1968), p. 144; Fredericksen and Zeri (1972), 74, 322, 573; Carlo Pedretti, "La *Femme échevelée* de Léonard de Vinci," *Revue de l'Art*, no. 25 (1974), p. 34, n. 42.

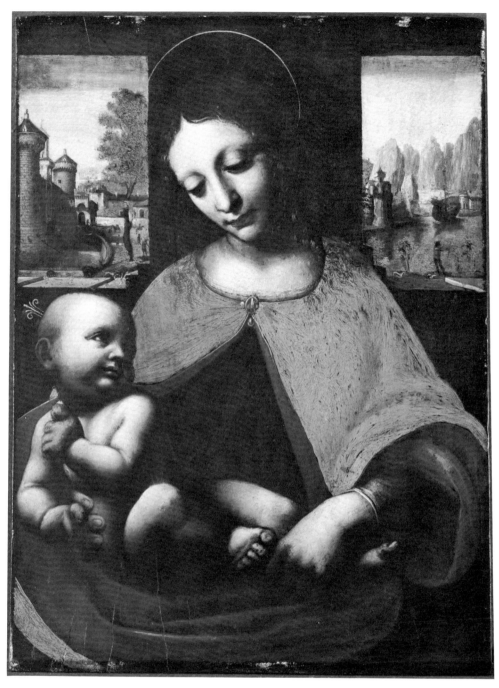

Figure 168.

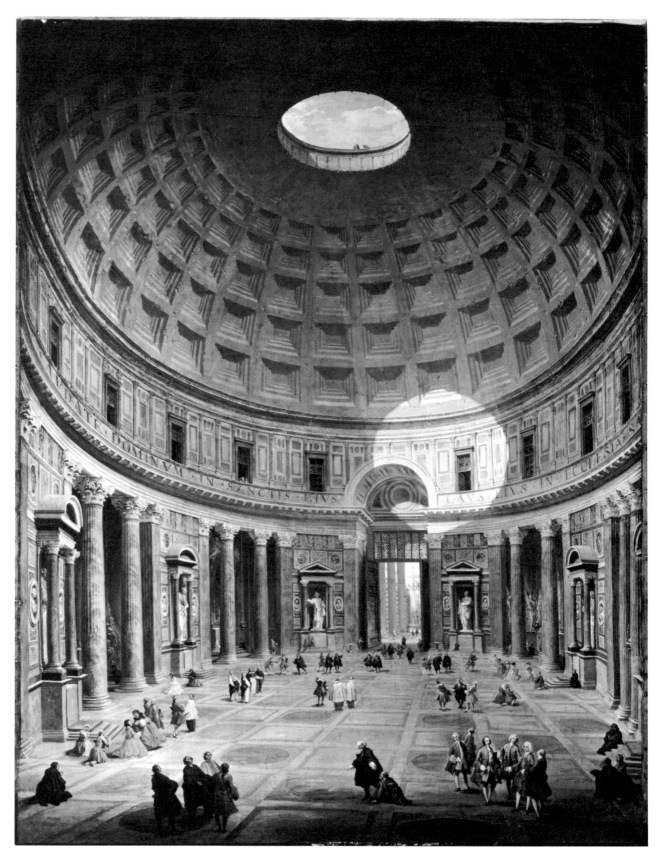

Figure 169.

GIOVANNI PAOLO PANINI

1691–ca. 1765

Panini (or Pannini) was born in Piacenza in 1691. He certainly must have been exposed to the stage designs of the Bibiena family in nearby Parma and Bologna, and he had had some training in architecture before he settled in Rome about 1717. He studied in the drawing academy of Benedetto Luti (1666–1724) and was influenced by the eclectic painter Giovanni Ghisolfi (1623–1683) and the Dutch topographical painter Gaspar van Wittel (called Vanvitelli; 1652/3–1735). In 1724 he married the sister-in-law of Nicholas Vleughels, Director of the French Academy at Rome. Owing perhaps to his connections with prominent Frenchmen and his commissions from Cardinal Polignac, emissary to Rome for Louis XV, he was accepted early in his career—in 1719—to the Academy of St. Luke, which in 1755 made him its president. He was also a member of the French Academy beginning in 1732. At about the same time, he became the most prominent scene-painter in Rome. He was patronized by the papacy and by princes. His views of ancient and contemporary Rome were in great demand, particularly among English tourists who began to invade Italy in ever-increasing numbers as the Grand Tour became a necessary part of the education of the English gentleman. Panini had two sons Giuseppe, an architect, and Francesco, an artist, who probably worked in his father's studio. Panini died in Rome.

169 Interior of the Pantheon in Rome 74.39

Canvas, 127 x 97.8 cm. Retouched signature at lower left: [?] P.P. Panini/Romae 1747. Inscription around collar of the dome: LAVDATE DOMINVM IN SANCTIS EIVS LAVS EIVS IN ECCLESIA SA[nctorvm].

Collections: Tyrwhitt-Drake, "Shardeloes," Amersham, Buckinghamshire (sale: Christie's, London, July 25, 1952, no. 148, to Reder); [David Koetser, New York]; Walter P. Chrysler, until 1969; [E. V. Thaw].

Purchase from the J. H. Wade Fund, 1974.

This painting, cleaned before acquisition, is in satisfactory condition. The bottom edge of the canvas has been cut an estimated five centimeters, judging from the stretcher impressions in the canvas at both sides and the top. A strip of repainting about 2.5 centimeters wide runs the entire length of the lower margin. There are a few very minor retouches, a repair in the center at the top of the canvas, and a minor area of repaint at the right of the signature. The signature has been strengthened; the first initial is illegible. (Although Panini used a variety of signatures throughout his career, in no other work did he use three initials before his last name.)

Unfortunately, there is no early documentation for this painting. It seems likely that it was either commissioned by William Drake (1723–1796) or purchased by his son, William Drake the Younger (1748–1795). The elder Drake could have commissioned it during his Grand Tour in Italy with his tutor in 1743 or sometime after his return (Lesley Lewis, *Connoisseurs and Secret Agents in Eighteenth-Century Rome*, London, 1961, p. 131, where it is reported that a Drake, accompanied by Holdsworth and Dawkins, was in Rome in February 1745). Certainly Drake's taste and appreciation for the new classicism was manifested in 1759 when he chose Robert Adam to supervise the decorative details of his family home, "Shardeloes." Drake's son, William the Younger, traveled in Italy in 1769 (for more information, see G. Eland, *Shardeloes Papers of the 17th and 18th Centuries*, London, 1947; unfortunately, Eland makes no specific reference to the paintings in the Drakes' collections). That either the father or the son was Panini's patron was suggested by Richard Paul Wunder in reference to two other paintings by Panini from the Drake Collection (later, the Tyrwhitt-Drake collection), now in the Walters Art Gallery, Baltimore ("Two Roman Vedute by Panini in the Walters Art Gallery," *Journal of the Walters Art Gallery*, XVII, 1954, 16–17).

The Pantheon, which later became the church of Santa Maria Rotunda or Ad Martyres, is still one of the most impressive and best preserved monuments of ancient Rome. The present building was erected in the reign of Hadrian between AD 125 and 128. The diameter of the rotunda and the height of the dome are about the same—approximately 43 meters, with the central oculus measuring 8.5 meters in diameter. The building obviously impressed Panini. The artist established his view from just in front and slightly to the east of one of the two free-standing, fluted Corinthian columns at the east side of the semi-dome of the apse. Facing north, he could see through the portal and portico to the Piazza della Rotunda, where there was a fountain surmounted by an obelisk of Ramses the Great (the fountain, built in 1575 after a model by Jacopo della Porta and formerly in front of the Temple of Isis on the Campus Martius in Rome, was added in 1711). An X radiograph of the canvas shows that Panini changed the preliminary drawing, adjusting the distortion of the perspective to give the illusion of even more space. He increased the overall feeling of height by elongating the triangular and semi-circular pediments over the altar shrines, the Corinthian capitals of the columns in front of the recessed niches and the frieze above them, the portal, and the metal grill below the barrel vault. The X radiograph also shows that he added some of the figures in the rotunda after painting in the design of the marble floor. Immediately after it was painted the picture became both an historical document and a pictorial record of the marble and porphyry veneer in the attic story, between the inscribed collar and the coffers of the dome, which was removed in 1747 and replaced by the present stucco decoration.

Panini and his followers painted many versions of this subject. Panini himself painted several, basically of two

different views of the interior: one represented in the Cleveland painting and another with two Corinthian columns in the immediate foreground and a vantage point from the center of one of the six great niches, immediately to the east of the semi-domed apse. This latter view extends beyond the columns to the lofty heights of the rotunda, with a glimpse through the portal and portico to the piazza beyond. Of Panini's two most important paintings of this view, one, dated 1734, was formerly in the collection of Perry B. Cott (Arisi, 1961, cat. no. 92, fig. 145); the other, of about the same date, is in a private collection in Milan (*ibid.*, cat.

Figure 169a. *The Interior of the Pantheon.* On canvas, 128 x 99 cm. Panini. National Gallery of Art, Washington, Samuel H. Kress Collection.

no. 91, fig. 144). This view may well have been Panini's favorite, for it is the view that appears much later in a series called "Interior of a Picture Gallery with the Monuments of Ancient Rome," commissioned in 1756 by the Duc de Choiseul, French ambassador to Rome. There are three other versions of this view: in the Metropolitan Museum of Art, the Louvre, and the National Gallery of Scotland.

A very close variant of the Museum's painting, dating from about 1740, of similar high quality but with different figure groupings, is in the National Gallery, Washington (Figure 169a). Another version of the same view, with the light from the oculus reflecting on the west side of the rotunda, is in the A. R. Lunde collection, New York (canvas, 123.5 x 97.4 cm, signed, and dated 1734; ex collections: R. H. A. Holbeck; John Barnes Foundation, New York; Sarah Barnes Roby Foundation, New York; see *Ars in Urbe*, exh. cat., New Haven, Connecticut, 1953, cat. no. 6, and *International Studio*, XCV, March 1930, illus. p. 58). Other similar versions are in the following collections: Marquess of Bath, Longleat, England (canvas, 124.5 x 99 cm; ex collections: Earl of Lichfield, Shugborough Hall, sale of August 10, 1842, no. 90); Mrs. Heywood Johnstone, Bignor Park, Pulborough (canvas, 123.2 x 96.5 cm; ex collections: J. Heywood Hawkins, Esq.; sale at Christie's, London, February 20, 1925, no. 77; exhibitions: Leeds, City Art Gallery, 1868, no. 203); and on loan to Southampton Art Gallery (lent from private collection). Richard Wunder, who has been most helpful in tracing paintings of the subject, says in a letter dated June 7, 1975, that the painting formerly in the collection of J. Paul Getty, Sutton Place, Surrey (canvas, 124.5 x 99 cm), is a replica of the Longleat version.

A very beautiful drawing of the Pantheon interior by Panini is in the collection of Count Seilern, London (pen and ink and wash with watercolor over black chalk, 336 x 262 mm; Johannes Wilde, "Michelangelo's Designs for the Medici Tombs," *Journal of the Warburg and Courtauld Institutes*, XVIII, 1955, 63, illus., and *Italian Paintings and Drawings at 56 Princes' Gate London SW 7*, London, 1959, II, no. 130, pl. XC).

For a more detailed account of the various versions of the subject, see Wixom (1975). NCW

EXHIBITIONS: CMA, March 1975: Year in Review, cat. no. 50, illus.

LITERATURE: T. P. Greig, "In the Auction Rooms," *Connoisseur*, CXXX (1952), 137, illus. p. 138; Bertina S. Manning, in *Paintings from the Collection of Walter P. Chrysler, Jr.* (Portland, Oregon, 1956), p. 38; Harald Olsen, *Italian Paintings and Sculpture in Denmark* (Copenhagen, 1960), p. 82; Ferdinando Arisi, *Gian Paolo Panini* (Piacenza, 1961), pp. 188 no. 199, 325; Estella Brunetti, "Panini e la monografia di F. Arisi," *Arte Antica e Moderna*, XXVI (April–June 1964), 182 n. 52, 195–96; Nancy Coe Wixom, "*Interior of the Pantheon, Rome*, by Giovanni Paolo Panini," CMA *Bulletin*, LXII (1975), 263–69, figs. 1, 6, and color illus, p. 261; CMA *Handbook* (1978), illus. p. 145.

GIOVANNI ANTONIO PELLEGRINI
1675–1741

A native of Venice, Pellegrini absorbed lasting impressions from Venetian colorism and the grandiloquent compositions of the High Renaissance, particularly those of Veronese. He studied under Paolo Pagani (1660–1716), but was influenced by the styles of Luca Giordano (1634–1705) and, to a lesser degree, Sebastiano Ricci (1659–1734). In 1704 he married Angiola Carriera, sister of the painter Rosalba Carriera. Rosalba's and Pellegrini's portraits of young females reveal a close contact between the two artists. In 1708 Pellegrini went to England with Marco Ricci; after Marco left, Pellegrini was joined by Marco's uncle, Sebastiano Ricci. He stayed in England until 1713. When the coveted commission to decorate the dome of St. Paul's went to Thornhill, Pellegrini left London for Düsseldorf. In Düsseldorf he served Elector Johann Wilhelm of the Palatine, whose residence at Bensberg he decorated between 1713 and 1714 with a series of large allegorical paintings. After two short sojourns in Hanover and Holland between 1716 and 1718, and a brief return to England and Venice in 1719, Pellegrini went to Paris in 1720 and received the commission for the decorations of the Banque Royal. He continued to travel, working in Würzburg, Prague, Dresden, and Vienna, but finally returning to Venice, where he died in 1741. His reputation had spread all through Europe, and his works strongly influenced European eighteenth-century painting, particularly in France.

170 *The Continence of Scipio* 68.207

Canvas, 131.5 x 107.2 cm.

Collections: James G. McMillan, Kenilworth, Illinois; [Ernest Joresco, Chicago].

Mr. and Mrs. William H. Marlatt Fund, 1968.

The painting had been lined before it entered the collection. Its height and width were increased by about 2 to 2.5 centimeters on all sides when tacking margins were let out. A small right-angle area of damage about 37 centimeters from the bottom and about 35 centimeters from the left margin is evident, as are scattered losses; otherwise, the painting is in good condition. In a pentimento the faint outlines of another figure can be seen between the two columns to Scipio's right.

The subject of the painting is the Roman general Publius Cornelius Scipio Africanus the Elder. He is shown after his victory over New Carthage in Spain as he, in an act of magnanimity, returns his victor's reward, the young bride of Allucius, to her bridegroom, along with all the offerings from her grateful parents (Livius XXVI, 50). It is noteworthy that Pellegrini owned a copy of Charles Rollins's *Histoire ancienne*, which includes the history of Carthage (Frances Vivian, "Joseph Smith and Giovanni Antonio Pellegrini," *Burlington Magazine*, CIV, 1962, 333, n. 45).

Pellegrini painted the subject numerous times, in both horizontal and vertical compositions. His horizontal version is exemplified by the painting formerly in the collection of the Earl of Derby, recently acquired by the Kunsthistorisches Museum, Vienna; it is based largely on Sebastiano Ricci's *Continence of Scipio* in the Palazzo Marucelli. The foremost example of the vertical format is the Cleveland painting.

There are four known repetitions or copies of the vertical composition by or after Pellegrini. One (75.6 x 59.4 cm) was formerly in the collection of Surgeon-Captain W. C. Thwaytes-Appleby, Westmoreland (on loan to Bowes Museum, Barnard Castle, County Durham, England; see [The Bowes Museum], *Italian Art 1600–1800*, comp. Tony Ellis, exh. cat., 1964). Eric Young (1965, p. 104, fig. 1) suggested that this may have been a sketch for our painting, but in Alessandro Bettagno's opinion it is a copy by a minor artist (letter of December 15, 1977). Bettagno also believes that the version belonging to H. D. Molesworth, Langley Park, Wexham, Buckinghamshire, is an excellent autograph replica. A third version, which seems to have been cut on the left side (130.2 x 100.3 cm), was at Julius Weitzner in London in 1969; its present whereabouts is unknown. A fourth version, formerly owned by Silvano Lodi, Munich, was offered but not sold at Christie's on July 8, 1977 (no. 109, 128.9 x 104.7 cm), and was offered again and sold on March 10, 1978 (no. 65, 130 x 105 cm; whereabouts unknown).

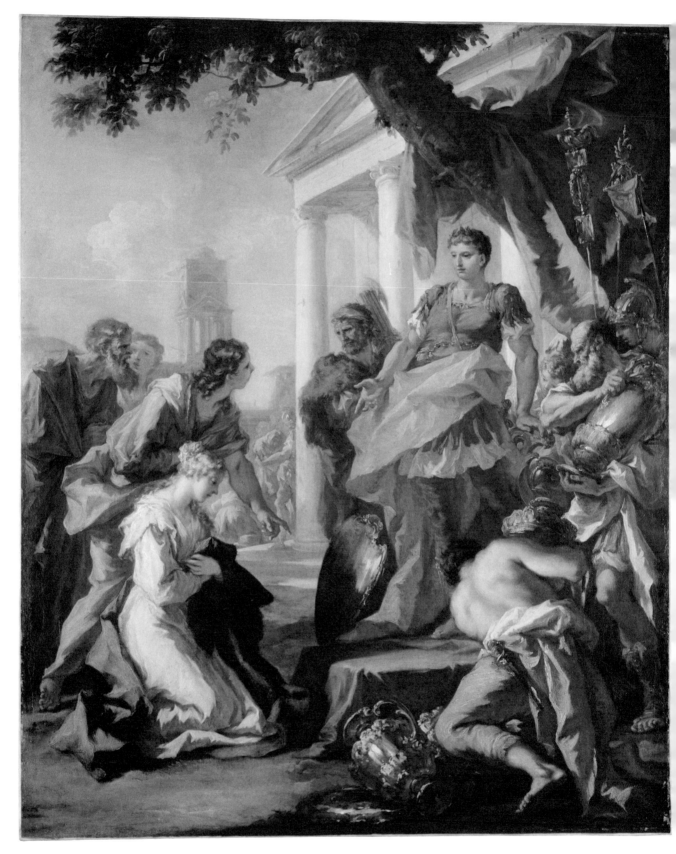

Figure 170.

The Cleveland painting was first mentioned and praised y Antonio Morassi (1958) when it was in the McMillan ollection in Chicago. Morassi suggested that it may be dentical to a painting belonging to Fritz Rothman, which Clara Steinweg (in Thieme-Becker, XXVI, 1932, 360) comares with the engraving by Thomas Park; the engraving, owever, reproduces a horizontal composition—likely the ne in the Kunsthistorisches Museum in Vienna.

Stylistically the Cleveland painting is closely related to orks of Pellegrini's English period, from 1708–13, such s *Rebecca at the Well*, in the National Gallery, London Michael Levey, *The Seventeenth and Eighteenth Century talian Schools*, London, 1971, p. 177); the wall paintings t Castle Howard; and the series of mythological figures at Hampton Court, all of which are characterized by lively rushwork, rich impasto, and light tonalities. The Tintoretesque male figure on the extreme left in the Cleveland ainting is ubiquitous in Pellegrini's oeuvre; it appears gain, for example, in *Sophonisba Receiving the Cup of oison*, Bayerische Staatsgemäldesammlungen, Munich. he barebacked male in the right foreground, shown heavng a vessel from the ground, appears in all the versions; he eveals Pellegrini's admiration for comparable figures in the aintings of Rubens. ATL

XHIBITIONS: CMA, January 1969: Year in Review, cat. no. 68, illus.

ITERATURE: Antonio Morassi, "Pellegrini and Guardi," *Emporium*, XXVIII (1958), 198–99, n. 6, fig. 10; Eric Young, "Some Pellegrini ketches and Their Chronology," *Apollo*, LXXXII (1965), 104; Edward J. lszewski, "A Rediscovered Holy Family by Francesco Trevisani," CMA ulletin, LXIV (1977), 28, fig. 4.

GIOVANNI BATTISTA PIAZZETTA
1683–1754

Giovanni Battista Piazzetta was born in Venice in 1683; he was the son of the sculptor and woodcarver Giacomo Piazzetta. He studied first with Antonio Molinari and later went to Bologna, where he studied with Giuseppe Maria Crespi. He was back in Venice by 1711. In 1727 he became a member of the Accademia Clementina in Bologna; in 1750 he was elected director of the Venetian Academy. He is considered one of the founders of the Venetian eighteenth-century school of painting; his style (after the twenties) and light palette had a strong influence on the painters who followed him. He painted altarpieces for various Venetian churches and produced genre scenes, portraits, book illustrations, and numerous drawings. He died in Venice in 1754.

171 *The Supper at Emmaus* 31.245

Canvas, 108.5 x 141.2 cm. Signed at lower left on edge of table: Piaceta F.

Collections: Giovanni Paolo Baglioni, San Cassiano, Venice, 1787; the family of Castiglioni, San Cassiano, Venice; Count Castiglioni, Padua; [Italico Brass, Venice].

Purchase from the J. H. Wade Fund, 1931.

The painting has been lined. It was superficially cleaned in the Cleveland Museum laboratory in 1978. Infrared and microscopic examination did not indicate any extensive restorations. Except for residues of old dark varnish in the recesses of the paint, a few minor retouchings, and somewhat yellowed varnish overall, the painting is in satisfactory condition. It will undergo further treatment.

The painting has generally been accepted as a work by Piazzetta. Goering (1936) placed it among works before 1727. At first, Pallucchini (1934) dated it about 1739, and then (1943) said it followed a little after the version in the Museo Civico in Padua, which he at first dated before or close to 1745 (see also Lucio Grossato, *Il Museo Civico di Padova, Dipinti e sculture dal XIV al XIX secolo*, Venice, 1957, p. 123) and later (1960) dated in the years immediately following 1740. Roberto Longhi (1961), the only scholar who rejected the attribution of our painting to Piazzetta, published it as a work by Federico Bencovich (1670–1740). Pietro Zampetti (Exh: 1968) fully accepted the Cleveland painting as a typical example of Piazzetta's style of the late 1730s.

The subject was very popular in Italy in the seventeenth and eighteenth centuries. This is the earliest of Piazzetta's versions; its horizontal composition and half-length figures are not directly related to any of the other versions or replicas, which increasingly emphasized the vertical. Compare, for example, with the versions in the Konstmuseum in Gothenburg and in the Museo Civico in Padua, and with a

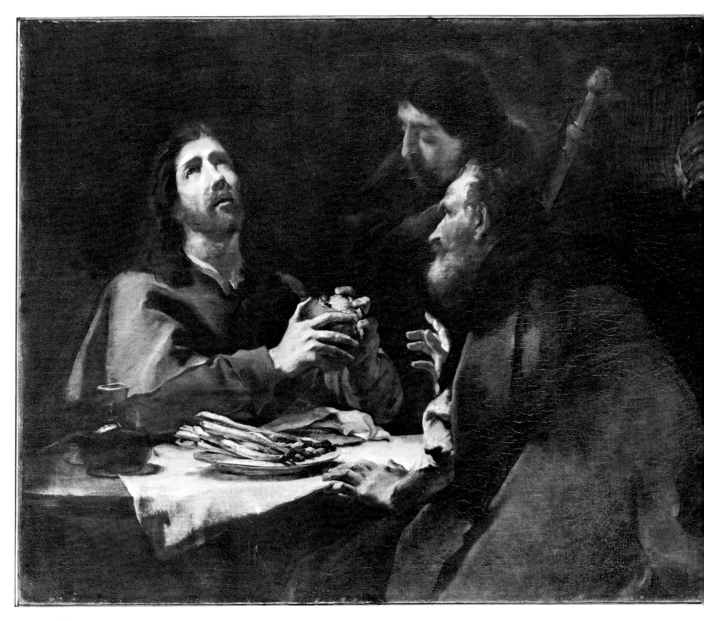

Figure 171.

study for the later versions, a drawing in the Städelsches Kunstinstitut in Frankfurt (Goering, 1936, p. 128, figs. A, B, and C). Another painted version of the subject is in the Chiesa dell'Annunziata in Genoa, replicas of which are in the museum in Grenoble and the Museo Nazionale delle Marche in Ancona; two more versions, now lost, are mentioned in Goering, p. 129.

A drawing of the head of a male saint—St. James—in the collection of Francis J. B. Watson, is related to the profile head in the foreground of the Museum painting. Watson (letter of September 9, 1950) suggested that the same model might have been used for both our painting and the drawing. According to Watson, the drawing was prepared for Mario Pittori, who made an engraving of it for a series on the Twelve Apostles issued in 1742.

An interesting drawing in reverse after our painting by Antonio Guardi is in a private collection in Zurich (290 x 430 mm; sale: Gutekunst & Klipstein, Bern, 1956; see Zampetti, 1965, and Pignatti, 1964). N C W

EXHIBITIONS: Florence, Pitti Palace, 1922: Mostra della pittura italiana del seicento e settecento, cat. no. 750 (catalogue by Roberto Longhi, et. al.); New York, Durlacher Brothers, 1934: An Exhibition of Venetian Painting 1600–1800, cat. no. 14; CMA (1936), cat. no. 162, pl. 38; San Francisco, 1940: Golden Gate International Exposition, cat. no. 163; Northampton, Massachusetts, Smith College, 1947: Italian Baroque Painting, cat. no. 27; Worcester (Massachusetts) Art Museum, 1948: Fiftieth Anniversary Exhibition of the Art of Europe during the XVI–XVII Centuries, cat. no. 22; CMA (1956), cat. no. 29, pl. XLVI; Baltimore Museum of Art, 1968: From El Greco to Pollock, cat. no. 38, illus.; Venice, Doge's Palace, 1968: Dal Ricci al Tiepolo, i pittori di figura del settecento a Venezia, cat. no. 58, illus. pp. 138–39 (catalogue by Pietro Zampetti).

LITERATURE: Cesare A. Levi, Le Collezione d'Arte e d'Antichita dal Secolo XIV ai Nostri Giorni (Venice, 1900), p. 252, no. 59; Aldo Rava, G. B. Piazzetta (Florence, 1921), p. 28, pl. 37; Otto Benesch, "Rembrandts Vermächtnis," Belvedere, III, pt. 6 (1924), 159, pl. 15; Benesch, "Maulpertsch zu den Quellen seines malerischen Stils," Städel-Jahrbuch, III–IV (1924), 114, pl. 91; Henry S. Francis, "The Supper at Emmaus by Piazzetta," CMA Bulletin, XVIII (1931), 188–90, illus. p. 186; Giuseppe Fiocco, in Thieme-Becker, XXVI (1932), 569–70; Rodolfo Pallucchini, L'Arte di G. B. Piazzetta (Bologna, 1934), pp. 41, 95, figs. 48 and 49; Edoardo (Wart) Arslan, "Studi sulla pittura del primo Settecento Veneziano," La Critica d'Arte, I (April 1936), 195; Max Goering, "An Unknown Sketch by Piazzetta," Burlington Magazine, LXVIII (1936), 129; Pallucchini, Giovanni Battista Piazzetta (Rome, 1943), p. 19, pl. 42; Benesch, "Rembrandt's Artistic Heritage," Gazette des Beaux-Arts, XXXIII (1948), 294; Francis, "Piazzetta's Model for The Assumption of the Virgin," CMA Bulletin, XLII (1955), 191; Pallucchini, Piazzetta (Milan, 1956), p. 26, pl. VII, figs. 46 and 47; Pigler (1956), p. 350; Lucio Grossato, Il Museo Civico di Padova; dipinti e sculture dal XIV al XIX secolo (Venice, 1957), p. 123; Terisio Pignatti, "Un disegno di Antonio Guardi," Bollettino dei Musei Civici Veneziano, I–II (1957), 29; Pallucchini, La Pittura Veneziana del Settecento (Venice, 1960), p. 81, fig. 171; Roberto Longhi, Scritti Giovanili, Opere complete di Roberto Longhi (Florence, 1961), I, pt. 1, 507, and pt. 2, 608, fig. 255 (attributed to Federico Bencovich); Pignatti, "Nuovi disegni di figure dei Guardi," Critica d'arte (Nuova), XI, no. 67–68 (1964), 6; Pietro Zampetti, Mostra dei Guardi (Venice, 1965), p. 305; Pallucchini, "Miscellanea Piazzettesca," Arte Veneta, XXII (1968), 107, 119, nn. 6 and 36; Fredericksen and Zeri (1972), pp. 163, 299, 573; Dizionario, IX (1975), 18; CMA Handbook (1978), illus. p. 142.

GIOVANNI BATTISTA PIAZZETTA

172 *The Assumption of the Virgin* 55.165

Canvas, 71.6 x 38.2 cm.

Collections: Tancred Borenius, London; [A. Morandotti, Rome].

Gift of Dr. and Mrs. N. Lester Farnacy, 1955.

This painting was superficially cleaned in the Cleveland Museum laboratory in 1978. Some old losses are apparent, and there has been some abrasion. The painting will be treated further and lined.

This sketch is the *modello* for the large altarpiece (Figure 172a) commissioned in 1743–44 for the Church of St. James in Zbraslav (King's Hall), near Prague (not for the

Figure 172a. Altarpiece: *The Assumption of the Virgin*. Piazzetta. Church of St. James, Zbraslav, near Prague. Reprinted from Rodolfo Pallucchini, *Piazzetta* (Milan, 1956), fig. 100.

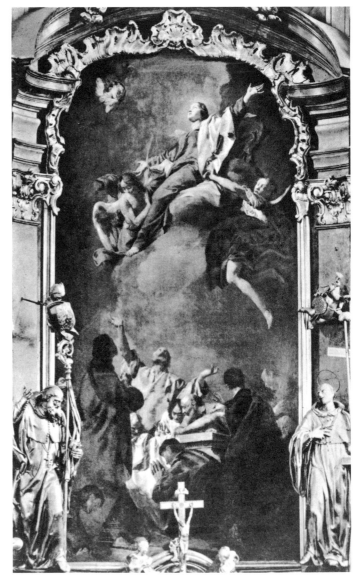

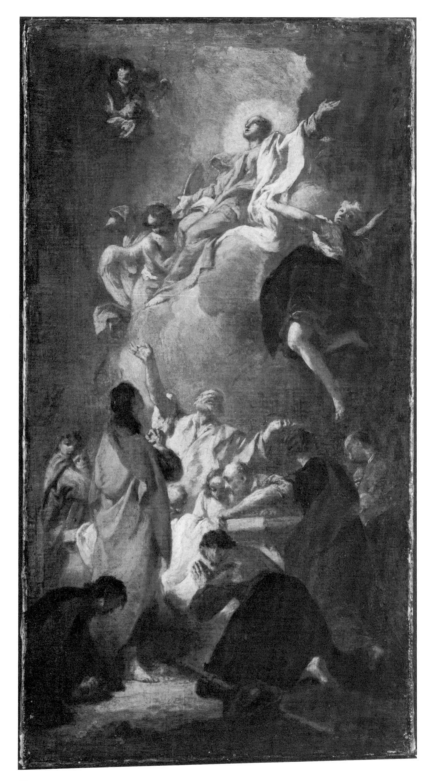

Figure 172.

Church of St. Arrigo in Prague, as stated by Aldo Rava in *G. B. Piazzetta*, Florence, 1921, p. 61, and by Henry S. Francis, 1955). The composition of the altarpiece follows that of the *modello* very closely.

Dr. Jaromir Neumann (letters of May 11, 1956, and January 30, 1969) of the Institut de Théorie et d'Histoire de l'Art in Prague plans to publish documents he has found concerning the commission for the St. James altarpiece, including Piazzetta's terms of contract with his patron, his relationship with his patron, and the artist's working habits. These documents, Dr. Neumann says, mention the Cleveland *modello*.

An earlier version of this subject, having a less complicated arrangement of figures, was painted in 1735 for the elector of Cologne; it was in the museum in Lille in 1801 and has been in the Louvre since 1957 (*The Age of Rococo: Art and Culture of the Eighteenth Century*, Munich, 1958, no. 157, illus. p. 85).

Two sketches in pen and ink for the Louvre altarpiece reveal that the artist experimented with the arrangement of figures. One of these sketches is in the Musée Wicar, Lille (Henry Pluchart, *Musée Wicar, Notice des Dessins, Cartons, Pastels, Miniatures et Grisailles exposées*, Lille, 1889, p. 79, no. 362), and the other is in the Kupferstichkabinett, Staatliche Museen, Berlin (no. 8468). NCW

EXHIBITIONS: CMA (1956), cat. no. 28; Baltimore Museum of Art, 1968: From El Greco to Pollock, cat. no. 38, illus.

LITERATURE: Henry S. Francis, "Piazzetta's Model for *The Assumption of the Virgin*," CMA *Bulletin*, XLII (1955), 189, 191, illus. p. 190; Rodolfo Pallucchini, *Piazzetta* (Milan, 1956), p. 40, fig. 99; Fredericksen and Zeri (1972), pp. 163, 308, 574; CMA *Handbook* (1978), illus. p. 142.

MATTIA PRETI
(called Il Cavalier Calabrese)
1613–1699

Mattia Preti was baptized on February 26, 1613, at Taverna, Calabria, a province of the Kingdom of Naples. He first visited Naples about 1630, on his way to Rome. In Rome he joined his older brother Gregorio, a painter in his own right, from whom Preti may have received his first instructions. Preti traveled extensively in subsequent years, visiting Florence, the Emilia, and Venice. He is variously documented in Rome between 1633 and 1653. He became a member of the Academy of St. Luke in Rome in 1653. Preti found a loyal patron in Doña Olimpia Aldobrandini, the Princess of Rossano, who was instrumental in his elevation to knighthood (Order of Malta), and whose favor led to important commissions for churches in Rome, such as S. Carlo ai Catinari in 1642–44 and S. Andrea della Valle in 1650–51. Shortly after 1651 Preti painted the frescoes in the church of S. Biagio in Modena. According to Bernardo de'Dominici (*Vite de'pittori, scultori, ed architetti napoletani*, III, Naples, 1742, 319–20, 324), Preti also visited France, Flanders, and Spain. He spent some five years in Naples, beginning in 1656. He visited Valmontone near Rome briefly in 1661, then settled in Malta, where he was commissioned to decorate the Cathedral of S. Giovanni at Valletta. He died in Malta in 1699.

Because of his extensive travels to many major art centers and his long stays in Rome and Naples, Preti developed a style that reveals influences from many leading masters, foremost among them Caravaggio, Guercino, Lanfranco, and Ribera. His works are known for their haunting realism and the exploitation of the dramatic effect of lunar light.

173 *St. Paul the Hermit* 69.109

Canvas, 102.9 x 76.2 cm.

Collections: Anonymous private collection, England (sale: Sotheby's, London, March 26, 1969, cat. no. 59, to Perretti); [Julius Weitzner, London].

Andrew R. and Martha Holden Jennings Fund, 1969.

The painting had been lined and partially cleaned before it entered the collection. There are numerous scattered flake losses throughout the canvas. Abrasions in the foreground and background occurred during previous cleanings. Broad areas of the background as well as shadows in the neck and upper chest of the figure have been reinforced. More recent areas of retouching can be seen along the top of the Saint's left thumb and over three deep scratches.

The Cleveland painting is one of two known, reduced variants of the full-figure composition of *St. Paul the Hermit* in Toronto (Figure 173a). The other variant—which is larger (130 x 100 cm) than the one in Cleveland—is in the church of San Fermo Maggiore in Verona. Licisco Magagnato (*La Pittura a Verona tra Sei e Settecento*, exh. cat.,

Figure 173a. *St. Paul the Hermit*. On canvas, 233.7 x 181 cm. Preti. Art Gallery of Ontario, Toronto. Purchase, Frank P. Wood Endowment.

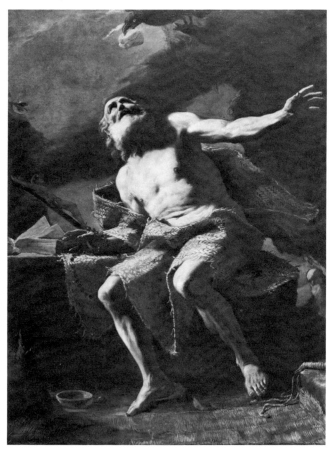

Verona, 1978, no. 21, p. 116, fig. 24) suggested that the Verona variant may be the one that belonged to Bartolomeo Dal Pozzo in 1718 (mentioned in Dal Pozzo's *Le Vite de pittori degli scultori et architetti veronesi*, Verona, 1718, p. 308). Like the painting in Toronto, the variant in Verona includes a raven carrying bread in his beak to St. Paul. In the Cleveland variant St. Paul has already received a loaf of bread. Unlike the version in Toronto, in both the Cleveland and Verona variants the saint holds a staff—in his right hand in the Cleveland painting, in both hands in the Verona picture. All three versions seem close in style. Likely the full-figure composition in Toronto preceded the two three-quarter-length variants. While the Toronto picture may date from Preti's Neapolitan period, ca. 1656–60, the variant in Cleveland is typical of a number of works painted in Malta ca. 1662–63.

In preparation for his dissertation, John Spike (letters of December 26, 1976; June 9, 1977; and April 26, 1978) examined Preti's Maltese works *in situ* and observed that works of this relatively short period share certain qualities with the Cleveland painting: a silvery light; an insistent, at times exaggerated, anatomical realism; and the use of opaque, white flesh tones. Spike pointed out the close resemblance of the Cleveland figure to Preti's *Blessed Pietro G. Mecatti*, one of the two pictures flanking the windows of the first bay of S. Giovanni's in Valletta, which in turn compares closely to St. Francis in the *Risen Christ Adored by Saints* (the Prado, Madrid), also of this period. Incidentally, St. Paul appears in the *Risen Christ* wearing a basket wrap similar to the one in the Cleveland painting. Spike made further comparisons between *St. Toscana*, which is opposite the *Blessed Pietro G. Mecatti* in S. Giovanni, and a *Penitent Magdalene* by Preti (sale: Rudolf Peltzer, Amsterdam, May 26–27, 1914, no. 281, present whereabouts unknown; see *Der Cicerone*, v, 1913, 419, illus. p. 420, fig. 11); and between Preti's *Penitent Magdalene* and her counterpart in the *Risen Christ*. Stylistically, Spike said, Mary Magdalene is related to corresponding figures in both the *Risen Christ* and the *St. Paul* in Cleveland. Obviously, it was Preti's practice to single out figures from his larger compositions and work them into smaller variants for private devotion.

Preti's biographer, Bernardo de'Dominici (1742, p. 342), mentions only one *St. Paul the Hermit*, which belonged to the Marchése Gagliano—not to the Duca Giordano, as stated by Salvatore Mitidieri ("Mattia Preti, detto il Cavalier Calabrese," *L'Arte*, XVI, 1913, 447, no. 30).

A three-quarter-length figure of *St. Paul the Hermit* by an anonymous artist in the Museo de Bellas Artes de Cataluña, Barcelona (inv. no. 10238), seems directly inspired by Preti's above-mentioned depictions of the saint. A T L

EXHIBITIONS: CMA, January 1970: Year in Review, cat. no. 148, illus.

LITERATURE: *Dizionario*, IX (1975), 227.

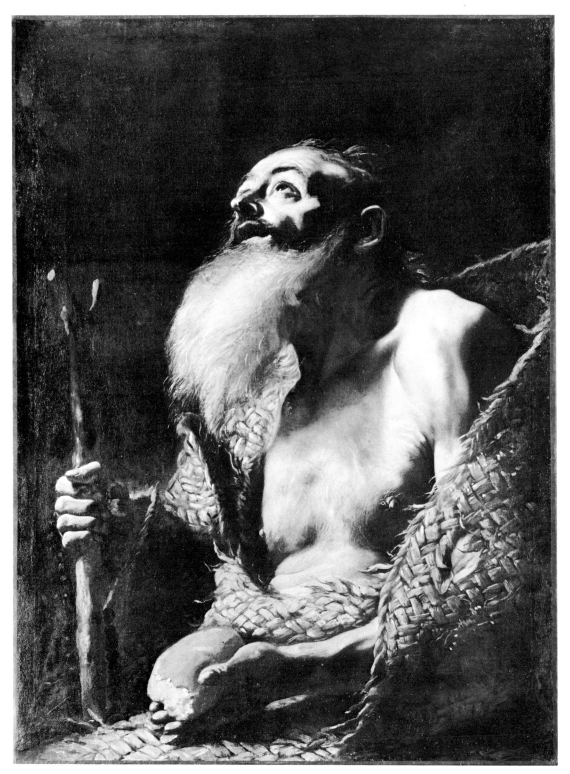

Figure 173.

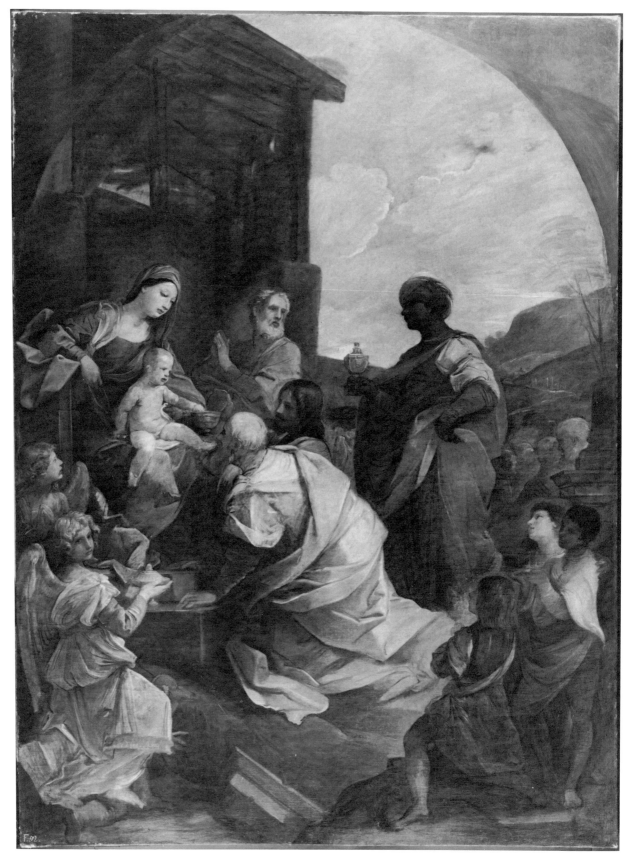

Figure 174.

394

GUIDO RENI
1575–1642

Reni was born in Calvenzano and died in Bologna. He was one of the major exponents of the classical baroque; like Albani and Domenichino, however, he received his first training in the studio of the Flemish Mannerist Denys Calvaert (born in Antwerp 1540, died in Bologna 1619). At the age of twenty, Reni joined the more progressive studio of the Carracci. About 1600 to 1603 he went to Rome, where he temporarily came in contact with the works of Caravaggio, the influence of which can be seen in Reni's *Crucifixion of St. Peter*, in the Vatican. Most of Reni's altarpieces and frescoes—particularly his *Aurora* fresco in the Casino Rospigliosi-Pallavicini in Rome—reveal an affinity for Raphael's classicism as it was interpreted by the Carracci. With the exception of a trip to Naples in 1622, his activities were restricted mainly to Bologna and Rome.

174 *Adoration of the Magi* 69.132

Canvas, 367.3 x 268.6 cm.

Collections: Cardinal Francesco Barberini, Barberini Palace, Rome; Barberini Collection, 1812; Barberini-Colonna di Sciarra Collection, 1880; Corsini Collection, Florence; [P. & D. Colnaghi & Co., Ltd., London].

Purchase, Leonard C. Hanna Jr. Bequest, 1969.

This vast canvas was cleaned by Joseph Alvarez in the Cleveland Museum laboratory in 1970. Several layers of very dark yellow varnish were removed. Retouching was kept to a minimum and was largely confined to eroded spots, particularly in the arched area, caused by the splattering of whitewash. Some deliberate scratches, probably resulting from a primitive attempt to remove encrusted whitewash and wax, were also retouched. Pentimenti visible throughout the canvas were left untouched. The most important pentimento occurs on the left, where a kneeling angel was painted over a figure (accompanied by a dog [?]) that is very similar to the kneeling child on the right. The spandrels were never painted because the altarpiece was meant to fit into an arched frame.

This monumental painting, one of several left unfinished at Reni's death in 1642, was delivered to the Barberini Palace in 1645, when final payment was made. The transaction is documented as follows (see Lavin, 1975, p. 34, no. 270):

"A Gioseppe Rena △ 34 m^{ta} sono per resto et int.º pagamento del pr'o d'un quadro fatto da Guido Rena, che rappresenta la rappresentala Rapp^{ne} [sic] di Magi consegnato à D. Servio N'ro Guardarobba . . . qº di 21 Aprile 1645 ——34."

The painting is also documented in an inventory of 1844:

"Venuta dei Magi, Guido Reni, al. p.ⁱ 15, lar. p.ⁱ 12." (Inventario Generale de Quadri dell'Eccma Casa Barberini, no. 464).

The documentation, of course, neither firmly proves that the Barberinis actually commissioned this picture nor establishes the date when Guido Reni began painting it. The number "F 92" in the lower left corner of the canvas is not related to the inventory of 1844; it is probably from an earlier inventory of Francesco Barberini's collection.

The *Adoration of the Magi* and other late works, such as *St. Mark in Prison* in the cathedral at Crema; the *Flagellation* in the Pinacoteca Nazionale in Bologna; and the *Adoration of the Shepherds* in the National Gallery, London, share stylistic features which are characteristic of Guido Reni's "ultima maniera." Forms and draperies, like those in monumental frescoes, are boldly outlined, creating a rhythmic flow from one form or movement to another. An all-pervading pearly gray atmosphere, with suggestive tones of pastel lightness—a departure from the vibrant richness of color in earlier works—unifies the canvas.

Before the painting was acquired by this Museum in 1969, it was published only once, by Emiliani (1958), who attributed it to Francesco Gessi (1588–1649). Gessi's works (for example, *The Pentecost* in the Church of SS. Filippo e Giacomo in Bologna) were cited and reproduced for comparison with the Cleveland picture, but they disprove rather than prove the claims of stylistic similarity. Cesare Gnudi (letter of August 2, 1972), who saw a photograph of the painting before it was cleaned, considers it to be a masterwork by Guido Reni, close in date to the *Adoration of the Shepherds* painted during the last years of Reni's life in the Certosa di San Martino in Naples. D. Stephen Pepper (letter of August 23, 1972) agreed with Gnudi.

According to Carlo Cesare Malvasia (*Felsina pittrice: Vite dei pittori bolognesi*, 1678; reprint, Bologna, 1971, p. 346), Guido Reni early in his career was commissioned by Camillo Bolognetti to paint a small *tavolina* of an *Adoration of the Magi* (now lost). The surprisingly large number of figures in the *tavolina* (thirty or more) approximately corresponds (if one includes the onlookers) to the number in two *Adoration of the Shepherds* paintings, one in Naples and one in London. The *tavolina* may well have been Guido's first concept for his later *Adoration* paintings, including the one in Cleveland. ATL

EXHIBITIONS: CMA, January 1970: Year in Review, cat. no. 149.

LITERATURE: Andrea Emiliani, "Un viaggio sconosciuto di Francesco Gessi," *Arte antica e moderna*, no. 1 (1958), 57, pl. 26b (as by Francesco Gessi); Cesare Garboli, *L'Opera completa di Guido Reni*, Classici dell'Arte, vol. 48 (Milan, 1971), 114–15, no. 202, illus.; Sherman E. Lee, "Guido Reni, *The Adoration of the Magi*," CMA *Bulletin*, LVIII (1971), 279–89, figs. 1–8, color illus. p. 277; Marilyn Aronberg Lavin, *Seven-*

teenth-Century Barberini Documents and Inventories of Art (New York, 1975), p. 34, Doc. 270, pp. 511, 535; CMA Handbook (1978), illus. p. 137; D. Stephen Pepper, "A New Late Work by Guido Reni and His Late Manner Re-evaluated," Burlington Magazine, CXXI (1979), 424, n. 30.

SALVATOR ROSA

1615–1673

Salvator Rosa was born at Arenella, near Naples, in 1615. He received his early training in the workshop of his uncle, Domenico Greco, and in the workshop of his brother-in-law, Francesco Fracanzano (a follower of the Spanish painter Jusepe de Ribera). He may have also studied with the Neapolitan battle painter Aniello Falcone. Rosa probably went to Rome in 1635; except for the years between 1640 and 1649, when he was in Florence, he lived in Rome until his death in 1673. In Florence he met Lucrezia, who became his mistress and bore him several children and whom eventually—on his deathbed—he married. In Florence he also met the poet and scholar Giovanni Battista Ricciardi, with whom he had a voluminous correspondence throughout his life. His home in Florence was the center of a sophisticated circle of actors, playwrights, writers, and musicians—the literati, among whom he played a leading role. During his first year in Florence he wrote his first satire, La Musica, followed by similar—that is, satirical—essays on poetry, painting, and related themes. He refused invitations to the courts of Sweden (1652) and France (1665). He was well known by his contemporaries not only for his skills as painter, etcher, engraver, playwright, poet, and musician but also for his excitability and arrogance. For most of the seventeenth century he had an influence on landscape painting in Europe. In the eighteenth and nineteenth centuries his praises were still being sung, particularly in England, in the writings of Horace Walpole, Sir Joshua Reynolds, and Percy Bysshe Shelley.

175 Landscape 58.472

Canvas, 144 x 176.7 cm. Signed at lower right with monogram.

Collections: Duke Francesco I d'Este, Modena; Duke Francesco V d'Este, Modena and Vienna: Duke Francis Ferdinand, Vienna; Maximillian, Duke of Hohenberg, Palace of the Prince of Liechtenstein, Vienna; [Rosenberg & Stiebel, New York].

Gift of Rosenberg & Stiebel, Inc., 1958.

The precise original dimensions of the canvas are undetermined; the tacking margins of the original fabric had been removed and the painting was enlarged by 1.3 centimeters on all four sides in order to fit a frame. The painting has been lined, and several major restorations were carried out in the past. Two large tears in the sky necessitated extensive overpaint. There are damages and abrasions throughout the painting, which is somewhat disfigured by old, darkened varnish and grime.

This is undoubtedly one of the paintings by prominent Roman painters commissioned by the Duke of Modena, Francesco I d'Este, in 1640 through his ambassador in Rome, Francesco Mantovani. Still in the Galleria Estense, the ducal palace in Modena, are two paintings by Rosa, executed between July and September 1640 and sent to the Duke of Modena on September 1 (Venturi, 1882, p. 249, docs. II=V). Pagani (1770) mentioned four paintings by Salvator Rosa in the ducal palace in Modena, among them the painting now in Cleveland. Our painting—described as a view of a lake, with a rugged rocky cliff, shepherds and their flocks by the shore, and a temple in ruins in the distance—was mentioned by Venturi (1882), who offered an unlikely attribution to the Flemish painter Vincenzo Armanno (possibly identical with Vincent Malo I, active ca. 1623–57, a little-known painter from Antwerp who spent most of his life in Genoa, studied with David Teniers the Elder, and painted mostly religious paintings in the tradition of Rubens and Brouwer). The four paintings attributed to Rosa remained in the ducal palace until the Italian government took over the sovereignty of the ducal holdings. The Galleria Estense was presented to the state by Francis V in 1869; at his death in 1875, the Este title and personal estate, including the Museum painting, were inherited by Duke Francis Ferdinand in Vienna. The duke, heir to the Austrian throne, married to the Princess of Hohenberg, left the painting to his son Maximillian, Duke of Hohenberg.

Two numbers, possibly inventory numbers (not yet identified), appear on the painting: in the lower right corner of the canvas is a varnished label reading "281"; and on the back of the stretcher is a label reading "Palazzo Reale di Modena, Guardaroba, N. 1114."

Luigi Salerno (1963) and Denis Mahon (orally, 1976) both said that the painting is unquestionably by Salvator Rosa. Dating from about 1640, it is related stylistically to a group of Rosa's early landscapes, such as: Tancred and Erminia (Figure 175a) in the Galleria Estense, Modena; Landscape with Travelers Asking the Way, in the collection

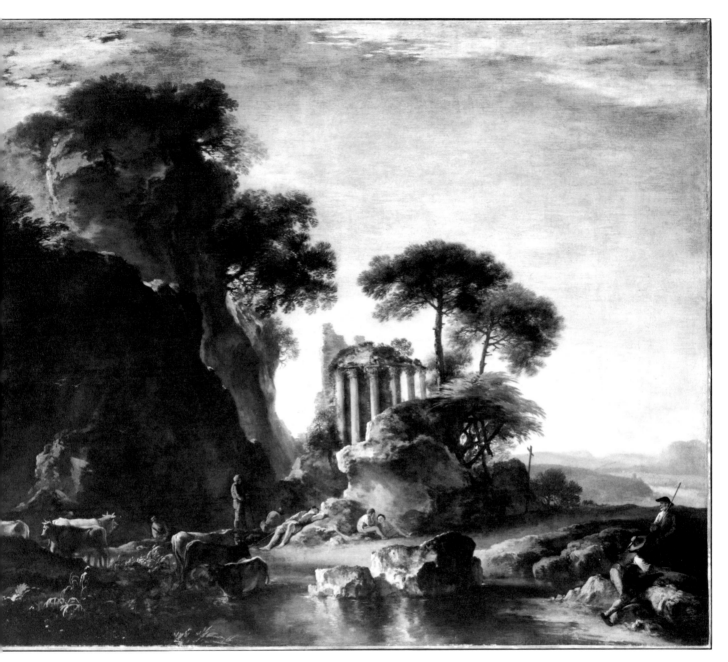

Figure 175.

Figure 175a. *Tancred and Erminia*. On canvas, 143 x 176 cm. Rosa. Galleria Estense, Modena.

of Denis Mahon (Salerno, 1975, no. 37); and the *Land-scape* in the Methuen Collection, Corsham (*ibid.*, no. 38)—all painted around 1640–41. These paintings, executed in Rome, show Rosa's development away from Mannerist compositional formulas; they reveal an awareness of the landscapes of Claude Lorraine with their asymmetrical compositions, their quality of light, and interest in spatial clarity. In turn, these early landscapes of Salvator Rosa influenced French landscape painters in the next century, such as Claude-Joseph Vernet. NCW

EXHIBITIONS: None.

LITERATURE: Gian Filiberto Pagani, *Le Pitture e sculture di Modena* (Modena, 1770), p. 142; Adolfo Venturi, *La R. Galleria Estense in Modena* (Modena, 1882), pp. 218–20, 378; Nancy Coe, "A Landscape Painting by Salvator Rosa," CMA *Bulletin*, XLVI (1959), 62–63, illus. p. 62; Luigi Salerno, *Salvator Rosa* (Milan, 1963), p. 140; Sherman E. Lee, "The Forest and the Trees in Chinese Painting," *National Museum Quarterly* [Taipei], 1 (October 1966), 5, pl. XVB; Fredericksen and Zeri (1972), pp. 117, 574; Salerno, *L'Opera completa di Salvator Rosa*, Classici dell'Arte, vol. 82 (Milan, 1975), no. 22, p. 86.

398

SALVATOR ROSA

176 Four Tondi:
A–D *Witches Scenes* 77.37–77.40

> Canvas, Diam. 54.5 cm (each).
>
> 176A Signed with monogram on large rock. 77.39
> 176B Signed with monogram on rock in lower right. 77.40
> 176C Signed with monogram on book in foreground. 77.38
> 176D Signed with monogram at lower right. 77.37
>
> Collections: Family of the Marchése Giovanni Niccolini, Florence; [Heim Gallery, London].
>
> Purchase from the J. H. Wade Fund, 1977.

All four tondi are in generally good condition, with only minor scattered abrasions. At some time in the past the paintings were cleaned incompletely; some areas of discolored varnish remain. Some of the retouchings are more extensive than would have been necessary.

The earliest published account of the four tondi was in 1677, by Bocchi and Cinelli, who had seen them in the palace of the Marchése Giovanni Niccolini in the Via dei Servi in Florence and described them as typical of the bizarre quality of Salvator Rosa's genius. The tondi were either commissioned or, more likely, acquired from the artist by Giovanni Niccolini's son Francesco, who had been minister of the Grandduke of Tuscany in Rome from 1621 to 1643 and had returned to Florence in 1644 (Salerno, 1978, p. 225, n. 4). Salerno (1963 and 1978) dates the tondi in the mid-forties, at the midpoint of Rosa's stay in Florence, from 1640 to 1649. They are closely related in style and in many details to the artist's other witchcraft scenes, the most important of which are the *Stregoneria* in the Palazzo Corsini, Florence (known in several versions by Rosa and others), and the *Witches' Sabbath* in the collection of Lord Spencer, at Althorp.

Of the *Witches Sabbath*, which represents a kind of anthology of the mechanisms of black magic (Salerno, 1978, p. 226), Rosa remarked in 1666 that he had painted it twenty years earlier—that is, in 1646. By comparison, the Cleveland tondi are much simpler, an indication that they may have been Rosa's first renderings of this subject. The circular shape of the paintings may have been consciously chosen by the artist not only because of the compositional challenge but also for symbolic purposes. The circle was a prerequisite for all rites of ceremonial magic; it served both to invoke magic power and to protect from it (Ross Alexander Coates, "The Influence of Magic on the Iconography of European Painting," Ph.D. dissertation, New York University, 1972, p. 70).

Rosa's poem, "La Strega," written about 1645–46 (published by Uberto Limentani, *Poesi e lettere inedite di Salvator Rosa*, Florence, 1950, pp. 48–50), contains much of the same imagery found in the Cleveland tondi. The poem and the paintings were inspired by ancient themes of black-magic revenge for unrequited love. Rosa was obviously

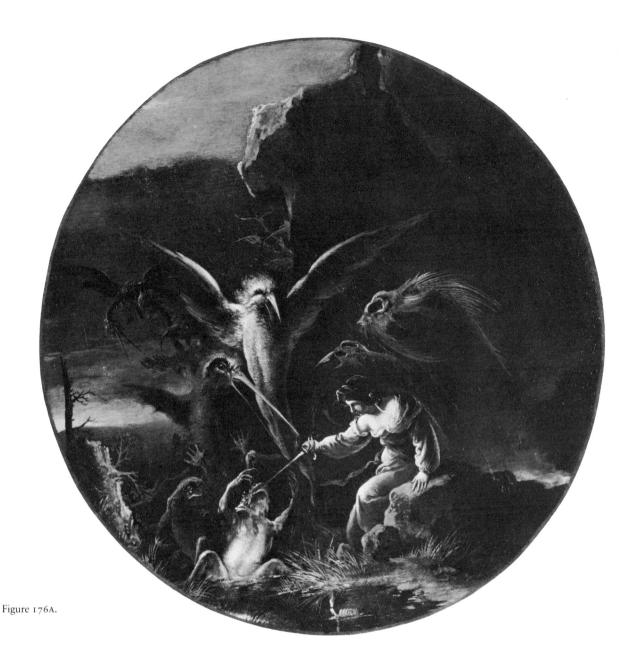

Figure 176A.

familiar with the well-known treatises on demonology and magic, foremost among them the *Malleus Malleficarum* (Salerno, 1978, p. 230, n. 18). The theme of love magic was also specifically treated by Rosa's friend Francesco Redi, a poet who, like Rosa, was inspired by such classics as Theocritus's second *Idyll*, Virgil's eighth *Eclogue*, and Horace's first and eighth *Satyre* (*ibid.*, p. 226).

The tondi, it seems, represent a progression in time from morning (176A), to day (176B), to evening (176C), to nighttime (176D)—each depicting an independent, unrelated scene.

The tondo whose setting is morning (176A) may be a fantasy based on Ovid's story of Circe (*Metamorphoses*, XIV), a popular subject in Italian art. The sharp-beaked birds may allude to Circe's reluctant lover Picus, son of Saturn, who was transformed by Circe into a woodpecker. Rosa also may have been inspired by the story of Simaetha and her lover Delphia as told by Theocritus (*Idyll II*); at one point in the story Simaetha bruises a lizard, an image that appears in two of the tondi (a toad in 176A and a lizard in 176B). According to James Hall's *Dictionary of Subjects and Symbols in Art* (London, 1974, p. 193), the lizard symbolizes logic, a branch of one of the seven liberal arts.

Rosa's Circe-like figure closely resembles Benedetto Cas-

399

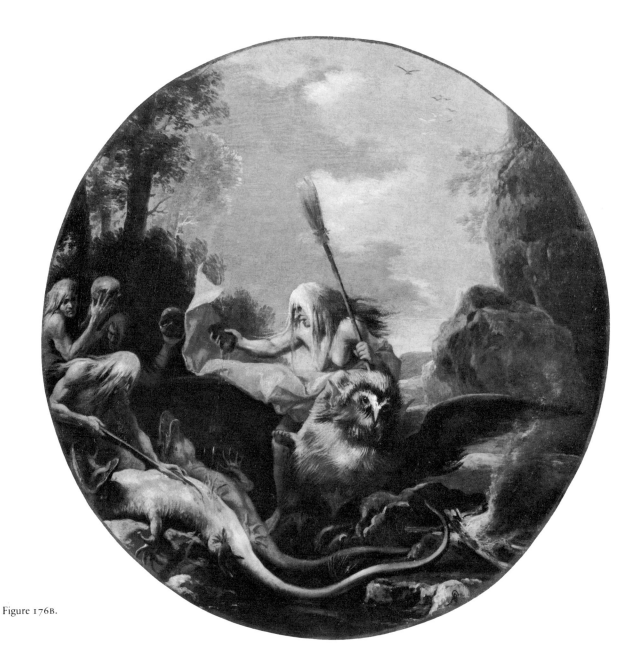

Figure 176B.

tiglione's *Sorceress* (sometimes called *Medea*), in the Wadsworth Atheneum, Hartford, which dates from the late 1650s to early 1660s. The *Sorceress*, in turn, is closely related to Castiglione's own *Circe* of ca. 1653 (Florence, Pitti Palace; Ann Percy, *Giovanni Benedetto Castiglione*, exh. cat., Philadelphia, 1971, p. 40, n. 127, illus. p. 32, fig. 20). The striking similarity in the poses of Rosa's and Castiglione's young sorceresses suggests a direct contact between the two artists, if not briefly in Florence in the mid-forties, certainly in Rome in the late 1640s to early 1650s (*ibid.*, p. 37).

The tondo set at midday (176B) shows a witch holding a broom in her hand and riding on an owl—a variation on a theme drawn from early sources of inspiration, such as Albrecht Dürer's woodcut of a witch riding a goat, or works of other artists whose witches ride skeleton birds (Salerno, 1978, p. 227, n. 13). Owls often appear in Rosa's paintings; their hypnotic eyes, like those of cats and snakes, were considered to be endowed with magic powers. A precedent for the owl and witch relationship is found in Apuleios's *The Golden Ass*, wherein a witch rubs herself with ointment and is transformed into an owl.

The two nocturnal tondi, one set at evening (176C) and the other in the midst of night (176D), depict witches' sabbaths and include the traditional paraphernalia of black

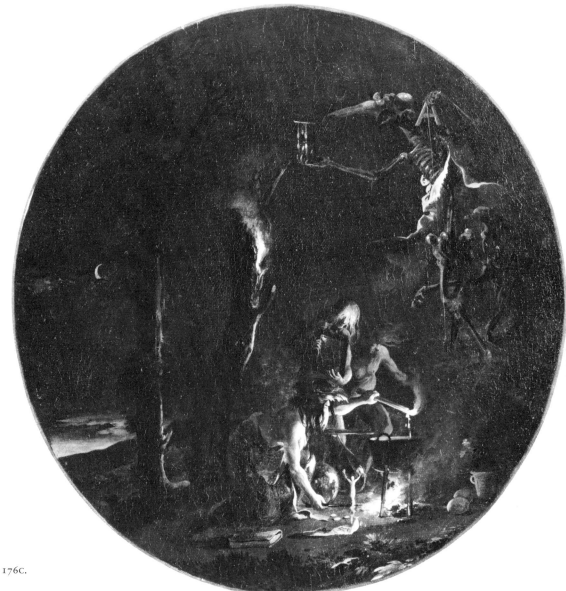

Figure 176C.

magic: the burning tree, to which Rosa refers in his poem, "La Strega" ("Let a cypress, let a myrtle burn"); the crystal ball; the wax statuette, which when stabbed by the witch is believed to actually affect a real person; and the Seal of Solomon, a five-point star drawn of interlaced triangles, which is seen on the sheet of paper in the foreground of the evening tondo. The group of witches around the cauldron (176C) anticipates a similar group in the Althorp *Witches' Sabbath* and is also reminiscent of the witches in Hans Baldung Grien's chiaroscuro woodcut of 1510. The large skeleton in this same tondo reveals Rosa's familiarity with the series of engravings by Filippo d'Angelo, especially his

"Gallo de India" series (Salerno, 1970, figs. 36 and 37). In the tondo set at night (176D), a warlock—somewhat reminiscent of Moses figures in art—tends to a boiling kettle while pointing with his traditional tool, the wand, toward some monstrous beasts, which seem based on sixteenth-century counterparts in Northern paintings. The composition of this scene before the bestial altar recalls Callot's worship of the goat (*Catalogue du l'oeuvre gravé de Callot*, II, Paris, 1927, illus. pl. 571), dating from ca. 1627.

Salerno (1975, fig. 82) drew attention to a small oval *Witches' Sabbath* that closely resembles the two nocturnal tondi in Cleveland. He (1975, fig. 80) also compared Rosa's

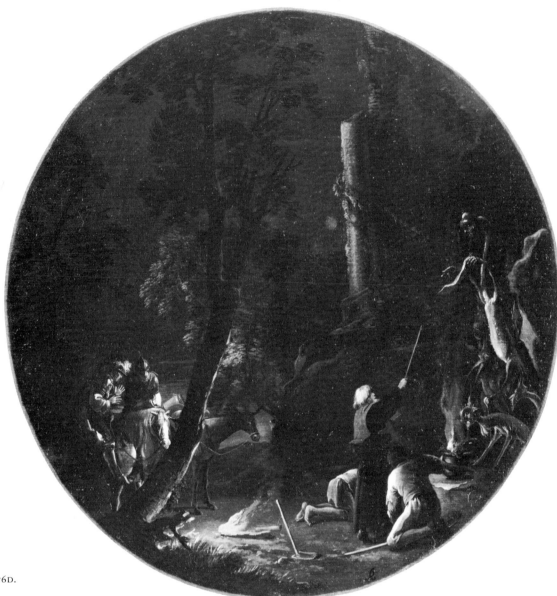

Figure 176D.

muscular witches in the Cleveland paintings with one of the same type shown consulting a book on black magic in a painting in the Pinacoteca Capitolina, Rome.

Rosa's figures in the Cleveland tondi mysteriously emerge from and disappear into their surrounding landscapes. Beautifully rendered with a freshness and intimacy that recalls Elsheimer's small landscapes on copper, Rosa's images of scary incantations are endowed with a romantic mood, which greatly appealed to nineteenth-century landscape painters.

Two copies (Figures 176a and 176b) of the tondi were shown at the exhibition Il Seicento Europeo in the Palazzo della Esposizioni in Rome in 1957 (cat. nos. 254a, b), on loan at the time from the collection of Busiri-Vici. According to Salerno, one other copy of the evening tondo appeared on the art market in Rome.

No known drawings are directly related to the four Cleveland tondi. There are two drawings by Rosa at the Metropolitan Museum of Art, one of which seems to be the first idea for his Corsini *Stregoneria*, and the other a preparation for a Witches' Sabbath. A third drawing, at Princeton (Michael Mahoney, *The Drawings of Salvator Rosa*, 1, New York, 1977, 336, no. 28.5), is a study for one of the figures in the *Witches' Sabbath* at Althorp. A T L

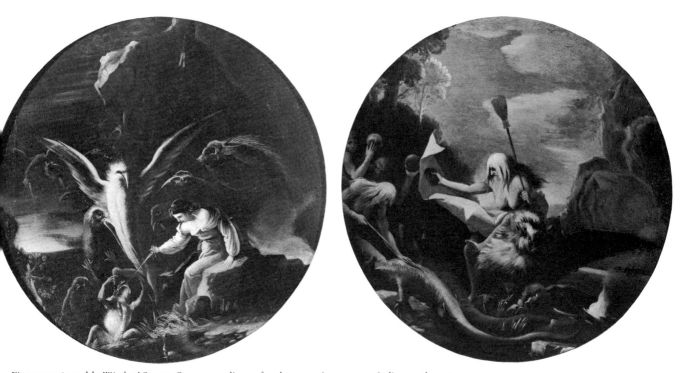

Figures 176a and b. *Witches' Scenes*. On canvas, diam. of each 53 cm. Anonymous, Italian, 17th century. Formerly Busiri-Vici Collection, Rome; present whereabouts unknown.

EXHIBITIONS: CMA, January 1978: Year in Review, cat. no. 42 (176A–D).

LITERATURE: Francesco Bocchi and Giovanni Cinelli, *Le Bellezze della citta di Firenze* (Florence, 1677), p. 408 (176A–D); Luigi Salerno, *Salvator Rosa* (Florence, 1963), pp. 39–42, 120, cat. no. 26, pl. 26 (176B); Salerno, "Il Dissenso nella pittura: Intorno a Filippo Napoletano, Caroselli, Salvatore Rosa e altri," *Storia dell'arte*, no. 5 (1970), 45, figs. 39–41 (176A,C,D); Helen Langdon, "Salvator Rosa in Florence 1640–1649," *Apollo*, C (1974), 195 (176A–D); Salerno, *L'Opera completa di Salvator Rosa*, Classici dell'Arte, vol. 82 (Milan, 1975), nos. 74–77 (176A–D), illus.; CMA *Handbook* (1978), illus. p. 138; Salerno, "Four Witchcraft Scenes by Salvator Rosa," CMA *Bulletin*, LXV (1978), 224–31, figs. 1–4 (176A–D) and 9–13, color illus. p. 223.

GIOVANNI BATTISTA SALVI
(called Sassoferrato)
1609–1685

Giovanni Battista Salvi was born in 1609 in Sassoferrato (in Umbria), the name by which he was later known. Little is known about the life and work of this painter. His one and only known large commission, *Madonna of the Rosary and Two Saints*, of ca. 1643, an altarpiece for the Dominican church of S. Sabina, had been donated by the Princess of Rossano and Borghese, wife of the nephew of Pope Innocent X, Camillo Pamfili (Joachim Joseph Berthier, *L'Eglise de Sainte Sabine*, Rome, 1910, pp. 313–15). Sassoferrato supposedly received his first training from his father. He left for Rome while still very young to study the works of Raphael and the Carracci. From Raphael he derived the format for many of his Madonna paintings; compare, for example, his *Madonna and Child* in Rome, Borghese Gallery, with Raphael's Mackintosh Madonna (National Gallery, London)—the prototype for the many small votive panels that were so popular during the Counter Reformation. That Sassoferrato's works also show the influence of Domenichino, whom he supposedly followed to Naples, is confirmed by his *Adoration of the Shepherds* (Museo e Galleria Nazionale di Capodimonte). Except for a visit to Venice in the 1660s, Sassoferrato spent most of his life in Umbria and Rome. He died in Rome in 1685.

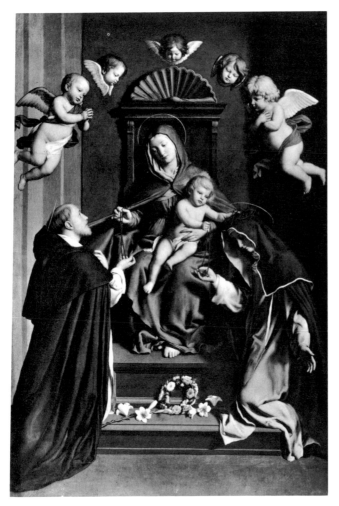

Figure 177a. *Madonna of the Rosary and Two Saints*. On canvas, 170.2 x 109.9 cm. Sassoferrato. Church of S. Sabina, Rome.

Figure 177b. *St. Catherine*. Drawing, 24.6 x 19 cm. Sassoferrato. Royal Library, Windsor Castle, England.

177 **St. Catherine of Siena** 66.332
*Receiving the Crown of Thorns and a
Rosary from the Christ Child*

Canvas, 74 x 84 cm.

Collections: Th. de la Noüe, Paris (sale: Hôtel Drouot, Paris, May 28, 1964, no. 12, as *Madonna of the Rosary* by Philippe de Champaigne); [Heim Gallery, Paris, 1966].

Mr. and Mrs. William H. Marlatt Fund, 1966.

The painting is in good condition. Grime and old varnish in the paint texture and mottled restorer's paint have given it a generally speckled appearance. Some areas of the painting have been abraded, revealing the underlying fabric threads. There is some lumpiness and there are planar distortions in what appear to be tears in the original support on the lower right quadrant.

In spite of the fact that the Cleveland painting was listed in the Hôtel Drouot sale in 1964 as *Madonna of the Rosary* by Philippe de Champaigne (Dorival, 1976, included it in his monograph on this painter under wrong attributions), it is, nevertheless, a typical work by Sassoferrato. A close compositional relationship exists between the Cleveland picture and Sassoferrato's Madonna and Child in the *Holy Family* (Ponce Museum). Because our picture is also closely dependent on the one documented altarpiece by Sassoferrato, *Madonna of the Rosary and Two Saints* (Figure 177a) in S. Sabina (the Cleveland painting faithfully repeats the figure of St. Catherine), it may be dated contemporarily, that is, ca. 1643.

There are three preparatory drawings for the major figures of the S. Sabina altarpiece: *St. Dominic*, in the Ashmolean Museum (Lurie, 1968, fig. 3); and the *Madonna and Child* (*ibid.*, fig. 4) and *St. Catherine* (Figure 177b), both at Windsor Castle. The *St. Catherine* obviously served for both the altarpiece and the partial replica in this Museum.

Sassoferrato made a few important changes in order to adapt the assisting figure of the large S. Sabina altarpiece to the format of this small votive image. He moved St. Catherine closer to the spectator, reduced her figure to half-length, and added paraphernalia to describe an interior. The saint is shown at prayer, kneeling in front of a table on which the Infant Christ (similar to the one in the S. Sabina altarpiece) appears, standing on her prayer cushion. Behind the Child's right shoulder a small portable crucifix appears in the darkness that engulfs the figures. As in the S. Sabina altarpiece, St. Catherine receives from the Christ Child the

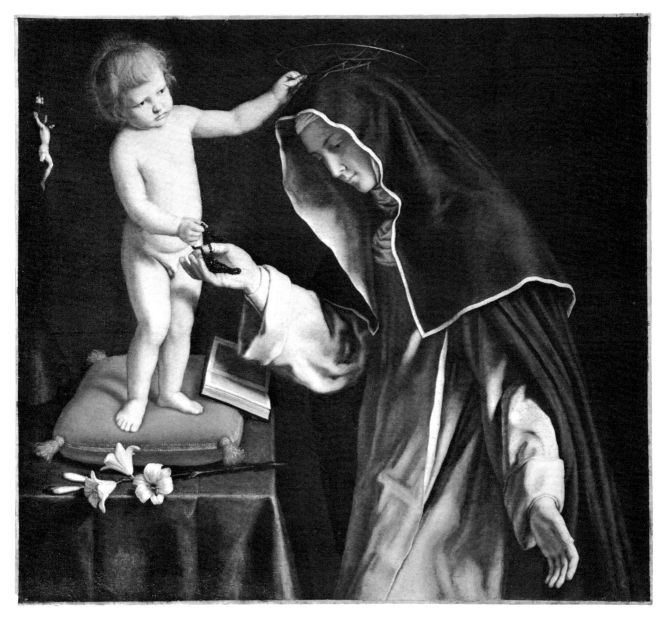

Figure 177.

crown of thorns, which she chose over the crown of gold, according to the legend, and which was pressed on her head until the thorns seemed to penetrate her brain. The lilies, too, are her symbols. By condensing the larger composition of the altarpiece and intensifying contrasts of light and dark, Sassoferrato created an image to evoke in the devout a visionary experience comparable to St. Catherine's own.

ATL

EXHIBITIONS: London, Heim Gallery, 1966: Summer Exhibition, Italian Paintings & Sculptures of the 17th & 18th Centuries, cat. no. 8, illus.; CMA, December 1967: Year in Review, cat. no. 67, illus.

LITERATURE: Ann Tzeutschler Lurie, "Two Devotional Paintings by Sassoferrato and Carlo Dolci," CMA *Bulletin*, LV (1968), 219–23, fig. 1; Fredericksen and Zeri (1972), pp. 184, 387, 574; Bernard Dorival, *Philippe de Champaigne 1602–1674: La vie, l'oeuvre, et le catalogue raisonné de l'oeuvre* (Paris, 1976), II, 392, no. 2082, pl. 2076; CMA *Handbook* (1978), illus. p. 137.

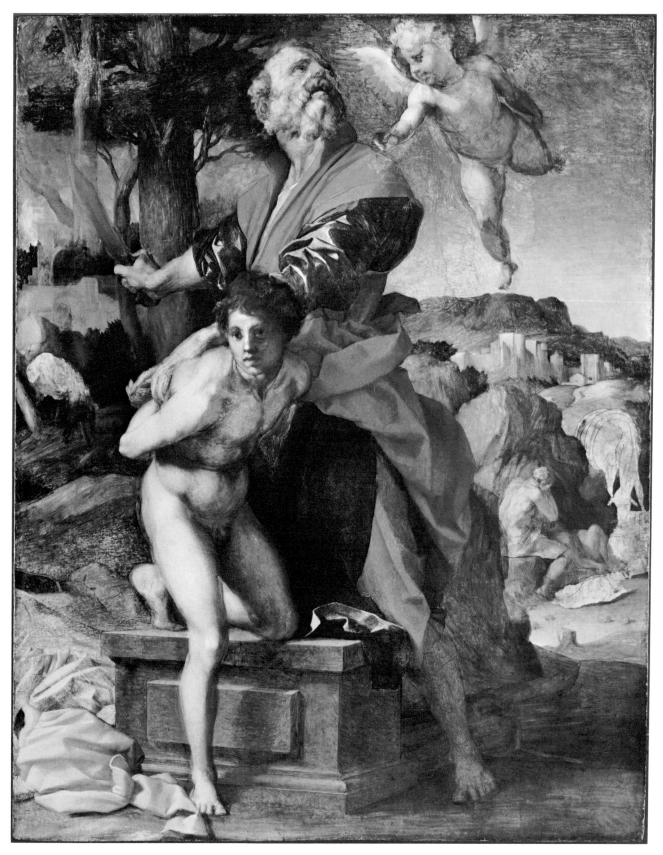

Figure 178.

406

ANDREA D'AGNOLO DEL SARTO
1486–1530

Andrea del Sarto was born in Florence in 1486, the son of Agnolo, a tailor. For a time he was erroneously called Andrea Vannucci, but Vannucci was not his family name. By 1506, after studying with Piero di Cosimo, he established an independent workshop with Franciabigio and later with the sculptor Jacopo Sansovino. He was acknowledged as an independent master by an entry dated December 12, 1508, in the guild of the "Medici e Speziali" in Florence. In about 1517 he married Lucrezia del Fede, who is said to have been the subject of several portraits. In May 1518 Andrea was invited by King Francis I to paint at the French court. He returned to Florence in October 1519, ostensibly to fetch his family, but he never went back to France. The rest of his life was spent in Florence, where he absorbed influences of Leonardo, Raphael, and Michelangelo. His paintings are now considered to be typically representative of classical High Renaissance painting and, at the same time, a starting-point for the development of the Mannerist style in Florentine art. Andrea del Sarto is the subject of two important monographs one by S. J. Freedberg and one by John Shearman (see Literature).

178 *The Sacrifice of Isaac* 37.577

Panel (poplar), 178.2 x 138.1 cm.

Collections: Cardinal Carlo de' Medici, Florence, 1649; Montalvi Collection, Florence; Peruzzi Collection, Florence; Zondadari Collection, Florence (see Biadi, 1829); William Cave (died 1858), Brentry House, near Bristol, bought in Florence in 1846; (sale: Christie's, London, June 29, 1854, no. 77, not sold); Mrs. Cave (sale: Christie's, London, June 29, 1854, no. 77, not sold); Mrs. Cave (sale: Christie's, London, June 22, 1858, no. 102, bought by Peters); George Cornwall Legh, High Legh, Co. Chester (according to Royal Academy exhibition catalogue, Winter 1882, no. 206, "purchased by George Cornwall Legh in 1862 at Florence; in the Tordanari collection"); Lieutenant Colonel Henry Cornwall Legh, High Legh, Co. Chester (sale: Sotheby's, London, May 21, 1935, to Spencer Samuels); [Spencer Samuels, T. Harris, London, and Durlacher Brothers, New York].

Delia E. and L. E. Holden Funds, 1937.

The painting is unfinished. The underdrawing is clearly visible, as are important pentimenti: in the position of the angel, the contours of Isaac, the painted-out form of a third figure in the group at the right, and in the trees at the left. Parts of the panel had been repainted (Francis, 1938, p. 40), but some of the repaint was removed in London before the Museum acquired the painting. A split in the panel extends vertically from the top of the pedestal through Abraham's arm. The painting was cleaned in 1976 in the Museum laboratory by Delbert Spurlock and Ross Merrill, who removed the darkened and yellowed varnish coating, old restorer's paint and accumulated grime. Small scattered areas

of cleavage were reattached, and losses were filled with colored wax. The wax coating on the back of the panel was removed, and two coatings of a solution of Saran resin were applied as a moisture barrier.

The Sacrifice of Isaac was commissioned ca. 1527 by Giovanni Battista della Palla as a gift (which was never sent) for Francis I of France. A comparative analysis of Andrea's three versions of this composition, together with studies of the pentimenti and preparatory drawings, indicates that the unfinished panel in Cleveland was the earliest (first pointed out by Francis, 1938), and was likely the first sketch. The definitive version in Dresden, Gemäldegalerie (Figure 178a)—the largest and only signed version, probably painted ca. 1527–29—went to della Palla, who was imprisoned in 1530 and died shortly thereafter (Freedberg, 1963, II, 146). A reduction of the Dresden version, painted ca. 1529 by Andrea, is in the Prado (no. 335; Shearman, 1965, II, no. 95). A replica of the subject was given by Napoleon to the museum in Lyons (no. 55) in 1811.

In the first half of the seventeenth century, both the Cleveland and Dresden versions of the *Sacrifice* belonged to

Figure 178a. *The Sacrifice of Isaac.* On panel, 213 x 159 cm. Sarto. Staatliche Kunstsammlungen Dresden, Gemäldedgalerie Alte Meister.

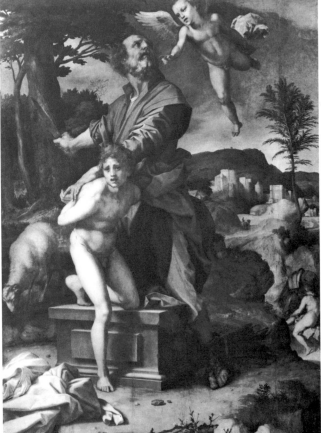

Cardinal Carlo de'Medici. Both were mentioned in a letter of October 26, 1649, to the Duke of Modena from his agent, Gemminiano Poggi, concerning an exchange of some of the Duke's pictures for some from the Medici collection (Venturi, 1882, pp. 256–57). The letter is so ambiguously styled that it is not clear whether both pictures were actually considered for exchange, or to which of them the agent was referring when he mentioned "the best of the Abrahams." That there were two pictures by Andrea of this subject in the Cardinal's collection is quite clear. One of them was a first sketch (*primo abbozo*); and we know that the other was the Dresden picture, for it is described, and its exchange noted, in the Medici inventories (Giovanni Poggi, "Cambi di quadri fra Firenze e Modena nel secolo XVII," *Rivista d'arte*, VIII, 1912, 45–51). The Dresden picture is also described, and Andrea's monogram signature noted, in an Estense inventory (Venturi, 1882, pp. 311, 313), before it entered the gallery of the Elector of Saxony in 1745.

Vasari (1568) tells of a sketch for the Dresden *Sacrifice* which so pleased one Paolo da Terrarosa that he ordered a

Figure 178*b*. *The Sacrifice of Isaac*. Giorgio Vasari (?), Italian, 1511–1574. Villa di Poggio Imperiale, Florence.

reduction of the Dresden picture. This reduced version (now in the Prado) looks like a composite of the Cleveland and Dresden versions; it therefore seems likely that the sketch referred to by Vasari is the painting now in Cleveland (Freedberg, 1963, II, 151, n. 11; Shearman, 1965, II, 269). Shearman (p. 281), too believes that Vasari must have seen the Cleveland version, for Vasari erroneously described the Dresden picture as having two nude figures in the background (Vasari, 1906 edition, V, 50), which is true of the Cleveland painting but not of the Dresden one. The Dresden painting has only one figure; the Prado painting has two figures, one nude and one clothed.

In Florence, at Poggio Imperiale, there is a copy (Figure 178*b*) after the Cleveland picture, which Shearman (1965, II, 269) and Härth (1959, p. 167, n. 2) believe to have been painted by Vasari in 1533. Freedberg (1963, II, 150) does not agree.

A hitherto unknown copy on canvas of approximately the same dimensions as the Prado version and apparently derived from it has been brought to our attention by its owner, A. Simkonas of Potts Point, Australia.

One other work, taken specifically from the Cleveland version (or possibly from a lost drawing for it), is the late seventeenth- to early eighteenth-century chalk drawing in Darmstadt (AE 2131, recto and verso), which, according to Shearman, is one of a group of pastisches after del Sarto. An attribution to Naldini, by Freedberg (1963, II, 151), is not convincing. (For further discussion of copies after versions, see Freedberg, 1963, II, 150–51, n. 15; and Shearman, 1965, II, 270, 281).

Preparatory drawings by Andrea for the Cleveland picture include a study for the seated youth in the background (in the Uffizi; 317F, recto) and (verso) a study for the drapery of Abraham. Other drawings by del Sarto support the belief of most art historians that the Hellenistic *Laocoön* group was a source of inspiration for the figure of Isaac in Andrea's *Sacrifice of Isaac*. A drawing (in the Uffizi; no. 339F) after the legs of a youth in the *Laocoön* group, probably taken from Bandinelli's copy or Marco Dente's engraving after the sculpture, is clearly reflected in the pose of Isaac. Even without the evidence of this drawing, however, the sculptural qualities and the pathos in Andrea's painting would point to the *Laocoön* as one prototype. Another drawing (in the Ashmolean Museum; no. 694), with a questionable attribution to Andrea, was obviously inspired by the head of Laocoön; it is less explicitly connected with the head of Abraham, although Freedberg calls this a study for the *Sacrifice*.

Other possibly related drawings include a study of a *putto* in the Uffizi (626E, verso), which Freedberg (1963, II, 148–49) convincingly associated with the Cleveland painting; Shearman (1965, II, 343), however, called it a study for the Passerini *Assumption* of 1526 in the Pitti Palace. The sketch on the recto has been connected with two works, the

408

altarpiece done for Becuccio Bicchieraio of Gambassi, of ca. 1527–28 (Freedberg, 1963, II, no. 70) and the *Assumption* commissioned by Margherita Passerini (Shearman, 1965, II, 343); both are close in date to the Cleveland *Sacrifice*, which Freedberg dates ca. 1527, and Shearman, ca. 1526–29.

In addition to the Laocoön group, other antique sculptures also have a possible relationship to the *Sacrifice*. The Hellenistic *Pasquino* group, as it appears in Cavalieri's engraving of 1511, may have been a basis for the relationship of the two figures and for the head of Abraham (Shearman, 1965, II, 270). And Michelangelo's *Rebellious Slave* of 1513 in the Louvre has much in common with the figure of Isaac, particularly in pose and muscularity.

To these ingredients—studies from life and reflections from antiquity—Andrea added a landscape taken from two Northern works (Härth, 1959). The trees on the left are from an engraving by Lucas van Leyden of the *Return of the Prodigal Son*; the buildings on the right are from a drawing (perhaps by Jacopo Sansovino, according to Shearman) after a Flemish *Pietà* of ca. 1520 in Berlin, Staatliche Museen (no. 630D).

There has been considerable speculation as to why del Sarto left the Cleveland panel unfinished. One strong possibility is that he was dissatisfied with the position of the angel, which is more successfully resolved in the two later versions. In its unfinished state, with underdrawing and pentimenti clearly visible, it shows the evolution toward the finished work in Dresden and the composite in the Prado, though neither of these equals the Cleveland painting in spontaneity and brilliance of execution. E F G and N C W

EXHIBITIONS: London, Royal Academy, Burlington House, 1882: Winter Exhibition, cat. no. 206 (lent by Colonel Henry Cornwall Legh); CMA (1936), cat. no. 65 (lent by Durlacher Brothers); CMA, 1971: Florence and the Arts, Five Centuries of Patronage, cat. no. 13, illus. (catalogue by Edmund P. Pillsbury).

LITERATURE: Giorgio Vasari, *Le Opere di Giorgio Vasari* (Florence, 1568; Milanesi ed., Florence, 1906), V, 52; Luigi Biadi, *Notizie inedite della vita d'Andrea del Sarto: Raccolte de Manoscritti, e documenti autentici* (Florence, 1829), p. 163, n. 2; Alfred von Reumont, *Andrea del Sarto* (Leipzig, 1835), p. 183, n. 1; Adolfo Venturi, *La Galleria Estense in Modena* (Modena, 1882), pp. 256–57; G. Redford, *Art Sales*, II (London, 1888), 251; H. Guinness, *Andrea del Sarto* (London, 1907), pp. 74–75; Graves (1914), III, 1198; Bernard Berenson, "Il Sacrifizio d'Abrama cambiato con un Quadro del Correggio," *Il Marzocco*, XXV (1930), 39; Henry S. Francis, "An Unfinished Version of the *Sacrifice of Abraham* by Andrea del Sarto," CMA *Bulletin*, XXV (1938), 39–42, illus. p. 37; Coe (1955), II, 216 no. 21; Isolde Härth, "Zu Andrea del Sartos 'Opfer Abrahams,'" *Mitteilungen des Kunsthistorisches Institutes in Florenz*, VIII (1959), 167, n. 2; Berenson, *Italian Pictures of the Renaissance: Florentine School* (London, 1963), I, 7; S. J. Freedberg, *Andrea del Sarto* (Cambridge, Massachusetts, 1963), I, figs. 179–184, pp. 77–79, and II, no. 66, pp. 146–51; Jaffé (1963), pp. 458, 460 (date 1519 is misprint for 1529); John Shearman, *Andrea del Sarto* (Oxford, 1965), I, 110–11, pls. 146, 148a and b, and II, no. 79, pp. 216, 281, 291, 336, 342, 361; *Selected Works* (1966), no. 140, illus.; Ralph T. Coe, "Rubens in 1614: The Sacrifice of Abra-

ham," *Nelson Gallery and Atkins Museum Bulletin*, IV (1966), 2, fig. 1; R. T. Coe "Rubens' *Sacrifice of Abraham*," *Art News*, LXV, no. 8 (1966), 38, fig. 3; Linda Murray, *The High Renaissance* (New York and London, 1967), p. 160, fig. 118; Fredericksen and Zeri (1972), pp. 8, 255, 573; *The Cleveland Museum of Art*, The Little Art Book, ed. Berthold Fricke (Hannover, 1975), p. 44, color illus.; CMA *Handbook* (1978), illus. p. 107; Rik Vos, *Lucas van Leyden* (Amsterdam, 1978), pp. 56–57, fig. 80.

ANDREA D'AGNOLO DEL SARTO

179 *Portrait of a French Lady* 44.92

Panel (poplar), 82.5 x 62.2 cm.

Collections: A. W. Young (sale: Christie's, London, February 26, 1910, no. 92; bought by Carfax, London); [Duveen, New York, by 1919, according to a letter of January 21, 1919, from Bernard Berenson to Lord Duveen of Millbank]; [James P. Labey and Glenn Hall, New York, 1920]; Mrs. Francis F. Prentiss, Cleveland, 1920.

The Elisabeth Severance Prentiss Collection, 1944.

Strongly discolored varnish and old restorations, especially in the shadows of the face and neck and in the sleeve ruffles, were removed and losses were retouched by William Suhr in 1954. Earlier—in 1938—small clusters of blisters (along the sitter's right shoulder and upward into the background, above the left shoulder, and near the bottom center of the painting) were laid down, and losses were filled in and retouched. Pentimenti are visible in the fingers of the sitter's left hand and the thumb of the right hand. Shearman (1965, II, 243) describes other pentimenti or possibly traces of old repairs, but these are not visible in an X radiograph taken in the Cleveland Museum laboratory in 1978.

Shearman (1965, I, 122, and II, 243) believed that del Sarto originally placed the subject behind a parapet, and that the hands, resting on the parapet, held a rectangular object, probably a book. With the removal of the supposed parapet, the figure acquired its alert, seated pose, which to Shearman prefigures what he called "the severely erect seated women" of Pontormo and Bronzino.

The book and parapet can be seen in a derivative portrait in the collection of the Earl of Normanton (see Shearman, 1960). Charles Sterling (*Italian Art and Britain*, exh. cat., London, 1960, pp. 51–52) attributes this work to Andrea Squazzella, who accompanied Sarto to France and was still working in Paris in 1537. Fritz Heinemann (letter of January 6, 1975) suggested that Squazzella was the painter of the Cleveland portrait as well.

The portrait, including the aristocratic French costume, seems to be reminiscent of Leonardo's court portrait of *Cecilia Gallerani* (Cracow, Czartoryski Museum). Del Sarto could have seen this portrait en route to France and therefore could have painted his *French Lady* during his stay at Fontainebleau, which would imply for the Cleveland portrait a date of 1518–19.

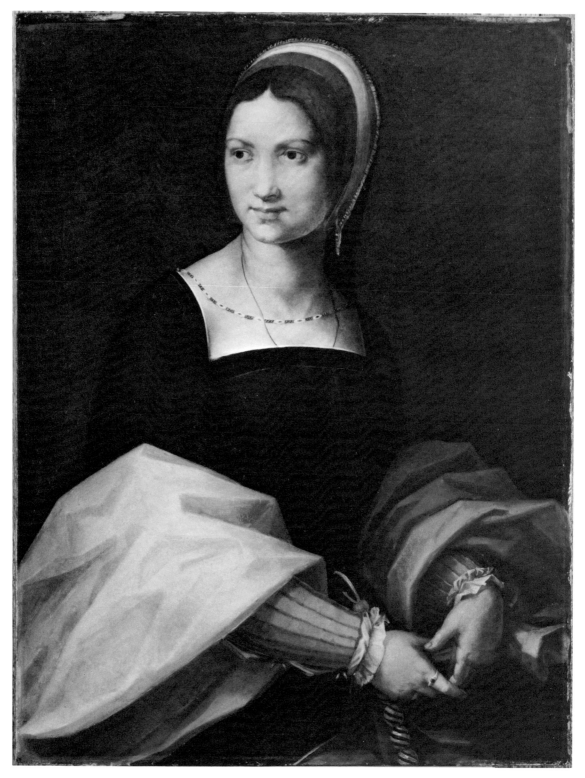

Figure 179.

Our painting is stylistically close to Andrea's *Charity*, in the Louvre, Paris, the only other known work from the artist's French sojourn. The Louvre *Charity* seems to reflect an exposure to Pontormo's Visdomini altar of 1518; the Cleveland portrait, too, suggests the possibility that Andrea was touched by that work, one of the first "major assertions of the style of Mannerism" (Freedberg, 1963, pp. 50–51). Other scholars visiting the Cleveland Museum (Anthony Blunt, 1956; E. K. Waterhouse, 1968; and Everett Fahy, 1971) have remarked on the Pontormesque qualities of the *French Lady*. One may speculate that Andrea, away from Florence, may have been remembering the portraits of his pupil Pontormo, as well as the latter's Visdomini altar (Luciano Berti, *Pontormo*, Florence, 1966, pls. XXXI, XXXV).

Although Freedberg (1963, pp. 50–51) accepts the possibility of Pontormo's influence on Andrea (Shearman does not), he rejects Andrea's authorship for the *French Lady*, attributing it instead to Pier Francesco Toschi (1502–1567) and comparing it especially to the latter's *Portrait of a Youth with a Garland of Flowers* (formerly in London, Thomas Agnew & Sons, as Pontormo). There is a superficial resemblance in the pose and position of the hands, but otherwise the comparison seems remote. EFG

EXHIBITIONS: CMA (1936), cat. no. 164, pl. XXXIV.

LITERATURE: *Arundel Society Portfolio* (London, 1910), pl. V; Joseph Arthur Crowe and Giovanni Battista Cavalcaselle, *A History of Painting in Italy* (London, 1914), VI, 181, n. 1; Bernard Berenson (1932), p. 17; L. Venturi (1933), III, pl. 453; Berenson, *Pitture italiane del Rinascimento* (Milan, 1936), p. 15; *Prentiss Collection Catalogue* (Cleveland, 1944), p. 10, no. 14, pl. II; Henry S. Francis, "Paintings in the Prentiss Bequest," *CMA Bulletin*, XXXI (1944), 88, illus. p. 94; John Shearman, "Three Portraits by Andrea del Sarto and His Circle," *Burlington Magazine*, CII (1960), 62, fig. 13; Sylvie Béguin, "Le 'Maître de Flore' de l'Ecole de Fontainebleau," *Art de France*, I (1961), 304; Berenson, *Italian Pictures of the Renaissance: Florentine School* (1963), I, 7, and II, pl. 1384; S. J. Freedberg, *Andrea del Sarto: Catalogue Raisonné*, II (Cambridge, Massachusetts, 1963), pp. 220–21; (as by Toschi; erroneously gives J. S. W. Erle Drax as ex collection); Jaffé (1963), p. 460; Shearman, *Andrea del Sarto* (Oxford, 1965), I, 77, 121–23, pl. 70b, and II, no. 53, pp. 243–44; Iris H. Cheney, review of S. J. Freedberg's *Andrea del Sarto*, in *Art Bulletin*, LIII (1971), 533; Edmund P. Pillsbury, *Florence and the Arts, Five Centuries of Patronage* (Cleveland, 1971), p. 55; *Dizionario*, I (1972), 128; Fredericksen and Zeri (1972), pp. 8, 530, 574.

GIOVANNI GIROLAMO SAVOLDO
Ca. 1480–after 1548

Savoldo, a Lombard painter from Brescia, northern Italy, was entered as a painter in the Medici Academy in Florence in 1508. Though he lived most of his life in Venice, he may have lived in Milan between 1532 and 1535. The earliest undisputed work by Savoldo is the altarpiece *Madonna and Child between Saints and a Musician Angel* in the church of S. Niccolo in Treviso, which he is recorded to have finished in 1521. The painting *Nativity with Donors* in Hampton Court is signed and dated 1527. He also executed altarpieces at S. Maria in Organo, Verona (1533), and S. Giobbe, Venice (1540). A letter written by Pietro Aretino in 1548 (*Lettere*, V, Paris, 1609) indicates that Savoldo was then still alive but declining.

180 *The Dead Christ with Joseph* 52.512
 of Arimathea

Panel (poplar), 105 x 191.8 cm.
Collections: Prince Liechtenstein, Vienna; [Frederick Mont, New York].
Gift of Hanna Fund, 1952.

The painting is in generally good condition except for repairs along the horizontal joints of the original panels. A heavy wax layer was removed in the Museum laboratory in 1976, and a Saran resin solution was applied in an effort to reduce the shrinking and swelling of the panels due to humidity and temperature change. Old losses along the two horizontal joints were inpainted at that time. Pentimenti are discernible in Christ's knee, which was originally raised higher, and in the arm of Joseph of Arimathea, which was stretched further to the right.

The attendant donor figure has been variously identified as Nicodemus, Joseph of Arimathea (Stechow, 1964), and even God the Father (Suida, 1903). Since its earliest documentation in the 1873 inventory of the Liechtenstein collection, this painting has been universally attributed to Giovanni Girolamo Savoldo. There have been differences of opinion concerning the date of this Pietà, but it is generally agreed that it is an early work of ca. 1524–27. Creighton Gilbert (letter of December 9, 1953) thought it should be placed toward the end of that period, closer to 1527. Gamba (1939) dates it as late as 1545, perhaps because he compares its spirit and iconography to Baccio Bandinelli's sculpture group made for the tomb in SS. Annunziata in Florence (now in S. Croce).

This Pietà is all that survives of the upper register of an altarpiece, part of a large formal altar then traditional in Venice. Many art historians have pointed out the emotional impact of this scene in which the pathos is intensified by the absence of other narrative detail. One precedent for a two-figure Pietà in the upper register of an altarpiece is Palma

Figure 180.

Vecchio's triptych of St. Barbara in S. Maria Formosa, Venice. Palma's Pietà is less forceful and is smaller in proportion to the rest of the altar, but it may have served as a prototype for Savoldo's work. Palma's Pietà has been dated ca. 1512–15 by Fasolo (1940) and ca. 1522–23 by György Gombosi (*Palma Vecchio, des Meisters Gemälde und Zeichnungen*, Stuttgart and Berlin, 1937, p. 85). Another earlier example of a two-figure Pietà, dated ca. 1515–20, is by the Ferrarese painter Giovanni Battista Benvenuti (called l'Ortolani): the *Dead Christ and Nicodemus*, formerly in the Achillito Chiesa collection in Milan and now in the Samuel H. Kress Collection, Honolulu Academy of Arts (Roberto Longhi, *Officina Ferrarese*, Florence, 1956, p. 75, pl. 241).

The Museum painting was the result of the artist's earlier experimentation with the subject matter; its iconography represents a distillation of at least two earlier versions. A progressive reduction of detail can be observed in their chronological sequence. The first was the *Deposition* (Boschetto, 1963, pl. 19), formerly in the Kaiser Friedrich Museum in Berlin and destroyed in 1945. The second, a *Pietà* (whereabouts unknown; illus. in Creighton Gilbert, "Savoldo's Drawing Put to Use, A Study in Renaissance Workshop Practices," *Gazette des Beaux-Arts*, XLI, 1953, 6, fig. 1), concentrates on the subject itself; only three figures attend Christ, and the landscape background is characterized by a lack of detail and depth. Savoldo may have used the same model for one of the donor figures in each of these two paintings. Of the three works, the Cleveland panel is both the simplest compositionally and the most poignant.

NCW

EXHIBITIONS: None.

LITERATURE: *Katalog der fürstlich Liechtensteinischen Bildergalerie im Gartenpalais der Rossau zu Wien* (1873), no. 21, p. 3; Bernard Berenson, *Venetian Painters of the Renaissance* (1897), pp. 124, 162 (1907 ed., p. 130); Wilhelm Suida, *Wien, Moderner Cicerone*, Vol. II (Stuttgart, 1903), p. 79; K. J. Hoess, *Die Fuerstlich Liechtensteinischen Kunstsammlungen in Wien* (1906), p. 42, illus. no. 5; J. A. Crowe and G. B. Cavalcaselle, *History of Painting in North Italy* (London, 1912), III, 319; David Preyer, *The Vienna Galleries* (Boston, 1912), p. 218; Roberto Longhi, "Cose bresciane del'Cinquecento," *L'Arte*, XX (1917), 113; Sergio Ortolani, "Di Gian Girolamo Savoldo," *L'Arte*, XXVIII (1925), 169; Adolfo Venturi, *A Short History of Italian Art* (New York, 1926), p. 310, illus. p. 309; Adolf Kronfeld, *Führer durch die Fürstliche Liechtensteinische Gemäldegalerie in Wien* (Vienna, 1927), no. 849, pp. 168–69; Longhi, "Due dipinti inediti di G. G. Savoldo," *Vita Artistica*, II (1927), 75; A. Venturi (1928), IX, pt. 3, 758, fig. 511; Longhi, "Quesiti Caravaggeschi: I precedenti," *Pinacotheca*, I (1928–29), 292, fig. 39; Suida, in Thieme-Becker XXIX (1935), 510; Suida, "Giovanni Girolamo Savoldo," *Pantheon*, XIX (1937), 50; Carlo Gamba, "Pittori bresciani del Rinascimento: Gian Girolamo Savoldo," *Emporium*, LXXXIX (1939), 388; Giusta Nicco Fasola, "Lineamenti del Savoldo," *L'Arte*, XLIII (1940), 68, fig. 11; Rodolfo Pallucchini, *La pittura veneziana del Cinquecento*, I (Novara, 1944), p. LXI; Creighton E. Gilbert, "Milan and Savoldo," *Art Bulletin*, XXVII (1945), 125–27, fig. 5; Suida, *The Samuel H. Kress Collection in the Honolulu Academy of Arts* (Honolulu, 1952), p. 42; Henry S. Francis, "The Liechtenstein *Pietà* by Savoldo," *CMA Bulletin*, XL (1953), 119–21, illus. p. 115; Gilbert, "The Works of Gerolamo Savoldo" (Ph.D. dissertation, New York University, 1955), p. 166; Berenson (1957), p. 158; Milliken (1958), illus. p. 34; Jaffé (1963), p. 457; Antonio Boschetto, *Giovan Gerolamo Savoldo* (Milan, 1963), pp. 41–44, pl. 20; Wolfgang Stechow, "Joseph of Arimathea or Nicodemus?" *Studien zur toskanischen Kunst: Festschrift für Ludwig Heinrich Heydenreich zum 23. März 1963* (Munich, 1964), pp. 297–98, fig. 8; Alessandro Ballarin, *Gerolamo Savoldo*, I Maestri del colore, no. 116 (Milan, 1966), p. 166, pl. IV; John Pope-Hennessy, *The Portrait in the Renaissance* (Washington, 1966), pp. 296–97, fig. 327, p. 327 n. 50; Fredericksen and Zeri (1972), pp. 184, 358, 574; Carlo Volpe, "Annotazioni sulla mostra Caravaggesca di Cleveland," *Paragone*, XXIII, pt. 1, no. 263 (January 1972), 59; *Dizionario*, X (1975), 185; Irving Lavin, "The Sculptor's 'Last Will and Testament,'" *Allen Memorial Art Museum Bulletin* [Oberlin College], XXV, nos. 1–2 (1977–78), 34–35, fig. 29, 36 n. 35; CMA *Handbook* (1978), illus. p. 111.

COSTANTINI DE' SERVI
1554–1622

Costantini de' Servi—painter, sculptor, and architect—was born in Florence in 1554. He studied painting with Santi di Tito, a Florentine mannerist painter (1536–1603), and he admired and copied the paintings of the Netherlandish painter Frans Pourbus. He painted in Naples and traveled extensively. In England he designed buildings and machines for the Prince of Wales. He spent time in Holland working for Count Maurice of Nassau. Later, when he was in Florence, he sent a model for a building to The Hague. Rudolf II patronized him and gave him a title of nobility. He traveled in Spain and spent the year 1609 in Persia. All of his journeys were sanctioned by Cosimo II of Florence, who employed him as his director of public works. He is probably best known as the sculptor of the bronze statue of St. Paul on the column of Marcus Aurelius in Rome, executed in 1585. He died in Lusignano in 1622 (G. K. Nagler, *Neues allgemeines Künstlerlexikon*, XVIII, Linz, 1911, 306).

Figure 181.

181 *Madonna and Child* 71.278

Tondo (poplar), Diam. 84.8 cm. Signed on rock at lower center:
OPS·DE/COSTA/NTINI/DESE/RVIS.

Collections: Mrs. Charles H. Bulkley, Cleveland, 1880s; Mr. and
Mrs. Robert J. Bulkley, Cleveland; [Adams, Davidson and
Company, Washington, DC, 1968].

Gift of Mr. and Mrs. Preston H. Saunders in Memory of Senator
Robert J. Bulkley, 1971.

The panel has a horizontal warp of 3.8 centimeters. It was
cleaned when it was on the art market in 1968. It is in
generally good condition, with a few scattered losses. The
tondo is most interesting from a conservator's point of view;
an X radiograph (Figure 181*a*) shows that it is painted on
top of an earlier, fifteenth-century Florentine or Umbrian
painting, the subject of which is an adoring Madonna with
the Christ Child and St. John, set in a landscape with hills
and a winding river. Costantini de' Servi turned the tondo
forty-five degrees and painted his *Madonna and Child* over
it, with no gesso ground in between. The ridges of the lower
paint surface are visible in a raking light.

This painting was incorrectly attributed to the Perugian
painter Eugenio di Giulio Costantini, who died in 1583
(*Connoisseur*, 1968; CMA *Bulletin*, 1972). The author is
indebted to Ulrich Middledorf (letter dated May 31, 1977)
for deciphering the signature at the bottom of the panel.
Middledorf also suggested that the Museum painting stylis-
tically resembled the miniature painting of Bernard Buonta-
lenti delle Girandole (1536–1608), a Florentine architect,
painter, and sculptor, who studied with Giorgio Giulio
Clovio. Everett Fahy (letter dated January 21, 1977) pointed
out that the composition of the *Madonna and Child* is de-
rived directly from the *Madonna del Sacco* by Andrea del
Sarto, in the cloister of SS. Annunziata in Florence.

This is the only known painting by this artist. It exempli-
fies the late mannerist—and in this case somewhat provin-
cial—style of the last decade of the sixteenth century and
the first decade of the seventeenth century in Florence.
 NCW

EXHIBITIONS: None.

LITERATURE: *Connoisseur*, CLXIX (December 1968), p. lxxx, illus.;
CMA *Bulletin*, LIX (1972), 157.

School of IL SODOMA
(Giovanni Antonio Bazzi)
Early sixteenth century

Il Sodoma was born in Vercelli in 1477. He was a pupil of
Giovanni Spanzotti (ca. 1450–1526/28) for seven years,
from 1490 to 1497. He was very much influenced by Leo-
nardo's Milanese work. Il Sodoma went to Siena, probably
in 1500, and remained there for the greater part of his life.
In Siena he came under the influence of Perugino, Fra Bar-
tolommeo, and Raphael. He was in Rome twice, once
about 1508, when he was working in the Vatican, and
again in 1513, when he was working at the Farnesina for
Agostino Chigi. His early work shows talent and great po-
tential, but his occasional ambiguity and the uneven quality
of his painting are not altogether pleasing. According to
Giorgio Vasari, Il Sodoma experienced an early decline. He
died in Siena in 1549.

Figure 181*a*. X radiograph showing underpainting.

Figure 182.

182 *The Crucifixion* 16.786

Canvas, 59 x 47 cm.

Collections: James Jackson Jarves; Mrs. Liberty E. Holden, Cleveland, 1884.

Holden Collection, 1916.

This little canvas was cleaned by Joseph Alvarez in the Museum laboratory in 1960. The paint film is in fair condition, with some general rubbing throughout, particularly in the landscape background. The painting is lined.

This *Crucifixion* has been generally attributed to the School of Sodoma. However, Bernard Berenson (1932) calls it an early work of Andrea del Brescianino of Siena (ca. 1507–after 1525); whereas Venturi (1931) says it is by Sodoma himself, calling it the most charming of all his early works.

The Cleveland *Crucifixion* shows influences from three other paintings by Sodoma and probably dates between the second and third. The earliest, dated 1501, is the *Crucifixion* in Montalcino, Museo d'Arte Sacra (first published and accepted as Sodoma by Enzo Carli, *Mostra delle opere di Giovanni Antoni Bazzi detto Il Sodoma*, exh. cat., Vercelli, 1950, pl. 1; see also John Pope-Hennessy, "A Sodoma Exhibition," *Burlington Magazine*, XCII, 1950, 326, where he says it is the earliest surviving work by Sodoma). Another *Crucifixion*, this one dated ca. 1503 (Carlo Brandi, *La Regia Pinacoteca di Siena*, Rome, 1933, pp. 290–91) like the Cleveland painting, has an isolated group of two figures supporting the swooning Mary in the foreground. The latest of this trio of paintings is the *Deposition* (in Siena, Pinacoteca; no. 413). The Cleveland Museum painting, although less pretentious and less formal, reflects Sodoma's style of this same early period. N C W

EXHIBITIONS: Boston (1883), cat. no. 449; New York (1912), cat. no. 13; CMA (1916), cat. no. 36; CMA (1936), cat. no. 105.

LITERATURE: Jarves (1884), no. 38, p. 14; M. L. Berenson (1907), p. 3; Rubinstein (1917), no. 37; Adolfo Venturi, *North Italian Painting of the Quattrocento*, Vol. I: *Lombardy, Piedmont, Liguria* (New York and Florence, 1931), 83, 105; Bernard Berenson (1932), p. 112 (as Andrea del Brescianino); B. Berenson, (1968), I, 65 (as Brescianino); Fredericksen and Zeri (1972), pp. 36, 294, 573 (as Brescianino).

FRANCESCO SOLIMENA
(called L'Abate Ciccio)
1657–1747

Solimena was a painter, architect, poet, and musician who was born in Canale di Serino. He was first apprenticed to his father, Angelo Solimena, for two years. He then left for Naples in 1674 to study with Francesco di Maria (1623–1690). In Francesco's workshop he collaborated with the still-life painter Giuseppe Recco, and it was there that he met Luca Giordano, whose influence on his work did not diminish until Giordano left for Spain in 1692. After Giordano's departure Solimena became the leader of the Neapolitan Baroque.

Solimena's dark, smoky shadows and his preference for dramatic twilight are stylistic ties with Mattia Preti. In his mature work, under the influence of the classical baroque painters, he tended toward a greater calm in his compositions and poses. Solimena was lavishly patronized by the Church in and outside of Naples; and although he rarely left his native region, he received commissions from many courts in Europe. Among his greatest admirers were the viceroys of Austria—Count Daun and Count Harrach—whose ascendancy followed the Spanish domination of Naples after 1707.

183 *The Risen Christ Appearing* 71.63
to His Mother

Canvas, 222.5 x 169.5 cm.

Collections: Unidentified church in France (sale: Palais des Congrès, Versailles, May 24, 1970 [withdrawn], fig. D, as Spanish School, seventeenth century, *La Résurrection*); [Heim Gallery, Paris, London].

Mr. and Mrs. William H. Marlatt Fund, 1971.

The painting was cleaned in London before it came to the Museum. Under infrared light small scattered retouches could be seen in the robe of the Madonna; otherwise, the painted surface is in excellent condition.

Ferdinando Bologna (1958), who first published the Cleveland painting, expressed doubts that the subject was a traditional *Noli me tangere* ("touch me not"), the words of the Risen Christ when he appeared to Mary Magdalene. Instead, Bologna suggested it was the Apparition of Christ to Saint Orsola Benincasa (1547–1618), a Neapolitan and founder of the congregation of the Theatines who had a vision of the Risen Christ in 1584. More likely, however, the painting represents the Risen Christ appearing to his Mother, a popular subject of Counter-Reformation paintings after its incorporation in the *Spiritual Exercises* of Ignatius of Loyola (Lurie, 1972, pp. 222–25). This interpretation is supported by the nineteenth-century inscription on the back of the painting (which includes an improbable attribution to Murillo):

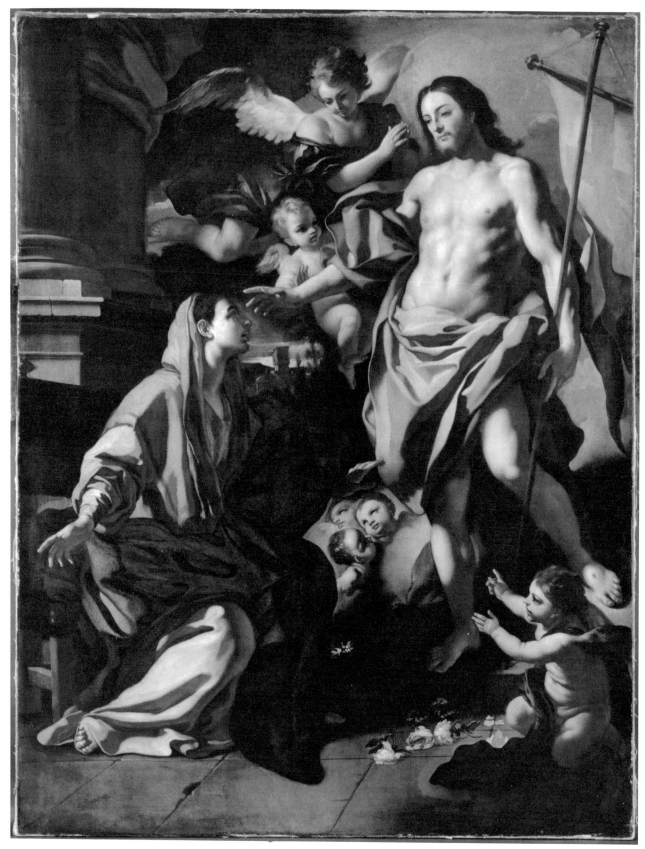

Figure 183.

Tableau du maître Murillo Bartolomé Esteban (Ecole Espagnol)—La Ressurèction de Jésus qui apparait a la mère. Les anges annoncent à Marie 'riène du ciel réjouis toi ton fils a réssucité.' Il fait encore sombre et le jours va se lever au destin de la vie. Murillo Bartolomé Esteban, née a Seville 1617–1689.

Solimena may have been familiar with other paintings of this subject, particularly one by Guercino (Pinacoteca Civica in Cento) and another by Guido Reni (now lost, formerly Dresden, Gemäldegalerie; see Figure 183a). Richard Spear (orally, 1973) added another possibility, a version by Domenichino, painted in Naples ca. 1635 (now in Genoa, Palazzo Almazzo-Pallavicini). Guido Reni's composition is reversed, as if from a print, in Solimena's work; and the vivacious gestures of Guercino's and Domenichino's figures contrast with the measured calm of Solimena's canvas. But such restraint in composition and gesture is characteristic of a documented painting by Solimena of ca. 1707–8, *Juno, Io, and Argus* (Dresden, Gemäldegalerie), and another work, *Rebecca and Eliezer* (Venice, Accademia). Because these share similarities with the Cleveland painting, it is plausible to date the three contemporaneously, that is, ca. 1708.

In a letter written August 30, 1708 (Caravita, 1869–70, pp. 384–87), Solimena stated that while he painted the *Juno, Io, and Argus,* for Canal, he was also working on a "quadrone" for a certain Padre don Fortunato, a friend of Canal's. Bologna (1958), seeing the obvious stylistic resemblance between the *Juno* and the Cleveland painting, suggested that our picture might have been the other work to which Solimena referred in his letter.

Solimena's *Madonna and Child,* commissioned by Count Harrach around 1730 (Figure 183b), has a Madonna—this one in full view—very similar to the one in the Cleveland painting. A copy of the Harrach *Madonna* is in the Niccolini collection in Carmignano. ATL

EXHIBITIONS: London, Heim Gallery, 1971: Fourteen Important Neapolitan Paintings, cat. no. 9, color illus.; CMA, December 1971–January 1972: Year in Review, cat. no. 55.

LITERATURE: B. de Dominici, *Vite dei pittori, scultori, e architetti napolitani* (Naples, 1742–44; reprint, Naples, 1840–46), p. 428; A. Caravita, *I Codici e le arti a Montecassino*, III (Montecassino, 1869–70), 384–87; Ferdinando Bologna, *Francesco Solimena* (Naples, 1958), pp. 189, 252; Theodore Crombie, "From Nuremberg to Naples," *Apollo,* n. s. CXIII (1971), 507; *La Chronique des Arts,* no. 1237 (1972), p. 87, no. 305, illus.; Ann Tzeutschler Lurie, "An Important Addition to Solimena's Oeuvre," CMA *Bulletin,* LIX (1972), 217–27, figs. 1, 5, 7, 11, and color cover; *La Chronique des Arts,* no. 1252–53 (1973), p. 8; Edward J. Olszewski, "A Rediscovered Holy Family by Francesco Trevisani," CMA *Bulletin,* LXIV (1977), 27–28, fig. 3, p. 36a n. 5; CMA *Handbook* (1978), illus. p. 140.

Figure 183a. *The Risen Christ and His Mother.* On canvas, 322 x 199 cm. Guido Reni. Formerly Gemäldegalerie, Dresden; destroyed during World War II.

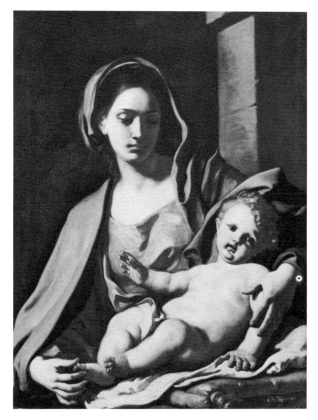

Figure 183b. *Madonna and Child.* On canvas, 99 x 76 cm. Solimena. Collection of Count Harrach, Castle Rohrau, Austria.

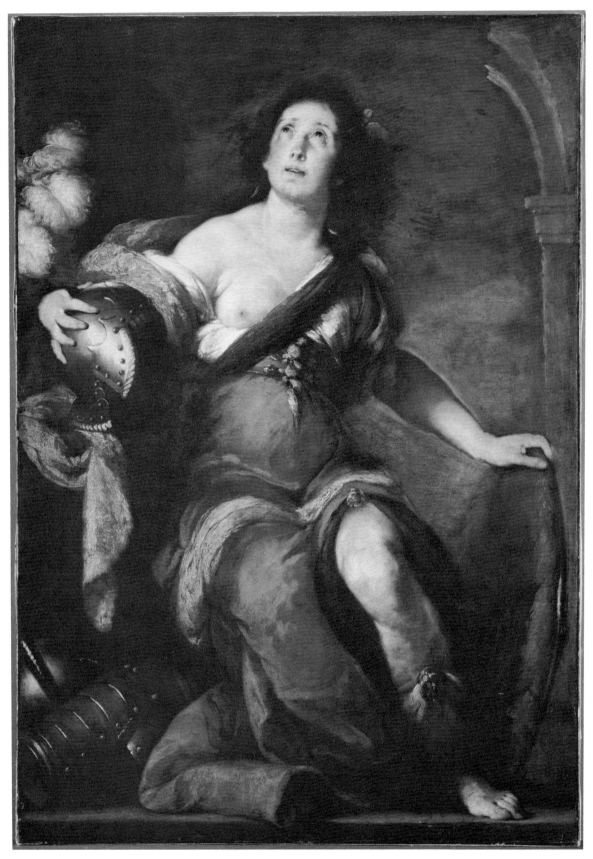

Figure 184.

BERNARDO STROZZI
1581–1644

Raffaello Soprani's *Le Vite dei pittori scultori e architetti genovesi a de forestieri che in Genova operarono* (Genoa, 1674) contains the first, and still informative biography of Bernardo Strozzi (called Il Prete Genovese), who was an influential figure in Genoese and Venetian baroque painting in the first half of the seventeenth century. His style owes much to Rubens and to the followers of Caravaggio—Saraceni, for one, or possibly Orazio Gentileschi, who was in Genoa at the same time as Strozzi—and certainly to Hendrick Terbrugghen, who lived in Italy between 1604 and 1614. After his father's death in 1596/97, Strozzi studied with the Sienese painter Pietro Sorri (then working in Genoa). About 1598 Strozzi became a Capuchin monk; ten years later he left the monastery to become a prelate. To support his family, he continued painting in Campi, a small village near Conegliano, where he came under the influence of the Tuscan Mannerists and the paintings of Federico Barocci (1526–1612), Giulio Cesare Procaccino (1574–1625), and Il Cerano (Giovanni Battista Crespi, 1575–1633). After the death of his mother in 1630, he refused to return to the monastery; he became embroiled in a controversy with his immediate superiors and the Pope and was apparently jailed for a time. He escaped, and early in 1631 he moved to Venice, where in 1635 he became a monsignor. He lived in Venice until his death in 1644. His pupils were Giovanni Andrea de Ferrari (1598–1669) and Antonio Travi (1608–1665) in Genoa, and Armanno Stroiffi (1616–1693) in Venice.

184 *Minerva* 29.133

> Canvas, 147.3 x 101.6 cm.
> Collections: [Italico Brass, Venice].
> Gift of Friends of The Cleveland Museum of Art, 1929.

The early history, provenance, and previous restoration records of this painting are unknown. Except for somewhat yellowed varnish and very minor, scattered retouches in the past, the painting is in excellent condition.

Although Lionello Venturi (1933) believed that this painting was executed during the last years that Strozzi was in Genoa, other art historians have generally agreed that it dates from Strozzi's Venetian period. During his late Venetian years Strozzi's Genoese style (with a great deal of influence from Rubens) reached fruition with the full-blown assimilation of Venetian Renaissance forms and rich color. *Minerva* follows the *Allegory of Sculpture* of 1635, now in Venice, Biblioteca Marciana (Mortari, 1966, pl. 341), and is closely related to other late works such as the *Allegory of Summer and Autumn* in Dublin, National Gallery of Ireland (*ibid.*, pl. 439); the *Annunciation* in Budapest, Museum of Fine Arts (*ibid.*, pl. 433); the *David* in Rotterdam,

Boymans-van Beuningen Museum (*ibid.*, pl. 441); the *Allegory of Painting, Sculpture, and Architecture* in Leningrad, The Hermitage (*ibid.*, pl. 413); and the drawing, *Head of a Woman*, in the Robert and Bertina Suida-Manning collection (*ibid.*, pl. 475).

Bertina Suida-Manning (Exh: 1965) questioned whether the subject is Minerva, the Roman counterpart of Pallas Athene, the goddess of wisdom. She thinks instead that the figure represents Bellona, the goddess of war and the sister of Mars—although, she admits, Strozzi has given us a "very non-bellicose goddess." There is a decided emphasis on the helmet, cuirass, and shield; and the owl—the traditional symbol for the goddess of wisdom—is missing. Still, there are precedents for this representation of Minerva; one that comes most immediately to mind is the fresco sketch by Paolo Veronese in the Pushkin Museum, Moscow (K. M. Malitskaya, *Great Paintings from the Pushkin Museum*, New York, 1964, pl. 17).

A black and red chalk drawing (Figure 184*a*) for the painting—thus far the only known full-scale drawing for a composition by Strozzi—is also in the collection of The Cleveland Museum of Art. NCW

Figure 184*a*. *Minerva*. Black and red chalk, 37.2 x 26.2 cm. Strozzi. John L. Severance Fund. CMA 53.626.

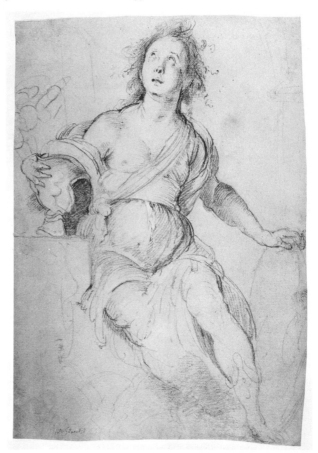

EXHIBITIONS: CMA (1936), cat. no. 166, pl. XXXVI; San Francisco, California Palace of the Legion of Honor, 1938: Venetian Painting from the Fifteenth through the Eighteenth Century, cat. no. 56, illus.; Toledo (Ohio) Museum of Art, 1940: Four Centuries of Venetian Painting, cat. no. 46, pl. 46; CMA (1956), cat. no. 42, pl. XLV; Detroit Institute of Arts, 1965: Art in Italy 1600–1700, cat. no. 204, pp. 177–78 (catalogue by Bertina Suida-Manning); State University of New York at Binghamton, 1967: Bernardo Strozzi: Paintings and Drawings, cat. no. 30, illus. p. 73 (Catalogue by Michael Milkovich).

LITERATURE: William M. Milliken, "*Minerva* by Bernardo Strozzi," CMA *Bulletin*, XVI (1929), 63–66, illus. pp. 61 and 62; Ella S. Siple, "Art in America, Italian Baroque Painting," *Burlington Magazine*, LV (1929), 105, pl. A; Frank E. W. Freund, "Ausstellungen und Neuerwerbungen der amerikanischen Museen," *Cicerone*, XXII (1930), 126, illus. p. 138; Henry Russell Hitchcock, Jr., "The *St. Catherine* by Bernardo Strozzi," *Bulletin of the Wadsworth Atheneum*, IX (1931), 15; L. Venturi (1933), III, pl. 582; Edoardo (Wart) Arslan, "Quattro Piccoli Contributi," *La Critica d'Arte*, III (1938), 77, n. 9; Giuseppe Fiocco, in Thieme-Becker, XXXII (1938), 208; Henry S. Francis, "A *Pietà* by Bernardo Strozzi," CMA *Bulletin*, XL (1953), 182–83; Luisa Mortari, "Su Bernardo Strozzi," *Bollettino d'Arte*, XL (1955), 328; Francis, "A Drawing for Strozzi's *Minerva*," CMA *Bulletin*, XLIII (1956), 125–26, illus. p. 125; Ann Maria Matteuci, *Bernardo Strozzi*, I Maestri del colore, no. 134 (Milan, 1966), pl. VI; Mortari, *Bernardo Strozzi* (Rome, 1966), pp. 61, 99, 173, 224, fig. 408, pl. IX; Fredericksen and Zeri (1972), pp. 193, 473, 573; CMA *Handbook* (1978), illus. p. 136; Mark M. Johnson, *Idea to Image* (exh. cat., Cleveland, 1980), pp. 45–46, fig. 52; Rodolfo Pallucchini, *La pittura veneziana del Seicento* (Milan, 1981), I, 160.

Figure 185a. *La Pietà*. On canvas, 100 x 125 cm. Strozzi. Galleria di Palazzo Bianco. On deposit in the Accademia Ligustica di Belle Arti, Genoa.

Circle of BERNARDO STROZZI
Early 1620s

185 *Pietà* 53.27

Canvas, 94.6 x 132 cm.

Collections: Cesare Jacini (sale: Galleria Geri, Milan, December 23, 1920, no. 266); [Italico Brass, Venice, purchased from Alessandro Brass].

Mr. and Mrs. William H. Marlatt Fund, 1953.

Unfortunately, this painting is in poor condition. The paint surface has been seriously worn. In the background the sienna ground is all that remains, an indication either of wearing or the possibility that the painting was left unfinished. The painting is lined.

This *Pietà* is a Genoese work painted in the early 1620s. Other paintings of this period, closely related in style and subject, are Strozzi's *Pietà* in Genoa, Accademia Ligustica (Figure 185a) and his *bozzetto* formerly in the De Masi collection in Genoa (Mortari, 1966, fig. 90).

Mortari (1966, p. 131) lists a *Deposizione* from a private collection in Genoa which was published by Giuseppe Delogu in 1929 ("Di Alcuni Dipinti inediti dello Strozzi," *L'Arte*, XXXII, fig. 2). The *Deposizione*, according to Mortari, may have been a *bozzetto* for the Cleveland picture. On the other hand, the *Deposizione* and the Cleveland painting may be one and the same: it is not known when Italico Brass acquired our painting; if it was after 1929 and Delogu's article, then the whereabouts of the Cleveland painting after the sale in 1920 (see Collections above) may well have been the Genoa collection mentioned by Delogu. In spite of the close relationship to the above cited works by Strozzi, the painting's poor condition allows only a tentative attribution to that master. NCW

EXHIBITIONS: Seattle Art Museum, 1954: Tenebrosi, cat. no. 20; CMA (1956), cat. no. 43, pl. XXIV; Vancouver (British Columbia) Art Gallery, 1964: The Nude in Art, cat. no. 38, illus.; Caracas (Venezuela), Museo de Bellas Artes de Caracas, 1967: Grandes Maestros, cat. no. 10, illus.

LITERATURE: Henry S. Francis, "A *Pietà* by Bernardo Strozzi," CMA *Bulletin*, XL (1953), 182–83, illus. p. 178; Luisa Mortari, "Su Bernardo Strozzi," *Bollettino d'Arte*, XL (1955), 328; Mortari, *Bernardo Strozzi* (Rome, 1966), p. 99, fig. 99; Donzelli and Pilo (1967), p. 385; Michael Milkovich, *Bernardo Strozzi: Paintings and Drawings* (exh. cat., Binghamton, New York, 1967), illus. p. 97; CMA *Handbook* (1969), illus. p. 114; Fredericksen and Zeri (1972), pp. 193, 396, 574.

Figure 185.

Figure 186.

424

GIOVANNI BATTISTA TIEPOLO
1696–1770

Tiepolo was born in Venice in 1696; he was the son of Domenico Tiepolo, a merchant. He married Cecilia Guardi, the sister of the painters Francesco and Giovanni Antonio Guardi; and they had nine children, including Lorenzo Baldissera, who became an assistant in his father's workshop, and Giovanni Domenico, who became his father's most important collaborator. Tiepolo served his apprenticeship under Gregorio Lazzarini. Although influenced by Sebastiano Ricci, Giovanni Battista Piazzetta, and Paolo Veronese, he soon developed his own highly personal style. His first important commission was for the fresco decorations in the archbishop's palace at Udine, which were completed in 1728. In 1750 Tiepolo went to Germany to decorate the Kaisersaal in the Würzburg residence of the Prince-Bishop Karl Phillip von Greiffenklau. He was elected first president of the Venetian Academy in 1755. In 1761 he was invited to Spain by Charles II to decorate the Royal Palace in Madrid; he remained there until his death in 1770. His works continued to have a tremendous influence on painters throughout the third quarter of the eighteenth century, particularly in Germany and Italy.

ter, New Hampshire) dated by Morassi (1962, p. 23, fig. 254) ca. 1761. Like the Cleveland sketch, this work includes a dark, shadowed area at the lower margin contrasted with figures appearing in dazzling light above; it also has a similar flying angel who blows a trumpet while holding another one in his free hand.

NCW

EXHIBITIONS: New York (1912), cat. no. 26; CMA (1916), cat. no. 37; CMA (1936), cat. no. 108; Birmingham (Alabama) Museum of Art and Springfield (Massachusetts) Museum of Fine Arts, 1978: The Tiepolos, Painters to Princes and Prelates, cat. no. 22, illus. p. 79; CMA, 1980: Idea to Image, cat. no. 85, illus. (catalogue by Mark M. Johnson).

LITERATURE: Miner K. Kellogg, "Works of Art Composing the Collection of Mr. Miner K. Kellogg, American Painter, 19 bis rue Fontaine St. Georges, Paris, 1858," typewritten manuscript in Museum archives; Rubinstein (1917) no. 38, p. 35; Henry S. Francis, "An Oil Sketch Decoration by Tiepolo," CMA Bulletin, XIX (1932), 115–17, illus. p. 113; Max Goering, in Thieme-Becker (1939), XXXIII, 153; Coe (1955), II, 91, no. 38; E. P. Richardson, "Archives of American Art Records of Art Collectors and Dealers, I: Kellogg," Art Quarterly, XXIII (1960), 274, 280; Antonio Morassi, A Complete Catalogue of the Paintings of G. B. Tiepolo, Including Pictures by His Pupils and Followers Wrongly Attributed to Him (London, 1962), p. 9, fig. 356; Guido Piovene and Anna Pallucchini, L'Opera completa di Giambattista Tiepolo, Classici dell'Arte, vol. 25 (Milan, 1968), no. 271, p. 129, illus. p. 128.

186 *Sketch for a Ceiling* 16.780

Canvas, 41 x 34 cm.
Collections: Miner K. Kellogg (1814–1889), Paris, 1858; Mrs. Liberty E. Holden, Cleveland, 1884.
Holden Collection, 1916.

This sketch was cleaned by William Suhr in 1932. Much of the red underpainting is exposed because of damages and abrasion. There are scattered, discolored retouchings. The painting may well have been reduced in size, for there is no tacking margin across the top edge. The sketch was cleaned and lined and the losses were inpainted by Delbert Spurlock in the Museum laboratory in March 1978.

It is not known for what ceiling this sketch was made. Morassi (1962), who dated it ca. 1750–60, pointed out that its iconography is close to that of the *Apotheosis of Francesco Morosini Peloponnesiaco* in the Palazzo Isimbardi, Milan (formerly on the ceiling of the Palazzo Morosini in Santo Stefano, Venice, and more recently—until 1953—in the Baron A. de Rothschild collection, Château Ferrières, near Paris). Burroughs (Exh: 1912) and Goering (1939) suggested that it might be a sketch for the *Allegory of Marriage* of ca. 1758, the ceiling fresco in the Salla della Capella in the Palazzo Rezzonico, Venice (Eduard Sack, *Giambattista und Domenico Tiepolo: ihr Leben und ihre Werke*, Hamburg, 1910, fig. 79). Additional evidence for dating the sketch in the late fifties to early sixties can be found in numerous other works of that period—among them, the *Triumph of Hercules* (Currier Gallery, Manches-

187 *Martyrdom of St. Sebastian:* 46.277
 Modello for an Altarpiece at Diessen

Canvas, 52.5 x 32.5 cm.
Collections: Convent Church at Diessen, sold in Munich in 1850; Dr. Max Kadisch, Vienna; [Jacques Seligman & Co., New York].
Delia E. and L. E. Holden Funds, 1946.

The painting was lined sometime before entering the Museum collection. There is some repainting around the edges and in the sky area, but in general the painting is in good condition.

The Cleveland *modello* was painted by Tiepolo for his first commission from Germany, which came in 1739 from the Augustinian convent at Diessen on the Ammersee in Bavaria. His finished altarpiece (Figure 187a) and a painting by Giovanni Battista Pittoni, the *Stoning of St. Stephen*, were commissioned at the same time and are both still in the convent. The Tiepolo altarpiece—above the third altar on the right, opposite Pittoni's *St. Stephen*—is recorded in a chronicle of the Diessen convent written by Augustin-Josef dall'Abaco (Munich, Bibliothèque de l'Etat, 1769–70) and in another manuscript entitled *Chronologia quintuplex*, of 1768, where the price is given as 600 florins. It is not known whether Tiepolo himself took the sketch to Diessen for approval. His *modello* and Pittoni's (both measuring 53.3 cm in height) were sold by the convent in 1850 in Munich. The subsequent whereabouts of Tiepolo's *modello* is unknown until the 1930s when it appeared in the collection of Dr. Max Kadisch, Vienna.

Figure 187.

Morassi (1962) believes that the Cleveland picture is the only *modello* for the Diessen altarpiece, although several versions or copies are known. He suggested (1962, p. 7) that one version, in the Pinacoteca in Brescia (formerly M. Filippini collection, Ospitaletto, near Brescia; canvas, 67 x 41 cm), might be by Giovanni Raggi (1712–1792/4); this version includes certain details that are missing from the freer, sketchier Cleveland *modello* and is therefore thought to have followed after the large altarpiece. Another version was owned by Thomas Agnew & Sons, London (88.9 x 45.7 cm, formerly Querini collection, Venice; *Art News*, XLVIII, January 1950, illus. p. 7). An old copy was formerly in Holzhausen, Stumm collection (photo in Kunsthistorisches Institut, Florence, no. 62711).

Three drawings for the figure of St. Sebastian are known. According to Sack (1910, p. 187), who did not document this statement, two of these appeared in Munich in 1850 and came from Diessen. The drapery arrangements, the general composition, the architectural background, and the tree in these two drawings are very close to the altarpiece and the Cleveland *modello*. One of the drawings to which Sack referred is in the collection of Archbishop Graf Széptycki at Lemberg (48 x 28 cm; Sack fig. 302), and the other was in the R. Guggenheim collection in Venice (P. Molmenti, *Giovanni Battista Tiepolo*, Milan, 1909, repr. p. 161). A third drawing, showing a figure roped to a tree, is in the Budapest Museum; Dr. Edith Hoffmann ("A Szépmüvészeti Muzeum Néhány Olasz Rajzáról," *As Országos Magyar Szépmüvészeti Múzeum Evkrönyvei*, Vol. 4, Budapest, 1927, p. 116, repr. fig. 53, p. 164) felt that this was the preliminary drawing that preceded the others for the Diessen altar.

N C W

EXHIBITIONS: Art Institute of Chicago, 1938: Paintings, Drawings and Prints by the Two Tiepolos, Giambattista and Giandomenico, cat. no. 4; San Francisco, California, Palace of the Legion of Honor, 1938: Venetian Painting from the Fifteenth Century through the Eighteenth Century, cat. no. 58, illus.; Detroit Institute of Arts and John Herron Art Museum (Indianapolis), 1952: Venice, 1700–1800, An Exhibition of Venice and the Eighteenth Century, cat. no. 66; CMA (1956), cat. no. 45, p. 32.

LITERATURE: Eduard Sack, *Giambattista und Domenico Tiepolo: ihr Leben und ihre Werke* (Hamburg, 1910), p. 187, no. 318; L. Froelich-Bume, "Notes on Some Works by Giovanni Battista Tiepolo," *Burlington Magazine*, LXXII (1938), 82, pl. IA; Ulrich Middeldorf, "Eine Tiepolo-Ausstellung in Chicago," *Pantheon*, XXI (1938), 146, illus. p. 147; Henry S. Francis, "Tiepolo's *Modello for The Martyrdom of St. Sebastian* at Diessen," CMA *Bulletin*, XXXIV (1947), 3–4, illus. p. 1; Bernard Berenson, "Giovan Battista Tiepolo," *L'Illustrazione Italiana*, VI (1951), 59, fig. 3; Morassi (1953), VII, 52, 53; Milliken (1958), illus. p. 46; Germain Seligman, *Merchants of Art: 1880–1960, Eighty Years of Professional Collecting* (New York, 1961), pl. 85; Morassi, *A Complete Catalogue of the Paintings of G. B. Tiepolo, Including Pictures by His Pupils and Followers Wrongly Attributed to Him* (London, 1962), p. 9, fig. 116; Guido Piovene and Anna Pallucchini, *L'Opera completa di Giambattista Tiepolo*, Classici dell'Arte, vol. 25 (Milan, 1968), p. 104, no. 125a; Fredericksen and Zeri (1972), pp. 196, 449, 574; CMA *Handbook* (1978), illus. p. 144.

Figure 187a. Altarpiece: *Martyrdom of St. Sebastian*. On canvas, 410 x 200 cm. G. B. Tiepolo. Augustiner-Kloster, Diessen, West Germany.

Attributed to GIOVANNI BATTISTA
TIEPOLO

188A *Horatio Cocles Defending Rome* 49.571
 against the Etruscans

188B *The Wounded Horatio Cocles* 49.572
 Swimming the Tiber

> Canvas, 135.1 x 208.1 cm (188A) and 137 x 208.5 cm (188B).
> Collections: Private collection, Venice; Ali Loebl; M. M. Steinmeyer and Stephan Bourgeois, Paris, before 1910; [A. W. M. Mensing, Amsterdam, 1918]; [Demotte, Paris, 1923–25]; Francesco Pospisil, Venice; [Alessandro Brass, Venice].
> Mr. and Mrs. William H. Marlatt Fund, 1949.

These paintings had been transferred before they entered the Museum collection; they were transferred again by William Suhr in 1951. Because buckling and cleavage of the paint film had occurred as a result of the deterioration of the adhesive between the two canvases, the Intermuseum Laboratory in Oberlin, Ohio, recommended a third transfer for both paintings. In the subsequent transfer of the *Wounded Horatio*, some old fillings covering original paint were discovered and removed. Later paint that extended the original design by 2.5 to 3.8 centimeters around all edges was also removed. Pentimenti in the arrow in the center of the painting, in the position of the shield above Cocles, and in the position of the tree in the upper center were left exposed. The *Horatio Cocles Defending Rome* was not transferred a third time, but old varnish and inpaint were removed, areas of cleavage were re-set, and inpainting and varnishing were completed in 1980. Both paintings have suffered extensively; there are numerous small vertical and horizontal losses in the paint layers, resulting perhaps from the transferring process or from rolling for shipment in 1951 (according to William Suhr's report of May 20, 1951).

In a letter dated July 10, 1912, Wilhelm von Bode stated that he had considered acquiring both paintings "sometime back" for the Berlin museum when they were in the possession of a distinguished Venetian collector. Stephan Bourgeois of New York, in a letter dated November 6, 1950, said that although he and Steinmeyer (co-owner of the paintings, with Bourgeois) had no records prior to the First World War, he recalled having bought both pictures in Paris shortly before coming to the United States in 1910; the paintings, he said, were brought to his attention by Ali Loebl, a cousin or uncle of Harry G. Sperling of F. Kleinberger Galleries, New York. Henry S. Francis, in a letter to Harry G. Sperling (November 30, 1950), said that because of Bode's interest in the paintings, their worth was recognized in Germany at the end of the nineteenth century, and that Hermann Goering attempted to find them in Italy during the occupation in the Second World War, but they had been successfully hidden.

The subjects are the legendary exploits of an ancient Roman hero. According to the story (Livy II, 10; Plutarch VI, 16; Valerius Maximus, III, 2), Horatio Cocles stood alone to defend the Sublican Bridge against Lars Porsena of Clusium, who had come with a whole army of Etruscans to avenge the wrongs of the banished tyrant Tarquin. One painting shows Horatio battling the Etruscans while the Romans cut away the bridge. The other shows Horatio in the Tiber, where he threw himself and either swam to shore safely or was drowned, depending upon which version of the story is used.

Horatio Cocles was not the most popular of Roman heroes, although he appears occasionally in Italian Renaissance painting and in the works of seventeenth-century Italian painters such as Federigo Zuccaro, Lazzaro Tavarone, and Bernardo Strozzi, as well as in Northern painting. The Cleveland paintings are the only known depictions of the subject by Tiepolo. An eighteenth-century contemporary of Tiepolo, Giuseppe Angeli (ca. 1709–1798), a student follower of Piazzetta, painted the fresco *Horatio Cocles Defending Rome against the Etruscans* before 1765 for the Palazzo Giovanelli in Noventa near Padua; a *modello* for the fresco is in the Pinacoteca del Seminario, Rovigo (Mercedes Precerutti Garberi, *Affreschi settecenteschi delle ville Venete*, Milan, 1968, fig. 44, p. 106). Though Angeli's painting is close in date, it has no direct relationship in style or iconography to the Cleveland painting.

Henry S. Francis (1951) associated our paintings with a series of ten large canvases—all vertical compositions—on the exploits of ancient Roman heroes which Tiepolo painted between 1725 and 1730 for the Ca' Dolfin in Venice. Three of these works are in the Metropolitan Museum of Art (Castiglione Collection); two are in the Kunsthistorisches Museum in Vienna; and five are in The Hermitage, Leningrad (Morassi, 1962, pp. 15, 34, 66). In addition to stylistic similarities, there are several details generic to the Ca' Dolfin series and other early works which also appear in the Museum paintings. For example, the winged salamander helmet in the Cleveland paintings is seen in two paintings from the Ca' Dolfin series, *Hannibal Contemplates the Head of Hasdrubal* (Vienna) and the *Capture of Carthage* (Metropolitan Museum). It also appears in the *Judgment of Solomon* fresco in the Sala Rossa of the Palazzo Arcivescovile in Udine, painted in 1727 or 1728; in the *Alexander and Campaspe in the Studio of Apelles* of ca. 1725, in the Montreal Museum of Fine Arts; and in *Scipio and the Slave*, a fresco in the Palazzo Dugnani in Milan, painted in 1731. The treatment of the architectural detail on the fortifications in *Horatio Cocles Defending Rome* is closely associated with similar fortifications in two works from the Ca' Dolfin series, *Capture of Carthage* and *Volumnia and Her Children before Coriolanus* (The Hermitage, Leningrad).

Everett Fahy (orally in 1971) said that the Cleveland paintings were definitely by the young G. B. Tiepolo. Mo-

Figure 188A.

rassi (1962), Pallucchini (1968), and Terisio Pignatti (letter of March 10, 1971), however, all disagree. Attributions to Tiepolo are sometimes difficult, for his workshop was enormous, and after the mid-1730s there was always a circle of talented artists around him; his name was synonymous with his collective workshops from the Würzburg period (1750–53) onwards.

Giovanni Raggi of Bergamo (1712–1792), Tiepolo's first important assistant, who worked with him during the 1730s, has been suggested as a collaborator on the Museum's paintings. Raggi, who followed his master to Venice, was a faithful but pedantic copier of Tiepolo's style.

Another name that has been associated with the Museum paintings is Francesco Salvator Fontebasso (1709–1769), a student of Sebastiano Ricci. There is no evidence that he ever studied with or worked with Tiepolo, however. From 1760 until 1762 he worked for the court at Leningrad. He is generally thought to be an imitator of Tiepolo and a follower of Ricci. In his works there is a static massing of

figures and a general shallowness in composition, and his elongated figures often display a histrionic tendency—qualities not present in the Horatios. Compare our paintings, for example, with Fontebasso's *Last Supper* in The Hermitage, his *Martyrdom of St. Catherine* (*L'Oeil*, XIII, March 1967, 11), or his *Banquet of Cleopatra* on the London art market (*Apollo*, LXXXI, June 1965, illus. 494). His four paintings (each 36 x 80 cm) dealing with *The Battles of Alexander* (painted ca. 1761–62), in the Musée de l'Ain in Bourg-en-Bresse in France, are battle scenes somewhat similar to the Horatios; but again there is a studied and pedantic arrangement of figures, and instead of depth there is a two-dimensional, stage backdrop effect (see *Venise au dix-huitième siècle*, Paris, Orangerie des Tuilleries, 1971, illus. nos. 54–57, p. 63).

Giustino Menescardi, who was born in Milan and worked in Venice after 1751 until 1776, has also been suggested as the author of the Museum's paintings. He, too, was very much influenced by Tiepolo and by Veronese as well. Both

429

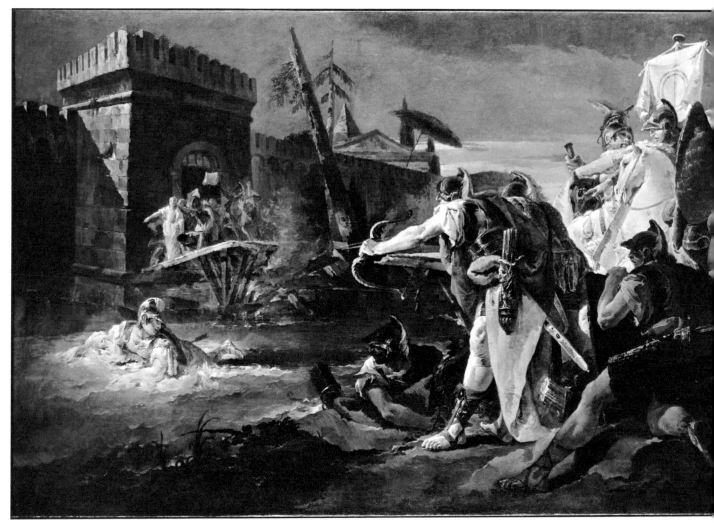

Figure 188B.

Morassi (1962, p. 9) and Pignatti (orally, 1974; and in letter of July 27, 1978, before the paintings were cleaned) have suggested Menescardi, the latter because of the squattiness of the figures in the Cleveland paintings and because the paintings compare closely with Menescardi's *Martyrdom of Two Saints* and *St. Matthew* in the Scuola del Carmine in Venice.

None of the above suggestions has proved entirely convincing. In addition to those mentioned, there were many other followers of Tiepolo in Venice and the Veneto, such as Fabio and Giambattista Cana, Jacopo Guarana, Giambattista Mengardi, and Costantino Cecini, among others. Most important was Tiepolo's son, Domenico, who entered his studio in 1743 and continued the studio well after his father's death. These less precocious painters, however, were not capable of the brilliant brushwork, the facile play with depths, the deliberate foreshortening, and the silvery tones of the Museum paintings. These qualities, on the other hand, suggest close comparisons to the early works of Tie-

polo dating from the late 1720s, a dating that diminishes the possibility that the pictures are the work of an artist in Tiepolo's workshop.

There are several early drawings associated with the Museum paintings. Perhaps the two closest examples are in the Victoria and Albert Museum, London (George Knox, *Tiepolo Drawings in the Victoria and Albert Museum*, London, 1975, nos. 2 and 3), dated ca. 1725. The heads of the figures in these two drawings (cf. especially Figure 188*a*, which is no. 3 in Knox's catalogue) are similar to the head of the swimming Horatio Cocles; the pose is almost identical; and there is a slight awkwardness in the position of the body and in the relation of the head to the neck, which are also weak figural passages in the Cleveland painting. G. Vigni (in *Disegni del Tiepolo*, Trieste, second ed., 1972, nos. 8 and 9) mentions two other Tiepolo drawings in the Museo Civico, Trieste, that include the crouching animal helmet ornament (Figures 188*b* and *c*); Vigni associates these drawings with the Ca' Dolfin series and, following

Knox, dates them to the same period. Among other related drawings is a head of a helmeted soldier (Figure 188*d*) in the Pierpont Morgan Library, New York (Arthur Miller, *Drawings of Tiepolo*, Los Angeles, 1956, repr. p. 25).

Even though the attribution to Tiepolo needs further study, his works of the period 1725–30 still offer the closest comparison. NCW

EXHIBITIONS: Amsterdam, Ant. W. M. Mensing, 1918: Tentoonstelling van Oude Meesters bij Frederic Muller & Co., cat. nos. 21, 20, illus. pls. 20 and 21; CMA, 1956: The International Language (no catalogue).

LITERATURE: Henry S. Francis, "A Drawing and Two Oils by Tiepolo," CMA *Bulletin*, XXXVIII (1951), 130–32, illus. pp. 136–39; Antonio Morassi, *A Complete Catalogue of the Paintings of G. B. Tiepolo Including Pictures by His Pupils and Followers Wrongly Attributed to Him* (London, 1962), pp. VII, 9; Guido Piovene and Anna Pallucchini, *L'Opera completa di Giambattista Tiepolo*, Classici dell'Arte, vol. 25 (Milan, 1968), p. 136 (*The Wounded Horatio Cocles Swimming the Tiber*); Fredericksen and Zeri (1972), pp. 196, 482, 574; CMA *Handbook* (1978), illus. p. 144 (*Horatio Cocles Defending Rome . . .*).

Figure 188*a*. *A Seated Roman Soldier Grasping a Shield*. Red chalk washed with water, 15.5 x 16 cm. G. B. Tiepolo. Victoria and Albert Museum, London.

Figure 188*b*. *Helmets and Quiver*. Pen and wash drawing, 19.3 x 24.6 cm. G. B. Tiepolo. Museo Civico di Storia ed Arte ed Orto Lapidario, Trieste.

Figure 188*d*. *Helmeted Head*. Pen and brown ink, and gray-brown wash, 18.1 x 14.1 cm. G. B. Tiepolo. The Pierpont Morgan Library, New York.

Figure 188*c*. *Helmets*. Pen and wash, 13.6 x 26.2 cm. G. B. Tiepolo. Museo Civico di Storia ed Arte ed Orto Lapidario, Trieste.

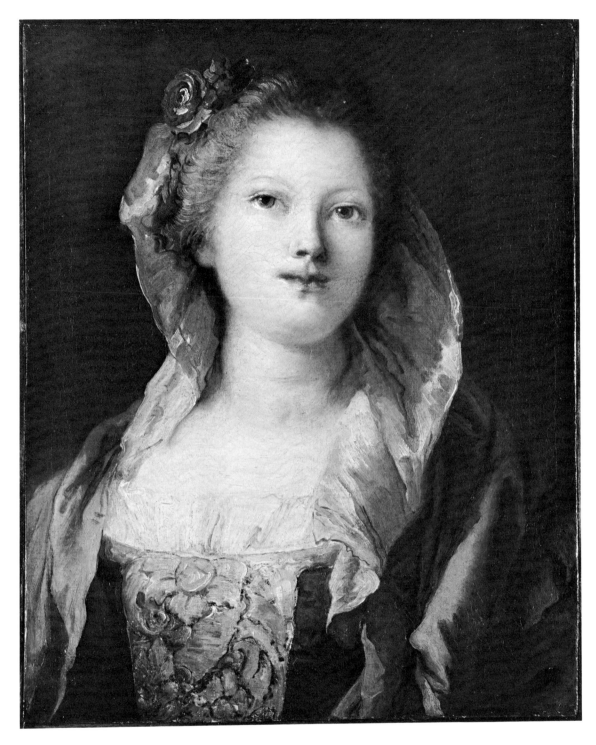

Figure 189.

432

GIOVANNI DOMENICO TIEPOLO
1727–1804

Giovanni Domenico was the eldest surviving son of Giovanni Battista Tiepolo and Cecilia Guardi (the sister of Giovanni Antonio and Francesco Guardi). Domenico was a child prodigy; he probably had no other master than his father. From 1750 to 1753 he was in Würzburg assisting his father in the decoration of the prince-bishop's residence. From that time on he was his father's most important collaborator; they worked together in Madrid from 1762 until 1770, when the elder Tiepolo died. Domenico married in 1776 and had two daughters, one of whom died in infancy. He died at the age of seventy-seven, in 1804, seven years after the fall of the Venetian republic. His work is of such high quality that it is often confused with that of his father.

189 *Portrait of a Lady* 52.541

Canvas, 60.4 x 48.6 cm.

Collections: Richard Owen, Paris, by 1925; [Thomas Agnew & Sons, London]; Henry C. Dalton, Cleveland, 1928, purchased from Agnew (see Exh: 1928); Harry D. Kendrick, Cleveland.

Gift of Harry D. Kendrick, 1952.

This lined canvas is in good condition, with minor damages and repairs in the lower left and in the scarf and bodice of the sitter. It was cleaned in 1961 by Joseph Alvarez.

The early history of the painting is unknown. It was first published in 1928 and was said to have been acquired in Spain. Written on the back of a photograph of the painting at I Tatti, in Bernard Berenson's handwriting, is the following: "Sent by Richard Owen, May 1925. . . . He got it in Spain." F. J. Sánchez-Cantón (1953) also said that the portrait had been in Spain, having left there more than a quarter of a century earlier. Sánchez-Cantón further pointed out the Spanish attire of the sitter. Gaya Nuño (1963) confirmed the Spanish provenance but, contrary to Berenson's note, said the painting belonged to a Spanish collection until 1935. Because of the lady's Spanish costume, it seems reasonable to assume that the portrait dates from Tiepolo's years in Spain; Gaya Nuño agrees, giving the portrait to Giovanni Battista Tiepolo and dating it to his last years there, 1765–70.

Although the painting was given to Giovanni Battista by Goering (1939), Sánchez-Cantón (1953), L. Venturi (1931), and Tietze (1935), Morassi (1941, 1958, 1962) has steadfastly maintained that it is by Domenico. It is, says Morassi, of the same feminine type as the three half-length busts in the Museo Lazaro Galdiano in Madrid (Paola della Pergola, "Tre ritratti del Tiepolo," *La Critica d'arte*, II, 1937, 252, pls. 175 and 176) and the portrait of a woman in a fur hat in a private collection in Bergamo (Mariuz, 1972, no. 228). Another portrait, called *Christina* (Figure 189a), which might possibly be of the same sitter, is in the Museum of

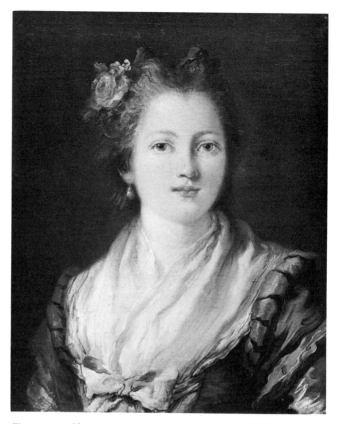

Figure 189a. *Christina*. On canvas, 60.3 x 49.5 cm. G. D. Tiepolo. Museum of Art, Carnegie Institute, Pittsburgh. Collection of Howard A. Noble.

Art, Carnegie Institute, Pittsburgh; though this painting was formerly given to Giovanni Battista, Morassi (1958, and 1962, p. 19) ascribed it to Domenico, and Mariuz (1972) is in agreement.

The attribution to Domenico seems most reasonable, for the oval, somewhat flat face in the Cleveland portrait lacks the subtle undulations typical of Giovanni Battista. Moreover, Domenico's portraits are, like this one, more decorative and less lively than those by his father. NCW

EXHIBITIONS: CMA, 1928: Representative Art through the Ages (no catalogue); CMA, 1934: Art of the XVIIth and XVIIIth Centuries (no catalogue); CMA, (1936), cat. no. 64; New York, Metropolitan Museum of Art, 1938: Tiepolo and His Contemporaries, cat. no. 19, illus. (as Giambattista Tiepolo); Art Institute of Chicago, 1938: Paintings, Drawings, and Prints by the Two Tiepolos, Giambattista and Giandomenico, cat. no. 37, illus.; Bordeaux, Galerie des Beaux-Arts, 1956: De Tiepolo à Goya, cat. no. 58 (as Giambattista); Birmingham (Alabama) Museum of Art and Springfield (Massachusetts) Museum of Fine Arts, 1978: The Tiepolos, Painters to Princes and Prelates, cat. no. 94, p. 104, illus. p. 105.

LITERATURE: *International Studio*, LXXXIX (April 1928), color illus. p. 55; L. Venturi (1931), pl. CCCCXXX (as Giambattista); L. Venturi (1933), III, pl. 595; Hans Tietze, *Meisterwerke Europäischer Malerei in Amerika* (Vienna, 1935), pl. 113 (as Giambattista, and dated 1762–70); Max Goering, "Ein Neuentdecktes Mädchenbildnis von Giovanni Battista Tiepolo," *Pantheon*, XXIV (1939), 224, 226, illus. p. 224; Goering, in Thieme-Becker,

XXXIII (1939), 153; Antonio Morassi, "Domenico Tiepolo," *Emporium*, XCIII (1941), 282, n. 14 (attributed to Gian Domenico); Francisco Javier Sánchez-Cantón, *J. B. Tiepolo en España* (Madrid, 1953), p. 36, pl. 38 (as Giovanni Battista); Coe (1955), II, 47, no. 10, illus.; Morassi, "Giambattista Tiepolo's *Girl with a Lute* and the Clarification of Some Points in the Work of Domenico Tiepolo," *Art Quarterly*, XXI (1958), 186, n. 4 (as Domenico); Morassi, *A Complete Catalogue of the Paintings of G. B. Tiepolo Including Pictures by His Pupils and Followers Wrongly Attributed to Him* (London, 1962), VII, 9 (as Domenico); Juan Antonio Gaya Nuño, *Pintura Europea perdida por España, De Van Eyck a Tiepolo* (Madrid, 1964), p. 95, no. 334; Fredericksen and Zeri (1972), pp. 198, 533, 574; Adriano Mariuz, *Giandomenico Tiepolo* (Venice, 1972), p. 117, pl. 227; CMA *Handbook* (1978), illus. p. 145.

TINTORETTO (Jacopo Robusti)

1518–1594

Tintoretto was born in Venice, the son of Battista Robusti, a dyer (*tintore*—from which the nickname "Tintoretto" is derived). Little is known of the origins of Tintoretto's style or of his personal life—even though several biographies are devoted to him. Two that appeared during his lifetime are: Giorgio Vasari, *Le Vite dei piu eccellenti pittori . . .* (1568); and Raffaele Borghini, *Il Riposo della pittura e della scultura* (1584). Additional biographical information is found in Carlo Ridolfi's *Vita* of Tintoretto (1642) and *Le Meraviglie dell'arte . . .* (1648), and in Marco Boschini's *La Carta del navigar pittoresco* (1660) and *Le Ricche Minere della pittura Veneziana* (1664). Tintoretto's biographers agree that he joined Titian's workshop at an early age but remained for only a very short time apparently because he aroused Titian's envy. Tintoretto rarely left his native city. In 1550 he married Faustina dei Vescovi; of their several children, three became painters who worked in their father's workshop: Marietta (ca. 1552–1590), Marco, and Domenico (born ca. 1560). The latter inherited his father's estate and continued his workshop.

190 Baptism of Christ 50.400

Canvas, 169 x 251.4 cm.

Collections: Colonel William T. Markham, by 1853 until at least 1869; Captain R. A. Markham, until at least 1910; E. G. Markham, London and Southcliff, Bembridge, Isle of Wight, until 1923; [Durlacher Brothers, London, from 1923 until at least 1929]; Arthur Sachs, Paris and New York, by 1931; [Jacques Seligman & Co., New York].

Gift of Hanna Fund, 1950.

The painting was cleaned and lined by the Fogg Art Museum Conservation Department in 1949. There is considerable abrasion, which is most evident in areas of dark pigment but negligible in the lights. There are flake losses in the lower left foreground, in the wing of the angel bearing Christ's robe, and in the foliage immediately above the angel's wing. A tear in the canvas above the angel's wing has apparently caused some of the flaking.

The first record of this painting dates from 1859, when it was exhibited in London; it was then in the collection of Colonel William T. Markham, who had acquired it in 1853. There is a continuous record of the painting from that time to the present.

Because there are several versions of this composition, differences of opinion exist concerning sequence and quality. The large vertical version in San Silvestro, Venice, has been universally given to Tintoretto and has been dated about 1580 (Borghini mentions this painting in his biography of the artist published in 1584). A version in the Prado (inv. no. 397) is described in the Prado catalogue (1972) as "earlier and better" than the San Silvestro painting; Bercken and Meyer (1923), however, felt that the Prado painting was the work of a pupil and that the Cleveland painting probably represented Tintoretto's earliest treatment of the subject. The marked pentimenti, particularly in the wings of the angels at the left, tend to support such a hypothesis. There is, moreover, an expansive quality in the composition of the Cleveland work, while in the other—most likely, later—versions the composition is more focused and considerably simplified. Hans Tietze (1948, p. 57) observed that Tintoretto and his studio often borrowed from earlier compositions but seldom literally reproduced an earlier version. In such a development of *Baptism* versions, a likely and logical successor to the Cleveland picture would seem to be the San Silvestro painting, in which there are no flanking angels, the landscape has been simplified, and the poses of Christ and the Baptist are resolved in a slightly different manner. Two preparatory drawings (in the Uffizi, nos. 12943 and 12961) for the San Silvestro painting show that the artist intended to develop a variation, or was experimenting with a more satisfactory resolution of pose.

Two additional versions are somewhat related to the San Silvestro painting: one in the church of San Pietro in Murano and another in the church of San Giorgio in Braida, Verona. Pittaluga (1925) assigned these two and the Prado

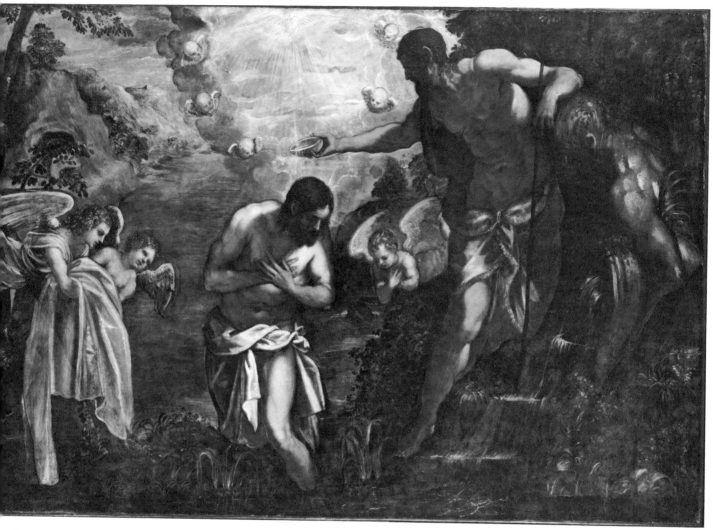

Figure 190.

version to assistants or pupils, and Barbantini (1937, quoting Pittaluga) agreed.

Among the several Tintorettesque versions of the *Baptism* is one that is quite different in conception from the rest of the group; it was executed between 1576 and 1581 for the upper hall of the Scuola di San Rocco. The mosaic in San Marco, Venice, borrows both from this version and from the one at San Silvestro.

A number of the compositional and iconographic ideas that appear in Tintoretto's versions of the *Baptism* were current among artists in Venice at the time. There are, for example, strong affinities between Tintoretto's conception of the subject and that of Paolo Veronese, which we note especially in two canvases—both dating from the 1570s—from Veronese's workshop: one is in the Pitti Palace and another is in a private collection in Switzerland (Mauro

435

Natale, et. al., *Art Vénetien en Suisse et au Liechtenstein*, exh. cat., Geneva, 1978, no. 74, p. 113).

The attribution of the Cleveland painting to Tintoretto was rejected by Pittaluga (1925) and Barbantini (1937). Tietze (1948) believed both the Cleveland and the Prado versions to be shop pieces. On the other hand, Bercken and Mayer (1923), B. Berenson (1957, and in various letters), and L. Venturi (1931 and 1933) accept the painting as the work of Tintoretto. Indeed, Berenson and Venturi praised it highly. Their admiration is justified by the glowing, chromatic palette; the firm, voluminous modeling of the nude figures; and the fervent gesture of Christ, effectively repeated by one of the attendant angels. All of these qualities are indicative of the sensitive vision and powerful handling of the master himself. Moreover, these qualities, typical of the artist's mature style, tend to give credence to Venturi's dating of the work in the 1560s. NCW

EXHIBITIONS: London, British Institution, 1859, cat. no. 45; Leeds, England, 1868, cat. no. 201; London, Royal Academy, 1873: Exhibition of the Works of the Old Masters, cat. no. 140; California Palace of the Legion of Honor (San Francisco) and Santa Barbara Museum of Art, 1946: Exhibition of the Arthur Sachs Collection (no catalogue).

LITERATURE: W. Roscoe Osler, *Tintoretto* (London, 1882), p. 97; Henry Thode, *Tintoretto* (Bielefeld and Leipzig, 1901), pp. 108, 139; J. B. Stoughton Holborn, *Jacopo Robusti Called Tintoretto* (London, 1903), p. 104; Nancy R. E. Bell, *Tintoretto* (London and New York, 1905), p. xliv; Stoughton Holborn, *Bryan's Dictionary of Painters*, IV, (New York, 1910), 261; Graves (1914), III, 1312–13; Erich von der Bercken and August L. Mayer, *Jacopo Tintoretto* (Munich, 1923), I, 194–96, and II, pl. 89; Mary Pittaluga, *Il Tintoretto* (Bologna, 1925), p. 257; A. Venturi (1929), IX, pt. 4, 615; François Fosca, *Tintoret* (Paris, 1929), p. 147; L. Venturi (1931), pl. CCCCVII; L. Venturi (1933), III, pl. 547; Nino Barbantini, *La Mostra del Tintoretto* (exh. cat., Venice, 1937), p. 179; *Les Chefs-d'oeuvre du Musée du Prado* (Basel, 1939), p. 36; Erich von der Bercken, in Thieme-Becker, XXXIII (1939), 194; Luc Bouchage, "Louvre to California, Today's Collectors: Arthur Sachs," *Art News*, XLV (October 1946), 75; Thomas C. Howe, Jr., "The Arthur Sachs Collection," *Bulletin of the California Palace of the Legion of Honor*, IV, no. 7 (1946), 59; Hans Tietze, *Tintoretto: The Paintings and Drawings* (London, 1948), p. 348; Helen Comstock, "The Connoisseur in America: A Venetian XVI-Century Painting," *Connoisseur*, CXXVII (1951), 118, and CXXVIII (1951), 61, illus. pp. 61 and 62; Henry S. Francis, "*Baptism of Christ* by Tintoretto," CMA *Bulletin*, XXXVIII (1951), 25–26, illus. pp. 32–35; Bernard Berenson (1957), I, 171, and II, pl. 1301; Milliken (1958), color illus. p. 36; John Canaday, *Metropolitan Seminars in Art: Great Periods in Painting*, Portfolio E: *The World in Order: The High Renaissance* (New York, 1959), p. 29, pl. E12; Germain Seligman, *Merchants of Art: 1880–1960, Eighty Years of Professional Collecting* (New York, 1961), pl. 99; Harold E. Wethey, *El Greco and His School* (Princeton, New Jersey, 1962), II, 35; Jaffé (1963), pp. 460, 462, fig. 3; Alsop (1966), color illus. p. 28; Hans Durst, *Alessandro Magnasco* (Zurich, 1966), p. 100, illus. p. 177, no. 25; *Selected Works* (1966), no. 142, illus.; Pierluigi de Vecchi and Carlo Bernari, *L'Opera completa del Tintoretto*, Classici dell'Arte, vol. 36 (Milan, 1970), p. 124, no. 246, illus.; Fredericksen and Zeri (1972), pp. 199, 277, 574; Francisco Javier Sánchez-Cantón, *Museo del Prado: Catalogo de las Pinturas* (Madrid, 1972), p. 688, no. 397; Jaffé, *Rubens and Italy* (Oxford, 1977), pp. 37, 73, 109 n. 72, 115 n. 37, pl. 244; CMA *Handbook* (1978), illus. p. 109.

TITIAN (Tiziano Vecelli)
Ca. 1488–1576

Titian was born about 1488 at Pieve di Cadore, a village in the Dolomites. He was a pupil of Giovanni Bellini and was influenced by Giorgione. Except for short stays in Rome—1545 to 1546—and in Augsburg—1548 to 1550/51—he spent his whole life in Venice. He died there in 1576.

191 *Adoration of the Magi* 57.150

Canvas, 142.2 x 228.3 cm.

Collections: Walsh Porter (sales: Christie's, London, April 14, 1810, no. 38; June 21, 1811, no. 40; May 6, 1826, no. 7); Samuel Rogers (sale: Christie's, London, May 2, 1856, no. 700, to a Mr. Ripp); Hugh A. J. Munro of Novar (sales: Christie's, London, May 18, 1867, no. 183; June 1, 1878, no. 121, to C. Butler); Butler Johnstone, 1881; William Graham (sale: Christie's, London, April 10, 1886, no. 472); J. Stewart Hodgson (sale: Christie's, London, June 3, 1893, no. 31); Ralph Brocklebank (sale: Christie's, London, July 7, 1922, no. 112); [Julius Böhler, Munich]; [Durlacher Brothers, London and New York]; Arthur Sachs, 1928 to 1957.

Mr. and Mrs. William H. Marlatt Fund, 1957.

Apparently, this painting was never finished, for much of the underpainting in the landscape at the upper left is visible. There are pentimenti in the unfinished legs of the kneeling king, in the man holding the mule, and in the left hind leg of the horse in the foreground. There is considerable rubbing and damage to the paint surface, although the figures of Mary, the Christ Child, the kings, and the figure at the extreme right are in reasonably good condition. The picture was cleaned in 1927 while on the art market (Burroughs, 1930), but no restoration records from that time are available. Richard Buck lined, but did not clean, the picture at Harvard University in 1950–51, noting that when he removed the old canvas lining he found a stamp with the monogram of Charles I of England on the back of the original canvas.

Because of the monogram, three Christie's sales catalogues stated that the painting was in the collection of Charles I, a gift of the Spanish court. The quality of the stamp, however, suggests that the monogram was a forgery —perhaps for sales purposes. This painting does not appear in the extant (but incomplete) inventories of the collection of Charles I, and there is no proof that it was a gift to him from the Spanish king. The Orléans Gallery and the artist Benjamin West have been named as former owners in some of the sales catalogues, but documentation is lacking for these assertions. After being in a succession of private English collections through the nineteenth century, the painting appeared on the art market again in 1927, at which time its merits were recognized by Detlef von Hadeln (expertise given in 1927 to Julius Böhler; and letter of June 13, 1958, to Henry S. Francis of The Cleveland Museum of Art).

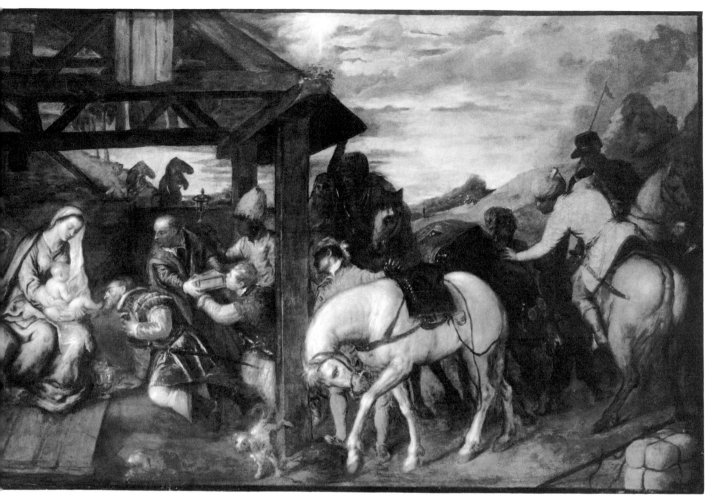

Figure 191.

Figure 191*a*. *Adoration of the Magi*. On canvas, 118 x 222 cm. Titian. Galleria Ambrosiana, Milan.

Considerable art-historical debate has centered around the several extant versions of Titian's *Adoration of the Magi*. After a visit in Titian's house in 1566, Giorgio Vasari wrote about the painting in 1568 as follows: "In a picture three braccia high and four broad, Titian painted the Infant Christ in the arms of the Virgin, and receiving the adoration of the Magi. The work comprises numerous figures one braccia high and is a very good one, as is another which he copied himself from this and gave to the 'old Cardinal of Ferrara'" (*Le Opere di Giorgio Vasari*, ed. Gaetano Milanesi, reprint, Florence, 1906, VII, 452). Opinion is divided, of course, as to which version Vasari saw. Further mention of a version of the subject is made in a letter from Titian to Philip II, dated April 2, 1561, in which the artist expressed his pleasure that the king approved four paintings, referring to one of them as "Re d'Oriente," i.e., Adoration of the Kings (Crowe and Cavalcaselle, 1881, II, 307, 519–20). This means that the king had actually received the latter work by 1561.

Historians have held controversial views about which is the copy for Cardinal Ippolito of Ferrara and which are the versions by Titian himself. The problem has centered primarily around the Cleveland painting and three other pictures: one in the Ambrosiana in Milan (Figure 191*a*), one in the Prado (Figure 191*b*), and another in the Escorial (Figure 191*c*).

Wethey (I, 64–65) believes that since Vasari could not have seen Philip II's *Adoration* dating from 1560–61, or the Ambrosiana version which was shipped by Titian to Cardinal Ippolito II d'Este in 1564, Vasari must have seen the Cleveland version.

The Ambrosiana painting was ordered by the cardinal as a gift to Henry II of France and Diane de Poitiers (Wethey, I, 25). The painting was never sent, however, for the king died in 1559, before the painting had been completed. The fleur-de-lis on the saddleback of the mule in this version, indicating its French destination, is also faintly visible in the Escorial and Cleveland versions. (This is not surprising, since Titian often repeated himself.) An inventory of 1618 lists this painting as a gift to the Biblioteca Ambrosiana from Cardinal Federigo Borromeo.

The painting in the Prado was listed in Charles IV's collection ca. 1785 (Wethey, I, 66) and was mentioned in the inventory made at Aranjuez in 1818 (no. 139).

The painting in the Escorial—sent there in 1574—was first described by Padre Siguenza in 1599 and later, by Padre Santos (1657–1698). It was also highly praised by Antonio Ponz in 1773 (Wethey, I, 66). Because the painting had been neither restored nor cleaned (it would not be cleaned until 1963) and was therefore barely visible in the poor light of the Iglesia Vieja, Crowe and Cavalcaselle (1877) mistakenly called it a Spanish copy, and thought that the version in the Prado was the one sent to the Escorial in 1574.

The composition and color of the four major versions vary only slightly in minor details, although the greatest departure is the Ambrosiana painting. The curious monogram on the bundle at the extreme right in the Cleveland painting does not appear in the Ambrosiana picture, and the camels behind the shed and the kneeling man at the extreme right are also missing. The robes worn by the Madonna and the first two kings are quite different from

Figure 191*b*. *Adoration of the Magi*. On canvas. 141 x 219 cm. Titian. Museo del Prado, Madrid.

Figure 191*c*. *Adoration of the Magi*. On canvas. 138 x 222 cm. Titian. El Escorial, Madrid.

those in the other three paintings. The horseman with raised hand at the upper right in the Ambrosiana version is considered by Wethey to be a self-portrait. Fritz Heinemann (orally, 1974) suggested that the figure at the extreme right in the Cleveland version is a self-portrait. The distant landscape with trees is found only in the Ambrosiana version. The Cleveland painting is the only one with a sunset. The pose of the horse in the foreground of all four paintings is undoubtedly of classical origin and was copied by Anthony van Dyck (Figure 191d) between 1622 and 1628 for his *Italian Sketchbook*. The first of the Magi, who appears in the costume of the Spanish court of the mid-sixteenth century, is probably a portrait of Philip II—not his father, Emperor Charles V (as frequently stated in the literature), who had already retired to the Monastery of Yuste in Estremadura, where he died in 1558. The year 1558 is the generally accepted date of the Cleveland painting.

In the nineteenth century, attributions for the Cleveland

Figure 191d. Drawing by Sir Anthony van Dyck after a painting by Titian. Chatsworth House, England. Reproduced by Courtesy of the Trustees of The British Museum, London.

Adoration were made to Bassano (Waagen, 1854) and to Schiavone or Bassano (Crowe and Cavalcaselle, 1881), but since then the Cleveland picture has generally been accepted as the work of Titian. Valcanover (1960) listed the Cleveland version under attributed works. Georg Gronau (letter of March 28, 1958) and L. Venturi (1933) thought it was undoubtedly by Titian. Tietze (1937, 1950) thought the Prado canvas was the first, and the Cleveland version second; he dated the Cleveland picture about 1559. Berenson first thought the painting in the Prado was the original version but later (*Tizian, Leben und Werk*, 1957) changed his opinion, saying that the Cleveland picture was the first. Pallucchini (1969) said it was a late work by Titian, of ca. 1560–65, and Wethey (1969), as pointed out earlier, suggested that it is probably the painting Vasari saw in Titian's studio in 1566. Wethey originally proposed that the provenance of the Cleveland painting was the Balbi Palace in Genoa, but later, in an addenda to volume I of his *Paintings by Titian* (published in volume III, 1975, 257) and in a letter of July 26, 1972, he corrected himself, saying that the Balbi Palace painting was instead the *Adoration* by Jacopo Bassano (now in the National Gallery of Scotland, Edinburgh). Wethey's position has since been corroborated by Hugh Brigstocke (1978).

Mayer (1930) suggested the unlikely possibility that the Cleveland painting was the one that originally hung in the Escorial. Unable to accept the Escorial picture as the work of Titian, he suggested that the original Titian had been removed during the French occupation of Spain under Napoleon in 1808 and that it was replaced by a Spanish copy. In 1937 Mayer withdrew this opinion and, at the same time, called the Cleveland painting the best of the existing versions.

Among variants after Titian is a painting in Belluno, church of S. Stephano (Taddeo Jacobi, *MSS on Titian*, 1817, as Ticozzi; Francesco Beltrame, *Tiziano Vecellio e il suo monumento*, 1853, p. 33, as Titian; Crowe and Cavalcaselle, 1881, II, 435, as Cesare Vecelli, Titian's pupil and cousin; Burroughs, 1930, p. 268, as Cesare Vecelli). Another variant, in the Österreichische Galerie in Belvedere, Vienna, is mentioned by Crowe and Cavalcaselle (1881, II, 456; see also Burroughs, 1930, p. 268). Others are: formerly in the collection of M. Altri, Paris (Mayer, 1937, pl. IIa, p. 183, where it is suggested that this is the latest version, begun by Titian and finished by pupils); formerly in a private collection in Bologna (Suida, 1933, pl. CCLVI); and the W. Löthy collection, Aarburg, Switzerland (E. Tietze-Conrat, 1954, pp. 3–8, in which it is said that this is the version painted for Cardinal Ippolito of Ferrara). An unidentified "Adoration des rois, du Titien, sur bois" is mentioned in an inventory of May 7, 1709, of the Château Chantilly (Mireille Rambaud, *Documents du Minutier Central concernant l'histoire de l'art*, 1700–1750, Archives Nationales, Paris, 1964, I, 526, 689). NCW

EXHIBITIONS: New York, Metropolitan Museum of Art, 1930: Exhibition of Works from the Arthur Sachs Collection (no catalogue); Art Institute of Chicago, 1933: A Century of Progress Exhibition of Paintings and Sculpture, cat. no. 138, pl. xx; New York, Metropolitan Museum of Art, 1934: Landscape Paintings, cat. no. 4; CMA (1936), cat. no. 180, pl. XXXI; New York, World's Fair, 1939: Masterpieces of Art, cat. no. 385; Toledo (Ohio) Museum of Art, 1940: Four Centuries of Venetian Painting, cat. no. 60, pl. 60; California Palace of the Legion of Honor (San Francisco) and Santa Barbara Museum of Art, 1946: Exhibition of the Collection of Arthur Sachs (no catalogue); Art Institute of Chicago, 1954: Masterpieces of Religious Art, p. 28, illus. p. 29; CMA (1956), cat. no. 51, pl. XIII.

LITERATURE: Waagen (1854), II, 267 (collection of Miss Rogers, as Bassano); Hugh A. J. Munro, A Complete Catalogue of Paintings (London, 1865), p. 15, no. 23; J. A. Crowe and G. B. Cavalcaselle, Life and Times of Titian (London, 1881), II, 308–9, 519–20 (as copy by Schiavone or Bassano); George Redford, Art Sales (London, 1888), I, 104; R. R. Carter, ed., Pictures and Engravings at Haughton Hall, Taporley (Cheshire) in the Possession of Ralph Brocklebank (London, 1904), p. 4, no. 2; Algernon Graves, Art Sales from Early in the Eighteenth Century to Early in the Twentieth Century (London, 1921), III, 211, 213; Bryson Burroughs, "Titian's Adoration of the Kings: An Important Loan," Metropolitan Museum of Art Bulletin, XXV (1930), 268–71, illus. p. 269; August L. Mayer, "Eine Anbetung der Heiligen Drei Könige von Tizian," Pantheon, V (1930), 60, 62, illus.; L. Venturi (1931), p. 386, pl. CCCLXXXVI; Wilhelm Suida, Tizian (Zurich and Leipzig, 1933), pp. 137–38, 174, 188; Venturi (1933), III, no. 526, illus.; Suida, Titien (Paris, 1935), p. 141; Hans Tietze, Tizian (Vienna, 1936), II 295–96, fig. 257; Mayer, "Two Pictures by Titian in the Escorial," Burlington Magazine, LXXI (1937), 183; Tietze, Titian's Paintings and Drawings (London, 1937), p. 336, pl. 257; Theodor Hetzer, in Thieme-Becker, XXXIV (1940), 116; Luc Bouchage, "Louvre to California, Today's Collectors: Arthur Sachs," Art News, XLV (October 1946), 75; Thomas C. Howe, Jr., "The Arthur Sachs Collection," Bulletin of the California Palace of the Legion of Honor, IV, no. 7 (1946), 59, illus. p. 60; Howe, "Two Paintings by Titian," Bulletin of the California Palace of the Legion of Honor, V (September 1947), 34–39, illus. p. 37; Tietze, Titian, The Paintings and Drawings (London, 1950), p. 49; Giovanni Galbiati, Itinerario dell'Ambrosiana (Milan, 1951), p. 189; E. Tietze-Conrat, "L'Adorazione dei Magi del Tiziano dipinta per il Cardinale di Ferrara," Emporium, CXIX (1954), 8, n. 5; Bernard Berenson (1957), I, 184; Berenson, Tizian, Leben und Werk (Leipzig, 1957), p. 234; CMA Bulletin, XLV (1958), illus. pp. 64–65; Julius S. Held, "Le Roi à la Chasse," Art Bulletin, XL (1958), 146; Milliken (1958), illus. p. 35; R. F. C., "Ingrandito e riaperto il Cleveland Art Museum," Emporium, CXXIX (1959), 21, illus. p. 19; Henry S. Francis, "Titian: The Adoration of the Magi," CMA Bulletin, XLVII (1960), 59–63, figs. 1–3; Francesco Valcanover, Tutta la pittura di Tiziano (Milan, 1960), II, 70, pl. 171 (under attributed works); Jaffé (1963), p. 460; Francisco Javier Sánchez-Cantón, Museo del Prado, Catalogo de la Pinturas (Madrid, 1963), p. 702 (second ed., Milan, 1972); Rodolfo Pallucchini, Tiziano (Florence, 1969), I, 165, 308, and II, figs. 444 and 447; Valcanover, L'Opera completa di Tiziano, Classici dell'Arte, vol. 32 (Milan, 1969), p. 129, no. 424, illus.; Harold E. Wethey, The Paintings of Titian (London, 1969), I, no. 5, pp. 66–68, pls. 122–23; Fredericksen and Zeri (1972), pp. 202, 273, 574; Arlene J. Diamond, "Cardinal Federico Borromeo as a Patron and a Critic of the Arts and His 'MVSAEVM' of 1625" (Ph.D. dissertation, University of California at Los Angeles, 1974), p. 85, 123, illus. fig. 26; American Artists in Europe (Liverpool, 1977), p. 8, under no. 2; Omaggio a Tiziano: La Cultura artistica milanese nell'età di Carlo V (Milan, 1977), p. 39; Hugh Brigstocke, Italian and Spanish Paintings in the National Gallery of Scotland (Edinburgh, 1978), p. 13, n. 15; CMA Handbook (1978), illus. p. 109; Angelo Walther, Tizian (Leipzig, 1978), pp. 53, 55, 190, pl. 76.

Circle of TITIAN

192 Head of St. John the Baptist 53.424

Canvas, 50.1 x 75.2 cm; with added shims, 52 x 76.5 cm.
Inscription on ribbon entwining the reed cross: ECCE AGNUS
DEI.
Collections: [Alessandro Brass, Venice].
Mr. and Mrs. William H. Marlatt Fund, 1953.

The painting was thoroughly examined by Richard Buck at
the Intermuseum Laboratory at Oberlin, Ohio, in 1971, at
which time superficial dirt was removed without disturbing
the varnish. The damage to the lined canvas is extensive;
fine flaking and general overall abrasion have exposed the
open-weave fabric in many tiny spots. Though the evidence
is vague and inconclusive, it is possible that the painting
may be a fragment from a larger piece.

When Giuseppe Fiocco (1924) discovered the painting at
the Vienna exhibition of 1924 he published it immediately
as the work of Titian, basing his opinion on a notation by
Carlo Ridolfi in *Le maraviglie dell'arte, ovvero, Le vite*
degli'illustri pittori veneti e dello stato (Venice, 1648, pt. 1,
175–76), where it is implied that Titian made a likeness of
Pietro Aretino as John the Baptist from a marble bust by
Sansovino. No such painting or sculpture by either artist is
known. Tietze and Tietze-Conrat (1936) question the ac-
curacy of Ridolfi's statement as well as the Titian attribu-
tion. Fiocco's premise was accepted by Suida (1933), Fogli-
ari (Exh: 1935), and Poensgen (1936). Berenson (1955,
1956, 1957) attributed the painting to Lorenzo Lotto, al-
though he confessed "that the modelling of the face is un-
usually good for Lotto, yet not too good for what he might
do under the strong influence of Titian." Wethey (1969)
thought the Lotto attribution unjustified and called it Ve-
netian School after 1580. It was published as School of
Titian by Fredericksen and Zeri (1972). NCW

EXHIBITIONS: Vienna, Sezession (second exhibition by the Verein der
Museumfreunde), 1924: Meisterwerke Italienischer Renaissance Kunst
aus Privatbesitz, cat. no. 112; Venice, Palazzo Pésaro, 1935: Mostra di
Tiziano, cat. no. 63 (catalogue by Gino Fogliari); CMA (1956), cat. no.
22, pl. IX.

Figure 192.

LITERATURE: Giuseppe Fiocco, "Notes of Various Works of Art: A Historical Titian," *Burlington Magazine*, XLV (1924), 199, illus. p. 198; Wilhelm Suida, *Tizian* (Leipzig, 1933), pp. 132, 175, pl. 268B (French ed., Paris, 1935, pp. 136, 180); Christopher Norris, "Titian: Notes on the Venice Exhibition," *Burlington Magazine*, LXVII (1935), 128; Georg Poensgen, "De Italiaansche Voorjaarstentoonstellingen in Venetië, Parma, Bologna en Brescia," *Maanblad voor Beeldende Kunsten*, XIII (1936), 19, fig. 2; Hans Tietze and E. Tietze-Conrat, "Tizian-Studien," *Jahrbuch der Kunsthistorischen Sammlungen in Wien*, X (1936), 140–41, illus. p. 141; Fernando A. Ghedini, *Note d'Arte* (Milan, 1940), p. 131, illus. p. 133; Bernard Berenson, *Lotto* (Milan, 1955), p. 141, pl. 317; Berenson, *Lorenzo Lotto* (London, 1956), pp. 106, 463, pl. 317; Berenson (1957), I, 101; Henry S. Francis, "Portraits by Lorenzo Lotto," *CMA Bulletin*, XLIV (1957), 43–46, illus. p. 42; Isabel Combs Stuebe, "The Johannisschüssel: from Narrative to Reliquary to Andachtsbild," *Marsyas*, XIV (1969), 10, n. 61; Harold E. Wethey, *The Paintings of Titian* (London, 1969), I, 178, no. x-34; Fredericksen and Zeri (1972), pp. 202, 518, 574; Rodolfo Pallucchini and Giordana Mariani Canova, *L'Opera completa del Lotto*, Classici dell'Arte, vol. 79 (Milan, 1975), no. 353 (under attributed works); *CMA Handbook* (1978), illus. p. 111.

FRANCESCO TREVISANI

1656–1746

Francesco Trevisani was born in Capodistria in 1656. He received his first lessons in drawing from his father Antonio, an architect. He was then sent to Venice for his formal training under Antonio Zanchi d'Este, who, with Giambattista Langetti and Johann Carl Loth, dominated the artistic scene in Venice. Trevisani was also in touch with the Augsburg painter Giuseppe Heintz, who had settled in Venice in 1625. In about 1678 Trevisani went to Rome, but nothing is known about his activity there until 1682, when he received his first commissions from Cardinal Flavio Chigi, who remained his patron throughout his life. His altarpieces, most of them destined for non-Roman sites, revealed his admiration for Guido Reni and Carlo Maratta. Not until 1696, in his fortieth year, did he paint his first Roman altarpiece—for the Crucifixion Chapel of San Silvestro in Capite. In 1697 he was admitted to the Academy of St. Luke. In 1730 he received the title of Cavaliere. In 1712 Trevisani, who was known for his poetry as well as his paintings, became a member of the Accademia degli Arcadi—an illustrious circle of literati, painters, and musicians, whose membership included the painters Carlo Maratta; his daughter, Faustina; and Giuseppe Ghezzi; the composer Arcangelo Corelli; and (most important to Trevisani) fellow Venetian Cardinal Pietro Ottoboni (Trevisani had painted Ottoboni's portrait in 1689, the year he became a cardinal). Ottoboni became one of the artist's most loyal patrons, and he gave him a studio in his palace at the Cancelleria. Trevisani died in Rome in 1746.

193 *Holy Family with St. Anne, Joachim, and the Young St. John* 74.108

Canvas, 157.9 x 106.7 cm.

Collections: Count Lorenzo Sferra-Carini and heirs, Rome; [Hazlitt Gallery, London].

Mr. and Mrs. William H. Marlatt Fund, 1974.

The lined canvas is the original size. It is in excellent condition except for scattered minor losses along the edges.

There is a mood of tranquility about this painting, a certain gentleness in all the figures, and a harmony of colors, of light and dark, that seem to reflect the "new" aesthetic, the "buon gusto," nurtured by the Accademia degli Arcadi in Rome (Olszewski, 1977, p. 29). The subject itself was a favorite among the Arcadians, who had chosen the Bambino Gesù—the Child who was born in a manger among shepherds—for their patron (DiFederico, 1977, p. 15).

The cat in the immediate left foreground of the painting implies that Trevisani knew of the *Madonna della Gatta* by Giulio Romano (Museo Nazionale, Naples), or other Renaissance examples (Olszewski, 1977, figs. 19–21). Giulio Romano's *Holy Family*, too, includes St. Anne and the young St. John but not St. Joachim.

Except for a smaller number of angels in glory and a few other minor details, the Cleveland painting has virtually the same composition as Trevisani's altarpiece in the Oratorio di S. Maria in Via in Rome, commissioned by Cardinal Ottoboni in 1729 (Figure 193a). DiFederico (1977) believes the Cleveland painting is a replica of this larger altarpiece because it is similar in light and colors to works that are roughly contemporary with the altarpiece, such as the *Birth of the Virgin* (Bolsena, S. Cristina) of ca. 1722–26 and the *Ecstasy of St. Francis* (Rome, S. Maria in Aracoeli) of 1729. Olszewski (1977, p. 33), on the other hand, suggested that the Cleveland painting preceded the altarpiece. He argued for a date in the mid-teens because of its close relationship to the *Madonna of the Rosary* at Narni (Cathedral), painted in 1714. The *Madonna* does in fact share some basic compositional elements with the Cleveland painting, and both display the pronounced classicism which is more typical of the earlier period in Trevisani's development.

Ellis Waterhouse (*Roman Baroque Painting*, Oxford, 1976, p. 118; and letter of November 6, 1977), Giancarlo Sestieri, and Anthony Clark saw the Museum's painting in the Eroli Studio on the Via del Babuini in Rome in 1972; the painting, according to Professor Pio e Silvio Eroli (letter of February 1, 1978), belonged to the Conte Lorenzo Sferra-Carini at that time. Waterhouse called the painting "a very good *modello* for the high altar of S. Maria in Via . . ."—thus agreeing with Olszewski's argument that the Cleveland painting preceded the altarpiece, though Waterhouse did not necessarily agree with Olszewski's dating in the mid-teens. If Waterhouse is correct, and our painting is indeed the *modello* for the altarpiece commissioned by

Figure 193.

Cardinal Ottoboni, then it is also possible—in fact, quite likely—that Ottoboni at one time owned the Cleveland painting.

Trevisani's biographer, Lione Pascoli, mentioned a *Holy Family* by Trevisani; no positive connection has been made between this and the painting now in Cleveland. A *Holy Family* was sold by the Earl of Oxford to Lady Ilchester in 1741 (Algernon Graves, *Art Sales from Early in the Eighteenth Century to Early in the Twentieth Century,* London, 1921, III, 216), but nothing further is known of its history. The title is too general and might well refer to any of a number of similar subjects—Rest on the Flight to Egypt, for example, of which Trevisani himself painted several versions. One, dating from ca. 1715, for Cardinal Ottoboni, now in the Gemäldegalerie, Dresden (Olszewski, 1977, fig. 6) has two cherubs—one holding a roll of swaddle —who are nearly identical to those in the *Holy Family* in S. Maria in Via. These cherubs also appear in two other related versions of the *Holy Family* that closely resemble Trevisani's altarpiece: one, formerly in Dresden, is now lost (*ibid.*, fig. 16); the other was sold on the art market in London (Sotheby's, March 5, 1969, no. 110, 132 x 94 cm). While these two paintings may have derived from an engraving after the altarpiece in Rome (both paintings are in reverse), some of the changes—in one the angel choir is replaced by God the Father and the Holy Dove—are so basic as to suggest the existence of another variant by Trevisani himself.

Pierre Rosenberg recently acquired a *Holy Family* by an admirer of Trevisani (148 x 101 cm), the only extant, close copy after the altarpiece in S. Maria in Via. DiFederico mentions two other *Holy Family* paintings: one, an altarpiece in the church of St. Heinrich in Prague (which he had not seen); and the other, a variant of the altarpiece of S. Maria in Via in the church of St. Agricol at Avignon (DiFederico, 1977, p. 65, under nos. 89 and 91). ATL

Figure 193a. *The Holy Family.* On canvas. Trevisani. S. Maria in Via, Rome.

EXHIBITIONS: CMA, March 1975: Year in Review, cat. no. 51, illus.

LITERATURE: Frank R. DiFederico, *Francesco Trevisani, Eighteenth Century Painter in Rome, A Catalogue Raisonné* (Washington, 1977), p. 65, no. 90, pl. 74; Edward J. Olszewski, "A Rediscovered *Holy Family* by Francesco Trevisani," CMA *Bulletin,* LXIV (1977), 25–36c, fig. 1.

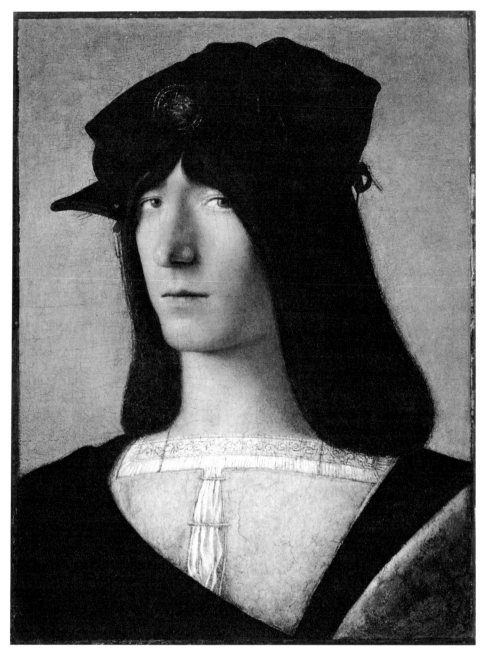

Figure 194.

BARTOLOMMEO VENETO
First half of sixteenth century

Very little is known of the life of the Lombard-Venetian artist Bartolommeo Veneto. His earliest-known painting, *Madonna with a View of Padua* (Venice, Palazzo Donà delle Rose), is dated 1502 and is signed "Bartolamio mezo Venizian e mezo cremonese," which might indicate either that his parents came from Cremona and Venice or that he himself lived in those two cities. He was probably a pupil of Giovanni Bellini; he was influenced by Giorgione and Lotto and also by the Milanese painters Boltraffio and Solario. After 1505 he used *Venutus* or *de Venetia* in his signature, which suggests that he had left Venice by this time. Records show that a Bartolommeo da Venezia worked at Ferrara from 1505 to 1508. The date on his last painting has been read as 1530 (Berenson, 1957, I, 11) or 1546 (Philip Hendy, *Some Italian Renaissance Pictures in the Thyssen-Bornemisza Collection*, Lugano, 1964, p. 159).

194 *Portrait of a Youth* 40.539

> Panel (transferred from original panel to canvas and back to panel), 42 x 30.8 cm. Painted surface: 39.4 x 29.2 cm.
>
> Collections: Baron Michele Lazzaroni, Rome and Paris, 1913; [Lord Duveen of Millbank, New York, 1914]; James Parmelee, Washington.
>
> Bequest of James Parmelee, 1940.

Unfortunately, this painting is very badly damaged and has been extensively repainted. It was transferred from the original panel before entering the Museum collection. In 1960 it was transferred back to panel by William Suhr. Despite the loss of a considerable amount of original paint (particularly in the jaw and lower cheek, in the hair, and in much of the background), the portrait still retains much of its original style and beauty.

Bernard Berenson, in the earliest-known publication of this picture (1916), dated it after 1520. Most authorities since have dated it between 1512 and 1515. This portrait and a version formerly in the Theodore M. Davis collection, Newport, Rhode Island (Mayer, 1928, p. 578), are among the earliest examples—perhaps earlier than 1512—in a continuous series of half-length male portraits by Bartolommeo which gradually became less Venetian, less indicative of Giovanni Bellini's influence, and more mannered in style.

It has been suggested more than once that the somewhat blurred Renaissance bronze medallion on the sitter's hat was the work of Andrea Briosco, called Riccio (Rossi, 1974, p. 81), and that it represents an allegory of humanistic virtue (perhaps of Fortune and Virtue or of Justice).

NCW

EXHIBITIONS: New York, Duveen Gallery, 1924: Exhibition of Early Italian Paintings, cat. no. 45 (see Valentiner, 1926); Art Institute of Chicago, 1933: The Century of Progress Exhibition, cat. no. 102; CMA (1936), cat. no. 173; San Francisco, Golden Gate International Exposition, 1939: Masterworks of Five Centuries, cat. no. 19, pl. 19.

LITERATURE: Bernard Berenson, *Venetian Painting* (New York, 1916), pp. 259–60, fig. 107; Richard Offner, "A Remarkable Exhibition of Italian Paintings," *The Arts*, V (1924), illus. p. 265; W. R. Valentiner, *A Catalogue of Early Italian Paintings Exhibited at the Duveen Galleries, New York April to May 1924: An Illustrated Record of Important Paintings by Old Masters Acquired by Sir Joseph Duveen and Disposed of by Him to Notable American Collectors* (New York, 1926), no. 45, illus.; August L. Mayer, "Zur Bildniskunst des Bartolommeo Veneto," *Pantheon*, II (1928), 90, 574, illus. p. 575; A. de Hevesy, "Un Bartolomeo Veneto," *Pantheon*, VII (1931), 227; Ernst Michalski, "Zur Stilkritik des Bartolommeo Veneto," *Zeitschrift für bildende Kunst*, LXV (1931–32), 180; L. Venturi (1931), pl. CCCLXIV; Berenson (1932), p. 52; Venturi (1933), III, pl. 477; Charles R. Beard, "Cap-Brooches of the Renaissance," *Connoisseur*, CIV (1939), 292; William M. Milliken, "A Hat Jewel of the Renaissance," CMA *Bulletin*, XXVI (1939), 122; Henry S. Francis, "The Bequest of James Parmelee," CMA *Bulletin*, XXVIII (1941), 16–17, illus. p. 21; *Duveen Pictures in Public Collections of America* (New York, 1941), pl. 146; Berenson (1957), I, 11; Fritz Heinemann, *Giovanni Bellini e i Belliniani*, I, (Venice, 1959), 78, 87, no. S. 3; Ferruccia Cappi Bentivegna, *Abbigliamento e costume nella pittura italiana*, I (Rome, 1962), 191, fig. 257; Fredericksen and Zeri (1972), pp. 17, 524, 573; *Dizionario* (1972), I, 386, fig. 377; Francesco Rossi, *Placchette, Sec. XV–XIX*, (Brescia, 1974), p. 81; William D. Wixom, *Renaissance Bronzes from Ohio Collections* (Cleveland, 1975), p. 4, repr. fig. 2; CMA *Handbook* (1978), illus. p. 102.

PAOLO VERONESE (Caliari)
1528–1588

Paolo Veronese was born in Verona in 1528. He died—a much respected painter—in Venice in 1588. He first went to Venice in 1555 (perhaps earlier) and was fascinated by the life and pageantry of the city. Vasari says he was a pupil of Caroto, but Ridolfi and Borghini say he studied with Antonio Badile, whose daughter he married in 1566. Veronese was very much influenced by Titian, as well as Domenico Brusasorci, Parmigianino, Moretto da Brescia, and Giulio Romano. He was a prolific painter of portraits; religious and mythological subjects; and many large works for contemporary villas, palaces, and churches. He shared with Tintoretto the role of leading painter of Venice after the mid-century, succeeding Titian, who was by then an elderly man. Numerous sources and documents tell us much about Veronese's life, but because few of his paintings are dated, the chronology of his work has been difficult to establish. Apparently Paolo's brother, Benedetto, and his sons Carlo and Gabriel, carried on his studio after his death. One of his close associates was Gianbattista Zelotti (ca. 1526–1578). He had many followers—the Veronese painter Paolo Farinato (1524–1606) was one—and imitators, such as the Paduan painter, Alessandro Varotari (called Il Padovanino, 1588–1648).

Figure 195.

Canvas, 102.2 x 104.2 cm.

Collections: [Miethke, Vienna, 1927]; [Italico Brass, Venice].

Gift of Mrs. L. E. Holden, Mr. and Mrs. Guerdon S. Holden, and the L. E. Holden Fund, 1928.

The painting is in stable condition. It is not possible to ascertain whether it had been cut down from a larger size because at some time in the past 8.9 centimeters on the left, 4.8 centimeters on the right, and 10.2 centimeters on the bottom had been added. When William Suhr lined the canvas in 1949 the additions were removed. There is marked abrasion over the entire surface, and there are small losses in paint and ground surfaces. The painting was cleaned in the Museum laboratory in 1978 to remove surface dirt.

Milliken (1928) first published the painting as a portrait of Ammiraglio Manfrin, an unidentified person whose name associates him with the Manfrin provenance given the painting at the time of its acquisition. A painting of nearly the same size, described as a "Ritratto di Onfrè Gius." by Caliari, was mentioned in the Manfrin sales catalogue of 1856, in Venice (information kindly provided by T. Pignatti, letter of January 28, 1980); a catalogue of a later auction, held at the Manfrin Gallery in Venice in 1897, does not list such a painting.

By comparing the Museum portrait with other portraits, Gombosi (1928) showed that its subject was actually Agostino Barbarigo, descendant of two doges, prominent Venetian philosopher, diplomat, and proconsul. In 1571 Agostino Barbarigo was second in command of the Venetian forces at the naval battle at Lepanto, where he was killed by a Turkish arrow. Gombosi based his identification on the close similarity between the Museum portrait and the portrait of Barbarigo in the *Apotheosis of the Battle of Lepanto* by Veronese in Venice, Palazzo Ducale. Portraits of Barbarigo by Veronese include one mentioned by C. Ridolfi (*Le Maraviglie dell'arte, ovvero, Le vite degli'illustri pittori veneti e dello stato . . .* , 1648, ed. Detlev von Hadeln, Berlin, 1914–24, II, 225). Another—called *Generale Barbarigo*, showing the subject with an arrow in one hand and a staff in the other—was listed in the collection of Giorgio Bergonzi in Venice in 1709 (C. A. Levi, *Le Collezione Veneziane d'Arte e d'Antichità dal secolo XIV ai mostri giorni*, II, Venice, 1900, 159–69, quoted in Pignatti, 1976, p. 237), but no documentation has been found that would identify this painting with the Museum portrait. Kelly (1931) supported the Barbarigo identification of the sitter in the Museum portrait by publishing (pl. IX, p. 213) an inferior full-length portrait by Veronese of the same sitter which has always been known as *Agostino Barbarigo*; this portrait was in the collection (as no. 116) that the Archduke Ferdinand II of Austria assembled before his death in 1595, and it is still preserved in his castle at Ambras, near Innsbruck.

Other artists also executed portraits of Barbarigo. The Budapest Museum owns a smaller study (60.2 x 48 cm) of the head of Barbarigo, after Veronese (Garas, 1965, no. 45; and Pignatti, 1976, cat. no. A 39). Another portrait (102.2 x 102.2 cm) seems to have been taken directly from the Cleveland portrait, with only a slight variation—a bit more of the sitter shows at the bottom of the canvas (a possible indication that the Museum's portrait might have been cut down); this painting was in the collection of Henry Doetsch (sale: Christie, Manson, and Woods, London, June 22, 1895, no. 43, as Tintoretto), subsequently in the collection of Louis Einstein, London, and now in the National Gallery, Washington (*European Paintings and Sculpture*, Washington, 1968, p. 123). There is also an anonymous, sixteenth-century Venetian woodcut portrait of Barbarigo inscribed with his name (Friedrich Lippmann, ed., *Engravings and Woodcuts by Old Masters*, VII, London, 1899, no. 47). Tiziano Aspetti executed a bronze bust portrait of Barbarigo, which is now in Venice, Palazzo Ducale (A. Venturi, *Storia dell'Arte Italiana*, Milan, 1937, XI, pt. 3, fig. 224).

Pallucchini (Exh: 1939) and others suggested that Veronese's drawing study of armor in Berlin, Kupferstichkabinet (no. 5120), was used as a model for the armor in the Cleveland painting.

Most scholars accept the Museum portrait of Barbarigo as the work of Veronese. Arslan (1948), however, suggested it was by Veronese's son Carletto.

The painting has been dated ca. 1565–70, but because Barbarigo is represented here with the arrow that mortally wounded him, it is more likely that it was executed shortly after his death in 1571.　　　　　　　NCW

EXHIBITIONS: CMA (1936), cat. no. 110; Venice, Palazzo Justinian, 1939: Mostra di Paolo Veronese, cat. no. 52 (catalogue by Rodolfo Pallucchini); CMA (1956), cat. no. 61, pl. XXXVIII; Los Angeles County Museum, 1979/80: The Golden Century of Venetian Painting, cat. no. 44, color illus. (catalogue by Terisio Pignatti).

LITERATURE: György Gombosi, "Veronese," *Magyar Müvészet*, IV (1928), 724, 728; William M. Milliken, "The Portrait of Ammiraglio Manfrin by Paolo Veronese: A New Accession for the Holden Collection," CMA *Bulletin*, XV (1928), 63–65, illus. pp. 61–62; Francis M. Kelly, "A Problem of Identity," *Connoisseur*, LXXXVII (1931), 211, pl. VIII; L. Venturi (1931), pl. CCCCXVII; Bernard Berenson (1932), p. 420; Venturi (1933), III, pl. 568; Giuseppe Fiocco, *Paolo Veronese 1528–1588* (Rome, 1934), pp. 32, 127; Erich von der Bercken, "The Paolo Veronese Exhibition at Venice," *Pantheon*, XXIV (1939), 30; CMA *Bulletin*, XXI (1939), illus. p. 127; Edoardo (Wart) Arslan, "Nota su Veronese e Zelotti," *Belli Arti*, I (1948), fasc. 5–6, p. 236, n. 10; Andor Pigler, *A Régi Képtár Katalógusa* (Budapest, 1954), p. 609; Berenson (1957), I, 130; Luisa Vertova, *Veronese* (Milan, 1959), unpaginated; Erica Tietze-Conrat, "Paolo Veronese Armato," *Arte Veneta*, XII–XIV (1959–60), 99; Klára Garas, *Italian Renaissance Portraits* (Budapest, 1965), no. 45, color illus.; John Walker, *National Gallery of Art* (Washington, 1965), p. 138; Guido Piovene and Remigio Marini, *L'Opera completa del Veronese*, Classici dell'Arte, vol. 20 (Milan, 1969), no. 139a, p. 11, illus.; Fredericksen and Zeri (1972), pp. 39, 510, 573; Everett Fahy and Sir Francis Watson, *The Wrightsman Collection*, Vol. V: *Paintings, Drawings, and Sculpture* (New York, 1973), pp. 19–20; Terisio Pignatti, *Veronese* (1976), I, cat. no. 172, pp. 135, 174, and II, fig. 449; CMA *Handbook* (1978), illus. p. 112; Detlev von Hadeln, *Paolo Veronese*, ed. Gunter Schweikhart (Florence, 1978), pp. 106, 120, under no. 36, fig. 137.

PAOLO VERONESE (Caliari)

196 *The Annunciation* 50.251

Canvas, 150 x 133.4 cm.

Collections: Balboni, Venice, until 1913; Leopold Koppel, Berlin; Albert Koppel, Switzerland and Toronto; [Rosenberg & Stiebel, New York].

Gift of Hanna Fund, 1950.

The painting is in very good condition. A crack running from the top to the bottom of the canvas, through the angel's shoulder, resulted perhaps from folding the canvas at some time before it was lined; the crack has been retouched. There is also a repaired tear below the protruding knee of the Virgin. There are minor retouchings in the leg of the angel and in the neck and hand of the Virgin. Linear reinforcements, now discolored, are disturbing.

The earliest documentation for this painting is the handwritten catalogue of the Koppel collection, by Max J. Friedländer, who states it was sold in 1913 by Balboni in Venice. Scholars have universally published it as an autograph work. Francis (1951), Vertova (1959), and others have dated it ca. 1572–73. Most recently Pignatti (1976) published it as a very late work, basing his judgment on the degree of compassion represented; the treatment of light and color; and the similarity to the *Annunciation* in the Suida-Manning collection, New York, and *The Martyrdom of St. Lucy* in the Bowes Lyon collection, near Kincardine, Ireland (Pignatti, 1976, I, nos. 315 and 279, respectively), both of which are considered to be late works. NCW

EXHIBITIONS: CMA (1956), cat. no. 60, pl. XLIII; Art Gallery of Ontario (Toronto), 1960: Titian, Tintoretto, Paolo Veronese with a Group of Sixteenth-Century Venetian Drawings, cat. no. 15, illus.; Poughkeepsie, New York, Vassar College Art Gallery, 1964: Masterpieces of 16th-Century Art (no catalogue).

LITERATURE: *Archiv für Kunstgeschichte*, II, no. 3 (Leipzig, 1914–15), no. 50, illus.; Henry S. Francis, "*Annunciation* by Veronese," CMA *Bulletin*, XXXVIII (1951), 39–40, illus. pp. 17 and 18; William M. Milliken, "1916 Cleveland 1951," *Art News*, XLIX, no. 2 (1951), illus. p. 34; B. Berenson (1957), I, 130, and II, pl. 1077; Luisa Vertova, *Veronese* (Milan, 1959), unpaginated; Rodolfo Pallucchini, "Tiziano, Tintoretto e Veronese a Toronto," *Arte Veneta*, XIII–XIV (1959–60), 300; Guido Piovene and Remigio Marini, *L'Opera completa del Veronese*, Classici dell'Arte, vol. 20 (Milan, 1968), 130, no. 297, illus. p. 131; Rudolf Heinemann, et al., *The Thyssen-Bornemisza Collection* (Castagnola, 1969), p. 346; Fredericksen and Zeri (1972), pp. 39, 305, 374; Terisio Pignatti, *Veronese* (Venice, 1976), I, no. 317, pp. 96, 162, 193, and II, figs. 679–82; CMA *Handbook* (1978), illus. p. 114; Detlev von Hadeln, *Paolo Veronese*, ed. Gunter Schweikhart (Florence, 1978), pp. 92, 116, no. 19, fig. 97.

Figure 196.

451

ANONYMOUS MASTER
Cremonese School, seventeenth century

197 *Portrait of Robert Castiglione* 16.804

Canvas, 121.2 x 98.7 cm. Inscription across bottom of the canvas: ROBERTVS CASTILLIONEVS CREMONAE PRETOR/ET IMPERIALIS VICARIVS AN D MCCXXXXVI.
Collections: James Jackson Jarves; Mrs. Liberty E. Holden, Cleveland, 1884.
Holden Collection, 1916.

The original fabric is in two pieces, with a vertical seam the entire length, slightly to the right of center. The painting had been lined sometime in the nineteenth century. The top and bottom of the original canvas appear to be cropped. The left and right tacking margins have been let out, increasing the overall width. Infrared examination revealed no extensive losses nor areas of restoration, although there are numerous spots of repair which may be associated with fabric damage. There is an intermittent cut or tear, sixty-seven centimeters long, running horizontally through the sitter's beard. There are restorations along all the edges and scattered throughout, most notably in the hat of the sitter and along the tear. Aged varnish has become dark and yellowed, and grime is embedded in the recesses of the paint. Colors are badly distorted.

The condition of this portrait makes it difficult to attribute. When the painting was purchased by Jarves, it was thought to be by Paris Bordone, in the circle of Titian. Later, Rubinstein (1917) gave it a more general attribution as North Italian. Various scholars over the years have suggested one of the Campi of Cremona (see Painting 140), or the Brescian School. The most convincing comment was made by Dr. Mina Gregori (orally, 1969); she suggests the possible authorship of Pietro Martire Neri (1591–1661), a painter born in Cremona who worked closely with Velázquez in Rome in 1650 and signed at least two copies of portraits of Innocent X in the manner of the master. One of these he changed to a full-length double portrait of the pope, with a prelate, not imitating Velázquez's modeling in the face. He also painted a portrait of Cristofo Segni, a major-domo to the pope, apparently after a lost sketch by Velázquez (August L. Mayer, "Pietro Martire Neri, ein Italienischer Nachahmer des Velazquez," *Belvedere*, VII, 1928, 60–63, figs. 1–3; and José López-Rey, *Velázquez' Work and World*, Greenwich, Connecticut, 1968, pp. 116, 126, pls. 142 and 167).

This portrait, commissioned in the seventeenth century, commemorates the period when the city of Cremona was under Spanish domination. The inscription, one line of which may have been cut, identifies the subject as Robert Castiglione, a prominent governing magistrate and imperial vicar in 1246, and a member of a branch of the Castiglioni family in Milan, whose coat of arms appears in the upper left. The distinguished office of imperial vicar dates back to Diocletian's partitioning and reorganization of the Roman Empire in the late third century. NCW

EXHIBITIONS: Boston (1883), cat. no. 434; Cleveland (1894), cat. no. 7.

LITERATURE: Jarves (1884), cat. no. 27; Rubinstein (1917), no. 22, p. 25; Underhill (1917), p. 20, illus. p. 17.

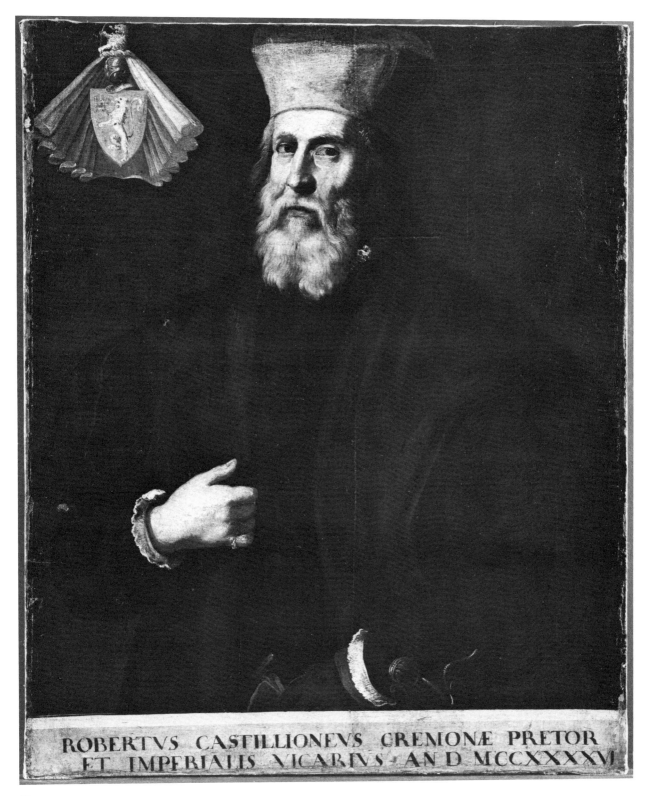

Figure 197.

453

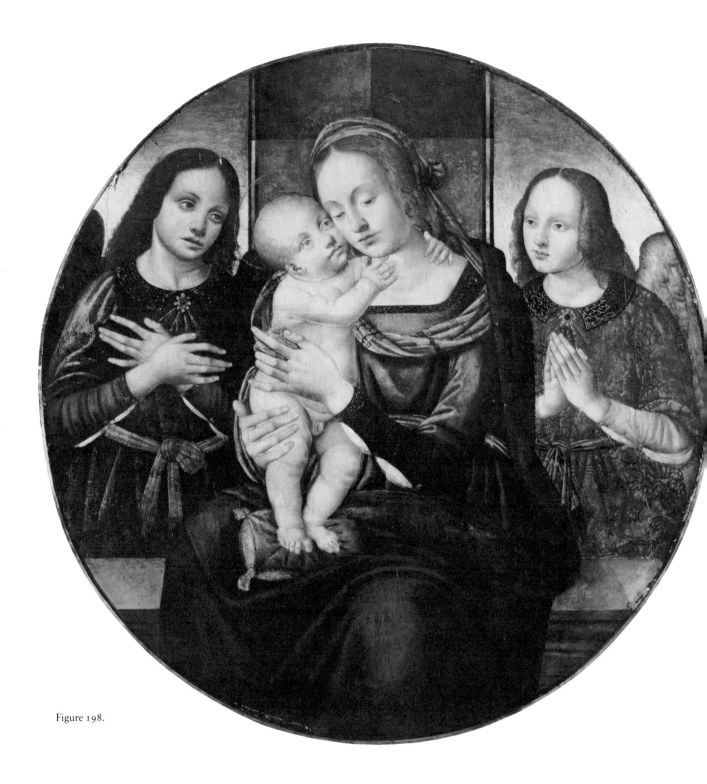

Figure 198.

ANONYMOUS MASTER

Florentine School (?), early sixteenth century

198 *Madonna and Child with Angels* 16.791

> Tondo panel (probably poplar), 89.8 x 85.4 cm.
>
> Collections: James Jackson Jarves; Mrs. Liberty E. Holden, Cleveland, 1884.
>
> Holden Collection, 1916.

Before it entered the Museum collection this panel was thinned down to 1.9 centimeters, and a cradle was applied. In 1942 it was cleaned by William Suhr, who removed a great deal of overpaint. Because the panel is severely worm-eaten, the painting is in unstable condition and in need of further attention. A vertical crack runs through the center. There are losses of paint film and gesso along the edges and along the crack as well as paint losses in the faces, in the blue garment of the Madonna, in the upper areas of the brocade in the center background, and in the left upper part of the sky.

This tondo was attributed to the Florentine School by Jarves (1884), who suggested it was possibly by Fra Diamante. In other publications it has been called school work of Piero di Cosimo, or Florentine School. More recently Everett Fahy (letters of February 2, October 5, and November 26, 1967, and Ph.D. dissertation of 1968, published 1976), attributed a group of works, including the Cleveland panel, to the so-called Master of the Holden Tondo. The work of this master, who seemed to specialize in tondi representing the Madonna and Child with Angels, has been confused in the past with paintings by Piero di Cosimo, Cosimo Rosselli, and Domenico Ghirlandajo. Fahy argued quite convincingly that this artist's work includes such paintings as the tondo of *The Holy Family with the Infant St. John the Baptist* (Figure 198a) in the Museum of Fine Arts, Boston; the tondo of the *Standing Virgin with Three Angels* in the Lee Collection, Courtauld Institute Galleries, London; and the tondo of the *Virgin and Child with Two Angels* in the Galleria Nazionale delle Marche, Urbino (see Fahy, 1976, for a more complete list). NCW

EXHIBITIONS: Boston (1883), cat. no. 443; New York (1912), cat. no. 22; CMA (1936), cat. no. 80.

LITERATURE: Jarves (1884), cat. no. 12, p. 10; M. L. Berenson (1907), p. 3; van Marle (1931), XIII, 381; Rubinstein (1917), no. 10, p. 17; Coe (1955), II, 82, no. 10; Mina Bacci, *Piero di Cosimo* (Milan, 1966), p. 116; Fredericksen and Zeri (1972), pp. 221, 328, 573; Everett Fahy, *Some Followers of Domenico Ghirlandajo* (New York and London, 1976), p. 171.

Figure 198a. *The Holy Family with the Infant St. John the Baptist.* On canvas (transferred from panel), diam. 101.3 cm. Florentine School, 15th century. Museum of Fine Arts, Boston, Bequest of George W. Wales. (Note: The painting is seriously damaged. The photograph shows it partially restored.)

ANONYMOUS MASTER
Genoese School, seventeenth century

199　*Still Life with a Spoonbill,*　　16.1001
　　a Hare, and Fish in a Larder

Canvas, 99.5 x 128.5 cm.
Collections: Mrs. Liberty E. Holden, Cleveland.
Holden Collection, 1914.

The lining canvas is attached with glue, which is becoming brittle. The thinly applied red ground is visible in some background areas. There are minor, scattered paint losses. Infrared and ultraviolet light reveal no evidence of a ledge or table edge.

An old attribution to Frans Snyders (still upheld by Z. v. Manteuffel, 1937) was probably suggested because of the large white bird, which was once believed to be a swan, the hallmark of many of Snyder's still lifes. But, as a "JFK" of the Frick Art Reference Library discovered, the bird is not a swan; it is a spoonbill (*platalea leucorodia*), whose European breeding places—in our day, at least—are the Netherlands, Austria, Hungary, and southern Spain (Kurt M. Bauer and Urs N. Glutz von Blotzheim, *Handbuch der Vögel Mitteleuropas*, Frankfurt am Main, 1966, pp. 430–32). There is a small-scale spoonbill in Snyder's *Concert of the Birds* in the Prado (Matías Díaz Padrón, *Catálogo de Pinturas*, Vol. 1: *Escuela Flamenca Siglo XVII* [Plates], Madrid, 1975, p. 238, no. 1761), but nevertheless the attribution to Snyders is untenable for stylistic reasons.

Silvano Lodi (orally, during a visit to this Museum in 1975) suggested the Spanish artist Alejandro de Loarte (active ca. 1626), who often used similar compositions for his larder still lifes. His paintings, however, invariably show a ledge, and none features a large white bird. Spanish scholars, among them Ramón Torres Martín (letter of July 6, 1976) and José Gudiol, found the attribution to Loarte, or any other Spanish artist, unacceptable.

William Jordan (letter of September 22, 1977) and Ingvar Bergström (letter of April 6, 1976) both proposed an Italian master, Bergström tentatively suggesting an artist from Naples, close to G. B. Recco and G. B. Ruoppolo.

The combination of dead and live animals, including hens or cocks, occurs in numerous seventeenth-century larder still lifes—Flemish, Spanish, and Italian alike. Live hens or cocks were particularly popular with the Genoese artist Antonio Mario Vassallo (see his *Larder* of ca. 1650–60 in the National Gallery, Washington). The bird in flight resembles Paolo Porpora's bird in *Still Life with Fruit and Flowers* (Palazzo San Vervasio, Pinacoteca Civica, Potenza).

Charles Sterling (letters of August 26, 1977, and October 10, 1978) suggested a master from Genoa, pointing to the striking white bird—this one a swan—in Bernardo Strozzi's *The Cook* (Palazzo Rosso). Strozzi's swan was in turn influenced by Snyder's swans, and it helped to reinforce the image among Genoese painters, both Italian and Flemish. As Sterling remarked, no other Italian Seicento painters featured such dramatic white birds in their still lifes. Another example is the swan in Pieter Boel's *Still Life* (collection of Baron Descamps, Brussels). Boel was a pupil of Jan Fyt and a nephew of Cornelis de Wael, whose sojourn in Italy included a stay in Genoa (Raffaello Soprani and Carlo Giuseppe Ratti, *Vite de' pittori, scultori, ed architetti genovesi*, I, Genoa, 1768, 466).

Sterling also convincingly argued for a Genoese master on the basis of style, referring to the way the brushstrokes in the hair and feathers parallel the already established contours of the animals. Also Genoese is the light, feathery touch with which the artist described not only feathers but the rabbit's fur and the scales of the fish as well. Works by Vassallo and the Cassanas come to mind. Ferdinando Arisi (letter of April 30, 1979) suggested that Giovanni Agostino Cassana (1658–1713) might well be the painter of the Cleveland picture, which he compared to Cassano's signed still life with fish and vases, dated 1704, now in the Nessi Collection at Bergamo. Everett Fahy (orally) suggested another Genoese painter, Bartolommeo Guidobono (1654–1709), whose animals in the *Sorceress* (Metropolitan Museum of Art) seem stylistically related to those in our painting.

The juxtaposition of the dead spoonbill with the bird in flight evokes symbolic overtones of life and death and reveals the hand of an innovative artist trained in the Italo-Flemish tradition.　　　　　　　　　　　ATL

EXHIBITIONS: None.

LITERATURE: Rubinstein (1917), p. 42, no. 48; Underhill (1917), p. 21; Z. v. Manteuffel, in Thieme-Becker, XXXI (1937), 190.

Figure 199.

Figure 200.

ANONYMOUS MASTER
Italo-Flemish, active ca. 1550–65

200 *Portrait of a Gentleman and* 16.793
His Wife

> Canvas, 100.3 x 141 cm. Inscription at upper left: AETA. SVAE.
> ANNO. XXXV. Inscription at upper right: AETA. SVAE. ANNO.
> XXVIII.
>
> Collections: James Jackson Jarves; Mrs. Liberty E. Holden,
> Cleveland, 1884.
>
> Holden Collection, 1916.

The painting is in generally good condition. It was cleaned
by William Suhr in 1948 and by Joseph Alvarez in 1960.
The paint surface is slightly abraded, particularly in the face
of the man and at the lower edge of the canvas. There are
small spots of repainting on the face of the woman.

Jarves (1884) attributed the painting to Giovanni Bat-
tista Moroni (ca. 1520/25–1578) from Bergamo, an artist
who was known for his austere and faithful realism in por-
traiture. Berenson (1907) at first accepted the attribution to
Moroni but then rejected it in favor of the possible author-
ship of Jan Stephan von Calcar (born in the duchy of Cleves,
was active ca. 1536, and died in Naples ca. 1546). The
Moroni attribution was revived later by Pillsbury (1971).
Merten (1928) and Cugini (1939) called the painting North
Italian, mid-sixteenth-century. Others have suggested attri-
butions to Nicolas of Neufchatel (1527–1590), and Antonio
Moro (born between 1517 and 1521, died after 1568).

In arguing for the Moroni attribution, Pillsbury (1971)
compared the male figure in the Cleveland painting with an
early portrait of a male painted by Moroni in 1547 (Phila-
delphia Museum of Art, John G. Johnson Collection). Un-
like Moroni's later portraits (see Painting 167), where the
figures appear in diffused light, in the Philadelphia and
Cleveland portraits the light is relatively harsh, making
their sitters stand out against the neutral background.
However, by comparison with the Cleveland portrait, the
Philadelphia one is distinctly more delicate and softer in
modeling the faces, thereby achieving that subtle character-
ization typical of Moroni which is lacking in the Cleveland
portrait.

Berenson's suggested attribution to Calcar is also uncon-
vincing. Attributions to Calcar, who closely imitated first
the style of Titian and then of Raphael, are generally uncer-
tain. One portrait ascribed to Calcar in a 1659 inventory of
the Austrian Imperial collections was later given to Moroni
(Vienna, Kunsthistorisches Museum, catalogue, 1928, no.
217). Another—a portrait of a male, of 1540 (Paris, Louvre)
—tentatively attributed to Calcar in the inventory of the
French Royal collection in 1683, appears to be weaker,
more diffused in structure, and more Venetian in style than
the Cleveland double portrait.

An attribution to Nicolas of Neufchatel (called Lucidel)
is also untenable, for stylistic reasons. Lucidel was born in
Mons, studied with Pieter Coeck in Antwerp, and worked
as a portraitist in Nuremberg from 1561 to 1567. His por-
traits show some influence from Titian and northern Italian
artists. His style, however, is generally harder and colder
than that of the Museum painting, and his work is closer to
Holbein (to whom his work is sometimes erroneously as-
signed) and to Antonio Moro than is our portrait.

Moro is yet another artist whose portraits bear compari-
son with the Museum painting. Particularly close in style
are two of Moro's self-portraits, one in Florence in the
Uffizi, dated 1558, and the other in the National Gallery,
Washington (formerly in the collection of Lord Spencer,
Althorp; Max J. Friedländer, *Early Netherlandish Paint-
ing*, Vol. XIII: *Antonis Mor and His Contemporaries*, Ley-
den, 1975, p. 102, pls. 176 and 178). These, it is true,
somewhat resemble the man in the Cleveland portrait, but
even if all three portraits are of the same sitter, they are not
close enough stylistically to warrant the suggestion that
they are by the same hand.

The woman in the Cleveland painting is also unidentified.
Those who support a Moro attribution for the painting also
argue for the possibility that she is Moro's wife, but there is
no evidence to substantiate this. We know almost nothing
about Moro's wife, except that her first name was Metgen
(Valerian von Loga, "Antonis Mor als Hofmaler Karls V
und Philipps II," *Jahrbuch der Kunsthistorischen Samm-
lungen des Allerhöchsten Kaiserhauses*, XXVII, 1908, 112,
fig. 10). Loga suggested that she might be the subject of
Moro's *Woman with a Dog* (Prado, *Catalogo*, 1963, no.
2114) because her costume is Northern and her hands are
less noble than those of Moro's usual sitters—the ladies of
the Spanish court at Brussels, Madrid, and Lisbon. Loga
also suggested that the lady in Moro's *Portrait of a Lady* in
the Art Institute of Chicago, dating from ca. 1560–70
(formerly in the collection of Lord Yarborough, Brocklesby;
Friedländer. *op. cit.*, pl. 196), may be of the artist's wife,
because its pendant, *Portrait of a Gentleman* (in the North
Carolina Museum of Art in Raleigh, formerly in the Yar-
borough collection; Friedländer, pl. 196) resembles the
self-portraits by Moro. Although the lady in the Chicago
portrait bears no likeness to the lady in ours, some stylistic
parallels can be drawn between the two paintings, and the
similarity in the costumes suggests a closeness in date.

Similarly, there are stylistic analogies between our por-
trait and Moro's *Portrait of a Man* (ex collections: Baron de
Beurnonville; sale; Sotheby's, London, June 26, 1957, no.
39, illus.), but there are distinct differences as well. It is
noteworthy that the belts and swords worn by the men are
similar, but more importantly it must be acknowledged
that Moro frequently—as in this portrait—treated his men
with more Venetian warmth and his women with more
Flemish realism (see, for example, his *Portrait of Lady*

Gresham, in the Rijksmuseum) than are found in the Cleveland double portrait.

Recently a *Portrait of a Young Nobleman in a French Suit of Armor* (100 x 80 cm; attributed to an anonymous master of the North Italian School of ca. 1570) was bought by Charles H. Schwartz of Hadlyme, Connecticut, in a sale at Christie's, New York, March 20, 1981 (no. 154, illus.). The portrait is strikingly close in style to the Cleveland painting, and the face of the sitter bears a familial resemblance to the woman in the double portrait.

A marten with a jeweled head is held in the left hand of the woman in the Cleveland portrait. This furred accessory became a fashion between the years 1520 and 1580, but usually only in court circles and the top rank of nobility (John Hunt, "Jewelled Neck Furs and Flohpelze," *Pantheon*, XXI, 1963, 151; see also Günther Schiedlausky, "Zum sogenannten Flohpelz," *Pantheon*, XXX, 1972, 469–79), and usually only in northern Italy or areas in close touch, such as the Munich court of Albrecht V and William V, Dukes of Bavaria.

Robert P. Bunkin (letter of May 7, 1976) has suggested that there may be a relationship between our painting and the *Portrait of a Young Noble* by Sofonisba Anguissola (ca. 1535/40–1625, Cremonese School) in the Walters Art Gallery (Federico Zeri, *Italian Paintings in the Walters Art Gallery*, Baltimore, 1976, II, no. 298, pl. 203).

The consensus, in short, seems to be that the Cleveland double portrait is the work of an artist who combined influences from the Netherlands with those of northern Italy, more specifically—because of the style of the sitters' costumes—an Italo-Fleming active in Italy during the beginning of the second half of the sixteenth century. N C W

EXHIBITIONS: Boston (1883), cat. no. 425; New York (1912), cat. no. 20; CMA (1916), cat. no. 27; Denver Art Museum, 1956: Clothes Made for Man (no catalogue); CMA, 1962: Art and Humanism in the Renaissance (no catalogue).

LITERATURE: Jarves (1884), no. 28; Bernard Berenson, *North Italian Painters* (1907), p. 271; M. L. Berenson (1907), p. 5, illus. (as Moroni); Underhill (1917), p. 20, illus. p. 39; Rubinstein (1917), no. 28, illus.; Frank J. Mather, *A History of Italian Painting* (New York, 1923), p. 423; Heinrich Merten, "Giovanni Battista Moroni: Des Meisters Gemälde und Zeichnungen" (Ph.D. dissertation, Philipps–Universität zu Marburg, 1928), p. 112; Adolfo Venturi (1929), IX, pt. 4, 276; Ciro Caverasazzi, "Alcuni ritratti di G. B. Moroni all'estero," *G. B. Moroni Pittore* (Bergamo, 1939), p. 34, illus. p. 41; Davide Cugini, *Moroni pittore* (Bergamo, 1939), no. 98, p. 152; Coe (1955), II, 88, no. 28; CMA *Handbook* (1969), illus. p. 96 (as School of Antonio Moro); Edmund P. Pillsbury, "Two Portraits by Giovanni Battista Moroni," CMA *Bulletin*, LVIII (1971), 75–82, figs. 4, 6, 8, 10; Fredericksen and Zeri (1972), pp. 145, 522, 573 (as follower of Moroni); Berthold Hinz, "Studien zur Geschichte des Ehepaarbildnisses," *Marburger Jahrbuch für Kunstwissenschaft*, XIX (1974), 181, fig. 47; CMA *Handbook* (1978), illus. p. 113.

Figure 201a. *Pope Sixtus IV*. On panel, 116 x 55 cm. Justus van Ghent, Flemish, 15th century, and Pedro Berruguete, Spanish, died 1503. Musée du Louvre, Paris.

460

ANONYMOUS MASTER
Italy (?), early sixteenth century

201 *Portrait of Pope Sixtus IV* 16.815

Canvas (transferred from panel), 70.2 x 51.4 cm.

Collections: James Jackson Jarves, Florence, after 1872; Mrs. Liberty E. Holden, Cleveland, 1884.

Holden Collection, 1916.

The painting was cleaned in 1933 by William Suhr. When the dirty, discolored varnish was removed, many details in the landscape were revealed, and, in fact, the whole formation was changed. The painting was transferred to canvas, probably at least one hundred years ago, judging by the blisters all around the edges. These blisters were treated. Losses in the alb just below the morse, in the left hand and in the face and mouth, and a thin scratch through both eyes have been retouched. In 1939 repeated problems with bloom made further work necessary. Suhr put down the paint along older cracks where the paint film had lifted and again cleaned the whole surface.

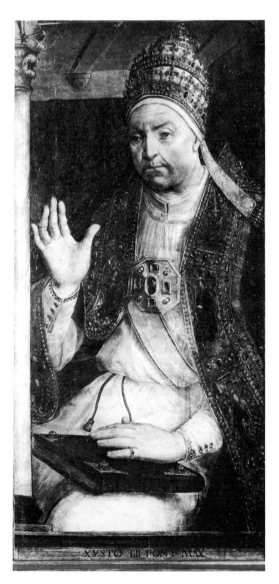

Figure 201.

The picture is a free adaptation of a panel showing Sixtus IV, now in the Louvre (Figure 201a), which once formed part of the decoration of the study of Federigo da Montefeltre in Urbino; according to Lavalleye (1936), the Louvre panel is a product of the early sixteenth century. The closeness of the subject to the frontal plane, the broad forms, the thick-fingered hands, and the beltless garment worn by the sitter in the Cleveland painting are distinct departures from the original. The forms and technique of the landscape vistas are close to Raphael's landscape backgrounds—as, for example, in his portrait of Angelo Doni of ca. 1505 (Florence, Pitti Palace).

Pope Sixtus IV died in 1484; just why a posthumous portrait of him was painted remains to be discovered. The picture has been attributed to Justus van Ghent and to Pedro Berruguete. Berruguete, however, died in Spain in 1503, which would make an attribution to him seem less plausible. W S

EXHIBITIONS: Boston (1883), cat. no. 406; New York (1912), cat. no. 14 (as Italian, sixteenth century); CMA (1936), cat. no. 93 (as Italian [?], late fifteenth century).

LITERATURE: Jarves (1884), cat. no. 10 (as Signorelli); M. L. Berenson (1907), p. 5 (as Justus van Ghent); Rubinstein (1917), no. 19 (as Italian [?], late fifteenth century); Jacques Lavalleye, *Juste de Gand: Peintre de Frédéric de Montefeltre* (Louvain, 1936), p. 138, n. 2; Chandler R. Post, *A History of Spanish Painting*, IX (Cambridge, Massachusetts, 1947), 152–53, 159, 161, fig. 45 (as probably by Berruguete); Coe (1955), II, 81, no. 5; *Juste de Gand, Berruguete et la Cour d'Urbino* (exh. cat., Ghent, 1957), p. 72; Gaya Nuño (1958), p. 116, no. 391 (as Berruguete); José Camon Aznar, *Summa Artis, Historia General del arte*, Vol. XXIV: *La pintura Española del siglo XVI* (Madrid, 1970), p. 179 (as Berruguete).

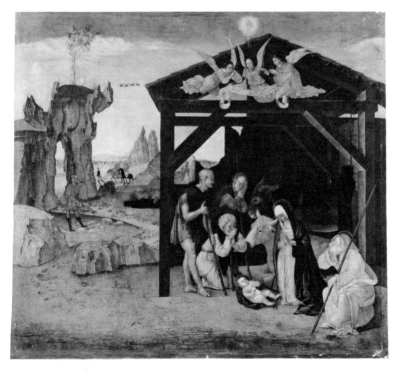

ANONYMOUS MASTER
North Italy, late fifteenth–early sixteenth century

202 *Adoration of the Shepherds* 16.782

Panel (poplar), 41.5 x 29.8 cm.
Collections: James Jackson Jarves; Mrs. Liberty E. Holden, Cleveland, 1884.
Holden Collection, 1916.

The panel is cracked in several places, and it has undergone extensive repainting. It was cleaned in 1953 by William Suhr. The painting is badly abraded, especially in the rocks; in the angel looking over the rocks; and in the face, hands, and knees of Mary. There are less serious abrasions in all the figures, in the cow, and in the left background. Dark spots in the lower left corner and in the background are losses.

This eclectic work has been attributed to Lorenzo Costa (the Elder, 1460–1535), and tentatively to Bramantino (M. L. Berenson, 1907). The Museum had formerly accepted the Bramantino attribution but has more recently been persuaded by the general consensus of art historians that the painting is not by him. Although no convincing alternatives have been suggested, the following have been named as possible authors or influences: Early Gaudenzio Ferrari (Frank J. Mather, notes in Museum files, 1921); Martino Piazza da Lodi (Wilhelm E. Suida, letter of January 4, 1944); Vincenzo Civerchio (Giorgio Nicodemi, letter of August 13, 1950); Butinone (C. Collins Baker, letter of October 25, 1930; Everett Fahy, orally, December 8, 1966); and Francesco Marmitta (E. K. Waterhouse, orally, March 14, 1968).

Certainly comparisons can be made between the Cleveland panel and the works of Butinone, Costa, Marmitta, and the early works of Bramantino. The two shepherds in the foreground and the Virgin and Child seem to have more to do with Costa (cf. the London *Nativity*; see Ranieri Varese, *Lorenzo Costa*, Milan, 1967, p. 37) and Marmitta than with Bramantino, though the general tonality of the picture as well as the foliage and other details recall the latter. A drawing of skeletons, now in Berlin (Wilhelm E. Suida, *Bramante Pittore e il Bramantino*, Milan, 1953, fig. 53), once attributed to Bramantino, recalls the two foreground shepherds in the Cleveland *Adoration*.

Though it is perhaps a little later and not necessarily by the same hand, the Cleveland painting may also be compared with a small *Adoration of the Shepherds* (Figure 202a) once ascribed to Ercole Roberti, now called North Italian, end of fifteenth century, in Cambridge (England),

Figure 202a. *Adoration of the Shepherds*. On canvas (transferred from wood), 37.1 x 40.4 cm. North Italian School, end of 15th century. Fitzwilliam Museum, Cambridge, England.

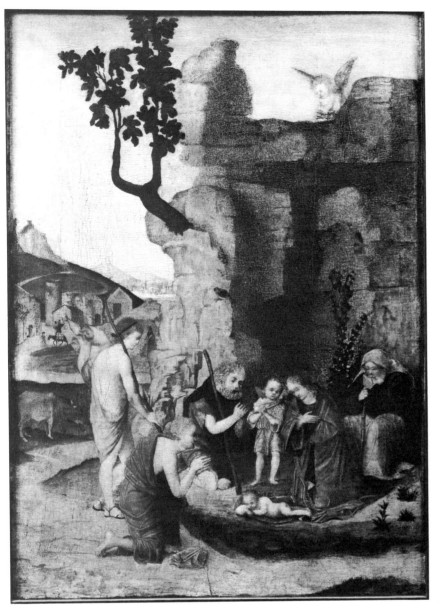

Figure 202.

Fitzwilliam Museum. There is a lack of unity in both paintings. About the Cleveland painting, for example, Rubinstein (1917) remarked that the two shepherds—one kneeling in the foreground and one standing—are not in the spirit of the rest of the composition. A like discrepancy exists between the background landscape and the grotto in the foreground. Similarly, in the Fitzwilliam painting, there is a stylistic division between the almost Borgognone-like figure and the landscape style of the background and foreground. The composition of the Nativity groups in the two pictures is similar, and the kneeling curly-headed shepherds and seated Josephs are almost identical, seemingly derived from some Northern source through Butinone.

The weakness of design of the Fitzwilliam picture suggested to its cataloguers the hand of one who was primarily a miniaturist; the same may apply to the Cleveland picture. A possible candidate for authorship would therefore be Francesco Marmitta (alive 1496, died 1505), gem cutter, illuminator, and painter of Parma, who was influenced by Ercole Roberti, Costa, and Bramantino. Though Marmitta's few known paintings and miniatures seem stronger than our little panel, some of the same types and influences are apparent (cf. the *Flagellation*, in *Sixty European and English Paintings in the National Gallery of Scotland*, Edinburgh, 1958, fig. 3; and the illuminated *Petrarch* in Kassel, Landesbibliothek). E F G

EXHIBITIONS: Boston (1883), cat. no. 20 (as Lorenzo Costa); CMA (1916), cat. no. 7 (as Bramantino[?], close to the Ambrosiana *Nativity*); CMA (1936), cat. no. 78.

LITERATURE: M. L. Berenson (1907), p. 4 (as probably Bramantino, in the period of the London *Adoration of the Magi* and the Cologne *Philemon and Baucis*); Rubinstein (1917), no. 7; B. Berenson (1932), p. 109 (as Bramantino[?]); Coe (1955), II, 82, no. 8; Maria Luisa Gengaro, "Problemi di Metodo per la storia dell'Arte: Il Bramantino," *Arte Lombarda*, I (1955), 123; Fredericksen and Zeri (1972), pp. 35, 270, 573.

Figure 203*a*.

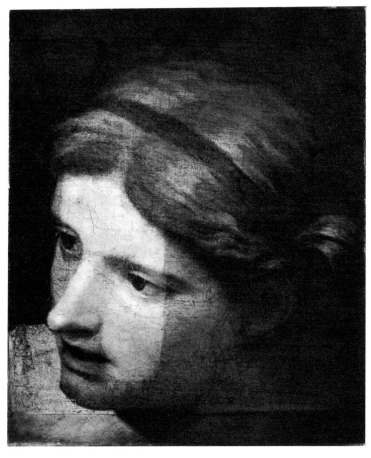

ANONYMOUS MASTER
North Italy, sixteenth century

203 *Listening Angel* 16.965

Canvas, 59.6 x 49.5 cm.

Collections: James Jackson Jarves, New York, before 1883; Mrs. Liberty E. Holden, Cleveland, 1884.

Holden Collection, 1916.

The painting is a badly damaged fragment from what must have been a very large work. The original support, a rather coarse canvas of irregular grain, has one vertical seam just to the right of the figure's ear. The fragment was enlarged at a later date by the addition of narrow horizontal borders at top and bottom, each about five centimeters wide. There is extensive overpaint in the face and shoulders of the figure. X radiographs reveal that the face was larger in its first state and that the whole composition was turned slightly clockwise from its original position in an apparent attempt to improve its proportion and design and prepare it for its new role as an independent composition. Such practices were common in order to render more saleable the mutilated pieces of a larger work. Figure 203*a* shows the picture partially cleaned.

The condition of the painting precludes any firm attribution. In the nineteenth and early twentieth centuries the painting was thought to have been by Correggio, although Jarves (1884) recognized that the added borders were "by another hand." The treatment and style of the hair as well as the facial features are Raphaelesque, though it is perhaps more accurate to suggest that the work is a product of the Bolognese School, a style that was heavily influenced by the works of Raphael and his followers in the first half of the sixteenth century.

Jarves (1884) wrote that a painting from his collection had come from the collection of Cardinal Fesch. Although he cited the *Two Putti* (Painting 211), it is possible that he meant this *Angel*, for in the first sale of the Fesch collection (Rome, March[?] 17–18, 1845, no. 204) there was a painting described as a "Tête d'Ange-Etude à l'instar du Corrège," by Pietro da Cortona. ATL

EXHIBITIONS: Boston (1883), cat. no. 442 (as *Head of an Angel*, by Correggio).

LITERATURE: Jarves (1884), p. 13, no. 34.

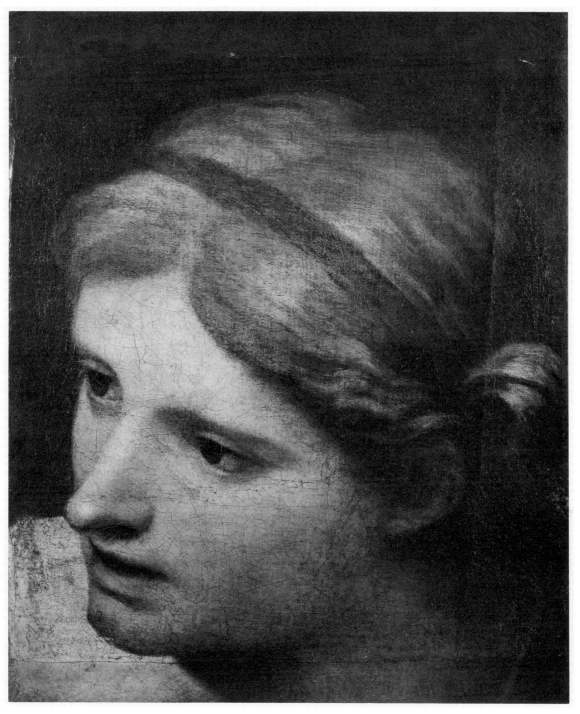

Figure 203.

ANONYMOUS MASTER
North Italy, follower of Jacques Courtois
(Le Bourguignon), early eighteenth century

204 *Battle Scene* 70.157

Canvas, 152.5 x 202 cm.

Collections: Brimo de Laroussilhe, Paris (sale: July 23, 1936); [Brummer Gallery, New York, inv. no. BR 946/9]; Ella Brummer, New York.

Gift of Mrs. Ella Brummer, 1970.

The original medium-weight, plain-weave fabric is in two parts with a horizontal seam in the center (77.5 cm from the bottom); it is mounted on a five-member stretcher. The lining canvas, which is attached with a glue adhesive, also has a horizontal seam (68 cm from the bottom). The paint was thinly applied over a red ground that is bleeding through in scattered areas, partly by design and partly because of abrasions. Brushmarks are visible, and highlights are indicated by a slight impasto. The large canvas is in reasonably good condition except for a few losses along the seam of the original fabric and a major repaired loss about ten centimeters long in the upper left portion of the canvas. The painting is discolored by dirty varnishes and surface grime; it is in the process of being cleaned.

This is one of two battle scenes that were acquired by the Brummer Gallery from Brimo de Laroussilhe in France in 1936. At that time they were attributed to Jacques Courtois (1621–1676), the famous French Jesuit battle painter who was born in Paris but spent most of his active life in Italy. Former owner Ella Brummer gave one of the paintings to this Museum and the other (Figure 204a) to the Museum of Fine Arts, Boston.

Undoubtedly, the two paintings are related compositionally to a number of battle scenes by Courtois—such as the ones in the Corsini Gallery, Florence, and the Pallavicini Gallery, Rome. Courtois's battle scenes and the paintings in Cleveland and Boston have certain characteristics in common: in all there is a crowding of soldiers and a focus on two or three men with drawn swords atop rearing horses (one usually seen from the back). Like Courtois, our artist shows turbaned Moslem and helmeted Christian soldiers engaged in battle, while wounded or dead soldiers lie scattered in the foreground and in the background troops approach from, or retreat to, the hills and distant fortifications. At close range, however, the Cleveland and Boston paintings lack Courtois's plasticity of figures and definition of space. Furthermore, the extreme sketchiness of the brushwork, the flickering light, and the physiognomies (which are almost grotesque), anticipate comparable scenes of the mid-eighteenth century.

Edward L. Holt (letter of April 26, 1971) who has made a thorough study of Courtois's work ("The British Museum's Phillips-Fenwick Collection of Jacques Courtois's Drawings and a Partial Reconstruction of the Bellori Volume," *Burlington Magazine*, CIII, 1966, 345–50), said he doubted that Courtois painted our picture. Basing his judgment on a photograph of the Cleveland painting, Holt suggested an attribution to the Flemish-Venetian Matteo Stom (active in Venice 1688–1700).

Matteo Stom, according to Pignatti, was the painter of three battle scenes now in the Museo Correr in Venice (*Cataloghi di raccolte d'arte*, no. 6: *Dipinti del XVII e XVIII Secolo*, Venice, 1961, II, 321–23, nos. 1676, 1677, and 1703); of the three, only one is still given to Stom (no. 1703), while the others are attributed to Francesco Simonini (1686–1753). Simonini's pictures, both in composition and style, are more closely related to the Cleveland and Boston pictures than is Stom's. One of Simonini's pictures (no. 1677) includes a cluster of soldiers on a hill, which has its counterpart in the Cleveland painting.

All these paintings commemorate one of the many battles fought between Venetians and Turks in the sixteenth and seventeenth centuries. In all the pictures, a striped flag looking very much like the Venetian flag (although the lion cannot be made out), distinguishes the Venetian army from its turbaned adversaries. One of the most famous battles was the battle of Canea, fought around 1668, in which Venice tried in vain to reconquer Crete from the Turks. A picture of this battle (Raffaella Arisi, *Il Brescianino delle Battaglie*, Piacenza, 1975, p. 47, no. 7, fig. 10) was painted

Figure 204a. *Battle Scene*. On canvas, 147.3 x 200.7 cm. Attributed to Jacques Courtois. Museum of Fine Arts, Boston.

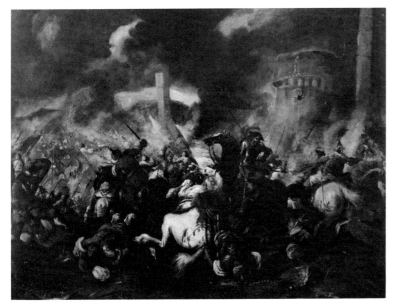

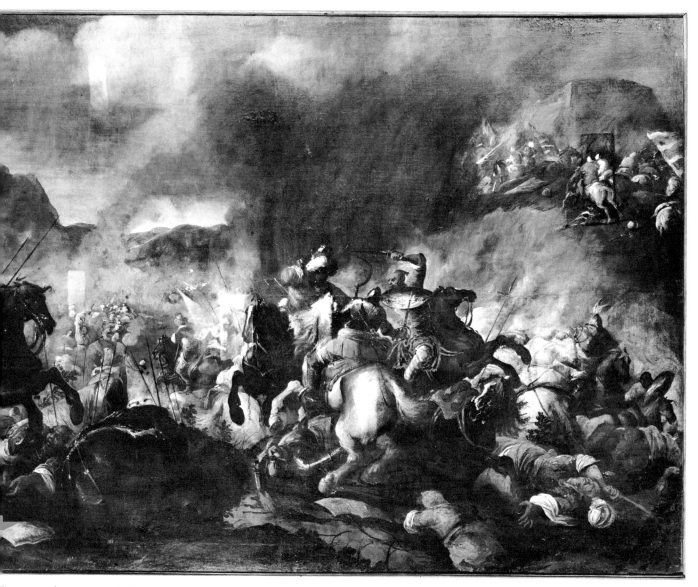

Figure 204 (during restoration).

by Francesco Monti, called Il Brescianino, who was a pupil of Courtois and a strong influence on Francesco Simonini. This or similar battles are also depicted in two paintings by Antonio Calza (1653–1725) from Verona (Licisco Magagnato, *La pittura a Verona tra Sei e Settecento*, exh. cat., Verona, 1978, figs. 53 and 54), who also was strongly influenced by Courtois early in his career. It seems certain that the artist of the two canvases in Cleveland and Boston is related to this circle of Courtois's followers. ATL

EXHIBITIONS: None.

LITERATURE: CMA *Bulletin*, LVIII (1971), p. 65, no. 36.

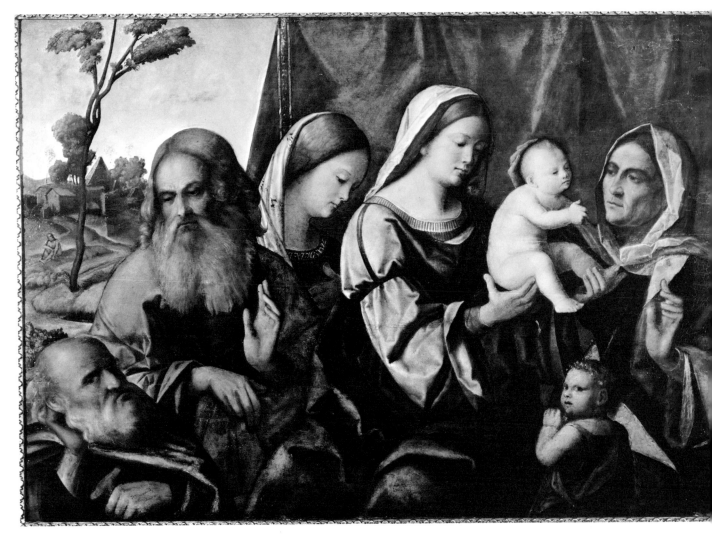

Figure 205.

468

ANONYMOUS MASTER
Venetian School, ca. 1510

205 *Madonna and Child with Saints* 16.796

Panel, 77.8 x 118.8 cm.
Collections: Duke of Mantua (?); [Grassi(?)]; James Jackson
Jarves; Mrs. Liberty E. Holden, Cleveland, 1884.
Holden Collection, 1916.

This panel was cleaned by William Suhr in 1933. It is split horizontally across the entire width just below center. There is considerable loss of paint at both sides of the panel and in the landscape at the left. The faces appear to have suffered less, although there is considerable repaint throughout. The panel will undergo a thorough technical investigation and will probably be transferred to a new, more stable support.

The Christ Child of this painting is here being adored by the young John the Baptist in the lower right. Heinemann (1962) identified the older female saint at the right as Anne, and the elderly saint standing at the left as Joachim, the parents of Mary. Of course, it is also possible that these two represent the parents of John, that is, Elizabeth and Zacharias. Joseph with the staff is at the lower left corner. The young female saint at the left of the Virgin has not been identified.

Jarves (1884), who attributed the painting to Vincenzo Catena, said that the painting was once in the collection of the Duke of Mantua, but as yet no documents have been found to confirm Jarves's statement. M. L. Berenson (1907) attributed the picture to Filippo da Verona, an attribution that has been generally accepted through the years by most scholars, including Bernard Berenson (1957), who added a question mark, and Fredericksen and Zeri (1972). Fritz Heinemann (1962) suggested the Grassi provenance and said the painting was in the manner of Bellin Bellino, whom Ridolfi identified as a member of the Bellini family. Most recently, Anchise Tempestini (1974) associated the painting with "Il Maestro Veneto dell'Incredulita di San Tommaso," the author of a painting in San Niccolò in Treviso. The Museum painting is associated with a group of three "Sacra Conversazione" paintings, all of half-figures (one in the Alte Pinakothek in Munich; and two others in Venice, in the Museo Correr and the Ca' d'Oro), variously attributed to Francesco Bissolo, Rocco Marcone, workshop of Giovanni Bellini, and others.

In its present state the painting cannot be securely attributed, but after cleaning it deserves further serious study.
 NCW

EXHIBITIONS: Boston (1883), cat. no. 415; New York (1912), cat. no. 6; CMA (1936), cat. no. 109.

LITERATURE: Jarves (1884), p. 11, no. 21; M. L. Berenson (1907), p. 3; Thieme-Becker, XI (1915), 565; Rubinstein (1917), no. 13, pp. 18–19; Coe (1955), II, 83, no. 13; B. Berenson (1957), I, 76; Fritz Heinemann, *Giovanni Bellini e i Belliniani*, Saggi e studi di storia dell'arte, no. 6 (Venice, 1962), I, 222, no. v36, and II, 528, fig. 596; Fredericksen and Zeri (1972), pp. 71, 352–53, 573; Rolf Kultzen and Peter Eikemeier, *Bayerische Staatsgemäldesammlungen Alte Pinakothek München: Venezianische Gemälde des 15. und 16. Jahrhunderts* (Munich, 1971), I, 69; Anchise Tempestini, "Il Maestro Veneto dell'Incredulita di San Tommaso," *Antichità Viva*, XIII, no. 2 (1974), 12, fig. 3.

ANONYMOUS MASTER

Venetian School, second quarter of sixteenth century

206 *Death of the Virgin* 16.797

Soft-wood panel (like spruce), 36 x 103.5. Painted surface approximately 25 x 103.5 cm.

Collections: [Gino Capponi Gallery, Florence]; James Jackson Jarves, 1883; Mrs. Liberty E. Holden, Cleveland, 1884.

Holden Collection, 1916.

This horizontal panel from a single piece of soft wood may have been trimmed at the ends; iron straps (.3 x 1.9 cm) are now nailed at the two vertical ends with hand-wrought nails. The lower horizontal edge of the panel shows evidence of fire damage. The wide margins around the painted surface suggest that it may have been enframed as part of a predella, which, being placed at the foot of a large altarpiece, likely would have been susceptible to charring from candles. At some time before Jarves purchased the panel it was removed from its original setting. In order to fit the painting into an elaborately sculptured Venetian frame (acc. no. 16.2079) of the early seventeenth century, 5.6 centimeters of repaint, matching the dirty and yellowed paint of the original, were added to the unpainted margins across the entire length at both the top and bottom. There has been additional and extensive repainting, some of which is very old. In 1977 the discolored varnish and recent restorer's paint were removed and losses were inpainted by the Museum conservation staff. A horizontal split in the center of the panel had caused some loss of paint; this damage was attenuated.

The panel was published as a Tintoretto by Jarves (1884) and as an early Tintoretto(?) by B. Berenson (1957). M. L. Berenson (1907) was the first to attribute it to Polidoro Lanzani (Venetian, 1515[?]–1565), an imitator and copier of Titian who was also influenced by Bonifazio Veronese (de' Pitati), Pordenone, and later by Veronese. Fritz Heinemann (orally, in 1974) suggested Andrea Meldolla (called Schiavone; Venetian, d. 1563), a pupil of Titian who was influenced by Parmigianino; certainly the influence of Parmigianino can be seen in the facial types, fluid brushwork, and sometimes sketchy style of the Cleveland panel. Fredericksen and Zeri (1972) suggest the uncertain attribution of Bonifazio Veronese (Venetian, 1487–1553), a pupil of Palma Vecchio. Unfortunately, the present condition of this panel makes its precise attribution to a particular master impossible. NCW

EXHIBITIONS: Boston (1883), cat. no. 430; New York (1912), cat. no. 16; CMA (1936), cat. no. 95.

LITERATURE: Jarves (1884), no. 25, p. 12; M. L. Berenson (1907), p. 3; Rubinstein (1917), no. 25, p. 27; B. Berenson (1932), p. 463; Georg Gronau, in Thieme-Becker, XXVII (1933), 207; Coe (1955), II, 87, no. 24; B. Berenson (1957), I, 171; Fredericksen and Zeri (1972), pp. 31, 307, 573.

Figure 206.

470

Figure 207.

ANONYMOUS MASTER
Venetian School, ca. 1600

207 *Preparation for the Crucifixion* 16.816

> Copper, 55 x 46.2 cm.
>
> Collections: James Jackson Jarves; Mrs. Liberty E. Holden,
> Cleveland, 1884.
>
> Holden Collection, 1916.

The painting is on a thick (17 mm) copper plate, which was
scored vertically, probably to provide tooth for the paint
layers (scoring is most clearly seen in the thinly painted sky
tones). There is apparently no ground layer; the oil-type
paint was applied directly to the copper as a thin-to-mod-
erately-thick paste. There are areas of open brushwork, and
there is a low impasto in the highlights. The painting was
recently cleaned by the Museum's conservation department.

The earliest attribution of this painting was to an anon-
ymous sixteenth-century Venetian master. According to a
note in the margin of the Holden Catalogue (Rubinstein,
1917), F. J. Mather believed it to be a copy from the seven-
teenth century, though he did not identify the work it cop-

ied. The retardif and the eclectic character of the painting account for the uncertainty in dating and attribution. Painted on copper, which is commonly, though not exclusively, associated with Northern masters, the painting combines elements of Northern mannerism and direct impressions of the imagery and style of the Venetian High Renaissance. Apparently the master was familiar with the art of both schools.

The rather limp figure of Christ, the circular composition, and the half-length foreground figures are striking similarities which the Cleveland painting shares with the *Carrying of the Cross*, an anonymous work close to the Le Nains. Jacques Thuillier (*Les frères Le Nain*, exh. cat., Paris, 1978, p. 278 ff.) suggested that this painting follows a drawing by Luca Penni, which is known in an engraving by Jean Mignon.

Designed in the manner of a *tableau vivant*, the Cleveland painting depicts some five scenes: to the extreme left of center, below the group of riders, John the Baptist is faintly visible, predicting the coming of Christ. The main group in the painting enacts the disrobing of Christ. To the right of this scene, the Virgin, amidst her companions, has fainted, while Mary Magdalene rushes to the scene with both arms outstretched. Behind this group, on the left, faintly visible, Christ is seen carrying the cross. In the foreground a rarely depicted scene is enacted: the dispute over the placement on the cross of the plate bearing the inscription, INRI (*Jesus Nazarenus Rex Judaeorum*, "Jesus of Nazareth, King of the Jews"), which was ordered by Pilate against the will of the Jewish priests (John 19:21; see also Gertrud Schiller, *Ikonographie der Christlichen Kunst*, II, Gütersloh, 1958, 98). Among the figures is a Jewish priest (to the extreme left), a Roman soldier with hammer and nails, ready to carry out Pilate's order, and a group of three persons on the right, separated by an arm of the cross, apparently debating the handing over of the inscription plate to the soldier. The portrait-like bearded nobleman facing the front is reminiscent of Venetian portraits by Tintoretto and his contemporaries; he specifically recalls Tintoretto's bearded man in a similar scene in the *Crucifixion*, in the church of San Cassiano in Venice (Schiller, *op. cit.*, p. 98, fig. 320), though in this work Christ is already on the cross. The rarity of this scene and its similarity to Tintoretto's description suggest that the artist of the Cleveland painting was familiar with Tintoretto's work.

The disrobing of Christ also rarely appears in art, although it occurred on three occasions according to the biblical account: "And they stripped him, and put on him a scarlet robe" (Matt. 27:28); "And after that they had mocked him, they took the robe off from him and put his own raiment on him, and led him away to crucify him" (Matt. 27:31); "And they crucified him, and parted his garments, casting lots . . ." (Matt. 27:35; see also Mark 15:24, Luke 23:34, and John 19:23). The disrobing, as it appears in the Cleveland painting, was likely derived from Bonaventura's *Meditations on the Life of Christ* (ed. Isa Ragusa and Rosalie B. Green, Princeton, New Jersey, 1961, p. 333), where it is described as follows: "He is stripped, and is now nude before all the multitude for the third time. . . . Now for the first time the Mother beholds her Son thus taken." The image of the swooning Mary apparently was also derived from this description (Emile Mâle, *L'Art Religieux de la Fin du Moyen Age en France*, Paris, 1908, p. 29).

Lacking visual examples for this specific disrobing, the artist may have borrowed from comparable figure groups in Venetian versions of the Baptism of Christ, substituting two executioners for St. John on the one side and the angel holding Christ's clothes on the other. Note, for example, the close correspondence between our center group and that in the *Baptism of Christ* attributed to Veronese (London, Courtauld Institute Galleries, Courtauld Lee no. 48); compare also with Tintoretto's *Baptism of Christ* (Painting 190). ATL

EXHIBITIONS: Boston (1883), cat. no. 424; CMA (1936), cat. no. 91.

LITERATURE: Jarves (1884), no. 26 (attributed to Tintoretto); Rubinstein (1917), p. 36, no. 40; Coe (1955), II, 86, no. 23; Fredericksen and Zeri (1972), pp. 246, 286, 573.

ANONYMOUS MASTER
Venetian School, seventeenth century

208 *Martyrdom of St. Andrew* 16.784

Canvas, 40.7 x 34.6 cm.

Collections: James Jackson Jarves; Mrs. Liberty E. Holden, Cleveland, 1884.

Holden Collection, 1916.

The ground and paint layers of the lined canvas are brittle. There are numerous scattered, minor losses, mostly along the edges, in the sky, and in the bottom foreground. The painting was cleaned and restored by William Suhr in 1930. At present the surface is covered with a moderately thick layer of grime; discolored varnish obscures the tonality and color harmony, making it difficult to determine the extent of overpaint.

The old attribution to a Venetian seventeenth-century master is convincing even though the painting was inspired by a Roman work—Guido Reni's *Martyrdom of St. Andrew* of 1608, in the church of San Gregorio al Celio, Rome. Our painting copies the center section of Reni's painting, which actually depicts St. Andrew's adoration of the cross rather than his crucifixion. For completeness of composition and iconography, the artist moved St. Andrew's cross

Figure 208.

into the foreground. Significantly, the cross in our painting is Latin, not the more commonly used, diagonal *crux decussata* that is seen on the distant hill to the right in Reni's painting. The Latin cross was more often used in northern Italy (see, e.g., Jacopo and Francesco Bassano's *St. Andrew*, in the parochial church in Cartigliano), and thus tends to support a Venetian attribution for our painting.

Another painting (private collection, Genoa), probably contemporary with ours, repeats a similar though some-

what larger section of Reni's painting. The artist is the Genoese Domenico Fiasella (1589–1669), who worked in Rome ca. 1607–17. Although he, too, included the cross behind St. Andrew, his cross—like Reni's—is the diagonal type. ATL

EXHIBITIONS: Boston (1883), cat. no. 414.

LITERATURE: Jarves (1884), no. 37; Fredericksen and Zeri (1972), pp. 173, 369, 573, (as copy after Reni).

Figure 209.

474

ANONYMOUS MASTER
Venetian School, ca. 1750

209 *Flowers in an Architectural* 64.286
 Fantasy

Tempera on canvas, 225 x 150 cm.

Collections: Private collection, Florence; [Francesco Romano, Florence]; Severance A. Millikin, 1959.

Gift of Severance A. Millikin, 1964.

The painting is an architectural fantasy which was meant to serve a purely decorative function—probably as one of a group of works originally designed as an ensemble. The unknown artist has here created a sophisticated illusion of depth, which he simultaneously defies with his composition of flowers and shell motifs in the foreground. Such self-conscious artifice, however, is fairly typical of decorative painting. The picture is the essence of the rococo spirit. The clever imitation of marble in the painted, illusory frame, and the delicately harmonized, pastel-like colors indicate a Venetian origin, as do the pierced dome and the rustic scrolls which were popular about the middle of the eighteenth century. The floral and foliate forms were clearly inspired by the flower paintings of Francesco Guardi.

NCW

EXHIBITIONS: Munich, 1958: The Age of Rococo, cat. no. 215.

LITERATURE: None.

Figure 210.

476

ANONYMOUS MASTER
Venetian School, eighteenth century

210 *Christic and the Woman Taken* 16.785
 in Adultery

Canvas, 34.6 x 43.5 cm.
Collections: Miner K. Kellogg; Mrs. Liberty E. Holden,
Cleveland.
Holden Collection, 1916.

On the stretcher, next to a seal which has lost its markings,
is a handwritten notation in ink: "Pordonone." The canvas
is lined. The painted surface is discolored by dirty varnish,
surface grime, and residue from previous cleaning(s). The
painting was last cleaned by William Suhr in 1949. There
are scattered small paint losses, and the thinly applied paint
is considerably abraded.

Henry S. Francis was the first to identify the painting
with the work of Sebastiano Ricci. Although its execution is
clearly inferior to Ricci's, the painting is in fact a direct copy
after Ricci's *Christ and the Woman Taken in Adultery* in
The Minneapolis Institute of Arts (Jeffery Daniels, *Sebas-
tiano Ricci*, Hove, Sussex, 1976, p. 76, fig. 127). While the
Minneapolis picture had originally been given to G. B. Tie-
polo, Anthony Blunt (Blunt and Edward Croft-Murray,
Venetian Drawings of the XVII and XVIII Centuries, London,
1957, p. 52), more convincingly attributed it to Ricci.

Fritz Heinemann (letters dated November 29, 1972, and
November 25, 1978) suggested that the copyist could be
the Venetian painter Giambattista Mariotti (ca. 1685–
1765). Heinemann compared the Cleveland painting with
Mariotti's sketch for the *Raising of Lazarus* in the Museo
Civico in Padua, and with other paintings by Mariotti in the
church of S. Croce, also in Padua, pointing out particularly
close parallels in the treatment of the garments.

Another possible candidate for the attribution of the
Cleveland picture is Gasparo Diziani, who was Ricci's most
faithful pupil and admirer. Diziani actually owned one of
Ricci's works, the *Adoration of the Shepherds*, according to
the inscription on Monaco's engraving after that painting.
Diziani made a copy (Venice, Academy) of another work by
Ricci, the *Satyr Visiting the Peasant* (Paris, Louvre; Edoardo
(Wart) Arslan, "Oeuvres inédites de Sebastiano Ricci," *Ga-
zette des Beaux-Arts*, XIII, 1935, 39, figs. 4 and 5), which
inspired the suggestion that the Cleveland painting may
also be a copy after Ricci by Diziani. Our picture, however,
is a much more exact copy after the original than is Dizi-
ani's *Satyr*.

Jefferey Daniels, during a visit to the Museum in 1980,
suggested that Francesco Fontebasso may have painted this
copy during his early years in Ricci's studio, in the 1730s.

ATL

EXHIBITIONS: Cleveland (1894), cat. no. 12; CMA (1936), cat. no. 92.

LITERATURE: Rubinstein (1917), p. 37, no. 41; Coe (1955), II, 86, no.
22; E. P. Richardson, "Archives of American Art Records of Art Collec-
tors and Dealers, I: Miner K. Kellogg," *Art Quarterly*, XXIII (1960), 274,
279–80, fig. 6; Fredericksen and Zeri (1972), pp. 247, 280, 573 (as Vene-
tian School, seventeenth century).

Figure 211.

Copy after CORREGGIO
Eighteenth century (?)

211 *Two Putti* 16.966

Canvas, 103 x 81.5 cm.

Collections: Cardinal Fesch, Palazzo Falconieri, Rome (?); James Jackson Jarves; Mrs. Liberty E. Holden, Cleveland, 1884.

Holden Collection, 1916.

Its present condition precludes a sound stylistic analysis of the painting. There is considerable overpaint. Dirty varnishes have rendered the light greenish-blue background (as seen in Correggio's frescoes at S. Paolo) a mossy green, the pink flesh tones a bronze color, and the pearly gray horn a brass color. These changes were observed when varnish and overpaint were removed from small problem areas during preliminary conservation examination. The original canvas seems to be in moderately good condition and may date as late as the eighteenth century. The canvas was lined about a century ago, judging from its condition and the wormholes in the stretcher. The stretcher was apparently replaced at the time the canvas was lined, for there are additional nail holes in the canvas which do not match the position of the nail holes in the present stretcher.

According to Jarves (1884), this painting came from the collection of Cardinal Fesch. However, there is no mention of the canvas in existing catalogues of the sales of this collection. It seems likely there was some confusion between this painting and the *Listening Angel* (see Painting 203) at the time of Jarves's publication.

The painting is a copy after one of the sixteen ovals with playful *putti* that Correggio painted for the spaces between the vaulting ribs below his ceiling fresco in the Camera di S. Paolo in Parma, executed ca. 1519. According to Cecil Gould (*The Paintings of Correggio*, London, 1976, p. 51), the frescoes allude to Diana as goddess of the chase. The frescoes had been commissioned by the Abbess Gioanna da Piacenza for her private quarters in the Benedictine nunnery of S. Paolo, but after her death in 1524 "the house was put under a strict *clausura* and virtually no sightseers were admitted for more than two centuries" (Gould, *op. cit.*), that is, until the 1790s, when the newly accessible paintings made a great impression on the art world. Gould (letter of January 14, 1979) also points to the possibility of an intermediate prototype, possibly a drawing done during the lifetime of the abbess, when the paintings were at least partially accessible, or even a presently unknown cartoon by Correggio himself. In any event, it seems most likely that the Cleveland painting copies a work contemporary with Correggio's, if not Correggio's own. But, given the present condition and apparent age of our canvas, it seems reasonable to conclude that it was painted at least no earlier than the late seventeenth century, but prior to the 1790s—that is, during the time Correggio's ceiling frescoes were inaccessible.

In the nineteenth century Paolo Toschi made a popular series of engravings after the Correggio frescoes. The Cleveland painting, however, seems to predate these.

A drawing at the Weimar Museum depicting five of the ovals with *putti* does not include the subject that inspired the copy in Cleveland. ATL

EXHIBITIONS: Boston (1883), cat. no. 419.

LITERATURE: Jarves (1884), no. 32.

Russia

ANONYMOUS MASTER

Byzantine style, late seventeenth–early eighteenth century

212 Portable Triptych Icon: 61.35
 The Crucifixion, The Resurrection, and
 Adoration of the Miracle-Working Icon,
 Vladimir Mother of God

Tempera on panels, in hinged brass frame, each panel enclosed in
cloisonné enameled inserts. Left panel 6.5 x 6.2 x .7 cm; center
panel 6.5 x 6 x .2 cm; right panel 6.2 x 6 x .5 cm. Overall
dimensions of frame when closed (including knobs and hinges):
7.3 x 6.9 x 3.4 cm. Inscribed throughout in traditional Church
Russian (Church Slavonic) with names of prophets, saints, etc.
Engraved on outside of brass frame (Figure 212a) is a cross with
the symbols of the Passion, inscribed (top to bottom): The King of
Glory; Jesus Christ; Victor; Lance [with which Christ was
speared]; Stick [tipped with acid to aggravate the wound]; the
initials R, B, M, L, G, G, standing for various personages
represented in the paintings; and at the lower center, the Russian
letters G A ("Golova Adama": Head of Adam).

Collections: Mrs. Harry F. Stratton, Cleveland.

Gift of Mrs. Harry F. Stratton, 1961.

All three panels appear to be stable. The central panel has a
slight convex warp. The tempera is very thinly applied, and
in some areas—such as the flesh tones, the architecture, the
folds of drapery, and the robe of the archangel—the draw-
ing is applied directly on the white ground. Small, scattered
losses on all panels have been covered with restorer's paint;
for example, the inscriptions on the right panel were ap-
plied over later gold paint along the top. Some of the draw-
ing—as in the crowns of the saints in the center panel—
bridges the crackle and losses, and is presumed to be later.
There is considerable loss in the center panel at the lower
left, where the entrance to Hell is described. The panel on
the left was examined under the microscope, at which time
inscriptions and lines could be seen beneath the dark sky on
either side of the cross, but these are not decipherable even
with the aid of infrared light. Uneven, yellowed varnish
distorts the pictures, and it is difficult to distinguish varnish
from glazes. In the center panel a cloisonné rabbit (of un-
determined date but certainly not earlier than the seven-
teenth century) obscures a partially rubbed Russian inscrip-
tion under it. The center panel is the only one of the three
that has a cloth backing.

Figure 212a. Exterior of brass frame.

Figure 212b. Inscription on paper scrap.

480

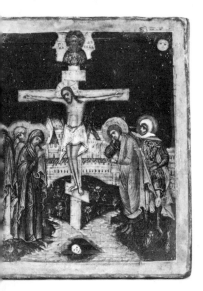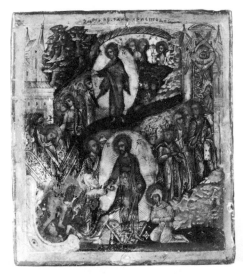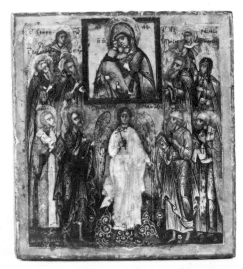

Figure 212.

A scrap of paper (Figure 212*b*) was found behind the center panel, but it is damaged and very difficult to read. Professor A. Dean McKenzie of the University of Oregon, who translated the numerous inscriptions and identified the iconography of the panels, likewise examined the writing on the paper scrap and in a letter of January 29, 1979, said that it refers to two brothers: Ivan Dmitrievich, one of the brothers, apparently presented this icon as a gift to his younger brother.

The first panel is a standard representation of the Crucifixion. It includes the walls of Jerusalem in the background, John the Evangelist and Longinus on the right, and the three Marys on the left. Above Christ on the cross is the Lord of Sabaoth; below the cross is the skull of Adam. The sun and the moon are in the upper corners.

The center panel describes the resurrection of Christ, who appears in two scenes: above, after leaving the tomb; and, lower center, at the mouth of Leviathan. In the lower scene, Adam and Eve are with Christ; the halos symbolize their sanctification in preparation for their resurrection with Christ. Others stand waiting to be rescued. Also in the lower scene, John the Baptist testifies to Christ's descent into Hell, where the Devil appears at the open chasm. In the upper right, Kings Solomon, David, and others are led by the Good Thief to the Garden of Paradise, whose doors are guarded by a seraph.

The third panel represents the adoration of the miracle-working icon. The icon, Vladimir Mother of God, in the upper central part of the panel, was originally painted in Constantinople about 1130 and is presently in the Tretyakov Gallery in Moscow. Below the icon a guardian angel, probably Michael, holding a sword and cross, is flanked by nine adoring saints—most likely the patron saints of the donors (left to right): George, Saba, Basil, John Chrisostomos, John the Baptist, John the Evangelist, Nicholas, Gregory, and Paraskevi.

All the figures in the three panels are in traditional Byzantine robes, with the exception of Longinus in the first panel, who is in armor, and St. George, at the extreme left in the third panel, whose robes reflect an Italian Renaissance tradition.

Such portable icons, which could be folded up and carried on trips, were quite common in Russia from about the seventeenth century. This exquisite small triptych was probably executed in the late seventeenth or early eighteenth century. It is in the Byzantine tradition of the School of Moscow. N C W

EXHIBITIONS : CMA, 1961: Year in Review, cat. no. 69, illus. p. 243.

LITERATURE : None.

Spain

AGUSTIN ESTEVE Y MARQUES
1753–1820(?)

Esteve was born in Valencia in 1753 (Baron de Alcahali, *Diccionario biografico de artistas valencianos*, Valencia, 1897, p. 111). He studied at the Academy of Fine Arts of San Carlos in Valencia. In 1772 he arrived in Madrid. He was deeply influenced by the theory and painting of Anton Rafael Mengs (1728–1779). He was an assistant to Goya, beginning probably in the early 1780s. After Charles IV and Queen Maria Louisa of Parma succeeded to the throne of Spain in 1788, Goya was made official court painter (in 1789). As Goya's assistant, Esteve made many royal portraits and replicas; he also produced portraits of merit independently. In 1800 the king named him "painter to the court." He probably did not work with Goya after 1808. When his royal patrons went into exile, Esteve, like Goya, painted Joseph Bonaparte's officials, but he remained a loyal Spanish patriot and was reinstated as court painter after the expulsion of the French. He painted his last royal portrait in 1816, by which time he was in financial difficulty and in ill health. He died in 1820 or soon after (Martin S. Soria, *Agustín Esteve y Goya*, Valencia, 1957).

213 Portrait of Juan Maria Osorio-Alvarez (The Boy with a Linnet) 46.431

Canvas, 120 x 84 cm. Inscription across bottom of the canvas: ELS. D. JUAN MARIA, OSORIO, ALVAREZ. D TOLEDO: NACIO EN 28 DAGOSTO, D 1780 Y FALLECIO, EN. Inscription on base of the bird cage: DIO.

Collections: Don Vicente Osorio Moscoso Fernandez de Cordóba, Count of Altamira and Astorga (?); [Duveen Brothers, New York].

Gift of Hanna Fund, 1946.

The painting appears to have been lined sometime before it entered the collection. Its right margin seems to have been cut, likely losing the date that followed the words "y fallecio, en" as well as the red letter "s" completing the word "Dios" on the base of the bird cage. The boy's face is somewhat abraded; the bird has been strengthened; and there is considerable retouching, particularly in the background. Although the inscription has been reinforced in places, there is no reason to believe that it is not original.

An expertise by August L. Mayer (dated April 10, 1931, and based on a photograph) accompanying the portrait when it entered the Museum stated that the painting was by Francisco de Goya, that it dated from ca. 1786–87, and that the subject was the son of Don Vicente Osorio Moscoso Fernandez de Cordóba, Conde de Altamira y Astorga (whose portrait by Goya, painted in 1788, is in the Metropolitan Museum, Lehman Collection; see Gudiol, 1971, I, no. 250, and II, fig. 354). Mayer's statements lack documentation, however. Nor has the provenance given by Duveen Brothers at the time of purchase been verified, for the important titles united in the house of Altamira were presumably dissolved upon the death in 1865 of the fifteenth count of Altamira, Don Pio Osorio Moscoso y Ponce de León.

An unsigned article in *Art Digest* (1947) stated that the sitter for the Cleveland picture was the cousin of Don Manuel Osorio de Zuñiga, whose portrait is in the Metropolitan Museum. According to O. N. V. Glendinning (letter, May 21, 1981), the sitter was Don Manuel's brother, not his cousin, and the portrait may indeed be posthumous —suggested by the date of the boy's death (apparently cut off; see above) and the symbolical connotation of the linnet.

Although our portrait is similar to Goya's representations of two sons of the Count and Countess of Altamira and Astorga, the subject of the Cleveland painting is more stiffly painted and doll-like, and the artist seems to have followed a formula. Goya's very appealing and well-known portraits are as follows: one, of Vicente Osorio de Moscoso, Conde de Trastamara, painted in 1786, was in the collection of the late Mrs. Charles S. Payson, New York (Gudiol, 1971, I, no. 210; II, fig. 299); the other, of Manuel Osorio Manrique de Zuñiga, painted in 1788, is in the Metropolitan Museum (Gudiol, I, no. 251; II, figs. 355 and 356). The latter portrait shows the boy holding a string attached to the leg of a magpie, crouching cats, and a birdcage containing several small birds. In our picture the child holds a cord attached to the leg of a hovering linnet, and an open birdcage rests on a damask-covered table at the right.

Despite brilliant passages of painting, the portrait does not appear to be the work of Goya himself, but rather of a competent contemporary of the young master. The attribution was changed in 1961 to Agustín Esteve y Marques, whose name was suggested by J. M. Pita Andrade (orally, 1960, when he saw the painting). Martin de Soria (letter of May 9, 1960) felt that the portrait was not by Esteve; he suggested the possibility of Mariano Salvador Maella (1739–1819) or his pupil, José Maea (1749–1826). N C W

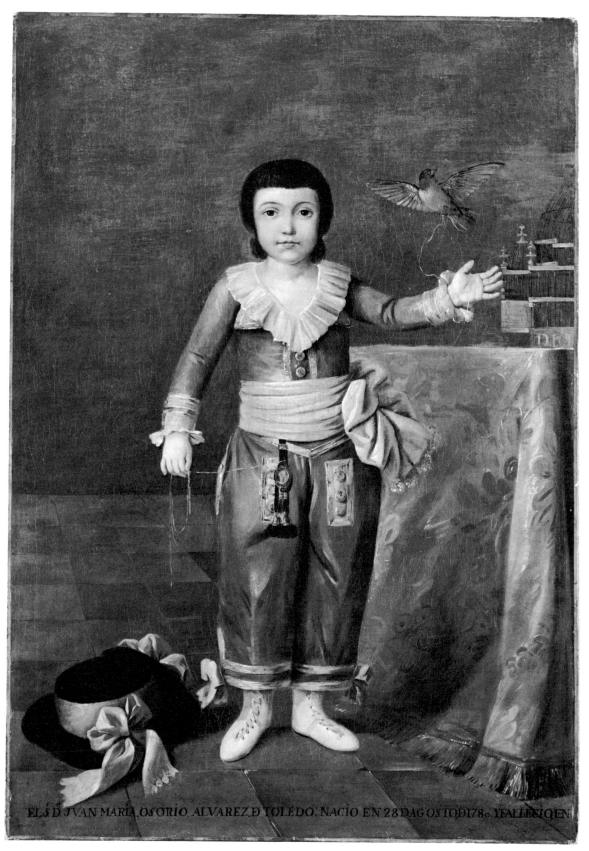

EL S D JVAN MARIA OSORIO ALVAREZ D TOLEDO. NACIO EN 28 DAGOSTO DI78o YFALLECIQEN

Figure 213.

EXHIBITIONS: Chattanooga (Tennessee) Art Association, The George Thomas Hunter Gallery of Art, 1952: First Loan Exhibition, cat. p. 1; Palm Beach, Florida, Society of the Four Arts, 1952: Spanish Painting Exhibition, cat. no. 16; Columbus (Ohio) Gallery of Fine Arts, 1954: Masterpieces of Spanish Painting, cat. no. 12; Winnipeg (Manitoba) Art Gallery, 1955: El Greco to Goya, cat. no. 19; Syracuse (New York) Museum of Fine Arts and Atlanta (Georgia) Art Association Galleries, 1957: Goya, Zurbarán, and Spanish Primitives—An Exhibition of Spanish Paintings, cat. no. 35; John Herron Art Museum (Indianapolis) and Museum of Art of the Rhode Island School of Design (Providence), 1963: El Greco to Goya, A Loan Exhibition of Spanish Paintings of the Seventeenth and Eighteenth Centuries, cat. no. 26, pl. 26.

LITERATURE: François Fosca, "Une Visite à Goya," L'Amour de l'Art, IX (1928), illus. p. 216; Carlyle Burrows, "Portrait of Don Juan Osorio-Alvarez," New York Herald-Tribune, July 22, 1945, Section IV, p. 4, illus.; Art Digest, XXI (September 14, 1947), 14; Henry S. Francis, "Don Juan Maria Osorio-Alvarez: The Boy with a Linnet," CMA Bulletin, XXXIV (1947), 112–14, illus. pp. 115–17; J. M. Pita Andrade, "Apportaciones Recientes a la Historia del Arte Español," Archivo Español de Arte, XXI (1948), illus. opp. p. 235; Gaya Nuño (1958), no. 892, p. 159.

FRANCISCO JOSE DE GOYA Y LUCIENTES
1746–1828

Francisco José de Goya y Lucientes was born in 1746 in Fuendetodos, a small village in the province of Aragon, near Saragossa, where his father, a master gilder, had settled. From 1759 to 1763 Goya was apprenticed to José Luzan, an artist trained in the tradition of Solimena in Naples. In 1766 Goya joined Francisco Bayeu, also from Aragon, in his workshop in Madrid. He married Bayeu's sister, Josefa, in 1773. Returning from a brief visit to Rome in 1771, he received his first major fresco commission, for the Basilica of El Pilar in Saragossa, a project which took ten years to complete. The paintings revealed his gifts of unified vision and great speed of execution, both of which he must have admired in Luca Giordano's paintings of Charles II and Tiepolo's paintings for Charles III of Spain. In 1774 there followed the fresco cycle for the Carthusian monastery, Aula Dei, and by 1775 Goya was in Madrid, where in 1776 he began to produce tapestry designs for the Royal Manufactory of Santa Barbara. In these tapestry designs Goya depicted scenes from common Spanish life, drawing on the traditions of French and Italian eighteenth-century genre painting. In 1780 he was admitted to the Royal Academy of San Fernando. In 1785 he became the Academy's assistant director of paintings; ten years later he became its director, succeeding Francisco Bayeu. Meanwhile, in 1786, he launched his career as court painter for Charles III; in 1789 he became court painter for Charles IV, advancing to the position of Primer Pintor de Camara in 1799. One year later he painted the Family of Charles IV (Prado, Madrid), in which the sheer beauty of the painted surface, the ephemeral shimmer of light and color, of costumes and jewelry, nearly makes one forget the unsparing frankness with which Goya portrayed the royal family. Although basically he did not depart from the canons of official portraiture at home, in France, and in England, Goya's portrayals from the very beginning were psychologically more intense, often bordering on the satirical and the grotesque. He continued to serve the court after Charles IV abdicated his throne in 1808 to his son Ferdinand VII, whose reign was subsequently suspended during the War of Independence. In 1814 Ferdinand VII returned to the throne and commissioned Goya to depict from memory the events of the second and third of May, 1808—the days of the fierce battle between the Spanish people and the Mamelukes of the Napoleonic army at the Puerta del Sol in Madrid, and its awful aftermath, the execution of the insurgents.

Goya's severe illness and ensuing deafness in 1792 seemed to sharpen his vision and quicken his pace. He continued to do remarkable portraits on commission, but his other works became increasingly intense and introspective, revealing more and more of his haunting vision of the follies and foibles of man and of the horrors of war. Out of these circumstances came the great cycles of etchings—the Caprichos of ca. 1799, the Desastros de Guerra of ca. 1810 to 1813, the Tauromaquia in 1815, and the Proverbios in 1819. Eventually, in 1824, like many of his friends who were disillusioned with the political events in Spain, he chose voluntary exile in France, but with royal permission, having given reasons of health as his motive for leaving Spain. He lived in Bordeaux for the remaining four years of his life. He is buried in the Church of San Antonio de la Florida in Madrid, where he had painted the brilliant frescoes for the cupola in 1798.

214 *Portrait of Don Juan Antonio 43.90
 Cuervo*

Canvas, 120 x 87 cm. Inscribed: Dn. Juan Anto. Cuerbo Directr de la Rl Academia ã Sn. Fern.ando Por su amigo Goya año 1819 (translation: Don Juan Antonio Cuervo, Director of the Royal Academy of San Fernando, by his friend, Goya, in the year 1819).

Collections: Don Francisco Duran y Sirvent, Madrid; M. Durand-Ruel, Paris; Godfrey S. Rockefeller, Greenwich, Connecticut: [Jacques Seligman & Co., New York].

Mr. and Mrs. William H. Marlatt Fund, 1943.

The painting is in good condition. There are some minor retouchings in the sitter's forehead and hair and in the background. There are some corrections by Goya in the gold braids of the coat lapel. More visible pentimenti show in the outlines of the left shoulder and arm and in the armchair, near the inscription. There is a seven centimeter double tear in the upper right, close to the edge of the canvas, which was repaired by William Suhr in 1953.

According to the inscription, the portrait represents Don Juan Antonio Cuervo, who was appointed Director of the Royal Academy of San Fernando in 1815. Cuervo is portrayed wearing the black costume of the Royal Academician, with its red and gold braiding; his short hair is in the style

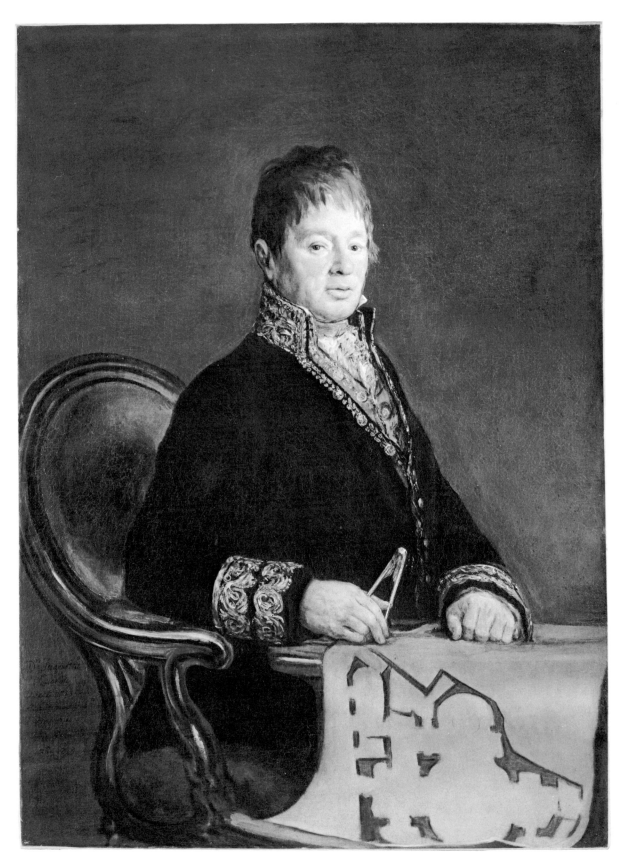

Figure 214.

that first emerged in England after 1790 and was adopted in Spain by 1819, the year of this portrait. Cuervo is seated at a table on which is spread the architectural plan of the parochial church of Santiago, built in Madrid in 1811 (Francis, 1943, p. 90). Cuervo was a pupil of the architect Juan de Villanueva, whom Goya also painted around 1795 to 1800 (Villanueva was one of the many architects whom Goya befriended). The portrait of Cuervo comes at the end of Goya's long career as a painter of royal and official portraits, a career that began in the courtly style of the French eighteenth century with such works as the Cleveland *Infante Don Luis de Borbón* (see Painting 215) and the *Conde de Floridablanca* of 1783, (Madrid, Banco de Urquijo). The late portraits, many of them of Goya's friends in Madrid—such as the *Don José Manuel Romero* of 1809 or 1810 in Chicago, the *Don Ignacio Omulryan y Rourera* in Kansas City, the *Francisco del Mazo* of 1815 in the Musée Goya in Castres, and Cleveland's *Don Antonio Cuervo*—clearly anticipated and influenced French portraits of the mid- to late nineteenth century.

In date and style the Cleveland portrait is closely related to a portrait of Cuervo's nephew (who was also an architect), *Tiburcio Perez y Cuervo*, painted one year later (Metropolitan Museum of Art). Both paintings are characterized by the artist's free, liquid brushwork and a restraint in color. Both subjects, one seated and one standing, are of robust physique, with the coil-spring tension of men of action and independence of mind. Their visual counterparts can be seen in another work by Goya, *The Forge* (New York, The Frick Collection), dating from 1818 to 1819. ATL

EXHIBITIONS: Madrid, Ministerio de Instrucción Pública y Bellas Artes, 1900: Obras de Goya, cat. no. 106; New York, Metropolitan Museum of Art, 1936: Francisco Goya, His Paintings, Drawings, and Prints, cat. no. 17, illus.; Museum of Fine Arts, Boston, 1939: Paintings, Drawings, and Prints from Private Collections in New England (not in catalogue); New York World's Fair, 1940: Masterpieces of Art, cat. no. 132; Art Institute of Chicago, 1941: The Art of Goya, cat. no. 137, illus.; Toledo (Ohio) Museum of Art, 1941: Spanish Painting, cat. no. 101, illus. (detail); Art Gallery of Toronto, 1944: Loan Exhibition of Great Paintings, cat. no. 28, illus. p. 20; Basel, Kunsthalle, 1953: Goya, cat. no. 33, illus.; Milwaukee Art Institute, 1957: An Inaugural Exhibition, El Greco, Rembrandt, Goya, Cézanne, Van Gogh, Picasso, cat. no. 46, illus.; CMA (1963), cat. no. 69, illus.; London, Royal Academy of Arts (Winter Exhibition), 1963/64: Goya and His Times, cat. no. 113; Mauritshuis (The Hague) and Orangerie des Tuilleries (Paris), 1970: Goya, cat. no. 50, illus.

LITERATURE: Paul Lafond, Goya (Paris, 1902), p. 126, no. 96 (with measurements: 128 x 87 cm); D. Elias Tormo y Monzo, Varios estudios de artes y letras, I (Madrid, 1902), 223; Albert F. Calvert, Goya (London, 1908), p. 134, no. 120, pl. 47 (with measurements: 128 x 87 cm); Valerian von Loga, Francisco de Goya (second enlarged edition, Berlin, 1921), pp. 141, 192, no. 202 (with measurements: 128 x 87 cm); Isabella Errera, Répertoire des Peintures datées (Paris, 1921), II, 532; Aureliano de Beruete y Moret, Goya as Portrait Painter, trans. Selwyn Brinton (London, 1922), pp. 172, 215, no. 281 (Spanish edition, Madrid, 1916, pp. 141, 181, no. 272, with measurements: 128 x 87 cm); August L. Mayer, Francisco de Goya, trans. Robert West (London and Toronto, 1924), p. 70, no. 248; Xavière Desparmet Fitz-Gerald, L'oeuvre peint de Goya, II (Paris, 1928–

50), 219, no. 508, pl. 422; Javier de Salas, "Lista de cuadros de Goya hecha por Carderera," Archivo español de arte y arqueología, VII (1931), 175, no. 16; Alfred M. Frankfurter, "Goya: A Fine Show at the Metropolitan," Art News, XXXIV, pt. I (January 25, 1936), 7, illus.; José Gudiol, Goya (New York, 1941), p. 114, illus. p. 86 (detail); Henry S. Francis, "A Portrait by Francisco José de Goya y Lucientes," CMA Bulletin, XXX (1943), 88–92, illus. pp. 85 and 94 (detail); Francisco Javier Sánchez-Cantón, Vida y obras de Goya (Madrid, 1951), pp. 117, 123, 172 (see also Sánchez-Cantón, The Life and Works of Goya, trans. Paul Burns [Madrid, 1964], pp. 111, 117, 161); Gaya Nuño (1958), p. 179, no. 1104; Elizabeth du Gué Trapier, Goya and His Sitters (New York, 1964), pp. 41–42, 51 n. 124, figs. 77 and 78; Bernard Myers, Goya (London, 1964), p. 39, pl. XL; Selected Works (1966), no. 193; Ann Tzeutschler Lurie, "Portrait of the Infante Don Luis de Borbón," CMA Bulletin, LIV (1967), 4, n. 14; Enriqueta Harris, Goya (London, 1969), p. 90, no. 40 and fig. 40 (color); Gudiol, Goya 1746–1828: Biography, Analytical Study and Catalogue of His Paintings (New York, 1971), I, 193, 340, no. 691, and IV, figs. 1.140 and 1.141 (color); Pierre Gassier and Juliet Wilson, The Life and Complete Work of Francisco Goya with a Catalogue Raisonné of the Paintings, Drawings, and Engravings, ed. François Lachenal (English edition, New York, 1971), p. 377, no. 1561, p. 298, fig. 1561; Rita de Angelis, L'Opera pittorica completa di Goya, Classici dell'Arte, vol. 74 (Milan, 1974), no. 612, illus.; CMA Handbook (1978), illus. p. 152; Xavier de Salas, Goya, trans. G. T. Culverwell (London, 1979), no. 564, illus. p. 199.

FRANCISCO JOSE DE GOYA Y LUCIENTES

215 *Portrait of the Infante Don* 66.14
 Luis de Borbón

Canvas, 152.7 x 100 cm.

Provenance: Infante Don Luis Antonio Jaime de Borbón, Arenas de San Pedro.

Collections: Maria Luisa, Duquesa de San Fernando, Madrid (youngest daughter of Don Luis, died 1847); Carlota Luisa, Duquesa de Sueca, Condesa da Chinchón, Boadilla del Monte (granddaughter of Don Luis, niece of Maria Luisa, died 1886); Adolfo Ruspoli, Duque de Sueca, Conde de Chinchón, Boadilla del Monte (son of Carlota Luisa, died, Paris, February 4, 1914; liquidation: Paris, February 7, 1914); Comte de Maubou, Paris; [Wildenstein & Co., New York].

Purchase, Leonard C. Hanna Jr. Bequest, 1966.

The overall condition of the painted surface is good; there are scattered pinpoint retouchings in the infante's face. Shadows on the nose, the chin, and the right hand have been strengthened. Additional minor retouches appear in the upper part of the background. A pentimento above the infante's hair indicates that Goya had first intended to portray him wearing the tricorne (in the fashion of Goya's portraits of Charles III, of 1786–88, showing the monarch dressed for the hunt), rather than with it tucked under his arm. There are also pentimenti in the outlines of the infante's arms and shoulders (see Figure 215a).

The portrait, dating from Goya's stay in the infante's residence at Arenas de San Pedro, near Avila, in 1783, launched the artist on a career as an official portrait painter. The Infante Don Luis de Borbón, brother of Charles III, was no longer a member of the royal household, however,

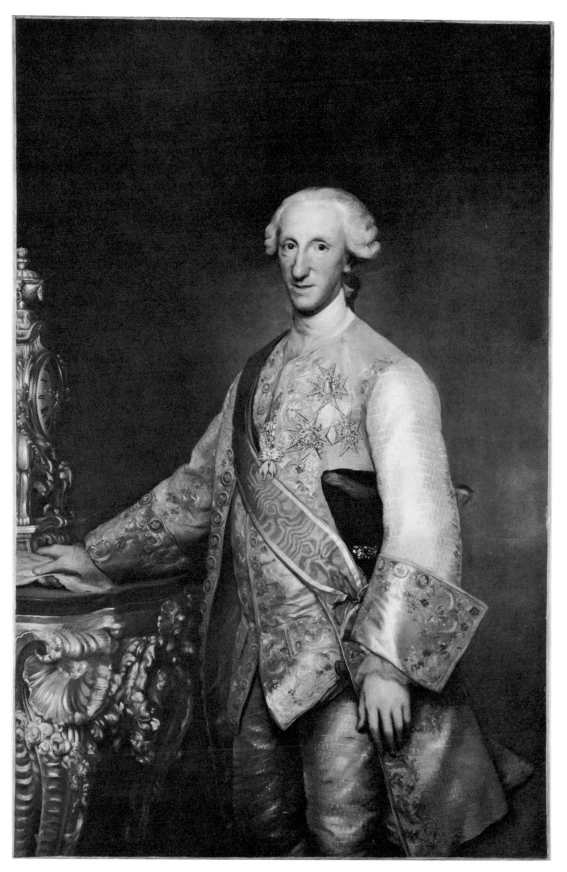

Figure 215.

at the time Goya visited him, having abdicated his royal rights and cardinalship in favor of marrying a woman below his rank, the beautiful Doña Maria Teresa de Vallabriga. Goya painted portraits of her (Figure 215b) and of their children, including one of the infante's little daughter, the Condesa de Chinchón, which is in the National Gallery, Washington (no. 2495). A painting of the entire family is in the collection of Prince Ruspoli, Florence (Gassier, 1979).

The Infante Don Luis de Borbón is portrayed wearing the diamond-set insignia of the Order of the Golden Fleece and three sashes (with pendant badges hidden by the left cuff). The three corresponding breast stars represent the Most Distinguished Order of Charles III, the Order of St. Januarius of the Kingdom of the Two Sicilies, and the Order of the Holy Ghost of France. In composition and paraphernalia the portrait clearly reflects the style of French court painting of the time and echoes Louis Michel van Loo's depiction of the Infante of ca. 1745, when he was still a cardinal (present whereabouts unknown; Lurie, 1967, p. 4, fig. 5).

The somewhat stilted and awkward pose of the infante in our portrait is reminiscent of the stern and sober portraits of Francisco Bayeu and his teacher, Anton Raphael Mengs (1728–1779), whose strong stylistic influence on Goya is seen in the Cleveland painting. Gudiol (1971, p. 250) even suggested that our painting may be a copy by Goya of a portrait by Mengs. Gassier not only considered this possibility but went a step further, suggesting an attribution to Mengs himself. In support of such an attribution, he cited two Boadilla del Monte inventories, one of 1847 and the other of 1856, in which Mengs was mentioned as the author of the painting now in Cleveland. However, as Gassier himself pointed out, the name Mengs is not associated with the painting in the later inventories of 1886 and 1899, in which the picture was said to have hung in the Goya room with its pendant portrait of Maria Teresa Vallabriga (Gassier, 1979, p. 18). In further support of his argument against a Goya attribution, Gassier pointed out that the Infante looks younger than fifty-six, the age he would have been in 1783 when Goya visited him at Boadilla del Monte and painted his portrait. In the group portrait of the family (now in the collection of Prince Ruspoli, Florence), which Goya painted during the same period, the Infante does appear much older. Gassier admitted the possibility (a very likely one, indeed) that Goya deliberately painted a younger representation to de-emphasize the thirty-one year difference between the ages of the infante and his wife as she appears in the pendant. Gassier erroneously described the condition of the painting as defaced; apart from scattered losses throughout the background and a few tiny losses in the infante's face, the painting is in good condition. Neither Gassier nor Gudiol appear to have been aware of the prominent pentimenti in the painting (discussed by Lurie, 1967, p. 5). Such changes, which are common in Goya's autograph works, argue against the idea that Goya copied the painting. The formal portrait of Charles III, an autograph work painted in 1786, in which the obvious pentimenti in the outline are almost identical to those in the infante's portrait, perhaps best exemplifies the artist's method of working.

In a sketch also painted during Goya's stay at Arenas de San Pedro in 1783 (private collection, France), the infante is portrayed with his architect, Ventura Rodriguez. Compositionally, this study is related to the portrait of the *Conde de Floridablanca* (Madrid, Banco de Urquijo), painted in 1783. The sketch commemorates the construction of the infante's palace, Boadilla del Monte, which was finished in 1765. The Cleveland portrait was eventually housed in the palace after the infante's death in 1785 and remained there in the Goya room until at least 1914.

Spaced across the bottom of the canvas are the red letters

Figure 215a. Infrared photograph showing pentimenti.

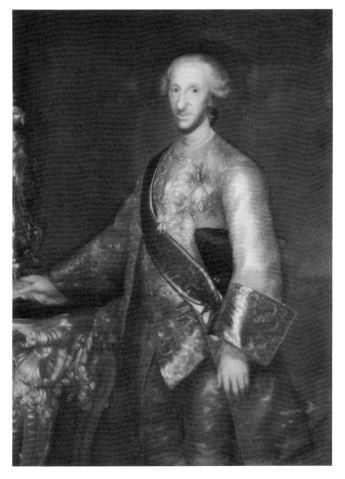

B (for Boadilla del Monte) and *S* (for Sueca, one of the titles acquired by the infante's granddaughter, Carlota Luisa, and passed on through the family). The inventory number 136 was added when Carlota Luisa's collection was catalogued after her death in 1886 (Gassier, 1979, p. 18).

Two other portraits of the Infante are listed under anonymous paintings in an inventory of January 1, 1808, of the collection of Manuel Godoy, who at that time was married to the infante's daughter, Maria Teresa, Condesa de Chinchón. One is believed to be the portrait in the Meadows Museum, Southern Methodist University, Dallas (acc. no. 70.10), attributed to Antonio Gonzales Ruiz; the other portrait has not yet been identified. (This information was kindly brought to my attention by Isadora Rose, who is preparing a doctoral dissertation on the role of Manuel Godoy, Prince of Peace, as art patron and collector in the Spain of Carlos IV.)

Aureliano de Beruete y Moret (1922) mentions another portrait of the Infante Don Luis, "in white uniform, more perfect than almost all the others of this [Boadilla del Monte] collection," and a pendant portrait of his wife, Doña Maria Teresa Vallabriga in the text. The latter is no. 59 in the author's list of paintings; however, the portrait of the infante cannot be identified with any of the paintings on that list. ATL

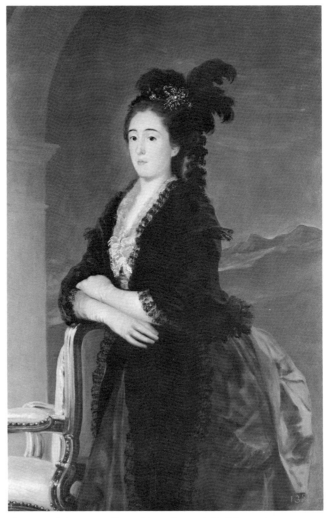

Figure 215*b. Portrait of Doña Maria Teresa de Vallabriga.* On canvas, 151.2 x 97.8 cm, painted ca. 1783. Goya. Collection Bayerische Hypotheken-und Wechselbank in der Alten Pinakothek, Munich.

EXHIBITIONS: Paris, Musée Jacquemart-André, 1961/62: Goya, cat. no. 21; CMA (1966), cat. no. 61, color illus. p. 216.

LITERATURE: Conde de la Viñaza, *Goya, su tiempo, su vida, sus obras* (Madrid, 1887), p. 228, no. XXXVIII; Paul Lafond, *Goya* (Paris, 1902), p. 120, no. 35; Don Elias Tormo y Monzo, *Varios estudios de artes y letras* (Madrid, 1902), p. 206; Albert F. Calvert, *Goya* (London and New York, 1908), p. 128, no. 51; Hugh Stoles, *Francisco Goya* (New York, 1914), pp. 138, 328, no. 46; Valerian von Loga, *Francisco de Goya* (second enlarged edition, Berlin, 1921), pp. 43, 188, no. 144; Aureliano de Beruete y Moret, *Goya as Portrait Painter*, trans. Selwyn Brinton (London, Bombay, and Sidney, 1922), p. 27 (Spanish edition, Madrid, 1916, p. 23); A. L. Mayer, *Francisco de Goya*, trans. Robert West (London and Toronto, 1924), p. 148, no. 172; Xavière Desparmet Fitz-Gerald, *L'Oeuvre peint de Goya*, II (Paris, 1928–50), 32, no. 311; Antonina Vallentin, *This I Saw, The Life and Times of Goya*, trans. Katherine Woods (New York, 1949), p. 64; José Gudiol Ricart, "Goya och Ventura Rodriguez," *Årsbok för Svenska statens konstsamlingar*, Vol. VIII: *Spanska Mästare* (Stockholm, 1960), 149, illus. p. 147; *Selected Works* (1966), no. 192; Wolfgang Stechow, "Cleveland's Golden Anniversary Acquisitions," *Art News*, LXV (September 1966), 44, 62, color illus. p. 39; Ann Tzeutschler Lurie, "Portrait of the Infante Don Luis de Borbón," *CMA Bulletin*, LIV (1967), 1–10, color illus. p. 1, fig. 15; Pierre Gassier and Juliet Wilson, *The Life and Complete Work of Francisco Goya with a Catalogue Raisonné of the Paintings, Drawings, and Engravings* (New York, 1971), p. 78, no. 212, p. 94, fig. 212; Gudiol, *Goya 1746–1828: Biography, Analytical Study and Catalogue of His Paintings* (New York, 1971), I, 52, 60, 249 no. 151, 250, and II, fig. 247; Rita de Angelis, *L'Opera pittorica completa di Goya*, Classici dell'Arte, vol. 74 (Milan, 1974), no. 156, illus.; CMA *Handbook* (1978), illus. p. 152; Gassier, "Les portraits peints par Goya pour l'Infant Don Luis de Borbón à Arenas de San Pedro," *Revue de l'Art*, XLIII (1979), 12–13, 16, 18, illus. p. 17, fig. 12; Xavier de Salas, *Goya*, trans. G. T. Culverwell (London, 1979), no. 147, illus. p. 177; José Camón Aznar, *Goya*, Vol. I: *1746–1784* (Zaragoza, n.d.), 151, illus. p. 272.

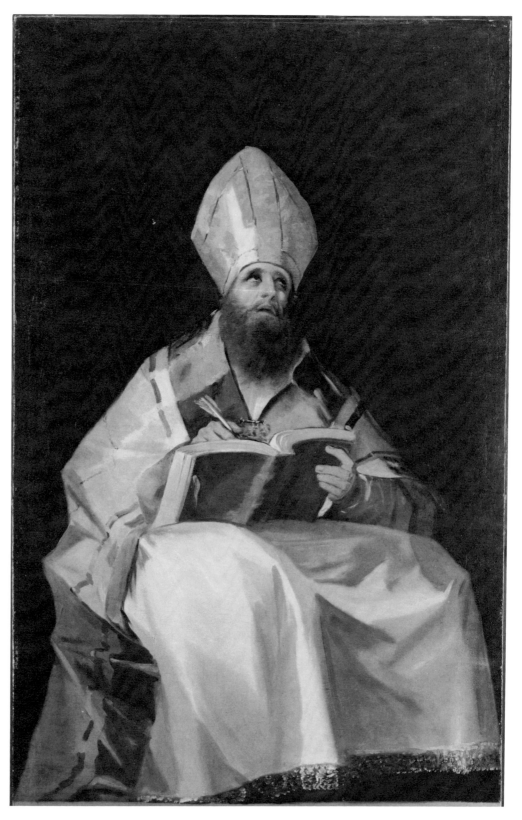

Figure 216.

FRANCISCO JOSE DE GOYA Y LUCIENTES

216 *St. Ambrose* 69.23

Canvas, 190 x 113 cm.

Collections: Theobald Heinemann, Munich; Contini-Bonacossi, Florence; [Pinakos, Inc., New York].

Purchase, Leonard C. Hanna Jr. Bequest, 1969.

The painting is in excellent condition. It was cleaned in 1970 by Mario Modestini. Traces of an old lining, probably from the beginning of this century, were showing along the sides of the painting, close to the edges, where the color was flaking. Several coats of darkened varnish were removed. No restoration was needed in the figure.

St. Ambrose is one of a series of paintings by Goya of the four Fathers of the Latin Church. Of the two still in Spain— *St. Gregory* (Figure 216a) and *St. Augustine* (Figure 216b) —*St. Augustine* is closest in composition and style to the Cleveland *St. Ambrose*. Another in the series, *St. Jerome* (Figure 216c), is exceptional because, unlike the others, St. Jerome is shown as a penitent sinner rather than a church father. Judging by their large size, the pictures were meant

to be hung in a church or some other ecclesiastical setting. Their provenance and dates are unknown.

The figures are echoes of Goya's earlier depiction of similar figures—the four Latin Fathers on the pendentives of a small hermitage church, Nuestra Señora de la Fuente in Muel, near Saragossa, built ca. 1770. In this series St. Jerome is shown in his ecclesiastical garments. (Poor replicas are in the parochial church of Remolinos; Lurie, 1970, p. 140, n. 5). From 1771 to 1772 Goya worked on his fresco in the Basilica of El Pilar in which the four Latin Fathers appear, sketchy but recognizable, in their ecclesiastical attire, on clouds, high up on the vault, in the company of their Greek counterparts. The same figures appear in the *bozzetto* for the fresco (Figure 216d). The poise and unerring aplomb of the figures, in spite of their small scale, anticipate the monumental cast of the Cleveland *St. Ambrose* and the three companion figures.

Gudiol (1971, p. 254) dated the four Latin Church Fathers 1781 to 1785 (close to Goya's portrait of the Infante Don Luis de Borbón; see Painting 215) because they have close stylistic ties to eighteenth-century painting and because they lack the distortion and spontaneous brevity that character-

Figure 216a. *St. Gregory*. On canvas, 183 x 115 cm. Goya. Museo Romantico, Madrid.

Figure 216b. *St. Augustine*. On canvas, 183 x 113 cm. Goya. D. Manuel Monjardin Collection, Madrid.

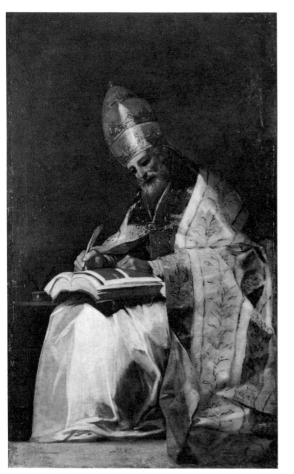

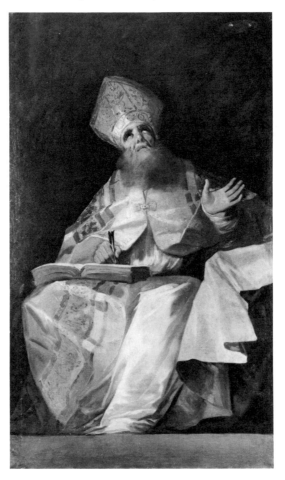

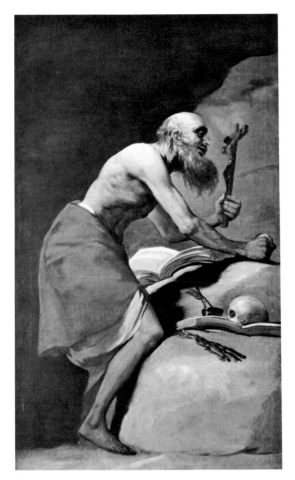

ize Goya's later figures. Gudiol maintains that the occasionally vigorous brushwork (see Figure 216e) in these four paintings is seen in even earlier works, such as the figure of St. Joachim in the mural decoration of Aula Dei, dated ca. 1774. Sánchez-Cantón (1951), on the other hand, voted for a date after Goya's second visit to Andalusia in 1796/97. Gassier and Wilson (1971) concurred, dating the four paintings ca. 1796 to 1798, a dating with which this author also agrees, as does José López-Rey (letter of May 9, 1978), who places the *St. Ambrose* stylistically between the paintings for the Santa Cueva at Cadiz of early 1796 and the frescoes for San Antonio de la Florida of 1798. ATL

EXHIBITIONS: Rome, Valle Giulia, Galleria Nazionale d'Arte Moderna, 1930: Gli Antichi Pittori Spagnoli della Collezione Contini-Bonacossi, cat. no. 28, pl. XIX; CMA, January 1970: Year in Review, cat. no. 145, pl. 1 (color).

LITERATURE: Francisco Javier Sánchez-Cantón, "Goya, Pintor Religioso," *Revista de Ideas Esteticas*, IV, nos. 15–16 (1946), 297; Sánchez-Cantón, *Vita y obras de Goya* (Madrid, 1951), p. 61 (see also Sánchez-Cantón, *The Life and Works of Goya*, trans. Paul Burns [Madrid, 1964], p. 63); Enriqueta Harris, *Goya* (London, 1969), p. 83, no. 5; Ann Tzeutschler Lurie, "Goya, *St. Ambrose*," CMA *Bulletin*, LVIII (1970), 129–40, figs. 1, 9, 10, 14, 16, 18, and color plate on p. 134; José Gudiol, *Goya 1746–1828: Biography, Analytical Study and Catalogue of His Paintings* (New York, 1971), I, 63, 254, no. 179, and II, 229, fig. 276; José Guerrero Lovillo, "Goya en Adalucía," *Goya, Revista de Arte*, no. 100 (January–February 1971), 215; Pierre Gassier and Juliet Wilson, *The Life and Complete Work of Francisco Goya with a Catalogue Raisonné of the Paintings, Drawings and Engravings*, ed. François Lachenal (New York, 1971), p. 165, no. 713, and p. 191, fig. 713; Rita de Angelis, *L'Opera pittorica completa di Goya*, Classici dell'Arte, vol. 74 (Milan, 1974), no. 324, illus.; CMA *Handbook* (1978), illus. p. 152; Xavier de Salas, *Goya*, trans. G. T. Culverwell (London, 1979), p. 92, no. 311, illus. p. 186.

Figure 216c. *St. Jerome*. On canvas, 183 x 113 cm. Goya. Norton Simon Museum, Pasadena, California.

Figure 216d. *Bozzetto* for the fresco *Regina Martyrum* in the basilica of El Pilar (detail). On canvas, ca. 1771. Goya. La Seo Museo Diocesano, Saragossa, Spain.

Figure 216e. Detail showing brushstroke.

EL GRECO (Domenico Theotocópuli)
1541–1614

El Greco was actually named Doménikos Zeotokópoulos (also spelled Domenikos Theotocopoulos); he was born in 1541 in Candia, the capital of Crete and a possession of Venice since the thirteenth century. There are no known records concerning his early years. The few early paintings attributed to him show a strong Byzantine influence from the icon painters of Crete. The exact date of his arrival in Italy is not known, but he probably went first to Venice, where he studied with Titian. A letter of recommendation dated November 16, 1570, from Giulio Clovio to Cardinal Alessandro Farnese, described El Greco as a young Candiote painter who had studied with Titian and had just arrived in Rome. In Venice El Greco was influenced by the Bassani, Tintoretto, and, of course, Titian. In Rome he encountered the works of Michelangelo and the Mannerist painters. He settled permanently in Toledo in 1577. The rest of his life he worked on numerous commissions for churches and convents in many other parts of Spain as well as Toledo. He died in 1614, leaving his workshop to his only son, Jorge Manuel (1578–1631), a mediocre painter and decorator who had taken an increasingly active part in his father's studio.

El Greco often painted several versions of a composition; still other versions were painted by his studio assistants. There is little documentation concerning such works, which has complicated the attribution and dating of the paintings and led to the inevitable variety of opinion among art historians about El Greco's work.

217 The Holy Family with Mary Magdalene 26.247

Canvas, 130 x 100 cm.

Collections: Convent of Esquivias, Torrejón de Velasco, near Toledo; Don Juan Gutiérrez, Torrejón de Velasco, 1899; Varga Muchuca, Madrid; M. Albarrán; Stanislas O'Rossen, Paris, 1908; Marczell von Nemes, Budapest (sale: Galerie Manzi, Joyant, Paris, June 18, 1913, no. 31); Gentile di Giuseppe, Paris; [M. Knoedler & Co., New York].

Gift of Friends of The Cleveland Museum of Art, 1926.

Harold Parsons, in a letter of April 27, 1926, told of a conversation he had had with Marczell von Nemes, former owner of the painting. Von Nemes said that at one time this painting had been attached to a door in the Convent of Esquivias and that a piece had been cut out to allow the key to pass through. Although there is no evidence to substantiate this claim, the painting has clearly suffered extensively. There are damages in the figure and face of the Child, and there has been considerable loss around the head of the Madonna, around the head of the Child, in the upper background, along the bottom of the canvas, and elsewhere throughout the painting. The painting had been in precarious condition for many years, with a serious loss of adhesion of the paint film to the ground. There is evidence of repeated cleanings in the past that have caused abrasion, most noticeably in the background, along the edges, and in the garment of the Madonna. The painting was cleaned and lined in 1958 by Wiliam Suhr. Fortunately, there is little paint loss in the faces of Joseph, Mary, and Mary Magdalene. Despite many vicissitudes, enough has survived to reveal the impressive hand of the master himself.

Two undated letters in the Museum files, both from Stanislas O'Rossen, former owner of the painting and a prominent tailor in Madrid and Paris, verify that this painting was originally installed in the Convent of Esquivias in the small village of Torrejón de Velasco. Both letters describe how the Mother Superior of the convent gave the painting in 1899 to the local mayor, Juan Gutiérrez, who in return had paid for the repair of a broken windowpane over which the nuns had placed the painting in order to keep out the drafts. A friend of the mayor bought it and in turn sold it to a Madrid painter, M. Albarrán, from whom Stanislas O'Rossen acquired it.

According to Wethey (1962, II, 58), this painting, which includes Mary Magdalene with the Holy Family, is the only one of its type entirely by El Greco. Wethey (*ibid.*, 188–89, nos. x99–x104) lists six replicas or copies after the original in Cleveland, by or later than the workshop of El Greco, in the following collections: Madrid, formerly Floréz collection (Camón Aznar, 1950, I, fig. 435); Bucharest, formerly Royal Palace (*ibid.*, fig. 434); Montreal, the heirs of Sir William van Horne (*ibid.*, fig. 429); Mexico City, Museo Nacional de Bellas Artes (Dr. Atl [Gerardo Murillo], *Catálogo de la pinturas y dibujos de la colección Pani*, Mexico

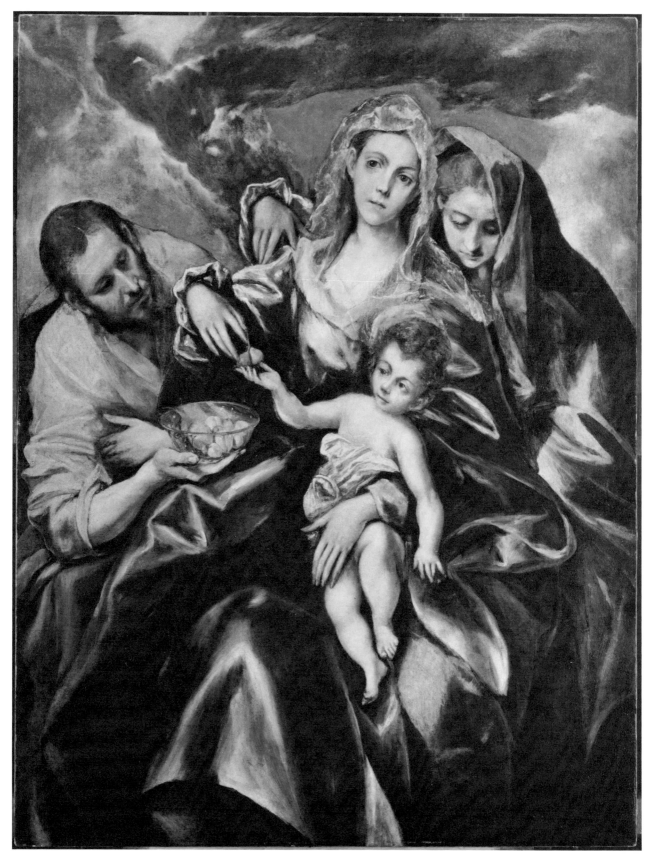

Figure 217.

City, 1921, fig. 77); New York, Hispanic Society (Trapier, 1929, p. 11, illus. p. 110, attributed to Francisco de Preboste); and Barcelona, Carreras collection (Goldschneider, 1938, pl. 96). According to the inventory prepared by El Greco's son, Jorge Manuel, in 1621, there are two paintings of the "Holy Family with a Mary," but these cannot be identified (Inventory II, nos. 112 and 142; San Román, 1927, pp. 297, 300). San Román thought that no. 112 from Jorge Manuel's inventory was the Cleveland picture, but this cannot be considered reliable, as he probably did not know all the versions (Wethey, 1962, II, 58).

The Museum painting represents a stage in El Greco's development of the subject, beginning with the very important *Holy Family* (with a nursing Madonna, without the Mary Magdalene) of about 1580 to 1585, at the Hispanic Society, New York (Figure 217a)—not to be confused with the later, probably seventeenth-century, copy of the Cleveland painting also at the Hispanic Society. Another *Holy Family* (with a nursing Madonna, and including Mary Magdalene) of about ten years later, now in the Hospital of St. John the Baptist in Toledo, Spain (Figure 217b), is closely related to our painting; the composition is virtually the same, except that in the Museum painting St. Joseph (holding the bowl of fruit) appears on the left instead of St. Anne, and Mary Magdalene appears on the right.

The Museum painting is almost universally respected for its quality in spite of considerable restoration. In the opinion of this author, it dates from the general period of ca. 1590 to 1595. Gudiol (1941) dates it 1586, Soehner (1957) dates it 1601 to 1603, and Cossio (1908 and 1972) dates it 1594 to 1604. NCW

EXHIBITIONS: Budapest, Musée des Beaux-Arts, n.d.: Dominico Theotokopuli el Greco 1547–1614 . . . Collection Marczell de Nemes, pl. 5; Munich, Alte Pinakothek, 1911: Sammlung des Kgl. Rates Marzcell von Nemes, Budapest, cat. no. 14; Düsseldorf, Städtische Kunsthalle, 1912: Ausstellung der Galerie Marzcell v. Nemes, cat. no. 65; Paris, Galerie Manzi, Joyant, June 15–16, 1913: Tableaux anciens . . . composant la collection de M. Marzcell de Nemes de Budapest, cat. no. 31, illus.; CMA (1936), cat. no. 156, pl. XXV; Philadelphia, Pennsylvania Museum of Art, 1937: Masters of Spanish Painting; Paris (exposition organized by the *Gazette des Beaux-Arts*), 1937: Domenico Theotocópuli, El Greco, cat. no. 25, illus.; CMA, 1956: The Venetian Tradition, cat. no. 16, pl. XXXV.

LITERATURE: Manuel B. Cossio, *El Greco* (Madrid, 1908), I, 332–33, 601 no. 310, 701–2, and II, pl. 45 bis (revised ed., Barcelona, 1972, pp.

Figure 217a. *Holy Family*. On canvas, 106 x 88 cm. El Greco. The Hispanic Society of America, New York.

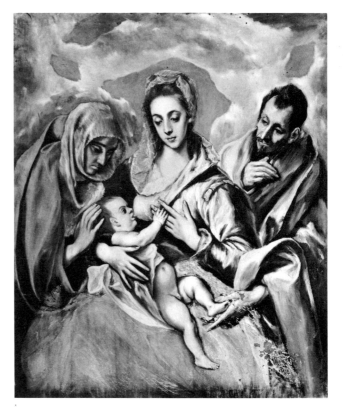

Figure 217b. *Holy Family*. On canvas, 127 x 106 cm. El Greco. Hospital of St. John the Baptist, Toledo, Spain.

192–93, 358 no. 35, 359); Albert F. Calvert and C. Gasquione Hartley, *El Greco* (New York and London, 1909), p. 129, pl. 53; August L. Mayer, "Bilder der Sammlungen Nemes," *El Museum*, I (1911), 460, illus.; Gabriel von Terey, "Die Greco-Bilder der Sammlung Nemes," *Kunst und Künstler*, IX (1911), 218; Mayer, "Domenico Theotokópuli ... Die heilige Familie," *Die Galerien Europas* (Leipzig, 1912), p. 496, pl. 4; *Los Grandes Maestros de la Pintura en España*, Vol. III: *Misticos de "el Greco"* (Madrid, n.d.), pl. 36; Maurice Barres and Paul LaFond, *Le Greco* (Paris, 1913), pp. iii, 140; Valeriano von Loga, "Los Cuadros de la Hispanic Society of America," *Museum: Revista mensual de arte español antigo y moderno*, III (1913), 124; Gabriel Mourey, "La Collection Marczell de Nemes," *Les Arts*, XII, no. 138 (1913), 12, illus. p. 19; Hugo L. Kehrer, *Die Kunst des Greco* (Munich, 1914), p. 71, pl. 47; Miguel Utrillo, *Domenikos Theotokopulos, El Greco* (Barcelona, n.d.), illus.; *Collection Marczell de Nemes, Budapest*, Vol. I: *Les Onze Grecoes* (Vienna, n.d.), pl. 10; Mayer, *El Greco* (Munich, 1916), p. 59, pl. 42; Charles Oulmont, "Collection M.-F. Gentili de Giuseppe," *Les Arts*, XIV, no. 162 (1917), 7, 8, illus. p. 9; Loga, *Die Malerei in Spanien* (Berlin, 1923), p. 232, n. 4; Mayer, *El Greco* (Munich, 1926), pp. 24, 59, pl. 42; William M. Milliken, "The Holy Family by El Greco," CMA *Bulletin*, XIV (1927), 3–6, illus. p. 1; F. de B. San Román, "De la vida del Greco," *Archivo español de arte y arqueología*, III (1927), no. 112, 297; E. Siple, "Art in America: The Boston and Cleveland El Grecos," *Burlington Magazine*, L (1927), 211; Elizabeth du Gué Trapier, *Catalogue of Paintings (16th, 17th, and 18th Centuries) in the Collection of The Hispanic Society of America* (New York, 1929), p. 111; "The Friends of The Cleveland Museum of Art," CMA *Bulletin*, VXII (1930), 50, illus. p. 51; P. Beda Kleinschmidt, *Forschungen zur Volks-kunde—Die Heilige Anna* (Düsseldorf, 1930), pp. 247–48 pl. 181; Mayer, *El Greco* (Berlin, 1931), p. 83; Al. Busuioceanu, "Les Tableaux du Greco de la Collection Royale de Roumainie," *Gazette des Beaux-Arts*, XI (1934), 299–300; Raymond Escholier, *Greco* (Paris, 1937), p. 123, color illus. p. 129; A. Heppner, "Greco-Tentoonstelling te Parijs," *Maandblad voor Beeldende Kunsten*, XIV (1937), 298, fig. 2; Maurice Legendre and Adolf Hartmann, *El Greco* (Paris, 1937), illus. p. 150; Ludwig Goldscheider, *El Greco* (New York, 1938), illus. pls. 100, 102–4; Hans Vollmer, in Thieme-Becker, XXXIII (1939), 6, 10, 11; Regina Shoolman and Charles Slatkin, *The Story of Art* (New York, 1940), pp. 226, 232, color illus. p. 78; José Gudiol, *Spanish Painting* (exh. cat., Toledo, 1941), p. 66; Shoolman and Slatkin, *The Enjoyment of Art in America* (Philadelphia and New York, 1942), pl. 408; Jean Cocteau, *Le Greco* (Paris, 1943), pls. 12 ff; José Lopez-Rey, "El Greco's Baroque Light and Form," *Gazette des Beaux Arts*, XXIV (1943), 80; Walter S. Cook, "El Greco to Goya," *Gazette des Beaux Arts*, XXVIII (1945), 68–69, n. 6; Stephan Bourgeois, "El Greco and His Family," *Art Quarterly*, IX (1946), 11–12, illus. p. 8, fig. 4; Anthony Bertram, *El Greco* (New York, 1949), pl. XXV; José Camón Aznar, *Dominico Greco* (Madrid, 1950), I, 570, 573, pls. 427 and 428; Germain Bazin and Suzanne Bresard, "Visage et Figures," *L'Amour de l'Art*, XLIX (1950–51), 7, no. 16; Bazin, *History of Classic Painting* (New York, Paris, and London, 1951), I, color illus. pl. 224; Alfred Frankfurter, "Venice, or the Fluent Brush," *Art News*, LV, no. 8 (1956), color illus. p. 32; R. H. Hubbard, *European Paintings in Canadian Collections: Earlier Schools* (Toronto, 1956), p. 41; Halldor Soehner, "Greco in Spanien," *Münchner Jahrbuch der bildenden Kunst*, VIII (1957), 164, 167; Gaya Nuño (1958), p. 197, no. 1314; Harold E. Wethey, *El Greco and His School* (Princeton, New Jersey, 1962), I, 46, 61, fig. 105, and II, 58–59, no. 86; Charles Wentinck, *El Greco* (New York, 1964), pp. 80–81, illus. pp. 54–55; Alsop (1966), p. 24; *Selected Works* (1966), no. 150, illus.; Enrique Lafuente Ferrari, *El Greco: The Expressionism of His Final Years* (New York, 1968), p. 57, color illus. fig. 34, no. 29, p. 157; Gianna Manzani and Tiziana Frati, *L'Opera completa del Greco*, Classici dell'Arte, vol. 35 (Milan, 1969), cat. no. 91a, p. 106, illus. p. 107; Aznar, *Summa Artis, Historia general del Arte*, Vol. XXIV: *La Pintura español del siglo XVI* (Madrid, 1970), p. 565; Gudiol, *Domenikos Theotokopoulos: El Greco, 1541–1614*, trans. Kenneth Lyons (New York, 1973), pp. 142, 345, cat. no. 85, color illus. p. 138, fig. 120; CMA *Handbook* (1978), illus. p. 149.

EL GRECO

218 *Christ on the Cross with Landscape* 52.222

Canvas (lined), 193 x 116 cm. Inscription on plaque at the top of the cross, in Hebrew, Greek, and Latin: Jesus of Nazareth, King of the Jews.

Collections: Convento de las Salesas, Madrid; [Tomás Harris, London]; [Rudolf Heinemann]; [M. Knoedler & Co., New York].

Gift of Hanna Fund, 1952.

The painting was restored and lined shortly before it entered the Museum collection, but records of the restoration were not kept. A photograph of the painting before it was cleaned appears in José Camón Aznar's biography of the artist (see Literature) and in the catalogue of the 1926 Madrid exhibition (Exh: 1926); the latter is a better photograph, which shows earlier restorations. The painting was examined in 1977 in the Cleveland Museum laboratory, and Museum conservators reported on its condition. There has been some abrasion to the paint surface, particularly in the sky. Horizontal bands toward the lower part of the canvas indicate it may have been rolled up at one time. The letters in the plaque above Christ's head have been reinforced, which could account for the incorrect spelling in the Greek inscription. There are some small paint losses on the figure and a thin horizontal loss across the bridge of Christ's nose. None of these damages disturbs the general reading of the painting as a whole. A clean, unpainted tacking margin exists on all four sides of the original canvas, indicating that the painting has not been reduced in size. If its present size is the original, then the iconography of the representation is unique, because the other closely related paintings of this subject show the foot of the cross where a skull and bones lie scattered about, and in the distance a horseman winds his way up the hill. Versions that include these details at the bottom of the picture are on canvases that are at least thirteen centimeters more in height.

The earliest-known provenance of this painting is the Convento de las Salesas in Madrid, from which it was purchased by Tomás Harris in 1952. The first monastery and college of Las Salesas Reales in Madrid was established in the middle of the eighteenth century; a second, called the Salesas Nuevas, was built in 1798 on the street of San Bernardo (Eliás Tormo, *Las Iglesias de Madrid*, Madrid, 1972, p. 176). In the latter, according to an early publication (*Paseo por Madrid*, 1815), there hung a "crucifixo" by El Greco, which is almost certainly the Museum painting.

The subject of Christ on the Cross was painted in many versions by El Greco, sometimes with the help of assistants. Wethey (1962, II, pp. 45–51) has catalogued the various representations, separating them from Crucifixion scenes that include other figures such as donors and saints. Wethey placed the Museum painting in the category "Christ on the

Figure 218.

Cross in a Landscape with Horseman (Type I)" in his very thorough and logical catalogue. Despite the absence of the horseman and landscape at the bottom of the picture, which has led to the suggestion that the canvas may have been cut, and in spite of harsh restorations, Wethey says that our picture is the finest of its type. He adds, however, that the original composition, of about the same date, ca. 1605 to 1610, can best be seen in the painting in the Philadelphia Museum of Art, Wilstach Collection, which is generally considered to be by El Greco and his workshop. Wethey mentions two other versions, both with the skull, bones, and horseman, which he considers to be largely by El Greco's hand and dated earlier, ca. 1585 to 1590: one is in Zumaya, Zuloaga collection (Wethey, 1962, II, no. 67); the other is in the collection of the Marqués de la Motilla (Figure 218*a*). Gudiol (1973) catalogues four versions of the subject: the Cleveland and Marqués de la Motilla paintings (which he considered to be by El Greco's own hand); a version in Toledo, Spain, Santa Cruz Museum; and one in New York, Wildenstein Gallery (in 1961). The latter two are smaller and are called El Greco and workshop. Gudiol dates all four paintings between 1587 and 1597. Wethey relegates the Toledo and New York paintings to the school works or copies section of his catalogue along with five others of his Type I (*ibid.*, nos. X50–X56) in the following collections: Paris, E. Gutzwiller; Madrid, Duquesa de Alba collection; Amsterdam, Rijksmuseum; Buenos Aires, Alejandro Shaw; and Buenos Aires, Museo Nacional de Arte Decorative (signed by Mateo Cereco).

Gudiol (1973), Camón Aznar (1950), and Cossio (1908 and 1972) all give the Cleveland painting an early date, but because it exemplifies the attenuated figure style of El Greco in the years 1605 to 1610, according to Wethey, or 1600 to 1605, according to Ferrari (1968), and because of its mood of mystical agony, the Cleveland painting fits logically into a later phase of stylistic development than the magnificent *Crucifixion with Donor* in the Louvre (Wethey, 1962, I, fig. 78), which dates from ca. 1590. The Louvre painting marks the full maturity of the artist, when his style became emancipated from Venetian painting but still was rooted in the Florentine-Roman Mannerist tradition that we have seen in El Greco's *The Holy Family with Mary Magdalene* (Painting 217). NCW

Figure 218*a*. *Christ on the Cross in a Landscape with Horsemen.* On canvas, 178 x 104 cm. El Greco. Collection of the Marqués de la Motilla, Seville.

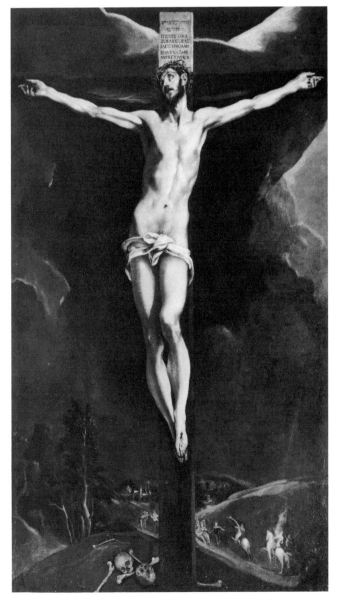

EXHIBITIONS: Madrid, Sociedad española de amigos del arte, 1926: Exposición del antiguo Madrid, cat. no. 900, p. 85, illus. (lent by Salesas Nuevas, Madrid); CMA (1958), cat. no. 50; Buffalo (New York), Albright-Knox Art Gallery, 1965: Religious Art, cat. no. 35.

LITERATURE: *Paseo por Madrid* (Madrid, 1815), p. 41; Manuel B. Cossio, *El Greco* (Madrid, 1908), I, no. 81, p. 564 (second enlarged edition, Barcelona, 1972, p. 367, no. 109); José Camón Aznar, *Domenico Greco* (Madrid, 1950), I, 646, fig. 491, and II, 1366, no. 178; Henry S. Francis, "A Crucifixion by El Greco," CMA *Bulletin*, XL (1953), 4–7, illus. pp. 1–2; John Canaday, *Metropolitan Seminars in Art: Great Periods in Painting, Portfolio 3: Expressionism* (New York, 1958), illus. p. 26; Milliken (1958), illus. p. 37; Gaya Nuño (1958), p. 203, no. 1387; Harold E. Wethey, *El Greco and His School* (Princeton, New Jersey, 1962), I, fig. 186, and II, 46–47, no. 68; Enrique Lafuente Ferrari, *El Greco: The Expressionism of His Final Years* (New York, 1968), p. 128 no. 94, p. 159 fig. 79 (color); Gianna Manzini and Tiziana Frati, *L'Opera completa del Greco,* Classici dell'Arte, vol. 35 (Milan, 1969), cat. no. 61c, illus. p. 101; Neil Maclaren, *National Gallery Catalogues: The Spanish School* (second ed., revised by Allan Braham, London, 1970), p. 39; Marilyn Stokstad, "Spanish Art from the Middle Ages to the Nineteenth Century," *Apollo,* LXXXXVI (1972), 500; José Gudiol, *Domenikos Theotocopoulos: El Greco, 1541–1614,* trans. Kenneth Lyons (New York, 1973), pp. 162, 347, cat. no. 117, illus. p. 158 fig. 140; *The Cleveland Museum of Art,* The Little Art Book, ed. Berthold Fricke (Hannover, 1975), p. 52, color illus.; CMA *Handbook* (1978), illus. p. 149.

BARTOLOME ESTEBAN MURILLO
1618–1682

Murillo was born in Seville, where he spent most of his life. When he was orphaned in 1628, his uncle put him in the studio of a relative, the minor Mannerist painter Juan del Castillo, with whom he stayed until 1639. He then painted for local fairs and executed small religious paintings for dealers who sent them to be sold in the Americas. In 1642 he met Pedro de Moya, who had studied with van Dyck and who introduced him to Flemish prints and copies of paintings. Antonio Palomino de Castro y Velasco wrote in 1724 (*El Museo pictórico y Escala óptica*, 3 vols., Madrid, 1715–24; reprint ed., Madrid, 1947, p. 1031) that Murillo went to Madrid in about 1645 or 1646 and became a protégé of Velázquez, but this is not documented. It is more probable that he never left Andalusia. In 1660 he founded the Academy of Arts in Seville; he also taught there. He was married in 1645; five of his eight children entered the Church. Murillo's first major commission, which successfully launched him upon his career, came from the Franciscans in Seville in 1645 or 1646. For them he painted eleven pictures, all of which show the influence of Ribera and Zurbarán. Murillo was a prolific painter; he soon became very popular, eclipsing Zurbarán in reputation and influencing the elder master's late style. He painted numerous genre scenes of religious subjects from both the Old and New Testaments, peopling them with contemporary Andalusian working people and even Sevillian street urchins. He also painted naturalistic portraits that revealed his own considerable psychological insight; these were usually full-length paintings with architectural backgrounds. In the nineteenth century Murillo's work was very popular because of its subject matter, but by the turn of the century his reputation had declined and his works were neglected. Only in the last twenty-five years has Murillo been appreciated again as an important master in Spanish seventeenth-century art.

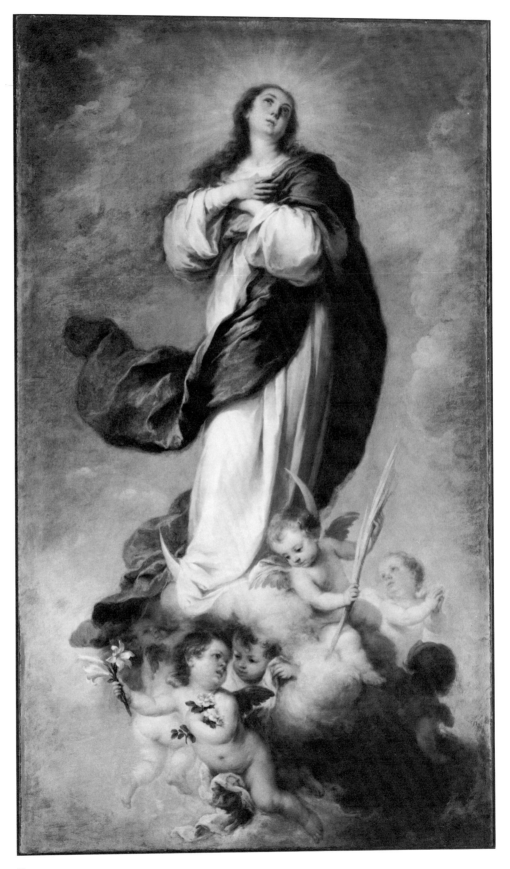

Figure 219.

219 *The Immaculate Conception* 59.189

Canvas, 220.5 x 127.5 cm.

Collections: Sir Thomas Sebright, Beechwood near Boxmoor, Hertfordshire; [F. Kleinberger & Co., New York].

Purchase, Leonard C. Hanna Jr. Bequest, 1959.

The previous history of restoration is unknown. Before the painting came to this Museum, restorers had added an excess amount of overpaint, not confining it to areas where losses had occurred. As a result, the original blues in the Madonna's robe, which had been damaged by abrasion and flaking, were totally obscured. The painting was cleaned and inpainted by Ross Merrill and Delbert Spurlock in the Museum laboratory in 1976, at which time two earlier lining fabrics were removed and the canvas was relined. The painting is approximately the same size it was originally. Compared to most Spanish seventeenth-century paintings, it is in superior condition.

The office commemorating the Immaculate Conception was formally instituted by Pope Paul V in 1615. In 1649 the Spanish painter, art historian, and artistic advisor to the Inquisition, Francisco Pacheco (1565–1654), wrote down the rules for the representation of the subject, based on the Book of Revelation, 12:1. Guido Reni in Italy and Murillo and his studio in Spain turned out countless paintings of this subject, establishing the pictorial form that is still most familiar today. Murillo consistently used contemporary genre scenes with simple people to interpret other biblical subjects as well (see Painting 220). His portrayals of the Immaculate Conception maintained a kind of sentimental popularity until the end of the nineteenth century, after which the artist and his work fell into neglect.

Martin Soria (letter of December 6, 1960) dated this painting ca. 1660 to 1670, and Wethey (1963) dated it ca. 1675 to 1680. Stylistically, it is closely related to the *Immaculate Conception* dating from 1678, in the Louvre (*Catalogue des peintures*, Paris, 1926, II, no. 1709), formerly in the collection of Marshal Soult. It virtually repeats the type in the Prado known as the Aranjuez *Immaculate Conception*, dated ca. 1675 to 1680 (*Catalogo de las pinturas*, Madrid, 1972, cat. no. 974), except for the position of the cherubim at Mary's feet and the areas which in the Cleveland painting are enlivened by fluttering accents and flickering highlights. Its relationship to the Louvre and Aranjuez paintings makes it reasonable to date the Cleveland painting close to 1680 (not ca. 1655, as earlier thought by Wixom, 1960). NCW

EXHIBITIONS: John Herron Art Museum (Indianapolis) and Museum of Art of the Rhode Island School of Design (Providence), 1963: El Greco to Goya: A Loan Exhibition of Spanish Painting of the Seventeenth and Eighteenth Centuries, cat. no. 52, pl. 52.

LITERATURE: Gustav Friedrich Waagen, *Galleries and Cabinets of Art in Great Britain* (London, 1857), p. 328; Charles B. Curtis, *Velázquez and Murillo* (London and New York, 1883), p. 140, no. 54b; Nancy Coe Wixom, "Bartolomé Esteban Murillo, *The Immaculate Conception*," CMA *Bulletin*, XLVII (1960), 163–65, illus. p. 161 (color); Harold E. Wethey, "Spanish Paintings at Indianapolis and Providence," *Burlington Magazine*, CV (1963), 207; CMA *Handbook* (1978), illus. p. 150; Juan Antonio Gaya Nuño, *L'Opera completa di Bartolomé Esteban Murillo*, Classici dell'Arte, vol. 10 (Milan, 1978), 92–93, fig. 72, no. 72; Diego Angulo Iñiguez, *Murillo*, II (Madrid, 1981), 121, under cat. no. 111.

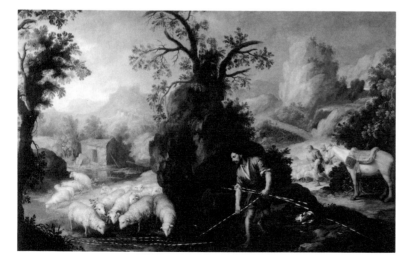

220　*Laban Searching for His Stolen*　　65.469
Household Gods in Rachel's Tent

Canvas, 242 x 375 cm.

Collections: Marquis of Villa-Manrique, Seville (?); Marquis of Santiago, Santiago Palace, Madrid, by 1787; [William Buchanan and W. G. Coesvelt, London, acquired in Spain through Buchanan's agent, G. Augustus Wallis, in 1809]; Marquis of Westminster, Grosvenor House, London; Hugh Richard Arthur Grosvenor, second Duke of Westminster, grandson of the Marquis of Westminster; (sale: Christie, Manson & Woods, London, July 4, 1924, no. 21); Jacques de Canson, Paris; Carlos Guinle, Rio de Janeiro; [Wildenstein Galleries, New York].

Gift of The John Huntington Art and Polytechnic Trust, 1965.

This lined canvas was cleaned, and the dirty, yellowed varnish was removed by Joseph Alvarez immediately after it was acquired by this Museum. There is some overpainting in the hills in the middle distance and in the two children at the lower left. The overall paint surface is somewhat abraded. A minimum of inpainting has been done along the horizontal seams where the three pieces of canvas were sewn together. There were five holes in the darkened opening of the tent, behind Rachel's head, which had been repaired in the past. Otherwise, the painting is in good condition.

Palomino (1724) related that the Marquis de Villa-Manrique at Seville commissioned Murillo to do a series of paintings on the life of David and that Ignacio de Iriarte (1621–1685) was to execute the landscape backgrounds for these scenes, but after a quarrel Murillo painted the entire series by himself. Palomino gave no dates, nor did he mention how many paintings were in this series, but no extant series on the life of David is known. The series on the life of Jacob, which includes the Cleveland painting, was owned by the family of the Marquis of Santiago in Madrid in 1787 (Cumberland, 1787, II, 124). Because, as Stirling-Maxwell (1896) pointed out, the original family name of Santiago was Manrique, there exists the possibility that Palomino may have confused the two families. He may also have been in error concerning the subject of the series.

The Jacob series was dispersed in the early nineteenth century. *Jacob's Dream* (Figure 220a), and *Isaac Blessing*

Figure 220a. *Jacob's Dream*. On canvas, 246 x 360 cm. Murillo. The Hermitage, Leningrad.

Figure 220b. *Isaac Blessing Jacob*. On canvas, 246 x 357.5 cm. Murillo. The Hermitage, Leningrad.

Figure 220c. *Jacob Laying the Peeled Rods before the Flocks of Laban*. On canvas, 221.6 x 360.7 cm. Murillo. The Meadows Museum, Southern Methodist University, Dallas.

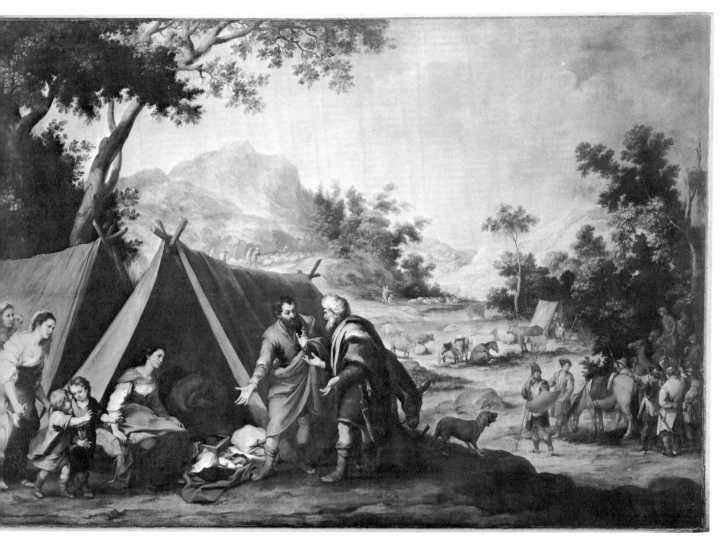

Figure 220.

Jacob (Figure 220*b*) are now both in Leningrad, The Hermitage; the whereabouts of *Jacob and Rachel* is unknown; *Laban Searching for His Stolen Household Gods in Rachel's Tent* is in The Cleveland Museum of Art; and *Jacob Laying the Peeled Rods before the Flocks of Laban* (Figure 220*c*) is in Dallas, Meadows Museum, Southern Methodist University.

The logic of Murillo's selection of these five episodes from the life of Jacob is difficult to explain. These scenes from the patriarch's life describe human inadequacies and the tribulations suffered by the true servants of God. Stechow (1966) pointed out a sixteenth-century representation of these five scenes in a series of ten tapestries, now

in the Royal Museum in Brussels, that were woven after designs by the Flemish artist Barent van Orley (M. Crick-Kuntziger, *La Tenture de l'Histoire de Jacob d'après Bernard van Orley*, Antwerp, 1954) Murillo may well have been familiar with these designs. Stechow, who gives a thorough history and iconographical background for the series of paintings, suggested that Murillo may have chosen his subjects on the basis of their compatibility with landscape settings. While Murillo does not slight the importance of the biblical story, as Stechow has said, it is the landscape that gives the painting its greatest claim to distinction.

This series is generally dated ca. 1665 to 1670. NCW

503

EXHIBITIONS: CMA (1966), cat. no. 64, color illus, p. 215.

LITERATURE: Antonio Palomino de Castro y Velasco, *El Museo pictorico y Escala óptica* (Madrid, 1715–24), III, 424 (reprint ed., Madrid, 1947, p. 1036; also reprinted in Francisco Javier Sánchez-Cantón, *Fuentes literarias para la historia del arte español* [Madrid, 1936], IV, 299); Richard Cumberland, *Anecdotes of Eminent Painters in Spain During the 16th and 17th Centuries* (London, 1787), II, 101–2, 124–25; John Young, *A Catalogue of the Pictures at Grosvenor House, London* (London, 1820), introduction and p. 24, no. 69, illus.; William Buchanan, *Memoirs of Painting, with a Chronological History of the Importation of Pictures by the Great Masters into England since the French Revolution* (London, 1824), III, 219, 221–22, 228–29, 233, 392; J. D. Passavant, *Kunstreise durch England und Belgien* (Frankfurt, 1833), p. 66; Gustav Friedrich Waagen, *Works of Art and Artists in England* (London, 1838), II, 315; Waagen (1854), II, 172; Moses F. Sweetser, *Artist Biographies: Murillo* (Boston and New York, 1877–78), VII, 86–87, 128; Ellen E. Minor, *Murillo* (London, 1882), pp. 51–52, 74; Charles Berwick Curtis, *Velázquez and Murillo* (London and New York, 1883), pp. 120–21; L. Alfonso, *Murillo, el Hombre, el Artista, las Obras* (Barcelona, 1886), pp. 195–96; Carlo Justi, "Murillo," *Zeitschrift für bildende Kunst*, II (1891), 161; Paul Lefort, *Murillo et ses Elèves* (Paris, 1892), cat. no. 10, p. 70; Sir William Stirling-Maxwell, *Annals of the Artists of Spain* (London, 1896), p. 1093; *Murillo*, Masters in Art, no. 10 (New York, 1900), p. 35; Justi, *Murillo* (Leipzig, 1904), p. 14; Albert F. Calvert, *Murillo* (London and New York, 1907), pp. 155–56; G. K. Nagler, *Neues Allgemeines Künstler-Lexikon* (Linz, 1908), p. 140; Narcisso Sentenach y Cabanas, *The Painters of the School of Seville* (London and New York, 1911), p. 198; August L. Mayer, *Die Sevillaner Malerschule* (Leipzig, 1911), pp. 173–74, pl. 55; Mayer, *Murillo*, Klassiker der Kunst (Stuttgart and Berlin, 1913), illus. p. 107; Theodore Ehrenstein, *Das Alte Testament im Bilde* (Vienna, 1923), fig. 34; Mayer, "*Laban in Search of His Household Gods*," *Apollo*, IX (1929), 79–80, illus. p. 80; Mayer, in Thieme-Becker, XXV (1931), 286; Mayer, *La Pintura Española* (Barcelona, 1937), p. 193; Mayer, *Historia de la Pintura Española* (Madrid, 1942), pp. 365–66; Emiliano M. Aguilera, Bartolomé Esteban Murillo (Barcelona, 1950), p. 20; Pigler (1956), p. 63; Louis Réau, *Iconographie de l'art Chrétien*, II (Paris, 1956), 150; Gaya Nuño (1958), p. 250, no. 1945; George Kubler and Martin Soria, *Art and Architecture in Spain and Portugal and Their American Dominions 1500 to 1800* (Baltimore, 1959), p. 277; Wolfgang Stechow, "*Bartolomé Esteban Murillo: Laban Searching for His Stolen Household God's in Rachel's Tent*," *CMA Bulletin*, LIII (1966), 367–76, figs. 1, 2, 3, illus. pp. 368–69 (color); *Selected Works* (1966), no. 154, illus.; William B. Jordan, "Murillo's *Jacob Laying the Peeled Rods before the Flocks of Laban*," *Art News*, LXVII (Summer 1968), 31, 69; Louise S. Richards, "Bartolomé Esteban Murillo: A Drawing for a Virgin and Child," *CMA Bulletin*, LV (1968), 238, fig. 3; Thomas Munro, *Form and Style in the Arts: An Introduction to Aesthetic Morphology* (Cleveland and London, 1970), pl. III; *CMA Handbook* (1978), illus. p. 150; Juan Antonio Gaya Nuño, *L'Opera completa di Murillo*, Classici dell'Arte, vol. 10 (Milan, 1978), 104, no. 206, fig. 206, pls. 40–42 (color); Diego Angulo Iñiguez, *Murillo*, II (Madrid, 1981), 33, cat. no. 32, and III, pls. 124–27.

JUSEPE (JOSE) DE RIBERA
1591–1652

Ribera was born in Játiva (Valencia) in 1591. He was the son of a shoemaker. According to Palomino, he was a pupil of Francisco Ribalta (1565–1628). He left Spain, and though he never returned, he frequently signed his work "Lo Spagnoletto." After trips to Lombardy, Parma, and Rome—where he sought out and copied the works of Raphael, the Carracci, and Caravaggio—he established himself in Naples (then part of the Spanish kingdom), probably about 1616. He married Catarina Azzolino, the daughter of a painter. The births of their seven children are recorded in Neapolitan baptismal records between 1627 and 1636. Ribera died in Naples in 1652.

Most of Ribera's commissions came from the monastery of S. Martino in Naples and from the various Spanish viceroys of Naples, such as the Duke of Alcalá, the Duke of Monterrey, and the Duke of Osuña. Many of these works were shipped back to Spain. Ribera's interpretation of Caravaggio's chiaroscuro had a significant effect on his pupils as well as on the Neapolitan school of painting. His contribution to seventeenth-century painting was to establish links between the Italian baroque and the remarkable works of Spanish artists such as Zurbarán and Velázquez. He also helped to spread Caravaggio's influence outside of Italy.

221 *St. Jerome* 61.219

> Canvas, 129 x 100.3 cm. Signed on spine of the book at the lower right: Jusepe de Ribera español/F.
>
> Collections: Private collection, Italy (?); [F. Kleinberger & Co., New York].
>
> Mr. and Mrs. William H. Marlatt Fund, 1961.

In 1961, before it entered the Museum collection, the painting was cleaned and restored by Thomas Wickens of London and lined by W. G. Hookins (letter of October 6, 1961, from Harry G. Sperling of F. Kleinberger & Co.). The painting is in very good condition, except for isolated, minor damages to the paint surface. An area of paint loss extends from the chest of the saint, along the inside of his exposed upper arm, up to his beard.

St. Jerome—ascetic and hermit, one of the most popular penitent saints of the Counter Reformation and a frequent subject in Spanish and Italian seventeenth-century painting—is shown here with his usual attributes: the stone with which he beat his breast, the skull that symbolizes the emptiness of human vanity, and the book that signifies scholarship. As Richard Spear (Exh: 1971) pointed out, the sentiment in this painting derives from Bolognese art and the work of such contemporaries as Guercino and Guido Reni, both of whom had significant influence on Ribera. Obviously, the artist was also influenced by the "tenebroso" style of Caravaggio.

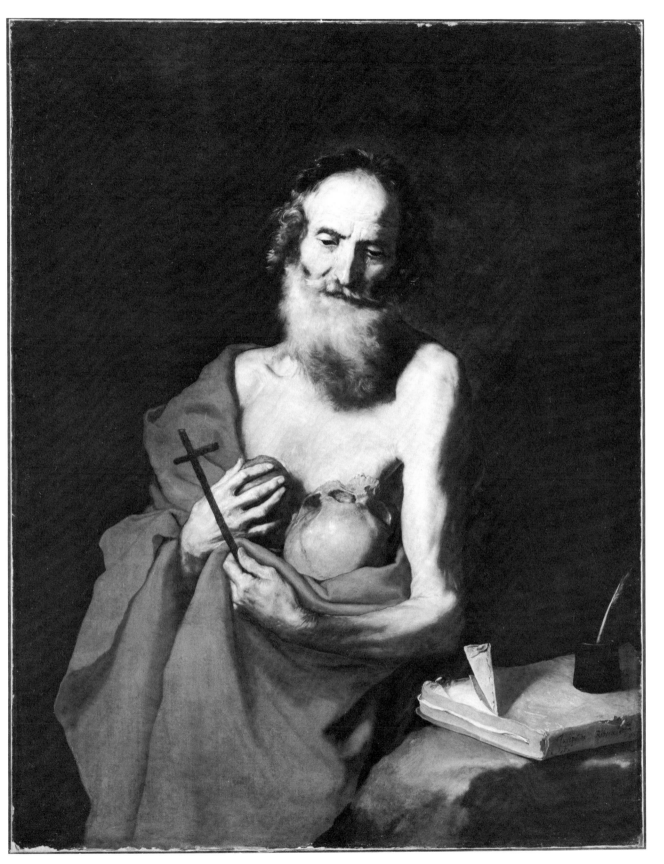

Figure 221.

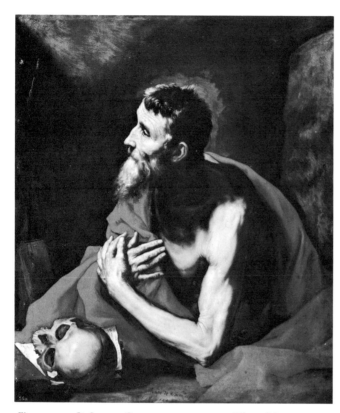

Figure 221a. *St. Jerome*. On canvas, 109 x 90 cm. Ribera. Museo del Prado, Madrid.

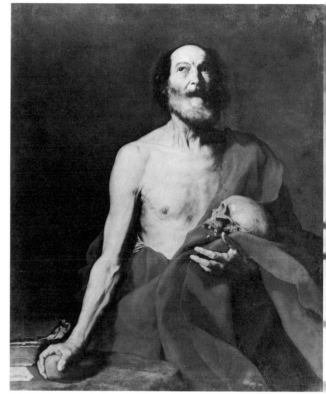

Figure 221b. *St. Jerome*. On canvas, 127 x 100.7 cm. Ribera. Fogg Art Museum, Cambridge (Massachusetts), Gift of Arthur Sachs.

This painting, unpublished before its acquisition by the Cleveland Museum, has been dated late in Ribera's career, ca. 1651 or 1652, by Carter (Exh: 1963) and Francis (1966). Spear (Exh: 1971) suggested the 1640s, despite the similarity to the *St. Jerome* in Naples, which is dated 1651 but was begun as early as 1638 (Elizabeth du Gué Trapier, *Ribera*, New York, 1952, p. 225). Spear pointed out the close affinity of the Cleveland *St. Jerome* to the *St. Jerome* of 1644 in the Prado (Figure 221a); he said further that the Cleveland painting is even closer to the *St. Jerome* of 1640 in the Fogg Art Museum, Harvard University (Figure 221b), which he feels may be of the same model. Craig Felton (orally, during a visit to the Museum, June 1977) accepted the painting as an autograph work.

A seventeenth-century copy of the Cleveland painting is in the Magisterial Palace, Valletta, Malta (Spear, Exh: 1971). N CW

EXHIBITIONS: CMA, November 1961: Year in Review, cat. no. 68, illus.; John Herron Art Museum (Indianapolis) and Museum of Art of the Rhode Island School of Design (Providence), 1963: El Greco to Goya: A Loan Exhibition of Spanish Painting of the Seventeenth and Eighteenth Centuries, cat. no. 68, pl. 68 (catalogue by David Carter); Jacksonville, Florida, Cummer Gallery of Art, 1965: 700 Years of Spanish Art, cat. no. 31, illus.; CMA, 1971/72: Caravaggio and His Followers, cat. no. 57, illus. p. 155 (catalogue by Richard E. Spear).

LITERATURE: Henry S. Francis, "*The Death of Adonis*, Jusepe de Ribera" CMA *Bulletin*, LIII (1966), 339–40, fig. 2; Craig Felton, "Jusepe de Ribera: A Catalogue Raisonné" (Ph.D. dissertation, University of Pittsburgh, 1971), pp. 127–28, 337, no. s-7; CMA *Handbook* (1978), illus. p. 151.

JUSEPE (JOSE) DE RIBERA

222 *The Death of Adonis* 65.19

Canvas, 184.4 x 238.8 cm.

Collections: Jean Bartoloni, Château de Versoix, Switzerland; La Comtesse de Rougé and La Marquise de Divonne, both daughters of Bartolini (sale: Christie's, London, April 1, 1960, no. 101, pl. LIII); [Frederick Mont, New York].

Mr. and Mrs. William H. Marlatt Fund, 1965.

This painting was cleaned and lined by William Suhr in 1965. There was extensive damage along all edges of the canvas. Along the left side the damage was especially severe, and the boar's head was almost obscured by dark, ambiguous inpainting below the *putto*'s outstretched arm. There are no major abrasions or damages in the figures.

Due partly to its neglected and dirty condition, the painting received very little attention until acquired by this Museum. It is one of two extant versions of the subject; the other, in the Palazzo Corsini, Rome (Elizabeth du Gué Trapier, *Ribera*, New York, 1952, fig. 81, p. 128), is signed and dated 1637. The Corsini version closely follows a classical source—perhaps the *Metamorphoses* of Ovid. It depicts Venus with outstretched arms, descending upon Adonis, who lies with his head turned to one side as if asleep, his back exposed and his body partially draped. The emphasis here is more on the drama of Venus's discovery than on the poignant realization that her lover is dead. The position of Adonis in the Corsini painting is reminiscent of the position of Abel in the painting, *Cain and Abel*, in the Städtische Kunstsammlungen in Bamberg (*Katalog*, 1927, no. 339). In the Cleveland painting, which must have followed the Corsini version, the compositional elements have been more closely interrelated. A distraught, kneeling Venus in torn garments, dropping roses from one of her raised hands, hovers over the outstretched, ashen figure of Adonis, who lies on his back, his wound deliberately exposed. Surrounding the two figures and enclosing them in the composition are the dog in the extreme right corner; a shadowy, open-mouthed figure emerging from the right; a cupid descending from above; the chariot of the goddess, led by a pair of doves, at the upper left corner; and the darkened figures of two cupids at the left, tethering the boar which is barely visible in the darkness at the lower left. Stechow (1966), comparing Ribera's version in Cleveland with the Corsini version of 1637, concluded that the Cleveland painting is far more monumental. Its figures are compositionally intertwined; the falling rose that hovers over Adonis's head in the exact center of the canvas creates a dramatic tension; and the vivid glow of color and the mysterious darkness produced a splendidly rhetorical and fully convincing tragedy.

Chenault (1971) cogently points out that the Cleveland painting is far more complex than the Corsini version, not only compositionally but iconographically as well. Chenault was convinced that Ribera had in mind an analogy between Christianity and classical mythology. She explains that Ribera must have known the epic poem *Adone*, published in 1623 by the Italian poet Giovanni Battista Marino. In the poem, Marino describes a shepherd named Clizio, whom Venus had left to watch over Adonis, and who, perhaps, is the shadowy figure at the right in the Cleveland painting. Marino's poem also describes a wound in the right side of Adonis (the same side as the wound of Christ), rather than in his groin (in the Corsini version there is no visible wound, and the right side is covered by drapery). In turn, Chenault felt, Marino may have derived this element from a painting of the *Death of Adonis* by Francesco Maria Vanni (now lost), in which the wound appears in the side of the youth. Chenault also pointed out that Marino was acquainted with French medieval iconography and that during his trip to Paris in 1615 he might have become familiar with an anonymous poem, written in Angers around 1300, in which the death of Adonis is compared to the sacrifice of Christ, a boar is compared to the Jews, and there is a similar theme of resurrection.

A painting by Ribera called *Venus and Adonis* is recorded in the 1634 expense account of the Duke of Monterrey, the Spanish viceroy of Naples, who made twelve shipments of paintings in 1633 from Naples to Madrid for the Palace of Buen Retiro (Carlo Justi, *Diego Velázquez and His Times*, London, 1889, p. 194; and Trapier, *op. cit.*, p. 236). Perhaps this is the *Venus and Adonis* mentioned in a letter written in 1656 by the Marquis of Liche, or Eliche (Trapier, p. 236; and Chenault, 1971, p. 76, n. 1), who sent it to Pasca in that same year to be sold for 4,400 reales in order to meet pressing expenses for the Buen Retiro (Duque de Berwick y de Alba, *Discursos leidos ante la Real Academia de Bellas Artes de San Fernando en la recepción pública del Excmo. Sr. Duque de Berwick y de Alba*, Madrid, 1924, p. 91). Another *Venus and Adonis* by Ribera was sold to Rodrigo de Trapia in 1634 (Domínguez Bordona, "Noticias para la historia del Buen Retiro," *Revista de la Biblioteca, Archivo y Musei*, X, 1933, 84). Still another version by Ribera, cited by Trapier (pp. 236, 282, n. 173; further clarified in letter of August 9, 1966), was in the *Carta de Dote* (dowry) of September 21, 1677, of Micaela Zapata Chacon, daughter of the Count of Casarrubios who married the Marquis of Mortara.

It is impossible at present to positively identify any of the above-mentioned paintings with the extant versions of the subject in Cleveland and in Rome, for detailed descriptions and measurements are missing from these early documents. Nor are there descriptions in the records before 1637 that would relate any of the works discussed with either the Corsini or the Cleveland painting. There is, however, a painting called *Perseus, Dead with a Goddess . . .*, which appears in the Alcázar inventory of 1686 (I. Bottineau,

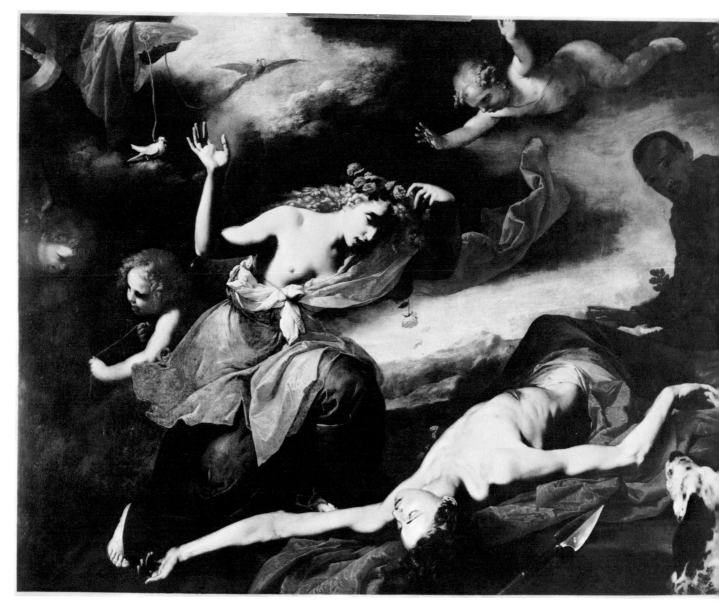

Figure 222.

"L'Alcázar de Madrid et l'Inventaire de 1686," *Bulletin Hispanique*, LX, 1958, 325, no. 886), whose description corresponds to the *Death of Adonis* in Cleveland (Chenault, 1971, p. 76, no. 1). According to the inventory, it was badly damaged. The description and measurements, 2.09 x 2.92 meters, were identical to those given in the Alcázar inventory of 1700, except that there is no mention of the frame nor any valuation of the painting given in the latter inventory. (The author is indebted to José López-Rey y Arrojo for checking these inventories and generously providing the information.)

The Cleveland painting has generally been accepted by scholars as the work of Ribera. Craig Felton (1971, and letter of September 27, 1971), however, listed it under "rejected attributions" and suggested the unlikely possibility that it is by an Italian, not a Spaniard. Felton tentatively attributed it to Jacopo Vignali (1592–1664), a Florentine artist influenced by Matteo Rosselli, Guercino, and Ribera (for further discussion of Vignali's works, see Carlo del Bravo, "Per Jacopo Vignali," *Paragone*, XII, no. 135, 1961, 28–42).

The *Death of Adonis* certainly shows the characteristics of style shared by Ribera and Guercino, for it recalls the latter's *Wounded Tancred Assisted by Ermina*, painted in 1621, now in the Galleria Doria-Pamphili, Rome. Guercino's *Venus Mourning the Death of Adonis*, of 1647, in the Dresden Gemäldegalerie, on the other hand, recalls two paintings by Ribera of that same subject.

A dramatically foreshortened, recumbent male figure also appears in other paintings by Ribera, such as the *Apollo and Marsyas*, dated 1637, in the Museo San Martino, Naples. NCW

EXHIBITIONS: On loan to the Musée d'Art et d'Histoire, Geneva, from ca. 1950 to 1960; CMA (1966), cat. no. 65, illus. p. 219.

LITERATURE: Henry S. Francis, "Jusepe de Ribera, The Death of Adonis," CMA *Bulletin*, LIII (1966), 339–47, figs. 5 and 6, and color illus. pp. 342–43; Wolfgang Stechow, "Cleveland's Golden Anniversary Acquisitions," *Art News*, LXI (September 1966), 43, illus. p. 40; Mahonri Sharp Young, "Letter from U.S.A.—Great Guns at Detroit and Cleveland," *Apollo*, LXXXIV (1966), 239, illus. p. 240; Jeanne Chenault, "Ribera, Ovid, and Marino: Death of Adonis," *Paragone*, XXII, no. 259 (1971), 68–73, 75–76, pls. 51 and 52; Craig Felton, "Jusepe de Ribera: A Catalogue Raisonné" (Ph. D. dissertation, University of Pittsburgh, 1971), pp. 414–15, nos. X–XI; Raffaello Causa, "La Pittura del Seicento a Napoli dal naturalismo al barocco," *Storia di Napoli*, V (Naples, 1972), pl. 282; Mark P. O. Morford and Robert J. Lenardon, *Classical Mythology* (New York, 1977), p. 111, illus.; CMA *Handbook* (1978), illus. p. 151; Barbara von Barghahn, "The Pictorial Decoration of the Buen Retiro Palace and Patronage During the Reign of Philip IV," (Ph.D. dissertation, New York University, 1979), pp. 105, 133.

DIEGO RODRIGUEZ DE SILVA Y VELAZQUEZ
1599–1660

Velázquez was baptized in Seville on June 6, 1599. His paternal grandfather was Diego Rodriguez de Silva, who came from a noble Portuguese family; Velázquez often used his name in later years, calling himself either Diego Velázquez de Silva or Diego de Silva Velázquez. At twelve he entered the studio of Francisco Pacheco (1564–1654), with whom he studied for a period of five to six years. In his petition for admission to the guild of St. Luke in Seville—which was granted in 1617—he revealed that he had studied with Francisco de Herrara the Elder (ca. 1590–1656) prior to his apprenticeship with Pacheco (Antonio Palomino de Castro y Velasco, *El Museo pictórico y Escala óptica*, 3 vols., Madrid, 1715–24; reprint ed., Madrid, 1947, p. 892). In 1618 Velázquez married Pacheco's daughter. By 1620 he was an established master in Seville, known particularly for his *bodegones*. In 1622 Velázquez traveled to Madrid, hoping to gain the favor of the court and to see the rich collection of paintings at the Escorial. He returned to Seville. One year later, through the Duke of Olivares, he received an invitation to the royal court, where he was to paint his first portrait of Philip IV (now in the Prado, Madrid). Henceforth he served Philip as official court painter and chamberlain of the palace. From 1629 to 1631 Velázquez visited Italy, likely inspired to do so by Rubens, with whom he had become acquainted when the latter visited Philip IV in 1628. Velázquez made a second journey to Italy from 1649 to 1651, with Queen Marianna of Austria, during which time he was delegated to acquire paintings for the royal palace. While in Rome he painted, among other works, the *Portrait of Pope Innocent X* (Doria Palace, Rome) and his servant *Juan de Pareja* (Metropolitan Museum of Art). Velázquez died at court in 1660; his wife died seven days later.

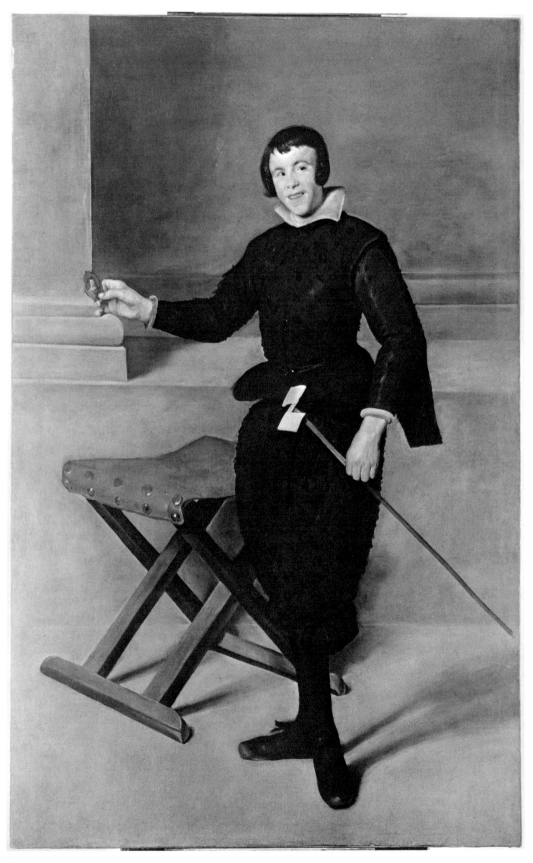

Figure 223.

223 *Portrait of the Jester Calabazas* 65.15
 (also known as Calabaçillas)

Canvas, 175 x 106 cm.

Collections: Royal Collections, Madrid; Duc de Persigny, Paris
(sale: April 4, 1872, "Le Fou" 750 fr. [*Dictionnaire de Ventes*, p.
297]); Maurice Cottier (died 1881), Château Cangé (Touraine);
Sir George Donaldson, London and Brighton, sold in 1915; Her-
bert Cook, later Sir Herbert Cook, lent to his father, Sir Frederick
Cook, Doughty House, Richmond; Sir Francis Cook, Bart., since
1956; (sale: Christie's, London, March 19, 1965, cat. no. 104,
illus., through Thomas Agnew & Sons, London).

Purchase, Leonard C. Hanna Jr. Bequest, 1965.

The painting is in good condition. There was a small hole in
the right corner of the jester's right eye and one in the
middle of the mouth. Some abrasions in the background
allow the red underpaint to show more in some places than
the artist intended—the underpaint, which Velázquez
placed on a white opaque ground, was used primarily to
animate the large areas of gray. The most radical change
was the inpainting of the right eye, probably for the pur-
pose of lessening the representation of the jester's strabism.
This may have been done in the latter part of the eighteenth
or nineteenth century, when, according to López-Rey
(1967, p. 224, no. 21), the painting was in the Buen Retiro
Palace. A document of May 24, 1803, states that the painter
Mariano Salvador Maella (1739–1819) had been entrusted
(at an unspecified date) with the restoration of eighteen
paintings from the palace, including the *Portrait of Cala-
bazas* now in Cleveland. It may have been Maella who was
responsible for adding over a half centimeter to the width of
the jester's spindly legs. In 1965 William Suhr cleaned the
portrait and removed the overpaintings, thus restoring
Calabazas's likeness, which is known to us through the
later portrait of him at the Prado. Although there is exten-
sive overpainting on the jester's right hand, the miniature
he holds in that hand shows no restoration or paint of a
later date, as had been suggested by various scholars (Gen-
sel, 1925; Trapier, 1948; Mayer, 1936).

The Cleveland painting is the first of Velázquez's two
extant portraits of Juan de Calabazas, or Calabaçillas, a
squint-eyed jester at the court of Philip IV of Spain, whose
full name, according to Justi (1888; and 1933, p. 705), was
Juan de Cardenas y Calabazas. A second portrait in the
Prado (Figure 223*a*), painted shortly before his death in
1639, shows him seated on a bench between two gourds—
a visual pun on his name, Calabazas, which means both
gourd and simpleton. The pinwheel or paper windmill (in
Spanish called *reguilete*, *rehilete*, or *molinillo de papel*) is
also an allusion to the jester's simplicity. In Cesare Ripa's
Iconologia (Padua, 1630, p. 557) a boy is pictured riding a
hobby horse and holding a toy windmill in his hand to
symbolize *pazzia*, that is, madness or folly; and in Mateo
Aleman's widely read, picaresque novel, *Guzman de Al-
farache* (first published in 1599), a pinwheel carried by a

boy symbolized idle dreaming (López-Rey, 1967, p. 220).

Another portrait of Calabazas (now lost) is listed in the
inventory of the collection of the Marqués de Leganés (José
López Navio, *La gran colección de pinturas del Marqués de
Leganés*, p. 292, no. 549, published in *Analecta calasancia*,
IV, no. 8, 1962, "otra [pintura] de calavazas con turbante.
de Velazquez, le taso en 200").

After Herbert Cook first published the portrait in 1906
and Beruete included it in the German edition of his mono-
graph published in 1909 (see translation by Selwyn Brin-
ton, 1920), scholars generally accepted it as work by Veláz-
quez—in spite of the disturbing overpainting and the fact
that the Buen Retiro Palace inventory of May 19, 1701 (the
first to mention our painting) did not accurately describe
the portrait. In the inventory, Calabazas is said to be hold-
ing a *retrato* (a miniature portrait) in one hand and a *villete*
(the eighteenth-century spelling for *billete*, a note or a let-
ter) in the other, as do several other Velázquez sitters. Be-
cause the Calabazas of our picture holds a portrait in his
right hand and a pinwheel in his left hand, some scholars,
such as Gué Trapier (1948) and Steinberg (June 1965),
were reluctant to identify our portrait with the one described
in the inventory of May 19, 1701. As a result, Alonso Cano
was suggested as an alternative attribution. López-Rey

Figure 223*a*. *Calabazas*. On canvas, 106 x 83 cm. Velázquez.
Museo del Prado, Madrid.

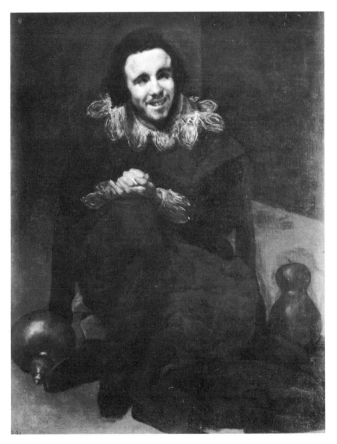

(1967) then argued convincingly that a mistake may have occurred, because the amanuensis to whom the inventory was dictated mistook the like-sounding word "*reguilete*" or "*rehilete*" (pinwheel) for "*villete*" (note or letter). The error was repeated in the Buen Retiro Palace inventory of 1716 compiled by Marentes (where the painting is no. 614), but as López-Rey (1967, p. 223) discovered, the palace keeper, Don Pedro Gil de Bernabé, corrected the mistake in his inventory of September 7, 1789 (where the painting is no. 178) as follows: *Otra [pintura] de Velázquez: Retrato de Velasquillo el Bufon, y el Ymbentario antiguo dice ser de Calavçillas con un Retrato en la mano y un reguilete* ("Another [painting] by Velázquez: portrait of Velasquillo, the buffoon, which according to an old inventory is Calabaçillas with a portrait and a pinwheel in his hands").

De Bernabé's mention of alternate names for the sitter—"Velasquillo" and "Calabaçillas"—clears up another confusion concerning the identity of the sitter that was caused by Mariano Salvador Maella's incomplete inventory of July 19, 1789, in which he mentioned no portrait of Calabazas or Calabaçillas, but under no. 178 listed one of "Velazquillo el Bufon" (with no mention of the artist). Evidently De Bernabé took it for granted that Velasquillo was the same as Calabazas (López-Rey, 1967, p. 222). It is possible that Maella fused the names Calabaçillas—the diminutive or endearing form of Calabazas—and Velázquez to form a new name. Trapier (1948, p. 148, n. 242) cites an eighteenth-century reference to a jester of Philip IV by the name of Velasquillo, but, according to López-Rey, no document has yet been found in the royal archives in Madrid to confirm the existence of a jester by that name.

Our portrait appeared in two additional eighteenth-century inventories of the Buen Retiro Palace: another drawn up by Maella that merely repeated the list of September 7, 1789; and an inventory of May 5, 1794, taken by De Bernabé, who accounted anew for each painting present in the Buen Retiro. An inventory of July 5, 1808—taken when the palace was occupied by the French army—still included our portrait. A later inventory, of February 11, 1814—after the expulsion of the French from Spain—merely repeats the list of July 5, 1808, apparently regardless of whether or not the paintings were still there.

The portrait was shown in the Exposition Retrospective at the Palais des Champs Elysées in Paris in July 1866, on loan from the Duke of Persigny. According to Pantorba (1955), the duke acquired the portrait in 1863 at an unidentified public sale of a collection in the north of England. After the sale of the duke's collection on April 4, 1872, the painting belonged to the painter, writer, and part-owner of the *Gazette des Beaux-Arts*, Maurice Cottier (died 1881), at the Château Cangé (Touraine). From there the portrait went to England, and eventually, in 1965, it entered the collection of The Cleveland Museum of Art.

The style of the portrait indicated a date during or shortly after the time when Calabazas served the Cardinal-Infante Don Fernando, whose brother, Philip IV, became regent of the Netherlands in 1632. Calabazas remained with the royal household of King Philip IV until his death in 1639. Francis (1965, p. 121) compared our portrait to one of Philip IV, dating from 1627, and to one of Ferdinand, dated ca. 1626 to 1628, but particularly to the one of Pablo de Valladolid of ca. 1633. López-Rey pointed to the nervous, somewhat tight modeling of the jester's face, which reminded him of Bacchus's face in Velázquez's large painting of 1628–29, and he suggested therefore that our portrait was painted before Velázquez left for his first visit to Italy. Camón Aznar (1964, I) and Moreno Villa (1939, p. 87) relate the date of the painting to a special event in the jester's life, that is, November 9, 1632, when the king gave him a new suit of *terciopelo labrado* (slashed or cut velvet), which Camón Aznar believes is featured in our portrait.

Dr. K. M. Laurence of the Welsh National School of Medicine, Penarth, Blem (memorandum of October 1965), estimated that the sitter's age was seventeen or eighteen when the Cleveland portrait was painted, and that the Prado portrait shows him at twenty-four to twenty-five. Dr. Laurence believed that the abnormalities of Calabazas's physique point to a mild hydrocephalitic condition. He thought that the jester's hollow left foot, with the toe pointing to the ground, was incapable of supporting weight, due perhaps to a lesion of the spinal cord (*spina bifida*) that caused paralysis in one or both legs. A T L

EXHIBITIONS: Paris, Palais des Champs-Elysées, 1866: Exposition Retrospective; CMA, November 1965: Year in Review, cat. no. 109, illus.

LITERATURE: Paul Mantz, "La Galerie de M. Charles Cottier," *Gazette des Beaux-Arts*, V (1872), 380–81; Charles B. Curtis, *Velázquez and Murillo* (London and New York, 1883), p. 33, no. 75; Carlo Justi, *Diego Velázquez und sein Jahrhundert*, II (Bonn, 1888), 694 (rev. English edition, trans. A. H. Keane [London and Philadelphia, 1889], p. 438; reprint [Zurich, 1933], p. 705, cat. no. 28, pl. 25; Spanish edition, rev. and ed. Juan Antonio Gaya Nuño, trans. Pedro Marradas [Madrid, 1953], pp. 704–6, fig. 193); Jacinto Octavio Picon, *Vida y obras de Don Diego Velázquez* (Madrid, 1899), mentioned under lost paintings; Paul Lafond, "Des Portraits de fous, de nains et de phénomènes," *La Revue de l'Art Ancien et Moderne*, XI (January–June 1902), pp. 226–27; Herbert Cook, "A Rediscovered Velázquez," *Burlington Magazine*, X (1906), 171–72, illus. p. 170; Elias Tormo, "Velazquez—el salon de Reinos del Buen Retiro, y el poeta del palacio y del pintor," *Boletin de Sociedad Española de Excursiones*, XIX (Madrid, 1911), 25, n. 1; *Catalogue of the Sir Frederick Cook Collection* (1913), no. 500; Walther Gensel, *The Work of Velázquez*, Classics in Art Series (New York, 1913), illus. p. 151; Maurice W. Brockwell, "The Cook Collection, Part III," *Connoisseur*, L (January 1918), 8, pl. XXIII; D. Aureliano de Beruete y Moret, trans. Selwyn Brinton, "Exhibition of Ancient and Modern Spanish Paintings at the Royal Academy, *Connoisseur*, LVIII (December 1920), 188; J. Moreno Villa, *Velázquez* (Madrid, 1920), pp. 38–40, illus. following p. 24; Brockwell, "Calabaçillas, the Buffoon," *Connoisseur*, LIX (February 1921), 116, 119–20, illus. p. 121; August L. Mayer, *Diego Velázquez* (Berlin, 1924), pp. 74–75; Gensel, *Velázquez*, Klassiker der Kunst (Stuttgart, Berlin, and Leipzig, 1925), p. 274, illus. p. 30; *Abridged Catalogue of the Pictures at*

Doughty House, Richmond, Surrey, in the Collection of Sir Herbert Cook, Bart. (London, 1932), p. 59, no. 500, pl. XX; Mayer, *Velázquez: A Catalogue Raisonné of the Pictures and Drawings* (London, 1936), p. 104, no. 445, and pl. 149; Moreno Villa, *Locos, enanos, negros y niños palaciegos* (Mexico City, 1939), p. 85, illus.; Mayer, *Velázquez* (Paris, 1940), p. 14; H. Vollmer, in Thieme-Becker, XXXIV (1940), 191; Ramon Gomez de la Serna, *Don Diego Velázquez* (Buenos Aires, 1943), pp. 64–65, 133, fig. 5; Enrique Lafuente, *The Paintings and Drawings of Velázquez* (London and New York, 1943), no. XXX, p. 19, pl. 32; Elizabeth du Gué Trapier, *Velázquez* (New York, 1948), p. 115; Juan Antonio Gaya Nuño, "Después de Justi. Medio siglo de estudios Velazquistas," *Velázquez y su siglo* (Madrid, 1953), pp. 853, 867, no. 34; José Ortega y Gassett, *Velázquez* (New York, 1953), p. LXVII, no. 67, illus.; Bernardino de Pantorba, *La Vida y obra de Velázquez* (Madrid, 1955), pp. 92–93 no. 32, 141; Gaya Nuño (1958), p. 320, no. 2833; Juan Rof Carballo, "Velázquez y la Normalidad," *Varia Velazqueña*, I (Madrid, 1960) 87; Emilio Orozco Diaz, "Un Aspecto del Barroquismo de Velázquez," *Varia Velazqueña*, I (Madrid, 1960), 196; Juan José Martín González, "Algunas sugerencias acerca de los 'Bufones' de Velázquez," *Varia Velazqueña*, I (Madrid, 1960), 253; Matila Lopez Serrano, "Reflejo Velazqueño en el arte del libro español de su tiempo," *Varia Velazqueña*, I (Madrid, 1960), 502; José López-Rey, *Velázquez: A Catalogue Raisonné of His Oeuvre* (London, 1963), pp. 52, 57, 264 no. 423, pl. 49; Francisco Javier Sánchez-Cantón, *Museo del Prado: Catalogo de las pinturas* (Madrid, 1963), p. 744, no. 1250; José Camón Aznar, *Velázquez* (Madrid, 1964), I, 447–48, illus., and II, 611, 1004; Pantorba, *Tutta la Pittura del Velázquez* (Milan, 1964), pp. 42–43, 86, pl. 43; Christie's, Manson & Woods, Ltd., "Paintings from the Cook Collection," *International Art Market*, V (May 1965), 50, no. 104; Frank Davis, "Old Master Canvases and Prints," *Country Life*, no. 137 (April 8, 1965), illus. p. 797; Henry S. Francis, "*Portrait of the Jester Calabazas,*" *CMA Bulletin*, LII (1965), 117–23, figs. 1, 2, 4, color illus. p. 115; López-Rey, "Letters to the Editor," *Art Bulletin*, XLVII (September 1965), 399; *Goya—Rivista de Arte*, no. 69 (November–December 1965), illus. p. 202; Leo Steinberg, review of López-Rey's *Velázquez: A Catalogue Raisonné of His Oeuvre*, in *Art Bulletin*, XLVII (June 1965), 283; Steinberg, "Letters to the Editor," *Art Bulletin*, XLVII (September 1965), 402; Alsop (May–June 1966), pp. 22–23, illus.; Alsop, "Les Chefs-d'oeuvre de première importance du second musée des Etats-Unis," *Connaissance des Arts* (June 1966), 55, 57, 60, color illus. p. 54; *Christie's Bi-Centenary Review of the Year: October 1965 – July 1966*, p. 24; *The Journal of the American Medical Association*, CXCVI (May 30, 1966), 765 and cover illus.; López-Rey, "Velázquez's *Calabazas with a Portrait and a Pinwheel,*" *Gazette des Beaux-Arts*, LXX (October 1967), 219–26, figs. 1, 4, 5; Ann Tzeutschler Lurie, "*Portrait of the Infante Don Luis de Borbón,*" *CMA Bulletin*, LIV (1967), 5; López-Rey, *Velázquez's Work and World* (Greenwich, Connecticut, 1968), pp. 87–92, 104; *CMA Handbook* (1978), illus. p. 149.

FRANCISCO DE ZURBARAN
1598–1662 or 1664

Zurbarán was born to a peasant family in the small Andalusian town of Fuente de Cantos in 1598. Early in 1614 he was in Seville working in the studio of a minor painter, Pedro Díaz de Villanueva. From 1617 to 1628 he lived in Llerena, a small city sixty miles from Seville. He was exposed to the work of Caravaggio and Ribera, among others. His paintings, with their clear-cut compositions and isolated figures and objects, have a sculptural quality, the influence of the sculpture tradition in nearby Seville, whose chief representative at that time was Juan Martínez Montañés. In 1629, at the request of the city, in recognition of his achievements, he moved with his wife and children and eight servants (some of whom were assistants in his already-well-established studio) to Seville, where he resided until 1658. His presence in Seville, one of Spain's major harbors for export, accounts in part for the existence of so many Zurbarán paintings and workshop copies in Spanish America. The brothers of Zurbarán's second wife, living in Colombia and Peru, provided a connection to the New World, as did the emigration of many citizens from Llerena after the war with Portugal. In 1634 Zurbarán was in Madrid, where he collaborated briefly in the decoration of the new Buen Retiro Palace under the direction of Velázquez. In the 1630s and 1640s he was one of Spain's most prominent painters. During the last fifteen years of his life he was eclipsed by Murillo, and in an effort to gain back some of his prestige, he introduced Murillo's lyricism into his own painting. His son, Juan, who had worked in his studio, died during the plague in 1649. Zurbarán eventually moved to Madrid, where he died in poverty, survived by only one daughter, from his third marriage. For many years Zurbarán was a favorite painter for Catholic churches and monastic orders such as the Dominican, Franciscan, and Carthusian. His paintings helped to reinforce their stringent disciplines and the emphasis on faith that was regenerated by the Counter Reformation and the Spanish Inquisition.

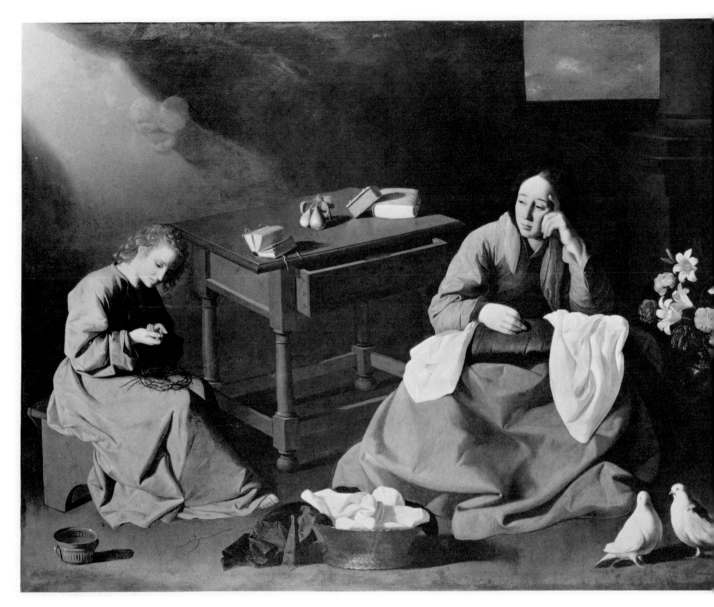

Figure 224.

Canvas, 165 x 22.2 cm.

Collections: Count of Walterstorff (Minister of Denmark to the French court) (sale: Paris, March 26–27, 1821, no. 65, p. 26, to Laneuville); [François Heim, Paris].

Purchase, Leonard C. Hanna Jr. Bequest, 1960.

The painting was cleaned just before it was purchased by the Museum in 1960. There was minor abrasion overall, and there were losses, particularly around the edges of the lined canvas and on the bridge of the nose of Christ. Unfortunately, some of the retouches have changed color in recent years and have become increasingly noticeable; it was, therefore, considered necessary to clean the painting anew, which was done in 1981.

Except for its appearance in the sale catalogue of 1821, the *Holy House of Nazareth* had not been published until it appeared on the market in 1960. Since then it has been accepted unquestionably as the work of Zurbarán. Before its publication by Guinard (1960), another version—in the collection of Dr. D. Agustín Paredes Norgueras of Valencia —had been thought by María Louisa Caturla (*Zurbarán: Estudio y catálogo de la exposición celebrada en Granada*, Madrid, 1953, cat. no. 1) and others to be the original; after learning of the Cleveland painting, Caturla accepted it with enthusiasm (letter of April 17, 1961, and publication of 1964).

One of the most important and poignant works of Zurbarán's youthful production, it dates from about the same time as the four scenes from the *Life of St. Bonaventure* of 1629 and the *Apotheosis of St. Thomas Aquinas* of 1631 in the Seville Museum. During this period Zurbarán painted several works dealing with the young Mary, and with Mary and the youthful Christ. The artist was interested in the human aspect of the subjects, basing them on the many apocryphal legends that were revived in the seventeenth century to popularize the Catholic faith during the Counter Reformation. In the Museum painting, Mary is represented as a pensive and deeply concerned mother, observing with poignant resignation, anticipation, and understanding the injury to her young Son which was symbolic of his future suffering for mankind. The isolated representation of furniture—in itself a still life—in a sparsely furnished room contributes to the feeling of humility and simplicity in the scene. The table also appears in other works by Zurbarán from ca. 1627 to 1630, such as the *Miraculous Cure of the Blessed Reginald of Orléans* in the Church of the Magdalen in Seville, the *Virgin as a Child with St. Joachim and St. Anne* in the Contini-Bonacossi collection, and the *Child Jesus with a Thorn* in the Manuel Sánchez Ramos collection (Gállego and Gudiol, 1977, p. 55).

Though the emphasis is on an intimate, commonplace reality, the scene is highly complex and didactically symbolic: arranged beside the sorrowing Mary are the roses and lilies that symbolize her charity and purity; the cloth in the basket on the floor represents the garments worn at the crucifixion; the bowl of water below Christ symbolizes the water of baptism and redeeming grace; the two pears on the table symbolize the Eucharist or the fruit of Mary's womb; the crown of thorns portends Christ's future ordeal; the doves are symbols of divine love and of the Holy Spirit; the open book refers to the word of God, the closed books to the record of the prophecies of the Bible. Heads of cherubim appear in the divine radiance on the left, and the stormy landscape through the open window suggests the storm of Christ's life and the night of his crucifixion.

The sources for Zurbarán's symbolism, style, and compositions are varied, deriving not only from the Middle Ages and the Renaissance but also from Mannerism (1525–1600), from Germany and the North, as well as Italy and Spain. Perhaps his most-often-used sources were engravings—Flemish, German, and Italian. José Manuel Pita Andrade (1965) points out that the inspiration for the pose and mood of the Virgin Mary in the Museum painting is derived from the great, enigmatic engraving *Melancolia I*, of 1514, by Albrecht Dürer. The source for the figure of the seated Christ has not yet been found, but it may well be in the engravings of such Flemings as Cornelis Cort, Martin Heemskerk, Marten de Vos, or Schelte à Bolswert, all of whom influenced Zurbarán.

At least ten other versions of the Museum painting exist. The version closest in quality (Figure 224a), perhaps by the master himself, is in a private collection in Boston (ex collection: George A. Hearn, sale: American Art Association,

Figure 224a. *Holy House of Nazareth*. On canvas, 149 x 203.2 cm. Zurbarán (?). Private collection, Boston.

New York, February 25, 1918, no. 352, illus. as by Antonio del Castillo y Saavedra, Spanish [1603–1667], a pupil of Zurbarán). The slight but perhaps significant differences in composition between this and the Cleveland painting are: the shape of the bowl in the lower left, the arrangement of flowers, and the absence from the Boston painting of the branch of thorns on the floor below Christ.

Another painting, following the Boston version of the composition, is in Barcelona, collection of Robert Espinal. This is a workshop replica of considerably less quality than either the Cleveland or Boston versions. The figure of Christ, with its thick neck and awkward shoulder construction, especially betrays its inferiority.

Another version, the above-mentioned painting in Valencia, collection of D. Agustín Paredes Norgueras (canvas, 160 x 207 cm), follows the Boston version closely and differs from the Cleveland painting in the same ways. Before the Valencia version was cut on all sides, its dimensions were probably the same as those of the Cleveland painting. Guinard (1960, no. 70) has called the Valencia painting a faithful workshop replica of the Cleveland painting, even though the Valencia painting corresponds more closely to the Boston painting.

There are other extant, later copies of what must have been a very popular painting by Zurbarán. One (canvas, 147 x 209 cm) is in a private collection in Mexico City; Moyssén (1968, fig. 9) and Martin Soria (letter of December 6, 1960) suggested this was painted in New Spain, perhaps after the visit of an engraver from Zurbarán's studio or from a copy of the Cleveland painting. A copy in Puebla, Mexico, in the church of San Miguelito de Cholula, has an additional figure, St. Joseph (Moyssén, 1968, fig. 13; Moyssén suggested it was painted in Mexico). Another painting in Mexico City, in the collection of Señor Rubello, has only the right part of the composition, with no figure of Christ (on canvas, 158 x 33.3 cm; ex collections: Dr. Lucio; Dr. Macias; Dr. Alfonso Amescus; Guadalupe A. de Amescus; photograph and information provided by Martin Soria, letter of February 7, 1961, where he called it Mexican, ca. 1700). Three other copies are in Madrid: one in the collection of Don Gustavo Morales, since 1931 (canvas, 84 x 112 cm; see José Cascales y Muñoz, Francisco de Zurbarán, Madrid, Barcelona, and Buenos Aires, 1931, pl. XIII, and Guinard, 1960, no. 68); another formerly in the Gavilanes collection (Francisco J. Sánchez-Cantón, Nacimiento e Infancia de Cristo, Madrid, 1948, I, illus. p. 288; see also Guinard, 1960, no. 69, where he calls it a good replica of the Cleveland picture, with figures closer together and larger than in other versions); a third one appeared on the Madrid art market. It was formerly in the collection of Dña. Bárbara de Braganza, and earlier was in the Convento de la Visitación, Madrid. It is mentioned by Antonio Ponz in his Viage de España, V (Madrid, 1793; reprint ed., Madrid, 1972), 258, no. 24. And finally, there is a copy in Rochester,

New York, collection of Rowland L. Collins (canvas; inscribed Auul de Torres and dated 1626).

Another painting by Zurbarán, excerpted from and probably painted after Cleveland's Holy House of Nazareth, is the Young Christ Wounded by a Thorn. The finest example of this subject, and the one accepted as unquestionably by the master, is in Seville, collection of Manuel Sánchez Ramos (canvas, 128 x 85 cm; ex collection: D. Cayetano Sánchez Pineda, Seville; Soria, Zurbarán, London, 1953, no. 20, pl. 6, and Guinard, 1960, no. 61). It is generally dated about 1630. The composition is an adaptation of the left portion of the Museum's painting, to which has been added a curtain in the upper left and an architectural background with shallow niches in the center. In addition, the position of the table was changed so that its edges are parallel with the upper and lower edges of the canvas.

There are at least seven other versions of the Young Christ Wounded by a Thorn. A picture in Madrid, collection of Joaquín Payá (canvas, 123 x 83 cm; Caturla, 1953, no. 3, pl. 3, and Guinard, 1960, no. 62), closely follows the Sánchez Ramos painting. A weaker version in Seville, Museo de Bellas Artes (canvas, 70 x 42 cm; Soria, op. cit., p. 138, and Guinard, 1960, no. 64), probably comes from Zurbarán's workshop, ca. 1640.

Other versions seem to be copied after the Cleveland painting or from an engraving of it, for the angle of the table is so faithfully followed. These include the painting presumably in Barcelona, private collection (canvas, 91 x 57 cm, ex collections: Mrs. Joseph Fuller Feder; French & Co.; G. Butler Sherwell, sale, Parke-Bernet, New York, March 25, 1964, no. 24; see Guinard, 1960, no. 65); the canvas in Madrid owned by the Vicomtesse de Aldama (see Guinard, 1960, no. 66); a later example showing the young Christ seated in a landscape, in the Los Angeles County Museum (canvas, 106 x 80 cm, ex collections: Earl of Londesborough; Mrs. R. A. Wertheimer, London; see Guinard, 1960, no. 63); a small painting on copper (14.5 x 21 cm) in the collection of Sr. Angel Barrero Mandacen, Madrid; and others in Mexico, collections of von Wetthenau and Don Demetrio Garcia (Gonzalo Obregon, Zurbarán en Mexico, Badajoz, 1964, p. 17). N C W

EXHIBITIONS: CMA, December 1960: Year in Review, cat. no. 70, illus. pp. 238–39.

LITERATURE: Paul Guinard, Zurbarán et les peintres espagnol de la vie monastique (Paris, 1960), pp. 139, 217, nos. 29–30, fig. 67; "Bibliografia," Archivo Español de Arte, no. 134 (1961), 186, no. 170, illus. opp. p. 180; Henry S. Francis, "Francisco de Zurbarán: The Holy House of Nazareth," CMA Bulletin, XLVIII (1961), 46–50, fig. 1 (color); Creighton Gilbert, "The Classics," Arts, XXXV (1961), 12, illus. p. 13; Malcolm Vaughn, "The Connoisseur in America: Cleveland's Zurbarán," Connoisseur, CXLVIII (1961), 76, illus. p. 77; Theodore Crombie, "Book Reviews: Zurbarán and Spanish Monastic Painting, An Important New Assessment," Apollo, LXXXVII (1962), 553, illus. p. 554; Jaffé (1963), 467, fig. 6; Ramón Torres Martín, Zurbarán, El Pintor Gotico del siglo XVII (Seville, 1963), no. 154a, illus. p. CLVII; Richard Burton, "In Cleveland: The Idea of a

Figure 225.

Museum," *Museum Journal*, LXIII (1964), illus. p. 273; María Luisa Ca-
turla, *Exposición Zurbarán: en el III centenario de su Muerte* (exh. cat.,
Madrid, 1964), p. 20; Antonio Bonet Correa, "Obras Zurbaránescas en
Méjico," *Archivo Español de Arte*, XXXVII (1964), 161–62; José Manuel
Pita Andrade, "El Arte de Zurbarán en sus inspiraciones y fondos arqui-
tectónicos," *Goya*, nos. 64–65 (1965), 246, color illus. p. 247; José Ca-
món Aznar, "Casi todo Zurbarán," *Goya*, nos. 64–65 (1965), 320; Car-
men Gómez-Moreno, *Spanish Painting: The Golden Century* (New York,
London, and Toronto, 1965), no. 10, p. 39; Raffaelo Causa, *Zurbarán*, I
Maestri del colore, no. 181 (Milan, 1966), pls. XIV, XV; *Pinturas Españolas
siglos* XVI–XVII, Vol. XIV of *Cuadros de collecciones españolas* (Barcelona,
1966), p. 14; Francisco López Estrada, "Pintura y Literatura: Una Con-
sideración Estética en torno de la Santa Casa de Nazaret, de Zurbarán,"
Archivo Español de Arte, XXXIX (1966), 25–50, pls. I, II; *Selected Works*
(1966), no. 152; Guinard, *Les Peintres Espagnols* (Paris, 1967), fig. 122;
Ann Tzeutschler Lurie, "Two Devotional Paintings by Sassoferrato and
Carlo Dolci," CMA *Bulletin*, LV (1968), 224, 227 n. 12, fig. 10; Xavier
Moyssén, "Zurbarán en la nueva España," *Conciencia y autenticidad
Historicas* (Mexico City, 1968), pp. 231–33, fig. 7; Diego Angulo Iniguez,
Pintura del Siglo XVII, Vol. XV of *Ars Hispaniae* (Madrid, 1971), pp. 134,
138, fig. 115; Jonathan Brown, *Francisco de Zurbarán* (New York, 1973),
pp. 24, 80, pl. 11 (color); Mina Gregori and Tiziana Frati, *L'Opera com-
pleta di Zurbarán*, Classici dell'Arte, vol. 69 (Milan, 1973), 90–91, no.
65, pls. XI, XII; *The Cleveland Museum of Art*, The Little Art Book, ed.
Berthold Fricke (Hannover, 1975), p. 55, color illus.; Julián Gállego and
José Gudiol, *Zurbarán 1598–1664* (New York, 1977), pp. 39, 55, 97, no.
247, figs. 257, 259; CMA *Handbook* (1978), illus. p. 150; Jacques Thuil-
lier and Michel Laclotte, *Les Frères Le Nain* (exh. cat., Paris, 1978), p.
281; *Trafalgar Galleries at the Royal Academy II* (exh. cat., London,
1979), pp. 64, 67, fig. 1.

ANONYMOUS MASTER

Mid-seventeenth century

225 *Old Woman Asleep* 16.777

Canvas, 30.7 x 40.5 cm (painted surface). Monogram at the right
end of window sill: ARD [or ADR]/F.

Collections: James Jackson Jarves ; Mrs. Liberty E. Holden,
Cleveland, 1884.

Holden Collection, 1916.

This canvas was cleaned by William Suhr in 1930, and in
June of 1958 Joseph Alvarez cleaned it again, partially. The
top margin has been let out and the tacking holes have been
filled. Cusping on the right, left, and bottom margins of the
original canvas indicates there has been no appreciable
change in the dimensions of the canvas. There are vertical
losses in the lower right and upper left. Some repainting has
been done in the window area, and there has been some
strengthening of the highlights in the veil and the face of the
old woman which is somewhat disfiguring.

Delphine Fitz Darby (1940) attributed this painting to
the Flemish painter David Ryckaert III (1612–1661), an
attribution that was based largely on a mistaken identifica-
tion of the monogram. Darby's comparative material is not

convincing. Ryckaert's brushwork is quite different from the technique used in this little painting.

The misreading of the monogram has also led to the suggestion that the Dutch painter Abraham van Dyck (1635/6–1672) was the author of the painting. That attribution also seems extremely unlikely.

It is tempting to consider the Flemish painter Adriano Rodríguez (Adriaen Dierickx), who was born in Antwerp in 1600 or 1618 and went to live in Spain (he died in Madrid in 1669). Antonio Palomino de Castro y Velasco (*El Museu pictórico y Escala óptica*, 3 vols., Madrid, 1715–24; reprint ed., Madrid, 1947, pp. 956–57) says that Rodríguez changed his name from the Dutch because it sounded so strange to the Spanish when he entered the Jesuit order in 1648. Palomino cited five paintings by Rodríguez of religious subjects, formerly in the refectory of the old Colegio Imperial (Jesuit College), now the Cathedral of S. Isidoro, that were apparently destroyed by a bomb in the civil war in 1936–38. Fernand Donnet (*Bibliographie Nationale de Belgique*, XIX, 1907, 624–25) says that Rodríguez was a master in Antwerp in 1629 and that he went to Spain in 1630. The only painting attributed to Rodríguez is a *Portrait of an Admiral* in Munich (A. L. Mayer, *Münchener Jahrbuch der Bildenden Kunst*, 1913, pp. 181 ff., illus. p. 182; Halldohr Soehner, *Spanische Meister*, Munich [Bayerische Staatsgemäldesammlungen], 1963, I, 241, no. 981), but it is not at all certain that he painted this portrait, because the costume of the admiral is possibly from ca. 1630, when Rodríguez may have been only twelve years old (if we assume that 1618 was his correct birthdate).

An attribution of the Cleveland painting to Rodríguez is admittedly tenuous, but it does seem very probable that the picture was painted by a Jesuit of Flemish origin in Spain. The face has some influence from Adriaen Brouwer and Nicolas Maes, while the brushstroke and colors are surely Spanish. W S

EXHIBITIONS: Boston (1883), cat. no. 47; Cleveland, Hickox Building, 1849: Art Loan Exhibition, cat. no. 16 (section I); CMA (1916), cat. no. 52.

LITERATURE: Jarves (1884), p. 13, no. 31; Rubinstein (1917), p. 44, no. 52; Delphine Fitz Darby, "A 17th-Century Flemish Painting in the Cleveland Museum," *Art in America*, XXVIII (July 1940), 98–108, fig. 1; Coe (1955), II, 90, no. 34.

Switzerland

JEAN-ETIENNE LIOTARD
1702–1789

Liotard was born in Geneva, Switzerland, in 1702. He was the son of a French goldsmith, a Protestant, who fled from France after Louis XIV revoked the Edict of Nantes in 1685. Jean-Etienne studied briefly in Geneva and was then sent by his parents to Paris, where from 1723 to 1726 he studied with the miniaturist J. B. Massé (1687–1767). He departed suddenly from Massé's studio and began a life of constant and restless travel. He accompanied the Marquis de Puysieux to Naples and Rome in 1735. In Rome in 1736 he met Sir William Ponsonby, the future Count of Bessborough, with whom he traveled in the Middle East for five years, from 1738 to 1743. He remained in Constantinople five years, assuming Turkish customs, manners, dress, and appearance. When he returned to Vienna in 1743, he had an extensive reputation as the so-called Turkish painter. His travels then took him to Darmstadt, Basel, Lyons, Paris, London (1753), Holland (1755), Geneva (1757), and Venice (1762), with frequent returns to Vienna. When in London the second time, in 1773–74, he exhibited at the Royal Academy. He enjoyed the patronage of the royal courts throughout Europe. At the age of fifty-four he married Marie Fargues, the daughter of a French merchant in Holland; she and their several children accompanied him thereafter on his restless wanderings. By the late 1770s his popularity had waned and he returned to Geneva, where he owned an attractive property. He spent his last few years there writing a technical treatise, *Traité des principes et des règles de la peinture* (which was published in 1781), and experimenting with various methods of painting on glass and porcelain. He died in June 1789—one month before the outbreak of the French Revolution.

Liotard is most noted for his portraits in pastel, a fashionable medium in the eighteenth century (see also Paintings 38 and 75). His particular contribution to portraiture was an unyielding naturalism, a refusal to flatter his sitters, which of course brought him some criticism. He also worked in oils and painted miniatures on ivory and enamel.

Figure 226.

226 *Portrait of a French Actress* 46.464

Pastel on parchment, 63.8 x 48.2 cm. Label on back of paper backing reads: "Portrait of a French actress, pastel on vellum from Adrian Hope collection. Examined May 1, 1909, HEGP."

Collections: Adrian Hope; Edward B. Greene, Cleveland (purchased from Arnold Seligmann, Rey & Co., Paris, 1939).

Gift of Edward B. Greene, 1946.

The picture is in generally good condition. The parchment was remounted on a fixed strainer which was removed to permit the necessary repairs to be made. Several layers of paper and the glue adhesives were removed during this operation. The parchment was then reattached to its refurbished strainer. Uneven removal of hair from the parchment has left a fine stubble in some areas, which has somewhat disfigured the pastel. Shiny streaks across the sitter's bodice and in the drapery near her right hand indicate some rubbing. This pastel was treated in 1978 by Ann Clapp at the Henry Francis Dupont Winterthur Museum Paper Conservation Laboratory.

On his frequent visits to Paris and elsewhere, Liotard was attracted to the world of opera and the stage. Many actors

Figure 227.

and actresses sat for him, as did prominent intellectuals and the social and royal elite, who brought him financial success and artistic acclaim. The lady in the Museum painting—as yet unidentified—could be a French actress; she is holding a black domino mask, an attribute of the acting profession, in her left hand. Her costume is too simple to be that of royalty. She may be La Camargo, then one of the most famous dancers at the Paris Opera. La Camargo appears in a drawing by Liotard of about 1746, now in the Albertina in Vienna (N. S. Trivas, "Liotard in France," *Connoisseur*, CVI, September 1940, p. XI).

 N C W

EXHIBITIONS: None.

LITERATURE: Henry S. Francis, "Three Eighteenth-Century Portraits," CMA *Bulletin*, XXXIV (1947), 213–14, illus. p. 236; Coe (1955), II, 66, no. 15.

JEAN-ETIENNE LIOTARD

227 *Portrait of François Tronchin* 78.54

Pastel on parchment, 38.1 x 46.3 cm. Signed and dated at lower right: par J. E. Liotard/1757.

Collections: François Tronchin (catalogue, 1765; see Literature); inherited successively by Jean-Louis Robert Tronchin, Armand-Henri Tronchin (testament of 1866, no. 187), Louis-Rémy Nosky Tronchin, Henry Tronchin (estate inventory, 1928, no. 77), Robert Tronchin, Marquise de Hillerin, and Marquis de Hillerin; acquired by Xavier Givaudan, 1950; inherited by André Givaudan.

John L. Severance Fund, 1978.

This pastel portrait is in excellent condition. It has never been treated with a fixative.

The subject of the portrait, François Tronchin (1704–1798), held a post in the city government in Geneva, Switzerland. Though a man of business, he was especially devoted to the pleasures of music and poetry, the theater, and the collecting of pictures. He came from a long-established, distinguished Protestant family. His brother Jean-Robert (1710–1793), a banker in Lyons, became Fermier Général of France in 1762. His cousin, Théodore Tronchin (1709–1781), was a famous physician, one of the first to vaccinate against smallpox, and a doctor to the children of the Duke of Orléans. Through Théodore, François had access to the duke's collection, then the most famous in all France.

François Tronchin studied in Paris, where he made friends with Voltaire. After returning to Geneva, about 1740, he began to collect paintings. By 1765, when Tronchin published a catalogue of his collection, he had acquired one hundred pictures. In 1770 he sold most of the Dutch, Flemish, and Italian pictures to Catherine II of Russia for The Hermitage in St. Petersburg. Then, upon the advice of Diderot, Catherine called upon Tronchin to inventory the celebrated collection of Baron de Thiers, which she had

been advised to purchase. His inventory contains precise descriptions, new attributions, and perceptive critical remarks.

After the sale of his first collection, Tronchin formed a second of almost two hundred and fifty paintings, mostly Dutch and Flemish, which he published in 1780 (a revised catalogue was published in 1798, after his death). This collection was dispersed at sale in Paris in 1801, except for about thirty pictures which the family retained—the Museum panel among them. Tronchin's taste was neither modern nor adventurous, and his interest in the art of his time was almost completely confined to such Geneva artists as Jean Huber (1721–1786), Pierre de la Rive (1753–1817), Jean-Pierre Saint-Ours (1752–1809), and Jean-Etienne Liotard.

After Liotard returned to Geneva in 1757, he became the portraitist of city notables and travelers to Geneva. Tronchin was the first to give a commission to the artist, who executed portraits of both Tronchin and his wife. Liotard and Tronchin were in frequent communication; we know that Liotard sold Tronchin a picture by Breckelenkam between 1756 and 1780 (Exh: Geneva, 1974, cat. no. 81). In his 1781 *Traité des principes et des règles de la peinture* (reprint ed., Geneva, 1945, pp. 108–9), Liotard wrote that Tronchin had "a very beautiful collection of paintings in his country house called Les Délices; he has two of my best works: the first is his portrait, half-length, contemplating a Rembrandt on an easel. Before him on a table are a book, mathematical instruments, and papers which indicate his taste for the arts, especially architecture. This picture and that of Madame, his spouse, painted with a hood, both in pastel, have, I think, extraordinary finish, brilliance, effect, truth, and surface."

The painting represented on the easel in our pastel is Rembrandt's *Lady in Bed*, painted about 1645–46, now in the National Gallery of Scotland (inv. no. 827). The picture, formerly in the collection of the Prince de Carignan, was sold at auction in Paris, July 30, 1742, at which time Tronchin could have acquired it. (Tronchin wrote to Diderot on August 1, 1772 [Archives Tronchin, 180, pièce 34, Bibliothèque Publique et Universitaire, Geneva], concerning auction sales, saying that Paris was "the center of sales for one who has the nerve to attend them.") The Rembrandt painting was originally rectangular; then it was cut to a rounded top. According to Tronchin's entry in his 1761 catalogue manuscript, now in the Karlsruhe archives (see Benisovich, 1953), it is the frame for the Rembrandt painting which is hanging empty on the wall in the pastel. The Rembrandt work was exchanged with Count Vitturi of Venice sometime between 1761 and 1765 (Exh: Geneva, 1974, cat. no. 200).

Tronchin is not represented here as the lively personality he must have been, but his costume and wig and the table-top objects lend great dignity to him in his role as patron of

the arts. His gesture draws our attention to the Rembrandt painting, obviously the pride of his collection at that time. What makes the portrait such a striking work of art is Liotard's absolute control of color and tone—shadowed whites, highlighted blacks, transparencies of flesh, shimmering reflections in the tabletop—and the startling reproduction of the Rembrandt painting, all in a medium that does not allow error or correction. W S T

EXHIBITIONS: Geneva, Société des Arts, Classe des Beaux-Arts, 1886: Exposition Liotard, cat. no. 36; Geneva, Musée d'Art et d'Histoire, 1925: Exposition Liotard (catalogue published in *Pages d'art*, January 1925, p. 103); Paris, Musée de l'Orangerie, 1948: Exposition Liotard-Füssli, cat. no. 14; Geneva, Musée d'Art et d'Histoire, 1974: De Genève à l'Ermitage, Les Collections de François Tronchin, cat. no. 347, illus., color cover.

LITERATURE: "Catalogue des Tableaux de Mon Cabinet, De Monsieur Tronchin, Conseiller, Genève 1765" (manuscript, Frick Art Reference Library), no. 97; Jean-Etienne Liotard, *Traité des principes et des règles de la peinture* (Geneva, 1781; reprint ed., Geneva, 1945), pp. 108–9; Johann Rudolph Sinner, *Voyage historique et littéraire dans la Suisse occidentale*, II (Neuchâtel, 1781), 42; Charles Giron, "L'Exposition Liotard," *Journal de Genève* (May 12, 1886), p. 2193; Henry Tronchin, *Le Conseiller François Tronchin et ses amis Voltaire, Diderot, Grimm, etc.* (Paris, 1895), p. 258, illus. (frontispiece); Edouard Humbert, Alphonse Revilliod, and J. W. R. Tilanus, *La vie et les oeuvres de Jean-Etienne Liotard 1702–1789* (Amsterdam, 1897), p. 129, no. 78, illus.; Daniel Baud-Bovy, "Le mouvement d'art en Suisse: Peintres genèvois," *Gazette des Beaux-Arts*, XXVIII (1902), 105; Jules Crosnier, "Bessinge," in *Nos Anciens et leurs oeuvres* (1908), p. 104, illus.; Léandre Vaillat, "J.-E. Liotard," *Les Arts*, X, no. 118 (1911), 24; Henri Clouzot, "Les Pastels de Genève," *La Renaissance de l'art français*, III (April 1920), 164; Louis Gielly, "L'Exposition Liotard en 1925," *Revue de l'art ancien et moderne*, L (1926), 256, 271; François Fosca, *Liotard* (Paris, 1928), pp. 65–69, illus. opp. p. 80 (Geneva, 1928, p. 57, illus. p. 161); Gielly, *L'Ecole genèvoise de peinture* (Geneva, 1935), pp. 46, 207; Lucien Fulpius, "Une demeure historique: Les Délices de Voltaire," *Genava*, XXI (1943), illus. p. 204; Paul Ratouis Limay, *Le Pastel en France au XVIIIème siècle* (Paris, 1946), p. 133; Jacques Combe, "Liotard," *Les Arts plastiques*, no. 9–10 (1948), 377; Michel Benisovich, "Les collections de tableaux du Conseiller François Tronchin et le Musée de l'Ermitage," *Genava*, n.s., I (1953), 40, no. 80, illus.; Fosca, *La vie, les voyages et les oeuvres de Jean-Etienne Liotard* (Lausanne and Paris, 1956), pp. 81–82, pl. XI; Fosca, "Un peintre genèvois du XVIIIᵉ siècle: Jean-Etienne Liotard," *Jardin des Arts*, no. 27 (1957), 168, illus. p. 166; Giovanni Previtali, *Jean-Etienne Liotard*, Maestri del Colore, no. 240 (Milan, 1966), unpaginated, pl. XII; Jean Cailleux, "Portrait d'un amateur," *VIIème Biennale Internationale* (1974), see Preface (unpaginated) and color illus.; Renée Loche and Marcel Röthlisberger, *Jean-Etienne Liotard* (Milan, 1978), cat. no. 220, color illus.

Index

537